Renoir

Renoir

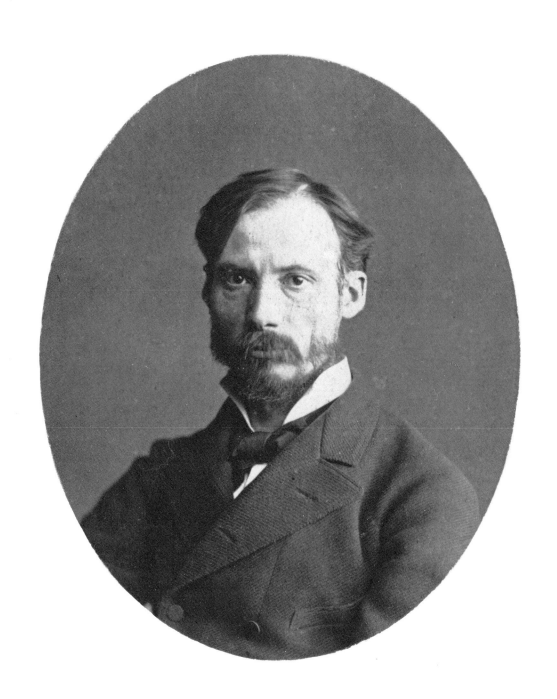

Renoir

HAYWARD GALLERY, LONDON
30 January – 21 April 1985

GALERIES NATIONALES DU GRAND PALAIS, PARIS
14 May – 2 September 1985

MUSEUM OF FINE ARTS, BOSTON
9 October 1985 – 5 January 1986

The exhibition has been organized by the Arts Council of Great Britain in collaboration with the Réunion des musées nationaux and the Museum of Fine Arts, Boston.

The exhibition and catalogue are made possible by a grant from the IBM Corporation.

Additional support for the presentation in Boston has been provided by the National Endowment for the Arts, a Federal agency.

Exhibition organized by Susan Ferleger Brades assisted by Jocelyn Poulton

Catalogue edited by Michael Raeburn

Designed by Dennis Bailey/ Editorial Design Consultants

Translations by David Macey

Colour originations by SCALA Istituto Fotografico Editoriale S.p.A., Florence

Printed and bound in Great Britain by Jolly & Barber Limited, Rugby

COVER *Dance at Bougival*, 1882–3 (detail) Museum of Fine Arts, Boston (no. 67)
FRONTISPIECE Photograph of Renoir, 1875 Musée d'Orsay, Paris (Galerie du Jeu de Paume)

Contents

Exhibition committee

Selectors

Anne Distel, *Musée d'Orsay, Paris*

John House, *Courtauld Institute of Art*

John Walsh, Jr, *The J. Paul Getty Museum, California, formerly of the Museum of Fine Arts, Boston*

Arts Council of Great Britain

Sir Roy Strong, *Chairman, Advisory Panel on Art*

Joanna Drew, *Director of Art*

Andrew Dempsey, *Assistant Director, London Exhibitions*

Susan Ferleger Brades, *Exhibition Organizer*

Réunion des musées nationaux

Hubert Landais, *Directeur des Musées de France, Président du Conseil Administratif de la Réunion des musées nationaux*

Michel Laclotte, *Inspecteur Générale des Musées, chargé de la conservation du Département des peintures du Musée du Louvre et des collections du Musée d'Orsay*

Irène Bizot, *Administrateur délégué de la Réunion des musées nationaux*

Museum of Fine Arts, Boston

Jan Fontein, *Director*

Theodore E. Stebbins, Jr, *John Moors Cabot Curator of American Paintings*

G. Peabody Gardner III, *Assistant to the Director*

Foreword

Renoir is perhaps the most popular French impressionist painter, but surprisingly there has not been a major retrospective exhibition of his work in Paris since 1933, in Britain since 1953 or in America since 1973. This exhibition aims to examine for the first time the full extent of Renoir's achievement, his seminal contribution to the impressionist movement and his relationship to European figurative and landscape painting traditions.

The exhibition follows those devoted to Millet and to Courbet which were jointly organized by the Arts Council of Great Britain and the Réunion des musées nationaux in 1976 and 1978 and, more recently, to Pissarro held in 1980 with the added participation of the Museum of Fine Arts in Boston.

The Arts Council was responsible for the administrative arrangements for the show with the collaboration of the Réunion des musées nationaux and the Museum of Fine Arts. The task of selecting Renoir's finest paintings from his prodigious output was undertaken with knowledge and enthusiasm by John House, Anne Distel and John Walsh, Jr, to whom we are most grateful. The catalogue has been written by Dr House and Mme Distel, and we would like to express our thanks to them and to Sir Lawrence Gowing, who has contributed an essay. We would also like to thank those who have given advice during the preparation of the exhibition and catalogue and whose names are given on page 8.

We are greatly indebted to the IBM Corporation for their sponsorship of the exhibition.

The exhibition has been made possible only through the generous collaboration of the owners of Renoir's paintings who have agreed to lend works central to their collections for such a long period. Their names are listed on page 9.

Joanna Drew
Director of Art, Arts Council of Great Britain

Hubert Landais
Directeur des Musées de France

Jan Fontein
Director, Museum of Fine Arts, Boston

Acknowledgments

The organization of a major international exhibition is always the work of many people, not all of whom can be properly acknowledged here. I would like to take this opportunity to thank our colleagues at the Arts Council of Great Britain and the Réunion des musées nationaux. In particular, Joanna Drew, Andrew Dempsey and Susan Ferleger Brades of the Arts Council; and Hubert Landais, Michel Laclotte and Irène Bizot at the Louvre.

In Boston, special recognition should go to Theodore E. Stebbins, Jr, assisted by Alexandra Murphy, Helen Hall, and Patricia Loiko in the Department of Paintings. Linda Thomas and Lynn Herrmann dealt with countless details of transport and insurance. Tom Wong and Judith Downes designed the installation. William Burback, Joan Hobson, Nancy Howard and Barbara Martin devised an ambitious educational program. Alain Goldrach, Jean Woodward, and Brigitte Smith were responsible for the inspection and care of the paintings. Janice Sorkow coordinated all photographic matters. Clementine Brown, Linda Patch and Charles Thomas helped assure a large audience. William Murphy oversaw all aspects of operations including security and installation, John Morrison and Clifford Theriault took care of implementing the design. Ross W. Farrar, G. Peabody Gardner III, Katherine Duane, Charles Taggart, and Janet Spitz guided the solicitation of funding and coordinated all practical matters.

Special thanks are due to John Walsh, Jr, former Baker Curator of Paintings, who was responsible for the planning and selection of this exhibition in its early stages. He was assisted by Cynthia Schneider, also formerly of the Paintings Department.

In addition to the generous support from the IBM Corporation for the entire exhibition, the Museum received a grant from the National Endowment for the Arts, a Federal agency.

Jan Fontein
Director

The organizers wish particularly to express their gratitude to Monsieur and Madame Charles Durand-Ruel, for their outstandingly generous support for the exhibition and its catalogue and to Mlle France Daguet and Mme Caroline Godefroy for their help and co-operation in the Archives Durand-Ruel. Special thanks are here given to Isabelle Cahn, who helped with the documentation of the chronology. We would like to thank the officers and employees of the French *état-civil* who have assisted us. We would also like to extend our gratitude to those who helped throughout the preparation of the exhibition and catalogue, namely William Acquavella, Juliet Wilson Bareau, William Beadleston, Mrs J. M. Beecham, Maria van Berge, François Bergot, Marie-Laure Bernadac, Ernst Beyeler, Annette Blaugurund, Marina Bocquillon, Richard Brettell, David Brooke, Harry Brooks, Kevin Buchanan, Christopher Burge, Claire Bustarret, Françoise Cachin, Jean-Gilles Cahn, David B. Cass, Claude Chambolle-Tournon, François Chapon, M. Jacques Chardeau, Hubert Collin, Me. Albert Collet, Philippe Comte, Desmond Corcoran, Claude Cosneau, Götz Czymmek, Anne D'Harnoncourt, MM. Dauberville, Marie-Amynthe Denis, Lieutenant-Colonel Denisse, Georges Dussaule, M. Dutar, Dennis Farr, Sarah Faunce, Richard L. Feigen, Mrs Walter Feilchenfeldt, Andrew Forge, M. Philippe Gangnat, Tamar Garb, Louis-Marcel Garriga, Christian Geelhaar, Mme Jacqueline George-Besson, Mary Giffard, Pontus Grate, Hélène Guicharnaud, Lynne Hanke, Paula H. Harper, M. Henkels, M. Henriquet, Jacqueline Henry, Norman Hirschl, Michel Hoog, Jill House, Ay-Whang Hsia, M. Kellermann, Peter Krieger, Monique Laÿ, Peter Lasko, Jean-Charles Leboeuf, Sir Michael Levey, Susanne Lindsay, Nancy Little, Hugh Macandrew, Madeleine Marcheix, Marlborough Fine Art (London) Ltd, Auguste Menez, Hamish Miles, Michael Milkovich, Charles Moffett, Sophie Monneret, Alexandra Murphy, David Nash, Philippe Néagu, Sasha Newman, Oriane Norembuena, Mme. Nouel, Pamela S. Parry, Anne Pingeot, Père Ploix, François Pomarède, Evelyne Possémé, Robert Ratcliffe, Gaillard Ravenel, Mme D. Rémy, John Rewald, Aileen Ribeiro, Michèle Richet, Joseph Rishel, Anne Roquebert, M. Edouard Senn, Frances Smyth, Claude Souviron, Michel Strauss, Charles Stuckey, Martin Summers, M. Suriano, David Sylvester, Antoine Terrasse, E. V. Thaw, Gary Tinterow and Michael Wilson.

Lenders

Renoir's worlds

JOHN HOUSE

Renoir's paintings present us at first sight with a world without problems or uncertainties: a world of smiling faces and luminous colour, conjured up by seemingly spontaneous technique. Their untroubled accessibility has brought many of his images an enormous popularity. But is this the whole Renoir? Is it even a half-truth about the man and his art? In the past twenty years this image has been vastly enriched, but essentially upheld, by a remarkable book, Jean Renoir's *Renoir, My Father*, which presents the memories and evocations of the painter's old age, filtered through the equally richly lived experience of his film-director son.[1] But as we explore the evidence of Renoir's earlier years – years for which we have no such eloquent testimony – we find a more confused, more contradictory picture: both his art and his life were built around contradictions which force us to reconsider our first impressions.

The development of his art was far from straightforward. In 1879 he could be hailed as the principal painter of the everyday life of modern Paris, yet by 1886 he was insisting on the prime importance of the nude.[2] In the 1870s he had developed an apparently effortless sketch-like technique, yet he spent the following decade in the shadow of Ingres and the artists of the Renaissance, teaching himself how to paint and draw; and even when his painting had regained its fluency in the 1890s, he advised the study of Mantegna as an integral element in a student's training.[3]

Socially, too, his position was contradictory. He came from a working-class family, yet cultivated wealthy middle-class patrons and friends, who remained for a decade unaware of his liaison with a working-class woman, until he married her in 1890, five years after the birth of their first child. His appearance and habits, too, belied the apparent serenity of his art. Always restive and nervous, he was ill at ease in social situations, often contradictory in the opinions he expressed. He worried constantly about the adequacy of his technical procedures, endlessly making rapid sketches even when he had nothing to say. Few, if any, of these were destroyed, to which we owe the mass of authentic but trivial canvases which have so damaged his reputation. To assess him as an artist, we have to re-examine his most fully realized paintings in all their diversity. But this diversity can best be understood by analyzing the contradictions which lie behind his life and art.

Renoir's father was a tailor, who moved from Limoges to Paris when Renoir was about three years old; in the later 1860s, aged nearly seventy, he retired and went with Renoir's mother to live at Louveciennes, a village about ten miles west of Paris. Renoir later described how his father's trade had been threatened by mechanization,[4] and his own first trade – he was apprenticed as a porcelain painter to a M. Levy – was also undermined by machine-produced goods which spoiled the market for hand-painted products.[5] Thus in his youth he had received his first artistic training in a traditional apprenticeship and had at the same time witnessed, in both his own trade and his father's, the destruction that technological development was bringing to these artisanal traditions. These experiences established basic attitudes and prejudices which he reiterated throughout his life – attitudes which went beyond a simple regret at lost manual skills to a nostalgia for the structures of society that had made such methods of production possible.

By studying with Gleyre and entering the Ecole des Beaux-Arts, Renoir was moving from this artisanal tradition of training to the codified educational methods of the art school. By deciding to become a painter he was also moving from a trade to a profession – from the skilled working class into which he had been born to an activity which, by the mid-nineteenth century, was essentially middle-class. Renoir himself later accepted that he was a bourgeois, but also insisted that he remained an 'ouvrier de la peinture'.[6] The friends he made in his new career were of a different class from himself. Bazille (cf. no. 6) was the son of a prosperous agronomist and vine-grower from the south who supported his son's artistic ambitions, Monet of a wholesale grocer from Le Havre who could afford to give his son an allowance when he chose to. Renoir, by contrast, seems to have depended on the money which he had himself earned as a decorative painter.[7] Thus when Bazille shared his studio with his friends, Monet was playing the role of a bohemian who had rejected parental authority, while Renoir simply had to seek the cheapest way to live. Two other good friends of these years, Jules Le Coeur (cf. no. 5), son of a successful business contractor, and Sisley (cf. no. 9), both had parents who could ease Renoir's difficulties by commissioning portraits from him.

The social frameworks which Renoir constructed for himself in his maturity reflected the disjunction between his class

identity and the circles with which his career as a painter brought him into contact. Personally he lived the life of a nomad,[8] in a succession of rented studios and apartments, even after his marriage to Aline Charigot in 1890 and the birth of their first two sons, Pierre in 1885 and Jean in 1894. De Wyzewa noted this restiveness in 1903: 'He has in his blood an unfortunate need for change, which illness has aggravated. He cannot stay two years in the same place: his nerves grow impatient, and he needs to try to feel better somewhere else. He has been like this all his life, just like Watteau, whom he resembles in so many ways.'[9]

From around 1873 to 1883 the focus of his life was his studio in the rue Saint-Georges in Paris, very much an artisan's lodging, which became the meeting place for the circle later eloquently described by Georges Rivière.[10] Renoir was on friendly terms with the colleagues who exhibited alongside him in the impressionist group exhibitions, and Monet always remained a close friend; but from this group it was only Pissarro, another outsider, who frequented the rue Saint-Georges studio. The other habitués were mostly younger men than Renoir, from a variety of professions.

Around 1880 he met Aline Charigot, who had recently come to Paris from her native Essoyes in southern Champagne to work as a dressmaker. Renoir first depicted her as one of the young models in his scenes of modern suburban life (cf. nos. 52 and 69), but, particularly after Pierre's birth in 1885, he came to associate her with her roots, depicting her as a country girl (cf. nos. 78 and 79).[11] We know little about his home life between his departure from the rue Saint-Georges around 1883 and his move, soon after his marriage in 1890, to the 'Château des Brouillards' in rue Girardon on the hill of Montmartre. There he and Aline cultivated a simple, rustic life style, deliberately rejecting any fashionable trappings.[12] He created another informal circle of younger friends who visited him regularly there, and he was evidently on easy, friendly terms with many of the young artists who frequented Montmartre.[13] His regular companions at the rue Saint-Georges and at the 'Château des Brouillards' were not a group of his peers. He seems to have been most at his ease amid people with whom he was in no way in competition – some of them outsiders like himself, including eccentrics like the musician Cabaner, and many younger men, with whom he was quickly on relaxed, informal terms.

He never bought a house or apartment in Paris. Only in 1895 did Aline persuade him to buy 'a house that he does not want to buy' in her native Essoyes. Even when he was spending every winter at Cagnes on the Mediterranean coast, and his ill-health made a more permanent home desirable, it was Aline who instigated their search for a property; it was she, too, it seems, who insisted that they build themselves a substantial house on the estate of Les Collettes, which they bought in 1907, instead of living in the picturesque old farmhouse that stood there.[14] But even as a houseowner, Renoir did not become a part of the communities in which he lived. The Renoirs' house at Essoyes was in the upper half of the village, along with the vine-growers, not the country workers; but, to the locals, their eccentrically dressed bands of bohemian visitors

marked them out as outsiders: they were tolerated by the village, not absorbed into it.[15] Cagnes and the house there were still further from Renoir's roots. Its isolation was only eased by the visitors, mainly younger artists, who came especially to see him; even before Aline's death in 1915, Renoir rented an apartment in nearby Nice to escape from it. He wrote to Albert André in 1914: 'I'm much enjoying myself in this apartment in Nice. I feel less cut off than at Les Collettes, where I feel as if I am in a convent.'[16]

The other facet of Renoir's social life belonged more closely with his art. From the mid-1870s onwards he built a circle of acquaintances among fashionable, well-to-do art lovers, largely through his contacts with the publisher Georges Charpentier and his wife (cf. no. 44). The many portrait commissions which Renoir gained from these contacts were virtually his sole livelihood between 1876 and 1880; after that, the dealer Paul Durand-Ruel began regularly to buy his work. One of Renoir's wealthy patrons, Paul Berard, became a lifelong friend, seemingly because he preferred the artistic *vie de Bohème* to the company of his own social set.[17] But Renoir's relations with his patrons, though cordial, generally retained a certain distance. Even with Madame Charpentier, whose salon he frequented, a warm, good-humoured friendship was structured around a recognition of the difference between patroness and her 'painter in ordinary', as he tellingly signed himself in a letter to her soon after painting her portrait, jokingly likening his role in the circle of his bourgeois patroness to that of a court painter in his beloved eighteenth century.[18]

In the 1890s, his main contacts among the artistic *haute bourgeoisie* were with the circle around Berthe Morisot – particularly with Mallarmé and with Morisot herself – contacts of which the diary of her daughter Julie Manet has left so vivid and sympathetic an account.[19] He was treated by these friends with great respect and a warm camaraderie, which Degas's photograph of Renoir with Mallarmé well expresses (repr. p. 306); but Renoir's style of life maintained a difference between him and them. They had known nothing of Aline until Renoir brought her with six-year-old Pierre to visit Berthe Morisot in the country in 1891, a year after their marriage. Their relations with Aline became cordial, but 'that very ungainly woman' who so surprised Morisot on their first meeting had no place in such artistic circles.[20] As in Madame Charpentier's circle, Renoir's role was like that of the eccentric artistic genius at the cultivated court. Another patron and friend of the 1890s, Paul Gallimard (cf. pp. 23–4), was valued by Renoir as 'a true eighteenth-century Frenchman'; later, when painting the portraits of the Bernheim family (cf. p. 269 fig. b), rich art dealers, he enjoyed looking in on their lavish life style, but always as an outsider.[21]

In his personal manners, Renoir made absolutely no attempt to conform with the norms of fashionable society. The greedy table manners and nervous tic which amused Berard greatly offended the mother of Jacques-Emile Blanche. On one occasion, he forgot to put on his dress coat for a formal dinner with the Charpentiers; his notorious absent-mindedness even found its place in contemporary gossip columns.[22]

In all of his social roles, Renoir was careful to stress his otherness, to emphasize that he did not naturally belong to that particular milieu. Jean Renoir's account suggests that he felt most at ease within the family circle. But the fact that he only married Aline when Pierre reached school age (a fact carefully concealed from Jean), and his reluctance to buy a house, preferring the mobility that renting allowed him, suggest that he was also unwilling to commit himself to the model of the nuclear family.

These paradoxes and contradictions recur in his friends' descriptions of his behaviour and conversation. All commented on his agitated, anxious personal manner, his restive gestures and his erratic, voluble patterns of speech. Beneath this surface agitation, his close friends found an essential simplicity and cordiality, though to another observer he appeared a misanthrope.[23] His anxiety expressed itself most obviously in an obsessive concern about the welfare of his children – a concern which Aline shared.[24] He also detested inactivity, solitude and silence. As early as 1866, Jules Le Coeur's sister commented that he was 'like a body without spirit when he has nothing underway'. Jeanne Baudot remembered how he loathed silence, always humming and talking to his models; his household, too, was always busy and bustling. But when the noise came from a phonograph which Jean was given, Renoir's hatred for machinery overrode his dislike of silence, and he declared that the instrument 'threatens to destroy a great blessing: silence'.[25] Contradictions like this were characteristic of Renoir. Throughout his life he found it difficult to make up his mind, incessantly changing his plans, and constantly changing the opinions he had just expressed.[26] As Pissarro wrote in 1887: 'Who can understand the most changeable of men?'[27]

It was because of the changefulness of his conversation that his friends were quick to condemn the dealer Vollard's book on Renoir. Georges Besson, reviewing the book, claimed to quote Renoir's own comments on Vollard's methods: 'He transcribed my opinions on everything and nothing. . . . In a conversation between friends, all sorts of outbursts and exaggerations are permitted; but to reproduce them exactly is a deception of the public. I've had ten different opinions on the same subject, according to the day and my mood. I mock an artist, a writer, a politician because one has to mock someone. Vollard has no tact, no sensitivity. I only have to utter some enormity, and he is delighted and rushes to his office to note it down.' To Jean, Renoir responded to Vollard's book in far more moderate terms.[28]

No one seems to have questioned that Renoir in fact made most of the remarks that Vollard attributed to him; but these remarks, when they were all presented as equally serious and considered expressions of his opinion, could be wholly misleading, isolated from their context in his conversation. For the present-day reader, Vollard's book remains an important source, but his evidence has to be weighed up against information from other sources. It was to avoid the recording of his casual, off-the-cuff comments that Renoir asked two of his other early interviewers, Walter Pach and Albert André, to avoid such anecdotes; André's account, in particular, remains the most balanced expression of the considered opinions of Renoir's later years.[29]

Renoir's uncertainties were not just personal; the practice of painting perpetually perplexed him. Discussion of his technical problems has focused, with some justification, on the decade of the 1880s, during which he deliberately set about relearning the methods of drawing and painting by studying the old masters, feeling that his technique of the 1870s had been too imprecise, too lacking in form.[30] But his very evident experimentation during these years – investigating ways of reconciling line and form, drawing and colour – should not obscure the fact that, throughout his career, he felt that his craft was inadequate. He continually pursued his quest for 'true painting' – a phrase which he had used as early as 1866. The theme of search and discovery recurs in his letters of the 1880s, certainly; he wrote to Deudon from Italy in 1881: 'I dare not tell you that I have found what I am looking for, because for around twenty years I've believed that I have discovered the art.' But even in the mid-1890s, when his phase of manifest experiment was past, he was still discontented with his work and claimed that he did not know how to paint or draw. One of his last utterances was, reputedly: 'I think I'm beginning to understand something about it.'[31]

The focus for his dissatisfaction was his lack of a real training in technique. He endlessly reiterated his belief that, first and foremost, a painter should learn his métier, and he attributed the current state of the art of painting to the breakdown of the tradition of apprenticeship, which had been replaced by the mechanical training of the art schools with their false worship of regularity.[32] He developed his attacks against regularity most fully in the draft proposals he wrote around 1884 for a projected *Société des irrégularistes*, at a time when his own technical uncertainties were at their height.[33] In his later descriptions of his own art he emphasized the prime importance of artisanal experience, values which echoed his father's trade and his own first training as a porcelain painter, insisting that he should be described as a 'painter' or even an 'ouvrier de la peinture' rather than as an artist.[34] He always distanced himself from the theorists and intellectuals of painting; but occasionally he also felt the need to emphasize that his modest claims for his art should not be taken too literally, and that painting was something more than mere craftsmanship: a true painter needed 'finesse and charm' and also 'serenity'; his work should give evidence of the 'supremacy of the mind'.[35]

Renoir's art reflected his anxiety in another way, in the masses of small, casual sketches he made. At times he claimed that these were his most experimental and imaginative work.[36] But he admitted that he produced them out of laziness when he could not sustain the effort needed for a substantial picture;[37] according to Arsène Alexandre, it was during his periods of anxiety that he 'multiplied his sketches, throwing numbers of them on a single canvas, here and there, heads of girls and children, flowers, fruit, fish, game – whatever he had in reach at the moment'.[38] It was not his intention to exhibit these,[39] but he later admitted that he had had to sell many of them in order to survive, since he did not produce enough substantial

pictures. By the early years of this century, the scraps he sold were already greatly damaging his reputation.[40] This continual need to paint, as a sort of nervous tic rather than out of any sustained concern with what he was doing, is a further symptom of his fear of inactivity and his need to occupy his senses in some way as a means of dealing with his anxiety.

In his conversations in his last years, Renoir repeatedly likened the course of his life and career to a cork thrown in a river, its movements dictated by the vagaries of the currents in the water, going it knows not where.[41] Certainly in his life and art we find him often changing course, restively searching, often without knowing what he sought. But many of his friends commented on the startling contrast between this Renoir whom they knew so well and the pictures he produced – pictures which showed no sign of their maker's perplexity and anxiety, and which presented a world untroubled by mistrust or social divisions.[42]

Renoir was adamant that he painted for pleasure. He often retold the story of his exchange with Gleyre when a student: '"Doubtless you paint for your own amusement?" "Yes, I assure you that if it didn't amuse me, I wouldn't do it."'[43] In his old age, when crippled by arthritis, he was sustained by his continuing ability to paint; he wrote to André in 1910: 'Happy painting which, very late in life, still gives you illusions and sometimes joy.'[44] The pleasure of painting was inseparable from his belief that paintings should give pleasure and that this was their prime purpose; he told André: 'Painting is done to decorate walls. So it should be as rich as possible. For me a picture – for we are forced to paint easel pictures – should be something likeable, joyous and pretty – yes, pretty. There are enough ugly things in life for us not to add to them. I well realize that it is difficult for painting to be accepted as really great painting whilst remaining joyous. Because Fragonard smiled, people have quickly said that he is a minor painter. They don't take people seriously who smile.'[45]

For Renoir, only a pleasing subject could produce a pleasing painting: all his statements about art show that subject and effect were inseparable for him. This point of view, in the hands of a Puvis de Chavannes or a Burne-Jones, provided a straightforward justification for an idealist art, consciously distanced from the social realities of the day. However, Renoir could not adopt their solution. There seem to have been two basic reasons for this. First, the process of abstraction and generalization by which Puvis and Burne-Jones created their ideal worlds was at odds with the intense physicality of Renoir's responses to the world and of the responses which he wanted his paintings to evoke; he told André: 'I like a painting which makes me want to stroll in it, if it is a landscape, or to stroke a breast or a back, if it is a figure.'[46] Secondly, his artistic experience was forged in milieux which insisted that an artist paint his own world, the contemporary scenes around him; as his brother Edmond wrote in 1879: 'Apart from its artistic value, his oeuvre has the particular charm of a faithful picture of modern life. What he has painted, we see every day; it is our existence which he has registered in pages which will surely remain among the most lively and the most harmonious of the age.'[47]

But for many of his contemporaries the world around them was not the untroubled, smiling place that Renoir presented; Manet and Degas in painting, Zola and Maupassant in literature, conceived of it very differently. Renoir's image was, as many of his associates realized, both selective and edited – in what he chose to paint and how he chose to paint it. He criticized Maupassant and Zola for seeing everything black; Maupassant criticized him for seeing everything rose; Degas could not forgive him for embellishing his models.[48] At the end of his life Renoir could freely accept this verdict: 'One must embellish,' he told Bonnard.[49] But within the modern-life painting of the 1870s his vision of the world was an anomaly.

On one level he refused to confront any significance in a scene beyond its purely visual effect. Outspoken in his opposition to narrative painting, he could envisage treating even a battle scene as he would a bouquet of flowers.[50] In the same terms, he was fascinated by childhood, seeking to re-create in his paintings of children his idea of the child's immediate response to visual experience, unconditioned by the knowledge of good and evil (cf. no. 95); he was enchanted by children, he told Roux-Champion, because 'their mouths utter only the words which animals would utter if they could talk'.[51] But of course his paintings present an image of an adult world, not merely a purely innocent optical surface. The basic assumptions which lay behind this image need to be isolated in order to understand his art, particularly since around his smiling pictorial world he constructed a homespun social philosophy; this vacillated between the descriptive and the prescriptive: between a wish to believe that the 'real' world was as he depicted it, and arguments to show why it ought to be like that, if it was not. Within his views about the structure of society, there were two crucial issues: first, the question of social order and hierarchy, and second, the role of women.

Renoir dreamed of a society where everyone knew their place, and harnessed this idea on to a vision of society before the rise of the bourgeoisie, who had, he claimed, swamped a natural order of inherited values by their ambitions and pretentions.[52] Most specifically, he railed against contemporary tastes for fussy, over-elaborate goods and against the machines that had made them – machines which had destroyed the worker's pleasure and pride in his work.[53] These attitudes, in themselves, recall the contemporary views of William Morris and the Arts and Crafts movements. But for Renoir they were not part of a desire radically to redesign society; they belonged to a mainstream of contemporary reactionary thinking. The social formations of which he dreamed were an idealized abstraction from his ideas about the past, which he developed into a cult for the remnants of eighteenth-century society; his wishes for the future amounted to little more than a desire to reverse the passage of time. For him the modern worker was a victim, ensnared by the machine and the demands of the capitalist market; but at the same time Renoir was terrified by the idea of Socialism and by the possibility that workers might themselves gain any power: 'From the day when the *ouvriers* called themselves *travailleurs*, France has been done for.'[54] The peasants of the south, he told Pach, should be happy with their

lot: '"You're fortunate – you have a little money; if you've had a bad season you don't suffer from hunger; you can eat, you can sleep, you have work that takes you out into the open air, into the sunlight." What more can anyone want? They are the happiest of men, and they don't even know it.'[55]

In the world around him, as an interviewer noted in 1892, Renoir felt a 'horror at its tormented aspects. . . . He loves everything that is joyous, brilliant and consoling in life.'[56] Sometimes he claimed that the world was so pleasant a place; he told Julie Manet that 'in the past when he frequented the Moulin de la Galette, he noticed how many delicate feelings there were among the people whom Zola depicted as appalling.' He remembered how, in the dazzling sunlight of Algiers, the sordid rags of a beggar came to look like a royal robe of gold and purple; only when he came close did he see him for what he was.[57] Such a transformation was not just the result of the southern sun; it reflected his personal quest for a surface beauty which transcended human suffering. On that occasion, distance lent enchantment and proximity brought disillusion; but his later memories of Algeria played down any awareness of barriers of race, culture and poverty. When Jeanne Baudot visited the place in 1904, over twenty years after his own visits, he wrote to her: 'I was glad to see that you were in Algeria, where one feels so far away yet so near, where the Arab seems like an old comrade whom one has always known. One mustn't, though, trust this amiable rogue too much, but it's all very amusing.'[58] Memory and selective vision could at times almost persuade Renoir that the world was the place of his dreams, a place without divisions, without conflicts of culture or interests, where everyone was content with their station in life – and, of course, a place where he, too, could feel that he truly belonged.

But he also realized how this vision, as he presented it in his paintings, involved a ruthless selectivity. Criticizing the work of Raffaëlli, he commented that 'there are no poor in painting'; on another occasion he said: 'When Pissarro painted views of Paris, he always put in a funeral; I would have put in a wedding.'[59] In his art, though, he could present this vision as if it were a reality. The view of Montmartre life in *Ball at the Moulin de la Galette* (no. 40) and *The swing* (no. 39) evokes the 'delicate feelings' he found there in scenes of decorous courtship; in *Luncheon of the boating party* (no. 52), the entertainments of the suburban riverside create a scene of untroubled sunlit festivity. His country peasants, even if they are working as washer-women (nos. 81, 117 and 118), never evoke heavy toil or dirt; they seem to relish their work in the sunlight. Around 1907, Renoir showed Maillol a canvas depicting two lovers in the countryside drinking a bowl of milk and explained to him: 'They have been walking, they are tired, they have arrived at a farm and they have been given a bowl of milk.'[60] This simple, seamless scenario sums up the vision of society of which Renoir dreamed, and which he depicted.

This vision was quite at odds with that of Renoir's impressionist colleagues. During the 1870s, both Degas and Manet treated modern urban scenes in compositions which undermined the conventional image of harmonious social interchange, using open spaces and breaks of focus to suggest that observed reality might be fragmented and incoherent. At the same time, Monet, in his studies of the effects of sunlight, was treating every element in a scene with equally weighted coloured touches, undermining the primacy traditionally given to the human presence. In pictures like *Ball at the Moulin de la Galette* Renoir paid lipservice to both of these alternative conventions, in the disjunction between foreground and background, and in the scatter of coloured patches which suggest the play of sunlight through the trees. But even here he did not pursue their implications: the various groups of figures are clustered together to suggest easy social interchange, with no trace of irony or distancing; and, under the play of light, the figures remain distinct, dominant focuses, rather than being absorbed into an ambient atmosphere. In Renoir's later compositions, even those depicting modern scenes, such as the *Dance* canvases of 1882–3 (nos. 67–9), the compositions became still clearer, the groups still more harmoniously interwoven: nothing distracts from the central core of human experience and the celebration of traditional humanistic values.

Pissarro's later peasant compositions, like Renoir's, present an idealized vision of the countryside, but his vision of labour evoked a potential future society, based on his anarchist political beliefs. Renoir, by contrast, distanced himself from overt political concern by turning the countryside into a site for idyllic and timeless visions of harmony and repose – politically reactionary in their appeal to such unquestioning values – as a refuge from the uncertainties of urban capitalist society.

At the end of his life Renoir told his son: 'Perhaps I've been painting the same three or four paintings throughout my life! What is certain is that since my trip to Italy [in 1881] I've been working away at the same problems.'[61] One of his recurrent themes was his simplified construction of human society; one was his vision of childhood; but the most important was his image of woman, particularly of the female nude.

At first sight, Renoir's view of woman seems contradictory. He once told Jean: 'I can tolerate only women in my home;'[62] but many other comments survive to show that the functions he allowed to the women in his life were specific and limited. He liked women to be practical and simple, and to stay at home, engaged in physical work; preferring peasants to city women, he disliked intellectual and educated women, women who thought and women who aspired to a profession.[63] He would accept women only as singers and dancers, he wrote in 1908, because 'in antiquity and among simple peoples the woman sings and dances and is no less a woman. Gracefulness is her domain and even her duty.'[64] Only men could provide real companionship; he ruefully wrote to Gallimard in 1900: 'I'm fine, but I need a man. It's rather boring in the evening.'[65] In his social world, then, 'culture' was a male preserve; women were admitted only into his category of 'nature', in an unquestioning endorsement of traditional male structures of sexual discrimination.

He explained his view of the female role to Jean: 'I love women. ... They doubt nothing. With them the world becomes something very simple. They give everything its correct value and well realize that their laundry is as important as the consti-

tution of the German empire. Near them one feels reassured.'[66] In many of his conversations with Jean, Renoir talked of his mother, who died only in 1896. No clear idea of her character emerges from his accounts, but Renoir clearly admired her greatly, and she came to stand for the basic qualities he sought in a woman: 'As she became older she became solid as steel.' He saw his wife Aline, apart from her appetite for food, as resembling his mother.[67] Given the unquestioning limitations that Renoir placed on a woman's legitimate role, it was Aline who took many of the domestic decisions in their life.[68] However, Renoir convinced himself that this was a part of a larger inequality – that in a relationship it was always the woman who wielded the power. Watching a boy and a girl quarrelling at Essoyes, he told Rivière that the girl would win: 'He took pleasure in noting the inevitable victory of the woman over the man.'[69]

But Rivière doubted that Renoir really liked women: 'Though he gave women a beguiling appearance in his paintings, and gave charm to those who had none, he generally took no pleasure in their conversation. With a few exceptions, he only liked women if they were susceptible to becoming his models.'[70] He could only value women unequivocally in entirely passive roles – as objects for the eye or the painter's brush; only thus could he retain his control, which he felt to be threatened by the assertion of a woman's will. He said that he wanted to paint figures 'like beautiful fruit', and on another occasion that he painted women 'as I would paint carrots'.[71] He insisted that his models did not think (cf. no. 43) and often repeated his criterion for judging a model, that her skin should 'take the light'.[72] As Rivière suggested, painting a model was, in a sense, Renoir's means of possessing her. Jeanne Samary commented: 'He marries all the women he paints . . . with his brush.' 'It's with my brush that I make love,' he used to say.[73]

He wanted his finished paintings of the female form to evoke the model's physical presence, hoping to make the viewer want 'to stroke a breast or a back', or even to immerse himself in the figure; as Denis recalled, Renoir 'was delighted with the idea of painting lavish shoulders; one will be able, he said, to swim in the modelling.'[74] But the women in his paintings are never given an active role; their beauties are displayed to the eye, put at the disposal of the male viewer, but they never address him directly as a potential partner. Where our eye contact is engaged, we are sometimes invited to share the woman's experience which is already complete within the painting – with her partner in *Dance in the country* (no. 69), with her baby in *The child at the breast* (no. 79); at other times, as in *La Loge* (no. 26), she is watching us watching her; in the later nudes, even when they do look out of the painting (e.g. nos. 101 and 121), their mood is distant and self-absorbed. Never did Renoir depict the woman's gaze as a question or a challenge to the viewer, as Manet so often did; her world is always safely confined within the picture.

The role of women in Renoir's paintings became increasingly generalized. In his modern-life scenes until the mid-1880s, they are presented as the central element in the visual pageantry of the everyday world, either on display in fashionable dresses, or as the objects of courtship (cf. nos. 28, 52, 67–9). His later *Bather* pictures, and many of his later costume pieces (e.g. nos. 115, 126), have no such specific references; in them, women are presented in two prime roles, associated either with adornment or with nature. The fusion of female figures with nature became the central preoccupation of his last years and was the theme of the painting he saw as his final testament, *The bathers* (no. 125).

It was by his representation of women that Renoir wanted his powers as a painter to be assessed. In the early 1890s he commented that 'in literature as well as in painting, talent is shown only by the treatment of the feminine figures'.[75] The art of a Degas or a Manet gives the lie to this as a generalization; but Renoir certainly revealed himself most fully in the image of woman that he constructed in his paintings – both his sensory sybaritism and his fear of overt emotional or intellectual engagement.

It was after 1900, and particularly in the south at Cagnes, that Renoir was able to resolve some of the uncertainties that had beset him, and to find a surer sense of his own personal and artistic identity. But this was not achieved by a reconciliation with the modern world around him, but rather by a geographical and temporal displacement. He was by now free of material worries; his work had attained high prices during the 1890s. By settling in the south for a large part of each year, he distanced himself from the fashionable world of Paris, of which he could never become a part, and sited himself in an area rich in associations with a timeless classicism – a tradition which was currently being propagated by the spokesmen of the Provençal literary revival which Frédéric Mistral had pioneered.[76] Physically, too, the south offered him a site where he could fuse observed reality with a framework of tradition. When he bought Les Collettes at Cagnes in 1907, with its ancient olive grove on a hillside overlooking the medieval town, he had in his grasp a world where he could imagine that the ancient pagan gods might come back to earth.[77]

At the same time, his relationship with artistic traditions was evolving. Since his boyhood he had felt a special affinity with the art of the French eighteenth century, as with its society; in the late 1880s, it was again French eighteenth-century art to which he turned in his search for a resolution to his problems about drawing, and he continued to emphasize his affinities with it in the early 1890s. Even at the end of his life, he could declare himself an eighteenth-century artist.[78] But in his last years, he seems also to have linked himself with a larger sense of his artistic heritage – with the antique, and with the great tradition of post-Renaissance figure painting, particularly Titian, Veronese and Rubens.[79] The example of French eighteenth-century art, and later of Titian and Rubens, can be felt in Renoir's paintings, but the general role which these mentors played for him is more important than any specific resemblances. These traditions from the past allowed him to find what he had been unable to find among his artistic contemporaries in Paris: an unquestioning belief in human beauty, based on the celebration of the splendours of the visible world rather than on the archeological reconstructions favoured by

academic art schools. The French eighteenth century provided him with the most immediate framework within which he could find his artistic identity; but with the increasing success and confidence of his later years, he felt able to claim a place within the mainstream of the western classical tradition – a position which distanced him still further from the ideas of the Impressionists among whom he had gained his first notoriety in the 1870s.

For one school of writing, Renoir, with his love of life, 'might have lived in any age whatsoever. The happenings of the moment had no significance for him'.[80] Renoir must, certainly, have dreamed that he might escape, in his life and art, from the loathed contingencies of his own age. Indeed, in the south, he felt that he was sheltered from the troubles of the world; he told Rivière: 'In this marvellous country, it seems as if misfortune cannot befall one; one is cosseted by the atmosphere.'[81] But the feelings which alienated him from the society of his own age were conditioned by that society, which denied him, a 'fine' artist from an artisanal background, a clear social and cultural place. Moreover, the artistic problems which he took with him to the south were issues which had long been central to his art – issues firmly located within Parisian debates about modern art in the later nineteenth century: debates about modernity and timelessness; about the status of the human figure within its surroundings; about colour and drawing. Similarly the vision of southern nature that he re-created there was conceived within Parisian frameworks of debate about art and about nature. His treatment of the southern landscape relates to discussions dating from the beginning of the eighteenth century about the rival claims of the northern and southern landscape traditions; and his whole conception of the south as a repository of timeless values was a product of a widely shared disenchantment with urban modernism.

Nor was Cagnes itself the oasis or time-capsule of which he dreamed. By 1900 the south was in the middle of a tourist boom, and Cagnes, close to the western fringes of Nice, was growing and changing rapidly.[82] Renoir left his first home there, the Maison de la Poste, of which he rented a half, because the grove of orange trees opposite the house was uprooted for redevelopment. He bought Les Collettes because its olive trees, too, were threatened with destruction.[83] By 1914, the suburbs of Nice reached Cagnes.[84] But even within the walls of his estate, the world of Les Collettes was not as he depicted it. He often painted, amid the trees, the little farmhouse, sometimes peopled by young figures in harmony with their surroundings (cf. no. 123); this modest, picturesque old building is presented as the hub of the place's life. Never, though, did he paint the massive stone house he built himself at Aline's urging in 1907–8, which commands the broad panoramas of the landscape.[85]

His last works painted at Les Collettes, notably *The bathers* (no. 125) were the most radiant of his career. But by the time he painted them his dream of a serene old age was broken. Aline had died during the First World War, and both his elder sons had been wounded in the fighting; he was himself crippled by arthritis. Nevertheless, he managed to distil his dream of

serenity into his painting, finally realizing, perhaps, that the free play of the painter's fantasy could create a world which real life could never match. His entire picture surfaces could be filled with richly coloured forms, eschewing the empty spaces he loathed in his compositions.[86] In his life, by contrast, the voids which he had always feared were by now an all-too-present reality.

He spoke late in his life about his dreams of painting the earthly paradise.[87] This quest is most evident in his last work, but his whole career reflects a similar preoccupation. His smiling Montmartre girls of the 1870s and the pretty young faces of the 1890s are all part of the same quest. He sought to create in his art a whole, undivided world which bore none of the scars of his own voyage through the later nineteenth century. Seen as a realist enterprise, the world which Renoir's art presents seems bland and often unconvincing; but, viewed as the construction of a mythic reality, its beauties, as well as its limitations, come into focus far more clearly.

NOTES

1. J. Renoir 1962; despite its historical inaccuracies, Jean Renoir's book is the richest existing source of information about the painter's responses to the world.
2. E. Renoir 1879, in Venturi 1939, II, pp. 334–8; Rouart 1950, p. 128 (*carnet* of Berthe Morisot, 11 January 1886).
3. Baudot 1949, p. 30.
4. J. Renoir 1962, pp. 37, 39–40.
5. Natanson 1896, p. 547; Vollard 1938, p. 146; J. Renoir 1962, pp. 75–6.
6. J. Renoir 1962, p. 223.
7. After the end of his employment painting porcelain, Renoir earned his living painting blinds (cf. Chronology for this and other documentation of Renoir's life); his earnings from this source seem to have financed his first studies as a painter (cf. André 1928, p. 52). Rivière (1921, p. 11) suggests that he continued to work as a decorative painter, alongside his fine art training, until the mid-1860s.
8. Two of his sons described him in these terms: J. Renoir 1962, pp. 204–5; C. Renoir 1960.
9. Duval 1961, p. 140 (diary of de Wyzewa, 28 March 1903).
10. Rivière 1921, especially pp. 61ff; Rivière 1926, p. 925.
11. On Renoir's vision of Aline, cf. J. Renoir 1962, pp. 253–6.
12. J. Renoir 1962, pp. 264–7, 276–7.
13. J. Renoir 1962, pp. 280–4; Jeanès 1946, pp. 29, 34.
14. Essoyes: Manet 1979, p. 74. Aline was already seeking a property at Cagnes before the opportunity to buy Les Collettes arose: Denis 1957, II, p. 35 (diary, February 1906). Les Collettes: Robida 1959, p. 38; C. Renoir 1960.
15. J. Renoir 1962, pp. 357–8, 364–5.
16. Letter from Renoir to André, 16 January 1914 (MS, Institut Néerlandais, Fondation Custodia, Paris).
17. Blanche 1937, p. 37.
18. Letter from Renoir to Madame Charpentier, 30 November 1878, in Florisoone 1938, p. 35.
19. Manet 1979.
20. Rouart 1950, pp. 160, 163.
21. Gallimard: J. Renoir 1962, p. 326. The Bernheims: J. Renoir 1962, pp. 442–3.
22. Blanche 1949, pp. 443–4 (letter from Mme Blanche to Dr Blanche, July 1881). Charpentier dinner: J. Renoir 1962, p. 139. Absent-mindedness, Noutous 1883, p. 218; and cf. E. Renoir 1879, in Venturi 1939, II, p. 337.
23. Friends' descriptions: Natanson 1896, p. 545; [Anon.], *L'Eclair*, 1892; Lecomte 1933, p. 529; Mallarmé 1981, VI, pp. 191–2 (diary of Henri de Régnier, December 1893). Misanthrope: Jeanès 1946, p. 30.
24. Alexandre 1920, p. 9; C. Renoir 1970, p. 35; J. Renoir 1962, pp. 259, 310–2.
25. [Anon.], *Cahiers d'aujourd'hui*, 1921; Baudot 1949, p. 68; J. Renoir 1962, p. 325.
26. In 1866: [Anon.], *Cahiers d'aujourd'hui*, 1921. In the 1890s: Manet 1979, pp. 152, 206, 212. Renoir often changed his opinion according to whom he was addressing, cf. Baudot 1949, p. 80; J. Renoir 1962, p. 142.
27. Pissarro 1950, p. 134 (letter from Pissarro to Lucien, 23 February 1887).
28. Besson 1921; J. Renoir 1962, p. 16.
29. Letter from Renoir to Pach, 28 March 1911 (copy of MS, Beinecke Rare Book and Manuscript Library, Yale University Library); letter from Renoir to André, 21 February 1918 (MS, Institut Néerlandais, Fondation Custodia, Paris).
30. The classic description of Renoir's 'crisis' is in Vollard 1938, pp. 213–8, where it is dated 'around 1883'; Vollard's dates are often inaccurate, and this dating should be treated as approximate.

31. 1866: comment recorded in letter from Jules Le Coeur to his mother, 14 May 1866, in Cooper 1959, p.164. 1881: cf. letter from Renoir to Durand-Ruel from Algiers, March 1881, in Venturi 1939, I, pp.115–6 – this letter was written before Renoir's trip to Italy, which is usually described as the beginning of his 'crisis'; letter from Renoir to Deudon from Naples, ? December 1881, in Schneider 1945, pp.97–8. 1885: letters from Renoir to Berard and Durand-Ruel, quoted in entry for no.77. 1890s: Manet 1979, p.62 (1895); Natanson 1896, p.547. 1919: J. Renoir 1962, p.457.

32. Baudot 1949, p.12; J. Renoir 1962, p.78; André 1928, pp.12–14.

33. Renoir's draft proposal, in Venturi 1939, I, pp.127–9; a related document in J. Renoir 1962, pp.232–6, very probably belongs to the same period. For details and dating of Renoir's project, cf. Pissarro 1980, pp.299–300 (letters from Renoir and Lionel Nunès to Pissarro, and from Pissarro to Monet, May 1884; Nunès was asked to work up a text from Renoir's notes). The idea of an *Abrégé de la grammaire des arts*, the title Renoir gave to this proposed publication, was clearly a response to such celebrated textbooks as Charles Blanc's *Grammaire des arts du dessin* (1867) and *Grammaire des arts décoratifs* (1882). Bailly-Herzberg (in Pissarro 1980, p.299) associates this project with Renoir's discovery of Cennino Cennini's *Il Libro dell'arte*; he wrote a preface for the 1911 edition of Victor Mottez's translation of Cennini. However, the date of his discovery of the book remains uncertain; this was placed by Vollard 'around 1883', along with Renoir's technical experiments (Vollard 1938, p.216; cf. above, and n.30), but it remains very possible that he discovered the book two or three years earlier and that it contributed to his decision to go to Italy late in 1881, in order to study Italian Renaissance techniques on the spot.

34. André 1928, p.62; J. Renoir 1962, p.36.

35. Vollard, 1938, pp.221, 289–290; Pach 1950, p.14.

36. Natanson 1896, p.547; André 1928, pp.49–50.

37. André 1928, p.55.

38. Alexandre 1920, p.9.

39. [Anon.], *L'Eclair*, 1892.

40. Letters from Renoir to Durand-Ruel, 25 April 1901 and 15 June 1908, in Venturi 1939, I, pp.166–7, 192. For the damage to his reputation, cf. also letter from Durand-Ruel to Renoir, 25 November 1903 (Archives Durand-Ruel): 'You have been quite wrong to give away or to allow people to take from you all these rough sketches which people are now circulating everywhere in order to prevent the sale of your fine paintings.'

41. André 1928, p.60; Vollard 1938, p.157; J. Renoir 1962, pp.40, 77, etc.

42. M[ellério] 1891; Alexandre 1892, p.6; Jeanès 1946, p.30.

43. e.g. André 1928, p.8.

44. Letter from Renoir to André, 12 January 1910 (MS, Institut Néerlandais, Fondation Custodia, Paris).

45. André 1928, p.30.

46. André 1928, p.42.

47. E. Renoir 1879, in Venturi 1939, II, p.337.

48. Maupassant: J. Renoir 1962, p.203. Zola: Manet 1979, pp.143, 150. Degas: Rivière 1935, p.24.

49. Bonnard 1941.

50. Anti-narrative painting: Besson 1929, p.4; J. Renoir 1962, pp.68, 179, 392–3. Battle: Baudot 1949, p.29; and cf. J. Renoir 1962, p.102; seeing a sketch for Delacroix's *Battle of Taillebourg* in Gallimard's collection, Renoir said that it was 'like a bunch of roses' (Meier-Graefe 1908, I, p.148).

51. J. Renoir 1962, pp.198, 310–1; Roux-Champion 1955, p.5.

52. Natanson 1948, p.16; J. Renoir 1962, pp.12–18, 100–1, 222, 382–3, etc.; Roux-Champion 1955, p.6.

53. Moore 1906, p.38 (implying that Renoir was already expressing these views in the later 1870s); Manet 1979, pp.133, 246–8; Alexandre 1933, p.8; J. Renoir 1962, pp.42, 341–2, 379–380.

54. Alexandre 1933, p.8; cf. also Rivière 1921, p.246; Baudot 1949, p.72; and Manet 1979, pp.133, 246–8.

55. Pach 1938, pp.112–3; cf. Rivière 1921, p.238, where a similar quotation is located at Essoyes.

56. [Anon.], *L'Eclair*, 1892.

57. Moulin de la Galette: Manet 1979, p.150; and cf. J. Renoir 1962, p.192. Algiers: Rivière 1921, p.190.

58. Letter from Renoir to Jeanne Baudot, 6 March 1904, in Baudot 1949, p.101.

59. Raffaëlli: J. Renoir 1962, p.380. Pissarro: Faure 1920, p.352.

60. Frère 1956, pp.237–8.

61. J. Renoir 1962, p.389; and cf. pp.392–3.

62. J. Renoir 1962, p.87.

63. J. Renoir 1962, pp.86–9, 113, 207–210, 253–6, 392; Vollard 1938, pp.245, 275.

64. Draft letter from Renoir to an unknown correspondent, 8 March 1908 (Archives Durand-Ruel, Paris); this is published in full by Daulte 1971, p.53, but wrongly dated there to 1888 (upon the basis of this letter alone, Daulte states that Renoir visited Cagnes in 1888).

65. Letter from Renoir to Gallimard, 28 January 1900 (Paris, Hôtel Drouot, 8 December 1980, lot 184).

66. J. Renoir 1962, p.86.

67. J. Renoir 1962, pp.86, 201–2, 208.

68. Manet 1979, pp.74, 152, 169; C. Renoir 1960; J. Renoir 1962, p.253.

69. Rivière 1928, p.673.

70. Rivière 1935, p.18.

71. Fruit: Vollard 1938, p.220. Carrots: Baudot 1949, p.66.

72. J. Renoir 1962, p.71; Vollard 1938, p.140.

73. Samary: J. Renoir 1962, p.186. Brush: André 1928, p.10.

74. André 1928, p.42; Denis 1920, in Denis 1922, p.114.

75. Rouart 1950, p.166.

76. Renoir's approach to Mediterranean culture can be closely paralleled with the ideas of the Félibriges, the spokesmen of the Provençal cultural revival. We know little of Renoir's contacts with the Félibriges and their ideas, but a few indications show that he would have been well aware of them. Late in his life, at least, he knew Joachim Gasquet (cf. Gasquet 1921); in 1891 he spent time on the Mediterranean coast at Tamaris with Téodor de Wyzewa at a time when de Wyzewa was closely in contact with the Félibriges (cf. his essays 'Reflexions sur le Félibrige', *La Revue félibréenne*, October, November, December 1892, pp.375–9, and 'Du soleil', in his *Nos maîtres*, 1895 – an extract from the latter is quoted here, p.268); probably in the 1890s, Renoir executed a decorative cover for Paul Gallimard for a copy of Mistral's *Mireio* (cf. Vauxcelles 1908, pp.24, 32; Paris, Galerie Georges Petit, Strauss, 1932, no.79).

77. Gasquet 1921, p.41; J. Renoir 1962, pp.144, 334; cf. too Besson 1929, pp.3–4; Georges-Michel 1954, p.28.

78. In youth: Alexandre 1892, p.13; Vollard 1938, pp.146, 162; J. Renoir 1962, pp.71–2. Later 1880s: cf. entry for no.81. 1892: [Anon.], *L'Eclair*, 1892. 1918: Gimpel 1963, p.34. For his general comments on the French school, cf. André 1928, p.24.

79. Pach 1938, pp.110–1; Rewald 1973, p.210; Vollard 1938, p.222.

80. Florisoone 1937, p.7.

81. Rivière 1921, p.250.

82. Between 1902 and 1914 the population of Cagnes grew from 3380 to 5044 (K. Baedeker, *Southern France*, editions of 1902 and 1914); bare statistics tell little of the vast social changes which were taking place there.

83. C. Renoir 1960.

84. Blanche 1919, pp.234–5.

85. Les Collettes, the estate and the buildings, is now conserved as a museum by the town of Cagnes; the new house contains memorabilia and a few works by the artist (cf.no.123); the place is unspoiled, an oasis amid the building developments around it, and is an evocative reminder of Renoir's last years.

86. André 1928, pp.44–5; cf. too Gimpel 1963, p.181; Schnerb 1908, p.596.

87. Gasquet 1921, p.41.

Renoir's collectors:
the pâtissier, the priest and the prince

ANNE DISTEL

Why should anyone today be interested in the collectors who owned paintings by Renoir a century or more ago? Dealers, experts and connoisseurs would argue that the documented 'pedigree' of a painting helps to confirm its authenticity and that, in the case of Renoir, such information is not to be scorned, even though he is quite close to us in time. Many people, however, would say that the learned references to be found in catalogues do nothing to help us enjoy the paintings themselves, or, worse, that they are an unfortunate reminder of their inevitably commercial nature. But the few collectors who appreciated the work of Renoir and his friends deserve to be remembered, as it is impossible to write the history of Impressionism without describing the vital role they played; they bought works which were sneered at by most so-called professional critics and by the majority of the public, and so enabled the artists to pursue their researches. As we pay homage to Renoir, we ought also to try to learn more about those who admired his work throughout his career. The chronological limits of this study will be set by the span of Renoir's life, because his prodigious posthumous fame represents another chapter in the history of taste, and space does not permit us to go into detail here.

Renoir's collectors belonged to very different social and professional groups and ranged from a self-educated *pâtissier* to a prince; that in itself represents something new in the history of art patronage. Renoir's paintings often changed hands over the years, and some of the owners were very rich; others came from modest backgrounds, at least so long as the prices remained low. It comes as no surprise to see that most of them also collected paintings by Manet, Degas, Monet, Cézanne, Pissarro, Sisley, Berthe Morisot, Mary Cassatt, Guillaumin, etc. From the early 1870s onwards the dealer Paul Durand-Ruel played a vital role, and he helped to maintain the unity of the 'school' in later years by finding buyers even when the exhibitions of the impressionist group had become a thing of the past. The fact that Renoir painted portraits also allowed him to reach people who were not normally patrons of the Impressionists and sometimes even to convert his models to the new painting without their realizing it.

The sixties
Acceptance by the 1864 Salon meant that Renoir could reasonably expect to make a living as a painter. There is no doubt that the young artist decided to become a portrait painter in order to keep body and soul together: his submission to the 1865 Salon included a portrait of the father of his friend Alfred Sisley (no. 2), a discreet invitation to potential clients, and portraits form the largest group among his surviving paintings from the 1860s. We will not go into the personality of the various models in detail, as it is not always possible to identify them with any certainty; suffice to say that almost all of them were connected with the artist's family or were close friends.[1] His submissions to the Salon during the 1860s were irregular and were, as is well known, often rejected by the Jury. And despite his attempts to exhibit with the few dealers who were prepared to accept work from young painters,[2] Renoir was, with a few notable exceptions, ignored by the critics during this period and remained unknown.

Impressionist sales and exhibitions: in search of an audience
After the interruption caused by the war of 1870 and the Commune, Renoir resumed his activities as a portrait painter,[3] but in 1872 he sold his first two paintings – a landscape and a still life – to the dealer Paul Durand-Ruel.[4] Durand-Ruel (1831–1922), who was already well known for his defence of Courbet and the painters of the Barbizon school, had fled to London in 1870. Here he came into contact with Monet and Pissarro and immediately began to buy their work, and on his return to Paris he continued to buy their paintings on a regular basis, as well as those of Sisley, Degas and Manet. However, he seems to have had little interest in Renoir's work until the middle of the decade; we know only of his purchase of two more, unidentified, canvases in December 1873 and April 1874, and he does not appear to have resold these at the time.

Seven works by Renoir were included in the first exhibition of the impressionist group in 1874, but as the catalogue did not include a list of lenders, our first documentation on Renoir's early collectors comes from the *procès-verbal* of the auction organized by members of the group (Monet, Morisot, Renoir and Sisley) on 24 March 1875 at the Hôtel Drouot, which included twenty paintings by Renoir.[5] In the course of the tumult he describes in his memoirs, Paul Durand-Ruel, who was the appraiser for the sale, acquired two Renoirs.[6] Renoir himself bought in two of his own works, and two others were bought by Monet's brother Léon, who was also a

collector. Auguste de Molins (1821–90), a Swiss painter living in Saint-Cloud who had exhibited with the Impressionists in 1874, bought two Renoirs, which his family sold to Durand-Ruel at the turn of the century (cf. no. 25).[7]

Stanislas-Henri Rouart (1833–1912), another painter connected with the group and a close friend of Degas, made only one modest purchase at the auction, but he was later to acquire *The Parisienne* (no. 28), which had been shown in the 1874 group exhibition, and *Riding in the Bois de Boulogne*, (p. 196 fig. a), which was rejected by the 1873 Salon – two huge paintings which he hung in his house in the rue de Lisbonne alongside his collection of Corot, Courbet, Daumier, Delacroix, Millet, Rousseau, Boudin, Cals, Fantin, Jongkind, Lépine, Puvis de Chavannes, Cézanne, Degas, Forain, Manet, Monet, Morisot, Pissarro, Sisley etc. The collection was broken up when it was auctioned on 9–11 December 1912.[8] Rouart was a graduate of the Ecole polytechnique, an enterprising industrialist and a charming painter in his own right. He was also a model for a whole generation of collectors. He preferred to buy direct from the artists he collected, though he also frequented the gallery of the legendary Père Martin (1817–91), a modest but very shrewd dealer – who bought Renoir's *La Loge* (no. 26) from the artist around this time.[9]

The banker Ernest Balensi, who bought a still life with flowers at the 1875 auction, was a sleeping partner in the firm of Durand-Ruel, and it is therefore uncertain whether he was bidding as a collector or as a business associate. Presumably he was in a sense playing both roles, as at the end of 1881 he 'bought' *Luncheon of the boating party* (no. 52) and resold it to Durand-Ruel a few months later.

A further canvas by Renoir, *Champ de rosiers* was sold to a M. Petitdidier. This was the family name of Emile Blémont (1839–1927), a lawyer by training and a man of letters, who was immortalized by Fantin-Latour in his *Coin de table* of 1872; Blémont bought Fantin's painting in 1897 and later presented it to the Musée Nationaux. André Salmon described him as 'a gentle little man with blond hair who wore a tight-fitting frock coat . . . he inherited a dyer's with a number of branches and a factory and was therefore able to endow a prize . . .'.[10]

Henri Hecht (d. 1891) bid successfully for *Avant le bain*, but he appears to have been acting on behalf of his friend Théodore Duret, who later owned the painting.[11] Duret (1838–1927) was a cognac merchant, an art critic and one of Manet's earliest defenders; there is a marvellous portrait of him by Manet, dated 1868, in the Musée du Petit-Palais. It seems, in fact, that of all the painters in the group it was Renoir who interested him least, but, as he himself states in the catalogue prepared when financial difficulties forced him to sell his paintings, his aim was to develop a coherent collection, and he therefore had to acquire good examples. In the monograph he wrote on Renoir in 1924, he describes how he met Renoir through Degas when he returned from the trip he made to Japan with Cernuschi (the founder of the museum in Paris which still bears his name) in March or April 1873. Degas told him that a minor dealer had a Renoir for sale and Duret bought it. This was *Summer* (no. 8), and shortly afterwards he also acquired

Lise with a parasol (p. 181 fig. f).[12] He can therefore be considered to be one of Renoir's most important patrons in the 1870s. Duret was also responsible for introducing Renoir to the '*japoniste*' group of collectors and thus for helping him to reach a wider circle of patrons. The group also included Deudon and Ephrussi, to whom we will return later.[13]

The buyers at the 1875 sale included another important critic, Arsène Houssaye (1815–96), a novelist and the editor of *L'Artiste*, who was one of the first critics to praise Monet and Renoir. He bought Renoir's *Seated woman*.[14]

Three Renoirs were bought by Georges Charpentier (1846–1905), who became one of the artist's most important patrons. In 1871 Charpentier had inherited a publishing house, which was already famous for its links with the romantic school, and later he published Flaubert, the Goncourt brothers, Alphonse Daudet, Maupassant and Zola. In 1872 he married Marguerite Lemonnier (1848–1904), who also came from a cultured background. They lived first in the place Saint-Germain l'Auxerrois and later at 11 rue de Grenelle, and Madame Charpentier's *salon* soon became famous as a meeting place for writers and the left-wing politicians of the day. Her guests included both Manet and Renoir, who became her 'painter in ordinary'. She commissioned portraits from Renoir, the most famous (no. 44) being shown at the 1879 Salon. It was this portrait which finally established his reputation. We do not know whether Georges Charpentier already knew Renoir in 1875 or whether the sale marked the beginning of their relationship, which was to end only with the deaths of the Charpentiers. The letters they exchanged with Renoir give us a good idea of the painter's relationship with his patrons:[15] in his letters to Monsieur Charpentier, Renoir asks for financial help, but when he writes to Madame Charpentier he tries to express the difficulties and joys of his life as a painter, and the somewhat forced social banter cannot conceal the real trust he obviously placed in her. Madame Charpentier chaperoned Renoir into a world which the son of a tailor from the rue d'Argenteuil could not otherwise have entered, and he captured its very essence in his portraits of her. The success of *Portrait of Madame Charpentier and her children* at the 1879 Salon was an indication of Renoir's growing fame.

Finally, the small version of *La Loge* (known then as *L'Avant-scène*; Daulte 1971, no. 115; cf. no. 26) was bought at the auction by Jean Dollfus. Dollfus (1823–1911) was a native of Mulhouse, who fled Alsace after the German occupation and settled in Paris.[16] He originally collected old masters, but later began to buy contemporary works, advised by his friend the painter Faller and Moureaux, a minor dealer. He was a great admirer of Renoir, and besides the small *La Loge* he owned five other of his works, including a commissioned copy of Delacroix's *Jewish wedding* in the Louvre (now in the Worcester Art Museum), *Portrait of Claude Monet* (now in the Jeu de Paume) and *Claude Monet reading* (Daulte 1971, no. 87).[17] All these works date from before 1880. It is interesting to note that Dollfus's collection, which remained intact until his death, contained nothing by Monet and only two Sisleys and one Pissarro.

The catalogue for the second impressionist group exhibition in 1876, which included eighteen Renoirs, does list the names of some private lenders. The fact that Edouard Manet is described as the owner of *Frédéric Bazille at his easel* (no. 6) is an indication of the older painter's affection for both the artist and his model. Dollfus is again mentioned, and the catalogue also tells us that a 'Monsieur Choquet' lent six paintings by Renoir (as well as several by Monet and Pissarro).

Victor Chocquet (1821–91) was a minor customs official who retired in 1867 and whose features are familiar to us from several paintings by Renoir and Cézanne.[18] Late in life, he came into an inheritance and filled his apartment opposite the Tuileries in the rue de Rivoli with a hundred or so paintings, not to mention his collection of watercolours and drawings. Delacroix held pride of place, with Cézanne a close second, but Corot, Courbet, Daumier, Dehodencq, Diaz, Manet, Berthe Morisot, Monet, Pissarro, Sisley, Tassaert and of course Renoir were also represented. Their paintings, many of them in old carved wooden frames, hung amongst his collections of eighteenth-century Sèvres porcelain, antique *faience*, clocks, bronzes, Louis XV furniture and a few examples of what antique dealers now call *haute époque*. The tastes of this modest and unconventional man anticipate those of our modern millionaires. The fascinating thing about Victor Chocquet is that, even without the major financial resources that are needed for speculation (though it is true impressionist paintings were not at the time expensive) and without any mentor, he unhesitatingly concentrated upon the best painters of the period. His collection was sufficiently remarkable for Zola to use him as the model for M. Hue, the retired head clerk who buys Claude Lantier's most uncompromising paintings and hangs them next to his Delacroixs in chapters eight and nine of *L'Oeuvre*.

We do not know precisely how Chocquet met Renoir, but the artist painted a portrait of his wife in 1875, and, shortly afterwards, portraits of Chocquet himself, his wife and his daughter.[19] The most important painting in his collection was the small version of *Ball at the Moulin de la Galette* (Hay Whitney Collection, New York), which is dated 1876; and of the paintings in the present exhibition, *The skiff* (no. 47) was owned by Chocquet. None of his Renoirs was painted later than 1880, even though Renoir remained in touch with the collector after that date; the two were linked by their mutual friendship with Cézanne.[20]

The catalogue for the 1876 group exhibition also lists the names of two dealers who should be mentioned: Legrand, who worked with Durand-Ruel before opening his own gallery at 22*bis* rue Laffitte and dealt mainly in impressionist paintings;[21] and Poupin, who had premises at 8 rue La Fayette and was also a business associate of Durand-Ruel's.[22]

Until 1875, Durand-Ruel himself owned almost no paintings by Renoir, but by about 1876 he had acquired fifteen or so. However, of these we can identify with certainty only those that he sold to Count Armand Doria in July 1876, which reappeared on the market when Doria's collection was auctioned in 1899.[23] According to his friend Degas, Count Doria (1824–96) had the features and manner of a Tintoretto,

and his face soon became familiar to those who attended sales at the Hôtel Drouot and to major and minor dealers alike. Initially, his tastes appear to have leaned towards the independents, the school of 1830 and the Impressionists, and the catalogue for the 1899 auction gives us a good idea of what was in his collection. It included works by his protégé Cals, by Corot, Daumier, Jongkind, Lépine and Vignon, as well as Degas, Manet, Monet, Morisot, Pissarro and Sisley. There were no fewer than ten Renoirs in the auction.[24]

Another of Durand-Ruel's clients who bought a Renoir from him at this time was Georges de Bellio (1828–94), a homeopathic doctor of Rumanian origin, who did not practise but did treat his painter friends when necessary, and who rarely refused to buy a painting if a friend needed money.[25] He eventually owned eight Renoirs, and the artist painted a portrait of his daughter, Madame Donop de Monchy, in 1892. It was thanks to the Donop de Monchy bequest that some of de Bellio's collection is now in the Musée Marmottan in Paris, the exceptions being the paintings sold by Donop de Monchy to the Prince de Wagram early in 1906 (these included several Renoirs). The jewels of the collection were the dazzling Monets, including the famous *Impression, sunrise*.

It was also from Durand-Ruel that in 1878 Charles Deudon (1832–1914) bought the *Dancer* shown at the first impressionist group exhibition of 1874 (p. 196 fig. b). As we have mentioned, Renoir met Deudon, who already knew Monet, Pissarro and Manet, through Duret.[26] In a letter to a common friend Renoir complains that, unlike Deudon, he did not have a 'fortune in Old England', which suggests that Deudon, who held a doctorate in law, had financial interests in this Paris store.[27] Whatever the case, he did have time to devote to impressionist art, and he visited Renoir while he was painting *Luncheon of the boating party* (no. 52) at Chatou in 1880.[28] When he retired to Nice at the turn of the century, Deudon was besieged by dealers hoping to buy his collection.[29]

Charles Deudon is inevitably associated with Charles Ephrussi.[30] Ephrussi (1849–1905) was originally interested in Japanese prints, but by 1880 he had also begun to buy impressionist paintings (Manet, Monet, Morisot, Sisley, Pissarro, Renoir). He was a man of fashion – Renoir depicts him in *Luncheon of the boating party* – but he was also a scholar and took over *La Gazette des Beaux-Arts* in 1885. Artist and collector were obviously on intimate terms; when he wrote to Duret from Algiers on 4 March 1881, Renoir remarked: 'I have left Ephrussy [*sic*] in charge of my Salon entry. That's one problem less.' Like the Charpentiers and Duret, Ephrussi encouraged Renoir to take part in the official Salon rather than in the group exhibitions organized by the Impressionists, and it was thanks to him that Renoir was able to reach a wider and more conventional audience.

The name of Georges Charpentier reappears among the lenders to the third impressionist group exhibition held in 1877, as does that of his friend Alphonse Daudet, transparently disguised by the initials 'A.D.'; the latter lent a portrait of his wife (now in the Jeu de Paume). The exhibition also saw the first appearance of a figure who was destined to become

famous both as a collector and as a painter: the lender of the delightful *Swing* (no.39), modestly described as 'M.C', was Gustave Caillebotte (1848–94), who was also an exhibitor and showed six of his own paintings. Although we do not know precisely how Caillebotte came to be enlisted in the impressionist ranks, it is clear that from April 1876 onwards he had simultaneously pursued his career as an artist, by taking part in the second group exhibition, and as a patron, by beginning to buy paintings.[31] Caillebotte's confidence in Renoir was such that he made him joint executor of his will with his brother Martial Caillebotte. Renoir was thus in a position to play an important role in 1894 when the question arose as to whether the State should or should not accept and display the Caillebotte bequest.[32]

A number of other clients of Durand-Ruel, including Ernest Hoschedé,[33] the singer Jean-Baptiste Faure[34] and Ernest May, owned Renoirs, but his works took second place to those of Manet, Monet, Sisley and Pissarro, as indeed they did in the dealer's own stock at that time. There were also three Renoirs in the collection of the composer Emmanuel Chabrier (1841–94), who was a friend of Manet, Degas and Monet.[35] They were bought back by Durand-Ruel when the collection was sold in March 1896; one of them, the 1876 *Nude (Anna)*, was sold to Shchukin shortly afterwards and is now one of the finest pieces in the Pushkin Museum in Moscow; two others, *Leaving the Conservatoire* and *Woman crocheting*, are now in the Barnes Foundation, Merion.

Before we end this survey of Renoir's early patrons, mention must be made of two other remarkable people who cannot quite be classified with the collectors discussed above. Most of what we know about Dr Paul Gachet (1828–1909) and his friend Eugène Meunier, or 'Murer' (1846–1906), derives from an essay by Dr Gachet's son Paul.[36] Gachet was a doctor who had been converted to homeopathy and who painted under the name 'Van Ryssel'. He became a close friend of Cézanne, Pissarro and, later, of Vincent Van Gogh, who thought he could take refuge with him simply because he was a doctor and a lover of painting. Only one episode in his life concerns us here: Renoir called Dr Gachet to the bedside of a young model as she was dying, and it was in memory of this that he gave him the so-called *Portrait of Margot* which Paul Gachet presented to the Jeu de Paume in 1951 (cf. no.36).[37]

Gachet's friend Murer was an equally interesting figure. The epitaph on his gravestone at Auvers-sur-Oise describes him as '*ouvrier – littérateur – peintre*', and he was by trade a *pâtissier*. He also wrote novels – which, according to his friend Paul Alexis in 1895, were 'neither naturalist, symbolist, romantic nor classical, but no one could describe them as banal' – composed poetry and painted. It was his boyhood friend Guillaumin who introduced him to the Impressionists, first to Pissarro and then to all the others. With the help of his half-sister Marie, Murer gave regular dinners at his home at 95 boulevard Voltaire on Wednesdays, typical of such gatherings at this period. Most of Renoir's letters to Murer consist of apologies for his inability to accept invitations.[38] Even so, Murer – whose portrait Renoir painted – did own a considerable number of the artist's paintings. In spite of recent research,[39] there is still no proper catalogue of Murer's collection. The well known list published by Paul Alexis (alias Trublot) in *Le Cri du peuple* on 21 October 1887 includes fifteen Renoirs, as well as eight Cézannes, twenty-five Pissarros, ten Monets, twenty-eight Sisleys, twenty-two Guillaumins, four Vignons, two Gachets ('Van Ryssel'), four drawings and watercolours by Delacroix and four drawings by Constantin Guys. Some of the Renoirs can be identified, and all of them appear to have been painted before 1880.[40] They included the portrait of Murer himself (Daulte 1971, no.246) and those of his sister Marie (Daulte 1971, nos.248–9) and his son (Daulte 1971, no.247), but the most important were *Arbour at the Moulin de la Galette* (Pushkin Museum, Moscow), *Portrait of Sisley* (Art Institute of Chicago) and *Chez Renoir* (Daulte 1971, no.188). Posterity has sometimes taken a harsh view of Murer, seeing him as nothing more than a calculating schemer who succeeded in buying works from artists at low prices simply because they were impoverished. There is no doubt some truth in that, but Murer's obvious and infuriating megalomania should not be allowed to obscure the real importance of his activities or the fact that he always believed that his protégés were destined for greatness.

The 1880s: Renoir at Wargemont

Jacques-Emile Blanche saw a direct connection between the evolution of Renoir's technique in the early 1880s and the new circles he was moving in.[41] He mentions two of the patrons we have already discussed – Deudon and Ephrussi – and Paul Berard. Paul-Antoine Berard (1833–1905) was a diplomat and company director who came from a family of protestant bankers, and from 1879 onwards he and his family were central to Renoir's life.[42] He was introduced to Renoir by Deudon. Renoir visited him at his town house at 20 rue Pigalle and often spent long periods at his country house in Wargemont, near Dieppe; they also corresponded.[43] Jacques-Emile Blanche, who was Berard's neighbour in Normandy, gives a very lively description of life at Wargemont.[44] Like the Charpentiers, these rich bourgeois had no affectations and could appreciate the painter's talent. They also succeeded in giving him confidence and self-control. The portraits painted for the family include the *Children's afternoon at Wargemont* (no.74), one of the masterpieces of this period (cf. also no.60). The friendship between the painter and his patron was to prove long lasting, and in 1900 it was Berard, who, at the artist's request, presented Renoir with the insignia of the Légion d'Honneur.

The announcement that the Berard collection was to be sold in May 1905 caused a sensation. Renoir received the news in a letter from an astonished Durand-Ruel on 8 March; the only reason given by the owner for his decision was that he wanted to 'leave his house, which he was finding too big and too cold'. It is possible that Berard, who was old and dying, hoped to live to see the painters he loved so much (Renoir, Monet, Sisley, etc.) receive the recognition they deserved. He would not have been disappointed, as the sale was a considerable success.

At this time Renoir's collectors also included the Grimprels,[45]

who were business associates of Berard's, Léon Clapisson (cf. no. 70), who was also connected with the Berard family,[46] the Havilands (cf. no. 73), who owned a famous porcelain factory in Limoges,[47] and Henri Vever, the jeweller and *japoniste*.[48] Robert de Bonnières, a poet, journalist and critic, who wrote for *Le Figaro*, *Le Gaulois* and *Gil Blas* and was an admirer of Wagner and contemporary music, was also an important collector.[49]

Another collector, much less well known than these, owned two masterpieces by Renoir: the Courtauld Institute's *La Loge* (no. 26) and the Frankfurt Museum's *End of the luncheon* (1879). Louis Flornoy (1846–1904) was a merchant and shipowner from Nantes who became President of the Tribunal de Commerce and, as an ardent Republican, Deputy Mayor of Nantes. He sold the two Renoirs to Durand-Ruel[50] at the turn of the century, and the catalogue for the sale held at the Hôtel Drouot on 10 April 1905 gives some idea of the rest of his collection. It included secondary works by Courbet, Corot, Dupré, Boudin, Jongkind, Pissarro and Sisley, and the work of minor painters like Cals, Lépine, Delpy, Japy, Piette and Vignon. It was, in other words, a typical 'enlightened' collection of the period.

It was at the end of the 1880s that Renoir's first American patrons appeared on the scene, including Cochrane and Fitzgerald in Boston, as well as Horace O. Havemeyer and his wife Louisine Waldron Elder (who was a friend of Mary Cassatt) in New York.[51]

It was again Durand-Ruel who brought Renoir these new clients. From 1881 onwards, he had been buying paintings from Renoir on a steady, if somewhat irregular, basis.[52] In 1883–7, he acquired noticeably fewer paintings, perhaps because of the business difficulties he was experiencing. His partner Jules Feder had been badly hit by the collapse of the Union Générale in 1882, and he was finding it extremely difficult to find new customers. From 1886 onwards, he desperately tried to extend his activities to the New World, where he held exhibitions and finally opened a branch in New York. His new ventures were successful, and business began to pick up in 1890 and 1891. It is greatly to Renoir's credit that, unlike Monet, he remained faithful to one dealer, and his loyalty to Durand-Ruel at this time laid the foundations for cordial relations and mutual trust in the years to come. When, in 1892, Durand-Ruel tried to persuade Pissarro to let him handle everything he produced, he argued that 'the reason I have been able to find Renoir buyers who are worthy of him is that I have all his paintings.'[53]

The 1890s: Renoir in the Musée du Luxembourg

During the 1890s paintings by Renoir first entered the State collections. In 1892 *Young girls at the piano* (no. 91) was bought for the Musée du Luxembourg thanks to the efforts of Mallarmé and Roger Marx. We will not dwell here on the details of the violent polemic caused in 1894 by Gustave Caillebotte's bequest of his collection of impressionist paintings to the French State.[54] But, after long and difficult negotiations between Caillebotte's executors (his brother Martial and Renoir) on the

one hand and the Administration des Beaux-Arts on the other – who were worried about the scandal that could be raised by the acceptance of paintings disliked by the majority of public opinion – a selection of works from the Caillebotte bequest was accepted by the Luxembourg and went on display in February 1897. Renoir was extremely well represented by *The swing* (no. 39), *Ball at the Moulin de la Galette* (no. 40), *Study* (no. 36), *Woman reading*, *The Seine at Champrosay* and *The railway bridge at Chatou*, all of which are now in the Jeu de Paume.

As we have already seen, Durand-Ruel had begun to extend Renoir's fame to the United States in the mid-1880s. His clients in the next decade included Crocker of San Francisco (1890), Delmonico (1891) and Sutton (1893) of New York, as well as Mrs Potter Palmer (1892) and Eddy (1894) in Chicago, all of whom bought Renoirs when they visited Paris. Other purchasers included Van Horn from Montreal and the long list of those who bought Renoirs from the dealer's New York branch. A number of German collectors also bought their first Renoirs in the 1890s, including Ressler (Berlin), Behrens (Hamburg) and Dr Linde (Lübeck),[55] before Cassirer became Durand-Ruel's official agent in Berlin at the beginning of the new century. Finally, it was in 1898 that the Moscow merchant Sergei Shchukin bought his first Renoir, *Nude (Anna)*, which is now in the Pushkin Museum.[56]

It is, however, time to return to France and to discuss two important figures, both of whom formed the basis of their collections before the turn of the century. The first is Félix-François Depeaux (1853–1920), a businessman from Rouen.[57] The walls of both his home at 35 avenue du Mont Riboudet, Rouen, and his Paris offices were covered with paintings. Depeaux had been a client of Durand-Ruel's since 1892, and when family conflicts forced him to sell his collection on 31 May–1 June 1906, it was found to include no fewer than forty-six Sisleys, a number of paintings by Monet and Pissarro (who met Depeaux on several occasions when he visited Rouen), as well as works by Gauguin and Toulouse-Lautrec.[58] Depeaux's collection of Renoirs included *Summer* (no. 8) and two still lifes with flowers, but the real jewel was *Dance at Bougival* (no. 67). Depeaux had long planned to bequeath part of his collection to the Rouen Museum and to use his influence to get the museum to buy paintings, and, despite his own difficulties, he did give it a fine collection of impressionist paintings in 1909.[59]

A second major collection of Renoirs was formed by Dr Georges Viau (1855–1939). Viau was a dentist by profession, but he was also an amateur painter who enjoyed mystifying his guests with his pastiches. He amassed a number of collections which were broken up one after another, both during his lifetime and after his death.[60] Viau was a close friend of Count Doria, and, whilst he did buy from dealers, he also liked to 'go to the source', which explains why he bought most of the canvases which had formerly belonged to Murer (cf. n. 40).

We must also mention Paul Gallimard (1850–1929), the son of a collector, bibliophile and art lover,[61] and the father of Gaston Gallimard, founder of the *Nouvelle Revue Française*. He

was a good customer of Durand-Ruel's and bought the *Bather* (no. 65) from him in December 1889. Apart from a few old master paintings, his mixed collection consisted mainly of French nineteenth-century works. All the great names from Ingres and Delacroix to Courbet and Cézanne were represented. Both Renoir and Monet knew Paul Gallimard well,[62] and Renoir painted a portrait of his wife and several of his mistress, the actress Diéterle.

On 6 May 1901, a small collection of twenty-one paintings by Boudin, Cézanne, Degas, Guillaumin, Monet, Pissarro, Renoir (six works) and Sisley was sold at the Hôtel Drouot in Paris. The works were all of high quality: Monet's *Snowscape, Honfleur* was bought by Camondo and later hung in the Jeu de Paume, and his *Springtime* was later acquired by the Musée de Lyon. Whereas most of the large collections which were broken up at this time were fairly mixed, this one consisted solely of impressionist works. The collector was described as 'M.G.', but it was widely known that he was a certain Abbé Gaugain (his name has sometimes been spelt 'Gauguin', by analogy with the painter). He had been, as we shall see, a regular client of Durand-Ruel (who organized the sale), but he had also made direct contact with several artists, including Pissarro, from whom he bought paintings in 1892 and 1893,[63] and Renoir himself. When Durand-Ruel sent Renoir the catalogue for the sale, he remarked: 'You will find six of your paintings here. . . . He must have bought them directly from you.'[64] In his letter of 25 April 1901, Renoir admitted: 'I was weak enough to be unfaithful to you on several occasions and dealt directly with the Abbé, but you had already refused everything I gave him and had said it was horrible, which is in fact true. But if I only sold good things I would die of hunger, and I thought he would keep them longer than this. He had been asking me for a view in the south of France for four years. For a long time I refused to carry out the commission, but eventually, I botched up a *Palais des Papes*, and that was that. But I have had enough of collectors, and I will not let myself be persuaded again.'[65] The dealer's reply arrived a few days later: 'The Abbé's collection will be sold on Monday. I think everything will go well and we should get high prices for everything. It is vital to reach high prices in auctions, even if they are fictitious. It is the only way we will have a major success. You say in your letter that I refused the paintings you sold to Abbé Gaugain. What gives you that idea? I would never have turned them down, particularly as they are very beautiful.'[66] Such are the strategies of the art market. Durand-Ruel had in fact already bought the whole collection for the sum of 101,000 francs,[67] so that the sale was at his risk; he knew the collection well, as thirteen of the works had been bought from his gallery between December 1887 and March 1900.[68]

Despite our information, the personality of the Abbé, with his unconventional taste, remains something of a mystery. Paul-Octave Gaugain was born on 4 April 1850 in the little village of Boulon, near Caen (Calvados), and came from a poor background. His father was a day-labourer and, when he registered the birth of his son, stated that he could not write; his mother was a lacemaker. We know nothing about his ecclesiastical career, but the Paris electoral registers tell us that he was a teacher, and we also know that he was headmaster of the Cours Saint-Augustin, 95 boulevard Haussmann. He retired to Boulon, where he became mayor, and died there on 24 June 1904. We have no idea what led him one day to enter Durand-Ruel's gallery. After the 1901 auction, he made a few other acquisitions, including two d'Espagnats, two Albert Andrés and a Loiseau, and when he died, his heirs asked Durand-Ruel to value the few paintings he left them.[69] Durand-Ruel was right when he said: 'The good Abbé will get a good deal;' he invested less than 50,000 francs and doubled his capital within the space of ten years. (It should be remembered, however, that an investment of this kind was far beyond the means of most people, at a time when a primary school teacher earned no more than 3,000 francs a year, while 90% of all state employees earned less than that.)

Renoir in the twentieth century

From now on, an increasing number of collectors and museums wanted to acquire works by Renoir. Renoir's relations with the French authorities responsible for fine arts were not always smooth. A minor controversy broke out over the celebrations organized for the Exposition Universelle, in which the Impressionists at first refused to take part, but the disagreement was finally resolved thanks to the diplomacy of Roger Marx.[70] It was then that Renoir finally received official recognition and was awarded the red ribbon of the Légion d'Honneur. In January 1900, he donated his *Portrait of Jean Renoir as a child* to the Musée Municipal in his home town of Limoges.[71] A year later, in January 1901, the Musée de Lyon acquired *Woman playing the guitar* (no.96), the first of an impressively daring and intelligent series of purchases of impressionist paintings. The French national museums could now, thanks to the Caillebotte bequest and their 1892 purchase, pride themselves on owning a representative collection of the artist's work, and two other bequests (though of unequal value) further enriched the national collections. In 1902, the music publisher Hartmann bequeathed a large *Portrait of a woman*, dated 1874, to the Musée du Luxembourg; and thanks to the magnificent bequest made by Count Isaac de Camondo (1851–1911), the Louvre was also to acquire three recent works by Renoir shortly before the First World War.[72] These were *Woman combing her hair, Young girl in a straw hat* and *Seated girl* (now in the Jeu de Paume).

It is worth noting that Camondo, a banker and an important collector with considerable resources, who had come to Durand-Ruel's help in the 1870s and to whom the French national museums owe several of the impressionist masterpieces in their possession, seems to have been attracted to Degas and Monet rather than to Renoir, and that the three Renoirs he bequeathed to the Louvre were very late acquisitions, made in 1910.[73] At the same time, he was also buying paintings by Bonnard and Matisse from Bernheim-Jeune.[74] Camondo's fame – Proust expressed his regrets at not being able to see his collections because Camondo would only receive him in the morning![75] – was such that he played a considerable

role in the history of taste. He also did a great deal for the Impressionists and for the next generation of painters.

French museums now owned a considerable number of paintings by Renoir,[76] and many foreign institutions were also eager to acquire his works. It was the English critic Roger Fry, who was then working for the Metropolitan Museum, who first suggested that the great New York museum should use the large financial resources at its disposal to buy *Portrait of Madame Charpentier and her children* (no. 44) when the Charpentier collection was sold in 1907.[77] German museums also began to buy impressionist paintings, including several Renoirs; Hugo von Tschudi, who was the director of the Nationalgalerie in Berlin between 1896 and 1909, was able, despite the opposition of the Kaiser, to buy *Summer* (no. 8), *Children's afternoon at Wargemont* (no. 74) and *Chestnut trees in flower*, the latter being purchased from Durand-Ruel on 6 June 1907; the museums in Bremen,[78] Frankfurt,[79] and Cologne (no. 9) immediately followed the example he had set. It is interesting to note that the museums preferred to buy the earlier works, taking advantage of the fact that the first generation of collectors had now died and that their collections were being broken up.

In this connection it is particularly interesting to find one collector who concentrated on Renoir's later period, which was still unpopular with a public that had by now become accustomed to the paintings of his impressionist period. In less than twenty years Maurice Gangnat acquired more than one hundred and fifty Renoirs, most of them painted between 1905 and 1919. The catalogue for the sale of his collection held in 1925 reveals the extent of his passion for Renoir and gives us a glimpse into the rest of his collection, which also included some very fine Cézannes.[80] Maurice Gangnat (1856–1924) was an engineer educated at the Ecole des Arts et Manufactures and was once a business associate of Alfred Natanson, a cousin of the founder of *La Revue blanche*. He retired from business relatively early and began to collect paintings. As early as 1904, he bought a Vuillard from Bernheim-Jeune, and he continued to buy from him until 1907.[81] The first Renoir he acquired appears to have been *Girl in a white pinafore* (Daulte 1971, no. 456), which he bought at the Berard sale in May 1905.[82] It was at the home of his old friend Paul Gallimard that he first met Renoir, and he subsequently became one of the few close friends to be invited to Les Collettes, Renoir's villa at Cagnes-sur-Mer. At the time of the sale of his collection, his son Philippe Gangnat presented *Gabrielle with a rose* (no. 116) to the French national museums in memory of his father.

In the first part of *Le Côté des Guermantes*, Proust mentions 'a young prince who liked impressionist painting and motoring'. The prince was Louis-Marie Philippe, Alexandre Berthier, Prince de Wagram (1883–1918), to whom we must give pride of place here.[83] We cannot discuss the whole of the collection that he acquired so feverishly between 1905 and 1908; in all, he bought several hundred paintings, ranging from Courbet to Cézanne and Van Gogh by way of Puvis de Chavannes, Degas, Manet, Monet, Sisley, Pissarro, Gauguin, Moreau, Vuillard and Camoin, as well as a number of old masters.

We will concentrate here upon the Renoirs he bought and those he wanted to buy. The Prince's grandfather had been a Marshal of the Empire, and on his mother's side he was related to the Rothschilds. At the start of 1905, having just graduated from Saint-Cyr, he suddenly began to collect not only paintings but also objets d'art and antique textiles. Somehow he came into contact with Adrien Hébrard, a bronze-caster with premises at 8 rue Royale (the son of the famous François-Marie Hébrard, a politician and director of *Le Temps*). Hébrard was extremely enterprising and became the Prince's mentor, introducing him into the world of art. In a letter of 12 April 1905, he outlined a full plan of campaign for the young man: 'I think that in a modern collection such as the one you are planning the leaders of schools should be represented by at least one of their most typical works . . . in these turbulent times everything centres upon a small number of artists, and in my view those artists are Delacroix, Courbet, Corot, Moreau, Manet, Renoir, Puvis and Claude Monet. I mention only these because their reputations are no longer in dispute, but I am tempted to add the names of Degas and Gauguin. The controversy surrounding the former has now died down, but the controversy over Gauguin is still at its height. Do you know Gauguin's work? If you do not, let me advise you to buy some of his paintings. The most expensive should cost no more than 4,000 francs; before he died, they were worth 300 francs and in ten years time they will cost 20,000 francs.' The Gauguins were certainly masterpieces, but they were also excellent investments for a young man with millions to play with. Hébrard defines his own role in his letter of 25 May 1905: 'I have the advantage of being neither a dealer nor a professional intermediary; when such people are involved, prices always rise to cover their commissions. I am a customer. I buy from the dealers and I pay them, because I have often had occasion to make purchases on behalf of collectors and museums who did not want to be directly involved. Being a business man, I get preferential terms. . . . My contacts in the press allow me to do more favours for artists then I ask of them. I would like nothing better, monsieur, than to give you the benefit of the small advantages I enjoy and the benefit of reduced prices. . . . All I ask is that you do not make that small task too difficult.'

Unfortunately, Alexandre de Wagram, who was stationed at Saint-Mihiel, near Metz, in his need for people to work on his behalf in the capital, had approached virtually every dealer in Paris as well as Hébrard, and that inevitably led to rivalries. He was also looking for paintings throughout France and even as far afield as Madrid, Milan and Berlin. The young collector bought from Durand-Ruel, Vollard, Barbazanges, Druet, Petit and Tedesco, but he dealt mainly with Hessel and the Bernheims. He bought frequently and in quantity. Given the size of the sums involved – several hundred thousand francs per year – Wagram paid in instalments and was allowed extended credit. He would often ask his dealers to store paintings for him. Very few of the paintings he bought hung on the walls of his town house in the avenue de l'Alma or in the apartment he took on the fourth floor of 27 quai d'Orsay (now quai Anatole France) in the spring of 1908.[84] It is, however, probable that they were changed frequently.

In 1905 and 1906, relations between Hébrard and the collector were extremely close, and in 1907 he became a partner in his bronze-casting business. It was Hébrard who introduced Wagram to Durand-Ruel (he received a commission on all the Prince's purchases) and who, at the end of 1905, advised him to buy, amongst other things, a superb series of early paintings by Renoir: *La Grenouillère* (nos. 12, 13 fig.a), *Leaving the Conservatoire* (Barnes Foundation, Merion), *Portrait of Chocquet* (Fogg Art Museum, Cambridge, Mass.), *La Source* (Daulte 1971, no. 124; Barnes Foundation), *Bather drying herself* (Daulte 1971, no. 528), a '*Grande femme nue assise*' (unidentified), *The servant girl* (Metropolitan Museum, New York) and *Portrait of a woman* (Fogg Art Museum). It was in connection with these purchases that Hébrard again gave Wagram the benefit of his advice on 29 January 1906: 'When one has the resources you have, one does not collect trifles, but only major pieces; when one has your sure and personal taste, it is inexcusable not to use it.' It was also through Hébrard that the Prince came into contact with Vollard. He acquired *The clown* (Kröller-Müller Museum, Otterlo) from Vollard in November 1905, but his most important purchases from that source were a series of Gauguins and Cézannes. Vollard in fact kept *The clown* and a number of other paintings including a Derain, for which he had not been paid, and relations between collector and dealer came to an abrupt end in April 1907.

At the same time as he was commissioning Hébrard to carry out various negotiations on his behalf, the Prince de Wagram was also working with another young dealer who was bursting with enthusiasm and activity. Henry Barbazanges had premises at 48 boulevard Haussmann and transferred his business to 109 faubourg Saint-Honoré in the spring of 1906. His first commission for the Prince was to go to Spain to look for works by El Greco and Goya, but he was soon on the track of impressionist paintings, and his greatest success came when he acquired part of the collection of Donop de Monchy, de Bellio's son-in-law, in January 1905, including a *Bather* by Renoir (which cannot be firmly identified). This partnership also came to an end in 1907, although Barbazanges was commissioned in 1910 and later to resell some paintings from the Prince's collection.

The Prince began to buy from Druet in autumn 1905, and in 1908 Druet bought some works back from him (including Seurat's *Le Chahut*, now in the Kröller-Müller Museum, Otterlo). On 6 September 1909, Druet was commissioned to sell thirteen of the Prince de Wagram's Renoirs, including *The Champs Elysées during the 1867 Exposition Universelle* (New York, Wildenstein, 1974, no. 3).

Finally, we must discuss the Prince's dealings with Jos Hessel and his cousins the Bernheims. It was at the end of May 1905 that he bought his first group of paintings from Bernheim-Jeune, and by the end of the year he had acquired some thirty other Renoirs, including *Portrait of the daughters of Catulle Mendès at the piano* (Walter Annenberg Collection). Early in 1906, he began to return some of the Renoirs, which he exchanged for other paintings, but the same year he bought several others, including *The engaged couple* (no.9) in June.

Wagram dealt mainly with Jos Hessel, who ran the Bernheim branch at 36 avenue de l'Opéra. Bernheim-Jeune was an old-established firm. Alexandre Bernheim (1839–1915) was born in Besançon and began to deal in paintings in Brussels. He moved to Paris in 1873, and by the late 1880s his sons Joseph (1870–1941) and Gaston (1870–1953) and their slightly older cousin Jos Hessel were all partners in the business. By 1900, Bernheim-Jeune had begun to concentrate, profitably, almost exclusively on the Impressionists and the painters of the younger generation. The firm's undoubted success probably explains why the Prince de Wagram decided to combine business with pleasure by becoming a partner in Bernheim-Jeune. Under the terms of a private agreement drawn up on 27 January 1907 and registered on 12 February, Bernheim and Hessel formed a joint company, with the Prince de Wagram as a sleeping partner; his name did not appear on the agreement. However, the partnership was short-lived, and in May 1907 the Prince took legal action against his associates, in order to bring it to an end. A year later, an amicable settlement had been reached.

This litigation and other unlucky commercial ventures had serious financial repercussions for the Prince de Wagram, and from this point onwards he appears to have had some difficulties. He settled his account with Durand-Ruel early in 1908, already relinquishing certain works, and it seems probable that he was now beginning to consider selling most of his collections. The whole of 1909 was taken up with negotiations which, with as many dealers involved as before, were as ineptly handled as those that had led to his acquisitions. There were rumours of a public auction, but his paintings were in fact disposed of piecemeal and informally. When Durand-Ruel was called in to value the paintings in the quai d'Orsay flat in April 1914, only a small part of the collection remained.[85] There were, however, still sixteen canvases by Renoir, including the small version of *Ball at the Moulin de la Galette* (Hay Whitney Collection, New York), *La Source* (Daulte 1971, no. 124; Barnes Foundation), *Mlle Henriot en travesti* (Columbus Gallery of Fine Arts, Columbus, Ohio) and *Child with a watering-can* (National Gallery of Art, Washington, D.C.). The valuation faithfully reflects the final state of a dream which was to perish, together with the Prince himself, in the final months of the war.

Several of the paintings which once belonged to the Prince de Wagram later came into the possession of Alfred Barnes (1872–1951), an extraordinary man who spent the enormous fortune he made from his pharmaceutical preparation Argyrol to buy paintings. His Renoirs, now in the Barnes Foundation at Merion, near Philadelphia, which opened in 1924, are especially notable. A number of these were bought from Durand-Ruel in May 1914, but the greater part of his collection appears to have been acquired in the early 1920s, when a lot of paintings came on to the market as a result of the artist's death.

When Renoir died, his studio contained an extremely important collection of paintings, as can be seen from the two portfolios prefaced by Albert André and Marc Elder and published by Bernheim-Jeune in 1931. Although most of the works are sketches from the last period, there were also a

number of major finished works, including several family portraits. The interesting point is that, unlike Degas's heirs in 1918–19, the artist's three sons did not follow the traditional custom of breaking up their father's collection by auctioning it, and their decision not to do so may have established a precedent. Contrary to René Gimpel's account,[86] Renoir did not leave any written instructions as to what was to be done with his collection. However, Gimpel does relate that Barbazanges, who was backed by the banker Orosdi, guaranteed the huge sum of 10,500,000 francs. He offered a share – which was refused – to 'the Durand-Ruels, Georges Bernheim, Rosenberg, Bernheim-Frères and Hessel, all of whom knew about the deal but valued the collection at only seven million.'[87]

Renoir made the transition from obscurity to fame in the space of fifty years. In a letter written to Durand-Ruel on 11 February 1909, he claimed that this made no difference to him: 'I am pleased to hear that collectors are more forthcoming. Better late than never. But that will not stop me from going on as I have always done, just as though nothing had happened'.[88] Not all of those who supported him when he began his career lived to see his triumph, but those who did were proved to have been right. They were as daring as the paintings they appreciated and were model collectors in their support for the avant-garde.

NOTES

1. See, e.g., nos. 5, 6, 11.
2. e.g. Carpentier (cf. no. 9).
3. See, e.g., Daulte 1971, nos. 69, 70, 99.
4. Purchases made on 16 March 1872: *Vue de Paris, Pont des Arts*, 200 francs (Durand-Ruel stock no. 1131); and on 23 May 1872: *Fleurs, pivoines et coquelicots*, 300 francs (stock no. 1470).
5. Bodelsen 1968, pp. 333–6. It should be noted that the first sale held by Ernest Hoschedé, the famous collector of impressionist paintings, on 13 January 1874 did not include anything by Renoir.
6. Durand-Ruel in Venturi 1939, II, p. 201. According to the *procès-verbal* of the 1875 sale he bought 'no. 38, *Argenteuil (bâteau)*, 50 × 65, 105 francs' and 'no. 42, *Le Pont-Neuf*, 75 × 92, 300 francs'. Curiously enough, it has proved impossible to find any record of purchases made at this time either in Durand-Ruel's *Journal* or in the *Brouillard* which records day-to-day transactions in the gallery (cf. entry on no. 21).
7. He was also in contact with Camille Pissarro (Paris, Hôtel Drouot, *Archives C. Pissarro*, catalogue of sale, 21 November 1975, no. 137 (3)). Cf. Monneret 1979, II, p. 53.
8. Paris, Galerie Manzi-Joyant, *Tableaux anciens et modernes composant la collection de feu M. Henri Rouart*, catalogue of sale, 9–11 December 1912, includes a detailed preface by Arsène Alexandre. Cf. Monneret 1979, II, pp. 201–4.
9. Père Martin had premises at 20 rue Mogador, later transferring his business to 52 rue Laffitte and finally to 29 rue Saint-Georges. Rouart wrote his obituary, which appeared in *Le Journal des arts* on 9 October 1891.
10. A. Salmon, *Souvenirs sans fin*, I, Paris 1955, pp. 44–5.
11. Cf. Paris, Galerie Georges Petit, *Collection de M. Théodore Duret*, catalogue of sale, 19 March 1894, with preface by Duret, no. 36 (Daulte 1971, no. 144). On Duret's friendship with Henri and Albert Hecht, see A. Distel, 'Albert Hecht, collectionneur (1842–1889)', *Bulletin de la Société de l'Histoire de l'Art Français, 1981*, 1983, pp. 269, 274. Cf. Monneret 1978, I, pp. 190–2.
12. *Lise* was sold back to Durand-Ruel on 6 June 1890, together with a '*Baigneuse*', which was in fact *La Source* (Daulte 1971, no. 124).
13. Undated letter from Renoir to Duret (Cabinet des Dessins, Louvre; Florisoone 1938, p. 39). In another note, Renoir asks for an invitation to a ball at Cernuschi's.
14. The Renoir bought by Houssaye (no. 33, *Femme assise*, 46 × 38) reappeared in the sale of his collection at the Hôtel Drouot on 22–23 May 1896 (no. 160, *Femme assise dans un jardin*, 45 × 35, signed on the left). Its present whereabouts are unknown. Cf. Daulte 1971, no. 80; Monneret 1978, I, p. 287.
15. Florisoone 1938; Robida, *Grandes heures*, 1958. Cf. Monneret 1978, I, pp. 130–1.
16. Many details about Dollfus's life and the history of his collection can be found in André Michel's introduction to Paris, Galerie Georges Petit, *Collection de M. Jean Dollfus par suite de son décès*, catalogue of sale, 2 March 1912.

17. The others were *Buste de femme* (Daulte 1971, no. 167) and a *Baigneuse* (Daulte 1971, no. 214). It is fascinating to compare the 220 francs Dollfus paid for *La Loge* in 1875 and the 31,200 francs that it realized in the 1912 auction. Even so, that is nothing compared with the 150,000 francs paid by the Louvre at the same auction for Corot's *Woman with a pearl*. Cf. Monneret 1978, I, p. 182.
18. A lengthy study of Chocquet's personality can be found in Rewald 1969, and there are also lively descriptions of him in the prefaces written by T. Duret and L. Roger-Milès for Paris, Galerie Georges Petit, *Tableaux Modernes ... vente par la suite du décès de Mme Vve Chocquet*, catalogue of sale, 1, 3 and 4 July 1899.
19. Not all the paintings owned by Chocquet figured in the catalogue for the 1899 sale, the major omissions being *Portrait of Madame Chocquet in white* (Staatsgalerie, Stuttgart) and the two portraits of Victor Chocquet (Reinhart Collection, Winterthur, and Fogg Art Museum, Cambridge, Mass.). It did, however, include ten paintings by Renoir, a pastel dated 1880 and a drawing.
20. Cf. Renoir's letter of 28 December 1881 to Chocquet from Capri and his letter of 2 March 1882 describing a stay with Cézanne in L'Estaque; in Joëts 1935, pp. 121–2. Cf. Monneret 1978, I, pp. 137–8.
21. The painting he lent in 1876 was a portrait of his daughter Delphine (Daulte 1971, no. 141). Legrand was also the assessor for the auction of *45 tableaux par MM. Caillebotte, Pissarro, Renoir, Sisley*, held at the Hôtel Drouot on 28 May 1877. The auction was not a success, with sixteen paintings by Renoir realizing only 2,005 francs; cf. Duret 1924, p. 45. In an undated note (Cabinet des Dessins, Louvre), Renoir asks Durand-Ruel to lodge some money with Legrand. Legrand was the French representative of the London firm of MacLean, which manufactured a cement suitable for decoration, and he had both Pissarro and Renoir experiment with painting on this material. A letter from Pissarro to Murer (25 November 1878) mentions Legrand as going to America in connection with an exhibition of impressionist paintings at about this time (Pissarro 1980, p. 132 n. 4); this is said to have been the first exhibition of its kind to be held in America. Legrand appears to have been connected with the famous Murer, and Gauguin relied upon this minor dealer at the beginning of his career (Pissarro 1980, pp. 246–7). At the time of the second impressionist group exhibition, Legrand wrote to Chocquet on 6 April 1876 to ask him if he wanted to sell 'the portrait of a man by Renoir exhibited as no. 214'; cf. Paris, Hôtel Drouot, *Lettres autographes de peintres impressionnistes adressées à Victor Chocquet*, catalogue of sale, 23 June 1969, no. 197. Cf. Monneret 1978, I, p. 325.
22. Poupin may simply have been acting on Durand-Ruel's behalf, as the title of the painting he lent in 1876 (*Femme au piano*) is identical to that of a canvas listed as being in the dealer's stock in 1876 (cf. no. 35). Durand-Ruel's *Brouillard* mentions that in April 1878 he deposited almost two hundred impressionist paintings with Poupin; the reasons for this transaction are not known. In the account he gave to Vollard (Vollard 1919, p. 101), Renoir described Poupin as a dealer in '*objets de Jérusalem*' who 'dabbled a bit in painting'.
23. The accounts for this period are missing from the otherwise admirable records of the Durand-Ruel Archives, and this makes the study of the late seventies somewhat difficult. Durand-Ruel appears to have sold the following Renoirs to Count Doria on 18 July 1876: no. 518, *Paysage vert*, 112.50 francs; no. 519 *Amandiers en fleurs (matin)*, 112.50 francs; no. 520 *Bouquet de glaïeuls*, 150 francs. Cf. Auguste Dalligny's biographical note in *Le Journal des Arts*, 29 April 1899; and Monneret 1978, I, p. 182.
24. Notably *Café concert* (National Gallery, London).
25. A lengthy study of de Bellio can be found in Niculescu 1970, 247, pp. 25–67; 249, pp. 41–85. On 4 May 1876, Durand-Ruel sold de Bellio a *Nature morte (melon)*, which appears in the inventory published by Niculescu. Cf. Monneret 1978, I, pp. 66–8.
26. Deudon bought the *Dancer* from Durand-Ruel on 17 May 1878 for 1000 francs (Archives Durand-Ruel). He also bought a pastel on 12 December 1882. In an undated note written before 30 November 1878 (cf. n. 30 below) Renoir tells Duret: 'I am at your disposal whenever you would like to introduce me to Monsieur Deudon' (Cabinet des Dessins, Louvre; Florisoone 1938, p. 39). Deudon is mentioned several times in Monet's notebooks, which are now in the Musée Marmottan; his name appears for the first time in November 1877. In a letter to Duret dated 24 August 1878, Camille Pissarro asks his friend to persuade Deudon to buy something from him (Pissarro 1980, p. 127). Duret's replies of 9 September and 30 October 1878 (Institut Néerlandais, Fondation Custodia, Paris) show that he did his best to satisfy the request. Cf. Monneret 1978, I, p. 179.
27. Letter from Renoir to Paul Berard, Tuesday 18 October [1887], in Berard 1968. It has proved impossible to verify this hypothesis.
28. Letter from Renoir to Paul Berard (1880; misdated to 1879 in Berard 1968).
29. Cf. the letters published in Venturi 1939, I, pp. 152–5. On 8 March 1899, Durand-Ruel, who had been introduced by Renoir, acquired, amongst other things, the *Dancer* (Archives Durand-Ruel).
30. A detailed study of Ephrussi's career will be found in Kolb and Adhémar 1984, pp. 29–41. On Saturday 30 November [1878], Renoir wrote to Madame Charpentier, telling her that he was to lunch with 'M. Charles Ephrussi and M. Deudon, who are close friends of Bonnat's', and that they had asked to see her portrait (Florisoone 1938, p. 35). Cf. Monneret 1978, I, p. 196.
31. At some point between 23 and 26 April 1876, i.e. during the second impressionist group exhibition, Monet noted that 'M. Caillebotte peintre' had bought three of his paintings (Musée Marmottan, Paris, MM 5160 (1)).
32. Caillebotte's bequest consisted of more than sixty works by Manet, Degas, Sisley, Pissarro and Cézanne including eight paintings by Renoir, two of which – *Place Saint-Georges* and *View of Montmartre* – were refused and returned to the artist's

brother Martial; those which were accepted are now in the Jeu de Paume. Caillebotte also owned a version of *Young girls at the piano* (no. 90) which bears the dedication '*A mon ami G. Caillebotte*' (presumably ruled out because it was so similar to the painting acquired by the State in 1892) and a portrait of his mistress Charlotte Berthier (Daulte 1971, no. 432).

33. A detailed study of Hoschedé by Hélène Adhémar can be found in Paris, Grand Palais, *Hommage à Claude Monet*, 1980, pp. 168–175. Three Renoirs were included in the enforced sale of his collection on 6 June 1878. Cf. Monneret 1978, I, pp. 286–7.

34. Cf. Callen 1974, pp. 157–177; Monneret 1978, I, pp. 207–8.

35. Chabrier's collection is discussed at length in Delage 1963, pp. 17–22. Cf. Monneret 1978, I, pp. 126–7.

36. Gachet 1956. Cf. Monneret 1978, I, pp. 219–220.

37. The relevant letters will be found in Gachet 1957, pp. 82–5, 87. Renoir also called in de Bellio to treat the young woman.

38. Cf. Gachet 1957, pp. 81–5.

39. Reiley Burt 1975, pp. 57–61, 92. Cf. Monneret 1979, II, pp. 96–8.

40. In 1896 Murer announced that on 16 May he would open 'a magnificent exhibition of impressionists, including thirty paintings by Renoir' in the Hôtel du Dauphin et d'Espagne, which he had recently acquired in Rouen (Gachet 1956, p. 164). Gachet points out (p. 177) that in 1897 most of the Renoirs became part of the first collection acquired by Dr Viau, the Paris dentist, which was sold on 4 March 1907. With the exception of *Portrait of Murer aged thirty*, Murer's son, who owned a garage in Beaulieu, had only a few remnants of the collection to offer Durand-Ruel after the Viau sale (Archives Durand-Ruel). Barbazanges, the young dealer who was looking for paintings for the Prince de Wagram in July 1906 or 1907, also expressed regrets at having travelled south for so little (Archives Nationales 173 Bis AP 430).

41. Blanche 1949, p. 152. Jacques-Emile Blanche and his father, a famous doctor, both lent paintings for the one-man show Renoir held at Durand-Ruel's gallery in April 1883. Jacques-Emile Blanche was for a long time the owner of *Bathers* (1885–7), one of Renoir's most important paintings of this period, now in the Philadelphia Museum of Art (p. 241 fig. a).

42. Cf. Berard 1938; Berard 1956; Daulte 1974, pp. 409–410; Monneret 1978, I, pp. 69–70. Paul Berard's name has often been spelled with an accent, but his family have informed us that Berard is the correct form, which he himself preferred.

43. For the correspondence between Renoir and Berard, see Berard 1968 and Paris, Drouot, 16 February 1979 and 11 June 1980.

44. Blanche 1937, pp. 35–9.

45. Cf. Daulte 1971, p. 414.

46. Cf. Daulte 1971, p. 411; Daulte 1974, p. 12. At the time when Renoir agreed to paint a second portrait of Madame Clapisson (no. 70), her husband had recently bought a small *Mosque in Algiers*, an *Arab Boy* (Daulte 1971, no. 406) and *Old Arab woman* (Daulte 1971, no. 400) from Durand-Ruel, of whom he was, besides, an excellent customer. He resold him these Algerian paintings on 21 April 1892 (Archives Durand-Ruel).

47. Cf. Daulte 1971, p. 414; J. and L. d'Albis, 'La Céramique impressionniste', *L'Oeil*, February 1974, p. 46; Boime 1976, pp. 156–8; Boime 1979, pp. 67–8; Monneret 1978, I, p. 269.

48. Monneret 1980, III, p. 49. His impressionist collections were auctioned in February 1897. Evelyne Possémé of the Musée des Arts Décoratifs, Paris, is currently preparing a study of Vever which will take in his activities as a collector.

49. Cf. *Portrait of Henriette de Bonnières* (1889; Musée du Petit-Palais, Paris). On 10 December 1888, Robert de Bonnières bought a *Baigneuse* and *Fleurs* from Durand-Ruel, which the dealer had recently acquired from Renoir. They were sold back in July 1894 and April 1897 respectively, together with works by Degas, Rodin, Cézanne and Manet (Archives Durand-Ruel). In his letter of 4 April 1901 to Duret, Renoir states: 'The portrait of Wagner belongs to M. Robert de Bonnières unless he has disposed of it' (Florisoone 1938, p. 40); that painting is now in the Jeu de Paume. Cf. Monneret 1978, I, p. 85.

50. Durand-Ruel bought a *Baigneuse* from him on 7 January 1899; the two paintings mentioned were bought on 8 February 1899 (Archives Durand-Ruel).

51. When Mrs Havemeyer died in 1929 the Metropolitan Museum inherited more than a thousand works of all types, including a superb series of impressionist paintings. A number of paintings which were not included in the Havemeyer bequest and which were formerly in the possession of the Havemeyers' daughter-in-law made record auction prices when they were sold by Sotheby Parke Bernet, New York, on 18 May 1983.

52. Without going into the details of the amounts credited to Renoir by Durand-Ruel from 1881 onwards (Archives Durand-Ruel: *Grand Livre* and *Journal*), it should be noted that the large-scale purchases of 1881 and 1882 (almost 30,000 francs for 1882 alone) declined steadily and sharply in the later 1880s, at a time when Durand-Ruel was buying increasingly from Monet (see p. 242).

53. Paul Durand-Ruel, letter of 28 November 1892 to Pissarro (Archives Durand-Ruel).

54. Cf. P. Vaisse, 'Le Legs Caillebotte d'après les documents', paper read to the Société de l'Histoire de l'Art Français on 3 December 1983, *Bulletin de la Société de l'Histoire de l'Art Français, 1983* (forthcoming).

55. Cf. C. Judrin, 'Acquisition par le Musée Rodin d'une peinture de Munch', *La Revue du Louvre*, nos. 5/6, 1981, pp. 387–9.

56. Cf. Monneret 1979, II, p. 278.

57. Cf. Monneret 1978, I, pp. 176–7.

58. Part of the Depeaux collection, including one Renoir, had already been sold on 25 April 1901. It is a matter of record that the sale held in May–June 1906 concerned 'the Depeaux collection belonging to the Société d'acquets Depeaux–Decap, whose liquidation was ordered by the Cour d'Appel, Rouen, on 7 February 1906'.

59. On 10 February 1906, Durand-Ruel, who had recently catalogued the Depeaux collection for auction, wrote to the owner: '*La Danse* and *Bouquet de chrysanthèmes* belonged to my private collection and only left it because you stated that you wanted to present them to the Rouen Museum. Had it not been for that solemn promise, I would never have agreed to let them out of my possession' (Archives Durand-Ruel). The latter painting was included in Depeaux's gift to the museum, while the former was the prize item in the 1906 sale, where it was bought by Depeaux's former brother-in-law Edmond Decap. A final sale of Depeaux's collection took place on 30 June 1921, after his death, and was dominated by the works of Lebourg and Guillaumin.

60. Cf. Monneret 1980, III, pp. 49–50.

61. Cf. Vauxcelles 1908; Monneret 1978, I, p. 220.

62. On 27 April 1893, Renoir wrote to Gallimard from Beaulieu to tell him that 'I think I will bring you back a landscape' (cf. entry for no. 92).

63. On 26 April 1892, Camille Pissarro wrote to his son: 'I will write to my collector, Abbé Gaugain, and ask him to look at my new things' (Pissarro 1950, pp. 279–280). Cf. p. 283 (8 May 1892), p. 288 (June 1883) and p. 302 (3 July 1893): 'He [Durand-Ruel] tells me that he saw my *Woman with a wheelbarrow* at Abbé Gaugain's and thought it was splendid.'

64. Paul Durand-Ruel, letter to Renoir in Magagnosc, 19 April 1901 (Archives Durand-Ruel).

65. Venturi 1939, I, pp. 166–7.

66. 4 May 1901 (Archives Durand-Ruel).

67. Paul Durand-Ruel, letter of 7 May 1901 to Abbé Gaugain (Archives Durand-Ruel).

68. The details of these transactions go beyond the scope of the present study and will be dealt with in a forthcoming article.

69. Twenty or so minor works by Albert André, d'Espagnat, Vogler, Maufra, Renoir, Valtat, Damoye, Loiseau and Faucher (Archives Durand-Ruel).

70. On 20 January 1900, Durand-Ruel wrote to Roger Marx, telling him: 'Renoir categorically refuses to have his paintings exhibited in either the *Décennale* or in the retrospective exhibition [the *Centennale*]. Degas, Monet and Pissarro are taking the same stand.' A second letter dated 30 March 1900 explains that 'Monet and Renoir ... are rightly very annoyed about the cavalier way the administration has treated them by selecting paintings from collectors and exhibiting them without consulting the artists or telling them how they would be displayed' (Archives Durand-Ruel). Cf. the letters to Roger Marx from the artists concerned in Paris, Musée du Louvre, Cabinet des Dessins, *Donation Claude Roger Marx*, November 1980–April 1981, nos. 78–81.

71. Durand-Ruel was responsible for sending the painting to M. E. Labussière, who was at the time Mayor of Limoges, on 23 January 1900. On 14 March, the dealer, like Renoir, expressed his surprise at having heard nothing more about it (Archives Durand-Ruel).

72. A survey of the collections left to the Louvre by Camondo will be found in Paris, Musée du Louvre, *Catalogue de la collection Isaac de Camondo*, second edition, 1922. Cf. Boime 1976, pp. 151–2; Boime 1979, pp. 64–5.

73. The three paintings were bought from Durand-Ruel: *Young girl in a straw hat* (bought 29 April 1910; acquired from Renoir 4 August 1908), *Seated girl* (bought 29 April 1910; acquired from Renoir 27 July 1909), and *Woman combing her hair* (bought 15 November 1910; acquired from Renoir 5 September 1910). These acquisitions were made after the will was drawn up in 1908 and probably reflect the donor's desire to complete his collection to accord with the museum's needs. Durand-Ruel had already tried to persuade Count de Camondo to buy works by Renoir and especially 'a small early canvas' (letter of 18 November 1897, Archives Durand-Ruel). When the pictures were left to the museum in 1911 and were listed in the press, Durand-Ruel made a point of writing to Arsène Alexandre and stating that the three Renoirs represented only the beginning of a collection which would have been more extensive had it not been for Camondo's death (letter of 19 August 1911, Archives Durand-Ruel). He made the same point in his letter of 4 August 1911 to C. Lalo. A letter from Camille Pissarro to his son Lucien makes it clear that Camondo always intended his collection to be left to the State (Pissarro 1950, p. 405). When the Charpentier collection was sold in 1907, it was rumoured that Camondo was going to buy *Portrait of Madame Charpentier and her children* (no. 44) for the Louvre (letter from one of the Durand-Ruel sons to Paul Durand-Ruel, 12 April 1907, Archives Durand-Ruel).

74. Purchases made on 8 March and 11 June 1910 (Archives Bernheim-Jeune: *Livre de Vente*).

75. Proust, undated letter to an unidentified correspondent à propos the artists portrayed in *Du Côté de Chez Swann* (Paris, Drouot, sale of manuscripts, 23 June 1969).

76. The collections were added to during Renoir's lifetime: *The rehearsal* was bequeathed to the Musée de Reims by Henry Vasnier in 1907. *Théodore de Banville* (pastel, c. 1882; now in the Cabinet des Dessins of the Louvre) was officially acquired from Madame Veuve Catulle Mendès on 22 December 1910 for the sum of 6,000 francs, with a contribution of 1,000 francs from the Société des Amis du Musée du Luxembourg (Archives Nationales F²¹ 4443). *Seated girl* (red chalk drawing heightened with white) was officially acquired from Vollard acting for Renoir for the sum of 100 francs on 18 August 1915 (Archives Nationales F²¹ 4262); this is a study for the painting of the same title in the Camondo bequest. *Portrait of*

Colonna Romano was the gift of the artist to the Musée Municipal, Limoges (15 June 1916). Another, larger, *Portrait of Colonna Romano* (now in the Jeu de Paume) was officially acquired from Renoir for 100 francs on 7 May 1918. It was in fact a gift: 'The painting is being given to us, but Monsieur Renoir would be flattered if it seemed that it was being acquired by the State and would be happy to accept a purely nominal payment of 100 francs' (note by L. Bénédite, 25 April 1918, Archives Nationales F²¹ 4262); cf. Renoir's letter of 30 March 1918 (Paris, Drouot, 7 December 1979), in which he mentions that he would like to give the portrait to the Luxembourg. *Madame Georges Charpentier* (*c*.1876–7; now in the Jeu de Paume) was a gift made by the Société des Amis du Luxembourg in 1919; when he visited the Louvre in August of that year, Renoir was delighted to see it hanging in the Salle La Caze (Rivière 1921, pp. 233–4).

77. Paul Durand-Ruel refused to sell Fry *Luncheon of the boating party* (no. 52) and *Dancer* (page 196 fig. b), but suggested that he should try to acquire *Portrait of Madame Charpentier and her children* at the Charpentier sale. At the same time he told him that he could expect competition from the German museums, in other words Dresden and Berlin (letter of 5 April 1907 to Fry, Archives Durand-Ruel). In his letter of 11 April he told Fry that his bid of 84,000 francs had been successful, 'despite Bernheim, who was bidding for either the Prince de Wagram or a German museum'. On Fry, see Monneret 1978, I, p. 218; and A. Bowness, *Petit Larousse de la peinture*, Paris 1979, p. 668.

78. *Portrait of Madame Chocquet*, bought from Durand-Ruel on 23 March 1910 (Daulte 1971, no. 173; present whereabouts unknown).

79. *End of the luncheon* and *Young girl reading*, brought from Durand-Ruel on 28 June 1910. Cassirer was paid a commission on this sale.

80. Paris, Drouot, *Gangnat*, 1925.

81. Gangnat bought another Vuillard and a Renoir on 12 February 1906; he also bought a Bonnard and a Jongkind on 17 May 1906, three Cézannes on 1 June 1906 and a Renoir on 19 January 1907.

82. Paris, Petit, *Berard*, 1905, no. 30.

83. Cf. M. G. de La Coste-Messelière, 'Un jeune prince amateur d'impressionnistes et chauffeur', *L'Oeil*, November 1969, pp. 20–6; E. de Gramont, *Mémoires*, II, *Les Marronniers en fleurs*, Paris, 1929, pp. 191–6; A. Salmon, *Souvenirs sans fin*, II, Paris 1956, p. 299; III, 1961, p. 147. All the information given here derives from the Berthier-Wagram archive in the Archives Nationales (173 Bis AP 429–30–31). The idea of exploring this archive was suggested by a note by Marie-José Salmon on the decorations commissioned by the Prince de Wagram, in Beauvais, Musée départementale de l'Oise, *L'Age d'or de Maurice Denis*, 1982.

84. The invoices presented by the interior decorator give us some idea of what the apartment was like: there was an antechamber with hangings in old gold taffeta and pedestals for houseplants; a grand salon hung with cream taffeta; a pink salon; a green salon; a smoking room; a dining room; the bedroom hung with antique tapestries and its dressing room. Judging by the number of paintings he contemplated hanging and the list of frames supplied – many of them antique – there do not appear to have been more than twenty or so paintings in the apartment at that time, though they included works by Courbet, Van Gogh, Puvis de Chavannes and Monet.

85. The inventory drawn up by Durand-Ruel in April 1914 includes sixteen paintings and one large red chalk drawing by Renoir, one Carrière, two Puvis, two Perroneaus, two Courbets, two Van Goghs and one Sisley; in all, thirty works are listed. The Prince de Wagram does not seem to have hung any paintings in the Château de Grosbois, which he also owned. The annual rent for the apartment was 16,000 francs, which is an interesting measure of comparison for the cost of the paintings.

86. Gimpel 1963, p. 154. When Gimpel and Georges Bernheim visited Monet in Giverny, Bernheim is said to have explained that Renoir's children would not be able to sell his paintings until two years after his death. Maître Collet, the lawyer in Paris who took over the chambers of Maître Duhan (who helped Renoir draw up his will), was kind enough to inform me that Renoir made only a short will in October 1908 and that it was mainly concerned with Les Collettes, which he had recently bought.

87. Gimpel 1963, pp. 199–200 (diary, 29 March 1922). A factor of about 3 should be applied to obtain current values in French francs (I.N.S.E.E.). Gimpel also reported that 'the young firm of Barbazanges' had bought the first 103 pictures for 1,500,000 francs and that they had an option on the remaining 600, divided into six lots spread over several years. Later (p. 264, 10 April 1924) he reported that Barbazanges had taken up the second and third lots in partnership with Georges Bernheim. Little is known about Barbazanges's career after the War, but from a letter from Georges Durand-Ruel to his brother Joseph (11 March 1921, Archives Durand-Ruel) it appears that the gallery at 109 faubourg Saint-Honoré had gone into liquidation and that Hessel had acquired the lease: 'Barbazanges and a certain Monsieur Hodebert have been put there in charge of day-to-day business, but Hessel retains overall control.' It was known as the 'Galerie Hodebert' and later as 'Galerie Georges Bernheim'. Gimpel (p. 34) refers to Barbazanges's activity as a dealer as late as 1927. On Jos Hessel, see T. Bernard, 'Jos Hessel', *La Renaissance de l'Art Français*, January 1930.

88. Venturi 1939, I, p. 194.

Renoir's sentiment and sense

LAWRENCE GOWING

We are tempted to expect great painters – especially painters who inherited a common realistic tradition – to measure themselves against a common standard. But they never do. The nature and quality of each remain wholly individual and incomparable. Few painters have given or owed more to one another than the Impressionists. Three or four of them were obviously stars of the greatest magnitude, yet each is measurable in a dimension of his own and no other. Renoir's art cannot claim that base in sensation and logic which, as Cézanne remarked with reason, makes an artist impregnable. Renoir's vision and imagining were at the service rather of sensuality and impulse. They are thus vulnerable to criticism. Renoir makes his own kind of sense, but the meanings communicated by sensuousness and sensuality in themselves are no longer as acceptable as they were in Renoir's time.

Yet the recent neglect of Renoir overlooks qualities that we can hardly spare from the repertory that painting affords us. We can recognize their rarity yet still hardly describe what they consist of. Is there another respected modern painter whose work is so full of charming people and attractive sentiment? And all in the best possible taste. Yet what lingers is not cloying sweetness but a freshness that is not entirely explicable. It is like a scent or the bloom on a grape. The self-management was impeccably natural and effortless, as if Renoir relied on what was innate. His son compared it to the sense of direction in a migrating bird. The assumptions that he took for granted are no longer unquestioned.

Renoir possessed, it seems from the beginning, an awareness that the other future Impressionists had no idea of. He had a sense of the image trade and retained that sense through the period in which painting and drawing were changing utterly, changing in the skills they could command, the formulations they supplied and the clientele they served, the period in which artists transformed the craft and lost the trade. A nostalgia for the manual craft was and is common. Degas who called for pictures painted 'comme une porte' had little idea how a door was painted. A Degas could not possibly have been painted that way (although an Ingres or a Chassériau possibly could.) Renoir was a tradesman not only by upbringing but by nature, and he never forgot it. So far from unfaithful, he always preserved an intelligent understanding of what the image tradition consisted in. The eighteenth century remained very present and imaginatively important to him all his life. For him a good Louis Quinze frame, which his patron had ready, was a positive reason for painting a portrait (and lowering his price). Renoir was acutely aware, as no one else, of the tragedy of the age which seemed until the very *fin de siècle* to lack a decorative style of its own. Not only the sadness but the impoverishment of human life, even a peril to the well-being of his family, were consequences of the failure of style which became the obsessions of his old age; his son recounted them at length. When the lack was made good it was too late for Renoir. If he had been eighteen years younger he might have adopted *art nouveau* as cordially as Seurat and more fluently.

Renoir had an instinct for naturalness, he never had to turn his back on anything in his boyhood make-up, as Monet and Cézanne both did. Their juvenile selves, the café cartoonist in Monet and in Cézanne the frustrated adolescent in a stew about sex and violence, were left behind or sublimated out of recognition. On the whole they were not missed. But Renoir maintained his foothold in the image trades all his life. He preserved the skills. The technique *au premier coup* with which the apprentice learned to brush Rococo-style decorations on porcelain and glazed linen blinds married fluency with conventional figuration in functional dabs not far, as Sickert pointed out, from the ideal economy of the new painting. Renoir was proud of the craft, and his facility was appreciated; his employers treated him like a member of the family.

Opinion now might not accept that one talent is any more natural than another. The meaning of the word itself has been in doubt; it was not understood that when Constable determined that there was room for 'a natural painture', he meant simply a way of painting that would be nature-like, resembling. But some temperaments take to painting more wholeheartedly than others; there is no doubt that Rubens was one of them, and some of his naturalness was communicated by the fluent linear skills of eighteenth-century *rubénisme*. No one had that quality of temperament in anything like the perfection of Rubens and Watteau except Renoir. The *rubéniste* tradition expired, and a chasm has opened between us and Renoir; the historicism in his facility separates us. The appearance of relaxed normality in Renoir's art is itself deceptive. That natural confidence is in fact one of the rarest qualities in the

whole history of painting. In the fullest degree it was shared only by Rubens himself.

There is a story that when Renoir was brought a study bearing his name that was a forgery, he found it less trouble to repaint it than to challenge the imposture. It reminds one of the well-attested fact that Rubens, wishing to alter an oil sketch, normally discarded it and started another rather than bothering with correction. The cases however were by no means parallel, and it is symptomatic that Renoir's turned on self-imitation. When studies which Renoir had left with his wife's family were found to have been made into rabbit hutches or used to keep the weather out, his relatives explained that they did not think that anything that came so easily could be of value; it is not certain that they were wrong. The look and sentiment of Renoir's sketches of his children recall irresistibly the silky roundness with which Rubens drew his infant son. In a family group of 1896 (p. 252 fig. f) the Renoir boys appear together with his wife and Gabrielle, the nurse who was his favourite model, giving an impression of curvaceous progenitive abundance, which even Rubens could hardly match, and an indulgent laxity, which is mimed in the group by the narcissistic gesture of a neighbour's daughter (whom Renoir also liked to paint). The parade of self-indulgence is the last quality to recommend itself to the ravaged taste of ninety years later. Renoir is cut off from us, more than anything else, by the fact that, unlike the two great painters who were his friends, his work offered no sign of what was to come, unless some of the subjects and style of his last years can be counted as contributing to the invention of the neo-classicism of the 1920s.

Nevertheless Renoir's traditionalism represented a perceptive insight into the quality that distinguished him from the other painters of his generation in the Batignolles. 'It is in the museum that one learns to paint,' he always said. His nature made him the heir to an accumulated momentum. With Renoir, as normally before him, the language of art evolved of its own accord; the artist merely spoke it. In this he was exceptional in his time and opposed to any painter since. He inherited a language that he felt to be a mother tongue. 'I believe,' he said 'that I have done nothing but continue what others have done before me.' His concession to contemporaneity was the minimum. 'One must do the painting of one's time. But the taste for painting, which nature cannot give you, is gained in the museum.'

In the context of the analytical naturalism of his circle in the 1860s there was something paradoxical in this insistence. But the continuity that Renoir followed was one not of will but of instinct. Only once or twice in his whole life is there any sign of the deliberation about style which the characteristic artists of his generation and the next persisted in. We honour Renoir as the last painter certainly and evidently made in the mould of post-Renaissance tradition, able to pay the same tribute to Delacroix and to Boucher as they did to their predecessors and lose nothing of himself. The unalterable personal essence of his work was sustained without sign of effort. Its only consistency and gravity were those of his own intimate sensuous responses, the consistency of his delight. Besides the intensity and insight of other talents, this relaxed facility, sometimes more like a habit, was all that he claimed, although he did not mind it being described as genius. The brush in his hand, held by it or bandaged to it for sixty-odd years, was part of him; it shared his faculty of feeling. In Renoir this was more than heroic; it was natural.

Late in his life Renoir told Vollard that the first picture that caught his fancy had been Boucher's *Diana bathing*. Some of his remarks were made almost at random, but we need not doubt the truth of this one. The spirit and the bathing subject reappeared in his work at intervals through his life. As an apprentice Renoir went to the museum instead of lunch, and his clear-sightedness there was remarkable. Rather few young painters manage to ask themselves how the idea and momentum of painting reached them. They assume that these things are common property. The eighteenth century through which Renoir made his way to his tradition was not merely the style dictated by the porcelain factory. It was how he recognized himself, and it entirely suited the debonair, rather casual sensitivity which mixed with sensuality in the early portraits. Renoir never tried to deepen the gravity or darken the pleasure that was natural to him. He later complained that good humour is never taken seriously; that was surely its advantage to him. In the early 1860s, when Delacroix was finishing the decorations in Saint-Sulpice and Courbet was reaching his defiant culmination, a taste for Boucher must have seemed as wilful as it would today.

Renoir went to study in the studio of Gleyre, and there at the age of twenty-one he met Monet, Sisley and Bazille, all within a few months of the same age. The last, the most accomplished and best endowed, seemed destined to be his closest friend. Gleyre appropriately accused Renoir of painting for amusement. The story and Renoir's retort must have improved in retelling down the years. Painting at Fontainebleau Renoir had recourse to the Barbizon style, like his friends, but the examples that were important for Impressionism, Courbet, Manet and in quite another category Delacroix, all took on a special significance for Renoir. Due to Courbet the impressionist grasp of the matter of life was always much more robust than the programme, the reduction of painterly notation to its summary essence, might have suggested. Renoir's development was punctuated for years by life-sized standing figures, culminating in a sequel to Courbet's *Demoiselles aux bords de la Seine*, a nude modelled on the Medici Venus (and accompanied by a little dog), which was both more stylish and more finished than anything the others painted (no. 15).

It was Manet who demonstrated, in the sheer economy of the tonal patch, the glamour and glitter of what the brush could do. Renoir's adaptation of his example to the sultry portrait of the same amiable model against freely-brushed patches of summer foliage (no. 8) was again more stylish and more seductive than anything the others had painted. Renoir always remembered that, at school with Gleyre, the museum had meant for him simply Delacroix, and his use of that example was both closer and more personal than the rest. His

splendid echo in a portrait of Madame Stora *à l'algérienne* (no. 17) showed just what Delacroix's orientalism meant to him. The liberated touches of colour could be animated and enforced by a continuous rhythm. Two years later the point of the *Parisian women in Algerian dress* (no. 20) was evidently the wanton dishabille of the group. Delacroix, as much as Boucher, supported the idea of style as a sensual indulgence, and both examples pointed to an unabashed hedonism quite foreign to his other sources and to his friends.

It was significant that all these styles were succeeding one another on Renoir's easel in the same years. None of his friends experimented so widely and inconsistently. None would have cared to embark on so many different styles, or to imitate them so closely. None was inspired by such unblushing hedonism. What gave Renoir's point of departure a commanding advantage was without doubt his capacity and determination from the first to please himself. It might not commend itself to the high-minded. Indeed, as we can read, it still does not. But his motivation certainly offered a compelling and, despite its traditionalism (or because of it), original blend of painterly and sexual greed.

Jean Renoir reported how his father's priorities were still ordered in old age; the nature of an egotist is clearer to his children than to anyone. 'Renoir had an almost physical aversion to doing anything he did not wish. . . . He was like a human sponge, absorbing everything that had to do with life. All that he saw, everything he was aware of, became part of himself. The thought that his every brushstroke gave back these riches a hundred fold did not occur to him until late in his career. When he took up his brush to paint he always forgot that his work might be of the slightest importance. The role . . . which implies a "giving" of oneself, seemed unrealistic to him, who wanted only to take. Of his own unbearable selfishness he had no conception.'

The idea of painting as a quite physical indulgence dictated the philosophy and the coherent strategy of life that were entirely his own. It was itself a kind of originality, and it was entirely conscious; questioned about it Renoir would answer with an unaffected and unforced coarseness. He was neither modest nor boastful about the phallic role in which he imagined his brush. An artist's brush had hardly ever been so completely an organ of physical pleasure and so little of anything else as it was in Renoir's hand. Its sensate tip, an inseparable part of him, seemed positively to please itself. In the forms it caressed it awakened the life of feeling and it led them not to climactic fulfilment but to prolonged and undemanding play without any particular reserve or restraint – or commitment. If the brush defines and records, it is for pleasure, and the shapes it makes, quivering in their pearly veil, discover satisfaction and completeness. One feels the surface of his paint itself as living skin: Renoir's aesthetic was wholly physical and sensuous, and it was unclouded. In essence his art had no other matter; human identity and character were seen entirely in terms of it. His ethos was ideal for an art that must express physical things in physical terms, and there was no great part in it for theory or thought or reflection, nor perhaps at root

even for generosity, open-hearted though he was. His love distributed its favours at random, decorating the visible scene with its capricious indifference. The fruits of his sentiment are abundant – in every sense voluminous: few, I think, look at them unmoved.

Renoir's love is still infectious. I don't doubt that we shall find it so again in this exhibition. One cannot help sharing it, and one returns to enjoy it. There is something oddly offhand but not unsympathetic in the mood of nervous, restless sociability in which one can feel that he painted (chattering, we are told, for fear of the silence). We recognize a moody man in the early photographs. Verbal commentary and critical debate do not bring us closer to him, and he did not welcome them. He suffered more than most from them. It is now strange to remember in front of the *Nude in the sunlight* (no. 36) that Albert Wolff, blind to anything but local, literal colour, pronounced this exquisite visual truth to be hideous because he could not conceive that the visual colour was not being imputed to the model.

If we need an introduction to painting it may indeed be sought where Renoir found it, in the museums, but reference to the eighteenth century or to Delacroix or to Courbet, though it may prepare us for the degree to which truthfulness is necessarily relative and metaphoric and so ultimately imaginative, will still be far from accounting for that marvellous, speculative leap that realism was able to make in the years around 1870, and quite soon to render its boldness more evidently truthful and natural than anything in art before.

Renoir's art as it developed in his thirties centred more and more on the mutations that conveyed the varying light on his subject. Often it was the dappling of shadow and sun under trees. Patches of direct light were caught and matched as they fell across the subject, creamy and rosy and pearly by turns, until they were lost in the shading of violet and indigo beyond. Reflected light collected in warm still pools where telling human features were found to float. The brush marked shape as light in streaky modulations; in the *Ball at the Moulin de la Galette* (no. 40) they slither like elvers in the current. The liquid and lucent medium of vision ripples over the roundness of life and puddles in the hollows into which the eye plunges as if for love. Which painter before Renoir ever watched the flow of pearly half-shadow down a girl's body settle in the hollow below the shoulder and then, beyond the armpit, collect again just above the breast, before tumbling deep into shade and reflection, as Renoir watched it in the *Nude in the sunlight*? Light washes over the shape, gathering softly incandescent, then streams away into the plashy coolness, watery or leafy, which is all around. Renoir had a special devotion to forest scenery 'which makes you feel there is water about'.

The motion of light and colour touches the form with a deliberate yet gentle attention, which is offered and felt as a caress. A touch of colour is quite simply and intentionally touch; it is both the gesture and sense. It is contact with surface, a felt awareness of feeling smoothness. The touch of skin and the touch of painting were felt as indistinguishable and ultimately identical. The brush, the fingertip, the organ

were thought of similarly – imagined in congress with the visual skin.

Touch was a conscious obsession with Renoir. It rather puzzled his son, who liked to keep his nails short for climbing trees. For the painter finger-nails had different and odd associations. They were thought of as existing to protect the all-important, significantly vulnerable fingertips, and not on any account to be shortened. 'You must protect the ends of your fingers: if you expose them you may ruin your sense of touch, and deprive yourself of a good deal of pleasure in life.' Touch and its visual counterpart were the centre of Renoir's purpose. He was uncommonly frank on the subject. 'What goes on inside my head doesn't interest me. I want to touch . . . or at least to see!'

In the joint evolution of the impressionist style Renoir and Monet often worked side by side: the differences between them are significant. At La Grenouillère in 1869, watching Parisians on holiday, Renoir was already entertained and entertaining (nos. 12, 13). There were traces of caprice in his view. The play that occupied Monet was the play of sun and shadow, the strictly visual phenomena that were to be elucidated systematically in strips of blue and gold. Unknowingly Monet's sober party was present at the demonstration of the grand theorems of light on water, which were not less than epoch-making, influencing how we see our world for ever. For Renoir the bustle and sparkle, the flutter and whisper of leaves and the stir of amusement compose by contrast a minor comedy of place and occasion.

The ways that Renoir's contemporaries painted were each comparatively consistent. Renoir decided how he would paint empirically, if not waywardly. The even granulation of colour in sunlight with which Monet and Pissarro explored landscape in the seventies was only one of the styles that opened to him. Liquid or crumbled dappling was equally possible. The tone was for preference bright and silvery, streaked or flecked with detail, it seemed on impulse.

For him the forms of landscape – in one memorable series of pictures the paths that wound through long grasses up sunlit meadows – lost themselves in an uncalculating reverie on the elusive relationship between a place and its atmospheric sheen. He was quite uninterested in the consecrated topography of a customary view, which often occupied Monet. His site was usually nowhere in particular, and when it was Paris the vapours of the place became a condensation of urbane picturesqueness. Renoir remarked that Pissarro's street scenes always included a funeral where he would have preferred a wedding.

Unlike the serious Impressionists, Renoir regarded the subject-matter of painting as an entertainment. He was even able to combine the pleasures with the commissions that made his living. None of the other painters of the circle had the taste nor perhaps the fluency for portraiture as a trade. Renoir destroyed the Romantic history pictures that he painted as a student soon afterwards, but a succession of sequels to his Algerian subject of 1870 and a copy of Delacroix's *Jewish wedding* remain as tributes to the master. The idea of deliberately sumptuous painting on the model of Delacroix preoccupied Renoir throughout his life, and the pervading red out of which the forms of his last pictures burst into florid blossom would not have suggested itself without Delacroix's interpretation of the Venetian example.

But Renoir's sentiment, as it announced itself in the seventies, was of quite a different kind. It had the domestic realism of his own generation; even the nudes had a suggestion of current life. His romantic subjects of lovers in gardens generated the festive genre pieces of parties at the Moulin de la Galette and the restaurant at Chatou which were specific and descriptive. None of his friends painted anything like them: they were as ambitious and as influential as anything that the Impressionists produced. They were the only works that represented the interactions of real people on specific occasions. Such subjects were outside the range of any other Impressionist until Toulouse-Lautrec began to paint night-life in the next decade.

Such explicitly illustrative pictures, especially of subjects so plainly pleasurable and enjoyed, have not attracted advanced support in the hundred years since they were painted. Serious critics do not take them seriously, unless to question their social enlightenment. These interactions of real people fulfilling natural drives with well-adjusted enjoyment remain the popular masterpieces of modern art (as it used to be called), and the fact that they are not fraught or tragic, without the slightest social unrest in view, or even much sign of the spatial and communal disjunction which some persist in seeking, is far from removing their interests.

If we look at Renoir as an illustrator of human interaction he has satisfying surprises to offer even in these best known pictures. In picture after picture, for example, a woman (Ellen Andrée in *Luncheon of the boating party*, no. 52, Suzanne Valadon in *Dance at Bougival*, no. 67) lets the concentrated admiration of a bearded young man, who is oblivious of anyone else or of us, rest steadily upon her; the intentness is almost palpable. She receives it; it bathes her; she luxuriates in it, smiles a little to herself. Presently an inward look and something in her bearing admit complicity. The two are at one; their state is blessed. Eventually in *Dance in the country* (no. 69) she laughs with open, irrepressible delight as the dance whirls her away towards the consummation of the theme that began fifteen years before with Alfred Sisley's courtly attention to his fiancée in Renoir's most substantial early picture (no. 9).

These passages steadily embody a relationship. They are images of what is mutual, tender and ardent, which returned to the stillness of painting the satisfaction that the painter had gaily plundered and would again. They show the painting of love and the love of painting to be intimately linked and treasured resources and lastingly add them to the richness of art. We find ourselves treating this, which we had taken for makeshift picture making, as great painting and notice that in this special dimension, which is Renoir's own and no one else's, there is no contradiction.

Renoir always denied being intelligent. Proclaiming that his models, whose distinction was how their skin took the light, did not and should not think, he was slyly offering to women

the happy state of passivity that he claimed for himself. But it happens that Jean Renoir, a genius of comparable calibre, in the fifth chapter of the masterpiece that he devoted to his father, recorded his attachment to the idea that we can trace in the steadiness and wholeness of this realization. We read that the idea that occupied Renoir most deeply was the idea of life as a state rather than an undertaking.

Reflecting thus about Renoir, and I find it irresistible, we abandon the enjoined detachment or abstraction from the traditionally illustrative essence of painting and the earnestness of modern art and revert to the level on which painting was appraised in the eighteenth century. We adjust our focus for example to the seriousness of sentiment and accept the concomitant sentimentality. We accept likewise his appalling lapses from that level of quality and competence imposed on French painting by J. L. David. Canvas after canvas may be found to lack either the elevation or the resolution of good painting.

The struggle of the 1870s was a severe one: it ended in worldly success, but it left Renoir discontented and as restless as ever. The support that he gained from the Charpentiers and their circle required acceptable, conventional painting, and Renoir was supplying it. The picture of Madame Charpentier with her children (no. 44) charmed in the same way as *La Loge* (no. 26) four years or more earlier. This was one of the moments of doubt that Renoir, who was no revolutionary, had in mind when he remembered in later years: 'I have never had the temperament of a fighter and I should several times have deserted the party if old Monet, who certainly did have it, had not lent me his shoulder for support.' In the event he did not desert. Rather than base his future on repetitive, fashionable portraiture, he set about reconstructing his art on a wholly new and more demanding basis.

A tour of Italy convinced him that he had never really learned either to draw or to paint. In Rome he found (as he wrote to Madame Charpentier) that Raphael's frescoes were full of sunshine although he had never painted out of doors. On a boat in the Bay of Naples, in full sunlight, Renoir painted the *Blonde bather* (no. 63), and when he had reworked it in keeping with his new discovery (probably in the version which is now numbered second, no. 65) her glowing fullness was enclosed within a wiry bounding line. On the way home he stayed with Cézanne at L'Estaque; at about the same time he came on the Treatise of Cennino Cennini, which convinced him of the primacy of drawing. Before the middle of the decade he had translated his style into terms of the severest classicism. Renoir's distaste for his 'sharp manner' in later years, when he produced revised, unfettered versions of the pictures that he painted then, has concealed how well founded in his own nature his criticism of Impressionism was. A sense of linear continuity was always an essential part of Renoir's handling of form and paint, and after the dry period it was never obscured again. The last of the big genre pictures, *The umbrellas* (no. 58), was altered to conform to the new outlook. The clear continuous line of the girl with the hatbox (one of Renoir's enchanted recipients of male admiration) and the

curving sequences of colour mutations (not only in the foliage) date from the revision.

The nearest point of classical purity in Renoir's tradition was the work of Ingres, whom he had watched from afar in the Bibliothèque Nationale when he was a student. It was his example and his restrained use of oil paint that Renoir recalled when he looked at Raphael in the Farnesina. They are visible in the serpentine rhythm of the *midinette* in *The umbrellas*. But he knew his natural level, and in planning the central work of his *ingriste* period, the *Bathers*, now, not by Renoir's wish, in Philadelphia (p. 241 fig. a), a more genial formality occurred to him, and he borrowed from the Girardon *Bain des nymphes* at Versailles. The formulation that he chose embraced, indeed demanded, new observation, which is clearest in his drawings for the picture, some of the most concentrated of his works, as fresh and unconventional as anything he did. Sharp delicacies of neck and chin, the wiry length of back and its arching were analysed at last with lucid, logical unity. This completeness gave a theme to the whole development of later years.

In the years that followed, the *ingriste* sharpness was assimilated to the natural freedom of his thought. In the process some of Renoir's masterpieces were painted. There is the lovely breadth of head in Julie Manet's portrait, a warrant in itself of the greatness of its painter. There is *Maternity* (no. 79), a picture in which he studied, with all the precision that he now commanded, the sentiment for naturalness which was the recurrent theme of his whole work. Artificial feeding was the greatest crime of all – 'not only because a child should bury its nose in its mother's breast, nuzzle it and knead it with its chubby hand.' Most moving, there is the portrait of Aline Charigot, whom he eventually married (no. 78), perhaps best of the many images instinct with reciprocated, active love, which give the lie to those who think that the role to which Renoir consigned women demeaned them.

The apotheosis of this development was again heralded by a meeting with Cézanne; he rented Maxim Conil's house at Montbriant, and the two old friends painted the view of Mont Sainte Victoire together. 'Doesn't Renoir paint outdoors?' Vollard asked once when Degas was attacking the *plein airistes*. The answer was, 'Renoir can do what he likes. Have you ever seen a cat playing with balls of coloured wool?' He played with the Provençal landscape to some purpose. Light was gently guided to the middle of form, gathering into glowing bosses on the rounded shapes. Volumes took on a new amplitude, arranging themselves quietly in space.

It was a foretaste of his destination. Renoir's grip on the particularity of his subject was never the most demanding. 'How difficult it is to know,' he said, 'just where the imitation of nature in a picture might stop. Painting need not stink of the model but it must have the perfume of life.' And to a painter, 'One must embellish, Bonnard, don't you think?' Renoir's embellishments in his last years became a total transformation. From Gabrielle, who joined the household as a nursemaid from Aline's village in Champagne and became the favourite model, a whole mythology of naturalness grew up. She and her charges inhabited a world undivided by the

particularities of personality, where emotion found at last its ideal vessels. Some of the images were both grandiose and commonplace. 'Renoir!' Cézanne said to Maurice Denis in disgust, 'What do you expect? He has been painting Parisian women.' Yet the unfolding of feeling dictates its own dignity and suggests the sumptuous and general architecture. A head shows its features, last emblems of specific faculties, without expression. No movement disturbs the ripening surface. The whole subject is physical and sensuous, and it breathes the scent of life. He had now no taste for dryness. Nor had he much use for realism. '"How strong!" they say, when Courbet is spoken of. . . . I prefer a penny plate, with three pretty tones on it, to acres of such painting, extra strong and utterly wearisome.' It will have been one of the remarks that he wished had been unsaid. If the weight and substance of the nudes painted after 1910 had any parallel in French painting it was the still lifes that Courbet painted in Sainte-Pélagie.

Even before Jean Renoir told us so much about the old man, we might have recognized a painter with a heartfelt theme. His theme was a sentiment amounting to obsession with the state of nature, under which everything that he painted was subsumed – flesh, his family, the life and mythology of the South and his sentiment for them all were in one aspect a fiction of his own imagining. Yet it was not and is not wrong to think of that as precious and threatened. Renoir's sense remains just as sensible and as durable as he hoped. In the simplicity of the stance, backed by tradition, face to face with natural life, quite unpretending and fallible yet always with the lively grace of what is unforced and unconcealed, Renoir remains incomparable. 'When I look back at my life I compare it to one of those corks thrown into the river. Off it goes, then it is drawn into an eddy, pulled back, plunges and rises, is caught by a grass, makes desperate efforts to get free and ends by losing itself, I do not know where . . .' He used to repeat the comparison often. 'When I look at the old masters I feel a simple little man, yet I believe that among my works there will be enough to assure me a place in the French School, that school which I love so much, which is so pretty, so clear, such good company. And with nothing rowdy about it . . .' Nobody will improve on Renoir's own summary. 'Each one sings his song if he has the voice.'

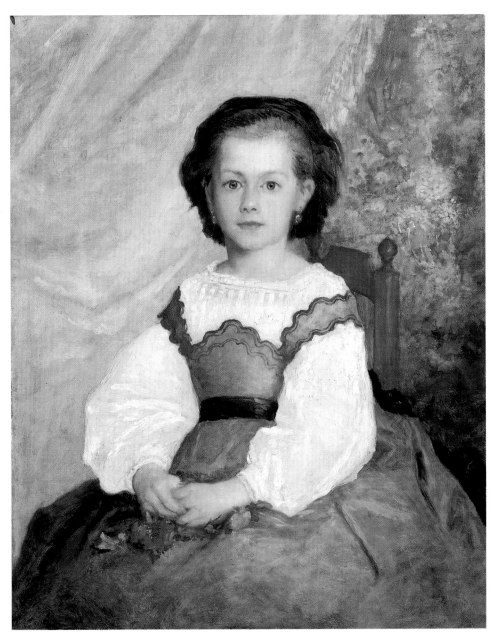

1. *Portrait of Mademoiselle Romaine Lacaux*, 1864. 81 × 65 cm.
The Cleveland Museum of Art

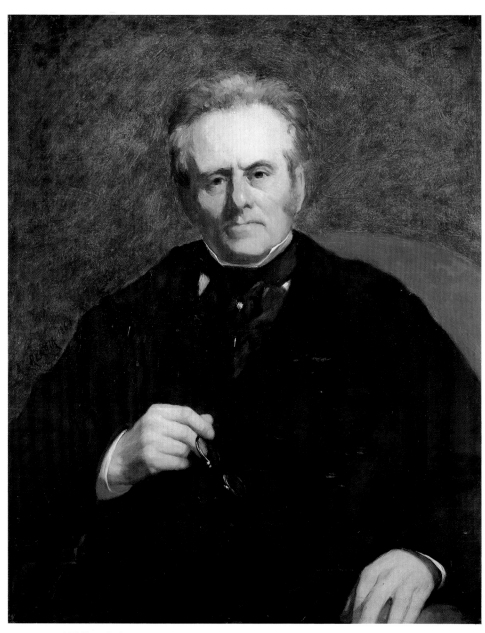

2. *Portrait of William Sisley*, 1864. 81 × 65 cm.
Musée d'Orsay, Paris (Galerie du Jeu de Paume)

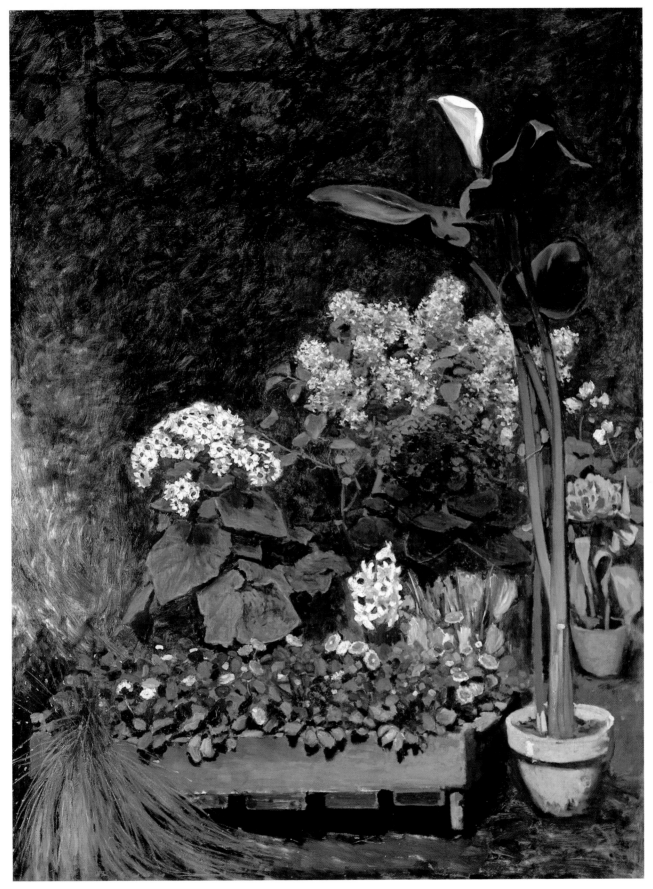

3. *Still life*, 1864. 130 × 98 cm.
Kunsthalle, Hamburg

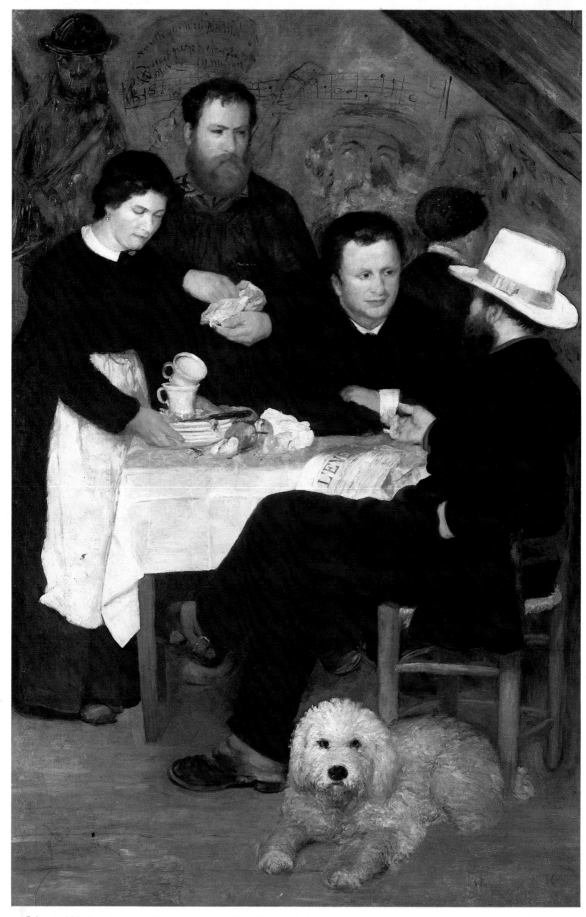

4. *Cabaret of Mother Antony*, 1866. 195 × 130 cm. (Detail opposite)
Nationalmuseum, Stockholm

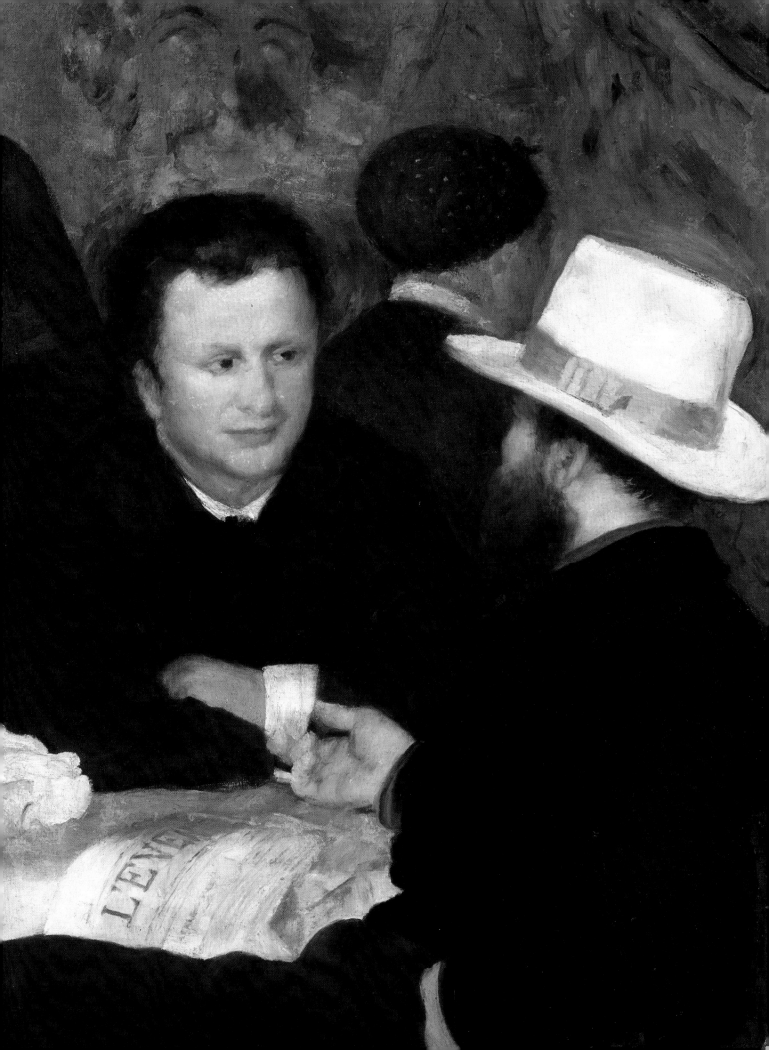

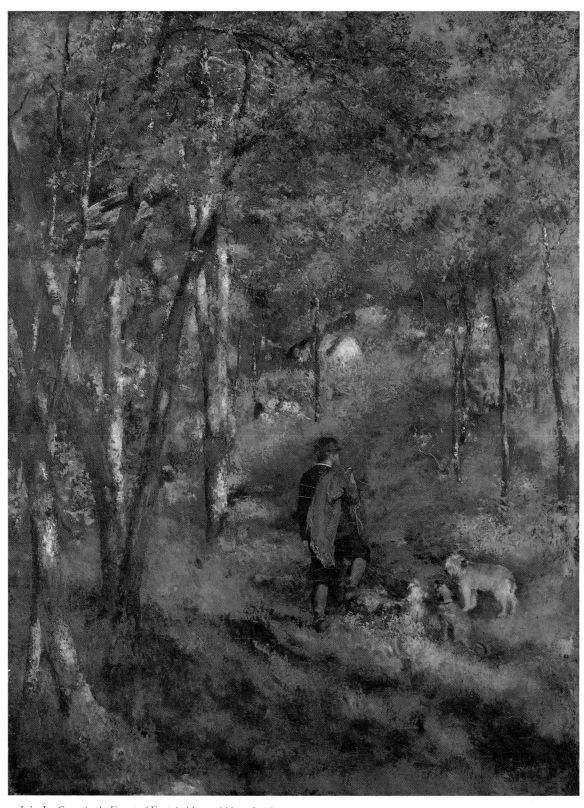

5. *Jules Le Coeur in the Forest of Fontainebleau*, 1866. 106 × 80 cm.
Museu de Arte de São Paulo

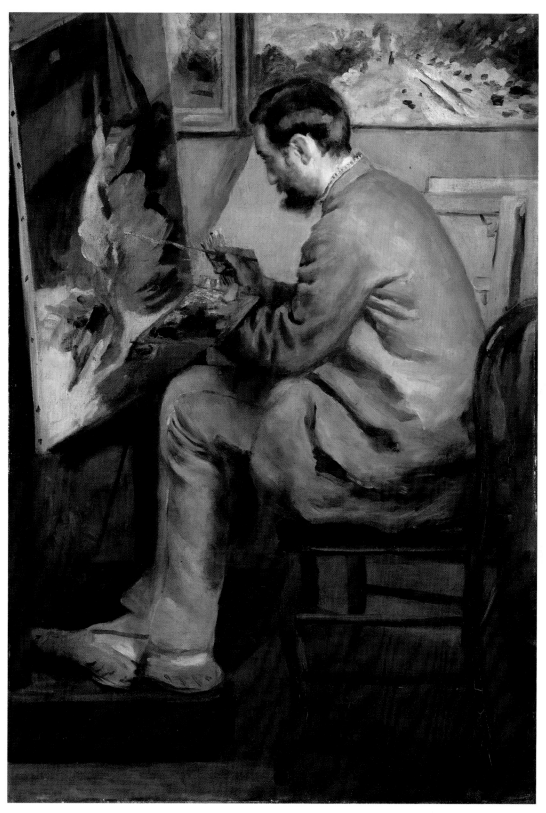

6. *Frédéric Bazille at his easel*, 1867. 105 × 73 cm.
Musée d'Orsay, Paris (Galerie du Jeu de Paume)

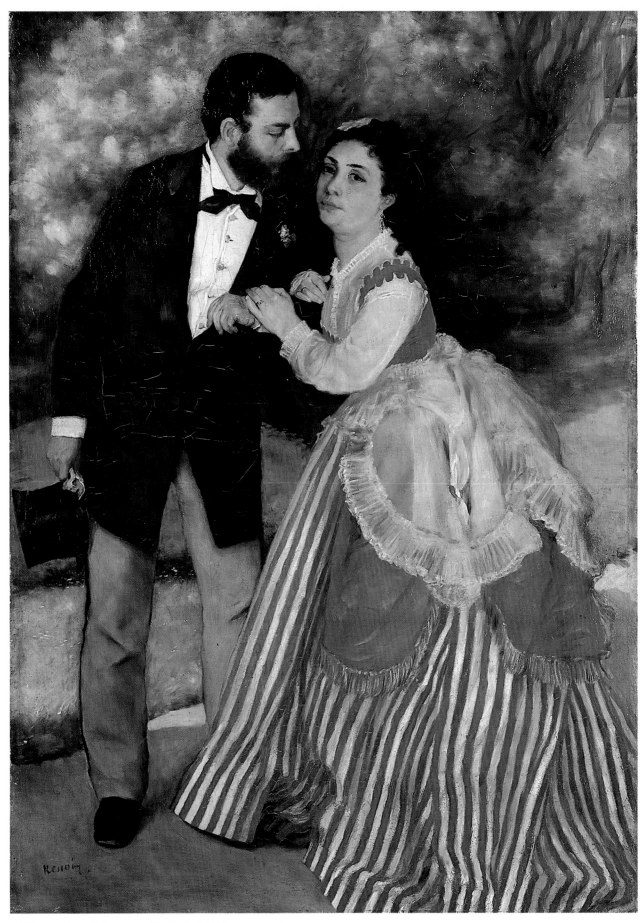

9. *The engaged couple* (known as *The Sisley family*), *c.*1868. 106 × 74 cm.
Wallraf-Richartz Museum, Cologne

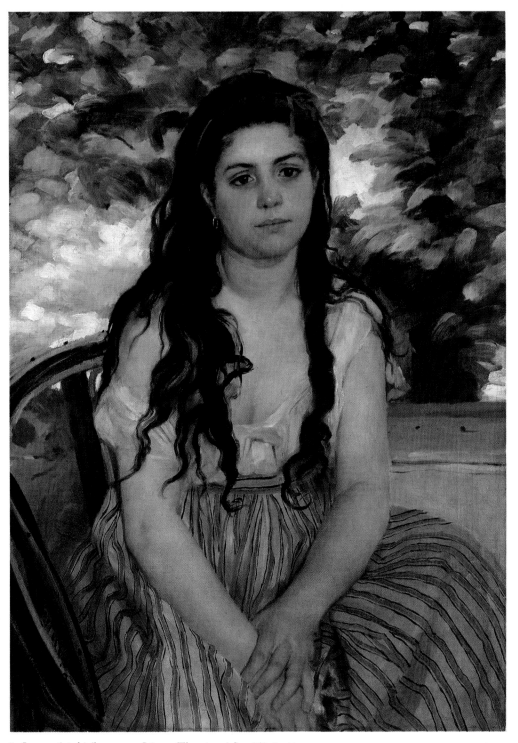

8. *Summer (study)* (known as *Lise* or *The gypsy girl*), 1868. 85 × 59 cm.
Nationalgalerie, Berlin

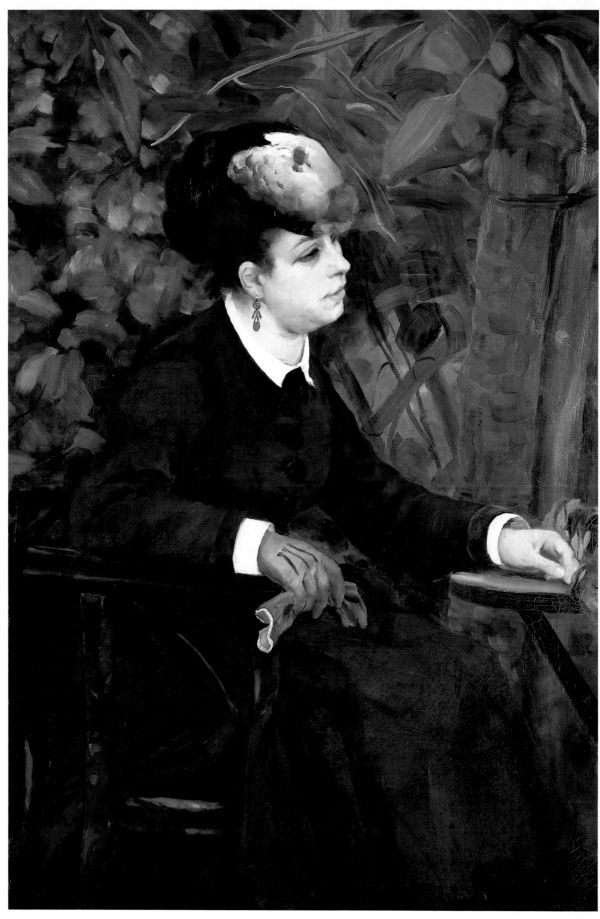

10. *Woman in a garden* (known as *Woman with a seagull feather*), *c.*1868. 106 × 73 cm. (Detail opposite)
Private Collection, on loan to Kunstmuseum Basel

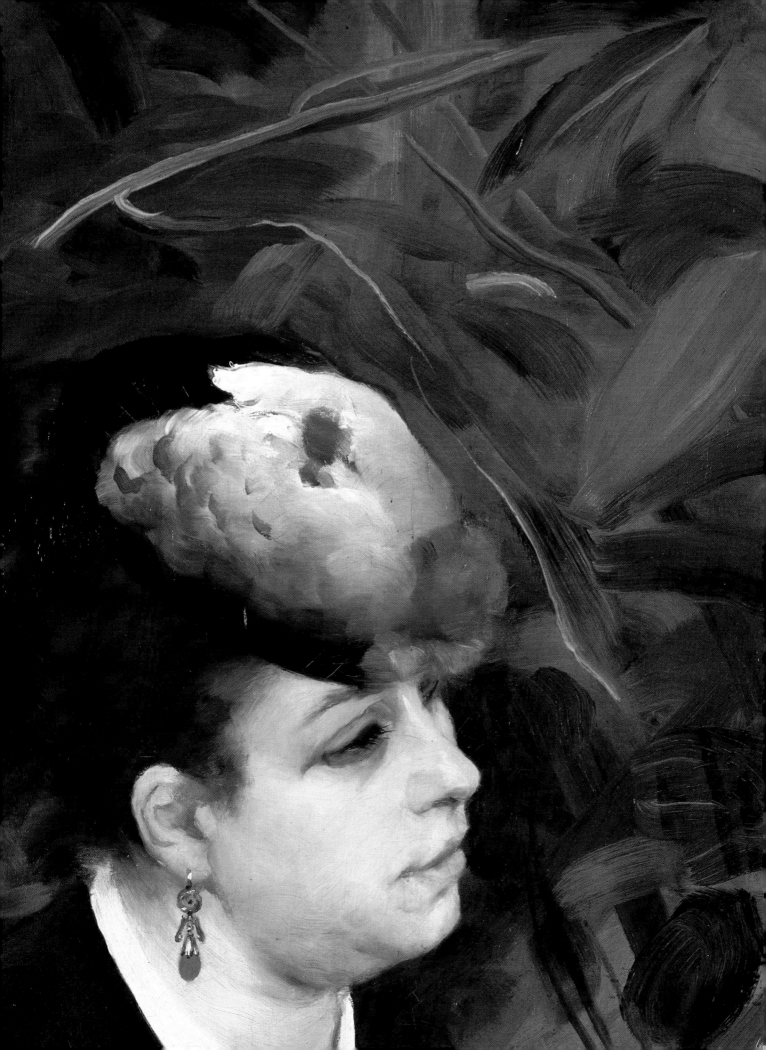

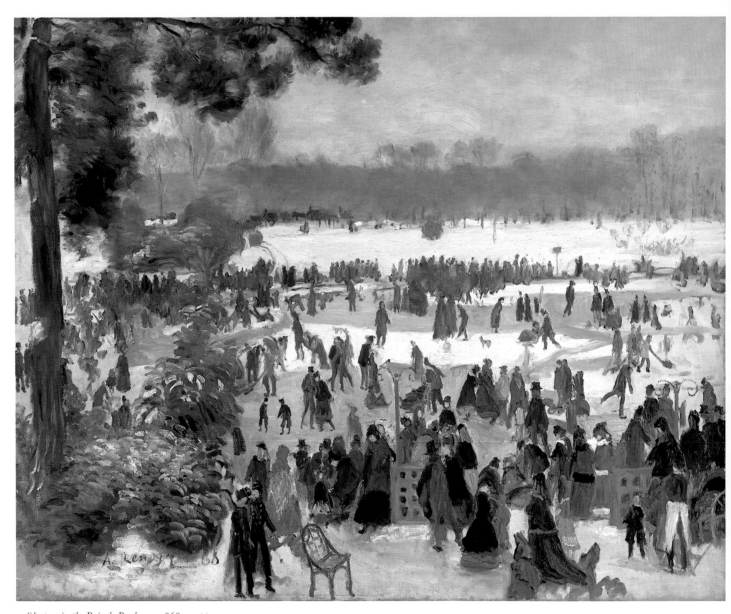

7. *Skaters in the Bois de Boulogne*, 1868. 72 × 90 cm.
Private Collection, U.S.A.

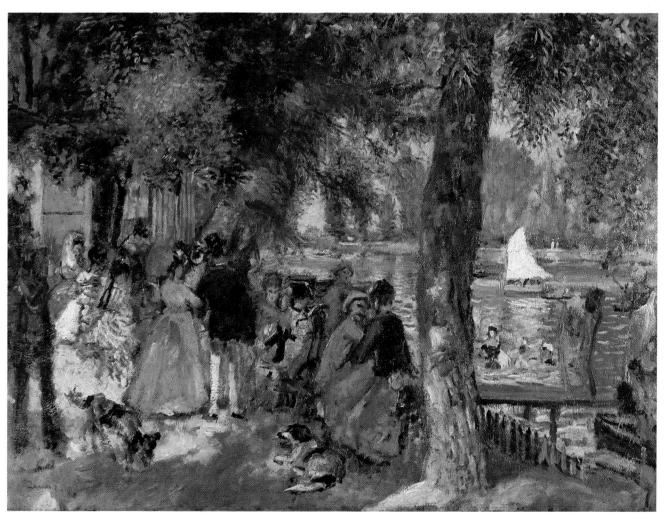

12. *La Grenouillère*, 1869. 59 × 80 cm.
Pushkin Museum, Moscow

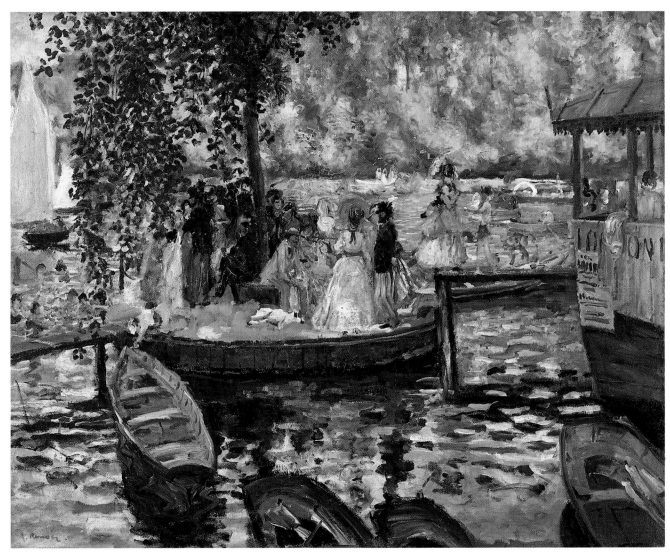

13. *La Grenouillère*, 1869. 66 × 86 cm. (Detail opposite)
Nationalmuseum, Stockholm

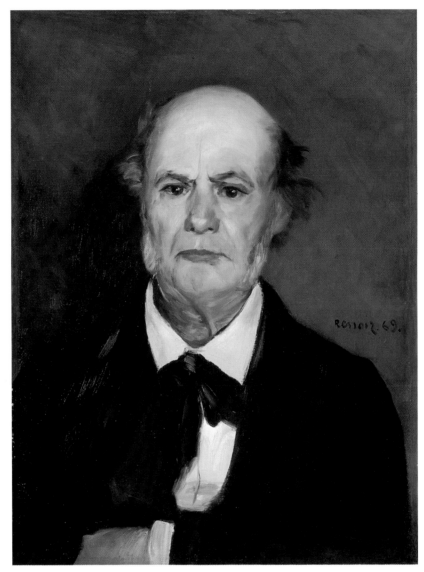

11. *Portrait of the artist's father, Léonard Renoir*, 1869. 61 × 46 cm.
The Saint Louis Art Museum

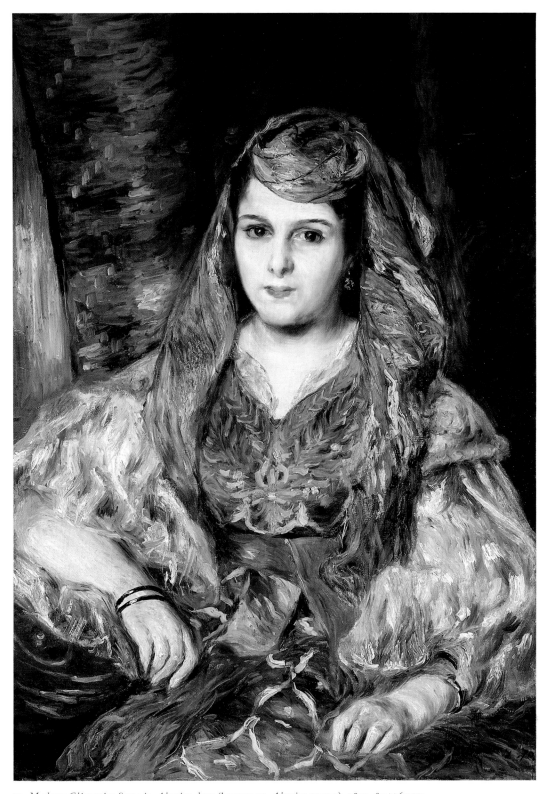

17. *Madame Clémentine Stora in Algerian dress* (known as *Algerian woman*), 1870. 84 × 60 cm.
The Fine Arts Museums of San Francisco

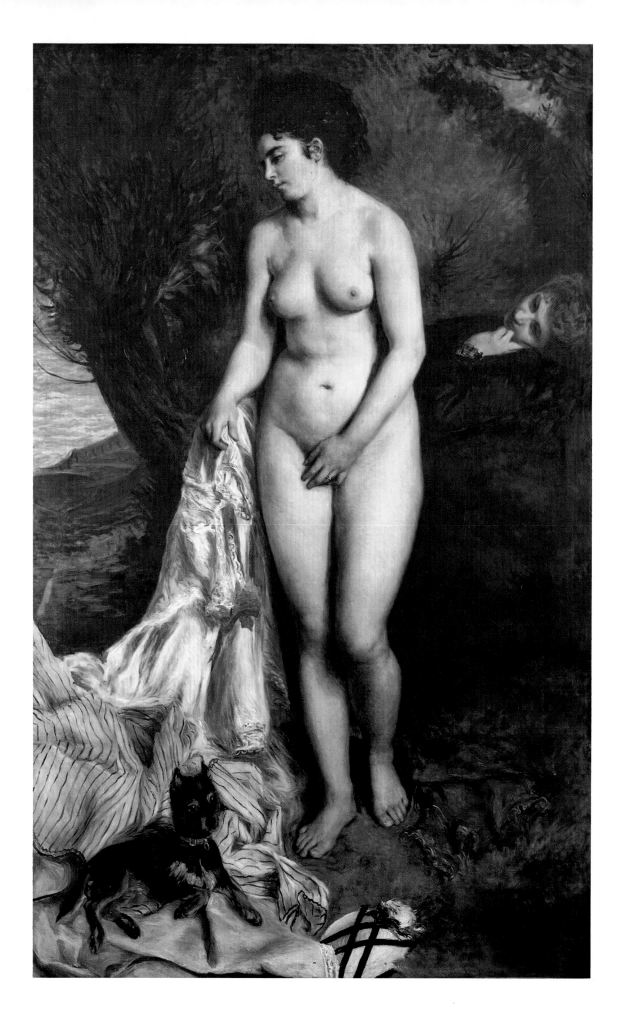

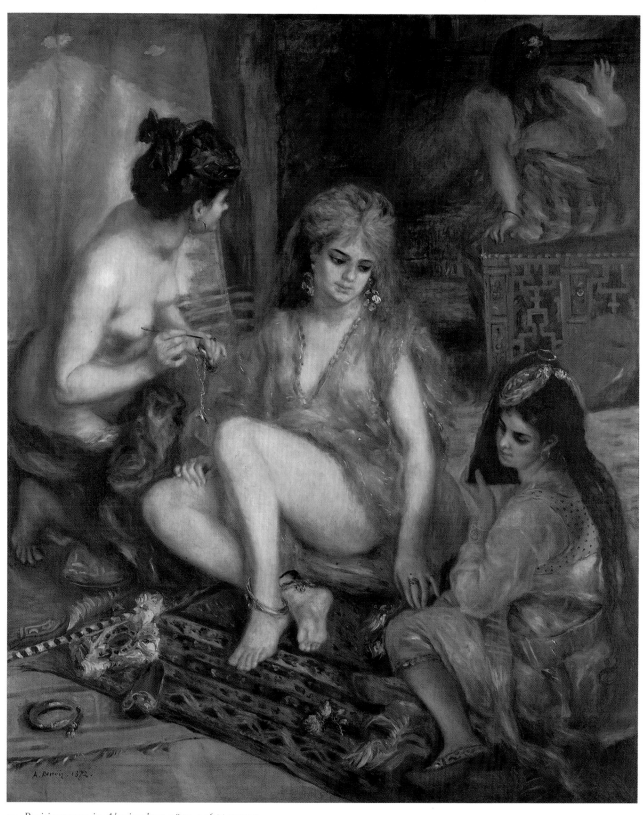

20. *Parisian women in Algerian dress*, 1872. 156 × 129 cm.
The National Museum of Western Art, Tokyo

15. *Bather with a griffon*, 1870. 184 × 115 cm.
Museu de Arte de São Paulo

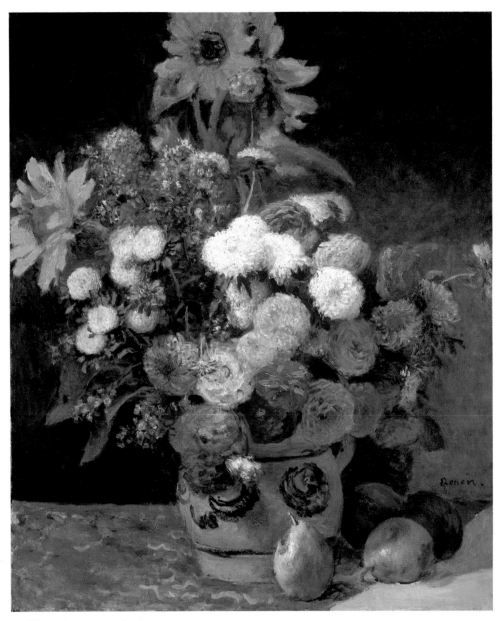

14. *Flowers in a vase, c.* 1869. 65 × 54 cm.
Museum of Fine Arts, Boston

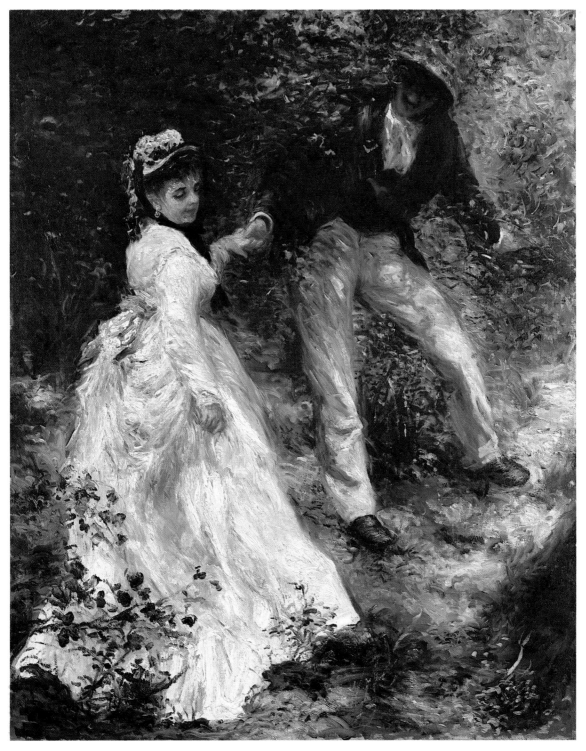

16. *The promenade*, 1870. 80 × 64 cm.
From a Private English Collection on loan to the National Gallery of Scotland

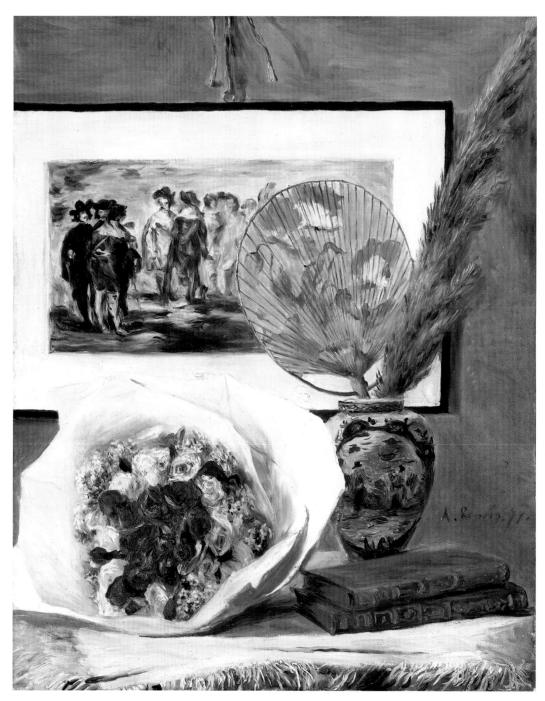

18. *Still life with bouquet*, 1871. 74 × 59 cm.
The Museum of Fine Arts, Houston

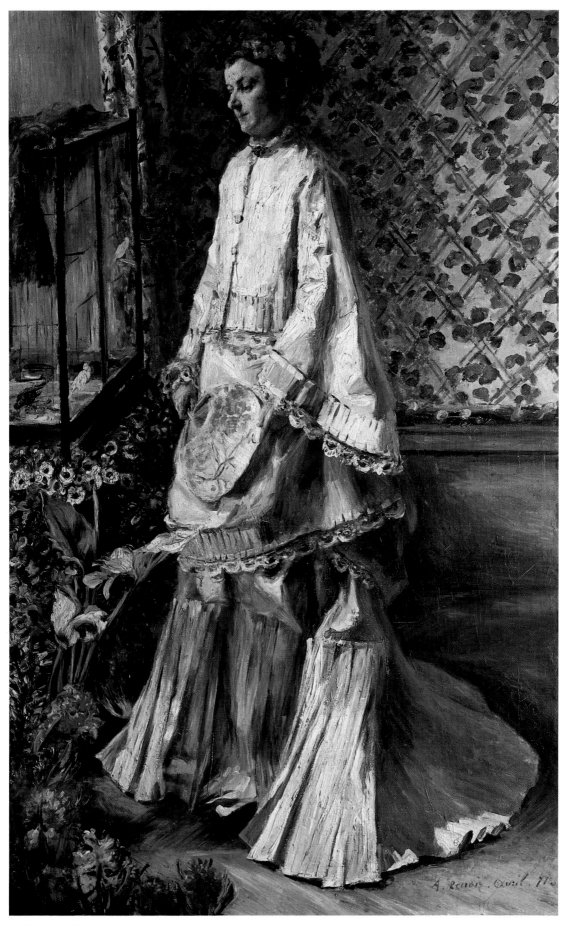

19. *Portrait of Rapha*, 1871. 130 × 83 cm.
Private Collection

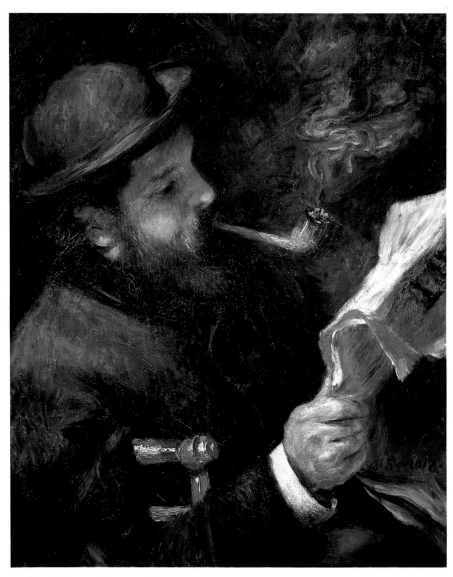

22. *Claude Monet reading*, 1872. 61 × 50 cm.
Musée Marmottan, Paris

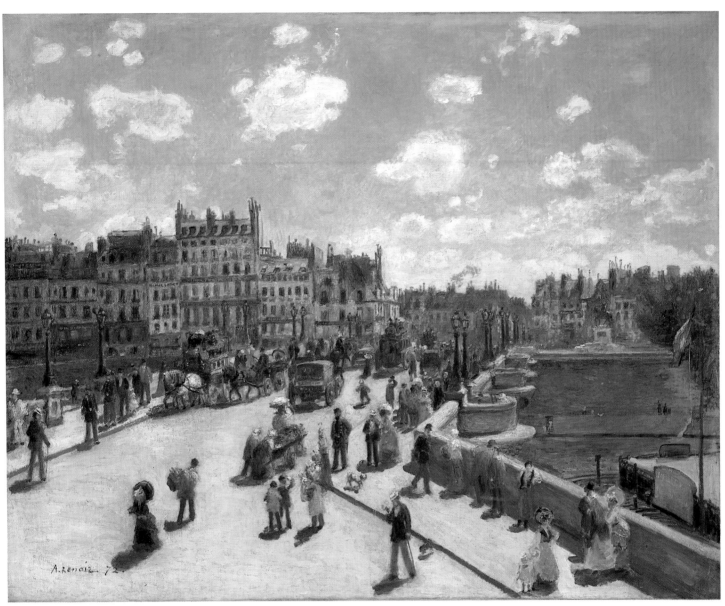

21. *The Pont Neuf*, 1872. 75 × 94 cm.
National Gallery of Art, Washington, D.C.

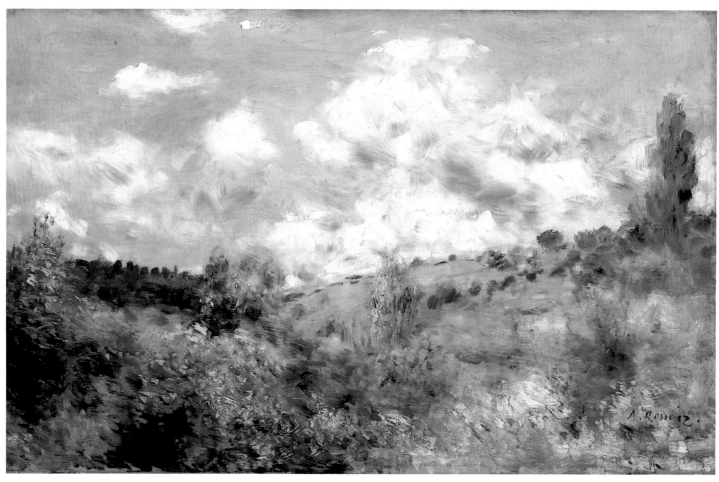

25. *High wind* (known as *The gust of wind*), *c.* 1872. 52 × 82 cm.
The Syndics of the Fitzwilliam Museum, Cambridge

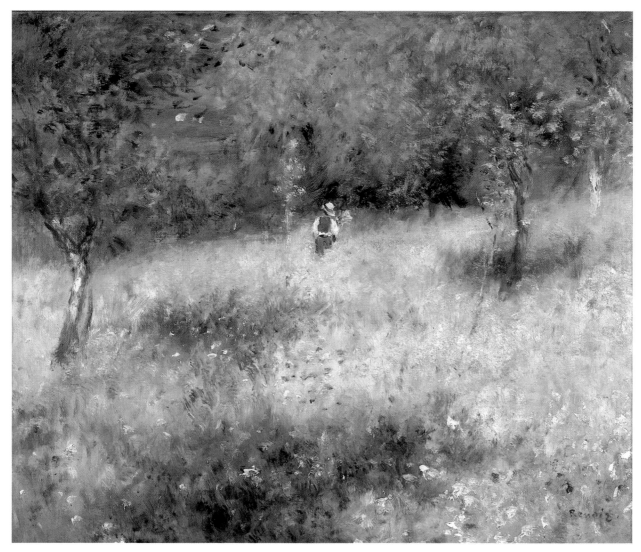

24. *Spring at Chatou*, *c.*1872–5, 59 × 74 cm.
Private Collection

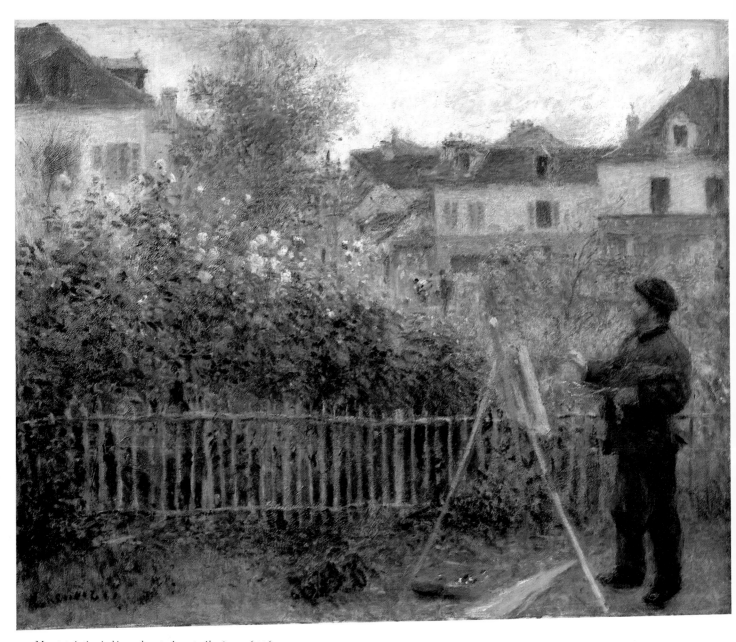

23. *Monet painting in his garden at Argenteuil*, 1873. 46 × 60 cm.
Wadsworth Atheneum, Hartford

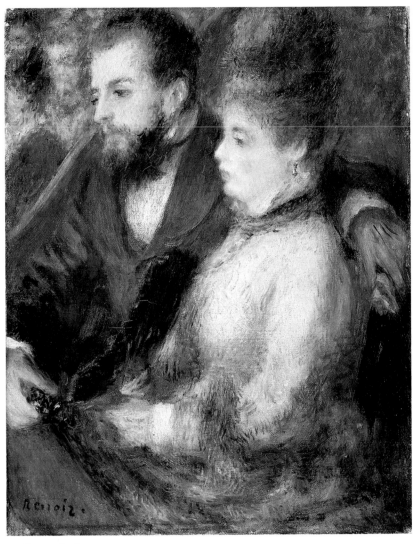

27. *Box at the theatre, c.* 1874. 27 × 22 cm.
Durand-Ruel, Paris

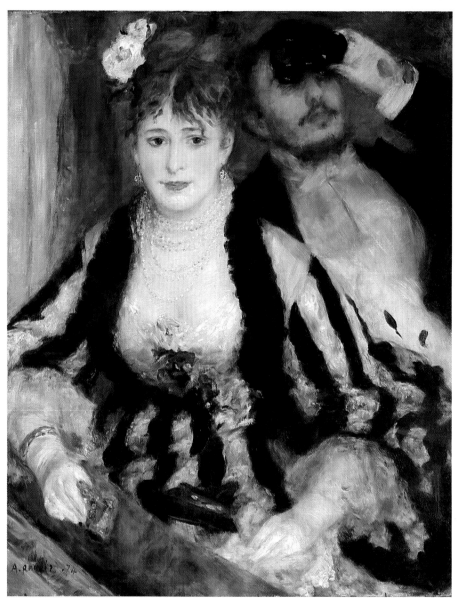

26. *The theatre box* (known as *La Loge*), 1874. 80 × 63 cm.
Courtauld Institute Galleries, London

28. *The Parisienne*, 1874. 160 × 106 cm
National Museum of Wales, Cardiff

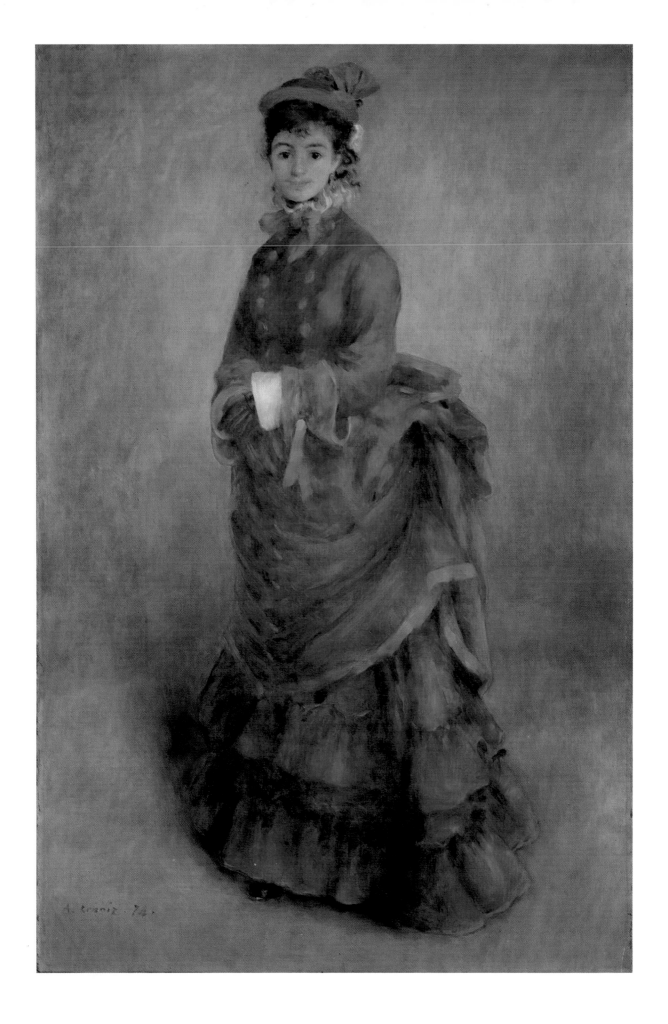

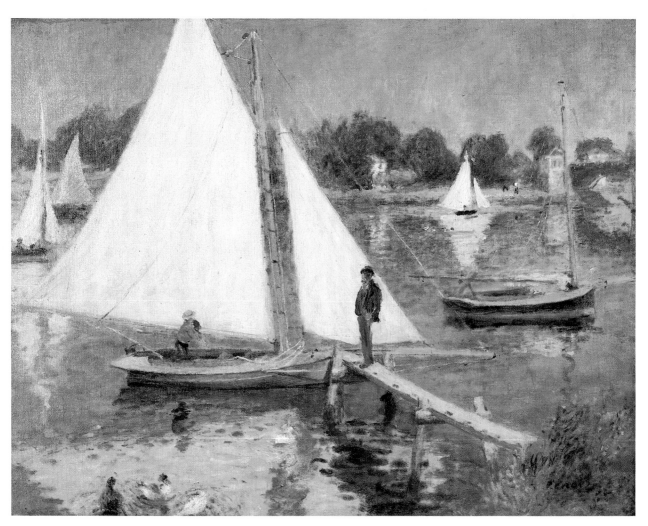

29. *The Seine at Argenteuil*, 1874. 51 × 65 cm.
Portland (Oregon) Art Museum

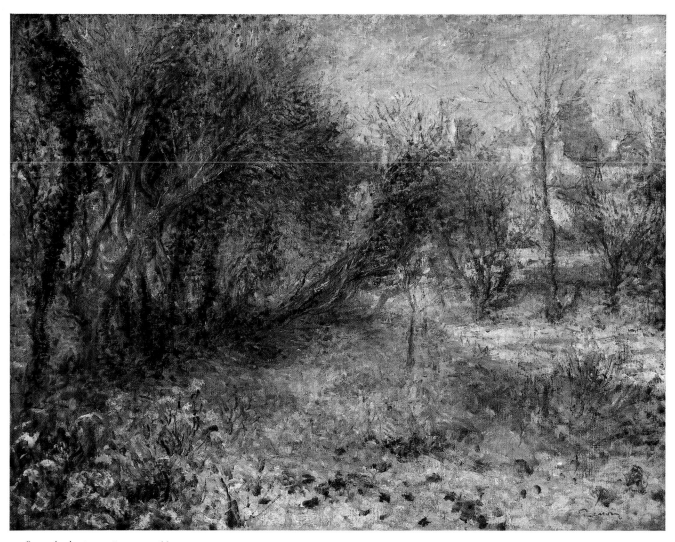

33. *Snowy landscape, c.* 1875. 51 × 66 cm.
Musée de l'Orangerie, Paris (Collection Walter–Guillaume)

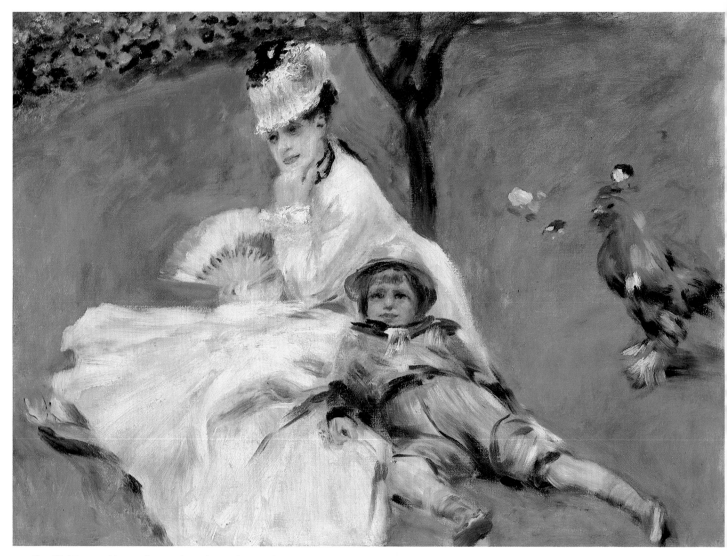

30. *Camille Monet and her son Jean in the garden at Argenteuil*, 1874. 51 × 68 cm.
National Gallery of Art, Washington, D.C.

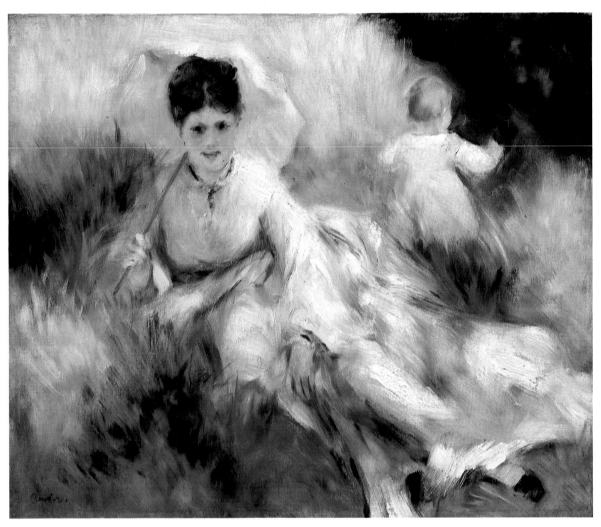

31. *Woman with a parasol*, *c.* 1874–6. 47 × 56 cm.
Museum of Fine Arts, Boston

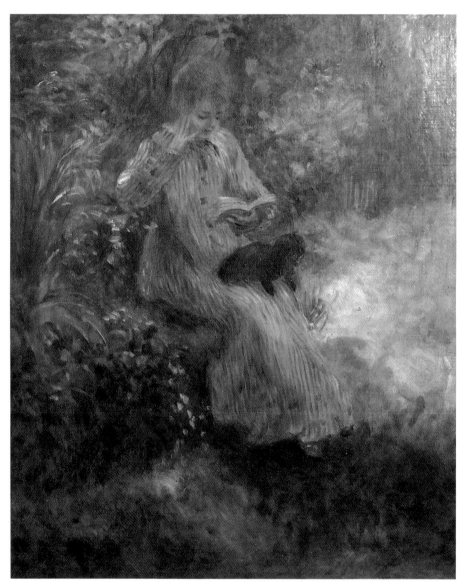

32. *Woman with a black dog*, 1874. 61 × 49 cm.
From the estate of the late Sir Charles Clore

34. *The lovers*, c. 1875. 175 × 130 cm.
Národní Gallerii, Prague

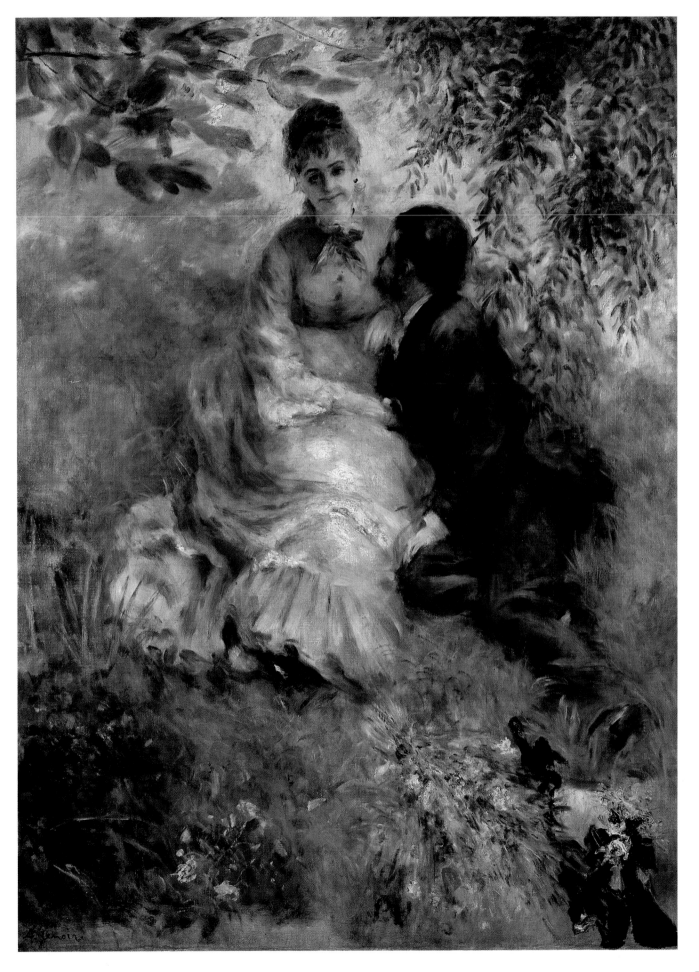

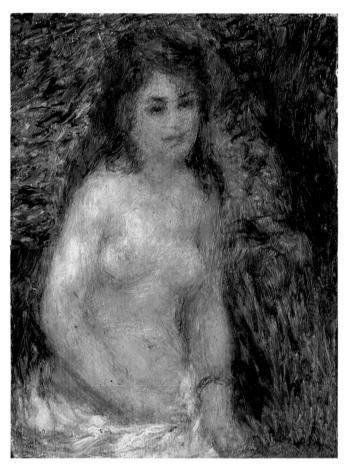

37. *Small bather*, *c.* 1876. 11 × 7 cm.
Mr and Mrs Alexander Lewyt
(reproduced actual size)

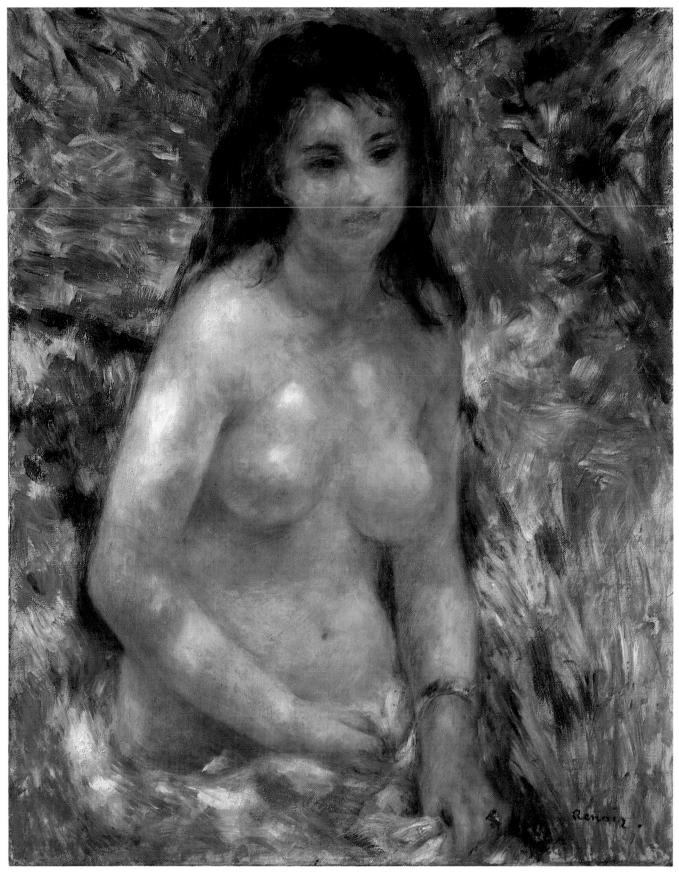

36. *Study* (known as *Nude in the sunlight*), 1875. 81 × 65 cm.
Musée d'Orsay, Paris (Galerie du Jeu de Paume)

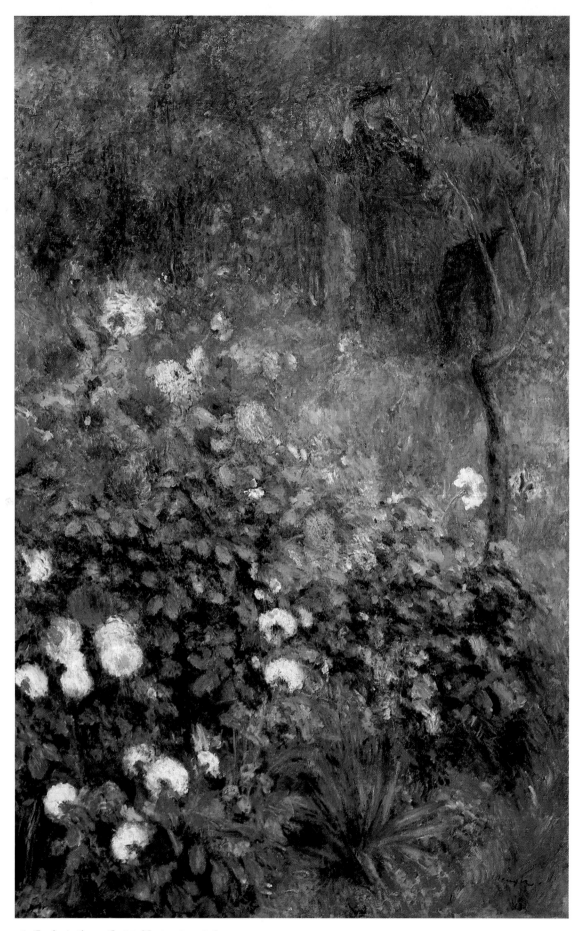

38. *Garden in the rue Cortot, Montmartre*, 1876. 151 × 97 cm.
Museum of Art, Carnegie Institute, Pittsburgh

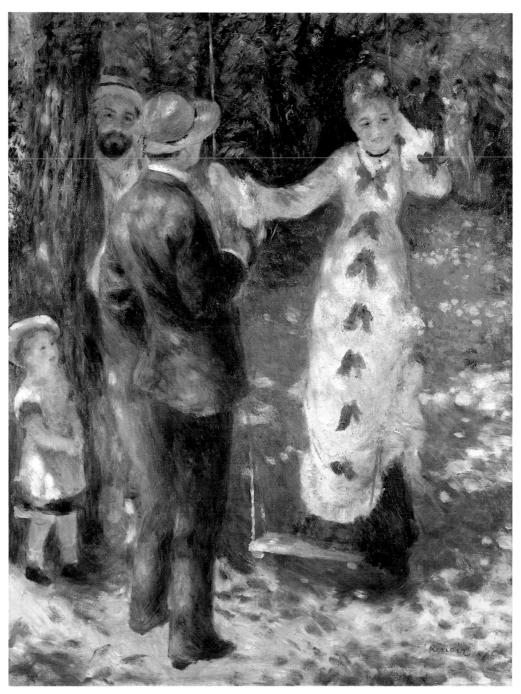

39. *The swing*, 1876. 92 × 73 cm.
Musée d'Orsay, Paris (Galerie du Jeu de Paume)

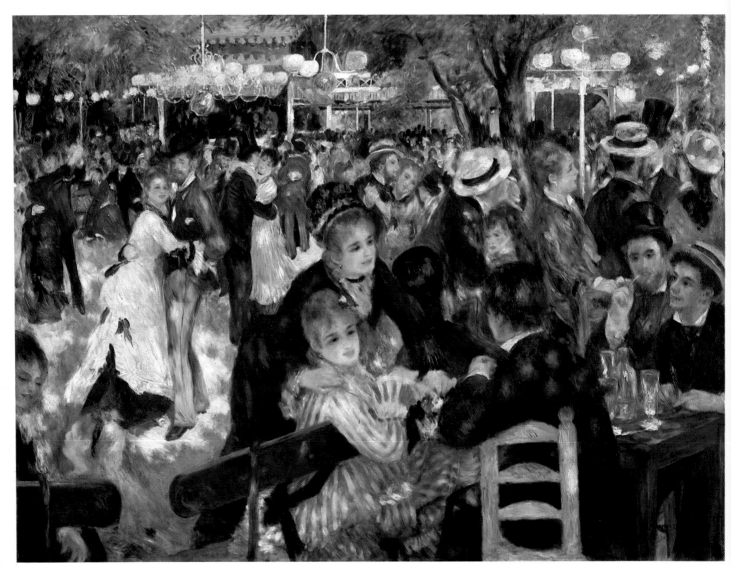

40. *Ball at the Moulin de la Galette*, 1876. 131 × 175 cm. (Detail opposite)
Musée d'Orsay, Paris (Galerie du Jeu de Paume)

35. *Woman at the piano, c.* 1875. 93 × 74 cm.
The Art Institute of Chicago

41. *At the café, c.* 1877. 35 × 28 cm.
Rijksmuseum Kröller-Müller, Otterlo

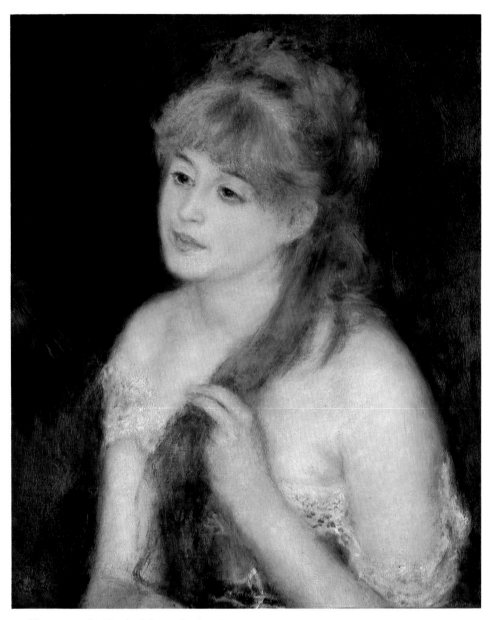

42. *Young woman braiding her hair*, 1876. 56 × 46 cm.
National Gallery of Art, Washington, D.C.

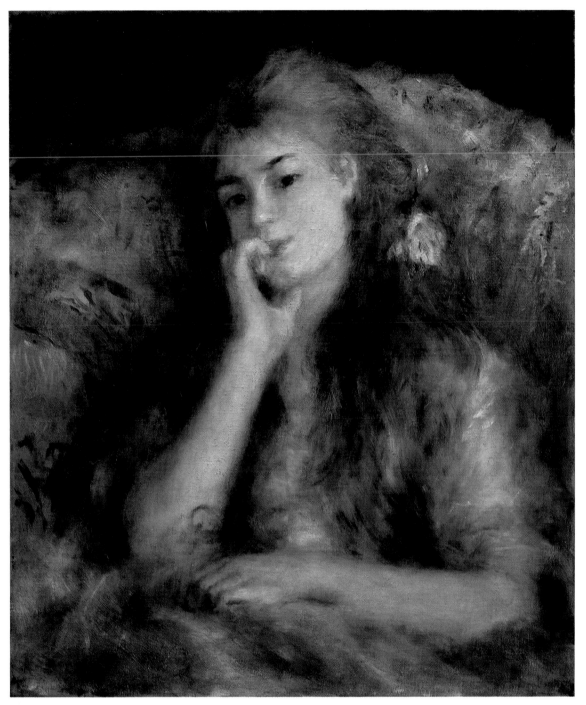

43. *Young woman seated* (known as *La Pensée*), *c.* 1876–7. 66 × 55 cm.
Accepted by H.M. Government in lieu of tax

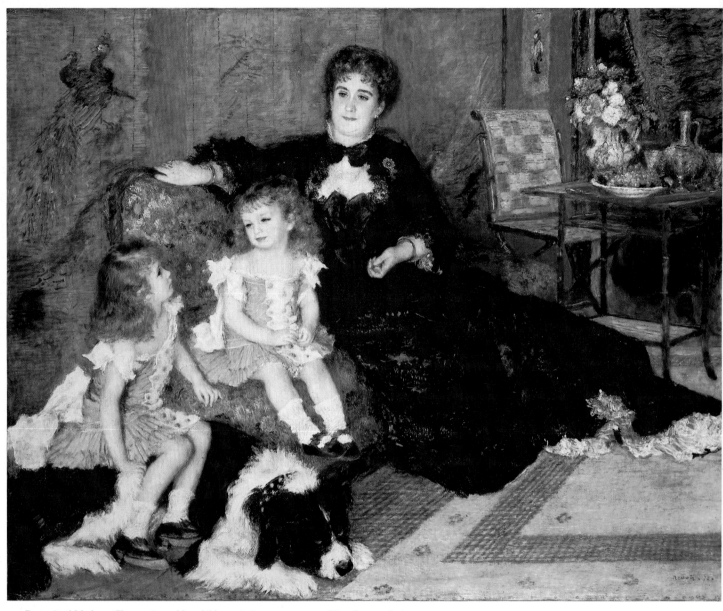

44. *Portrait of Madame Charpentier and her children*, 1878. 154 × 190 cm. (Detail opposite)
The Metropolitan Museum of Art, New York

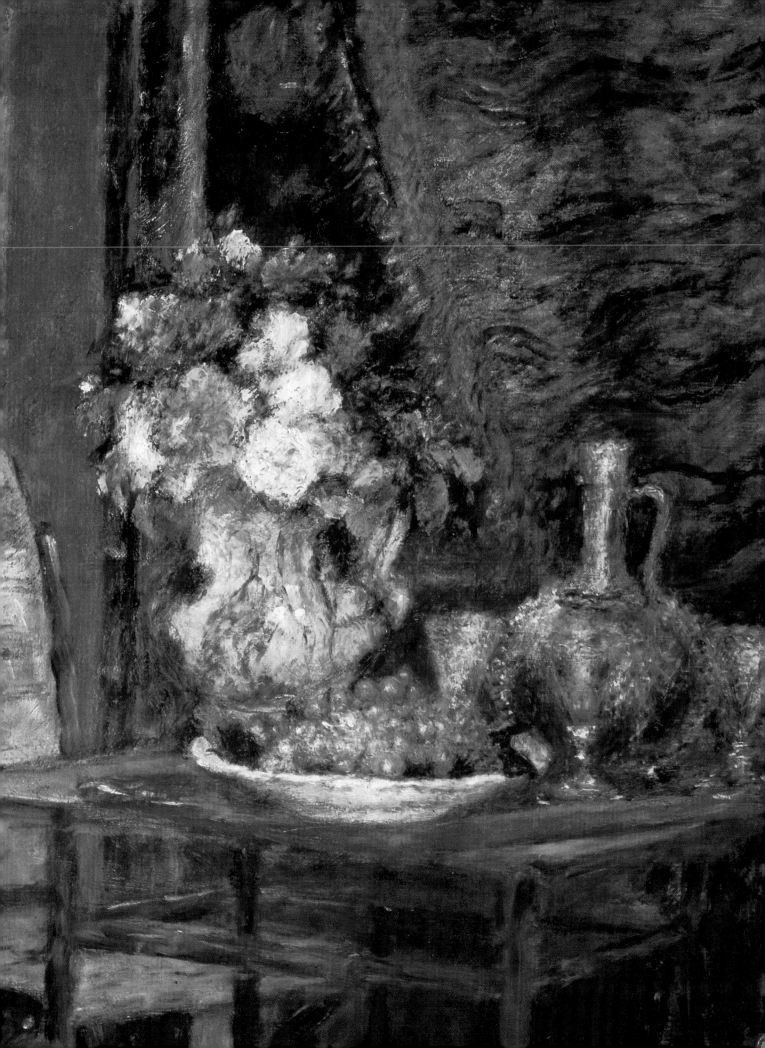

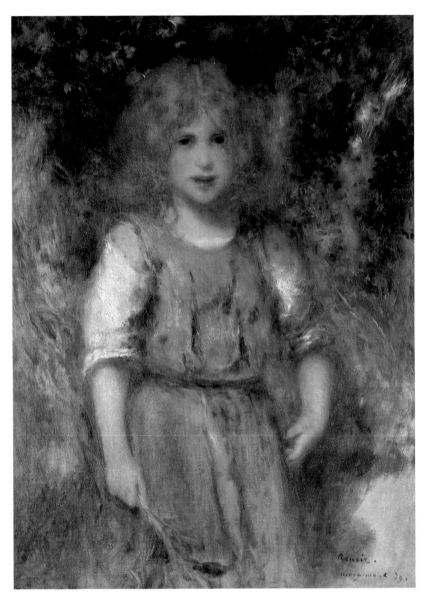

46. *Gypsy girl*, 1879. 73 × 54 cm.
Private Collection, Canada

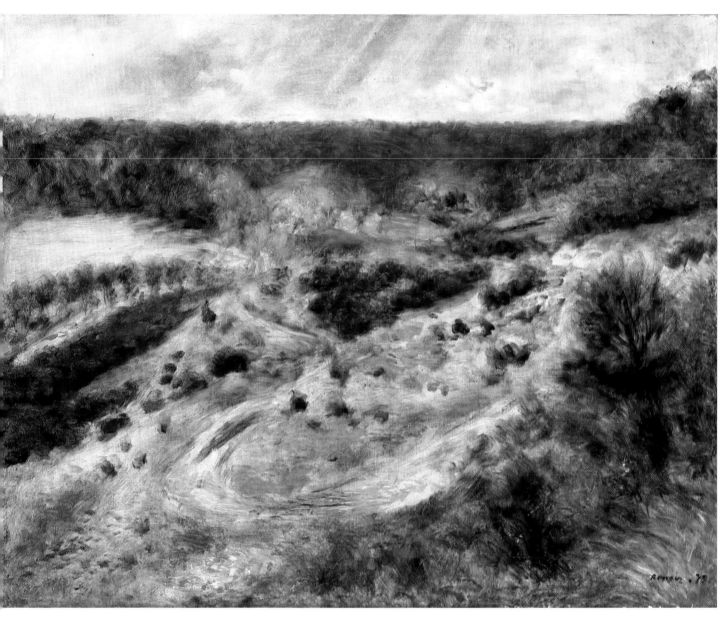

45. *Landscape at Wargemont*, 1879. 80 × 100 cm.
The Toledo Museum of Art

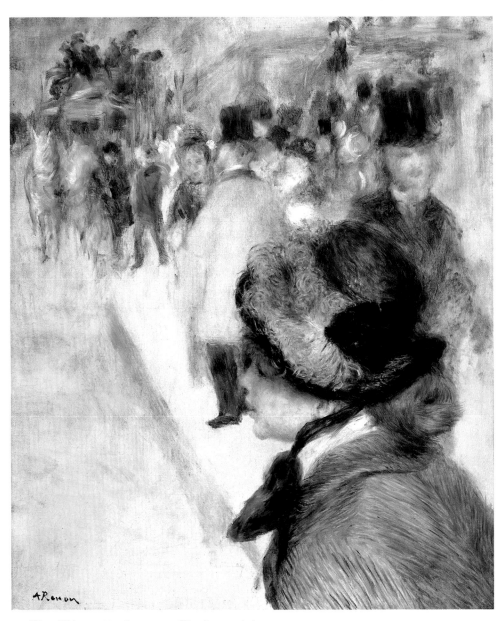

49. *Place Clichy, c.* 1880. 65 × 54 cm. (Detail opposite)
Anonymous loan to the Fitzwilliam Museum, Cambridge

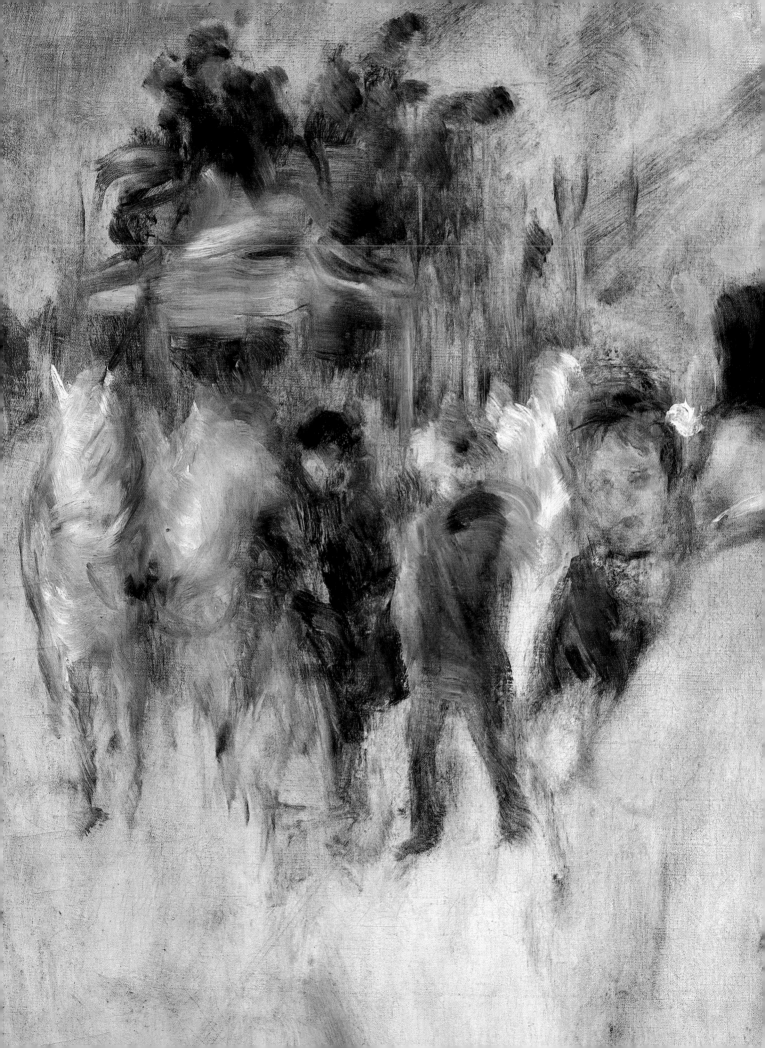

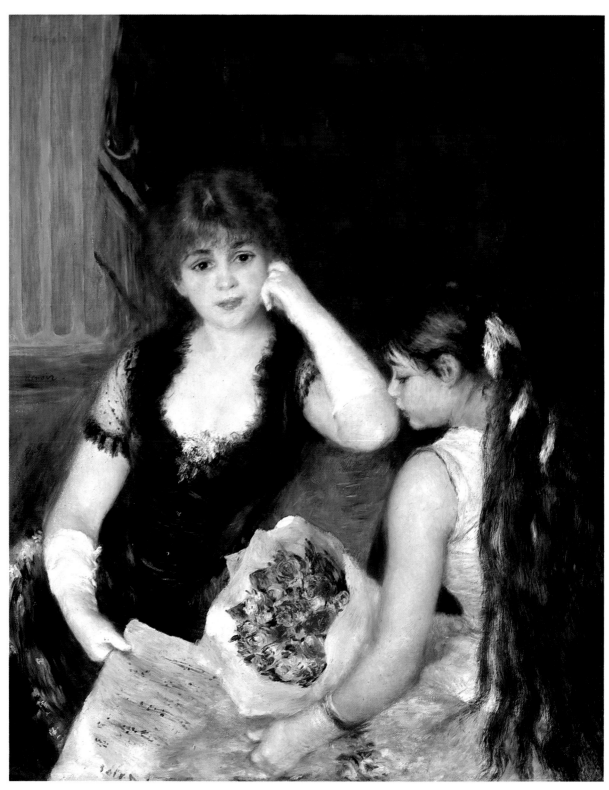

51. *A box at the Opéra* (known as *Dans la loge*), 1880. 99 × 80 cm.
Sterling and Francine Clark Art Institute, Williamstown, Massachusetts

59. *Geraniums and cats*, 1881. 91 × 73 cm.
Private Collection, New York

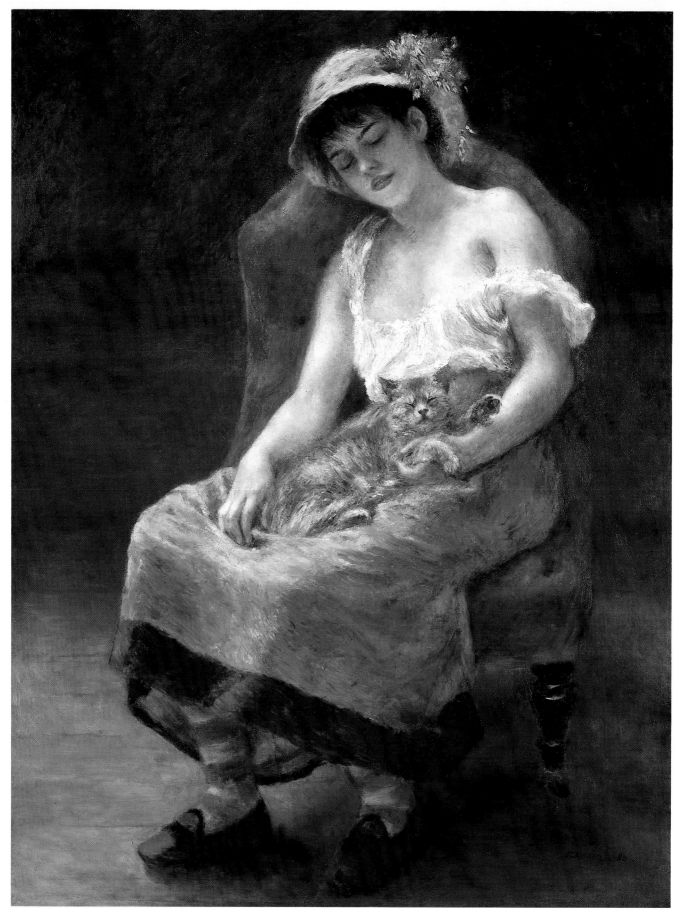

50. *Sleeping girl* (known as *Girl with a cat*), 1880. 120 × 94 cm.
Sterling and Francine Clark Art Institute, Williamstown, Massachusetts

54. *Young woman reading an illustrated journal*, c. 1880–1. 46 × 56 cm.
Museum of Art, Rhode Island School of Design

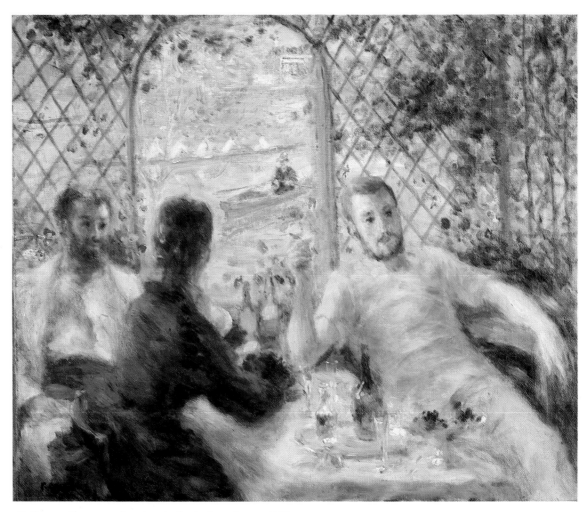

48. *Oarsmen* (known as *Luncheon by the river*), *c.* 1879. 55 × 66 cm.
The Art Institute of Chicago

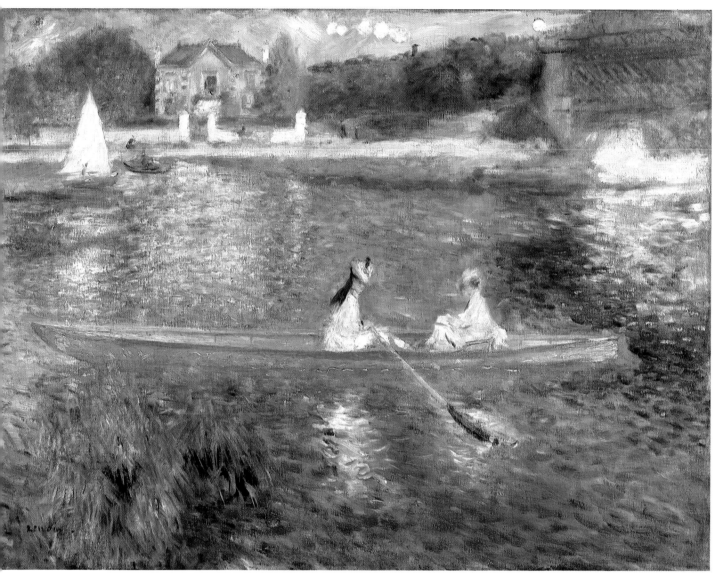

47. *The Seine at Asnières* (known as *The skiff*), *c.* 1879. 71 × 92 cm.
The Trustees of The National Gallery, London

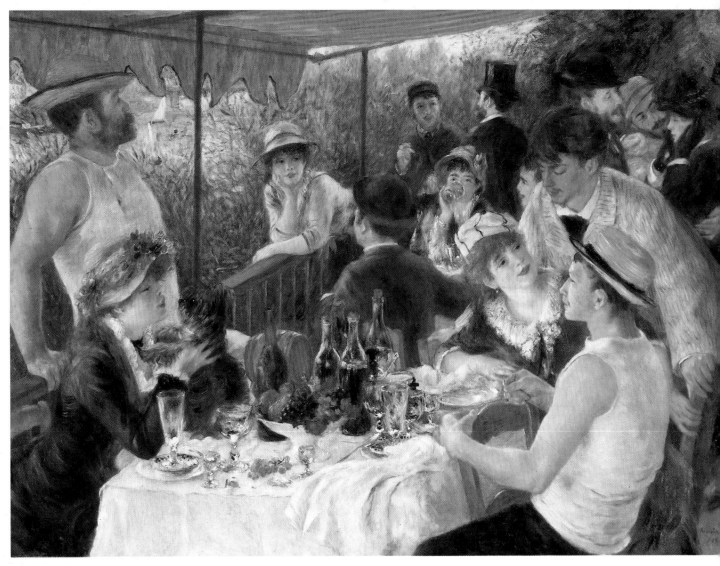

52. *Luncheon of the boating party*, 1880–1. 130 × 173 cm. (Detail opposite)
The Phillips Collection, Washington, D.C.

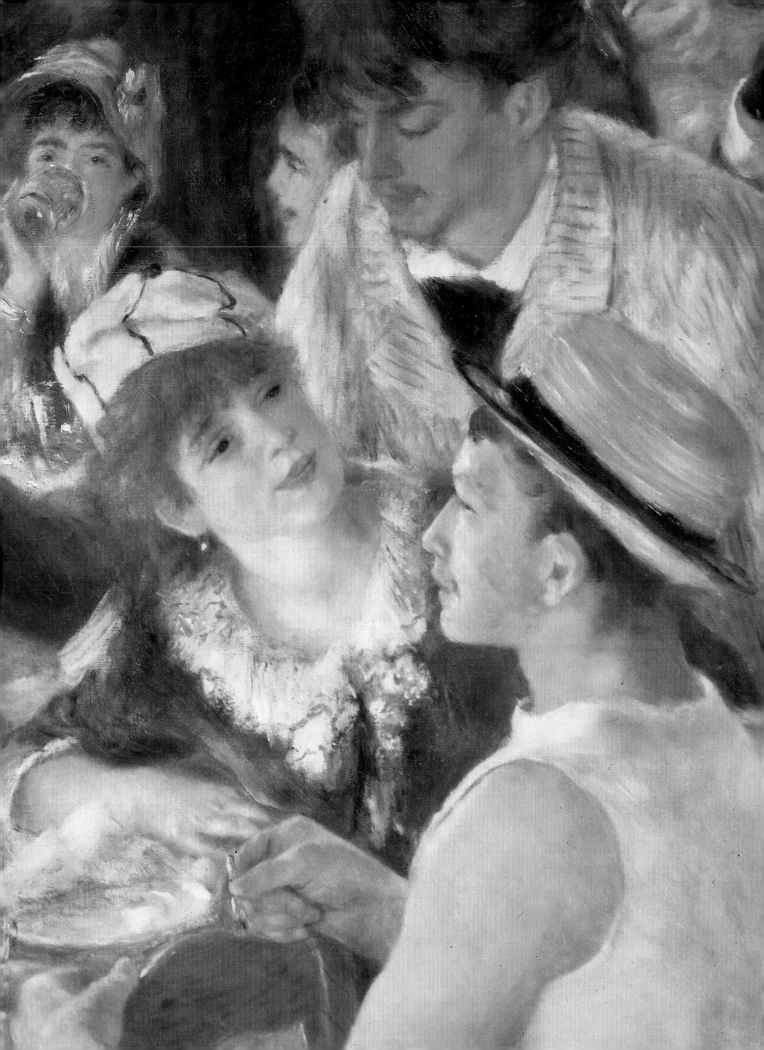

55. *Algerian landscape: The Ravin de la Femme Sauvage*, 1881. 65 × 81 cm.
Musée d'Orsay, Paris (Galerie du Jeu de Paume)

56. *The mosque* (known as *Arab festival*), 1881. 73 × 92 cm.
Musée d'Orsay, Paris (Galerie du Jeu de Paume)

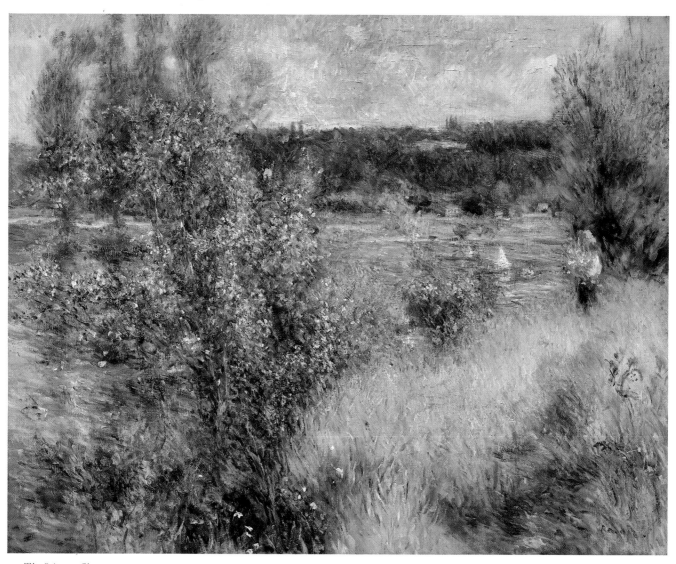

57. *The Seine at Chatou, c.* 1881. 74 × 93 cm. (Detail opposite)
Museum of Fine Arts, Boston

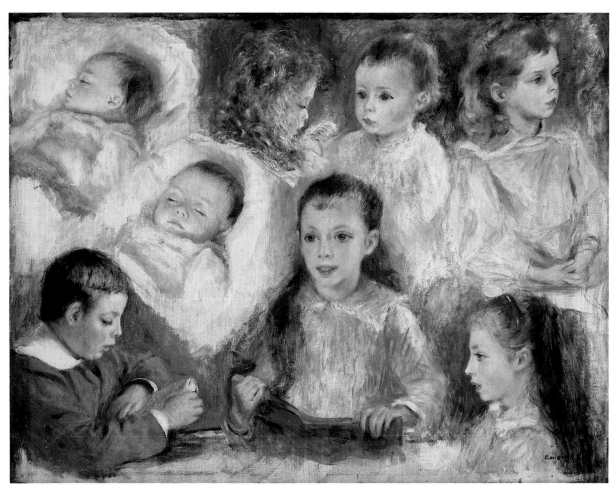

60. *Sketches of heads (the Berard children)*, 1881. 62 × 83 cm.
Sterling and Francine Clark Art Institute, Williamstown, Massachusetts

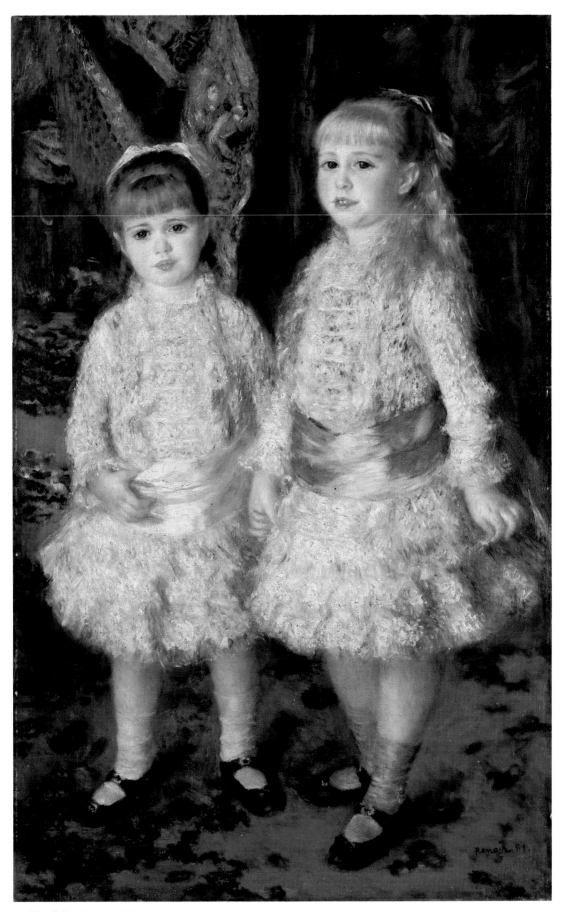

53. *The Cahen d'Anvers girls*, 1881. 119 × 74 cm.
Museu de Arte de São Paulo

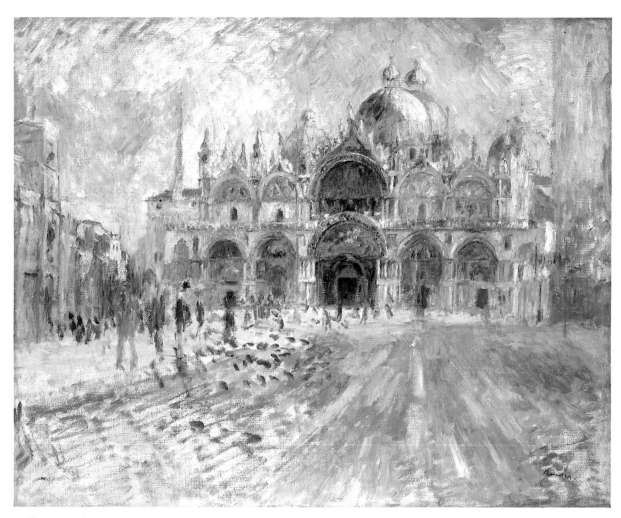

61. *Piazza San Marco*, 1881. 65 × 81 cm.
The Minneapolis Institute of Arts

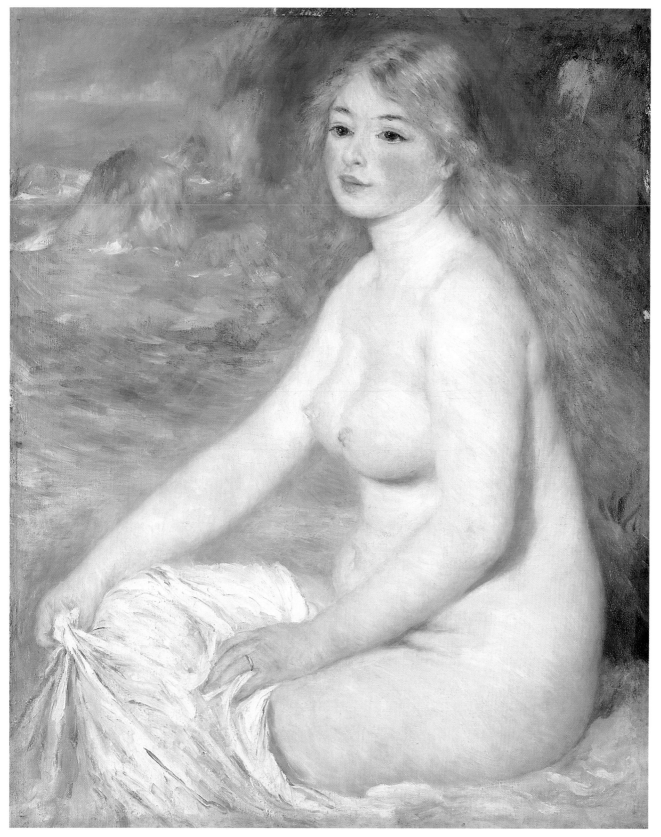

63. *Bather* (known as *Blonde bather I*), 1881. 82 × 66 cm.
Sterling and Francine Clark Art Institute, Williamstown, Massachusetts

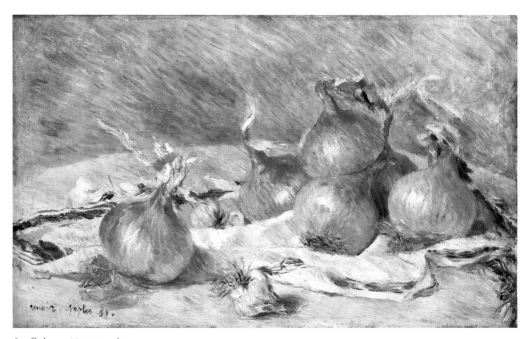

62. *Onions*, 1881. 39 × 60 cm.
Sterling and Francine Clark Art Institute, Williamstown, Massachusetts

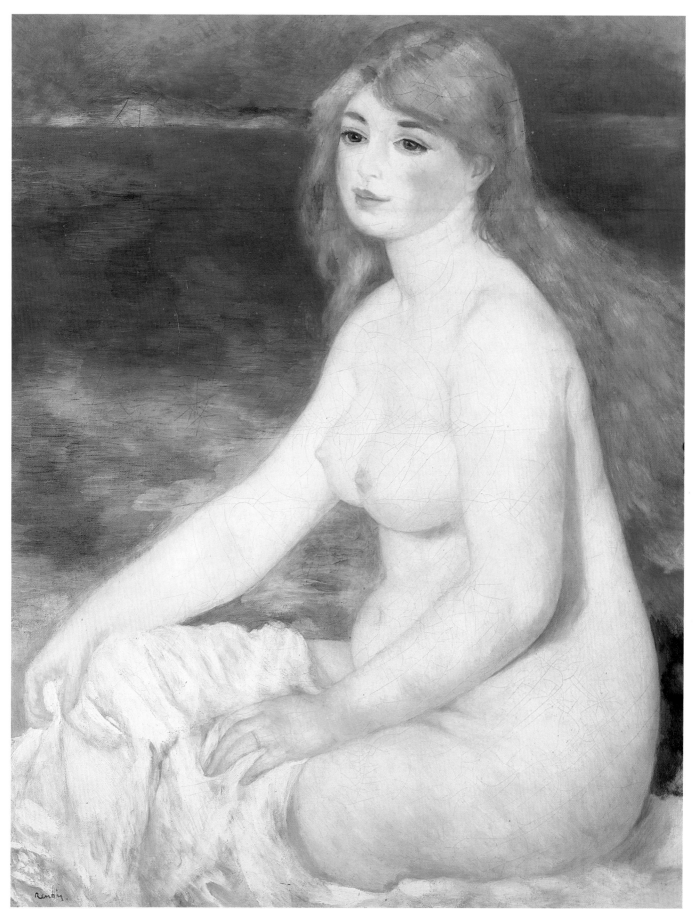

65. *Bather* (known as *Blonde bather II*), *c.* 1882. 90 × 63 cm.
Private Collection

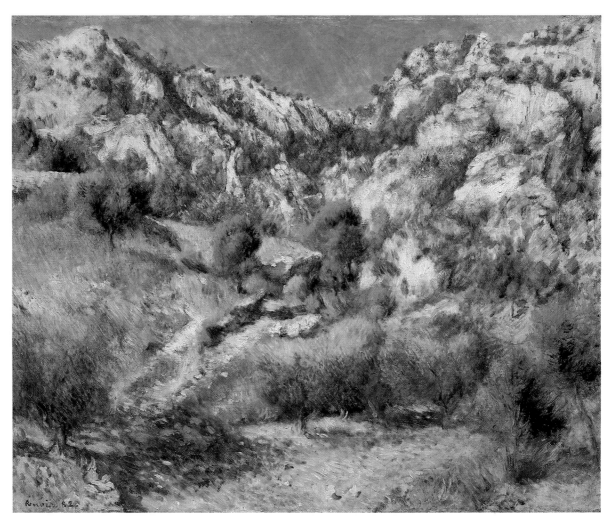

64. *Rocky crags at L'Estaque*, 1882. 66 × 82 cm.
Museum of Fine Arts, Boston

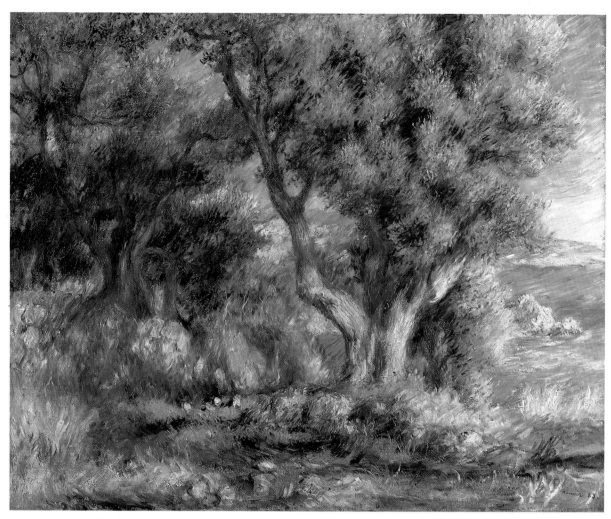

71. *Landscape near Menton*, 1883. 66 × 81 cm.
Museum of Fine Arts, Boston

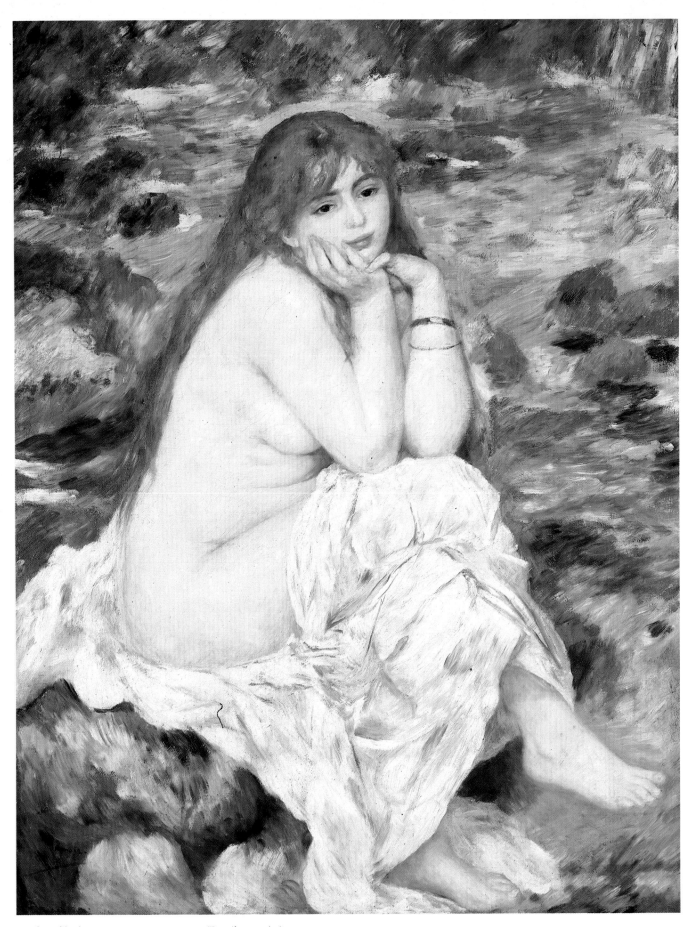

72. *Seated bather*, *c.* 1883–4. 121 × 91 cm. (Detail opposite)
Fogg Art Museum, Harvard University, Cambridge, Massachusetts

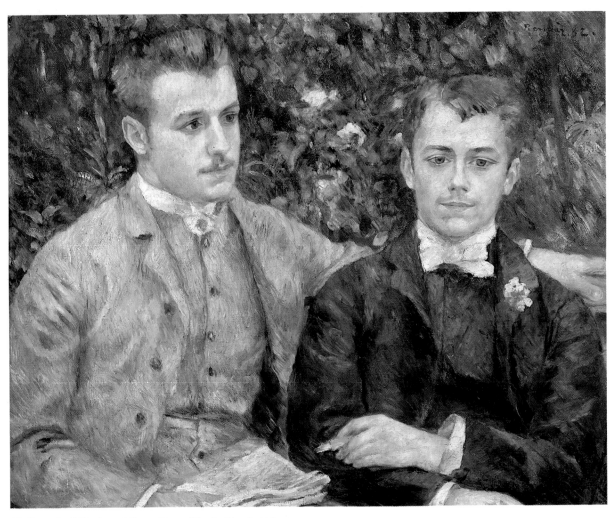

66. *Portrait of Charles and George Durand-Ruel*, 1882. 65 × 81 cm.
Durand-Ruel, Paris

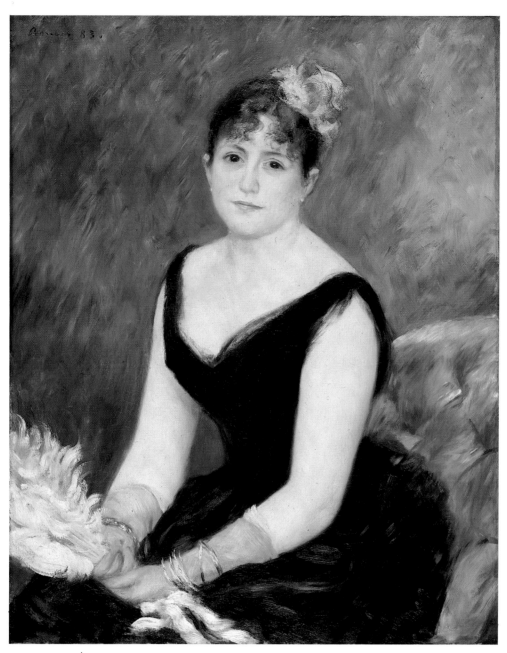

70. *Portrait of Madame Clapisson*, 1883. 82 × 65 cm.
The Art Institute of Chicago

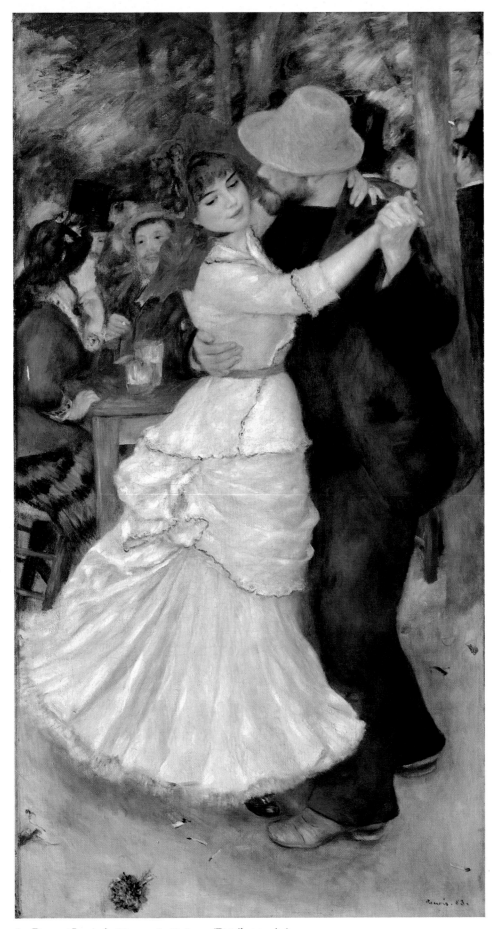

67. *Dance at Bougival*, 1882–3. 182 × 98 cm. (Detail opposite)
Museum of Fine Arts, Boston

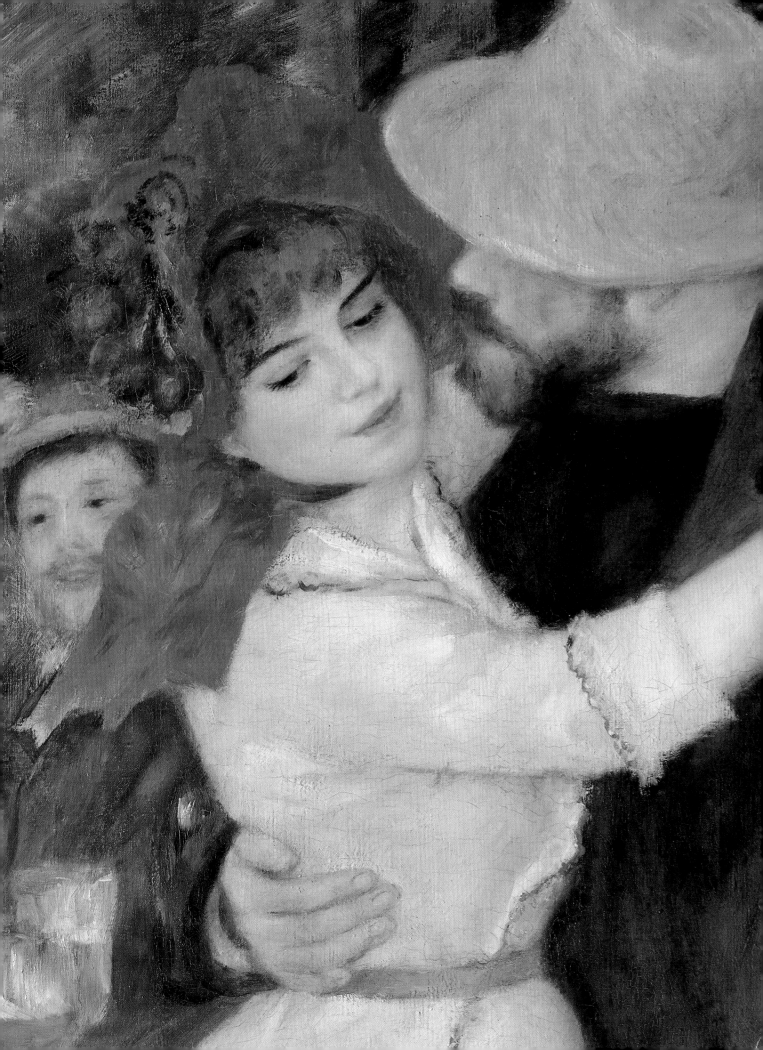

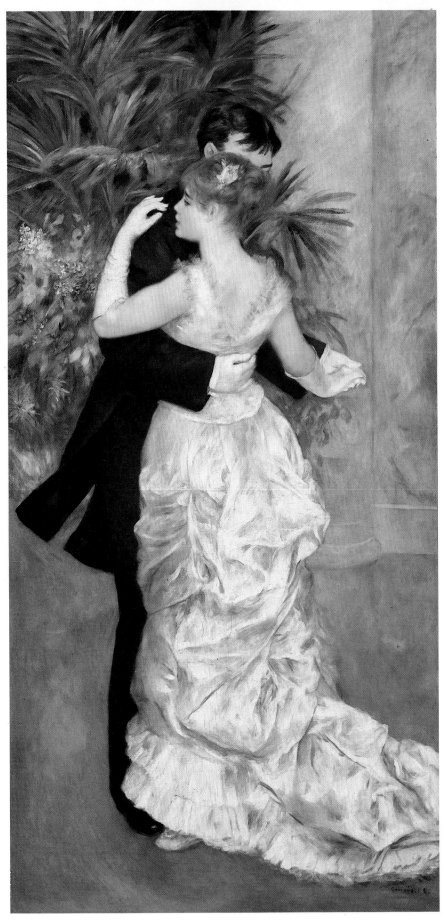

68. *Dance in the city*, 1882–3. 180 × 90 cm.
Musée d'Orsay, Paris (Galerie du Jeu de Paume)

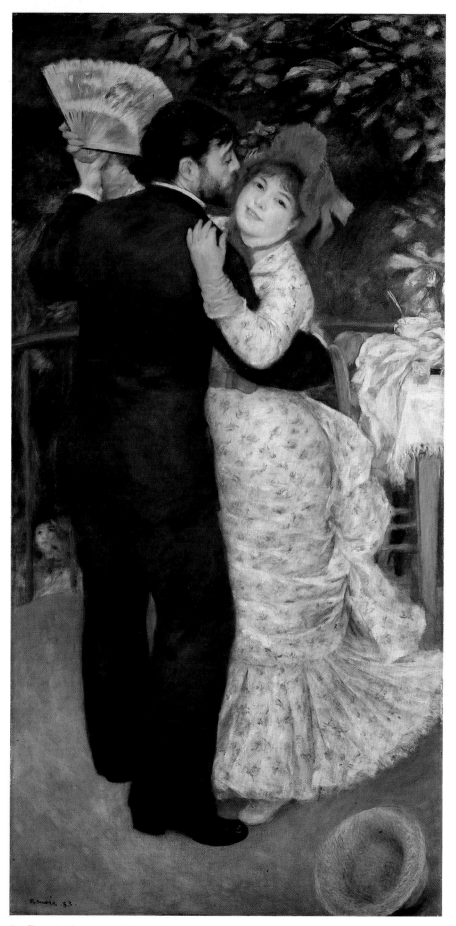

69. *Dance in the country*, 1882–3. 180 × 90 cm.
Musée d'Orsay, Paris (Galerie du Jeu de Paume)

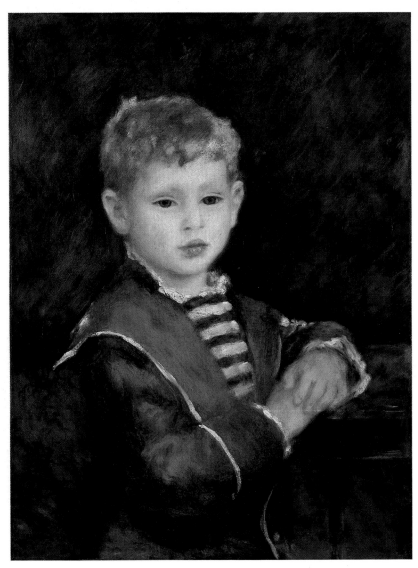

73. *Portrait of Paul Haviland*, 1884. 57 × 43 cm.
The Nelson-Atkins Museum of Art, Kansas City, Missouri

58. *The umbrellas*, *c.* 1881 and *c.* 1885. 180 × 115 cm.
The Trustees of The National Gallery, London

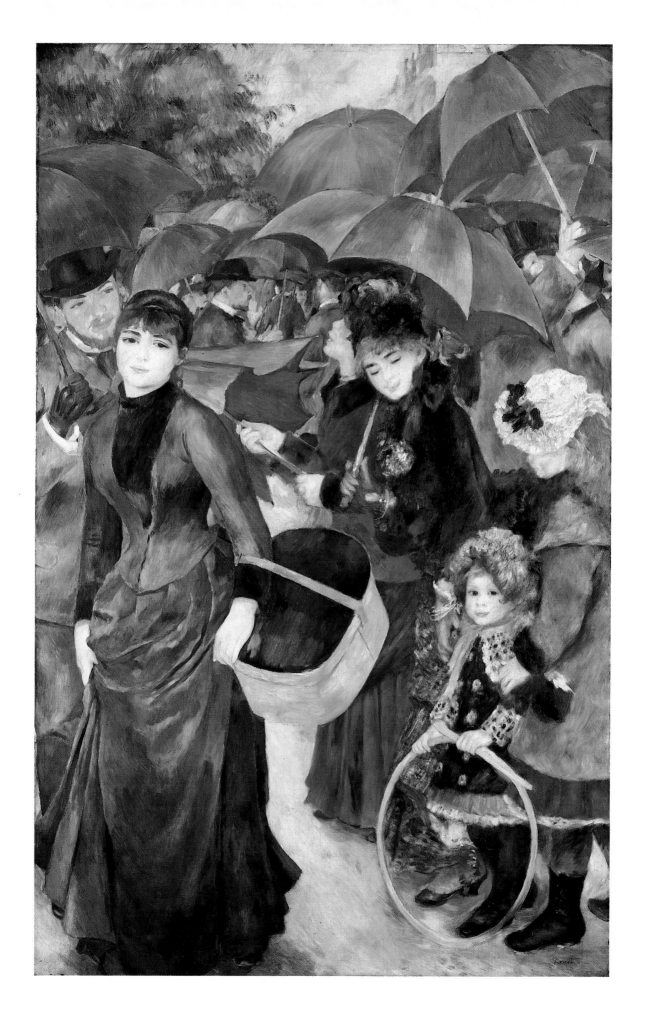

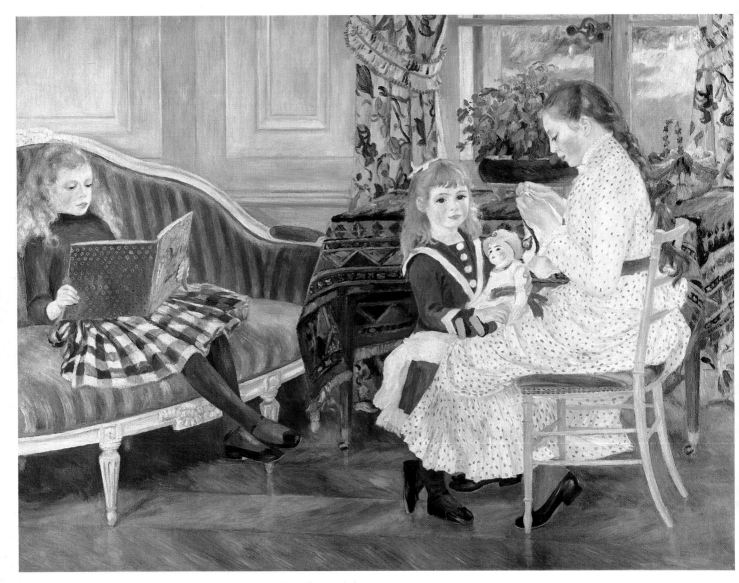

74. *Children's afternoon at Wargemont*, 1884. 127 × 173 cm. (Detail opposite)
Nationalgalerie, Berlin

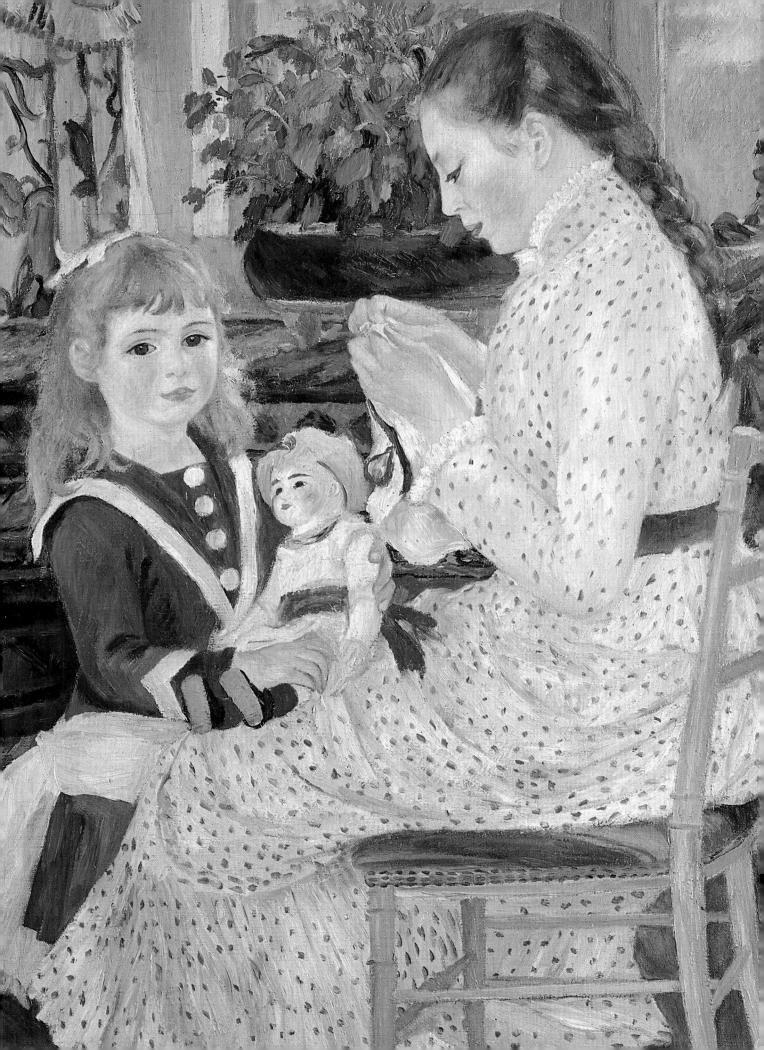

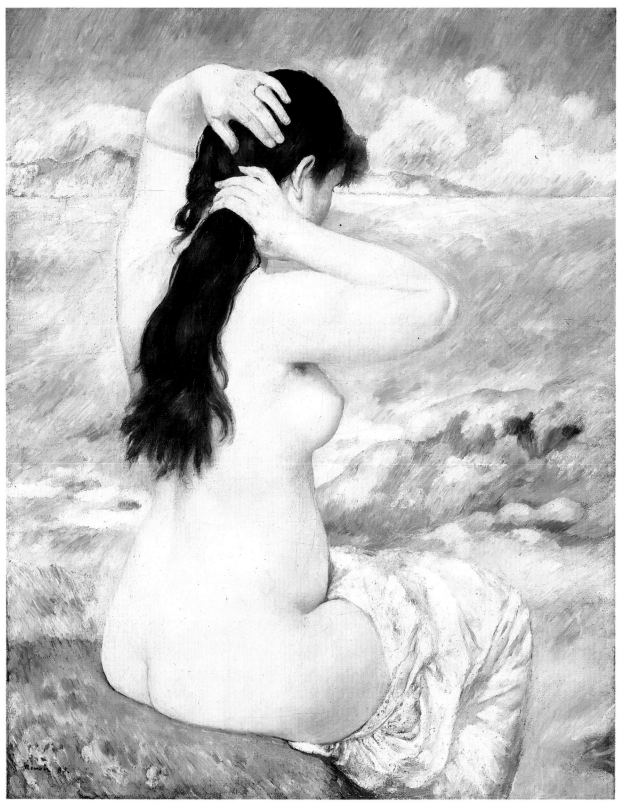

75. *Bather* (known as *La Coiffure*), 1885. 92 × 73 cm.
Sterling and Francine Clark Art Institute, Williamstown, Massachusetts

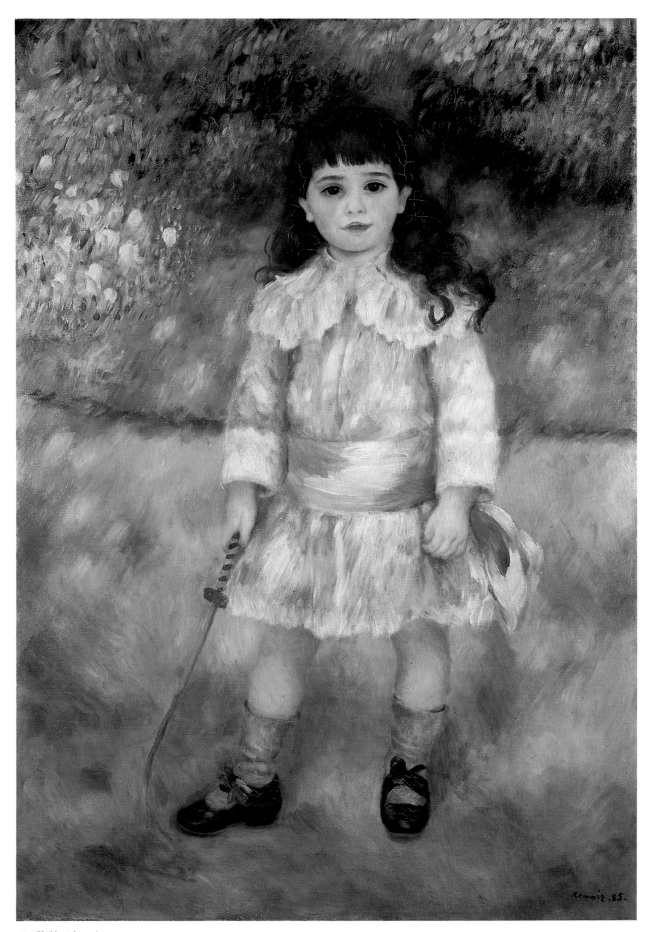

76. *Child with a whip*, 1885. 105 × 75 cm.
The State Hermitage Museum, Leningrad

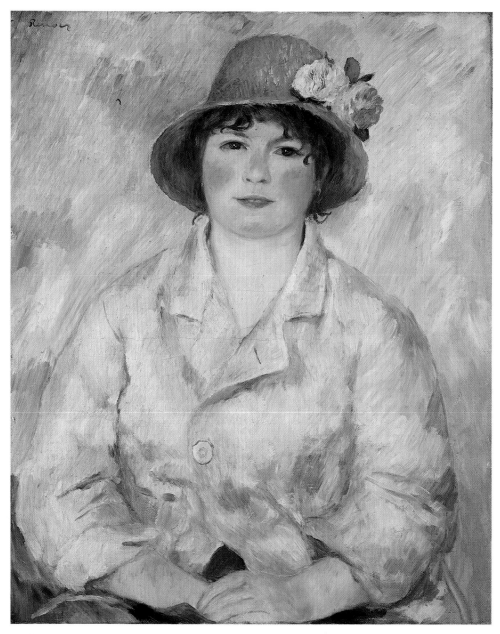

78. *Portrait of Aline Charigot (Madame Renoir)*, *c.* 1885. 65 × 54 cm.
Philadelphia Museum of Art

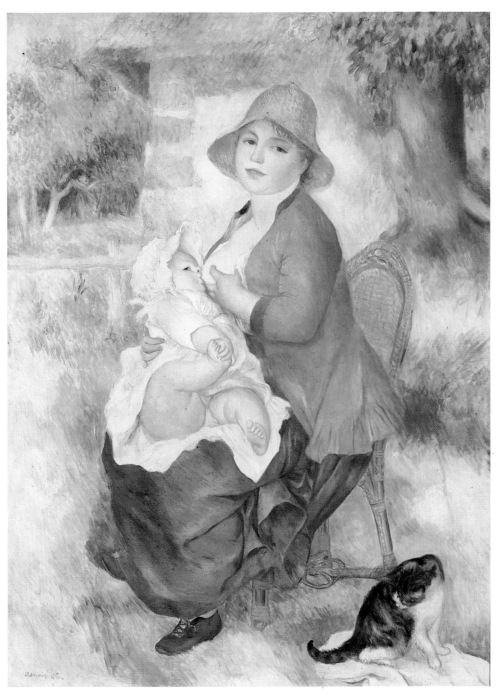

79. *The child at the breast* (known as *Maternity*), 1886. 74 × 54 cm.
Anonymous loan, Museum of Fine Arts, St Petersburg, Florida

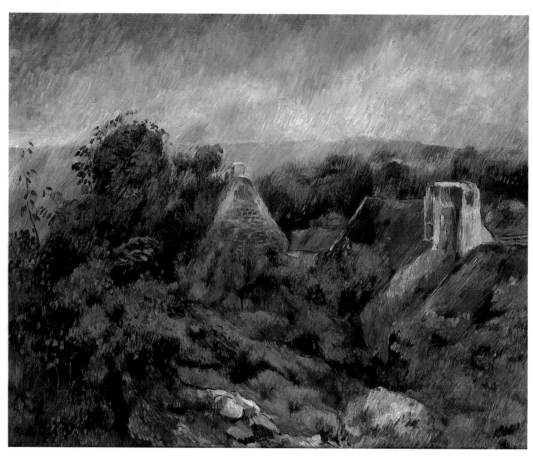

77. *La Roche-Guyon, c.* 1885. 47 × 56 cm.
Aberdeen Art Gallery and Museums

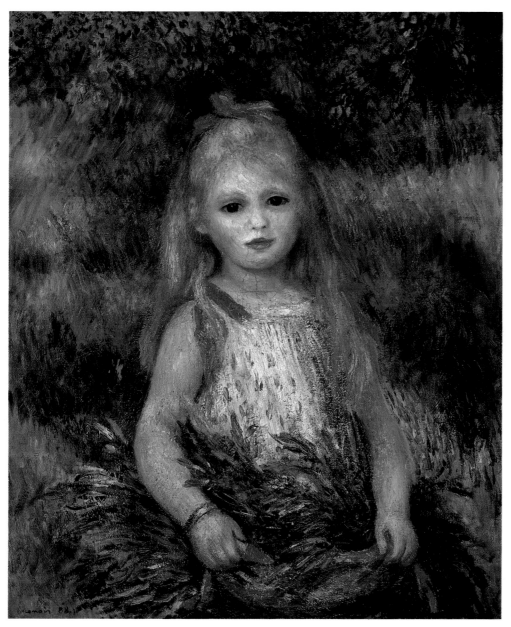

80. *Little girl carrying flowers*, 1888. 66 × 54 cm.
Museu de Arte de São Paulo

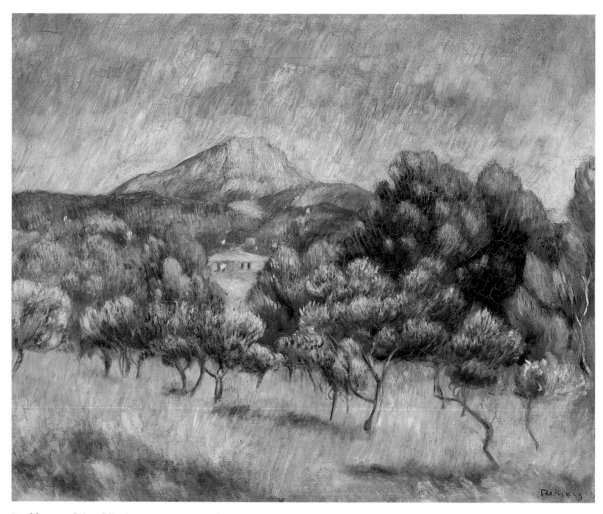

82. *Montagne Sainte-Victoire, c.* 1888–9. 53 × 64 cm.
Yale University Art Gallery, New Haven

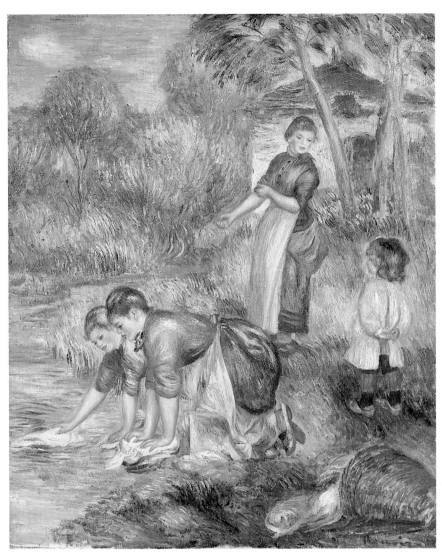

81. *Washerwomen*, *c.* 1888. 56 × 47 cm.
The Baltimore Museum of Art

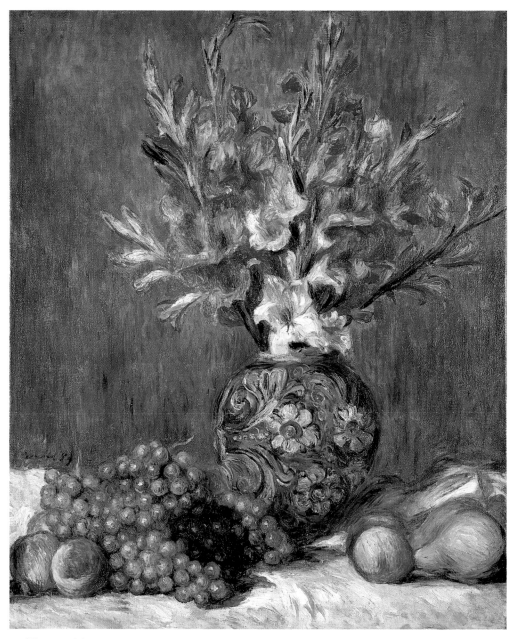

83. *Flowers and fruit*, 1889. 65 × 53 cm.
Private Collection

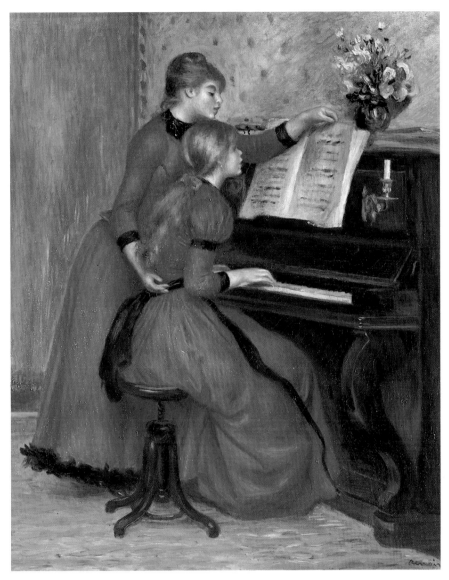

84. *The piano lesson*, c. 1889. 56 × 46 cm.
Joslyn Art Museum, Omaha, Nebraska

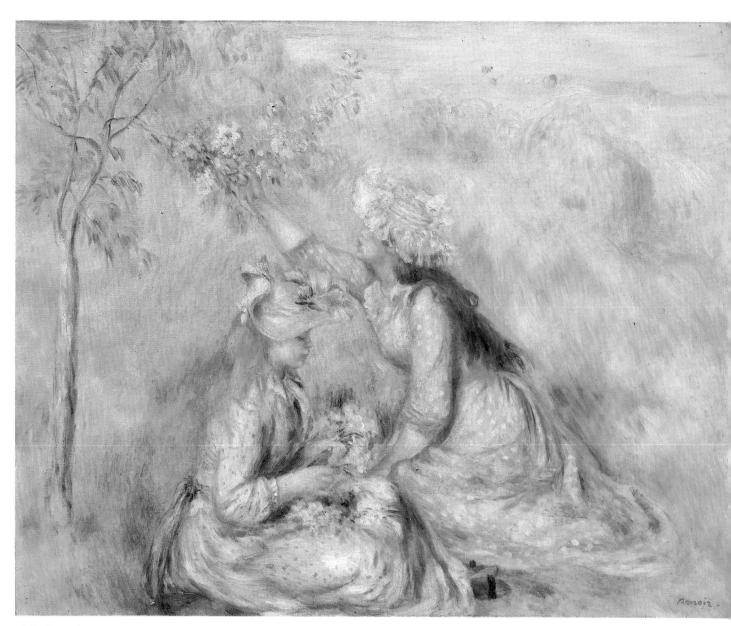

86. *In the meadow, c.* 1890. 65 × 81 cm.
Museum of Fine Arts, Boston

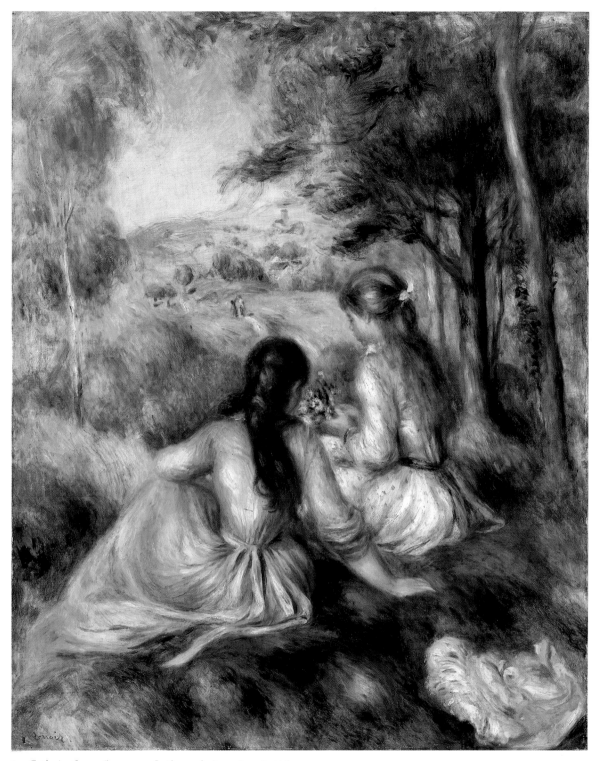

85. *Gathering flowers* (known as *In the meadow*), *c.* 1890. 81 × 65 cm.
The Metropolitan Museum of Art, New York

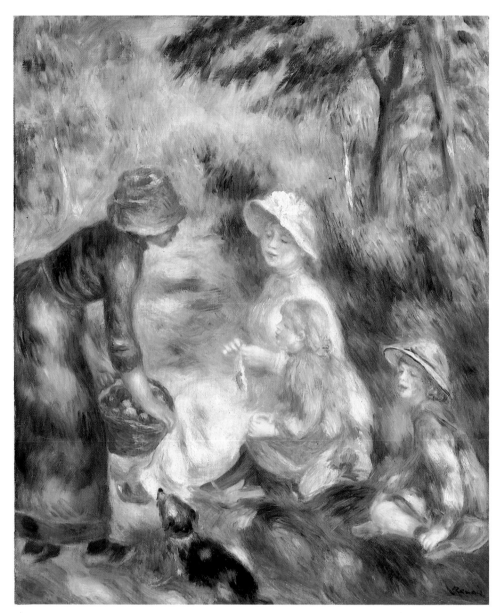

87. *The apple seller, c.* 1890. 66 × 54 cm.
The Cleveland Museum of Art

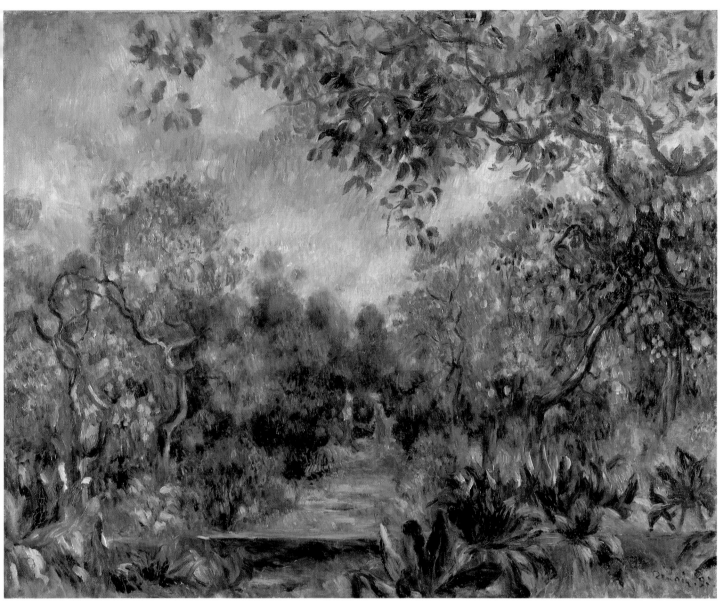

92. *Landscape at Beaulieu*, 1893?, 65 × 81 cm.
The Fine Arts Museums of San Francisco

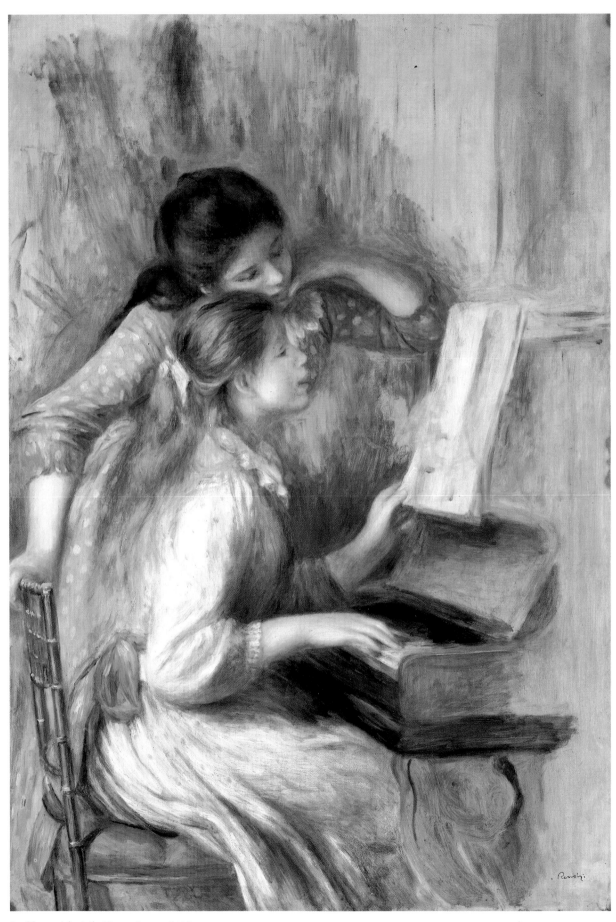

89. *Young girls at the piano*, 1892. 116 × 81 cm.
Musée de l'Orangerie, Paris (Collection Walter–Guillaume)

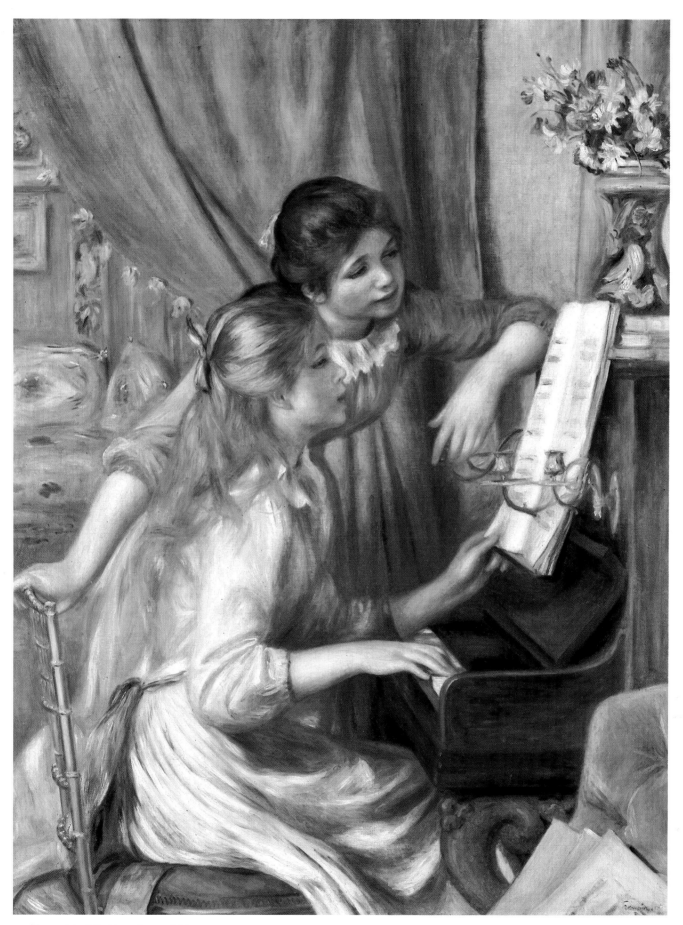

91. *Young girls at the piano*, 1892. 116 × 90 cm.
Musée d'Orsay, Paris (Galerie du Jeu de Paume)

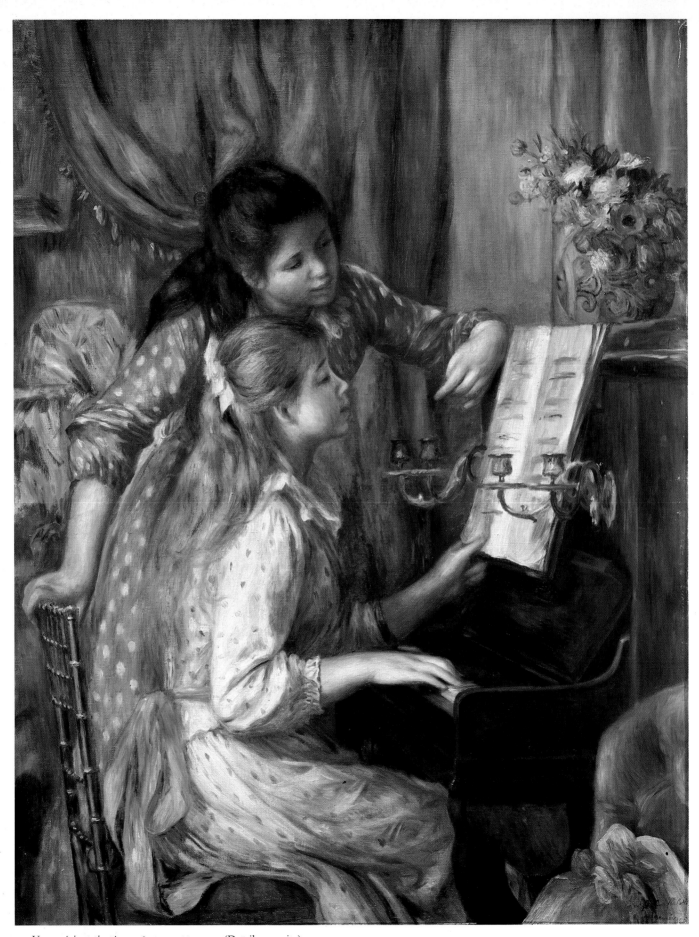

90. *Young girls at the piano*, 1892. 117 × 90 cm. (Detail opposite)
Private Collection

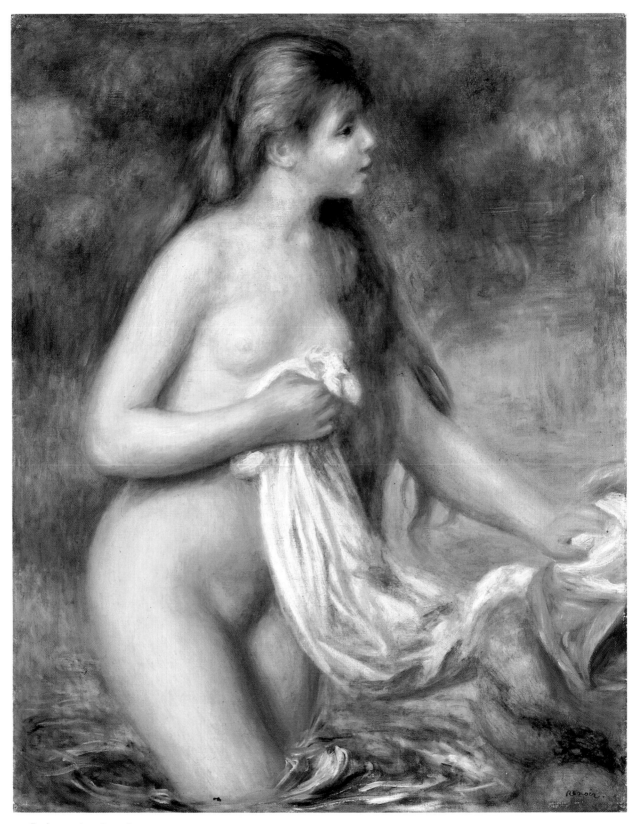

94. *Bather, c.* 1895. 82 × 65 cm.
Musée de l'Orangerie, Paris (Collection Walter–Guillaume)

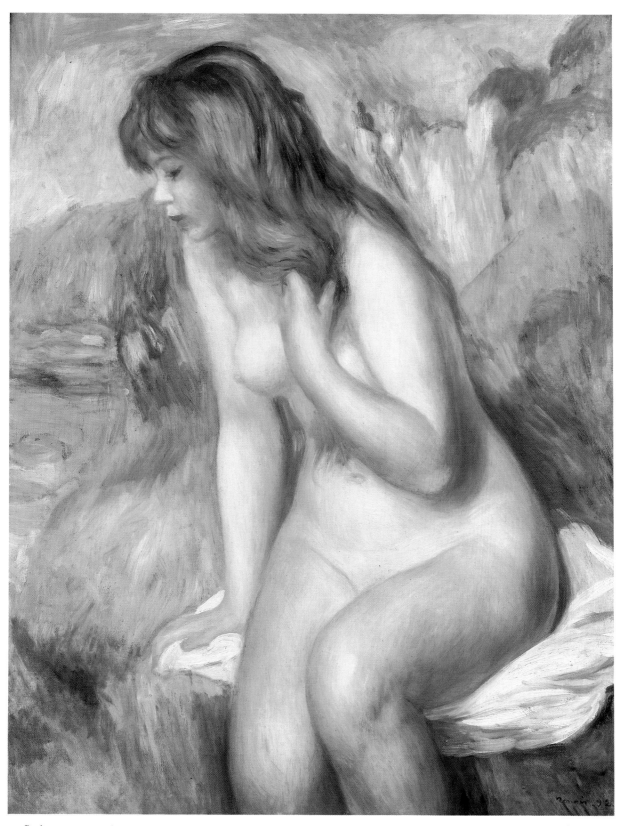

88. *Bather*, 1892. 80 × 64 cm.
Durand-Ruel, Paris

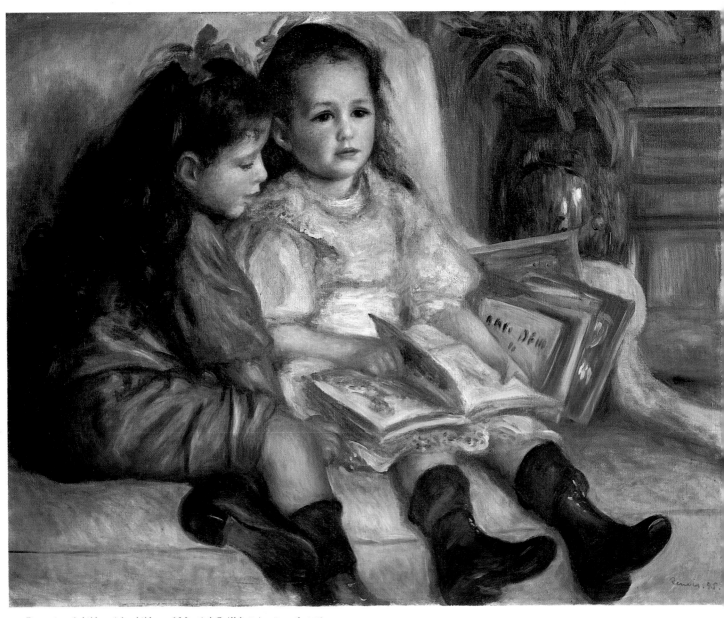

93. *Portraits of children (the children of Martial Caillebotte)*, 1895. 65 × 82 cm.
Private Collection

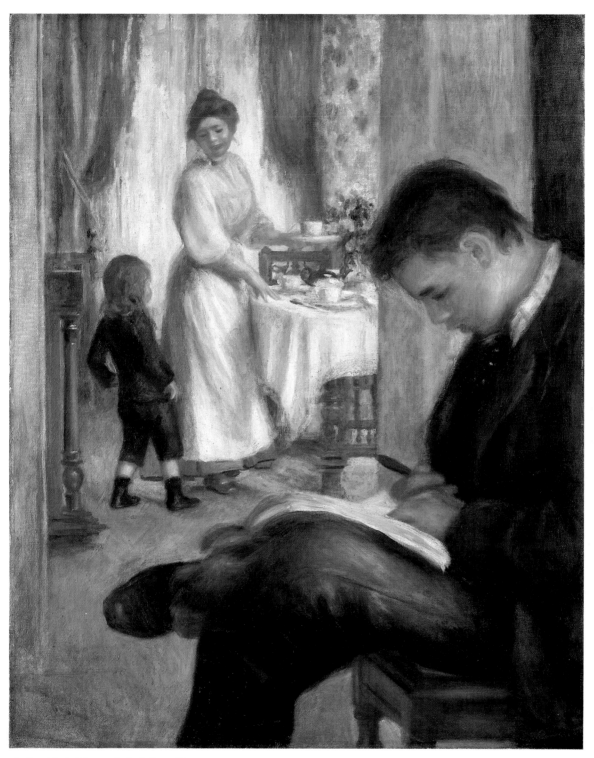

98. *Breakfast at Berneval*, 1898. 82 × 66 cms
Private Collection

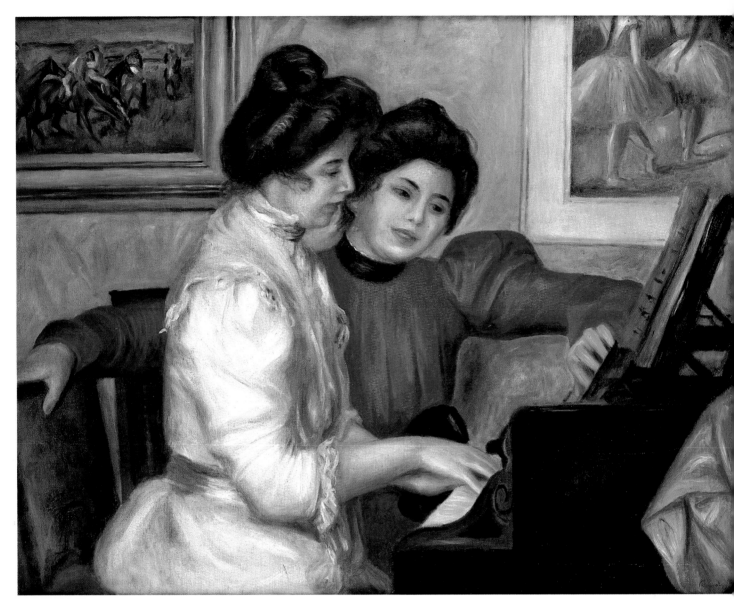

97. *Yvonne and Christine Lerolle at the piano*, 1897. 73 × 92 cm.
Musée de l'Orangerie, Paris (Collection Walter–Guillaume)

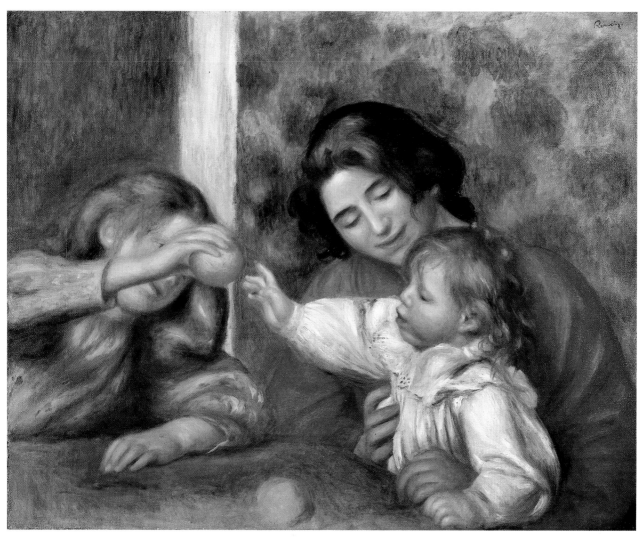

95. *Gabrielle, Jean and a girl*, 1895–6. 65 × 80 cm.
Private Collection represented by Acquavella Galleries, Inc., New York

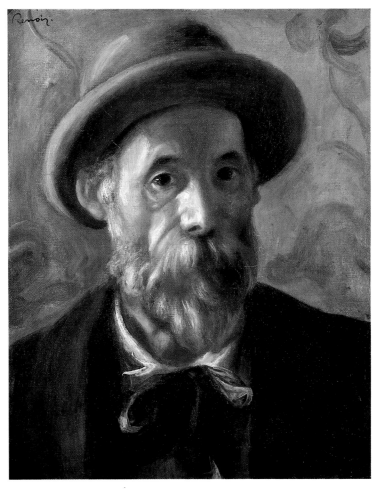

99. *Self-portrait*, 1899?. 41 × 33 cm.
Sterling and Francine Clark Art Institute, Williamstown, Massachusetts

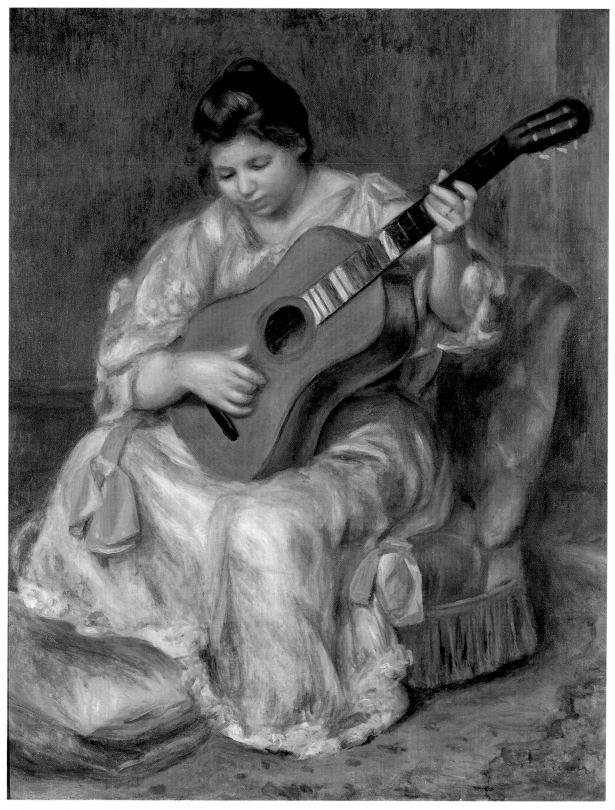

96. *Woman playing the guitar*, 1896–7. 81 × 65 cm.
Musée des Beaux-Arts, Lyon

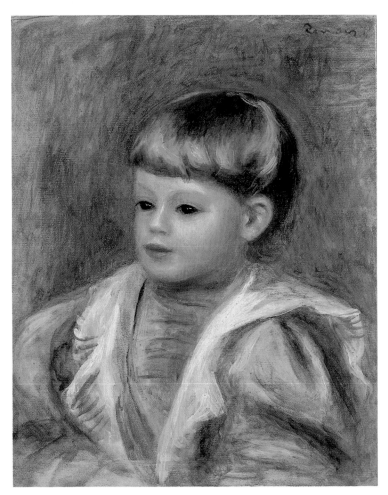

105. *Portrait of a child (Philippe Gangnat)*, 1906. 41 × 33 cm.
Private Collection

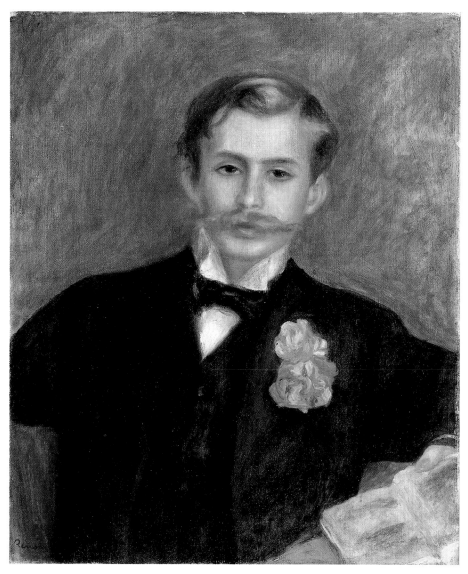

100. *Portrait of Monsieur Germain*, *c.* 1900. 55 × 46 cm.
Norton Gallery & School of Art, West Palm Beach, Florida

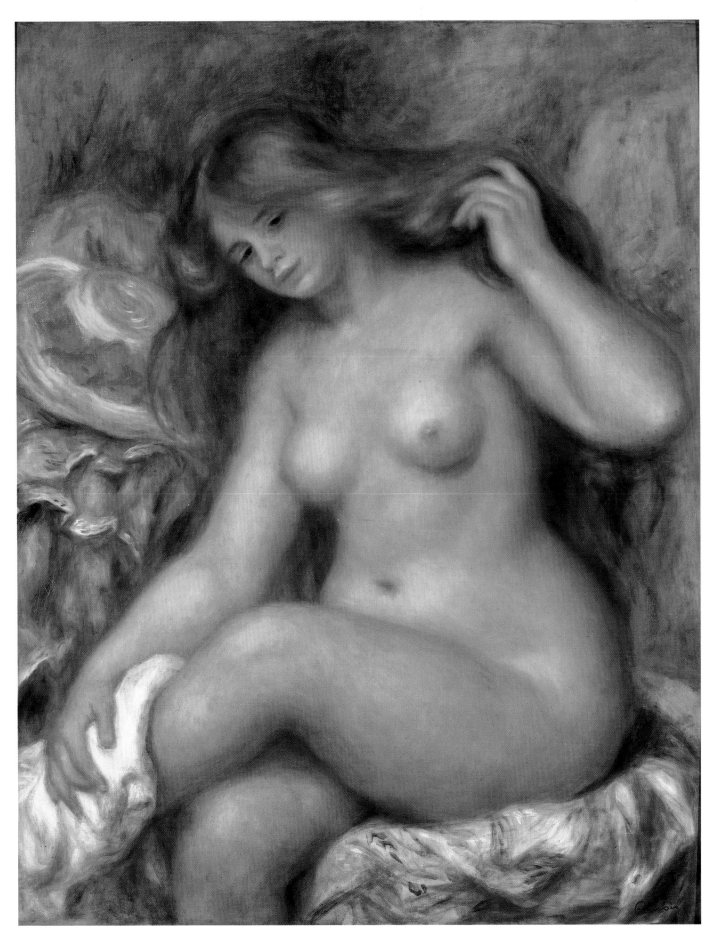

102. *Bather, c.* 1903. 92 × 73 cm.
Kunsthistorisches Museum, Vienna

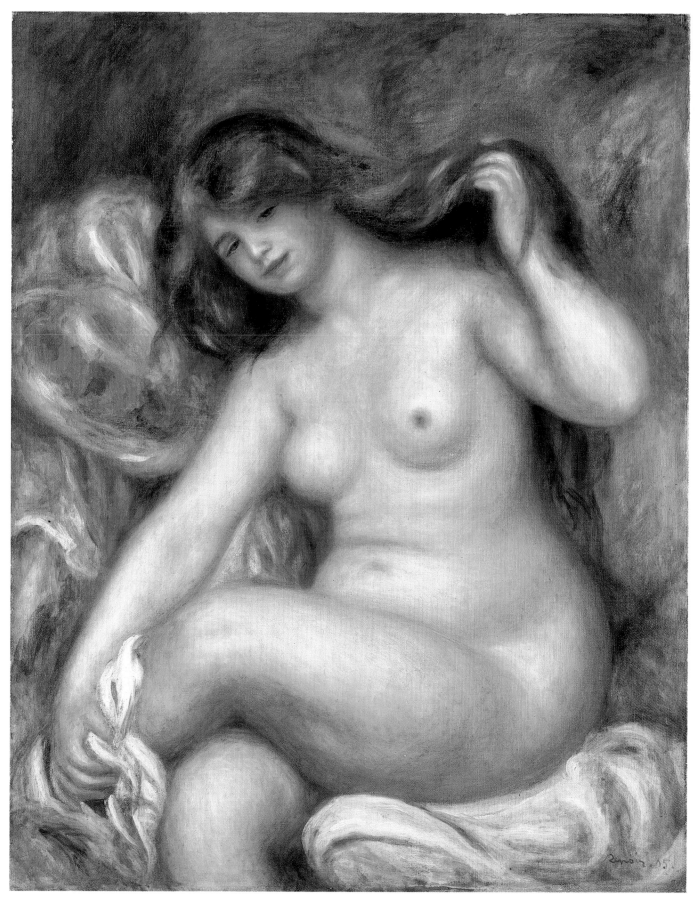

103. *Bather*, 1905. 97 × 73 cm.
Private Collection

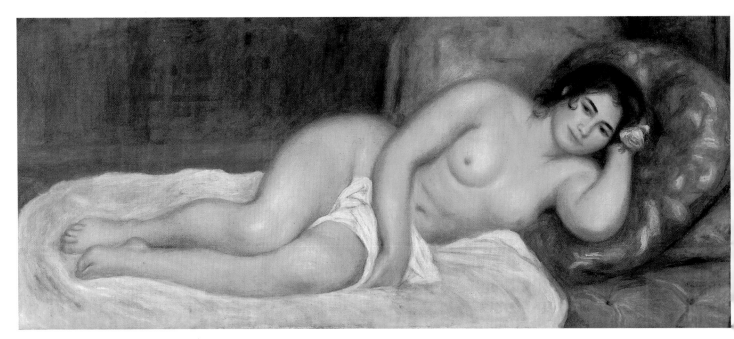

101. *Reclining nude*, 1903. 65 × 156 cm.
Private Collection

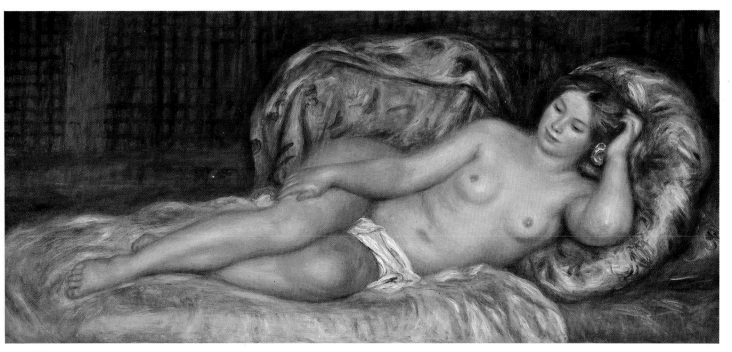

106. *Nude on the cushions*, 1907. 70 × 155 cm.
Musée d'Orsay, Paris

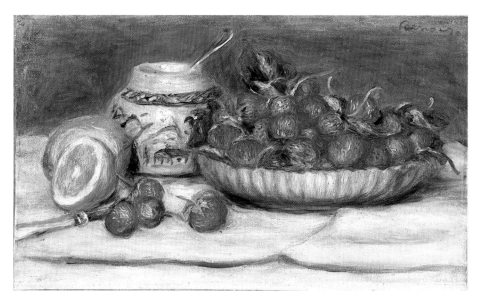

104. *Strawberries, c.* 1905. 28 × 46 cm.
Musée de l'Orangerie, Paris (Collection Walter–Guillaume)

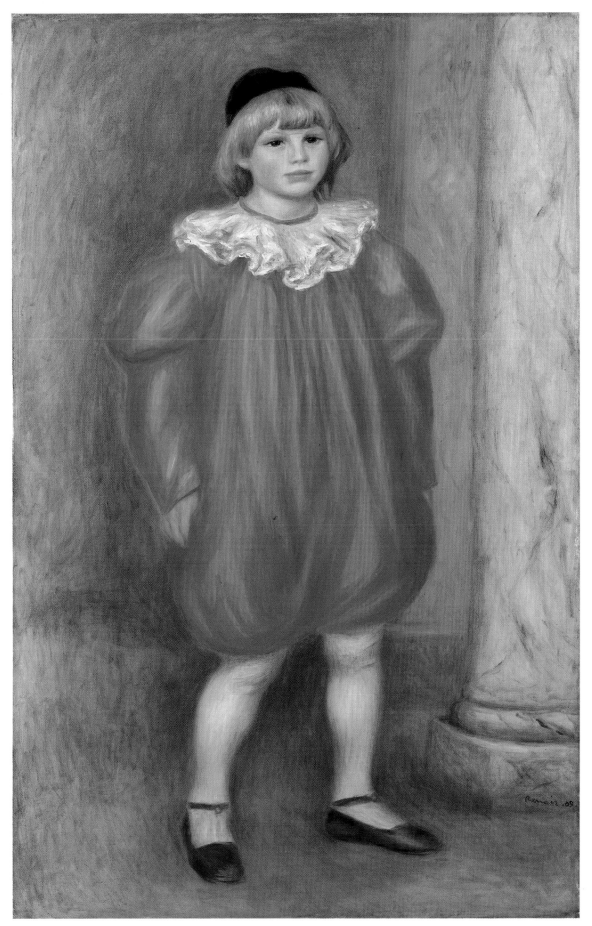

110. *The clown*, 1909. 120 × 77 cm.
Musée de l'Orangerie, Paris (Collection Walter–Guillaume)

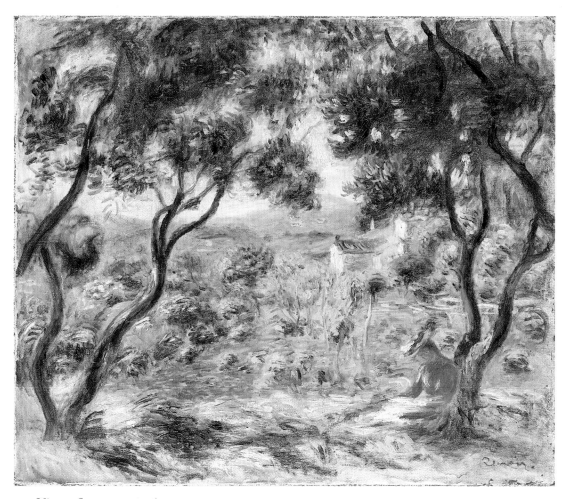

109. *Vines at Cagnes, c.* 1908. 46 × 55 cm.
The Brooklyn Museum

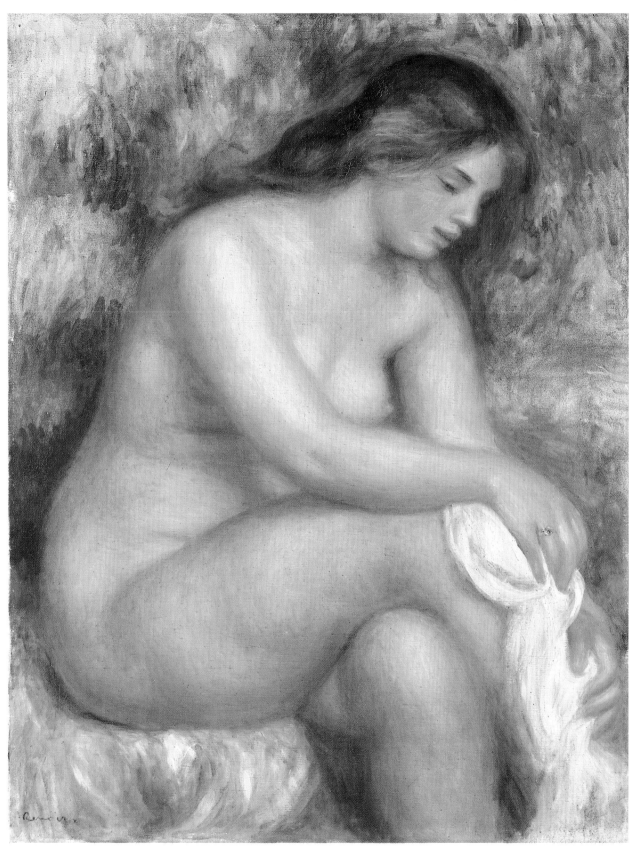

111. *Bather drying her leg, c.* 1910. 84 × 65 cm.
Museu de Arte de São Paulo

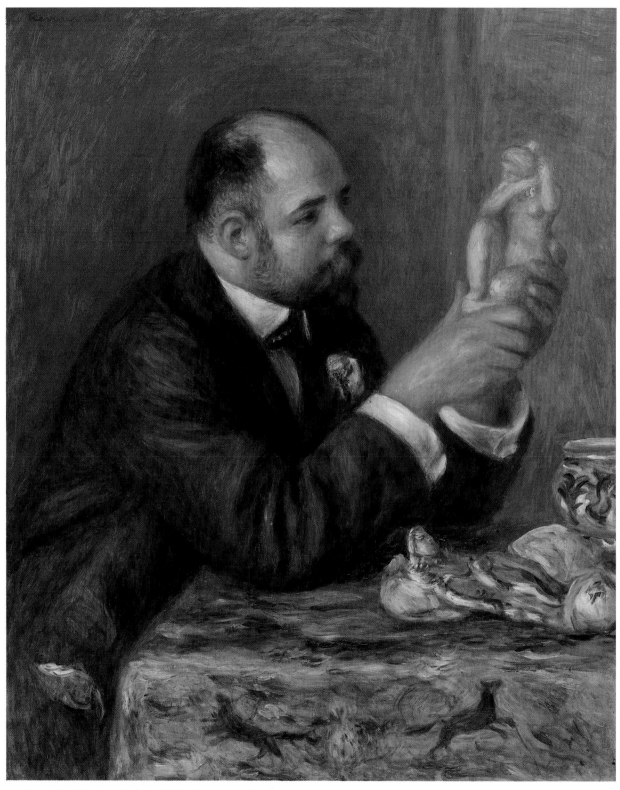

107. *Portrait of Monsieur Ambroise Vollard*, 1908. 82 × 65 cm.
Courtauld Institute Galleries, London

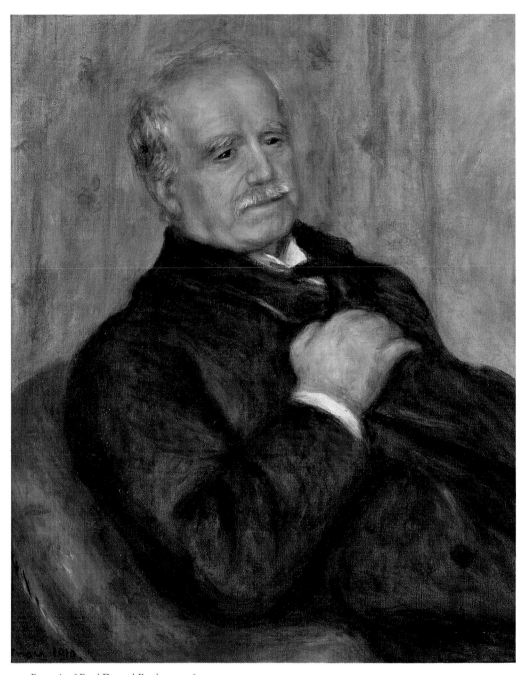

113. *Portrait of Paul Durand-Ruel*, 1910. 65 × 54 cm.
Durand-Ruel, Paris

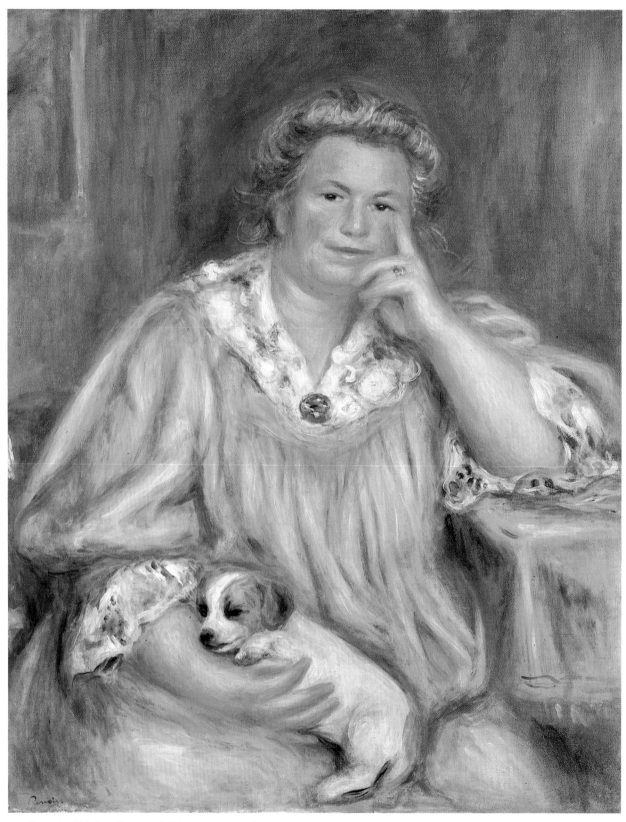

114. *Portrait of Madame Renoir with Bob, c.* 1910. 81 × 65 cm.
Wadsworth Atheneum, Hartford

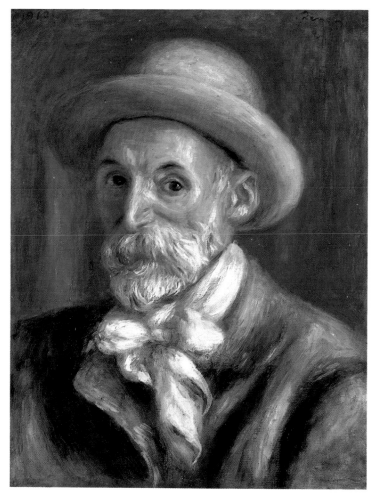

112. *Self-portrait*, 1910. 47 × 36 cm.
Private Collection

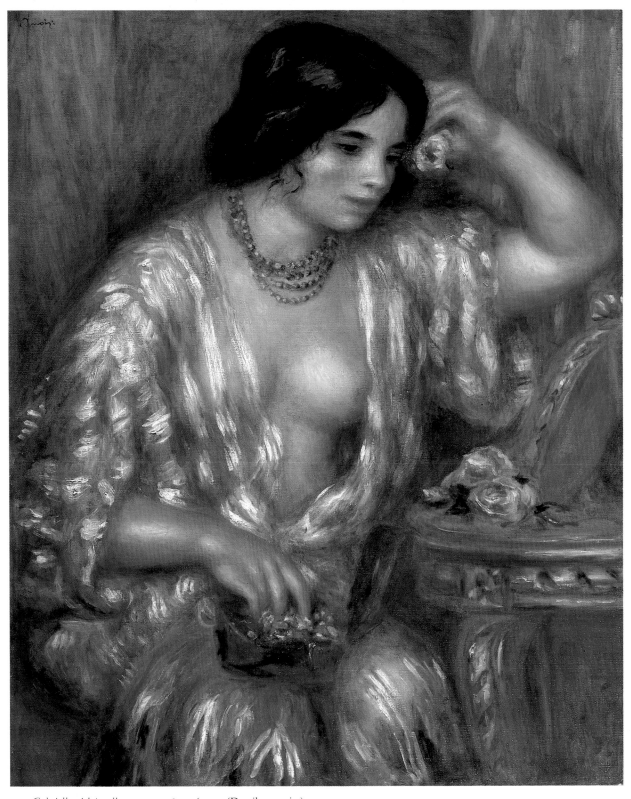

115. *Gabrielle with jewellery, c.* 1910. 81 × 65 cm. (Detail opposite)
Private Collection

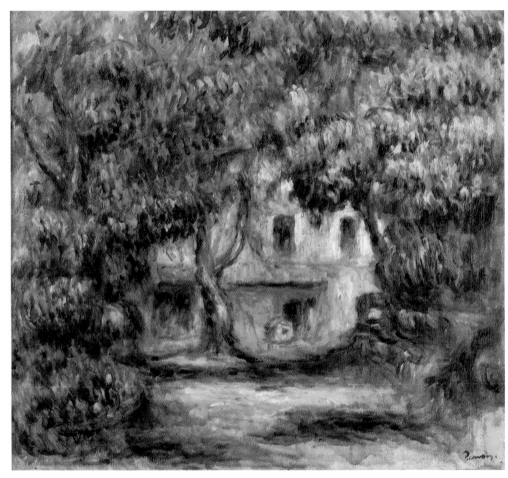

123. *The farm at Les Collettes, c.* 1915. 46 × 51 cm.
Musée Renoir "Les Collettes", Cagnes-sur-mer

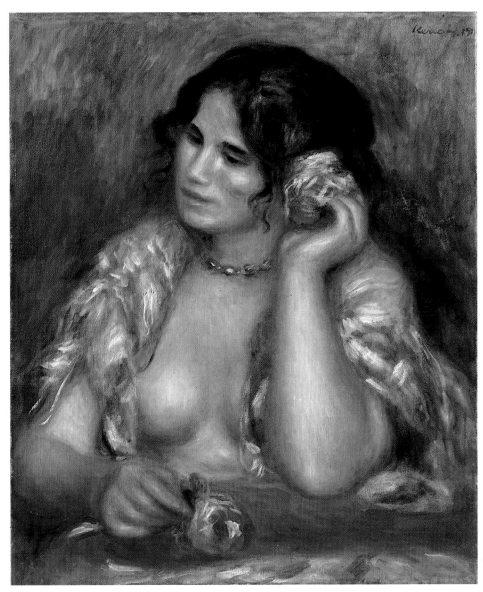

116. *Gabrielle with a rose*, 1911. 55 × 47 cm.
Musée d'Orsay, Paris (Galerie du Jeu de Paume)

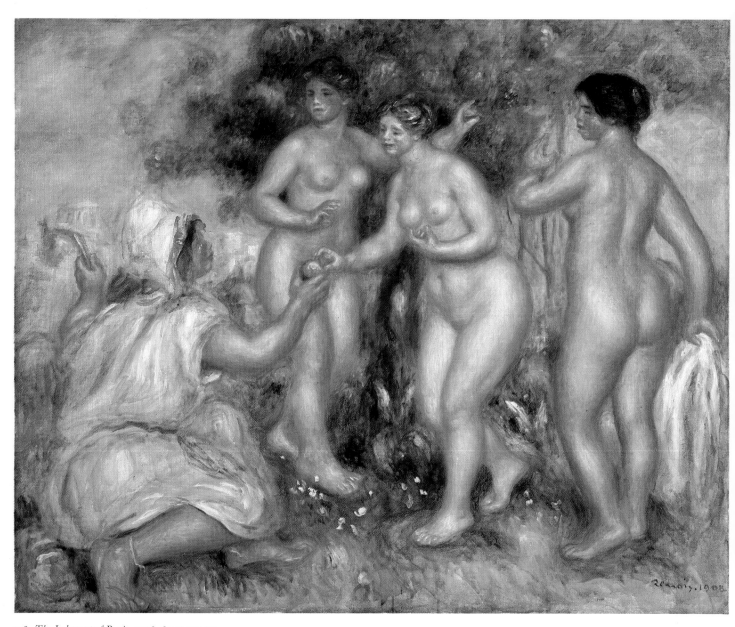

108. *The Judgment of Paris*, 1908. 81 × 101 cm.
Private Collection, Japan

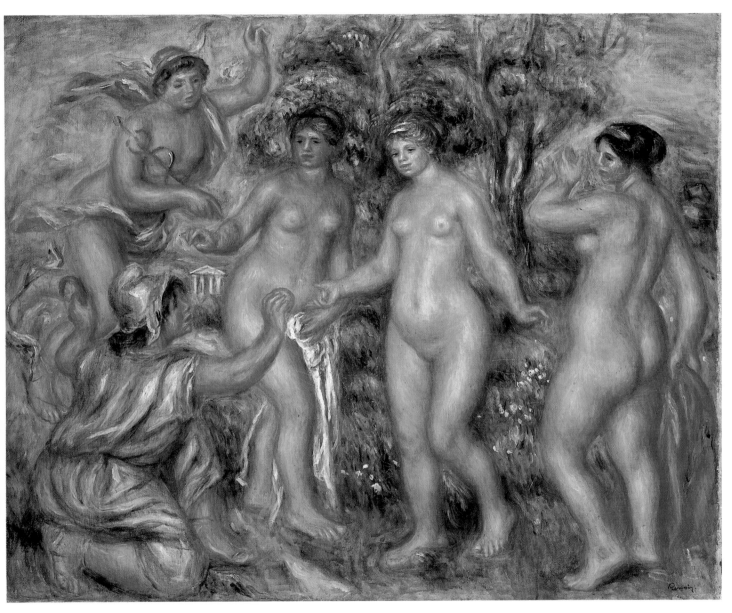

119. *The Judgment of Paris, c.* 1913–14. 73 × 92 cm.
Hiroshima Museum of Art

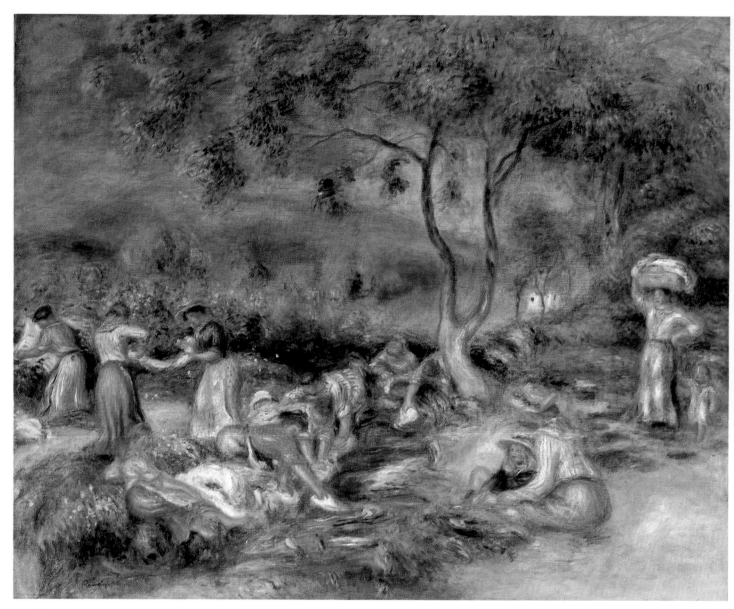

117. *Washerwomen at Cagnes, c.* 1912. 73 × 92 cm.
Private Collection

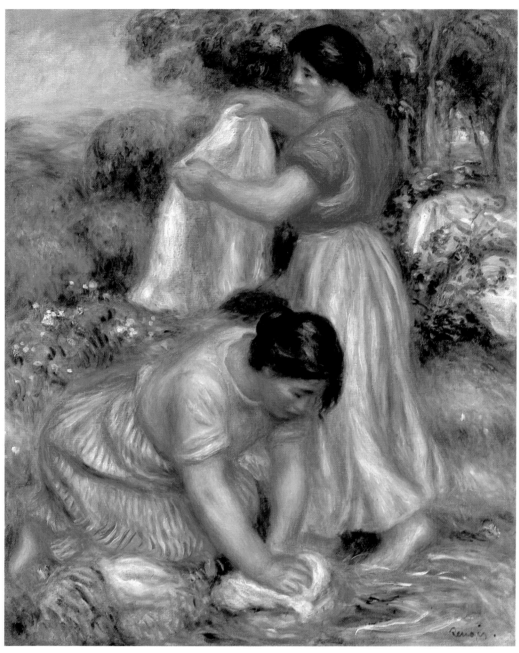

118. *Washerwomen*, c. 1912. 65 × 55 cm.
The Metropolitan Museum of Art, New York

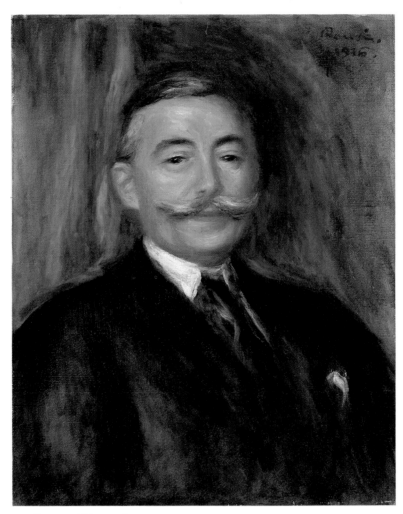

124. *Portrait of Maurice Gangnat*, 1916. 47 × 38 cm.
Private Collection

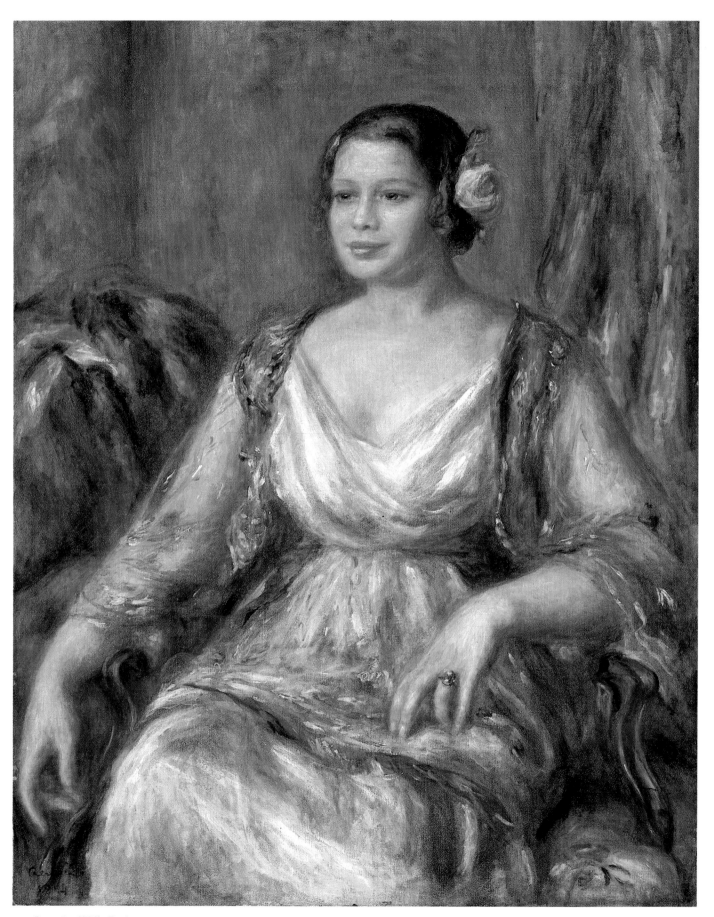

122. *Portrait of Tilla Durieux*, 1914. 92 × 74 cm.
The Metropolitan Museum of Art, New York

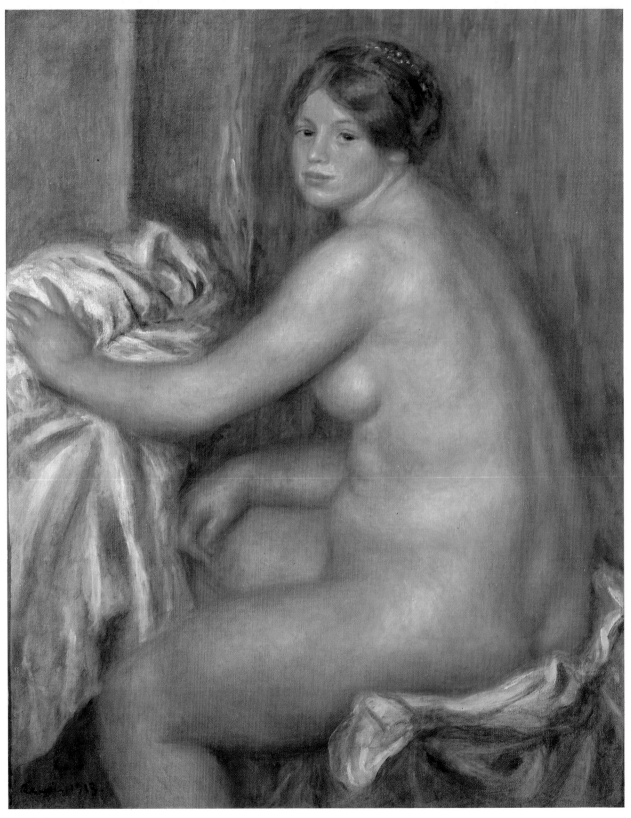

120. *Bather*, 1913. 81 × 65 cm.
Mr and Mrs Alexander Lewyt

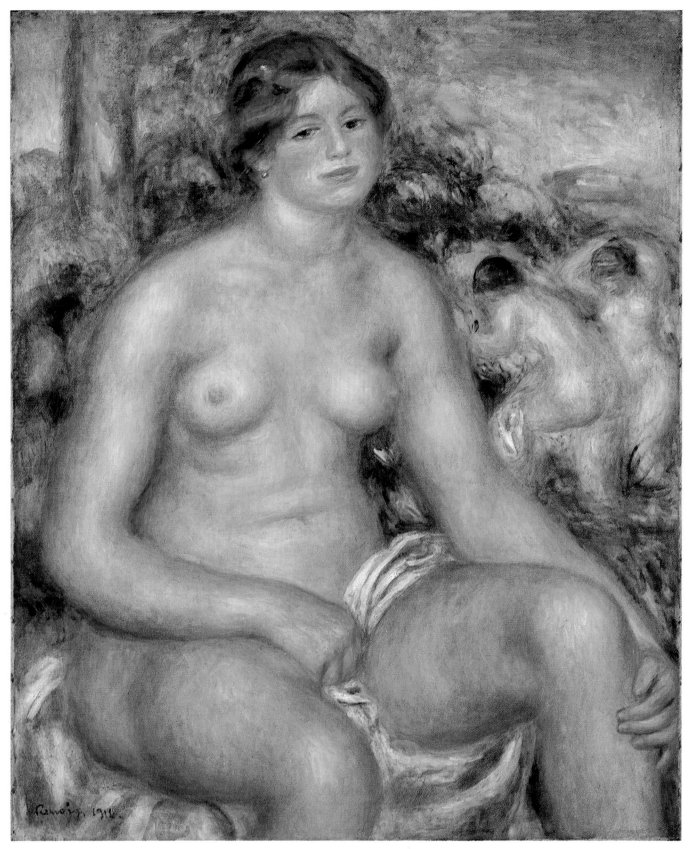

121. *Seated bather*, 1914. 81 × 67 cm.
The Art Institute of Chicago

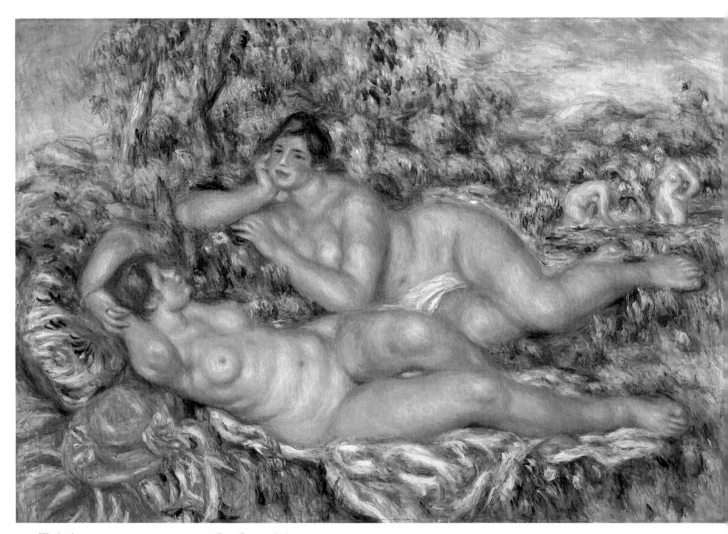

125. *The bathers*, *c*. 1918–19. 110 × 160 cm. (Detail opposite)
Musée d'Orsay, Paris (Galerie du Jeu de Paume)

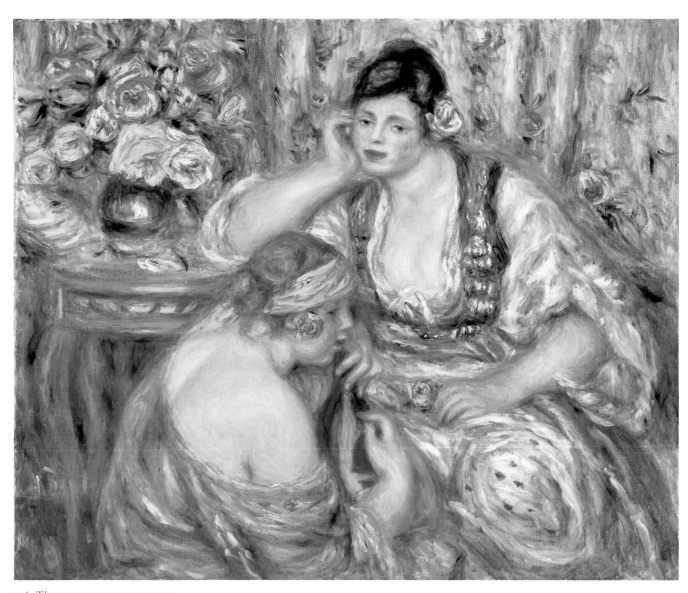

126. *The concert, c.* 1919. 75 × 93 cm.
Art Gallery of Ontario, Toronto

Catalogue of the exhibition

Explanatory note

The catalogue is arranged in seven chronological sections: the 1860s, 1871–80, 1880–3, 1884–7, 1888–98, 1899–1909, 1910–19. Entries for each picture appear in approximate chronological order within the relevant section.

The catalogue for 1864–80 (with the exception of entry no. 1) has been written by Anne Distel, 1880–1919 and entry no. 1 by John House.

Titles are given in English, followed by French. Original titles are given wherever possible. All paintings are oil on canvas. Dimensions are given in centimetres, to the nearest cm (inches are given in parentheses, to the nearest $\frac{1}{2}$ inch); height precedes width. Paintings are exhibited in London, Paris and Boston unless otherwise stated.

References in the text and at the foot of each entry are generally given in abbreviated form, e.g., for literature, Silvestre, 1882, or, for exhibitions, 1882, Paris, and are keyed to the Selected bibliography (pp. 320–3) and Exhibition history (pp. 315–9). References to sales are given in abbreviated form, e.g. Paris, Drouot, 19 February 1982. Exhibitions listed at the foot of each entry include all known exhibitions of the picture during Renoir's lifetime. Where later exhibitions have catalogues with informative material on the picture in question, the catalogue is listed under Literature. Works listed under Literature at the foot of each entry include only the most important references specifically to that picture; references to other works cited appear within the text of the entry.

Complete provenances of pictures in the exhibition have not been included. In many cases, early histories cannot be reliably documented, while subsequent histories are often difficult to reconstruct because of the understandable wish of owners and dealers to maintain confidentiality. Where it has been possible to determine the early history of a picture, or where later history is of particular interest, this information has been included in the entry.

The 1860s

On 1 April 1862, Pierre-Auguste Renoir passed the entrance examination to the Ecole Impériale et Spéciale des Beaux-Arts; he was just twenty-one. For a young man from a modest background who was originally destined for a career as a porcelain painter this was a decisive step and no doubt represented the culmination of a great many hopes.

Ingres, Cogniet, Robert-Fleury, Flandrin, Cabanel and Signol were all teaching at the Beaux-Arts in 1863, but only Signol appears to have made any lasting impression on the painter, who later referred to him in conversation with Vollard. It is possible that Renoir submitted a painting to the 1863 Salon and that it was rejected. But, unlike Manet, Whistler, Pissarro and the others, Renoir did not take part in the famous Salon des Refusés. In 1864, however, his *La Esmeralda*, a painting inspired by Victor Hugo's *Notre Dame de Paris*, was accepted by the Jury. The painting is now lost, and Renoir himself said that he destroyed it. At this time Renoir described himself as a pupil of Gleyre, who ran the private school he had been attending since 1861. Gleyre was a self-confessed republican, and his relatively liberal stance and disinterested attitude had brought him many pupils. Bazille enrolled in his school in late 1862 and was joined a few months later by Monet and Sisley; they had a number of ideas in common and soon came to form a group. Monet was no doubt the most 'advanced' member of the group. He had already enjoyed the benefit of direct advice from Boudin and Jongkind and was therefore more readily able to formulate principles which went against the norms of academic teaching, notably the absolute necessity both of working from nature (and, if need be, in the open air) and of retaining the freshness and spontaneity of the sketch in the finished work.

Renoir's submission to the 1865 Salon consisted of a very sober portrait of the father of his friend Sisley (no. 2) and an unidentified painting entitled *Soirée d'été*. Whereas Monet caught the eye of the critics with his two landscapes, Renoir appears to have gone unnoticed. Despite that, 1865 does mark the true beginning of his career. In 1865–6, he frequently visited the Forest of Fontainebleau, but, whereas Monet was working at Chailly-en-Bière (it was there that he began his large *Déjeuner sur l'herbe* in the summer of 1865 and that he was joined by Bazille), Renoir appears to have preferred Marlotte, where his friend Jules Le Coeur (cf. no. 5) bought a house in April 1865. He also frequented the cabaret (inn) of Mother Antony, the subject of his famous painting of 1866 (no. 4). Unlike his friends Monet and Bazille, Renoir was, despite Daubigny's pleas in his favour, rejected by the 1866 Salon, as were Manet and Cézanne. The Jury did in fact accept what Renoir himself described as a 'rough sketch' but rejected the painting on which he had set his hopes, and he therefore refused to exhibit anything. It now seems possible to identify the painting rejected in 1866, which Jules Le Coeur's sister described as 'a landscape with two figures': in Bazille's 1870 painting of his *Studio in the rue de La Condamine* (fig. a), a large framed composition can be seen hanging on the wall which depicts a standing nude looking at a fully-clothed woman who sits at her feet. This painting (fig. b) has never been convincingly identified, but it seems that the seated figure corresponds in every detail to a painting signed

FIG a. Frédéric Bazille, *Studies in the rue de La Condamine*, 1870. Musée d'Orsay, Paris (Galerie du Jeu de Paume).

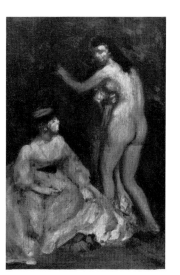

FIG b. Frédéric Bazille, *Studio in the rue de La Condamine*, 1870 (detail of fig. a).

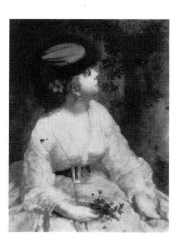

FIG c. Renoir, *Portrait of a woman*, 1866.
Present whereabouts unknown.

by Renoir and dated 1866 (fig. c). Like Manet, Monet and Zola's Lantier in *L'Oeuvre*, Renoir must have cut out and kept a fragment of a large painting, and that painting must have been the canvas rejected in 1866. It was presumably rejected because its style and inspiration were so close to Courbet; it greatly resembles the *Women bathing* exhibited at the 1853 Salon (now in the Musée Fabre, Montpellier).

In company with Monet, Sisley, Bazille and Pissarro, Renoir was once more rejected in 1867: his submission was again similar to Courbet, although the mythological subject-matter of *Diana the huntress* (fig. d) does suggest a certain concession to official art. In this connection it is interesting to note that when M. de Couessin X-rayed Bazille's *Studio in the rue de La Condamine* in the laboratories of the Direction des Musées de France, it was found to be painted over a sketch related to *Diana the huntress*. If, as seems probable, this smaller version (fig. e) is in fact a preliminary study by Renoir, it provides concrete evidence of his method of working – which accorded with the traditional teaching of the Ecole des Beaux-Arts. It may, however, be a sketch by Bazille, who could have taken the opportunity to paint the model sitting for Renoir. Whatever the truth of the matter, this chance discovery is a reminder of the intimacy which existed between the two artists, who, as we know from Bazille's correspondence, had worked together ever since their first meeting in Gleyre's studio.

It was at about this time that a young brunette named Lise Tréhot first appeared in Renoir's life. She posed for *Lise with a parasol* (fig. f), the painting which, as we can see from contemporary drawings and caricatures (figs. g, h, i), gave the artist his first success at the 1868 Salon. Emile Zola's comment is of particular interest: 'This *Lise* seems to me to be a sister to Claude Monet's *Camille* [Kunsthalle, Bremen]. . . . She is one of our wives, or rather our mistresses, and is painted with great

truthfulness and a successful exploration of the "modern".' This brief comment – Zola in fact gets Renoir's first name wrong – indicates that Renoir was still a junior member of the group, especially when compared with Monet. A number of critics stressed Renoir's debt to Manet, and one of them pointed out the similarity between *Lise* and Whistler's *Woman in white* (*Symphony in white no. 1*; National Gallery of Art, Washington, D.C.), which was exhibited at the Salon des Refusés in 1863. Renoir's success was, however, tinged with scandal and, as Castagnary puts it, his painting was accordingly 'relegated to the lumber room under the eaves with Bazille's *Family* [now in the Jeu de Paume] and not far away from Monet's large *Ships* [now lost].'

Lise was also the model for *Summer (study)* (no. 8), which was exhibited at the 1869 Salon, and for the *Bather with a griffon* (no. 15), Renoir's submission to the 1870 Salon. These figure paintings reveal both the dominant influence of Courbet and a certain willingness to make concessions to the official authorities, at least in terms of subject-matter. Although Renoir's output of these years consists mainly of figure paintings (portraits and Salon works), he also painted still lifes (e.g. no. 3) and landscapes, including several views of Paris, which are related to those painted by Monet in 1867. Some, like the *Pont des Arts* (fig. j), are very classical, but others, like *The Champs Elysées during the 1867 Exposition Universelle* (New York, Wildenstein, 1974, no. 3) – which is reminiscent of Manet – and *Skaters in the Bois de Boulogne* (no. 7), represent more original solutions to compositional problems. The same spirit of freedom appears in the series of landscapes painted at La Grenouillère in 1869 (cf. nos. 12, 13). These were painted at Monet's side and show his increasing influence on his friend's vision. The authority of Monet's style and his lively palette stimulated developments in Renoir that were fully realized at the beginning of the 1870s.

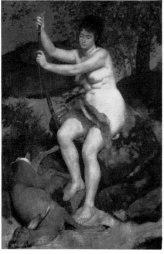

FIG d. Renoir, *Diana the huntress*, 1867.
National Gallery of Art, Washington, D.C. (Chester Dale Collection, 1962).

FIG e. X-ray of Bazille's *Studio in the rue de La Condamine*, showing a sketch related to *Diana the huntress*.

FIGS g, h, i. Caricatures of *Lise with a parasol* by Gill in *Le Salon pour rire,* 1868, Oulevay in *Le Monde pour rire, Le salon repeint et mis à neuf,* 1868, and Chassagnol neveu in *Le Salon du Tintamarre,* 1868.

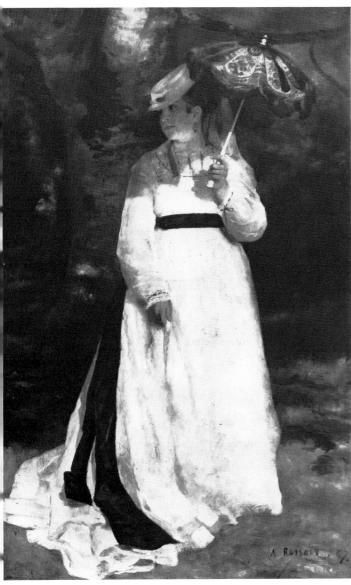

FIG f. Renoir, *Lise with a parasol,* 1867.
Museum Folkwang, Essen.

FIG j. Renoir, *Pont des Arts,* 1867.
The Norton Simon Foundation.

vincingly; within the conventions of formal portraiture, Romaine Lacaux is viewed with close observation and presented as an alert, vivacious young girl.

The painting passed from the family of the sitter into the collection of Edmond Decap, with whose family it remained until after Renoir's death.

LITERATURE
Barnes and de Mazia 1935, p. 374 no. 2
New York, Duveen, 1941, no. 1
H.S. Francis, '"Mlle. Romaine Lacaux" by Renoir', *Bulletin of the Cleveland Museum of Art*, June 1943, pp. 92–8
Drucker 1944, pp. 25, 192 no. 3
Pach 1950, p. 32
Daulte 1971, no. 12
Chicago, Art Institute, 1973, no. 2
Callen 1978, pp. 7, 25

1

Portrait of Mademoiselle Romaine Lacaux

Portrait de Mademoiselle Romaine Lacaux
1864
81 × 65 cm (32 × 25½ ins)
Signed and dated centre right:
A. RENOIR / 1864
The Cleveland Museum of Art
(Gift of the Hanna Fund), 42. 1065

COLOUR *p. 37*
Exhibited in Boston only

Romaine Lacaux was born in Paris in May 1855; her father was a manufacturer of terracotta goods with premises at 27 rue de la Roquette (information from Didot-Bottin, *Annuaire*, 1870); it was perhaps through the contacts he made as a porcelain painter that Renoir obtained this commission. Reportedly the portrait was commissioned while Renoir was visiting Barbizon, where the Lacaux family was on vacation (New York, Duveen, 1941).

The painting is a synthesis of varied artistic traditions. The girl's pose and setting, and her crisply defined form, bear the imprint of the Ingres tradition of formal portraiture; but the blonde tonality, dominated by greys with soft accents of blues and reds, reveals Renoir's allegiance to the light-toned (*gris-clair*) painting widespread in Paris by the 1860s, of which Corot was the most celebrated mentor. The brushwork – soft yet visible, and quite broad in places – suggests that Renoir was also looking at the masters of freely handled oil painting; the example of Velasquez seems particularly relevant here, notably his child portrait, *The Infanta Margarita*, in the Louvre. Renoir succeeded in fusing these diverse traditions very con-

2

Portrait of William Sisley

Portrait de William Sisley
1864
81 × 65 cm (32 × 25½ ins)
Signed and dated diagonally mid left:
A. Renoir. 1864
Musée d'Orsay, Paris (Galerie du Jeu de Paume), RF 1952–3

COLOUR *p. 38*
Exhibited in London and Paris only

After his initial success in 1864, Renoir had a second painting accepted by the 1865 Salon. According to the catalogue, one of the works exhibited was a *Portrait de M.W.S.*, and there is every reason to believe that it was this painting; that the model is in fact William Sisley, the father of the painter Alfred Sisley, has been confirmed by a family photograph published by a relative of the artist. William (or Guillaume) Sisley was the son of an Englishman who had settled in France and was born on 6 December 1799. We do not know exactly when or where he died; his name does not, however, appear in the *Annuaire commercial Didot-Bottin* for 1871, although he was previously listed as a businessman living in the Passage Violet (the Passage no longer exists but was in the tenth *arrondissement* of Paris), and it is presumed that he died at about that time. Nothing is known about him, but legend has it that he was a man of some means who allowed his son Alfred to devote himself to painting. Alfred Sisley, who attended Gleyre's studio at the same time as Bazille, Monet and Renoir, soon became a close friend of Renoir's. It can reasonably be assumed that he was originally responsible for the commission and that he saw it as a way

to help his gifted but impoverished friend.

Champa compares this portrait with Ingres's *Portrait of Monsieur Bertin* (in the Louvre) and with Fantin-Latour's portraits, but he stresses that, despite his borrowings, Renoir's work is clearly distinct from these influences, which were in fact antithetical, but which he had also fully assimilated.

The portrait, with the firmly modelled flesh heightened with red and shaded with warm tones contrasting with the dense black of the suit, is fairly austere, despite the mellow red of the armchair picked up unobtrusively in the bottom right-hand corner. The blackish-brown background has deliberately been left uneven and is reminiscent of the tones used by Fantin-Latour in the portrait of Delacroix in his *Homage to Delacroix* shown at the 1864 Salon (now in the Jeu de Paume), or the backgrounds of certain of Manet's still lifes of this period and also of Thomas Couture's oil sketches. Despite its obvious qualities, the painting does not seem to have been noticed by a single critic at the time; it is of course true that neither the artist nor his model was well known.

The portrait once belonged to Sisley's sister Aline-France, who later married Dr Leudet (Leudet was once thought to have been the sitter). In 1910 Bernheim-Jeune bought it from the Leudet family and immediately sold it to Ernest May, who kept it for only a few months. It was acquired by the Musées Nationaux in 1952.

LITERATURE
Sisley 1949, p. 252
Daulte 1971, no. 11
Champa 1973, p. 35
Rewald 1973, p. 121

EXHIBITIONS
1865, Paris, Salon (1802)
1912 (June), Paris, Durand-Ruel (*Portraits*) (6)

3

Still life

Nature-morte
1864
130 × 98 cm (51 × 38½ ins)
Signed bottom right: A. Renoir
Kunsthalle, Hamburg (Eigentum der Stiftung zur Förderung der Hamburger Kunstsammlungen), 5027

COLOUR *p. 39*

Exhibited in London and Paris only

This still life is related to another painting of the same dimensions (fig. a), which represents the same elements seen from a slightly different angle and is signed and dated 'A. Renoir 64'. The pink flower mottled with white (a poppy or perhaps a very open tulip) in the centre of that painting and the

grass in the foreground do not, however, appear in the version here. All the flowers depicted – daisies, an arum lily, a tulip, a hyacinth, cineraria and a sprig of white lilac – suggest spring. They are all common plants that could be found in any ordinary garden, and the artist has grouped them without any particular artifice, deliberately suggesting that there is no need for a sophisticated decorative arrangement. The same bright colours are used in both paintings, but the one here is much less finished than the Winterthur version, in which a slight shift of viewpoint allows the artist to place the arum lily in the centre and to eliminate the somewhat dead area to the left. The variety of flowers allows Renoir to display all his stylistic powers. As he later explained to Georges Rivière: 'Painting flowers is a form of mental relaxation. I do not need the concentration that I need when I am faced with a model. When I am painting flowers I can experiment boldly with tones and values without worrying about destroying the whole painting. I would not dare to do that with a figure because I would be afraid of spoiling everything. The experience I gain from these experiments can then be applied to my paintings.' (Rivière 1921, p. 81.)

These still lifes should be compared with a painting by Monet, also of spring flowers and also dated 1864 (fig. b). Monet's arrangement of the flowers is, however, much more 'artistic' and decorative, and in that sense it is closer to the still lifes painted by Courbet in the 1860s.

The early provenance of this work is unknown, but it belonged at one time to the painter Max Liebermann. It is possible that this is the painting which was auctioned as a Monet at the Hôtel Drouot on 29 May 1900 (no. 17); the dimensions are the same and, according to the catalogue, no signature had been noted at that time. A *Snowscape* by Monet (Louvre, Collection Victor Lyon) was also included in the sale, and both paint-

FIG a. Renoir, *Still life, arum and flowers*, 1864. Oskar Reinhart Collection, 'Am Römerholz', Winterthur.

FIG b. Claude Monet, *Spring flowers*, 1864. The Cleveland Museum of Art (Gift of Hanna Fund, 53.155).

ings belonged to one 'M.P.'. The *Still life* appears to have been withdrawn from the sale, perhaps because it was realized that it was not in fact by Monet.

The painting was acquired by the Hamburg Kunsthalle in 1958.

LITERATURE
? Meier-Graefe 1912, p.6
Meier-Graefe 1929, p.16 n.2
New York, Duveen, 1941, no.2
Champa 1973, p.41

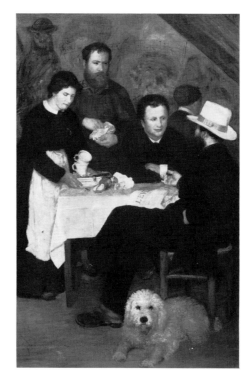

4

Cabaret of Mother Antony

Le Cabaret de la mère Antony
1866
195 × 130 cm (76½ × 51 ins)
Signed and dated bottom right:
RE[NOIR] 1866 (on earlier photographs
a second signature is also visible;
cf. Meier-Graefe 1912, p.5)
Nationalmuseum, Stockholm

COLOUR *pp.40, 41*
Exhibited in Paris only

'The *Cabaret of Mother Antony* is one of my pictures that I remember with most pleasure. It is not that I find the painting itself particularly exciting, but it does remind me of good old Mother Antony and her inn in Marlotte. That was a real village inn! I took the public room, which doubled as a dining room, as the subject of my study. The old woman in a headscarf is Mother Antony herself, and that splendid girl serving drinks is her servant Nana. The white poodle is Toto, who had a wooden leg. I had some of my friends, including Sisley and Le Coeur, pose around the table. The motifs that make up the background were borrowed from scenes painted on the wall; they were unpretentious but often successful paintings by the regulars. I myself drew a sketch of Mürger on the wall and copied it in the upper left-hand corner of the painting.' This is how Renoir described his first large-scale composition to Vollard, adding that the 'frescoes' in the inn had been destroyed

shortly afterwards and that this painting was hung there to replace them.

Meier-Graefe identified the man seen in profile in the right foreground as Sisley, the figure in the centre as Le Coeur and the man who is rolling a cigarette as Renoir himself; but the standing figure has in fact nothing in common with the tense, thin-faced young man depicted in the little canvas Bazille painted shortly after this (now in the Jeu de Paume). No subsequent identifications of the male figures have been unanimously accepted, but Meier-Graefe's identification of Sisley may well be correct – what little can be seen of his face does look like the portrait in Cologne (no.9) – while a photograph published by Cooper allows the bearded figure standing in the centre to be plausibly identified as Jules Le Coeur (cf. no.5). It has often been suggested that this man is Claude Monet, but such suggestions are quite unacceptable if we compare this portrait with that of Monet in Bazille's *Improvised stretcher* (now in the Jeu de Paume), which was also painted in the summer of 1865, or with the more unusual portrait by Carolus-Duran dated 1867 (Musée Marmottan, Paris). It also seems unlikely that Monet, who was fully occupied with his own projects, would have bothered to pose for his friend at this time. To add to the confusion, in his memoirs Jean Renoir identified 'Sisley standing and Pissarro seen from behind. The clean-shaven man is Franc-Lamy' – but there appears to be no evidence for this.

We also have a previously unpublished description of the *Cabaret of Mother Antony* by the first known owner of the painting. In a letter of 10 August 1905, the bronze-caster A.A. Hébrard tried to persuade the Prince de Wagram to buy what he described as 'an extraordinary work painted before 1870 in Marlotte and representing the interior of Mother Anita's [sic] famous inn, with the painters Bos, Lecoeur and Sysley [sic], mother Anita and her servant Nana, whom all the painters . . . knew. *All the figures are life size.*' There is no record of anyone called Bos in the catalogues or registers of the Salon. Either he never existed or this is a slip of the pen on Hébrard's part. If we knew who 'Bos' was, it might help us to identify the clean-shaven man.

However, even though we do not know who these young men are, their clothes definitely suggest bohemian artists, and they surely belonged to the small group of painters who gathered at Marlotte in the Forest of Fontainebleau; Marlotte was, to use Duret's phrase, 'an annexe to Barbizon'. There is documentary evidence that Renoir was in Marlotte in late March and at the beginning of April 1866, and we also know that his friend Jules Le Coeur bought a house there in the spring of 1865 and that Renoir often stayed with him.

It is certainly no accident that the news-

paper which is so conspicuously on display should be *L'Evènement*. It was in *L'Evènement* that Zola defended Manet in April–May 1866 and that he paid a brief tribute to Monet's *Camille* (Kunsthalle, Bremen). The inclusion of the newspaper suggests that the three men are discussing painting, and the genre scene thus takes on an almost 'historical' significance. It has often been pointed out that Renoir's choice of subject owes a great deal to Courbet, but it should be remembered that *After dinner at Ornans*, which is sometimes seen as the source for Renoir's painting, was acquired by the State at the 1849 Salon and sent to the Musée de Lille, so that it is unlikely that Renoir knew it, although he may have seen a description or a reproduction of it. It is also possible that Renoir was thinking of paintings of similar themes by François Bonvin. However, this composition, with its almost life-size figures, can more usefully be compared with Monet's huge *plein air* painting *Le Déjeuner sur l'herbe*, which was initially painted at Chailly in the summer of 1865 and reworked in Bazille's studio in the winter of 1865–6. (The left-hand fragment, which is in the Jeu de Paume, and the central section, which is in a private collection, were recently shown together in the *Hommage à Claude Monet* exhibition at the Grand Palais, Paris, 1980.) Just like Monet, Renoir felt a need to cover a large surface, but he was less daring than his friend and chose to represent his figures in an interior, carefully framing them with the edges of the canvas and picking them out against the unusual background of a wall covered with caricatures. The rear view of Mother Antony marks the transition between the figures and the ground, albeit somewhat clumsily. Renoir uses a palette of blacks, greys, browns and whites and has a portrait-painter's concern with the physical representation of the faces, which were of only secondary importance to Monet. The dog adds a touch of humour: Toto is the only 'character' looking directly at the spectator and echoes the grimaces of the caricatures in the background. This portrait of a group of artists is made more topical by the allusion to Zola and might be seen as a rustic version of Fantin-Latour's large-scale manifesto-paintings (*Homage to Delacroix*, exhibited at the 1864 Salon, and the later *Studio in the Batignolles*, exhibited at the 1870 Salon, both now in the Jeu de Paume).

To conclude, we might note that Renoir's cosy image of Mother Antony's cabaret was not exactly shared by two other 'realists'. In an entry in their *Journal* dated August 1863, the Goncourt brothers also describe the establishment of 'Antony, who harbours wretched painters, along with Mürger's disgraceful phalanstery and licensed harem [Mürger was the author of *Scènes de la vie de Bohème*]. There are paintings scrawled all over the house; the windowsills are like palettes and the walls look as though house-painters had wiped their hands on them. We ventured out of the billiard room into the dining room, which is daubed with guardroom caricatures and cartoons of Mürger. There were three or four men there, wearing rough jackets and looking like thuggish workmen, but they could have been either boaters, barbers or daubers. It was three in the afternoon and there they were having lunch with the disreputable women of the house, who come out from the Latin Quarter and go back the way they came, in their slippers and with no hats on. No one is certain if there are still painters or a landscape school here. It seems that Antony's is like the Closerie des Lilas, a rough party that goes on day and night with people playing guitars and breaking plates, and with the occasional stabbing. They have exhausted the forest and it is deserted. I saw only two artists' umbrellas at the Mare aux Fées, this majestically robust landscape of granite, green grass and purple heather that used to be like one big open-air studio, with the artists' mistresses sewing and mending in the shade of the easels.' (E. and J. Goncourt, *Journal, vol. 1, 1851–1863*, Paris 1956, pp.1305–6, 1309–10.)

The first known mention of this painting comes in another letter (9 August 1905) from Hébrard to the Prince de Wagram: he tells him that the owner – whom he had met through a friend who is himself in touch with the owner at the stock exchange – is going to sell it. Hébrard committed himself so far that he was forced to buy the painting himself, as the Prince was reluctant to pay the asking price of 45,000 francs. It remained in Hébrard's possession for several years and was not sold until 1912, when it was exhibited in Amsterdam. An annotated catalogue in the possession of M. Charles Durand-Ruel states that it was sold to a Mr Klas Fähraeus of Sottsjöbaden near Stockholm for 55,000 florins. It was presented to the National-museum by a group of friends of the museum in 1926.

LITERATURE
Meier-Graefe 1912, p.4
Vollard 1918, I, p.122 no.484
Vollard 1918, *Jeunesse*, p.23
Vollard 1919, pp.37–9
Gasquet 1921, pp.43–4
Drucker 1944, pp.26–7, 192 no.4
Cooper 1959, pp.167, 325
J. Renoir 1962, pp.119–120, 125–6
Daulte 1971, no.20
Champa 1973, pp.41–4, 87
Chicago, Art Institute, 1973, no.4
Rewald 1973, p.134
Callen 1978, p.26
Gaunt and Adler 1982, p.8
Paris, Grand Palais, 1983, p.293

EXHIBITIONS
1906 Basel (514)
1910 Venice (12)
1912 Amsterdam (436)
1917 Stockholm (91)

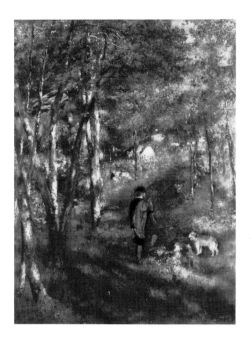

5

Jules Le Coeur in the Forest of Fontainebleau

Jules Le Coeur et ses chiens se promenant en forêt de Fontainebleau
1866
106 × 80 cm (41½ × 31½ ins)
Signed and dated bottom right:
Renoir / 1866
Museu de Arte de São Paulo,
Assis Chateaubriand

COLOUR *p. 42*

This landscape of trees and rocks will be familiar to anyone who knows the Forest of Fontainebleau. It depicts Renoir's friend the painter Jules Le Coeur with his dogs and is an interesting example of Renoir's experiments with a technique based mainly on the palette knife. Both the subject and the technique are reminiscent of the hunters painted by Courbet, but the general spirit of the composition and the fact that it represents the Forest of Fontainebleau relate it more closely to the lively landscapes of Diaz, one of the most famous members of the Barbizon school. Renoir himself stated that Diaz had a considerable influence on him when he met him in the Forest of Fontainebleau early in his career. Diaz's attractive subject-matter, his vivid palette and brilliant technique, with rich effects of texture, must certainly have appealed to a young artist who was sensitive to both craftsmanship and virtuosity.

The light-hearted realism and the highly picturesque costume – that of a harmless brigand – worn by his friend (who also posed for *Cabaret of Mother Antony*, no.4) introduce a personal note into a relatively ordinary subject. The artist is looking down

on the scene and on the figure climbing a path that rises up through the greenery of the forest. The format accentuates the verticality of the composition, and the tree trunks on the left give it rhythm. The other, sloping, trunks then lean it slightly to the right, and the trail of light which catches the vegetation and the rocks leads the eye in the same direction. The figure of the young man in the midst of the luxuriant vegetation introduces a sense of scale and stabilizes the composition. We do not know of any other major work in which the artist used a palette knife so systematically, and Renoir himself states that he had difficulty with it and soon abandoned the technique. Once again Renoir displays his ability to assimilate the influence of others and leave his personal mark on them.

The friendship between Jules Le Coeur (1832–82) and Renoir has been described by Cooper. Le Coeur came from a wealthy background and gave up architecture for painting. He was in a position to give his friend material help by commissioning him to paint portraits of all his family and even by obtaining him a commission for some decorative work. His elder brother Charles (1830–1906), who was also an architect, built Prince Georges de Bibesco's house in Paris and asked Renoir to decorate the ceilings in 1868. We know from watercolours (Dumas 1924, pp. 361, 366) that the decorations consisted of pastiches inspired by Fragonard and Tiepolo. There is some documentary evidence that Jules Le Coeur had a painting accepted by the 1866 Salon, but his name does not appear in any Salon catalogue, and the only firm documentation of his work as a painter is his submission of a landscape and a portrait to the 1873 Salon des Refusés, at which Renoir also exhibited.

According to Vollard (who dates the work to 1864), Renoir told him that it was accepted by the 1865 Salon. That cannot be true, but is perhaps a confused memory of the work in connection with a different Salon. The same landscape reappears without the figure in a painting which is said to have been executed near Moret (repr. in Dumas 1924, p. 366); here, Renoir uses a different technique and sketches the landscape with rapid brushstrokes.

The painting was probably never exhibited during the artist's lifetime, and we do not know exactly when it ceased to belong to the Le Coeur collection. It was acquired by the Museu de Arte de São Paulo in 1958.

LITERATURE
Vollard 1918, *Jeunesse*, p. 23
Vollard 1918, I, p. 123 no. 488
Cooper 1959, pp. 164, 325
Champa 1973, p. 40
Rewald 1973, p. 164
Callen 1978, p. 40

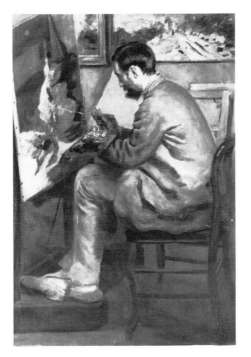

6

Frédéric Bazille at his easel

Frédéric Bazille peignant à son chevalet
1867
105 × 73 cm (41½ × 28½ ins)
Signed and dated bottom right:
A. Renoir 67.
Musée d'Orsay, Paris (Galerie du Jeu de Paume, Bequest of Marc Bazille, 1924), RF 2448

COLOUR *p. 43*

It has long been known that this portrait of Bazille painting once belonged to Manet. We also know that the subject of the still life Bazille is shown painting (fig. a) was also painted by Sisley at the same time (fig. b), and that the painting hanging on the wall is a recent snow scene by Monet (fig. c). This

is, in other words, a perfect symbol of the friendship that united the members of the little group in about 1867, and there is another reminder of the fact that between 1865 and 1870 Bazille and Renoir often shared a studio which was also used by Monet and Sisley: Bazille's *Portrait of Renoir* (in the Jeu de Paume), which could be considered a companion piece to this painting, was kept by Renoir until he died.

In this intimate portrait Renoir takes an obvious pleasure in painting the tall figure of Bazille as he sits on a little chair in front of his low easel in his untidy clothes and his slippers. Whereas most of Renoir's portraits have a neutral background (e.g. nos. 2, 11), here he surrounds the figure with paintings and shows no real concern for spatial structure. In that sense, the painting is reminiscent of Manet's *Portrait of Zola* (no. 18 fig. a), which was exhibited at the 1868 Salon. The dominant greys and beiges bring out the pink flesh tones; the warm grey of the suit harmonizes with the bluish-grey of the background, whilst the touch of red in the strap of Bazille's slipper and the bright colours on the little palette in his hand lighten the generally sober harmony.

The extreme economy of means clearly recalls Manet, and we can well understand why he liked this painting, even though he was not particularly attracted to Renoir. According to Alexandre, Bazille's father was overcome with emotion when he saw this portrait of his late son at the second impressionist group exhibition in 1876 and tried to buy it. Manet gave it to him in exchange for Monet's *Women in the garden* of 1866–7 (which is now also in the Jeu de Paume).

FIG a. Frédéric Bazille, *Heron and jackdaws*, 1867. Musée Fabre, Montpellier.

FIG b. Alfred Sisley, *Heron with opened wings*, 1867. Musée Fabre, Montpellier, on deposit from Musée d'Orsay, Paris.

LITERATURE
Pothey 1876
Alexandre 1892, p. 7
Vollard 1919, p. 52
Meier-Graefe 1929, p. 26
Scheyer 1942, pp. 125, 129–130
Paris, Louvre, 1958, no. 338
Daulte 1971, no. 28
Roskill, M., *Van Gogh, Gauguin and the Impressionist Circle*, London 1971, p. 54
Champa 1973, p. 46
Rewald 1973, pp. 182, 367
Callen 1978, p. 28
Gaunt and Adler 1982, no. 3

EXHIBITIONS
1876 Paris, Deuxième exposition (224; lent by M. Manet)
1910 Paris, Salon d'Automne

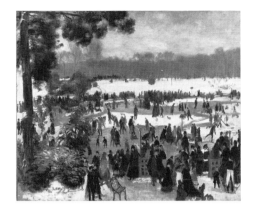

7

Skaters in the Bois de Boulogne

Patineurs au Bois de Boulogne
1868
72 × 90 cm (28½ × 35½ ins)
Signed and dated bottom left:
A. Renoir 68
Private Collection, U.S.A.

COLOUR *p. 48*

Vollard was the first known owner of the painting and also provides the first indirect commentary on it by citing Renoir's description of this youthful work: 'People walking and skating in the Bois de Boulogne. I have never been able to stand the cold, and my output of "winter effects" is limited to this painting and two or three little studies. In any case, even if you can stand the cold, why paint snow? It is one of nature's illnesses.' Renoir's dislike of snow obviously sets him apart from the other members of the impressionist group, especially from Monet, and their well-known interest in a subject that had already been painted by Gustave Courbet. But it is of Monet that one is reminded by this painting, the joyous animation of the silhouetted figures recalling some of his beach scenes, and, by analogy, of the art of Boudin and Jongkind. The choice of a viewpoint which is slightly above the subject is a device frequently used by Monet; Manet also uses it in his view of *The Exposition Universelle of 1867* (Nasjonalgalleriet, Oslo).

A few touches of bright colour stand out against the dominant greys and browns and make a powerful visual impression. The apparently casual spatial organization is in fact easily readable thanks to the gradual reduction in the size of the figures. Some elements, such as the tree on the left, are not, however, to scale and show that this is a lively transcription of a scene which the artist enjoyed observing.

In the illustrated *Paris-Guide* published to coincide with the 1867 Exposition Universelle, Amédée Achard dwells at some length on the charms of winter: 'In winter, scenes worthy of Siberia can be enjoyed at little expense in the Bois de Boulogne: the frost transforms the delicate branches of the birches into arabesques of silver, and the snow covers the dark foliage of the pines with a white veil. . . . During these shining hours, the frozen surface of the lakes has the consistency of stone and the sheen of a mirror, and crowds of skaters come from every corner of the city. . . . Nothing could be more charming than this spectacle; it is an opera set painted by winter.' The writer then goes on to describe the Champs-Elysées – which Renoir also depicted that very year (New York, Wildenstein, 1974, no. 3) – during the Exposition Universelle, which was held on the Champ de Mars on the opposite side of the Seine.

Subjects drawn from contemporary Parisian life, which were also popular with magazine illustrators, allowed Renoir to escape from the constraints of large Salon paintings and to diversify his technique by forcing him to deal with unexpected compositional problems like those posed, a little later, by La Grenouillère (cf. nos. 12, 13).

LITERATURE
Vollard 1918, I, p. 5 no. 18
Vollard 1919, p. 48
Meier-Graefe 1929, p. 20
Drucker 1944, p. 193 no. 11
Cooper 1959, p. 168
Champa 1973, pp. 57–8
Rewald 1973, p. 190
London, Sotheby's, 26–27 June 1978, no. 717

FIG c. Claude Monet, *Snowscape, Honfleur*, 1867. Private Collection, U.S.A.

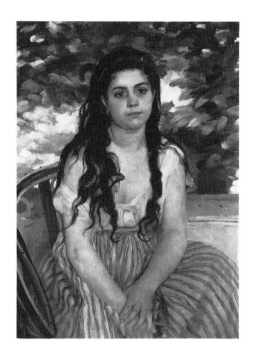

8

Summer (study)
(*known as* Lise *or* The gypsy girl)

En été (étude) (dit *Lise* ou *La bohémienne*)
1868
85 × 59 cm (33½ × 23 ins)
Signed bottom left: A. Renoir
Staatliche Museen Preussischer
Kulturbesitz, Nationalgalerie, Berlin

COLOUR *p. 45*

Exhibited in London and Paris only

Renoir, who at the time still described himself as a pupil of Gleyre, exhibited only one painting at the 1869 Salon. It was then known as *Summer (study)*. The model is Lise Tréhot (1848–1922), who had already posed for *Lise with a parasol* (p. 181 fig. f), Renoir's first success at the 1868 Salon. This young woman shared Renoir's life between 1866 and 1871, and her image, which he painted again and again, has become identified with these years of his artistic apprenticeship. A study of Lise and of the works for which she posed – several of which are shown here (cf. nos. 10, 15, 20) – will be found in Cooper's long article. *Summer* is relatively small in format, and its subject-matter recalls similar works by Courbet (cf. *Girl with seagulls, Trouville*, 1865, Deeley Collection, New York, and *Jo, the beautiful Irish girl*, Metropolitan Museum of Art, New York) which are halfway between the 'modern' genre figure and the individualized portrait, and which also relate to the long tradition of the *figure de fantaisie*. There is nothing particularly daring about the well-balanced layout of this portrait. Although the very stylized foliage in the background suggests the open air, the even light, the model's pose, the 'artistic' disorder of her clothes and the way her hair hangs down over her shoulders all smack of studio conventions. If we compare this painting with Monet's *Women in the garden*, painted in 1866–7, which was once owned by Bazille, or with Bazille's own *Family gathering*, exhibited at the 1868 Salon (both works are now in the Jeu de Paume), Renoir's caution becomes very obvious. Presumably he described it as a 'study' in the catalogue in order to make the vigorous and deliberately unfinished handling of the bright green leaves (a feature which recalls *Women in the garden*) and of the dark, tangled hair acceptable to the Jury. On the other hand, even the most traditional Jury would not have been shocked by the smooth, even modelling of the body and its cool tones. However, despite a certain formalism in the composition and even in the handling of paint, the portrait does give a forceful picture of the physical presence of the model. .

According to Théodore Duret, it was precisely because he was 'struck by the charm of the girl and the quality of execution' that he bought the painting, the first by Renoir that he had ever seen, from a minor dealer in the rue La Bruyère for 400 francs in 1873. The name of the dealer is unknown. When the collection of François Depeaux of Rouen was auctioned, *Summer* was jointly purchased by the dealers Bernheim-Jeune, Durand-Ruel and Rosenberg (?) for 4,500 francs. It was presented to the Nationalgalerie, Berlin, by Mathilde Kappel in 1907.

LITERATURE
Paris, Galerie Georges Petit, *Collection Depeaux*,
 sale catalogue, 1 June 1906, no. 40
Meier-Graefe 1912, p. 30
Duret 1924, p. 14
Rey 1931, pp. 47–8
Barnes and de Mazia 1935, p. 380 no. 11
Drucker 1944, pp. 30, 193 no. 10
Cooper 1959, p. 168
Daulte 1971, no. 33
Champa 1973, p. 54
Rewald 1973, pp. 217, 230
Berlin, Nationalgalerie, *Verzeichnis der Gemälden und
 Skulpturen des 19. Jahrhunderts*, 1976, p. 319
Callen 1978, p. 33

EXHIBITIONS
1869, Paris, Salon (2021)
?1900, Paris, Centennale (555; *Jeune fille à
 M. Rosenberg*)

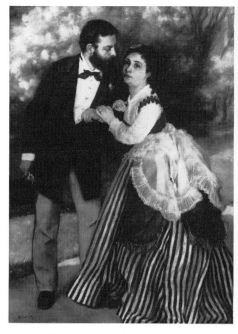

9

The engaged couple
(*known as* The Sisley family)

Les Fiancés (dit *Le Ménage Sisley*)
c. 1868
106 × 74 cm (41½ × 29 ins)
Signed bottom left: Renoir
Wallraf-Richartz Museum, Cologne

COLOUR *p. 44*

Exhibited in Paris only

This painting was acquired by the Cologne Museum in 1912 and soon became one of the most famous images ever painted by Renoir: as early as 1919, Picasso paid homage to it in a number of drawings (cf. fig. a). However, all the comparisons which have been drawn between this and thematically related paintings of other periods – those by the English painter Lawrence (1769–1830), those deriving from the medieval courtly tradition and those by Rubens – merely emphasize the nineteenth-century atmosphere of Renoir's painting. The young woman hangs tenderly and somewhat theatrically on the arm of the man, who turns towards her. His top hat is somewhat incongruous for the countryside, and she almost seems to be waiting for a sign from a photographer – an impression heightened by the rather woolly handling of the background foliage, which resembles the backdrops sometimes used by contemporary photographers.

Without wishing to 'read' the painting as though it were a naturalist novel, as contemporary critics like Zola, Astruc and Castagnary sometimes read paintings by Renoir and Monet, it is easier to see this young woman in the company of Courbet's

Girls on the banks of the Seine or with the women friends who posed for Monet's *Déjeuner sur l'herbe* than with Degas's bourgeois heroines or Manet's somewhat morose professional models.

This painting has traditionally been seen as a double portrait of Renoir's friend the painter Alfred Sisley (1839–99) and his companion, Eugénie Lescouezec (born, Toul, Meurthe et Moselle, 17 October 1834, died Moret-sur-Loing, Seine et Marne, 8 October 1898). Sisley, who had English parents and who retained his British nationality throughout his life, met Renoir in Gleyre's studio, and a little later they worked side by side at Marlotte (cf. no. 4). It is difficult to date their first meeting with any precision, but it was obviously prior to 1864, when Renoir painted a portrait of Sisley's father (no. 2). Renoir's first portrait of Sisley (Bührle Foundation, Zurich) surely also dates from the same period; it is usually dated 1868 but on stylistic grounds must be earlier. Many years later, Renoir told his son Jean that Sisley's companion had become a model when her family was ruined. In 1867 she gave birth to a son, Pierre, who was legally recognized by Sisley, and later bore two more children. According to her birth certificate she was the daughter of an infantry officer (who was killed in a duel when she was still a child) and worked as a florist. The couple lived at 27 Cité des Fleurs, Les Batignolles (although the catalogue for the 1868 Salon gives Sisley's address as 9 rue de la Paix; this was the address of the studio Renoir shared with Bazille).

A letter from Renoir to Bazille published by Poulain suggests an alternative identification for the female figure in this portrait. Renoir writes: 'I have put Lise and Sisley on show at Carpentier's [Carpentier sold artists' materials and had become a dealer]. I will try to get a hundred francs out of him, and I am going to put my woman in white up for auction; I'll take what I can get for it – it doesn't matter.' The last sentence is probably a reference to *Lise with a parasol* (p. 181 fig. f),

FIG a. Pablo Picasso, *Le Ménage Sisley (after Renoir)*, 1919. Musée Picasso, Paris.

exhibited at the 1868 Salon, but the reference to 'Lise and Sisley' seems to refer to the painting we are discussing here. If that is the case, the sitter would be Renoir's usual model Lise Tréhot, and the female figure does in fact resemble the woman in *Summer* (no. 8). There are, however, no contemporary portraits of Eugénie Lescouezec to provide a basis for comparison, and we do not have any descriptions of her. If Lise did pose for the Cologne portrait, it would not be an intimate portrait of two friends, but a conventional work, a genre scene. That suggestion would be borne out by the fact that Renoir tried to sell it to a dealer who, as Nancy Davenport points out, specialized in genre scenes. Although the letter cited above has generally been dated to autumn 1868, it was probably written in September 1869, since Renoir ironically tells Bazille, who was on holiday with his parents, not to 'come to Paris just to empty a bottle of ink over the Carpeaux group'. That incident, in which ink was thrown over Carpeaux's statues on the exterior of the new Opéra, took place in late August 1869.

Nevertheless, the painting's traditionally accepted date of 1868 has to be retained in view of its similarities with *Summer*. It is obviously more daring than *Lise with a parasol* of 1867, but we know that Renoir intended that work for the Salon and that, following the example set by Monet's *Camille* (Kunsthalle, Bremen), he therefore produced a polished stylistic composition, even though he did introduce some new elements, like the shadows which fall quite naturally across the young woman's face.

The engaged couple, to use the title by which this painting was known at the beginning of this century, is in a sense Renoir's answer to Monet's *Women in the garden* of 1866–7 (in the Jeu de Paume). But whereas Monet gives a prominent place to the garden setting and to the division between light and shade, Renoir brings forward the figures and with a kind of 'horror vacui' leaves only a minor role to those elements that suggest the garden. Working in the open air was an essential precondition to painting for Monet, but for Renoir it was still a minor issue. Like *The clown* (Kröller-Müller Museum, Otterlo), which was also painted in 1868, this painting also reveals Renoir's admiration for Manet's full-length figure paintings, such as *The fifer* (of which, much later, he made a drawing; cf. Duret 1924, fig. 5). Renoir, however, carefully paints in the ground on which his figures are standing, whereas Manet subtly modulates a neutral background.

If we compare this painting with Bazille's masterly *Family gathering* (in the Jeu de Paume), which he exhibited at the 1868 Salon, and especially with the couple who link arms in the middle distance, we can see the extent to which the two artists could arrive at different solutions even when they

were working along similar lines. Renoir is the more conservative of the two, but the virtuosity of his style and the sureness of his technique are greatly superior to those of his friend.

The Berlin dealer Cassirer sold the painting in April 1906 to Bernheim-Jeune, from whom it was bought on 19 June by the Prince de Wagram for 22,500 francs. Early in 1909, there was talk of his selling it through Hébrard, but it was in fact Henry Barbazanges who negotiated its sale to the Cologne Museum in 1912.

LITERATURE
Meier-Graefe 1912, pp. 8, 32
Jamot 1923, p. 268
Duret 1924, p. 73
Poulain 1932, pp. 156–7
Paris, Orangerie, 1933, no. 4
Barnes and de Mazia 1935, pp. 378–380 no. 10
Drucker 1944, pp. 29–30, 193 no. 9
Zervos, C., *Pablo Picasso, Oeuvres de 1917 à 1919*, III, Paris 1949, nos. 428, 429, 430
J. Renoir 1962, pp. 118–9
Cologne, Wallraf-Richartz Museum, *Gemälde des 19. Jahrhunderts*, 1964, pp. 103–4 and bibliography
Daulte 1971, no. 34
Champa 1973, pp. 54–5
Rewald 1973, p. 180
Callen 1978, p. 32
Wallrath, R., *Zur Kunst des 19. Jahrhunderts im Wallraf-Richartz Museum*, Cologne 1980, pp. 60–3
Gaunt and Adler 1982, no. 5
Davenport, N., 'Armand-Auguste Deforge, an art dealer in nineteenth-century painting and "La peinture de fantaisie"', *Gazette des Beaux-Arts*, February 1983, pp. 79–88

EXHIBITION
? 1904, Berlin, Cassirer (51; *Das Brautpaar*)

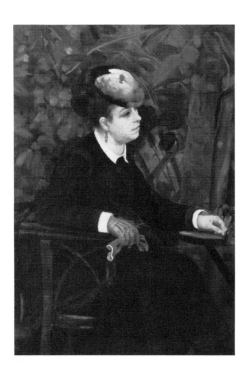

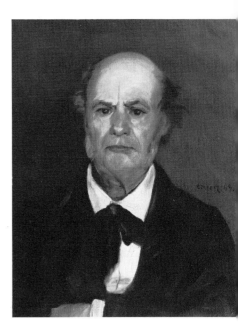

the figure are still reminiscent of Courbet, and the handling of the foliage in the background recalls *Summer* (no. 8). Cooper has also pointed out that Lise is wearing the coral and gold earrings she wore in *Lise with a parasol* (1867; p. 181 fig. f). All these points suggest that the work dates from around 1867–8.

The painting belonged to Henri Rouart, who was one of the first enthusiasts to collect Renoir, and it was auctioned when his collection was sold in 1912. It was then in the collection of Thea Sternheim until 1919.

LITERATURE
Paris, Galerie Manzi-Joyant, *Collection Rouart*, sale
 catalogue, 9–11 December 1912, no. 270
Meier-Graefe 1929, p. 58
Cooper 1959, p. 167
Daulte 1971, no. 83

10

Woman in a garden (*known as* Woman with a seagull feather)

Femme dans un jardin
(*dit La Femme à la mouette*)
c. 1868
106 × 73 cm (41½ × 28½ ins)
Signed bottom left: Renoir.
Private Collection, on loan to Oeffentliche
Kunstsammlung, Kunstmuseum Basel

COLOUR *pp. 46, 47*

Exhibited in London and Paris only

This young woman is recognizable as Lise Tréhot (cf. no. 8), in a bright blue dress which makes the mustard-yellow of her gloves and the white of her collar even more dazzling. She is wearing an extraordinary hat with a seagull's feather in it, and the brilliant rendering of the shimmering blue-grey and beige fully justifies the painting's traditional title. Again, this is not simply a portrait of Lise. The layout chosen by the artist and the fact that she is looking at an object we cannot see both emphasize the point that this is a model posing for a painter. Renoir stresses the modernity of his subject by the fashionable costume (which his contemporaries thought incompatible with high art) and the rustic chair. The young woman is almost expressionless, and there is no immediate allusion to tell us anything about her.

Meier-Graefe dated this painting to 1872, but it is obvious on stylistic grounds alone that it is earlier than that. The clear lines of

11

Portrait of the artist's father, Léonard Renoir

Portrait de Léonard Renoir, père de l'artiste
1869
61 × 46 cm (24 × 18 ins)
Signed and dated mid right: Renoir. 69.
The Saint Louis Art Museum, 37 : 1933

COLOUR *p. 52*

For this small intimate portrait, Renoir's framing concentrates our attention on the face and almost totally ignores the hands, only one of which is half visible. The axis of the body is subtly oblique and slightly off-centre, and the shadows thrown to the left vigorously bring out the painting's relief. A comparison with the earlier commissioned *Portrait of William Sisley* (no. 2) shows a definite evolution in technique: the brushwork is much more lively, especially in the handling of the hair and beard and in the deliberately simplified background. The personality of the model obviously freed the artist from the need to respect the conventions.

According to research carried out by Henri Hugon, Léonard Renoir was born in Limoges on 7 July 1799 and died in Louveciennes on 22 December 1874. He was a tailor and married Marguerite Merlet, a dressmaker, at the Mairie in Saintes on 17 November 1828. The young couple settled in Limoges, and all their children were born there with the exception of the youngest, the critic and writer Edmond Renoir, who was born in Paris on 12 May 1849. Renoir's parents retired to Louveciennes in 1868. His mother outlived his father by many years and did not die until 1896. A few brief allusions

show that Renoir always maintained close links with his family and that when this portrait was painted he was once more living with his parents (see entry on nos. 12, 13).

Like many other portraits of the Renoir family, this painting belonged to Vollard. It was bought by the Saint Louis Art Museum from Knoedler in New York in 1933.

LITERATURE
Vollard 1919, facing p. 10
Hugon 1935, pp. 454–5
Cooper 1959, p. 327
New York, Wildenstein, 1969, no. 1
Daulte 1971, no. 44
Chicago, Art Institute, 1973, no. 7
New York, Wildenstein, 1974, no. 2

12

La Grenouillère

La Grenouillère
1869
59 × 80 cm (23 × 31½ ins)
Signed bottom left: A. Renoir
Pushkin Museum, Moscow

COLOUR *p. 49*

Exhibited in London and Paris only

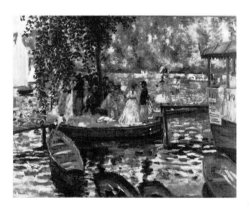

13

La Grenouillère

La Grenouillère
1869
66 × 86 cm (26 × 34 ins)
Signed bottom left: A. Renoir.
Nationalmuseum, Stockholm

COLOUR *pp. 50, 51*

Exhibited in Paris only

In his letter of 25 September 1869, Monet describes his plans for the next Salon to Bazille: 'I do have a dream, a painting of the bathing place at La Grenouillère. I have made a few poor sketches, but it is no more than a dream. Renoir, who has just spent two months here, also wants to paint the same picture.'

La Grenouillère, which is not to be confused with Fournaise's restaurant (cf. no. 52), was an open-air café and bathing establishment on the Ile de Croissy, on the Seine not

far from Bougival. It was a fashionable spot, as we can see from the detailed account published in *L'Evènement illustré* by Raoul de Presles on 20 June 1868: 'La Grenouillère is Trouville on the banks of the Seine, a meeting place for the noisy, well-dressed crowds that emigrate from Paris and set up camp in Croissy, Chatou or Bougival for the summer. . . . On a well-tarred old barge firmly moored to the bank . . . stands a wooden hut, painted green and white, and there is a wooden balcony to the front of the barge. . . . Refreshments of all kinds are on sale in a large room. To the left there is a boat-builder's yard; the bathing huts are to the right. One reaches the floating house by crossing a series of highly picturesque but very primitive footbridges. One footbridge connects the island with a little islet with a surface area of no more than ten square metres or so. A tree stands in the middle of the islet; there is only one tree and, to tell the truth, it seems somewhat surprised to be there. Most of the men and women who want to see the human race reduced to its most basic expression crowd on to this tiny islet. There is a small bathing area to the left of the islet; the river bed is of fine sand and the bathing area is roped off so that no one can get out of their depth. . . . Boats are moored all around the island, and the boaters, men and women alike, lie asleep in the shade of the great trees. . . . Each group, elegant, select, artistic or aristocratic, is made up of people who live or own property in the vicinity.' The author then lists the regulars, beginning with the painters Gérôme, Willems, Lambinet, Vibert and Frémiet and the owners of the opulent houses to be found in the area. His description, which lends a certain plausibility to Jean Renoir's claim that the painter was first introduced to La Grenouillère by Prince Bibesco, differs greatly from that given a few years later by Guy de Maupassant in *La Femme de Paul* (1881) and *Yvette* (1885). He describes a 'rowdy, screaming crowd', a 'mixture of drapers' assistants, ham actors, hack journalists, gentlemen whose fortunes are still in trust, shady stockjobbers, degenerate revellers and corrupt old hedonists', haunting a place 'which reeks of stupidity, vulgarity and cheap romance'. The truth probably lies somewhere between the two extremes. Joel Isaacson points out that a number of journalists and illustrators published their impressions of La Grenouillère in 1869. Riou's illustration for the article in *L'Evènement illustré* quoted here was also published in *La Chronique illustrée* on 1 August 1869, to which Isaacson refers. The bathing spot received its final consecration when Napoleon III and Empress Eugénie visited it in July of the same year. When Monet and Renoir, who both lived nearby (Monet in Saint-Michel-Bougival and Renoir with his parents at Voisins-Louveciennes), began to paint La

Grenouillère it was, then, very much in the news.

We have here two versions of a painting by Renoir, but there are considerable stylistic and compositional differences between them. There is also a third painting of the scene (fig. a) in the Oskar Reinhart Collection in Winterthur. The Moscow version (no. 12) shows people walking on the river banks; the Winterthur version depicts the footbridge connecting the Ile de Croissy and the little islet – which Maupassant calls 'the Flowerpot'; and the Stockholm version (no. 13) shows the little islet and the footbridge connecting it to La Grenouillère itself. There is also one other painting in the series (fig. b).

Monet did not paint the river bank, but produced two different views of the footbridge (fig. c and Wildenstein 1974, I, no. 136) and one of the island itself (fig. d). It is especially interesting to compare the latter with no. 13. Renoir adopts a closer viewpoint, which allows him to emphasize the figures, while his free brushwork rapidly sketches the young woman on the right who is crossing the footbridge leading to the main establishment and the bathers on the left, who are almost indistinguishable from the shimmering water itself. These figures appear to be an integral part of a scene which has no depth, in which there is no real transition between the water and the foliage in the background, presumably on the opposite side of the Seine. The reworking in the foreground suggests that Renoir tried to articulate it in a variety of different ways. Monet's painting, which uses a limited range of colours, is infinitely more structured: the

islet is at the centre of converging lines and the figures are carefully scaled to the landscape, as is the transition from the truncated boats in the foreground to the trees silhouetted against the sky in the background.

If we compare no. 12 (in Moscow), a modern version of Watteau's *Embarkation for the Isle of Cythera* (no. 117 fig. a) and probably the earliest of the series, with fig. a (in Winterthur) – which is so close to the Monet that it would be easy to take one for the other – the extent to which Renoir has tried to assimilate Monet's technique and spirit becomes strikingly obvious.

Neither Monet nor Renoir exhibited a painting of La Grenouillère – an eminently 'modern' subject – at the 1870 Salon. There was, however, one painting of it there: Heilbuth's *By the water's edge* (no. 1346; fig. e) was an immediate success. In the review of the Salon he published in *La Revue contemporaine* on 15 June 1870, A. Baignières wrote: 'I had heard that M. Heilbuth had decided to paint a spot near Bougival which is commonly known as La Grenouillère. It is certainly a beautiful spot, but the people who frequent it leave a lot to be desired. The men are ill-bred and the women are painted already. What could the artist do? . . . The countryside forms a charming background. But it is the figures that are the real tour de force: they are elegant, picturesque and natural. The young women are well dressed, the men are smart and the boats are painted in harmonious colours.' Both honour and painting were saved!

These two paintings probably have the same provenance, and both were once owned by the artist's brother Edmond. When he

was asked about Renoir's and Monet's paintings of La Grenouillère, Paul Durand-Ruel commented that 'Renoir also painted the subject several times. Two of his studies were in the possession of his brother, who has since sold them.' (Letter of 13 July 1903, Archives Durand-Ruel.) He added that he himself owned a third picture (the one which is now in the Reinhart Collection). The Stockholm painting was an anonymous gift to the museum in 1923; the Moscow painting was bought from Vollard by the collector Ivan Morosov in 1908.

LITERATURE (for both versions)
Meier-Graefe 1912, p. 11
Vollard 1919, p. 45
Duret 1924, pp. 80–1
Poulain 1932, pp. 160–2
Drucker 1944, pp. 27, 193 no. 12
J. Renoir 1962, pp. 200–1
Champa 1973, pp. 56–66
Rewald 1973, pp. 226, 228, 230, 232
Paris, Grand Palais, 1974, no. 35
Callen 1978, pp. 12, 40, 42–3
Isaacson, J., *Claude Monet, observation et réflexion*, Neufchâtel 1978, pp. 16, 81–2
Gaunt and Adler 1982, no. 6
Isaacson 1982, pp. 100–1
Marly-le-Roi – Louveciennes, Musée Promenade, *De Renoir à Vuillard, Marly-le-Roi, Louveciennes, leurs environs*, May–June 1984, pp. 33–7

FIG a. Renoir, *La Grenouillère*, 1869.
Oskar Reinhart Collection, 'Am Römerholz', Winterthur.

FIG b. Renoir, *La Grenouillère*, 1869.
Private Collection.

FIG c. Claude Monet, *La Grenouillère*, 1869.
Reproduced by courtesy of The Trustees of the National Gallery, London.

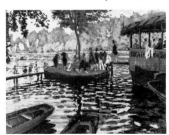

FIG d. Claude Monet, *La Grenouillère*, 1869.
The Metropolitan Museum of Art, New York.

FIG e. François Heilbuth, *By the water's edge*, engraving from *Chefs d'Oeuvre de l'art contemporain, Le Salon de 1870*, album Boetzel, Paris, 1870.

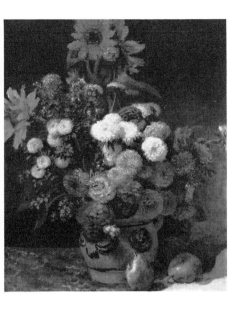

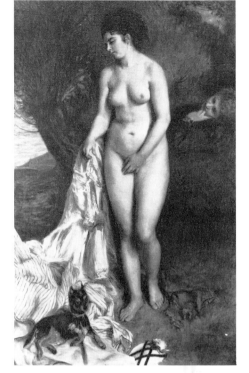

strokes make the depiction of the flowers much less precise.

Durand-Ruel acquired the painting in 1891 from a collector named Duze and sold it to J.T. Spaulding in January 1925.

LITERATURE
Meier-Graefe 1929, p. 94
Chicago, Art Institute, 1973, no. 12
Rewald 1973, p. 230
Wildenstein 1974, I, no. 139

14

Flowers in a vase

Fleurs dans un vase
c. 1869
65 × 54 cm (25½ × 21 ins)
Signed bottom right: Renoir.
Museum of Fine Arts, Boston (Bequest of John T. Spaulding, 1948), 48.592

COLOUR *p. 56*

This still life of flowers and fruit, which evokes the Ile de France in late summer, has generally been dated to the 1870s. Rewald and Wildenstein, however, argue that both this and a still life by Monet (in the J. Paul Getty Museum, Malibu) which shows the same flowers in an identical vase and the same fruit – Monet in fact added bunches of grapes and a basket of pears – were painted in 1869, when Renoir and Monet were neighbours in Bougival and consequently often worked together. This does in fact seem a plausible date for a magnificent display of technique, which shows the extent to which Renoir was freeing himself from the influence of Monet as well as from that of Courbet and Fantin-Latour. Monet moved the vase of flowers slightly away from the centre and tried to construct a pictorial space in which the plane of the table on which the vase and fruit stand plays a major role. Renoir chose a frontal presentation, with the central motif taking up almost the whole of the canvas. The very sharp contrast between the light areas and those which are left in shadow gives the whole composition an undeniable strength.

This still life is a logical sequel to the series of bouquets painted for the Le Coeur family in 1866 (cf. the example in the Fogg Art Museum, Cambridge, Mass.), but it is much freer, and the thick, spirited brush-

15

Bather with a griffon

La Baigneuse au griffon
1870
184 × 115 cm (72½ × 45 ins)
Signed and dated bottom right:
A. Renoir. 70
Museu de Arte de São Paulo,
Assis Chateaubriand

COLOUR *p. 54*

Compared with paintings like *Summer* (no. 8) and *The engaged couple* (no. 9), this *Bather with a griffon*, which Renoir chose to send to the 1870 Salon, represents a definite return to the past. The painting is an obvious tribute to Courbet and combines a 'classical' theme with realist details like the model's crumpled dress and the fashionable little dog. The influence of Courbet – the Courbet of *Women bathing* (Musée Fabre, Montpellier) and *Girls on the banks of the Seine* (Musée du Petit Palais, Paris) – is visible in the chosen figure-type. The curious relationship (or non-relationship) between the large sculptural figure (which, in 1870, the critic Marius Chaumelin saw as 'a caricature of the Medici Venus' – even though the model is certainly Lise Tréhot, cf. no. 8), the greenery in the background and the incongruous bust of a young woman, which is inexplicably placed in the middle distance, does not seem to have disturbed contemporary critics. They tended rather to criticize the yellowish tone of the flesh (Duranty, Goujon) and the inaccurate

draughtsmanship (Mézin). Although one caricature of the *Bather* was published (fig. a), it was Renoir's *Woman of Algiers* (fig. b), which caught the eye of the critics, including Arsène Houssaye, at the 1870 Salon, and they stressed its similarity to Delacroix.

The first known owner of this painting was the Dutch collector Hoogendijk. M. Henkels's study of this pioneering and nonconformist collector has yet to appear, but even so we can dismiss the legend – repeated by Gimpel – which has it that his family thought he was mad because he bought paintings by Cézanne. When Hoogendijk's collection was sold in 1912, Durand-Ruel asked Renoir for his opinion about his own works in the collection, and the artist told him not to 'get worked up about those clumsy daubs' (letter of 23 March 1912; Venturi 1939, I, p. 202). The painting was acquired by Bernheim-Jeune, who sold it to Auguste Pellerin, the owner of a famous collection of Cézannes and Manets. It was acquired by the Museu de Arte de São Paulo in 1958.

LITERATURE
Chaumelin 1870
Duranty 1870
Goujon [1870], pp. 94–5
Mézin [1870], p. 37
Amsterdam, Frederik Muller, *C. Hoogendijk Collection*, sale catalogue, 22 May 1912, no. 56
Reinach 1913, pp. 371–5
Paris, Orangerie, 1933, no. 7
Drucker 1944, pp. 29, 74, 193 no. 13
Cooper 1959, p. 168
Gimpel 1963, p. 165
Daulte 1971, no. 54
Champa 1973, p. 40
Rewald 1973, p. 240
Gaunt and Adler 1982, no. 7

EXHIBITIONS
1870, Paris, Salon (2405; *Baigneuse*)
1913, Paris, Bernheim-Jeune (4; *La Baigneuse au griffon*)

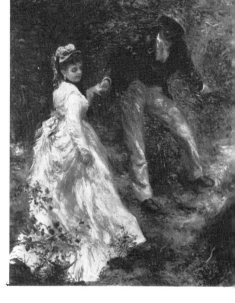

16

The promenade

La Promenade
1870
80 × 64 cm (31½ × 25 ins)
Signed and dated bottom left:
A. Renoir. 70
From a Private English Collection on loan to the National Gallery of Scotland

COLOUR *p. 57*

This painting dates from 1870 and not, as is sometimes claimed, from 1874, and in terms of subject matter it is clearly related to *The engaged couple* (no. 9). This similarity, however, underlines the fact that a major stylistic development has come about in a relatively short space of time. The figures are now successfully integrated into the landscape, while a detail like the leafy branch on the left suggest the distance between the spectator and the young woman in white – a device also used by Monet in the partial sketch for his *Déjeuner sur l'herbe* (National Gallery of Art, Washington, D.C.). The play of light and shade is uniformly controlled, and the handling of the fabrics matches the virtuoso use of a limited range of colours to render the foliage and the ground. Later, Renoir returned to the same theme in a drawing published in *La Vie moderne* on 29 December 1883 (fig. a), where the positions of the man and woman are reversed.

This painting was sold with the collection of Gustave Gouspy (or Goupy) (Hôtel Drouot, Paris, 30 March 1898, no. 33). It was bought by Durand-Ruel, who sold it to Cassirer in 1908. It then became part of the collection of B. Köhler in Berlin.

2405. LA BAIGNEUSE, par M. RENOIR.

Cette baigneuse est représentée évidemment avant le bain, et elle paraît en avoir bon besoin.
Elle est sage encore, couverte de cette crasse tutélaire qui protège la vertu. Que deviendra-t-elle après le bain? mystère!

FIG a. Caricature of *Bather with a griffon* by Bertall, '5eme promenade au Salon de 1870', *Le Journal amusant*, 18 June 1870.

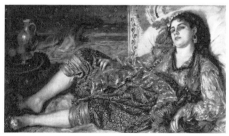

FIG b. Renoir, *Woman of Algiers*, 1870. National Gallery of Art, Washington, D.C. (Chester Dale Collection, 1962).

LITERATURE
Meier-Graefe 1912, p. 37
Jamot 1923, p. 270
Paris, Orangerie, 1933, no. 8a
New York, Duveen, 1941, no. 8
Daulte 1971, no. 55

EXHIBITIONS
1901, London, International Exhibition (93)
1904, Berlin, Cassirer (65)
1912, Frankfurt-am-Main (104)

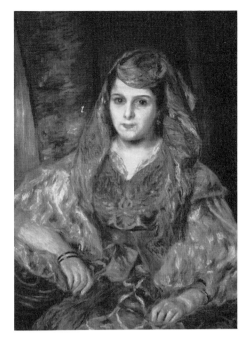

LITERATURE
Vollard 1918, I, p. 94 no. 378
Vollard 1919, p. 49
Alazard, J., 'L'Exotisme dans la peinture française au
 XIXème siècle', *Gazette des Beaux-Arts*, 1931, p. 253
London, Tate Gallery, 1953, no. 3
Gimpel 1963, p. 70
Daulte 1971, no. 47
Chicago, Art Institute, 1973, no. 8

EXHIBITION
1906, Marseille (52)

17

Madame Clémentine Stora in Algerian dress (*known as* Algerian woman)

Madame Clémentine Stora en costume algérien
(dit *L'Algérienne*)
1870
84 × 60 cm (33 × 23½ ins)
Signed and dated bottom right:
A. Renoir. 70.
The Fine Arts Museums of San Francisco
(Gift of Mr and Mrs Prentice Cobb Hale in
Honor of Thomas Carr Howe Jr), 1966.47

COLOUR *p. 53*

This is definitely a portrait of Clémentine
Valensi-Stora (1845/7 – 1917), the wife of a
Parisian dealer in carpets and antiques, and
not a genre painting like *Woman of Algiers*,
for which Lise Tréhot sat and which was
exhibited at the 1870 Salon (no. 15 fig. b), or
like the later *Parisian women in Algerian dress*
(no. 20). As those contemporary critics who
noticed *Woman of Algiers* at the 1870 Salon
noted, that painting is a testimony to Renoir's
growing admiration for Delacroix. Some-
what later, in about 1875, he made a copy of
Delacroix's *Jewish wedding* (in the Louvre)
for the collector Jean Dollfus (The Worcester
Art Museum, Worcester). Renoir's notion
of exoticism was somewhat dated: for him it
still meant North Africa and not Japan.

According to Gimpel, the painter Helleu
found the painting in the possession of the
model's family. In 1906 it was in the pos-
session of Claude Monet, who kept it until
he died.

FIG a. Renoir, Couple on a hillside,
La Vie moderne, 29 December 1883.

1871–1880

After the war, Renoir quickly got back to work (cf. no. 19) and, encouraged by his earlier successes at the Salon, decided to submit paintings to the Jury once more. He was, however, rejected in 1872 (cf. no. 20) and when in 1873 he submitted *Riding in the Bois de Boulogne* (fig. a), a very large (261 × 226 cm) painting of a lady on horseback (Mme Darras) and a young boy on a pony (Charles Le Coeur's son Joseph), and a *Portrait* (unidentified), they too were rejected and were therefore exhibited at the Salon des Refusés organized that year. In terms of both their style and their ambitions, these paintings are obviously the result of the experiments of previous years. A very definite development becomes apparent by 1873 and grows

more pronounced over the next few years: Renoir's palette becomes lighter and his brushwork is more delicate and more lively. This change probably reflects the influence of Monet, whom Renoir often visited in Argenteuil (cf. nos. 23 and 30). At the same time, Renoir remains faithful to his former subjects, painting portraits, 'scenes of modern life', which come close to being genre paintings, and landscapes.

The fact that he had been rejected by the Salon in 1873 and that he was constantly in contact with Monet, Pissarro and Sisley certainly encouraged Renoir to take an active part in the first group exhibition, which was held in the boulevard des Capucines in the spring of 1874. The participants, who were to

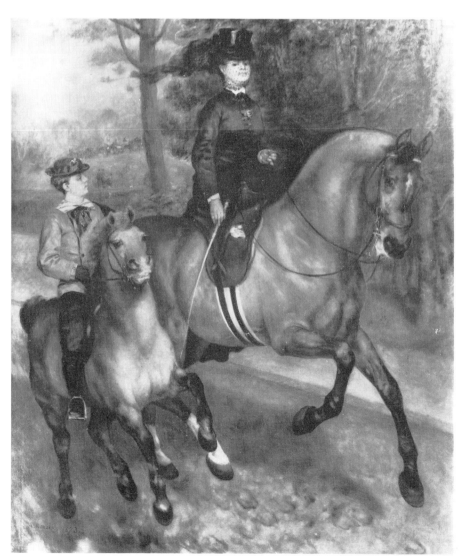

FIG a. Renoir, *Riding in the Bois de Boulogne*, 1873.
Kunsthalle, Hamburg.

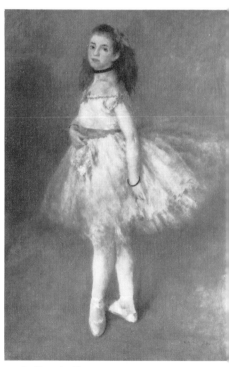

FIG b. Renoir, *Dancer*, 1874
National Gallery of Art, Washington, D.C.
(Widener Collection, 1942).

become known as 'the Impressionists' (the word derives from the title of Monet's *Impression, sunrise*), included Degas, Pissarro, Sisley, Cézanne, Berthe Morisot, Guillaumin and others, as well as Monet and Renoir. Manet, however, chose to exhibit at the official Salon. Renoir showed a considerable number of recent paintings which had not previously been seen by the public, including the *Dancer* (fig. b), *La Loge* (no. 26), *The Parisienne* (no. 28), *Harvesters* (Bührle Collection, Zurich) and three unidentified works listed as *Fleurs*, *Tête de femme* and *Croquis*. As Jacques Lethève points out, several major newspapers refrained from commenting on the exhibition, and most of the articles which did appear were by critics who had already been won over to the cause (though some of them were at times ambivalent). Renoir's paintings were particularly well received, and even *Le Charivari*'s Louis Leroy (who attributed Renoir's *Dancer* to Guillaumin) spared him his mordant irony to some extent. Leroy was the author of the famous article which tried to discredit the group and it was he who coined the term 'impressionist'. Renoir was also one of the principal organizers of the 1875 auction; an assessment of its importance will be found in the essay on Renoir's collectors (pp. 19–20).

The experiment of an independent exhibition was repeated for a second time in 1876. The catalogue lists fifteen paintings by Renoir and gives the names of some of the lenders. The animosity of the critics must have hurt these intrepid collectors (see p. 21) almost as much as it hurt the artists themselves. *Le Figaro*'s Albert Wolff, for instance, was one of the most acrimonious and decried the paintings as being, in Maillard's words, 'enough to make the cab horses rear up in fright'. Renoir again escaped relatively lightly, although his *Study* of a nude (no. 36) was criticized, as was his *Promenade* – probably the painting in the Frick Collection in New York – 'a young woman going for a walk and pushing her two daughters ahead of her' (Blémont). Arthur Baignières's description of it is less than flattering: 'From a distance it looks like a bluish mist with six blobs of chocolate standing out against it. What is it? As one comes closer, one realizes that the blobs are the eyes of three people and that the mist is a young woman and her daughters. I prefer M. Ingres's portrait of M. Bertin.' The other paintings to have been identified include those that were in the Chocquet and Dollfus collections as well as the *Portrait of a girl* (McIlhenny Collection, Philadelphia), *Woman at the piano* (no. 35) and *Frédéric Bazille* (no. 6).

Renoir showed no fewer than twenty-one recent paintings at the third group exhibition in 1877, including *Ball at the Moulin de la Galette* (no. 40), the small *Portrait of Madame G. Charpentier* (Jeu de Paume), a *Portrait of Madame Alphonse Daudet* (Jeu de Paume) and *The Seine at Champrosay* (Jeu de Paume). His portraits of *Député Spuller* (Norton Simon Foundation, Pasadena) and the actress *Jeanne Samary* (Pushkin Museum, Moscow) were widely discussed because of the personality of the models.

For Renoir, the exhibition was only a relative success. The best reviews came from critics who were already friendly, like Georges Rivière, and the apparent attempts of writers like Paul Mantz and Roger Ballu to try to understand what he was doing were simply an excuse to denounce the futility of his efforts. Renoir did not take kindly to being described as an *intransigeant* and once more tried to exhibit at the Salon. In 1878, *The cup of coffee* (Daulte 1971, no. 272) was accepted; Renoir humbly described himself again as a 'pupil of Gleyre'.

Perhaps it was because he was now more popular with both collectors (the dealer Paul Durand-Ruel, who seems to have been somewhat ambivalent in the early seventies, when he supported Manet, Monet, Pissarro, Sisley and Degas, was now buying occasional paintings from Renoir) and critics that Renoir decided not to take part in the fourth group exhibition in the spring of 1879. The fact that he also enjoyed unquestioning support from the publisher Georges Charpentier and his wife, whose *salon* was extremely influential, must also have been a contributory factor. In any case, he exhibited two large paintings at the official Salon in 1879: the *Portrait of Madame Charpentier and her children* (no. 44) and a full-length *Portrait of Mlle Jeanne Samary* (fig. c). His strategy paid off, and Renoir at last achieved true fame, at least within a limited circle of critics and patrons; outside that circle, his reputation was still not assured.

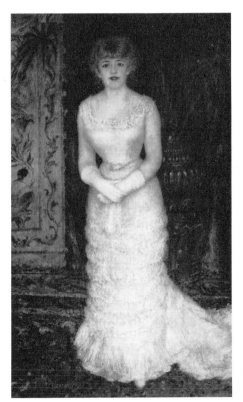

FIG c. Renoir, *Portrait of Mlle Jeanne Samary*, 1878. State Hermitage Museum, Leningrad.

18

Still life with bouquet

Nature-morte au bouquet
1871
74 × 59 cm (29½ × 23 ins)
Signed and dated bottom right:
A. Renoir. 71.
The Museum of Fine Arts, Houston
(Robert Lee Blaffer Memorial Collection,
Gift of Mrs Sarah Campbell Blaffer), 57–1

COLOUR *p. 58*

Fantin-Latour's *Studio in the Batignolles* (repr. p. 296), which was exhibited at the 1870 Salon, is an explicit tribute to Edouard Manet, who is shown surrounded by a group of friends, including Renoir. A year later, Renoir painted this still life, in which, as S. Lane Faison Jr has recently shown, every object contains a reference to Manet. The most obvious is the sepia-toned print hanging from a red cord painted in trompe l'oeil fashion; this is a proof of a print entitled *The little cavaliers* and signed 'Ed. Manet, after Velasquez', an etched interpretation of a copy Manet made in oils of a painting in the Louvre which was at the time attributed to Velasquez. Manet appears to have attached great importance to this etching; he exhibited it for the first time at the 1863 Salon des Refusés, then in his 1867 exhibition, and finally at the 1869 Salon (cf. Paris, Grand Palais, 1983, no. 37). By choosing to paint that particular print, Renoir is paying tribute both to Manet and to Velasquez, whom he too admired. Faison points out the resemblance between the bouquet of red and white roses, which are surrounded with lilac and tightly wrapped in dazzlingly white paper, and the bouquet in Manet's *Olympia*. The group of objects on the right – two books, a

Japanese fan and a feathery plume of grass in what seems to be a small Chinese vase – echoes the quill in the inkwell and the Japanese print in Manet's *Portrait of Zola* (fig. a). Indeed, the very composition of the still life is reminiscent of that of *Portrait of Zola*, which shows a pedestal table strewn with objects and prints hanging on the wall. Although Renoir adopts a device dear to both Manet and Degas by cropping the left-hand edge of the engraving, he does maintain a certain feeling of depth (the shadows thrown by the frame and the bouquet help to sustain the illusion), whereas Manet places the elements of his composition in a single vertical plane. Technically, Renoir maintains his delicacy of touch (notably in his handling of the plants and the fringed edge of the cloth on the table), and this too brings out the difference in the temperament of the two artists.

Renoir liked bouquets of very tight rosebuds; one such bouquet appears in *Dans la Loge* (1880; no. 51), and there is a painting of another in the Walter-Guillaume Collection (Musée de l'Orangerie, Paris). The presence of a fairly ordinary Japanese fan is a discreet reference to the fashion for things Japanese, which had been popular with artists and collectors for some years. Renoir appears to have been less interested in the aesthetic solutions suggested by the Far East than his friends, and in his paintings Japanese curios are never more than accessories in the hands of a Parisian *coquette* (cf. *Camille Monet reading* and *Woman with a fan*, both in the Clark Art Institute, Williamstown).

The early provenance of this painting is unknown. On 10 March 1906, however, Ambroise Vollard invoiced the Prince de Wagram for 'a Renoir still life with a carpet, books, a Japanese vase, a fan and flowers in the foreground, and a reproduction of an antique painting on the wall in the background. 8000 francs' (Archives Nationales 173 bis AP 430). The painting was presumably recovered by Vollard shortly afterwards, with others for which he had not been paid.

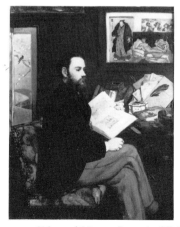

FIG a. Edouard Manet, *Portrait of Zola*, 1868. Musée d'Orsay, Paris (Galerie du Jeu de Paume).

LITERATURE
Vollard 1918, I, p. 122 no. 487
Chicago, Art Institute, 1973, no. 9
Faison 1973, pp. 571–8
Callen 1978, p. 47

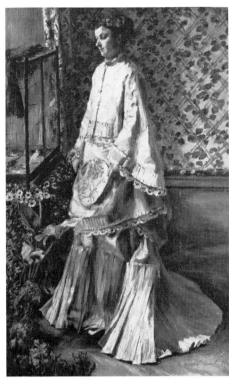

light-toned painting is much more intimate than many of the figures Renoir painted at this time, and it has a frankness which is rarely found in contemporary paintings.

Durand-Ruel acquired the painting from a certain 'Madame Maître' on 11 October 1898, but there is no evidence that Edmond ever married. In 1909, he sold it to Poznansky, a Russian collector who was then living in Paris. It later belonged to Auguste Pellerin.

LITERATURE
Meier-Graefe 1912, p. 35
Duret 1924, p. 52
Drucker 1944, pp. 33, 194–5 no. 16
Cooper 1959, pp. 163, 168
Daulte 1971, no. 66
Daulte, F., 'Une grande amitié, Edmond Maître et Frédéric Bazille', *L'Oeil*, April 1978, p. 40

EXHIBITIONS
1900, Berlin, Secession (244)
1906, Basel (517)

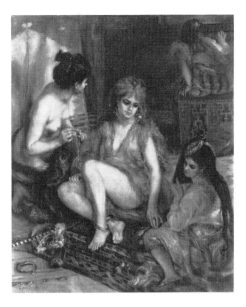

20

Parisian women in Algerian dress

Parisiennes habillées en algériennes
1872
156×129 cm ($61\frac{1}{2} \times 50\frac{1}{2}$ ins)
Signed and dated bottom left:
A. Renoir. 1872.
The National Museum of Western Art, Tokyo, P. 1959–182

COLOUR *p. 55*

Exhibited in London and Paris only

19

Portrait of Rapha

Portrait de Rapha
1871
130×83 cm (51×32 ins)
Signed and dated bottom right:
A. Renoir. avril. 71.
Private Collection

COLOUR *p. 59*

This figure in an interior is generally believed to be a portrait of Edmond Maître's mistress Rapha. Maître was a close friend of Bazille's and later became Jacques-Emile Blanche's mentor. He was a minor official who worked for the City of Paris, spent his leisure time playing music and reading, and enjoyed the company of painters. Maître remained in Paris during the siege of the city, and it was probably in his apartment in the rue Taranne, near Saint-Germain-des-Prés, that this portrait was painted in April 1871, in other words during the early days of the Commune.

This elegant image of a young woman in an elaborate dress and holding a Japanese fan in a modern interior – the trellis pattern on the wallpaper is similar to that in an earlier still life (no. 3) – is specifically contemporary; but the inclusion of the caged birds suggests that Renoir wanted to paint a genre scene without the mawkishness such a subject might suggest and was returning to a theme popular in the eighteenth century, a period which he greatly admired.

Although it is somewhat anecdotal, this

This large composition is dated 1872 and was, according to Duret, rejected by the Salon. It marks an obvious return to a theme Renoir had already dealt with in his *Woman of Algiers* (no. 15 fig. b), which had been quite well received when exhibited at the 1870 Salon. It is in fact a free transposition of Delacroix's *Women of Algiers* (fig. a), a painting which he admired greatly; much later, when he visited the Louvre with Berthe Morisot's daughter Julie Manet in 1897, he stood in front of it for a long time and then said, 'When you've done something like that you can sleep peacefully at night.' (Manet 1979, p. 143.) Renoir makes no attempt to conceal the artificiality of his painting; the women are models posing in a studio and the reference to Delacroix is there for all to see. As Cooper suggests, one of the models is surely Lise Tréhot (cf. no. 8), and this would have been one of the last works for which she posed before leaving Renoir to marry the architect Georges Brière de l'Isle in April 1872. Meier-Graefe, who takes a harsh view of this painting, sees it as torn between the influence of Courbet and that of Delacroix. Although he exploits the sumptuous effects of the embroidered muslin, the velvet and the brightly coloured rugs (as in *Portrait of Madame Stora*, no. 17) Renoir

seems to have deliberately tried to restrict the range of colours; the flesh tones are restrained and the grey and beige tones of the background and the floor help to subdue the whole painting. As in *Riding in the Bois de Boulogne* (p. 196 fig. a), which was submitted to the 1873 Salon but rejected, the daring diagonal positioning of the figures appears to be the result of earlier experiments.

Parisian women in Algerian dress is basically a Salon painting. As A. Callen wittily points out, Renoir – the *refusé* – has finally come very close to Régnault's *Salomé*, which was one of the highlights of the 1870 Salon and one of the last works of a young artist who was very popular both with the critics and the public, and who, like Bazille, was to be killed during the Franco-Prussian War.

By taking his inspiration from Delacroix's orientalism, Renoir seems to be deliberately ignoring the more recent fashion for things Japanese. It is ironic, then, that the painting, which once belonged to the famous pastry-cook Murer (see p. 22), should have been acquired by Kogiro Matsukata in 1921; he was one of the first Japanese collectors to take an interest in Western painting.

Although Paul Signac greatly admired Renoir, knew him personally and owned several paintings by him, he took a strong dislike to this painting when he saw it in Camentron's gallery in the rue Laffitte in January 1898: '*Femmes d'Alger à leur toilette*, a Renoir painted in 1872 and obviously influenced by Delacroix's painting. It is something of a mixture; some parts are completely botched, but others are quite pretty. All the somewhat nervous charm of Renoir's women is there already. You can tell he likes buttocks and breasts and the sight of flesh glimpsed through gauze. A brothel scene rather than a harem scene – you can already sense that there is one thing Renoir will never have – a sense of balance.' There is in fact nothing surprising about Signac's comments; he himself wanted to achieve a mathematical discipline and made no secret of his disappointment on hearing that Renoir loathed Seurat's *Models* (Barnes Foundation, Merion), which he himself admired greatly.

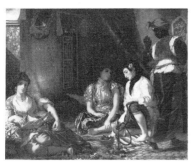

FIG a. Eugène Delacroix, *Women of Algiers*, 1834. Musée du Louvre, Paris.

LITERATURE
Duret 1906, pp. 131–2
Meier-Graefe 1912, pp. 21–4
Vollard 1918, I, p. 94 no. 376
Rivière 1921, p. 13
Jamot 1923, pp. 264–5
Duret 1924, pp. 25, 33
Vollard 1938, pp. 166–7
Drucker 1944, pp. 36, 195 no. 20
Rewald 1952, p. 275
Gachet 1956, pp. 171–2
Cooper 1959, pp. 168–9
Daulte 1971, no. 84
Rewald 1973, p. 272
Callen 1978, no. 17
Pickvance 1980, p. 159

EXHIBITIONS
1913, Paris, Bernheim-Jeune (5)
1914, London, Grosvenor House (7)

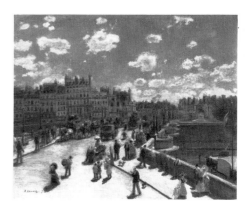

21

The Pont Neuf

Le Pont-Neuf
1872
75 × 94 cm (29½ × 37 ins)
Signed and dated bottom left:
A. Renoir. 72.
National Gallery of Art, Washington, D.C.
(Ailsa Mellon Bruce Collection, 1970),
2430

COLOUR *p. 61*

Renoir completed this view of the Pont Neuf in 1872, but it was not the first time he had chosen to paint a well-known view of Paris. He had already painted a view of the *Pont des Arts* in 1867 (p. 181 fig. j), and both *Skaters in the Bois de Boulogne* (1868; no. 7) and *The Champs Elysées during the 1867 Exposition Universelle* (New York, Wildenstein, 1974, no. 3) can be regarded as belonging to the same series of urban views. Renoir's choice of subject was probably directly influenced by Monet, who painted several views of Saint-Germain l'Auxerrois, the Quai du Louvre and the Jardin de l'Infante from a window in the Louvre colonnade in the spring of 1867. Similar subjects were also popular with many other artists – notably Jongkind and Lépine – and magazine illustrators.

Renoir is on the right bank and looking down over the Pont Neuf, which is one of the oldest bridges in Paris and which spans both arms of the Seine. The buildings on the quai de l'Horloge to the left have changed much less since Renoir's day than those on either side of the rue Dauphine in the background. To the right we see the statue of Henri IV on its plinth and, below the quai, one of the many bathing establishments of the period.

When John Rewald asked him about this painting, Renoir's brother Edmond told him: 'We had established our quarters at the entresol of a little café at a corner of the quai du Louvre, but much nearer the Seine than are the present buildings. For our two coffees, at ten centimes each, we could stay at that café for hours. From here Auguste dominated

the bridge and took pleasure, after having outlined the soil, the parapets, the houses in the distance, the place Dauphine and the statue of Henri IV, in sketching the passers-by, vehicles and groups. Meanwhile I scribbled [Edmond was a journalist] except when he asked me to go on the bridge and speak with the passers-by, to make them stop for a minute by asking them the time and so on.' Even if we did not have this eye-witness account, the vivacity of Renoir's notations would still suggest direct obser-vation. He was sufficiently interested in his contemporaries to take them as a subject, but by choosing a relatively large format he clearly demonstrated that he wanted to pro-duce a painting and not merely a study, and it is in that that his attitude is so innovatory. Monet also painted the Pont Neuf at this time, but he depicted it in the rain and from a slightly different angle (Wildenstein 1974, I, no. 193). After 1900, Pissarro also painted the bridge, but from the other side of the river. The short grey shadows emphasize the light harmony of the dominant blues and golds.

This is in all probability the *Pont-Neuf* which, according to the *procès-verbal* for the sale, was bought by Durand-Ruel at the auction at the Hôtel Drouot on 24 March 1875 (see p. 27 n.6). He paid 300 francs for it. Durand-Ruel was probably acting on behalf of someone else, as there is no record of the transaction in his account books, and a num-ber of witnesses claim that Hazard bought it in 1875. Hazard's collection was auctioned a few days before Renoir's death on 1, 2 and 3 December 1919, and the painting was sold for what was then a record price of over 100,000 francs – a sharp contrast with the ridiculous price it made with such difficulty in 1875.

LITERATURE
Duret 1924, p.102
Vollard 1938, p.183
Rewald 1945, p.181
Gimpel 1963, pp.139, 141
Bodelsen 1968, p.335
Rewald 1973, pp.280–1, 285, 354
Callen 1978, p.47
Stuckey, C.F., 'What's Wrong with this Picture?'
 Art in America, September 1981, p.98
Washington, D.C., National Gallery of Art,
 Manet and Modern Paris, December 1982 – March
 1983, no.5

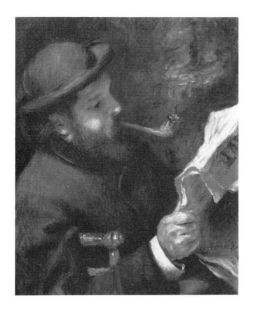

22

Claude Monet reading

Claude Monet lisant
1872
61 × 50 cm (24 × 19½ ins)
Signed bottom right: A. Renoir.
Musée Marmottan, Paris

COLOUR *p.60*

Monet and Renoir met in Gleyre's studio, and their friendship and mutual respect were to be lifelong, with Monet outliving Renoir by a few years. The portrait of *Monet reading* was painted in about 1872, after Monet had moved to Argenteuil, and it has a companion piece, *Camille Monet reading* (also in the Musée Marmottan), a portrait of the artist's wife. In this intimate portrait of a friend in a typical pose Renoir shows all his ability for free expression. The brushwork is clearly visible, and the intense colours and touches like the orange in the model's beard and the blue smoke rising from his pipe were the elements which did most to antagonize the critics. Another portrait of Monet, painted in 1875 (and owned by Dollfus), was shown at the second impressionist group exhibition in 1876 – probably the version now in the Jeu de Paume (repr. p.298). That shows Monet as a painter, palette in hand, and makes an obvious concession to tradition. Although the model's name is masked by the initials 'M.M.', a few friendly critics did recognize him and also praised the painting.

This work was kept by Monet and given to the Musée Marmottan by his son in 1966.

LITERATURE
Daulte 1971, no.85
Paris, Musée Marmottan, *Monet et ses amis*, 1971,
 no.98
Gaunt and Adler 1982, no.10

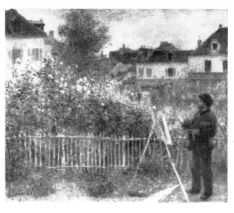

23

Monet painting in his garden at Argenteuil

Monet peignant dans son jardin à Argenteuil
1873
46 × 60 cm (18 × 23½ ins)
Signed bottom left: A. Renoir
Wadsworth Atheneum, Hartford
(Bequest of Anne Parrish Titzell, 1957)

COLOUR *p.64*

This painting dates from 1873, and it does more to evoke the friendship that existed between Renoir and Monet than any com-mentary could possibly do. It also shows that in the early seventies they were work-ing along very similar lines. Renoir portrays Monet painting a hedge of multicoloured dahlias in the open air, probably in his garden at Argenteuil. The canvas Monet is painting is dated 1873 (Wildenstein 1974, I, no. 286). It seems, then, that Renoir left his studio and painted this familiar scene from life. Although the features of the model have not been painted in any detail, Monet is im-mediately recognizable with his familiar round hat which also appears in the portrait of *Monet reading* (no. 22) and that of *Monet painting* (in the Jeu de Paume). The painting gives us a clear idea of how Monet worked, using light equipment which could easily be transported. In contrast with the other land-scapes he painted at this time (e.g., nos. 24, 25), Renoir here adopts a fairly strict com-positional organization; presumably it was inspired by the subject-matter itself. The background, with the greyish-blue roofs of the houses standing out against the opaque sky, brings out the exuberant profusion of the dahlias, which are growing over the fence. The fence itself makes it seem that the painter is standing on a stage. The overall oblique line of the painting follows that of the top of the hedge and leads the eye to the figure of Monet at his easel. The complex texture of the painting shows how Renoir uses an accumulation of small, nervous brushstrokes to give the surface a scintil-

lating pictorial richness. Canvases like this are very close to the style of Monet and Pissarro.

The painting was acquired by Durand-Ruel for 800 francs at a public auction (Hôtel Drouot, Paris, 17 April 1896, no. 87) for Decap, the brother-in-law of F. Depeaux. It reappeared at an anonymous sale (in fact of part of the collection of the famous dramatist Georges Feydeau) on 14 June 1902 (no. 17), where Durand-Ruel again bought it, for 4,700 francs.

LITERATURE
Vollard 1918, I, p. 88 no. 351
Vollard 1919, p. 307
Daulte 1971, no. 131
Chicago, Art Institute, 1973, no. 17
Rewald 1973, pp. 284–5 (Rewald also reproduces
 Monet's painting)
Callen 1978, p. 57

EXHIBITIONS
1905, London, Grafton Galleries (258)
1910, Paris, Durand-Ruel (36)
1912 (June), Paris, Durand-Ruel (*Portraits*) (29)

24

Spring at Chatou

Printemps à Chatou
c. 1872–5
59 × 74 cm (23 × 29 ins)
Signed bottom right: Renoir.
Private Collection

COLOUR *p. 63*

Exhibited in London only

This painting, which must have been executed between 1872 and 1875, is a perfect example of impressionist research. Renoir takes as his subject an expanse of grass which has no structure in itself and subtly punctuates it by sketching in the supple lines of the tree trunks and by introducing a deliberately oblique and indistinct horizon. A small human figure painted in grey, white and yellow is sufficient to balance the whole composition. He also uses a system of very small brushstrokes which appear to have been rubbed into the canvas and a multitude of multicoloured strokes painted with a very full brush to suggest the white, purple and pink flowers in the foreground. The leaves of the trees are painted with irregular strokes, enlivening the upper part of the canvas.

The painting was included in the inventory of Durand-Ruel's stock in 1891 and was sold to Cassirer on 13 June 1910.

LITERATURE
Cooper 1954, p. 110 no. 53
London, Royal Academy, 1974, no. 97

25

High wind
(*known as* The gust of wind)

*Grand vent (*dit *Le Coup de vent)*
c. 1872
52 × 82 cm (28½ × 32 ins)
Signed bottom right: A. Renoir.
The Syndics of the Fitzwilliam Museum,
Cambridge, 2403

COLOUR *p. 62*

Exhibited in Paris and Boston only

Renoir did not often use the elongated format which is so well suited to the subject chosen here – an ordinary landscape, from the Ile de France, seen under a cloudy sky with a high wind blurring the outlines of the vegetation. There is no figure to distract the spectator's attention from the central theme: the impression of wind. Renoir uses a wide variety of effects, alternating between a full brush and very thinly brushed strokes which leave the prepared canvas visible.

This is definitely the *Grand vent* which Renoir included in the auction held on 24 March 1875 (see pp. 19–20), together with a number of his other works and paintings by his friends. The auction allowed Renoir to show the public a painting which, like the *Harvesters* which had caused such a scandal at the 1874 group exhibition, was far removed from the classical notion of the 'finished' painting.

This painting was bought at the auction by the painter Auguste de Molins for 55 francs. His family sold it to Durand-Ruel in 1899. Alphonse Kann, a great Cézanne enthusiast, bought it from the dealer in 1908. (For its later provenance see the 1960 Fitzwilliam Museum Catalogue.)

LITERATURE
Bodelsen 1968, p. 335
Cambridge, The Fitzwilliam Museum,
 Catalogue of Paintings, 1960, I, p. 192, no. 2403
London, Royal Academy, 1974, no. 95
Callen 1978, p. 50

EXHIBITION
1917, Zurich (165)

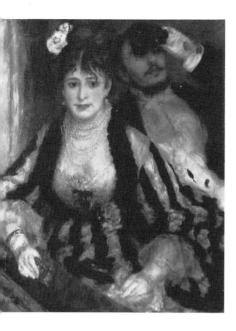

26

The theatre box
(known as La Loge)

La Loge
1874
80 × 63 cm (31½ × 25 ins)
Signed and dated bottom left:
A. Renoir. 74.
Courtauld Institute Galleries, London
(Samuel Courtauld Collection), H.H. 210

COLOUR p. 66
Exhibited in London only

This painting, which has become one of the symbols of Impressionism, was shown at the first group exhibition in April 1874. According to Meier-Graefe, the sitters were the artist's brother Edmond and a model known as Nini or 'Gueule-de-Raie' [literally, 'fish-face'], though her ugly nickname seems singularly ill-suited to the charming figure we see in the La Loge (which was also known as L'Avant-scène). It was Renoir's first treatment of a theme he returned to a number of times during his career. The subject immediately reminds one of Degas, but it should not be forgotten that the theatre, which was a very important part of life in Renoir's time, was a common source of inspiration for painters. Daumier, for instance, drew several 'theatre boxes' and all the artists in the impressionist group were drawn to this typically 'modern' subject. The critics who reviewed the 1874 exhibition dwelt on this painting at length and stressed its novelty. Prouvaire saw the woman as a typical cocotte, 'one of those women with pearly white cheeks and the light of some banal passion in their eyes . . . attractive, worthless, delicious and stupid'. Montifaud, however, thought she

was 'a figure from the world of elegance'. Their views are not, of course, necessarily contradictory. The obvious pleasure the painting gave them did not, however, make them overlook its purely pictorial qualities; on the contrary, Burty, Chesneau and especially Montifaud all praised them. It is noteworthy that none of the critics who reviewed the exhibition unfavourably attacked La Loge directly.

The painting has lost none of its charm: the young woman lets herself be admired, whilst her companion has his head raised and is probably watching the people in neighbouring boxes rather than what is happening on the stage. The anecdotal interest of the painting is, however, less important than its pictorial qualities. Until now, Renoir's flesh tones had tended to be somewhat dull, but here the contrast with the rendering of the dress and the flowers gives them more colour. Every brushstroke picks out a detail, but everything is subordinated to the overall effect. Late in life Renoir told Albert André that he liked his paintings to be 'filled to bursting point', both at the superficial level and in depth, and Paul Jamot is perfectly right to apply the artist's remarks to La Loge, which he describes as 'Renoir's finest masterpiece, one of those rare paintings in which everything is a source of delight, in which everything is novel, surprising and unexpected. At the same time everything in it cries out to be compared with the greatest masters of the art of painting.'

There is also a smaller (27 × 22 cm) version of the painting (Daulte 1971, no. 115), with the small strokes perfectly adapted to the smaller format. It is probably a copy made for sale (it was bought at the 1875 auction by Jean Dollfus, cf. p. 20) rather than a study, just as the smaller version of Ball at the Moulin de La Galette, now in the Hay Whitney collection (cf. no. 40), is probably a copy made for a collector.

Durand-Ruel exhibited La Loge in London and returned it to the artist on 12 March 1875. Renoir told Vollard that it was sold to the famous Père Martin, a minor dealer in Paris who 'followed' all the Impressionists, for 425 francs. It was later acquired by Louis Flornoy (see p. 23), a collector from Nantes, but we do not know just when he bought it. He lent both La Loge and End of the luncheon (now in Frankfurt) for the 'Exposition des Beaux-Arts' which was held in Nantes in 1886. In February 1899, Louis Flornoy sold these two Renoirs, a Bather by the same artist and several Jongkinds to Durand-Ruel. The dealer paid 7,500 francs for La Loge.

La Loge became the jewel in Paul Durand-Ruel's personal collection. In 1925 it was sold to Percy Moore Turner, who immediately resold it to Samuel Courtauld.

LITERATURE
Burty 1874
Castagnary 1874
Chesneau 1874
Hervilly 1874
Montifaud 1874, p. 208
Malte, C. de [Villiers de l'Isle Adam?],
 'Exposition de la Société anonyme . . .', 1874, in
 Thomson, R., 'A Neglected Review of The First
 Impressionist Exhibition', Gazette des Beaux-Arts,
 September 1982, p. 91
Meier-Graefe 1912, pp. 44–5, 56
Vollard 1918, I, p. 82 no. 325
Vollard 1919, pp. 63–4, 185
Rivière 1921, pp. 16, 18, 20
Jamot 1923, pp. 265–9
Duret 1924, p. 42
Paris, Orangerie, 1933, p. xxiv and no. 17
Barnes and de Mazia 1935, pp. 237, 385–8 no. 34
Drucker 1944, pp. 36–7, 194 no. 15
Cooper 1954, pp. 108–9 no. 51
Rewald 1973, pp. 316–334
Lévy, L., 'Daumier, le japonisme et la nouvelle
 peinture', Gazette des Beaux-Arts, March 1984,
 p. 104
Callen 1978, p. 54
Gaunt and Adler 1982, no. 16

EXHIBITIONS
1874, Paris, Première exposition (142; La loge)
1874, London, Society of French Artists (12; At
 the theatre)
1886, Nantes (893; La loge, owned by
 M. Louis Flornoy)
1892, Paris, Durand-Ruel (63; La loge, owned by
 M. Fleurnois [sic])
1899, Paris, Durand-Ruel (74; La loge 1874)
1900, Paris, Centennale (562; La loge, owned by
 Mme A.F. Aude)
1903, Budapest (42)
1904, Brussels (128)
1905, London, Grafton Galleries (251; At the Theatre
 – In the Box 1874)

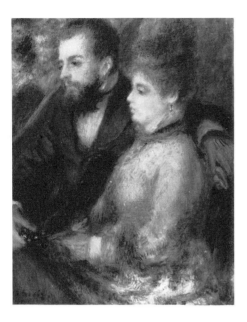

27

Box at the theatre

Dans la loge
*c.*1874
27 × 22 cm (10½ × 8½ ins)
Signed bottom left: Renoir.
Durand-Ruel, Paris

COLOUR *p. 65*

This delightful little painting is a reminder of Renoir's liking for working in a small format. If we compare this painting with its contemporary, the Courtauld Institute's *La Loge* (no. 26), we can see how Renoir adapts his technique to the chosen format. Here, he uses small, nervous strokes. Although the painting belonged to Edouard Lainé (1848–88), who was a friend of Rouart, Degas, Jeantaud and Lepic and the director of a major brass foundry which specialized in taps, he did not sit for it. The man depicted bears no resemblance to Lainé, whom Degas included in a portrait of his friends *Jeantaud, Linet and Lainé* (in the Jeu de Paume).

LITERATURE
Daulte 1971, no. 92

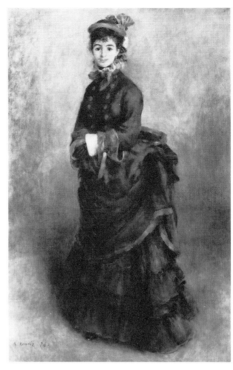

28

The Parisienne

La Parisienne
1874
160 × 106 cm (63 × 41½ ins)
Signed and dated bottom left:
A. Renoir. 74.
National Museum of Wales, Cardiff

COLOUR *p. 67*

Exhibited in London only

On 16 February 1898, the painter Paul Signac wrote in his diary: 'Vuillard was kind enough to take me to see the Rouart Collection. . . . I saw so much that I came out with my head spinning. The things I remember best are a sketch by Delacroix . . . and a large portrait of a woman in blue painted by Renoir in 1874. The dress is blue, a pure, intense blue. The contrast makes the woman's skin look yellowish and the reflection makes it look green. The interaction between the colours is captured admirably. It is simple, fresh and beautiful. It was painted twenty years ago, but you would think it had come straight from the studio.' Twenty years earlier – in the spring of 1874 – the painting had been shown at the first exhibition held by the group of painters who were about to become known as the 'Impressionists'. Most of the critics who were at least trying to understand which way the new painting was developing simply mentioned it in passing, as did Montifaud, Burty, Lora and Chesneau (who thought it a 'failure'). *Le Rappel*'s Jean Prouvaire, however, liked Renoir and

interpreted his *Dancer* (p. 196 fig. b), *The Parisienne* and *La Loge* (no. 26) as images of 'the three stages that the young women of Paris often go through', from adolescent to *cocotte*. He admitted that the artist probably had no intention of painting a sequence of 'stages', but he could not stop himself thinking of the plot of a novel: 'The toe of her ankle boot is almost invisible, and peeps out like a little black mouse. Her hat is tilted over one ear and is daringly coquettish. Her dress does not reveal enough of her body. There is nothing more annoying than locked doors. Is the painting a portrait? It is to be feared so. The smile is false, and the face is a strange mixture of the old and the childish. But there is still something naïve about her. One gets the impression that this little lady is trying hard to look chaste. The dress, which is extremely well painted, is a heavenly blue.'

The sitter was probably Madame Henriot, a young actress whom Renoir often used as a model at this time, but by calling his painting 'Parisienne', Renoir turns her into a type. Her modern dress, with its pleats and ruffles, lent itself well to a display of the painter's talents, and the resultant image has all the detail of a contemporary fashion plate.

Henri Rouart, who was the first owner of this painting, was one of the first important collectors to buy Renoir's works (see p. 20). When his collection was sold in 1912, *The Parisienne* was jointly purchased by Knoedler and Durand-Ruel, who sold his share in it to Knoedler on 6 June 1913. It was bequeathed to the National Museum of Wales by Miss Gwendoline E. Davies in 1952.

LITERATURE
Burty 1874
Chesneau 1874
Lora 1874
Montifaud 1874, p. 308
Prouvaire 1874
Alexandre 1892, p. 16
Paris, Galerie Manzi-Joyant, *Vente Henri Rouart*, sale catalogue, 9–11 December 1912, no. 268
Rewald 1952, p. 276
Ingamells, J., *The Davies Collection of French Art*, Cardiff 1967, pp. 69–71
Daulte 1971, no. 102
Chicago, Art Institute, 1973, no. 14
Callen 1978, p. 53
Gaunt and Adler 1982, no. 14

EXHIBITIONS
1874, Paris, Première exposition (143; *Parisienne*)
1892, Paris, Durand-Ruel (106; *La dame en bleu*, owned by M. Rouart)

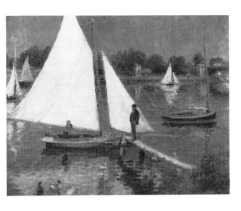

29

The Seine at Argenteuil

La Seine à Argenteuil
1874
51 × 65 cm (20 × 25½ ins)
Signed bottom right: Renoir.
Portland (Oregon) Art Museum
(Bequest of Winslow B. Ayer), 35.26

COLOUR *p. 68*

As we have already seen, Monet and Renoir worked side by side at La Grenouillère in 1869 (nos. 12, 13) and once painted the same still life (cf. no. 14). In 1874 they once more painted almost identical views of the Seine at Argenteuil (cf. fig. a). There are a number of minor differences between their paintings, but both artists approached the idea of painting a procession of yachts and rowing boats on the Seine in the same spirit. They set up their easels on the Petit-Gennevilliers side of the river, near the Pont d'Argenteuil; one arch of the bridge and the toll house on the Argenteuil bank can be seen on the extreme right. Renoir appears to have been influenced by Monet rather than vice versa, and the brushstrokes which render the coloured reflections on the water are more fragmented than usual. However, the greater fluidity of his style gives a more shimmering quality to some of the shadows (especially the shadow of the pontoon in the foreground), whereas Monet uses more sharply contrasting effects. When this painting was executed, Monet was living in Argenteuil, and Renoir often went there to paint with him (cf. no. 23). In

1873, they had painted almost identical views of a *Duck pond*; Monet's version is in a private collection in Paris and the Renoir was formerly in the collection of Emery Reves.

This painting appeared in the 1891 inventory of Durand-Ruel's stock. It was acquired from him by Winslow B. Ayer in November 1926.

LITERATURE
Rewald 1973, p. 352
Callen 1978, p. 48

EXHIBITION
1908 (May–June), Paris, Durand-Ruel (*Paysages*)

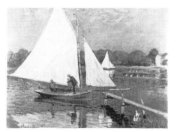

FIG a. Claude Monet, *Oarsmen at Argenteuil*, 1874. Private Collection.

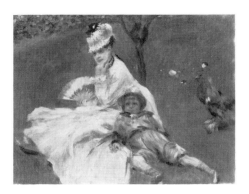

30

Camille Monet and her son Jean in the garden at Argenteuil

Camille Monet et son fils Jean dans le jardin à Argenteuil
1874
51 × 68 cm (20 × 26½ ins)
Unsigned
National Gallery of Art, Washington, D.C.
(Ailsa Mellon Bruce Collection, 1970), 2432

COLOUR *p. 70*

Late in life, Claude Monet told Marc Elder the story behind this painting: 'This delightful painting by Renoir, which I am so pleased to own, is a portrait of my first wife. It was painted in our garden at Argenteuil when Manet, enchanted by the colour and the light, had decided to do an open-air painting of people underneath the trees. While he was working, Renoir arrived. The charm of the hour appealed to him too, and he asked me for a palette, a brush and a canvas, and there he was painting side by side with Manet. Manet watched him out of the corner of his eye and went over to look at his canvas from time to time. He would grimace, slip over to me, point at Renoir and whisper in my ear, "That boy has no talent. You're his friend, tell him to give up painting!". . . Isn't that funny, coming from Manet?' Vollard and later writers all tell the same story, which reminds us that Manet also painted Camille Monet and her son Jean (who was born in 1867) in the summer of 1874. The pose is identical and the angle almost the same, but

FIG a. Edouard Manet, *The Monet family in the garden*, 1874.
The Metropolitan Museum of Art, New York.

the format of the painting is larger, and Monet can be seen gardening on the left (fig. a). Whether or not the story about Manet's jibe is entirely accurate (Tabarant, for instance, refuses to believe it), it may contain a grain of truth. At the time when Renoir and Manet painted their twin portraits of Camille and Jean, Manet owned Renoir's portrait of Bazille (no. 6), painted some seven years earlier. Renoir himself tells us that when Manet looked at his more recent work, he said, 'No, it is not as good as the portrait of Bazille.' It would seem, then, that he had reservations about Renoir's new style, although at the time he was painting at Argenteuil he was more open than usual to the influence of his younger friends and, indeed, was systematically experimenting with *plein air* painting. There is, however, no sign of Renoir's lively spontaneity in Manet's more sedate painting. Renoir was rarely so successful at capturing an ephemeral scene with a few brushstrokes. The casual handling of the background and the unrealistically slender tree trunk under which Camille is sitting merely enhances the virtuoso treatment of the figures. The whole painting prefigures the use of space in Bonnard's gardens. Camille's features are familiar from other paintings, as she often posed for both Renoir and Monet. Here, Renoir individualizes her face with a few deft strokes, whereas Manet's portrayal of her is much more allusive.

LITERATURE
Vollard 1919, pp. 52, 67
Elder, M., *Chez Claude Monet à Giverny*, Paris 1924,
 p. 70
Paris, Orangerie, 1933, no. 20
Tabarant, A., *Manet et ses oeuvres*, Paris 1947,
 pp. 252–7
Gimpel 1963, p. 155
Daulte 1971, no. 104
Rewald 1973, pp. 341–2
Gaunt and Adler 1982, no. 17
Paris, Grand Palais, 1983, no. 141

EXHIBITION
1913, Paris, Bernheim-Jeune (6)

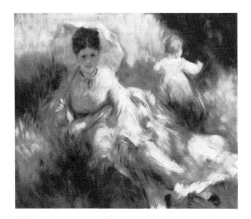

31

Woman with a parasol

Femme à l'ombrelle
c. 1874–6
47 × 56 cm (18½ × 22 ins)
Signed bottom left: Renoir.
Museum of Fine Arts, Boston (Bequest of John T. Spaulding, 1948), 48.593

COLOUR p. 71

The subject of this rapidly sketched little painting – a young woman half lying on the grass and a blonde child who appears to be trying to run away – was one of Renoir's favourites, and it has an immediate and lasting charm. It is sometimes said that the young woman is Camille Monet.

It is painted with long, silkily undulating strokes and reveals the variety of techniques used by Renoir. The virtuoso execution and details like the bluish shadows on the white dress and the little black shoes which peep out from underneath it all recall Manet. The face of the young woman is picked out against her pink parasol and is slightly shaded with green to reflect the dominant tone of the grass. Where the sunlight filters through, the grass is transformed into pure yellow.

It seems reasonable to assume that this painting was executed around 1874–6.

LITERATURE
Meier-Graefe 1929, p. 61
Daulte 1971, no. 260
Atlanta, High Museum of Art, *Corot to Braque,
 French Paintings from the Museum of Fine Arts,
 Boston*, 1979, no. 57

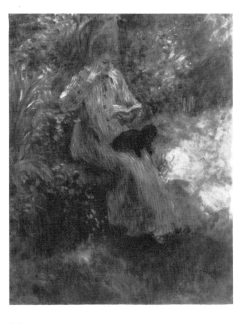

32

Woman with a black dog

Femme au chien noir
1874
61 × 49 cm (24 × 19 ins)
Signed bottom right: Renoir.
From the estate of the late Sir Charles Clore

COLOUR p. 72
Exhibited in Paris and Boston only

In this work, which can be dated to 1874, Renoir again takes as his subject the human figure in a landscape, or rather amidst foliage.

The attitude of the girl – a little mannered, but that is how Renoir often liked his models to pose – the simplicity of her dress, the little black dog, a dark patch to which the eye is irresistibly drawn, all suggest that it is a sketch taken from life. The fluent technique is suited to rapid annotation.

It seems very probable that this is the *Femme au chien noir* that Renoir offered to the public at the famous impressionist auction of 24 March 1875. The picture was sold to a M. de la Salle (or Delasalle). In June 1892 it was bought by Durand-Ruel from a collector named Picq, who owned twelve paintings by Renoir as well as a number of works by Sisley and Pissarro, but we know nothing more about him. Durand-Ruel sold the work to the Berlin dealer Cassirer in June 1901.

LITERATURE
W. Grohmann, C. Müller, I. Kiepenheuer,
 Die Sammlung Ida Bienert, Potsdam, n.d., p. 24
Bodelsen 1968, p. 335
Daulte 1971, no. 105
London, Royal Academy, 1974, no. 99

33

Snowy landscape

Paysage de neige
*c.*1875
51 × 66 cm (20 × 26 ins)
Signed bottom right: Renoir.
Musée de l'Orangerie, Paris
(Collection Walter–Guillaume), RF1960–21

COLOUR *p. 69*

As we know from his comments on *Skaters in the Bois de Boulogne* (no. 7), Renoir did not like snow. John Rewald tells us that when a young artist showed him a winter scene in 1910, Renoir remarked: 'White does not exist in nature. You admit that you have a sky above that snow. Your sky is blue. That blue must show up in the snow. In the morning there is green and yellow in the sky. These colours must also show up in the snow when you say that you painted your picture in the morning. Had you done it in the evening, red and yellow would have to appear in the snow.' (Rewald 1973, pp. 210, 236 n. 28.)

This snow scene is in a sense an application of Renoir's theory, but it is also a reminder that his friends Sisley, Monet and even Pissarro had a predilection for this kind of subject. In terms of style and technique, it is very similar to the landscapes Monet painted at Argenteuil in about 1875 and to *The Seine at Champrosay* (Jeu de Paume), which Renoir exhibited in 1876.

LITERATURE
Vollard 1918, II, p.104
Drucker 1944, p.193 no.11
Paris, Orangerie, 1966, no.19
Paris, Orangerie, 1984, pp.174–5

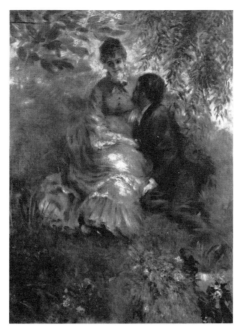

34

The lovers

Les Amoureux
*c.*1875
175 × 130 cm (69 × 51 ins)
Signed bottom left: A. Renoir.
Národní Galerii, Prague

COLOUR *p. 73*
Exhibited in London and Paris only

This painting is of course related to the earlier *Promenade* (no.16) and *Engaged couple* (no.9) and shows how much Renoir was attached to its theme, but it should also be compared with the later *Ball at the Moulin de la Galette* (no.40), if only to bring out the artist's stylistic development. The large format is not that of the traditional genre scene and, as Jamot points out, 'Renoir narrowly but successfully avoids the trap of sentimentality.' Although this is a *plein air* painting, Renoir exercises a certain restraint in his rendering of the play of the light on the figures, indicating that the painting cannot be later than 1875, which is in fact the accepted date. According to Vollard, the young man is the painter's younger brother Edmond, but it is more likely to be the painter Franc-Lamy, who also posed for *Ball at the Moulin de la Galette*. The young woman is certainly the actress Henriette Henriot, who frequently posed for Renoir at this time (cf. no. 28).

The collector Conrad N. Pineus (cf. no.45) deposited the work with Durand-Ruel in January 1921, from whom it passed to the dealer Jos Hessel in 1923.

LITERATURE
Vollard 1918, I, p. 74 no. 294
Jamot 1923, pp. 270–1
Daulte 1971, no.127

EXHIBITION
?1912 (June), Paris, Durand-Ruel (*Portraits*)
(24; M. *Rivière and Melle. M.*)

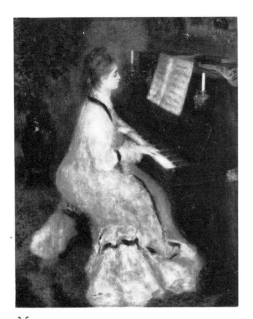

LITERATURE
Barnes and de Mazia 1935, pp. 261, 401 no. 97, 451
Chicago, Art Institute, *Catalogue of Paintings*, 1961,
 p. 384
Daulte 1971, no. 187
Chicago, Art Institute, 1973, no. 20
Chicago, Art Institute, *Toulouse-Lautrec*,
 October–December 1979, pp. 158–9

EXHIBITIONS
1876, Paris, Deuxième exposition
 (219; *Femme au piano*, owned by M. Poupin)
?1908, New York, Durand-Ruel (5)

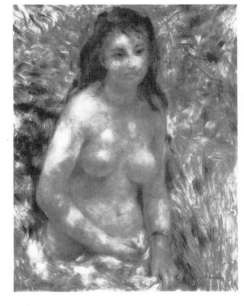

35

Woman at the piano

Femme au piano
c. 1875
93 × 74 cm (36½ × 29 ins)
Signed bottom left: Renoir.
The Art Institute of Chicago (Mr and
Mrs Martin A. Ryerson Collection),
1937.1025

COLOUR *p. 80*

The bluish tones of the dress worn by this
woman playing the piano in a dim, dark
interior, which is lit only by the orange light
of the candles, reveal Renoir as a true
impressionist painter. This was the first time
he had dealt with this classic subject, but he
was to return to it frequently (cf. nos 84,
89–91, 97). In compositional terms, the
painting is quite original: the painter is
slightly above his model, and the figure and
the piano take up the entire pictorial space.
The only reference to the real space of the
room in which the scene takes place is a vase
containing a plant on the floor in the upper
left-hand corner. This is a scene from con-
temporary bourgeois life, and the painting
is deliberately devoid of any anecdotal
allusion. The model has not been positively
identified, but she is already recognizable as
one of the artist's favourite physical types.

This is probably the painting Renoir
showed at the second exhibition organized
by the impressionist group in 1876. The
owner was a certain Poupin, who was a
business associate of Durand-Ruel's (cf. p. 27
n. 22). Durand-Ruel's stock lists for 1876
also include a *Femme au piano*, which was
deposited with a M. Cottineau of the rue
Rambuteau on 3 July 1880, but there is no
further record of it. This painting was sold
to Martin Ryerson by Durand-Ruel in 1911.

36

Study (*known as* Nude in the sunlight)

Etude (dit Torse de femme au soleil)
1875
81 × 65 cm (32 × 25½ ins)
Signed bottom right: Renoir.
Musée d'Orsay, Paris (Galerie du Jeu de
Paume, Bequest of Gustave Caillebotte,
1894), RF 2740

COLOUR *p. 75*

Renoir showed this study at the second im-
pressionist group exhibition in 1876. The
few critics who liked it described it as 'a
superbly coloured study of a nude' (Pothey)
and as 'a well posed and well lit study of a
young nude' (Blémont). Armand Silvestre,
writing in *L'Opinion*, described it in more
detail: 'M. Renoir uses a delightful pink
flesh tone. I like his study of a female nude
enormously. . . . It is the work of a true
colourist.' Unfortunately, the only review
that had any real effect on the contemporary
public was that by *Le Figaro*'s all-powerful
Albert Wolff: 'Would someone kindly explain
to M. Renoir that a woman's torso is not a
mass of decomposing flesh with the green
and purplish blotches that indicate a state of
complete putrefaction in a corpse . . .' Shortly
afterwards, Louis Enault went even further
and told the readers of *Le Constitutionnel*
that: 'It is depressing to look at this large
study of a nude woman; her purplish flesh is
the colour of game that has been hung for
too long, and someone really should have
made her put on a dress.'

It should be noted that Renoir had already
been criticized for the unfinished quality of
his work in 1874 and that, although he was
normally very cautious, his decision to

exhibit a study was a deliberate challenge to the critics.

The composition itself is daring; the figure is slightly off-centre, and the background, which suggests violently lit plants, is in places barely covered and completely abstract. The background emphasizes the incredibly free rendering of the effect of light filtering through the foliage and dappling the skin of the nude model. The light dissolves the blurred lines of the face and brings out the dehumanization of the model, who is in a sense treated simply as an object. The painting is, however, full of Renoir's characteristically joyous and spontaneous sensuality.

Vollard and Jamot both say that the sitter was a young model named Anna, who, according to Rivière, also sat for the Pushkin Museum's *Nude (Anna)*, although the red-headed woman we see here bears little resemblance to the figure in that painting.

Certainly Renoir used a model known as Anna, whose full name was Alma Henriette Leboeuf, and her great-grandson Jean-Charles Leboeuf recalls that some paintings by Renoir were still in the family between the wars. This Anna was born in Chenoise (Seine et Marne) on 11 January 1856 and died at her parent's home at 47 rue Lafayette, Paris, on 18 February 1879. In one of his well-known letters to Dr Gachet, which were published by Gachet's son, Renoir writes: 'Please, I beg you to go and see Mlle L . . . at 47 rue Lafayette tomorrow morning,' explaining that his model is ill. On 25 February 1879, he informed Gachet that she had died. Both Renoir and Gachet named the model as Margot, and a model named Marguerite Legrand also sat for Renoir, but it seems almost certain that Renoir's letter refers to Anna Leboeuf, who died at the age of twenty-three.

This study was bought by the painter Gustave Caillebotte, probably shortly after the 1876 exhibition.

LITERATURE
Blémont 1876
Enault 1876
Pothey 1876
Silvestre 1876
Wolff 1876
Vollard 1918, I, p. 95 no. 381
Vollard 1919, p. 72
Rivière 1921, p. 29
Jamot 1923, p. 276
Drucker 1944, p. 212 no. 134
Gachet 1957, pp. 85, 89–90
Paris, Louvre, 1958, no. 345
Daulte 1971, no. 201
Rewald 1973, p. 386
Paris, Grand Palais, 1974, no. 37
Callen 1978, p. 61

EXHIBITIONS
1876, Paris, Deuxième exposition (212; *étude*)
1892, Paris, Durand-Ruel (11; *Torse; effet de soleil*, owned by M. Caillebotte)

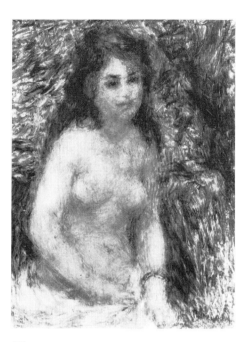

37

Small bather

Petite baigneuse
c. 1876
11 × 7 cm (4½ × 3 ins)
Signed bottom right: Renoir.
Mr and Mrs Alexander Lewyt

COLOUR *p. 74*

This miniature version of the painting in the Jeu de Paume (no. 36) is a reminder of the artist's liking for very small formats, and we know that he painted several other examples at this time.

The painting was photographed by the dealer Bignou, who appears to have owned it between the wars, but its early provenance is unknown.

38

Garden in the rue Cortot, Montmartre

Le Jardin de la rue Cortot à Montmartre
1876
151 × 97 cm (59½ × 38 ins)
Signed bottom right: Renoir.
Museum of Art, Carnegie Institute, Pittsburgh (Acquired through the generosity of Mrs Alan M. Scaife and family, 1965)

COLOUR *p. 76*

We know from Georges Rivière that Renoir was quite delighted when he found a room to rent in the outbuildings of an old folly in the rue Cortot on the Butte Montmartre (see Chronology: 1875, p. 298). It was not far from the Moulin de la Galette, which he wanted to paint (cf. no. 40). Renoir was particularly pleased with the large overgrown garden, which is surely the one in the painting. Renoir adopts a large vertical format, which lends itself well to the contrast between the flowers and plants in the foreground and the two men talking in the middle ground (it is sometimes said that they are Sisley and Monet, but neither was in Paris at this time). The unusual composition suggests that Renoir is looking down on his subject and indicates his obvious desire to produce a decorative painting. He uses a wide range of techniques, and some areas have been highly worked to give a very complex texture.

It is interesting to compare this painting with the decorative panels which Monet

executed for Ernest Hoschedé during the summer of 1876 and which were intended for the Château of Rottembourg in Montgeron (cf. Paris, Grand Palais, *Hommage à Monet*, 1980, nos. 61–4).

This painting may have belonged to Murer; in October 1887, Trublot (a pseudonym for Paul Alexis) published a catalogue of the Murer collection in *Le Cri du peuple* (reprinted by Gachet), and it includes a painting entitled '*Son jardin, sur la Butte Montmartre*'. We know definitely that it was later in the possession of Durand-Ruel, who already owned it in April 1890. He sent it to his New York branch in 1917.

LITERATURE
Rivière 1921, pp. 129–131
Meier-Graefe 1929, p. 133
Gachet 1956, p. 171
New York, Wildenstein, 1969, no. 18
Daulte 1971, no. 193
Chicago, Art Institute, 1973, no. 21
Gaunt and Adler 1982, no. 25

EXHIBITIONS
1912, Munich, Thannhauser (2)
1912 (February–March), Berlin, Cassirer (2)
1918, New York, Durand-Ruel (9)

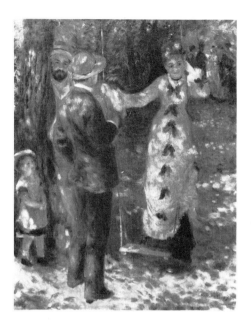

39

The swing

La Balançoire
1876
92 × 73 cm (36 × 28½ ins)
Signed and dated bottom right: Renoir. 76.
Musée d'Orsay, Paris (Galerie du Jeu de Paume, Bequest of Gustave Caillebotte, 1894), RF 2738

COLOUR *p. 77*

This painting is thought to have been executed in the garden in the rue Cortot (cf. no. 38). The models were Jeanne, a young woman from Montmartre, and perhaps the painter Norbert Goeneutte. It obviously reflects the same preoccupations as the large painting of *Ball at the Moulin de la Galette* (no. 40). The play of the light and dark patches on the ground and on the figures is, however, rather more systematic, and this shocked G. Vassy, the critic of *L'Evénement*, when the painting was shown at the 1877 exhibition. He wrote that 'the sunlight effects are combined in such a bizarre fashion that they look like spots of grease on the models' clothes.' L. Leroy, for his part, writing in *Le Charivari*, took offence at the 'violent' blue. The more friendly critics praised *The swing* in much the same terms as they praised *Ball at the Moulin de la Galette*. Rivière mentioned the garden in the rue Cortot and added: 'The figures do not have the noisy gusto of the dancers at the Moulin; one gets the impression that they live peacefully in the countryside, far away from the usual preoccupations of life. We have to go back to Watteau to find a painting with the charm that pervades *The swing*.' His comments were published in *L'Impressionniste* on 6 April, and the cover of the issue two weeks later featured a sketch of *The swing* by Renoir.

Painters have often found inspiration in works of literature, and it is equally common for authors to be inspired by paintings. Newton has demonstrated that there is a close connection between Renoir's *The swing* and a passage in Zola's *Une Page d'amour*, which was published in 1878. The author describes his heroine 'standing on the very edge of the swing and holding the ropes, with her arms outstretched . . . she was wearing a grey dress decorated with mauve bows. . . . That day, the sunlight was like light-coloured dust in the pale sky. A gentle rain of sunbeams fell between the leafless branches.' The heroine's daughter Jeanne 'watched the sunlight as it began to fall on her. . . . What amused her most were the pale spots which danced on her shawl; they were a beautiful golden yellow and looked almost like little animals.'

Gustave Caillebotte had already acquired this painting by the spring of 1877.

LITERATURE
L'Impressionniste, 21 April 1877 (cover illustration: sketch after *The swing*)
Leroy 1877
P[othey] 1877
Rivière, *Exposition*, 1877, p. 4
Rivière, *Intransigeants*, 1877, p. 298–9
Roger-Ballu 1877
Sébillot 1877
Vassy 1877
Alexandre 1892, pp. 28–9
Geffroy 1894, p. 122
Meier-Graefe 1912, p. 62
Vollard 1918, I, p. 95 no. 380
Vollard 1919, p. 72
Rivière 1921, pp. 136, 264
Duret 1924, p. 43
Barnes and de Mazia 1935, pp. 395–6 no. 63
Drucker 1944, pp. 111, 152–3, 184
Paris, Louvre, 1958, no. 352
Newton, J., 'Zola impressionniste I, II', *Les Cahiers naturalistes*, nos. 33–4, 1967, p. 137
Rewald 1973, pp. 385, 388, 392
Callen 1978, p. 62
Gaunt and Adler 1982, no. 25

EXHIBITIONS
1877, Paris, Troisième exposition (185; *La balançoire*, owned by M.C. . . .)
1883, Paris, Durand-Ruel (28)
1892, Paris, Durand-Ruel (23)
1917, Barcelona (823)

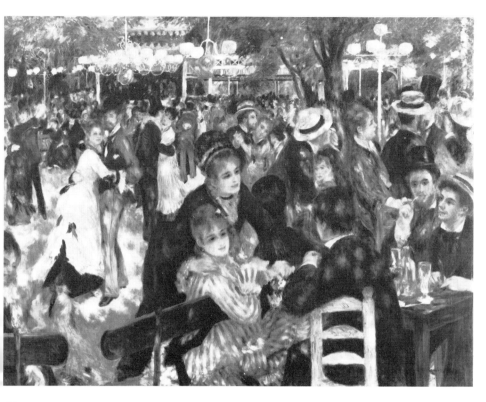

40

Ball at the Moulin de la Galette

Bal du Moulin de la Galette
1876
131 × 175 cm (51½ × 69 ins)
Signed and dated bottom right: Renoir. 76.
Musée d'Orsay, Paris (Galerie du Jeu de
Paume, Bequest of Gustave Caillebotte,
1894), RF 2739

COLOUR *pp. 78, 79*

Exhibited in Paris only

One of the first favourable reviews of the
third impressionist group exhibition of 1877
was by a critic who used the fanciful pseudo-
nym of 'Ch. Flor O'Squarr'. In his description
of *Ball at the Moulin de la Galette* he writes:
'The painter has caught perfectly the raucous
and slightly bohemian atmosphere of this
open-air dance hall, perhaps the last of its
kind in Paris. Dancing takes place in the
shabby little garden attached to the windmill.
The harsh daylight is filtered through the
greenery, sets the blonde hair and pink
cheeks of the girls aglow and makes their
ribbons sparkle. The joyful light fills every
corner of the canvas and even the shadows
reflect it. In the centre we see a crowd of
dancers caught up in a frantic choreography.
The whole painting shimmers like a rainbow
and makes one think of the dainty Chinese
princess described by Heinrich Heine: her
greatest pleasure in life was to tear up satin
and silk with her polished, jade-like nails
and watch the shreds of yellow, blue and

pink drift away in the breeze like so many
butterflies.'

According to Renoir's friend and biogra-
pher Georges Rivière, the entire painting
was executed 'on the spot' at the dance hall
at the top of the Butte Montmartre, situated
at the foot of the windmill from which it
took its name. The mill is all that remains,
but old postcards show that the bright green
wooden buildings and the trellis still stood
on a patch of waste ground in about 1900.
Renoir had taken a studio nearby in the rue
Cortot (cf. no. 38), specifically to paint this
scene. Rivière also gives us the names of the
friends and occasional models who posed
for this vast composition: 'Jeanne's sister
Estelle is sitting on the bench in the fore-
ground; Lamy, Goeneutte and I are sitting
at the large table littered with glasses of
cordial – the usual *grenadine*. Gervex, Cordey,
Lestringuez, Lhote and others posed for the
dancers. In the middle, a painter of Spanish
origin called Don Pedro Vidal de Solares y
Cardenas is dancing with Margot; he came
from Cuba and is wearing "Merd'Oye"
[goose-shit green] trousers.' Franc-Lamy
(1855–1919), Goeneutte (1854–94), Gervex
(1852–1929) and Cordey (1854–1911) were
all painters, but their work generally has
little in common with Renoir's. Pierre-
Eugène Lestringuez was, according to Jean
Renoir in his memoirs, a civil servant who
was fascinated by the occult and was a friend
of the composer Chabrier, while Lhote was
a journalist. Renoir in fact remained close to
most of these friends of his youth.

Until he painted this dance-hall scene,

Renoir had usually painted only single
figures or couples, though the large formats
he sometimes used did demonstrate his con-
siderable expertise. Here, he paints a large
number of moving figures; the open-air
lighting is further complicated by the effect
of the lamps hanging from the trellis and is
muted by the shadows thrown by the leaves
of the acacias. There is a certain similarity
between this popular crowd scene and
Renoir's paintings of the bathing establish-
ment at La Grenouillère (cf. nos. 12, 13), but
it is also a distant relative of Manet's *Music in
the Tuileries* (National Gallery, London).
Although Rivière insists that the painting
was done 'on the spot' – which must have
posed certain difficulties, given its size –
Renoir must also have worked from sketches.
That he did in fact do so is confirmed by
Vollard. According to Vollard, Renoir told
him: 'Franc-Lamy found a sketch under
some stretchers in my studio one day; it was
a sketch of the Moulin de la Galette that
I had done from memory. He told me that I
simply had to execute the painting.' There
are considerable differences between the
painting in the Jeu de Paume and the small
study (64 × 85 cm) in Ordrupgaard, near
Copenhagen (Daulte 1971, no. 207). The
study is painted with small, rapid strokes
and may in fact be an early version of the
large painting. There is also a very summary
study (46 × 28 cm) of the couple dancing in
the middle distance (Daulte 1971, no. 205).
It is, however, uncertain whether the smaller
canvas (78 × 114 cm) in the Hay Whitney
Collection (Daulte 1971, no. 208), in which
the composition is identical and which is
also dated 1876, is an early version – the
version painted on the spot – or, as seems
more likely, a copy of the large painting
made for Victor Chocquet, who appears to
have been its first owner.

The painting in the Jeu de Paume is ob-
viously Renoir's most ambitious work of
this period, and he understandably wanted
it to be seen by the public and therefore
exhibited it in 1877. It shows how he trans-
posed the spontaneous technique he had
experimented with on a small scale around
1874 to a large-scale work. The composition
itself is highly original. The figures in the
foreground – both left and right – are cropped
so as to suggest that reality continues beyond
the edges of the frame. The rapidly diminish-
ing scale of the figures both suggests the
movement of the dancers and leads the eye
to the background, where a few touches of
bright colour (which are very different from
the smoother treatment in the foreground)
are used to conjure up a crowd of expressive
silhouettes. The light is concentrated in the
strange round patches which speckle the
dark jacket of the seated man who is seen
from behind in the foreground and the striped
dress of the woman next to him. It was this
dissolution of form and the vibrant colour

which contemporary critics like Sébillot, Ballu and Mantz found most objectionable. *Le Moniteur universel*'s critic found it ridiculous that the figures should be 'dancing on a surface which looks like the purplish clouds that darken the sky on a thundery day', but he did admire Renoir's skilful composition. Burty, too, complained about the lack of discipline. Some critics, however, followed Rivière and openly expressed their admiration for the painting. Its admirers included Maillard – even though he was hostile to the impressionist group – Jacques, Zola and Montifaud. Rivière's defence of the painting is based essentially upon the fact that he sees it as 'a page of history, a rigorously accurate portrayal of a precious moment in Parisian life'. But he then goes on to say that 'the thing that distinguishes the Impressionists from other painters is that they paint their subjects for their tones and not for their own sake. . . . M. Renoir wanted to find a contemporary note, and he has succeeded.'

In 1893, a few months before Gustave Caillebotte's bequest of this painting and the rest of his collection to the State (see p. 23) provoked a final outburst from the establishment critics, Gustave Geffroy described the painting as follows: '*Ball at the Moulin de la Galette* is one of the most successful products of direct observation and the use of light to create atmosphere: it expresses the intoxication of dancing, the noise, the sunshine and the dust of a dance in the open air, the excitement on the faces and the casual poses, the rhythmic swirl of the dresses – pink, light blue, dark blue and black – a burst of passion, a sudden sadness, a quick flare-up, pleasure and fatigue. These are the heroines of sentimental ballads, with their delicate faces, their expressive hands and their fleeting or tired gestures which express their hopes, drunkenness, relaxation or sullen boredom.'

The July 1879 issue of *L'Artiste* – 1879 was the year of Renoir's success at the Salon with his *Portrait of Madame Charpentier and her children* (no. 44) – contains an advertisement for a print of *Ball at the Moulin de la Galette* by Guillemet after Renoir: 'This charming painting . . . one of Renoir's best works, has been bought by M. Caillebotte, who would not exchange it for Bouguereau's *Venus*.' Caillebotte probably bought the painting at the 1877 exhibition, and he included it in the background of one of his self-portraits. Pissarro saw it when the Caillebotte collection finally went on show at the Luxembourg in 1897 and described it as 'a masterpiece'.

LITERATURE
[Anon.], *Moniteur universel*, 1877
Burty 1877
Flor O'Squarr 1877
Jacques 1877
Maillard 1877
Mantz 1877
Montifaud 1877, p. 339
P[othey] 1877
Rivière, *Intransigeants*, 1877, pp. 298–9
Rivière, *Rédacteur*, 1877
Roger-Ballu 1877
Sébillot 1877
Zola 1877, in Zola 1970, p. 282
L'Artiste, July 1879
E. Renoir 1879, in Venturi 1939, II, p. 336
Darzens, R., *Nuits à Paris*, Paris 1889, chap. VI
Alexandre 1892, p. 28
Geffroy 1893
Geffroy 1897
Montorgueil, G., *La Vie à Montmartre*, Paris 1899, p. 122
Bénédite, L., *Exposition universelle de 1900; Rapports du Jury international, t. 1, 2ème partie, Beaux-Arts*, Paris 1904, p. 424
Meier-Graefe 1912, p. 56
Vollard 1918, I, p. 91 no. 361
Vollard 1919, pp. 72, 74, 144
Rivière 1921, pp. 131–140
Jamot 1923, pp. 277–9
Duret 1924, p. 83
Paris, Orangerie, 1933, p. xxx and no. 29
Barnes and de Mazia 1935, pp. 247, 394–5 no. 62
Drucker 1944, pp. 48ff., 122–3, 201 no. 41
Pissarro 1950, p. 433
Paris, Louvre, 1958, no. 351
London, Tate Gallery, *The John Hay Whitney Collection*, December 1960 – January 1961, no. 47
J. Renoir, 1962, pp. 192–3, 212, 215, 218, 290
Daulte 1971, no. 209
Hautecoeur, L., 'L'Artiste et son oeuvre', *Gazette des Beaux-Arts*, May–June 1973, p. 339
Rewald 1973, pp. 385–6, 388, 392
Paris, Grand Palais, 1974, no. 36
Callen 1978, p. 63
Gaunt and Adler 1982, no. 26

EXHIBITIONS
1877, Paris, Troisième exposition (186; *Bal du Moulin de la Galette*)
1883, Paris, Durand-Ruel (35)
1892, Paris, Durand-Ruel (10)
1917, Barcelona (824)

FIG a. Drawing by M. E. Vernier, engraved by M. Yon-Perrichon, *Les Moulins de Montmartre*, illustration in *Paris-guide*, 1867.

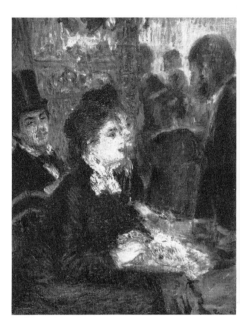

41

At the café

Au Café
*c.*1877
35×28 cm ($13\frac{1}{2} \times 11$ ins)
Signed bottom right: Renoir
Rijksmuseum Kröller-Müller, Otterlo

COLOUR *p. 81*

This small painting is generally thought to date from 1876–7. It has been rapidly sketched and then vigorously reworked with a full brush and is a charming example of Renoir's liking for small formats. The man in the top hat is traditionally identified as Georges Rivière, an old friend and the painter's biographer, and the young women are probably two of Renoir's usual models.

Renoir also painted a small portrait of Georges Rivière seen in profile in 1877 (National Gallery of Art, Washington, D.C.).

Renoir treats this scene from the café life that was so important to the artists who gathered at the Café Guerbois and the Nouvelle Athènes with his usual spontaneity and borrows a subject dear to both Manet and Degas. As Isaacson points out, Renoir's choice of subject may have been influenced by illustrations in contemporary newspapers, but it also expresses Renoir's deep desire to 'record a faithful picture of modern life', as Edmond Renoir puts it in an article written in 1879. That ambition was, of course, shared by all the painters who belonged to the impressionist group.

The early provenance of this little painting is unknown, but there are accurate descriptions of it in several lists of works that belonged to the Prince de Wagram between 1907 and 1909. We do not know which

dealer handled the painting before it became part of the Kröller-Müller collection.

LITERATURE
Meier-Graefe 1929, p.130
Gaunt and Adler 1982, no.29
Isaacson 1982, p.105

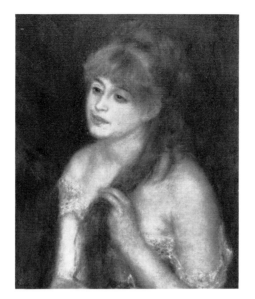

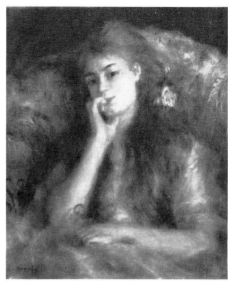

42

Young woman braiding her hair

La Chevelure
1876
56 × 46 cm (22 × 18 ins)
Signed and dated bottom left: Renoir 76
National Gallery of Art, Washington, D.C.
(Ailsa Mellon Bruce Collection, 1970),
2435

COLOUR *p. 82*

Tradition has it that this painting is a portrait of a young Parisian woman named Mlle Muller, but nothing more is known about the model. The painting is anyway a genre figure rather than a portrait; Renoir painted many such figures of this type which were relatively commercial. We have only to compare this painting, with its delicately modelled and shaded flesh tones and the silky hair seen against an indeterminate dark ground, and the daring *Nude in the sunlight* (no.36), which Renoir exhibited in 1876, to see the distance that separates the two works. We can also see how Renoir tones down his initial vision and works on it in order to achieve paintings like *Young woman braiding her hair* or some of his portraits of this period.

LITERATURE
Paris, Bernheim-Jeune, 1919, II, pl.105
Paris, Orangerie, 1933, no.30
Daulte 1971, no.172

EXHIBITION
1913, Paris, Bernheim-Jeune (11; *La chevelure, 1876*)

43

Young woman seated (*known as* La Pensée)

Jeune femme assise (dit *La Pensée*)
c.1876–7
66 × 55 cm (26 × 21½ ins)
Signed bottom left: Renoir.
Accepted by H.M. Government in lieu of tax

COLOUR *p. 83*

This belongs to the same series of half-length portraits as *Young woman braiding her hair* (no.42) and is probably almost contemporary (*c*.1876–7) with it – but it is much freer.

Renoir once told Albert André that 'I took an aversion to one of my paintings when someone baptized it *La Pensée*', and his somewhat tart comment almost certainly applies to this painting. It was sold under that title when the collection of Comte Armand Doria, one of Renoir's first collectors, was auctioned in 1899 and when that of Jules Strauss, who bought a lot of Renoirs from Durand-Ruel and Bernheim-Jeune at the turn of the century, was sold in 1902.

LITERATURE
Paris, Galerie Georges Petit, *Collection Comte Armand Doria*, sale catalogue, 4–5 May 1899, no.202
Paris, Drouot, *Collection Jules Strauss*, sale catalogue, 3 May 1902, no.49
Meier-Graefe 1912, p.93
Vollard 1918, I, p.86, no.343
André 1923, p.27
Jamot 1923, pp.272–3
London, Sotheby's, *Seven Paintings of the Estate of the late Jakob Goldschmidt of New York City*, sale catalogue, 15 October 1958, lot no.7
J. Renoir 1962, p.71
Daulte 1971, no.227

EXHIBITIONS
1900, Paris, Centennale (557; *Portrait*, owned by M. Strauss)
1901, Berlin, Secession (205; *Der Gedanke*)
1914, London, Grosvenor House (62)

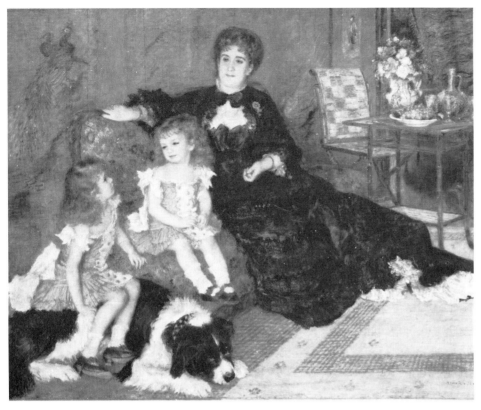

44

Portrait of Madame Charpentier
and her children

*Portraits de Madame Charpentier
et de ses enfants*
1878
154 × 190 cm (60½ × 75 ins)
Signed and dated bottom right: Renoir. 78.
The Metropolitan Museum of Art,
New York (Wolfe Fund, 1907, Catherine
Lorillard Wolfe Collection), 07.122

COLOUR *pp. 84, 85*
Exhibited in Boston only

On 27 May 1879, Camille Pissarro wrote to
Murer, telling him that Renoir 'has been a
great success at the Salon. I think he has
made his mark. So much the better; poverty
is so hard.' Renoir owed his success at the
Salon to his *Portrait of Madame Charpentier
and her children* and his *Portrait of Mlle Jeanne
Samary* (p.197 fig.c). Mme Charpentier was
very well known, thanks to her literary and
political salon, and her husband Georges
Charpentier was the publisher of Flaubert,
Zola and the Goncourt brothers. As a result
of their contacts and influence, the portrait
was very well placed at the Salon. Even so,
the critics were not completely won over.
They obviously wanted to avoid offending
the principal model and at the same time
wanted to herald the prodigal's return to
the Salon: 'We must not pick quarrels with

M. Renoir; he has returned to the bosom of
the Church and we should bid him welcome.
Let us forget about form and simply talk
about coloration,' wrote Baignières. The
general view was in fact that Renoir was a
gifted colourist but that his draughtsmanship
was open to criticism. According to Bertall,
the portrait was 'a very incomplete sketch
done in accurate tones . . . a slack, transparent
sketch, which seems to have been done with
different coloured balls of cotton wool. . . .
The draughtsmanship does not bear talking
about! There is a complete absence of per-
spective.' This critic suggests that Renoir
should take lessons from Bastien-Lepage!
The young J.K. Huysmans, whose work
was, as it happens, published by Charpentier,
was rather more enthusiastic: 'M. Renoir
decided that it would be preferable to paint
Madame Charpentier at home with her chil-
dren and going about her day-to-day business
rather than have her adopt a conventional
pose in front of a red or purple curtain. . . . It
is an interesting experiment and deserves to
be praised. The flesh tones in this portrait
are exquisite and the grouping of the figures
is ingenious. It is painted somewhat thinly,
and the props the artist has introduced are
rather garish, but it is skilfully executed and,
above all, it is daring! In a word, this is the
work of an artist who has talent and who is
an independent, even if he does exhibit at
the official Salon.'

According to Edmond Renoir, the portrait
of the young woman and her children was
'painted at her home. None of the furniture

was moved from its usual place and nothing
was prearranged to emphasize one part of
the painting rather than another.' There is
certainly little resemblance between this por-
trait and the society portraits painted by
fashionable artists like Bonnat or Carolus-
Duran, who were at pains to stress that they
were working in the tradition of the grand
style. But whatever Edmond may have to
say about the matter, Renoir wanted his
portrait of Madame Charpentier, her daughter
Georgette (born 1872) and her son Paul
(born 1875; Zola was his godfather) – who
is often mistaken for a girl because of his
blond ringlets and the dress he is wearing –
to be a painting in the classic sense of the
term: a large format, skilful composition
and sumptuous costumes. Renoir knew his
models well, as he had already painted a *Por-
trait of Georgette Charpentier* in 1876 (Daulte
1971, no.178; the rather arch pose is remi-
niscent of the younger girl in Degas's *Portrait
of the Bellelli family* in the Jeu de Paume) as
well as a half-length *Portrait of Madame
Charpentier* (Jeu de Paume), which he showed
with some success at the 1877 impressionist
group exhibition. The most unconventional
aspect of this portrait is its evocation of the
unpretentious charm of the room itself. It
has been described as a Japanese salon, but
nothing in it is as clearly defined as it would
have been by a painter like Alfred Stevens.
We do not know, for instance, whether there
is a screen in the background or just a hang-
ing embroidered with peacocks. The floral
design of the sofa on which the models are
sitting, the esparto rug and the bamboo
furniture are simply indications of the per-
sonal taste of the mistress of the house. It is
the sumptuous handling of paint and the
rendering of Madame Charpentier's famous
black dress and the hair of the children that
holds one's attention rather than the subject
itself.

Proust describes this painting at some
length in *Le Temps retrouvé* (Part 1, Chapter 1).
He knew the model and somewhat harshly
describes her as 'ridiculously petty bourgeois',
but he is full of praise for the painting,
which he compares with 'Titian at his best'.
Despite his snobbish prejudices he does also
recognize the important role of people who,
like the Charpentiers, discover unknown
geniuses, and he ends by suggesting that
'posterity will learn more about the poetry
of an elegant home and the beautiful dresses
of our day from Renoir's painting of the
salon of the publisher Charpentier than from
Cot's portrait of the Princesse de Sagan or
Chaplin's portrait of the Comtesse de la
Rochefoucauld.'

For the purchase of the painting by the
Metropolitan Museum of Art at the Char-
pentier sale in 1907, see pp. 25, 29 n. 77.

LITERATURE
Baignières 1879, p. 51
Banville 1879
Bertall 1879, pp. 86–7
Burty 1879
Castagnary 1879, in Castagnary 1892, II, p. 384
Champier 1879, pp. 107–8 (cites Chesneau and
 Castagnary)
Chesneau 1879
E. Renoir 1879, in Venturi 1939, II, p. 336
Roger-Ballu 1879, p. 1155
Syène 1879, p. 11
Huysmans 1883, pp. 58–9
Alexandre 1892, p. 34
Bénédite 1907, pp. 130–5
Meier-Graefe 1912, p. 62
Vollard 1918, I, p. 91 no. 362
Vollard 1919, pp. 91–102
Gervex, in Fénéon, F., 'Souvenirs sur Manet',
 Bulletin de la vie artistique, 15 October 1920, p. 610
Rivière 1921, pp. 77, 167–176
Jamot 1923, pp. 274–5, 336
Duret 1924, pp. 54–8, 66
Barnes and de Mazia 1935, pp. 398–9 no. 79
Florisoone 1938, p. 31
Drucker 1944, pp. 128–9, 201 no. 51
Rewald 1945, p. 136
Robida, Grandes heures, 1958, pp. 55–9, 81, 135
J. Renoir 1962, p. 138
Daulte 1971, no. 266
Rewald 1973, pp. 419–420, 424, 430
Callen 1978, p. 67
Pissarro 1980, p. 133
Gaunt and Adler 1982, no. 31

EXHIBITIONS
1878, Paris Salon (2527; Portraits de Mme G.C. . . .
 et de ses enfants)
1886, Paris, Petit (124)
1886, Brussels (2)
1892, Paris, Durand-Ruel (110)
1900, Paris, Bernheim-Jeune (19)
1904, Brussels (129)

45
Landscape at Wargemont

Paysage à Wargemont
1879
80 × 100 cm (31½ × 39½ ins)
Signed and dated bottom right: Renoir. 79.
The Toledo Museum of Art
(Gift of Edward Drummond Libbey), 57.33

COLOUR *p. 87*

Renoir painted this landscape during one of his first visits to Wargemont near Dieppe, where the Berards (see p. 22) owned an estate, and we know from Jacques-Emile Blanche how much the artist enjoyed his stays on the Normandy coast. Thematically, this astonishingly sinuous landscape, which was painted very rapidly (the paint has been applied very thinly), is somewhat reminiscent of *High wind* (no. 25), but the comparison reveals the development in the artist's technique. The panoramic vista of a landscape with no outstanding features to catch the eye is subtly structured by the brushwork itself. It is perfectly in keeping with Renoir's usual choice of subject.

Durand-Ruel sold this landscape to a collector named Steinbart on 30 May 1909 and bought it back from him on 14 October 1910. On 10 December 1917 he sold it again, to Conrad N. Pineus of Gothenburg.

LITERATURE
Meier-Graefe 1929, p. 121
Paris, Orangerie, 1933, no. 48
Chicago, Art Institute, 1973, no. 26
Toledo, Museum of Art, *European Paintings*, 1976,
 pp. 135–6

EXHIBITION
1914, Copenhagen (179)

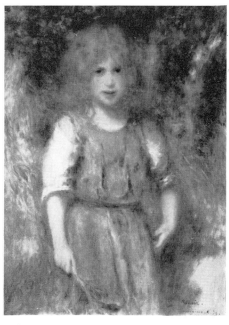

46
Gypsy girl

La petite bohémienne
1879
73 × 54 cm (28½ × 21 ins)
Signed, dated and inscribed bottom right:
Renoir./Wargemont 79.
Private Collection, Canada

COLOUR *p. 86*

The *Gypsy girl* was also painted while Renoir was a guest of the Berards at Wargemont (cf. no. 45), and he used the same girl as a model in *Mussel-fishers at Berneval* (no. 81 fig. a), which he exhibited at the 1880 Salon. Paintings of picturesque little girls in rags were commonplace at the Salon at this time. He concentrates on her very appealing face, barely sketching in the hands and background, and narrowly avoids a hollow sentimentality.

Daulte has drawn attention to a drawing related to the painting.

This was probably one of the first of Renoir's paintings to be bought by Charles Ephrussi (see p. 21). Ephrussi died in 1905, but we do not know when the painting left his collection. Later it belonged to Bernheim-Jeune, and between the wars it was in the possession of the dealer Paul Rosenberg.

LITERATURE
Vollard 1918, I, p. 94, no. 377
Paris, Bernheim-Jeune, 1919, II, pl. 108
Barnes and de Mazia 1935, pp. 76 no. 90, 259
Daulte 1971, no. 291
Daulte 1974, p. 11

EXHIBITIONS
1883, Paris, Durand-Ruel (1; *Petite bohémienne*,
 owned by M. Ch. Ephrussi)
1913, Paris, Bernheim-Jeune (14)

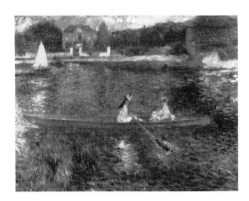

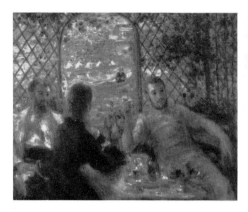

Jeune and Durand-Ruel (who later sold his share in it to Bernheim-Jeune).

LITERATURE
Paris, Galerie Georges Petit, *Tableaux modernes . . . succession de Mme. Vve. Chocquet*, sale catalogue, 1, 3–4 July 1899, no. 93 (*La Seine à Asnières*)
Paris, Bernheim-Jeune, 1919, II, pl. 115
Gaunt and Adler 1982, no. 33

EXHIBITION
1913, Paris, Bernheim-Jeune (16; *La Yole 1880*)

47

The Seine at Asnières
(*known as* The skiff)

La Seine à Asnières (dit *La Yole*)
c. 1879
71 × 92 cm (28 × 36 ins)
Signed bottom left: Renoir.
The Trustees of The National Gallery, London, 6478

COLOUR *p. 95*
Exhibited in London and Boston only

Despite this painting's traditional title, it is not in fact certain that it was executed at Asnières. By the mid-nineteenth century Asnières had, like Chatou, become popular with the oarsmen of Paris, whereas sailing enthusiasts tended to congregate at Argenteuil. In contrast to his friend Caillebotte, who painted oarsmen on the Seine in about 1880, Renoir painted two young women in hats, who are rowing along slowly and without ever venturing too far away from the bank.

This study, which anticipates the canvases of girls in boats which Monet painted at Giverny between 1887 and 1890, is dominated by the violent contrast between the orange of the boat and the blue water, with the reflection of the boat almost overpowering the bright blue. Renoir uses repeated brushstrokes to achieve a density of colour that has rarely been equalled. The same violent colour harmony also appears in other thematically related paintings, as for instance, in the background of *Luncheon by the river* (no. 48). The presence of the train on the bridge to the right is a discreet reference to Monet, and it is in fact impossible not to be reminded of Monet, so great are the similarities between Renoir's painting and those his friend painted at Argenteuil. This is one of a series of paintings of people in boats which are generally agreed to have been executed in 1879–80.

The painting belonged to Chocquet, one of Renoir's first patrons (cf. p. 21), and was included in the sale of his collection in 1899, where it was jointly purchased by Bernheim-

48

Oarsmen (*known as* Luncheon by the river)

Canotiers (dit *Déjeuner au bord de la rivière*)
c. 1879
55 × 66 cm (22 × 26 ins)
Signed bottom left: Renoir
The Art Institute of Chicago
(Potter Palmer Collection), 1922.437

COLOUR *p. 94*

This painting can be seen as a first version of the large canvas begun by Renoir during the summer of 1880 (no. 52). It was probably painted at Chatou, but in a letter to Murer, Renoir mentions a stay at Nogent-sur-Marne, and it may have been painted there. The smaller version looks like an elaborate study inspired by contemporary reality, rather like the paintings Renoir had executed ten years earlier at La Grenouillère (cf. nos. 12, 13), and was probably painted in 1879–80. As Isaacson points out, there is a certain similarity between this painting and a slightly earlier magazine illustration; the comparison brings out the extent that Renoir was moving away from the conventional subjects of Salon painting. Renoir includes a trellis in several of his paintings; here it helps him to make the transition between the space in the foreground and the secondary scene of boats and an oarswoman.

Daulte has identified the figure on the left as M. de Lauradour, a friend who posed for the artist on several occasions.

The ledgers of the Galerie Boussod et Valadon from the period when Van Gogh's brother Théo was working for the gallery show that they bought this painting from Legrand for 200 francs on 21 November 1887. (This is presumably the same Legrand who worked with Durand-Ruel in the 1870s, cf. p. 27 n. 21). The next day, it was sold to Guyotin, another dealer, for 350 francs. He then sold it to Durand-Ruel for 1,300 francs on 21 March 1892. On 22 March it was dispatched to Durand-Ruel's New York branch, where it was acquired by Mrs Potter Palmer.

LITERATURE
Meier-Graefe 1929, p.124
Maxon, J., *The Art Institute of Chicago*,
 New York 1970, p.86
Daulte 1971, no.305
Chicago, Art Institute, 1973, no.28
Rewald, J., 'Théo Van Gogh, Goupil and the
 Impressionists', *Gazette des Beaux-Arts*,
 January 1973, p.14, February 1973, Appendix I
Isaacson 1982, p.105

EXHIBITION
1910, Chicago (51)

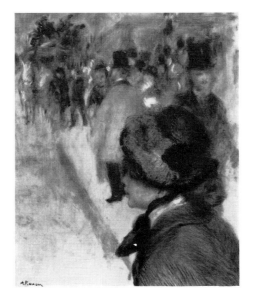

49

Place Clichy

La Place Clichy
*c.*1880
65 × 54 cm (25½ × 21 ins)
Signed bottom left: A Renoir
Anonymous loan to the
Fitzwilliam Museum, Cambridge

COLOUR *pp. 88, 89*

Exhibited in Paris and Boston only

Critics have often discussed the astonishing cropping of the figure of the young woman in the foreground of this painting. The precision of line is stressed by the empty space to her left, which allows the artist to exploit the luminous effect of the preparatory coat of white, and by the coloured blur which evokes the crowd of passers-by in the middle distance. Degas often composed his paintings in this way, taking his inspiration from Japanese prints and from photographs. In Renoir's case it is unlikely that the initial idea for this composition came from the same sources – a small preparatory sketch published by Denys Sutton is composed along the same lines – but one cannot help thinking of photographic, or even cinematographic techniques. It may also have derived from newspaper illustrations (cf. nos. 41, 48). The important point to note is that, although this painting looks like spontaneity itself, there appear to have been several preliminary studies for it. In addition to the drawing already mentioned, there is a detailed study of the young woman in a hat who appears in the foreground (Bührle Collection, Zurich; though this may in fact be a later version). There is also a schematic sketch of the man who is seen from behind in the middle distance and of the woman next to him.

The extreme precision of the details of the figure in the foreground – the feather in her hat and the use of pastel-like streaks of colour to convey the texture of her coat in accordance with a technique Renoir often used at this time – contrasts strikingly with the shimmering colours of the small figures, which are reminiscent of the secondary figures in *Ball at the Moulin de la Galette* (no. 40). There is no topographical detail to allow us to identify the setting, but it does not really matter if it is the Place Pigalle or the Place Clichy. Some subtle human geography may have allowed Renoir's contemporaries to identify the atmosphere of one or the other square, but it now escapes us completely. As Jamot points out, this painting, which probably dates from about 1880, marks the appearance of a new type of model in Renoir's work: the doll-faced types who can also be seen in *Luncheon of the boating party* (no. 52) and *Dance in the city* (no. 68). The painting contains no explicit allusion as to what this pretty, pert *grisette* might be doing in the street, but in a drawing for an illustration published in *La Vie moderne* on 8 December 1883 (reproduced in Rewald 1945), Renoir shows a man in a top hat speaking to a young woman as she crosses the street.

The painting once belonged to the critic Adolphe Tavernier, who had links with the Impressionists and was close to Sisley. It was acquired at the sale of his collection in 1900 by the Marquise Arconati-Visconti. A very detailed description of it appears in a list of works that belonged to the Prince de Wagram between 1907 and 1909, but we do not know whom he bought it from or whom he sold it to. We do, however, know that Samuel Courtauld bought it from Reid and Lefevre in London in June 1924.

LITERATURE
Paris, Galerie Georges Petit, *Vente collection
 Adolphe Tavernier*, sale catalogue, 6 March 1900,
 no.64 (*Place Clichy*)
Meier-Graefe 1912, p.64
Jamot 1923, p.280
Drucker 1944, pp.55, 203 no.66
Cooper 1954, p.111 no.55
Sutton 1963, pp.392–4
Daulte 1971, no.326
London, Royal Academy, 1974, no.100
Callen 1978, p.69
Isaacson 1982, p.107

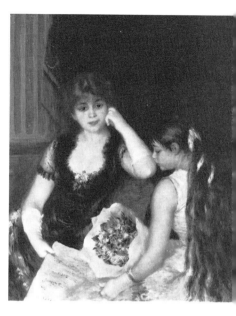

appointed with his unenthusiastic comments.

Angèle also sat for a second painting, which may have been a study for the Williamstown canvas; it is a half-length portrait of the sleeping model with her right arm behind her (Daulte 1971, no. 328).

Durand-Ruel bought *Jeune fille au chat* from Renoir for 2,500 francs on 6 January 1881 and sold it to Kuyper on 29 May 1883. Kuyper exchanged it (and a Degas) for a Schreyer in Durand-Ruel's gallery on 23 May 1891. The painting was still in the dealer's gallery when Gimpel visited it in January 1923.

LITERATURE
Zola 1880, in Zola 1970, p. 341
Meier-Graefe 1912, pp. 67–8
Vollard 1918, I, p. 86, no. 342
Rivière 1921, pp. 137–8
Drucker 1944, pp. 43–4, 86, 197 no. 28
Gimpel 1963, p. 226
Daulte 1971, no. 330
Rewald 1973, p. 443

EXHIBITIONS
1880, Paris, Salon (3196; *Jeune fille endormie*, *1.20 × 0.92*)
1882, Paris, Septième exposition (137; *Jeune fille au chat*)
1883, Paris, Durand-Ruel (48; *Jeune fille endormie*, owned by M. Durand-Ruel)
1892, Paris, Durand-Ruel (87; *La femme au chat*, owned by M.J.D.)
1899, Paris, Durand-Ruel (?77 or 79; *Jeune fille dormant 1880* or *La femme au chat 1880*)
1905, London, Grafton Galleries (223)

50

Sleeping girl
(*known as* Girl with a cat)

Jeune fille endormie (dit Jeune fille au chat)
1880
120 × 94 cm (47 × 37 ins)
Signed and dated bottom right: Renoir. 80.
Sterling and Francine Clark Art Institute, Williamstown, Massachusetts, 598

COLOUR *p. 92*

Renoir exhibited his *Sleeping girl* at the 1880 Salon, together with *Mussel-fishers at Berneval* (no. 81 fig. a), which was painted during a stay at Wargemont (cf. no. 45). The most striking feature of this painting is the bright blue of the girl's dress, which looks even more vivid against the red of the armchair in which she is sitting. Georges Rivière insists that the model, Angèle, was a real-life character straight out of Zola or Maupassant, a cheeky *gamine* from Montmartre who used slang and was said to keep bad company, though one would not think it from the painting. There is, however, something surprising about the incongruous hat worn by the sleeping girl and by the clash between her striped 'peasant' stockings and the eminently bourgeois *fauteuil-crapaud*. This strongly naturalist painting attracted little critical attention at the Salon. According to Zola, Renoir's submission – like that of Monet, who also returned to the Salon in 1880 – was badly hung 'in the circular gallery which runs around the garden ... the dancing sunlight shows it to very poor advantage', but that is virtually all he had to say about it. Cézanne, acting on behalf of the artists themselves, had asked Zola to write the article, but Monet and Renoir were presumably dis-

51

A box at the Opéra
(*known as* Dans la loge)

Une Loge à l'Opéra (dit Dans la loge)
1880
99 × 80 cm (39 × 31½ ins)
Signed and dated top left: Renoir. 80.
Signed mid-left: Renoir.
Sterling and Francine Clark Art Institute, Williamstown, Massachusetts, 594

COLOUR *p. 90*

Exhibited in Boston only

In 1880 Renoir returned to a subject he had already painted in 1874 (cf. no. 26), and the result is curiously similar to a painting by Manet's pupil Eva Gonzalès, who exhibited *A box at the Théâtre des Italiens* at the 1879 Salon, and to the paintings Mary Cassatt showed at the impressionist group exhibition of 1879. Renoir himself refused to take part in that exhibition. Unlike Renoir's earlier painting, the work here implies a certain decorum. Tradition has it that the models were the wife and daughter of M. Turquet, the Under-Secretary of State for the Beaux-Arts, who does not seem to have been particularly sympathetic towards the 'Indépendants'. Renoir originally included the figure of a man on the right of the composition, but subsequently erased him. Although the painting was never exhibited at the Salon, in terms of both subject-matter and style it is one of the works that Renoir could have contemplated submitting to an official Jury. In our discussion of the *Still life* (no. 18) we have already referred to the simple bouquet of fresh flowers which Renoir liked to place amongst the velvet of the theatre and the elegant dresses.

It is interesting to note that one of the

most popular paintings at the 1880 Salon was
Jean-Paul Laurens's *Portrait of Mlle Turquet*.

This painting is probably the one described
as *Une loge au théâtre* which Durand-Ruel
bought from the dealer Dubourg for 1,500
francs on 30 November 1880. Durand-Ruel
sold it to Sterling Clark on 23 June 1928.

LITERATURE
[Anon.], 'Salon d'Automne', *L'Illustration*,
 15 October 1904, p. 265
Roger-Marx, C., 'Le Salon d'Automne',
 Gazette des Beaux-Arts, December 1904, p. 160
Vollard 1918, I, p. 84, no. 333
Rivière 1921, p. 69
Meier-Graefe 1929, p. 127
Paris, Orangerie, 1933, no. 53
Drucker 1944, pp. 185, 203 no. 64
Williamstown, Clark Art Institute, 1956, no. 104
Gimpel 1963, p. 181
Daulte 1971, no. 329
Chicago, Art Institute, 1973, no. 30
Callen 1978, p. 71

EXHIBITIONS
1882, Paris, Septième exposition (139; *Une loge à
 l'Opéra*)
1883, Paris, Durand-Ruel (45; *La loge*, owned by
 M. Durand-Ruel)
1892, Paris, Durand-Ruel (93; *La loge*, owned by
 M.J.D.)
1904, Paris, Salon d'Automne (13; *La loge*, owned by
 MM. Durand-Ruel and sons)
1904, Berlin, Cassirer (60)
1905, London, Grafton Galleries (224; *At the
 Theatre – in the Box 1880*)
1912, Paris, Manzi-Joyant (179; *Dans la loge*)

1880–1883

During these years Renoir first achieved a degree of financial success when the dealer Durand-Ruel began to purchase his paintings in considerable numbers early in 1881; never again was he to experience real financial insecurity. He was now able to travel for the first time, and he was to travel widely over the next twenty years.

But it was not his comparative prosperity alone which encouraged him to leave Paris and the urban and suburban subjects which had been the basis of his art for the past decade. His first two expeditions, in 1881, followed the two most conventional paths for nineteenth-century French artists: to North Africa in the footsteps of Delacroix, in search of light, colour and exotic life; and to Italy in the footsteps of Ingres, to study the art of the Classical world and the great Renaissance masters in the museums. At one and the same time, he felt the need to explore the legacy of the two opposing traditions in French painting, the linear and the colourist.

The contrasting goals of these two trips directly reflect the problems Renoir was facing as an artist. In the mid-1870s he had adopted a style which largely replaced drawing and traditional tonal modelling with juxtaposed patches of colour; later in the decade, though, he had begun to move in more fashionable circles and to gain portrait commissions. The demands of depiction and the expectations of his sitters forced him sometimes to adopt more traditional methods, though he continued at the same time to paint some of his boldest colour-patch paintings. Renoir's own uncertainties coincided with a period of disillusion in the impressionist group as a whole, around 1880. The strategy of independently organized group exhibitions had brought little real success, and even such erstwhile supporters as Zola were encouraging the Impressionists to go beyond the sketch and to produce ambitious, resolved modern-life paintings. Renoir's *Luncheon of the boating party* (no. 52), undertaken just after Zola's 1880 Salon reviews, reflects both Renoir's own dissatisfaction and the novelist's challenge: it was conceived on a large scale, with its whole composition and the individual forms in it carefully structured and clearly articulated.

This more defined treatment of form reflects technical experiments which Renoir had begun to undertake before leaving for Italy in the autumn of 1881. He was already studying Ingres's oil-painting technique before this trip, which shows that he was reconsidering the role of line in his art. In some paintings of 1879–80, too, he worked in translucent veils of colour over a densely primed white ground – a method which demanded great sureness of handling, since it did not allow for overpainting (cf. no. 45); but in other paintings of the period he described forms in more opaque colour, sometimes with the delicacy of a miniaturist (cf. no. 60).

It is possible that Renoir had by this date already discovered Cennino Cennini's *Il Libro dell' Arte*, the early fifteenth-century Florentine manual of painting technique. Vollard placed this discovery 'around 1883', that is after Renoir's trip to Italy, but Vollard's dates are often inaccurate; the book, with its discussions of fresco technique, may well have contributed to Renoir's decision to visit Italy in 1881.

Algeria seems largely to have conformed to his expectations, as he harnessed his bold and flexible techniques of coloured sketching to the depiction of its lavish foliage and colourful local types. However, he came in retrospect to see the Italian trip as the watershed in his career. Two discoveries in Italy particularly helped shape his responses to the problems he was tackling: in Rome, Raphael's decorations at the Villa Farnesina (rather than the Vatican *Stanze*); in Naples, the antique mural paintings from Pompeii. From his studies, he wrote, he had come to understand 'the grandeur and simplicity of the ancient painters'; this lesson showed itself both in his technique and in his treatment of his subjects. He began to seek 'broad harmonies', rather than the 'small details which dim the sunlight', and recognized that the richest effects could be achieved with the simplest palette; while, as for subject-matter, he found mythological themes treated with the easy informality of scenes from everyday life, quite unlike the rhetorical compositions and learned archeologizing of current Neo-Classical Salon painting. When he met and worked with Cézanne at L'Estaque early in 1882 on his return journey from Italy, Renoir would also have seen his colleague's current attempts to find a tauter pictorial structure, of colour and brushwork, for translating his experiences of nature.

These encounters helped Renoir sense the possibility of reconciling in painting the contingent with the permanent: that in nudes or landscape the study of outdoor light and colour could be grafted on to a clear formal structure without dislocating it; and that informal everyday scenes could be re-created in more permanent, traditional forms, and timeless themes revitalized by direct observation. This synthesis became the focus of his quest as a painter, but he found no easy solutions: over a decade of experimentation with techniques and methods lay ahead of him, during which the rival claims of direct observation and traditional forms, of open-air painting and studio work, at times seemed irreconcilable.

The general patterns of his work changed little in the immediate aftermath of his visit to Italy. He continued to paint commissioned portraits, and he sold to Durand-Ruel many landscapes and still lifes, as well as figure subjects which included both nudes and modern-dress themes; landscapes intended for sale to the dealer were his main output during his travels. This stock-in-trade was interspersed with some more ambitious pro-

jects. His three *Dance* canvases of 1882–3 (nos. 67–9), simpler and more clearly structured than *Luncheon of the boating party*, were among the last of his major pictures of urban and suburban recreation. However, during the same years he became preoccupied by the theme of nude figures by the seashore; he had planned such a picture in 1881, before leaving for Italy, and returned to the idea on the island of Guernsey in 1883; but on this occasion he intended his outdoor sketches to be only 'documents for making paintings in Paris' – an explicit return to more traditional practice, which led to the production of *Seated bather* (no. 72) in his Paris studio.

Renoir had refused to exhibit in the impressionist group exhibition in 1881, as in 1879 and 1880; reluctant to exhibit in the group show of 1882, which Durand-Ruel organized, he could not stop the dealer from including a group of paintings that he already owned. However, he co-operated willingly in April 1883, when Durand-Ruel mounted Renoir's first one-man exhibition, an ambitious group of seventy mainly recent works. Renoir continued to submit paintings, mainly portraits, to the Salon until 1883 (cf. no. 70), though he became increasingly disillusioned with his prospects in this forum, since his works were badly hung and little noticed, despite the success he had gained in 1879 with *Portrait of Madame Charpentier and her children* (no. 44). It was only in 1884 that he stopped submitting to the Salon, as he became more preoccupied with technical experiments.

Renoir's social life during these years was divided, as it had been in the late 1870s, between the circle of Bohemian friends who visited him regularly in his studio in the rue Saint-Georges, and the network of contacts which brought him portrait commissions. Around 1880 he met a young dressmaker, Aline Charigot, who worked near his studio. She became one of his models and accompanied him on part of his Italian trip (cf. no. 63); but she may not have become his regular companion until around 1884, when she became pregnant and he left the rue Saint-Georges. Among his bourgeois patrons, he maintained close contacts with Madame Charpentier and her circle and became particularly friendly with Paul Berard (see no. 60), who regularly welcomed him in his country house outside Dieppe.

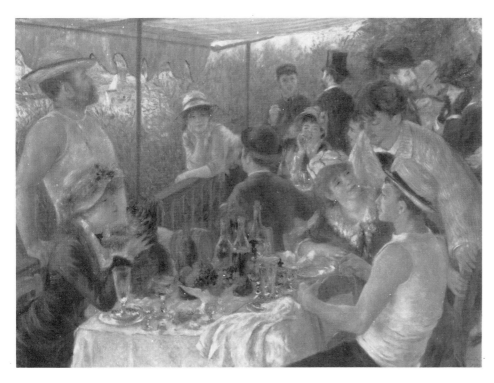

52

Luncheon of the boating party

Le Déjeuner des canotiers
1880–1
130 × 173 cm (51 × 68 ins)
Signed and dated bottom right:
Renoir./1881.
The Phillips Collection, Washington, D.C.

COLOUR *pp. 96, 97*

Exhibited in Paris only

Luncheon of the boating party is a second large, multi-figure subject of informal recreation, a follow-up to *Ball at the Moulin de la Galette* of 1876 (no. 40), on a canvas of the same size. Though the picture is dated '1881', Renoir sold it to Durand-Ruel in mid-February 1881; thus his outdoor work on it belongs to the summer of 1880, with any necessary reworking and elaboration added during the following winter. He wrote to Berard, presumably in August or September 1880, to announce the project: 'I hope to see you in Paris on the first of October, for I am at Chatou. I couldn't resist sending all my decorations packing, and I'm doing a painting of oarsmen which I've been itching to do for a long time. I'm not getting any younger, and I didn't want to defer this little festivity which later on I won't any longer be able to afford – already it's very difficult. I don't know if I will finish, but I've told Deudon about my troubles and he has given me his approval; even if the enormous expenses I'm incurring prevent me from finishing my picture, it's still a step forward, one must

from time to time attempt things that are beyond one's capacity.' Later in the autumn he wrote to Berard again: 'I'm obliged to go on working at this wretched painting because of a high class *cocotte* who had the impudence to come to Chatou wanting to pose; that put me a fortnight behind schedule and, in a word, today I've wiped her out and . . . I no longer know where I am with it, except that it is annoying me more and more' (Berard, 1968).

Renoir had painted occasional large canvases throughout the 1870s; most recently he had exhibited *Mussel-fishers at Berneval* (no. 81 fig. a) without success at the 1880 Salon. However, *Luncheon of the boating party*, with its many figures and complex spatial organization, was a more ambitious project than any of these except for *Ball at the Moulin de la Galette*. Renoir may have been encouraged to undertake another such theme in summer 1880 by the challenge which Zola issued to the Impressionists in his review of that year's Salon, to paint ambitious, substantial modern-life subjects, worked at over a period of time, rather than being satisfied with informal sketches (cf. Zola 1970, pp. 335–8, 341). In the four years that separated *Ball at the Moulin de la Galette* from *Luncheon of the boating party*, Renoir had come to see the limitations of an exclusive dedication to open-air effects. Portrait commissions had forced him to individualize his figures more precisely (cf. nos. 53, 60), and in his handling of paint he had experimented with alternatives to the freely brushed, superimposed layers of colour of *Ball at the Moulin de la Galette* (cf. nos. 45, 49).

Luncheon of the boating party reflects these

changes. The touch and colour are more varied and serve to distinguish individual figures and their features, rather than absorbing all into an overriding harmony of coloured atmosphere; the composition, though complex, has a far clearer overall structure, framed by foreground figures at both sides and receding in a gentle diagonal through the centre. Though he still suggests effects of outdoor sunlight, diffused by the awning under which the figures take their lunch, the play of coloured light is now confined within individual forms; while the white tablecloth and vests of the two foreground men show rich nuances of soft colour, they remain distinct, light-toned anchors to the whole composition, set against the darker tones and accents of brighter colour around them. It has been suggested that the crucial role given to white in the picture reflects Renoir's experience of the North African light in Algeria in spring 1881 (London, Royal Academy, 1984). However, Renoir sold the picture before he left for Algiers; thus the clear whites in such Algerian pictures as *Arab festival* (no. 56) were only a development of experiments which he was already making in paintings such as *Luncheon of the boating party* before he travelled south. Renoir himself later described the changes in his technique after *Ball at the Moulin de la Galette*: 'After that painting, he profoundly changed his handling, his palette became richer, and, he said, he knew better than before how to compose his figures' (Rivière 1921, p. 140).

The painting's final surface is dominated by crisp contrasts. Comparatively smoothly brushed areas with soft variations of colour are juxtaposed with impasted brightly coloured accents; warm and cool colours, dark and light tones lie beside each other. At certain points, the paint is very thick, notably in the highlights on the still life on the table; but close alongside these are small areas where the canvas, primed with a light grey, is virtually unpainted. At many points, rich vermilion accents were added to animate the final surface very late in its execution – on the dress of the girl leaning on the balustrade in the centre, around the ruff of the girl seated at bottom right, and in many other places. These emphasize the closely coordinated relationships of colour which run throughout the painting, alongside the sequences of dark and light tones. These two methods of surface organization, by colour and by tone, had traditionally been used separately, or with one subordinated to the other. This was how Renoir had used them in earlier paintings: in his *Cabaret of Mother Antony* of 1866 (no. 4) colour accents are subordinated to the tonal structure, while in *Ball at the Moulin de la Galette* of 1876 tone is subordinated to colour. Here, though, Renoir managed to combine both methods, to produce a picture where tonal architecture and

lavish coloured interplay can coexist and complement each other on equal terms.

The execution of the painting was a complex and protracted business. No preparatory studies survive for it; some may have been lost, but the surface of the picture suggests that much was worked out on the final canvas during its execution. Some contours have been shifted, notably in the bottom right figure. Elsewhere, erased colours show through superimposed paint layers; most notably, in several places strong reds seem to have been overpainted with more restrained colours: reds show through in the trousers of the man at bottom right, down the back and around the hat of the girl at the left, and beneath some parts of the background figures. These suggest that, in its earlier stages, the picture contained larger areas of bright colour, and that during its execution Renoir made a wholesale revision, by emphasizing tonal contrasts in these larger areas, and reserving his sharpest colour for the vibrating red accents which he added across many parts of the canvas after the erasure of these larger red areas.

Without the evidence of X-rays it is hard to tell how extensively Renoir changed the canvas. Dry paint layers run beneath the contours of several of the figures, ignoring their final positions, which may suggest that they were added, or their position was altered, while the painting was underway. In particular, very different configurations of paint lie beneath the top-hatted figure in the background. This figure has generally been identified as Charles Ephrussi, banker and amateur art historian (cf. p. 21); Renoir's second letter to Berard about the picture may well explain his late arrival on the canvas: 'I don't know if Ephrussi has got back yet; I'm wasting this week too, because I've done it all. . . .' This suggests, understandably enough, that the picture was painted additively, with Renoir's various sitters posing when they could visit him at Chatou; this is confirmed by the passage of the same letter, quoted above, in which he described the visit of the *cocotte* who wanted to feature in it.

The identity of the models has been the subject of some debate; the various identifications are summarized by Carey (1981). Most plausible are those given by Meier-Graefe in 1912, which correspond exactly to the indications on an early photograph of the painting in the Archives Durand-Ruel; this photograph notes as unknown the identity of certain figures that Meier-Graefe does not mention, which suggests that it may well have been his source. Aline Charigot, later Renoir's wife (cf. nos. 78, 79), sits at bottom left, with, above her, Alphonse Fournaise Jr, son of the proprietor of the restaurant where the scene is sited. The girl leaning on the balustrade is listed (Archives Durand-Ruel) as an unknown model; she is

talking to Baron Barbier, an ex-cavalry officer and bohemian friend of Renoir's and a close friend of Maupassant. Beyond, an unknown man (Archives Durand-Ruel) talks to the top-hatted Ephrussi; below them the model Angèle is drinking. At top right Renoir's friends Lestringuez and Lhote (the latter, in a straw boater, also modelled for the 1882–3 *Dance* pictures, nos. 67–9, and both had appeared in *Ball at the Moulin de la Galette*) talk to a girl. Jean Renoir identified her as the actress Jeanne Samary, but the earlier sources do not name her. At bottom right the journalist Maggiolo leans over the model Angèle (appearing for a second time), while at bottom right is Gustave Caillebotte, 'made to look much younger' (Archives Durand-Ruel). Jean Renoir's suggested alternative or additional identifications, made many years later, do not carry conviction, except, perhaps, for the suggestion that the girl at bottom right is not Angèle (who, as seen drinking in the background and in no. 50, was a brunette), but rather the actress Ellen Andrée, a golden blonde who posed for many other pictures, including Degas's *L'Absinthe*.

The site was the upstairs terrace of the Restaurant Fournaise, on an island in the Seine at Chatou, with a view downstream to the Chatou railway bridge in the background. The building appears as Renoir depicted it in a contemporary photograph (Catinat, p. 45; Carey, p. 3); it still exists, in very dilapidated condition, and there are plans to restore it. Renoir had painted members of the Fournaise family before, and he used the terrace as the site for other pictures, notably the so-called *At La Grenouillère* of 1879 (Jeu de Paume; La Grenouillère was in fact a little further downstream) and *On the terrace* of 1881 (Art Institute of Chicago). The Restaurant Fournaise was at this date a celebrated meeting place among the oarsmen on the Seine to the west of Paris. A luncheon there, just like the one Renoir composed in 1880–1, was described by the journalist Gustave Goetschy in 1879 in *La Vie moderne*, to which Renoir often contributed: 'The meal is tumultuous; the glasses are filled and emptied with dizzying speed; the conversation goes to and fro, interrupted by the clatter of the knives and forks which perform a terrible dance on the plates. Already a rowdy, heated intoxication rises from the tables, all filled with the débris of the meal, on which the bottles quiver and shake.' ('Les Canotiers: poème naturaliste traduit du javanais', *La Vie moderne*, 23 August 1879, p. 318.)

Many early commentators on Renoir's picture described it in terms which clearly echo journalism of this type; but Renoir, in composing it, was at pains to prevent the picture, or any of its parts, from being legible in narrative terms. The gestures and expressions of the figures are consistently amicable yet consistently inexplicit: we are

given no access to the content of their interchanges or the nature of their relationships; even the girl at top right, often described as modestly covering her ears from the blandishments of the man beyond her, may simply be adjusting her hat before leaving. Renoir established a milieu, and sought out the gestures most characteristic of its rituals; he knit these together into closely interwoven relationships of colour, tone, shape and pattern, but their interconnections are pictorial, rather than psychological or narrative. Renoir consistently rejected the codes of legibility so widely used in contemporary genre painting, using his subjects to evoke moods rather than to tell a story (cf. also nos. 67–9).

Luncheon of the boating party is perhaps a sort of tribute to an old master painting which Renoir studied throughout his career: Veronese's *Marriage feast at Cana* in the Louvre (fig. a). The group at lower left of Veronese's vast composition bears a generic similarity to Renoir's picture in its theme, an image of contemporary festivity, and also in its richness of colour and texture and in the way in which it was composed; Renoir, like Veronese, favoured densely interwoven compositions, and disliked open spaces in pictures – a fascinating contrast to the unexpected intervals and voids which Degas consistently introduced into his paintings.

Durand-Ruel bought the painting for a high price in February 1881, and sold it that December to the banker Balensi, who, apparently, failed to pay for it. Durand-Ruel took it back in April 1882, and it became one of the centrepieces of his private collection, until in 1923 his sons sold it to Duncan Phillips, in order to finance new premises for the Durand-Ruel gallery (cf. New York, Wildenstein, 1969).

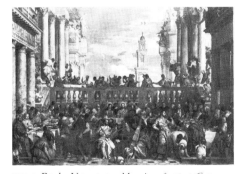

FIG a. Paolo Veronese, *Marriage feast at Cana*. Musée du Louvre, Paris.

LITERATURE
Silvestre 1882, p.151
Morel 1883, p.2
Lecomte, *Art impressionniste*, 1892, pp.201–4
Mauclair 1902, pp.221–2
Mauclair, *Impressionists*, 1903, p.123
Lecomte 1907, p.250
Meier-Graefe 1908, I, p.292
Duret 1910, pp.178–9
Meier-Graefe 1912, pp.105–6
Rivière 1921, pp.138,184–7
Duret 1922, pp.101–2
Jamot 1923, pp.321–4
Duret 1924, pp.81–2
Meier-Graefe 1929, pp.152–4
Barnes and de Mazia 1935, pp.404–5 no.116
Drucker 1944, pp.62–3, 204–5 no.74
Pach 1950, p.74
Rouart 1950, p.104
Catinat 1952, pp.37–51
Rouart 1954, pp.53–7
J. Renoir 1962, pp.200–4
Gimpel 1963, pp.181, 225
Berard 1968, pp.3–5
New York, Wildenstein, 1969, Foreword
Daulte 1971, no.379
M. Carey, *Pierre-Auguste Renoir, The Luncheon of the Boating Party*, Washington 1981
Gaunt and Adler 1982, no.36
London, Royal Academy, 1984, p.222

EXHIBITIONS
1882, Paris, Septième exposition (140)
1883, Paris, Durand-Ruel (37)
1883, Boston (26)
1886, New York, American Art Association (185)
1892, Paris, Durand-Ruel (5)
1898, Paris, Durand-Ruel
1899, Paris, Durand-Ruel (83)
1904, Paris, Salon d'Automne (11)
1905, London, Grafton Galleries (244)
1917, Zurich (167)

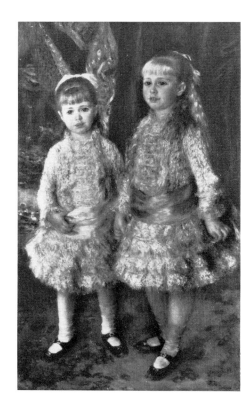

53

The Cahen d'Anvers girls

Les Demoiselles Cahen d'Anvers
1881
119 × 74 cm (47 × 29 ins)
Signed and dated bottom right: Renoir. 81.
Museu de Arte de São Paulo,
Assis Chateaubriand

COLOUR *p.103*

The story of this commission is a good example of how Renoir built up his network of portrait patrons, and of the difficulties of relations between patrons and painter. Duret, the art critic and supporter of the Impressionists, had taken Renoir to the receptions given by Cernuschi (the orientalist with whom Duret had travelled to Japan); here Renoir met Charles Ephrussi (the financier who became director of the *Gazette des Beaux-Arts*), who in turn introduced him to Madame Cahen d'Anvers, wife of a banker (see Duret 1924). She commissioned, first, a portrait of her eldest daughter Irène (Bührle Foundation, Zurich), and then the present double portrait of her two younger daughters Elisabeth (born December 1874) and Alice (born February 1876).

Renoir completed the picture just before leaving for Algiers late in February 1881; as he told Duret, he could not tell whether it was good or bad (letter of 4 March 1881; Paris, Braun, 1932). Payment seems to have been delayed, for Renoir wrote ill-humouredly to Charles Deudon

(also one of Cernuschi's circle) on 19 February 1882 while recovering from pneumonia at L'Estaque: 'As for the Cahens' 1,500 francs, I think I can tell you that I find that pretty stiff. How mean can you get? I must really give up with the Jews' (Schneider 1945). The Cahen family were not satisfied either: no one wanted the picture in their room, and it was relegated to the servants' floor. Here the Bernheims found it around 1900, after Renoir had told them where to seek out past commissioned portraits by him (Dauberville 1967, p.219). Madame Cahen lent the picture to the Bernheim exhibition in 1900, but soon afterwards the Bernheims bought it for their private collection (cf. Dauberville 1967, p.552).

The painting, exhibited in 1900 as *Rose et bleu*, is a fantasia on the elaborate dresses of the little girls, the blonde in blue, the brunette in pink, set in a richly decorated salon. Renoir has chosen a format comparable to seventeenth-century court portraiture, and particularly to Van Dyck's full-length portraits of children, where the diminutive scale of the models demands a more intimate close-up viewpoint, which is combined with the trappings of the grand portrait. Renoir told Blanche around this date of his problems satisfying his portrait patrons: 'If I rework a head the next day, I'm done for; but it's a portrait, it's necessary for a mother to recognize her daughter' (Blanche 1933, p.292). The younger girl, later Lady Townsend of Kut, remembered in old age that only the pleasure of wearing the lace dress had consoled her for the boredom of posing for Renoir (Jullian 1962).

Renoir intended to exhibit this portrait at the 1881 Salon (Florisoone 1938). It has been suggested (White 1969) that the picture was actually shown there; however, this seems unlikely unless the Salon catalogue misrecorded his exhibit, for the two oils he showed (nos.1986–7) were each listed as *Portrait de Mlle ****.

LITERATURE
Wright 1915, p.120
Duret 1924, p.62
Paris, Braun, *L'Impressionisme*, 1932, p.11
Barnes and de Mazia 1935, p.405 no.117
Florisoone 1938, p.40
Schneider 1945, p.99
London, Arts Council, 1954, no.54
Jullian, P., '"Rose" de Renoir retrouvée par Philippe Jullian', *Figaro Littéraire*, 22 December 1962
Dauberville 1967, pp.219, 552
White 1969, pp.335, 338
Daulte 1971, no.361 and pp.45, 410

EXHIBITIONS
1900, Paris, Bernheim-Jeune (15)
1913, Paris, Bernheim-Jeune (20)

54

Young woman reading an illustrated journal

Jeune femme lisant un journal illustré
c.1880–1
46 × 56 cm (18 × 22 ins)
Signed top right: Renoir.
Museum of Art, Rhode Island School
of Design, Museum Appropriation, 22.125

COLOUR *p. 93*

Renoir executed many small informal modern-life subjects of this type in the later 1870s and early 1880s. It is fully finished in its own terms, but freely painted, with soft supple brushwork and rich opaque colour. Three-dimensional form is suggested by coloured nuances alone, without conventional tonal modelling; the varied warm hues used in painting the girl's hair focus on the ways in which the light catches it, giving little clue to the actual colour of the hair. The painting is probably roughly contemporary with *Luncheon of the boating party* (no. 52): both pictures are enlivened with heightened reds and red-oranges – here particularly where the girl's hair crosses her eye and cheek. Indeed it is possible that the model here was his wife-to-be Aline Charigot, since she looks similar to the lower left figure in *Luncheon of the boating party*, generally identified as Aline. Informally though this picture is composed, its internal relationships are carefully considered – for instance, the way in which the decorated vertical bands at upper right set off the sweeping brushwork of the hair.

Pictures of girls reading had been common at least since the eighteenth century (cf. Fragonard's *L'Etude*, p. 250 fig. a), but Renoir has here wittily questioned the expectations of this theme by concealing the eyes of the reading girl and by displacing the visual focuses of the picture, locating the main highlights on her neck and wrist and on the page she is reading. The double-page spread in the magazine is very characteristic of contemporary illustrated weeklies such as

La Vie parisienne or Georges Charpentier's *La Vie moderne*.

Durand-Ruel purchased the picture at the Morten I. Lawrence sale (New York, 29 January 1919), but it seems to have been in his stock in the 1880s; it may be the same as *Femme regardant des images* which he bought from Renoir in December 1885 and shipped to New York in February 1886, where it was probably exhibited in the American Art Association exhibition that spring. According to the records of the Rhode Island School of Design, the present painting was bought from Durand-Ruel by Erwin Davis soon after it arrived in the United States in 1886.

LITERATURE
L.E.R., 'Renoir in the Museum', *Bulletin of the Rhode Island School of Design*, April 1923, pp. 18–20
Daulte 1971, no. 300

EXHIBITION
? 1886, New York, American Art Association (? 259)

55

Algerian landscape: The Ravin de la Femme Sauvage

Paysage d'Algérie: Le Ravin de la Femme Sauvage
1881
65 × 81 cm (25½ × 32 ins)
Signed bottom left: Renoir.
Musée d'Orsay, Paris (Galerie du Jeu de Paume), RF 1943–62

COLOUR *p. 98*

Tired after completing the portraits of the Cahen d'Anvers girls (no. 53), Renoir left for Algiers around the end of February 1881, on a quest traditional among French nineteenth-century painters, in search of sunlight and exoticism. His letters from the trip record his enthusiasm for the place – the fertility of the land, the kind climate, the rich vegetation (cf. especially letter to Mme Berard, March 1881, Archives Durand-Ruel; extracts, Paris, Drouot, 11 June 1980, lot 92). During his first visit he focused mainly on landscapes in the immediate surroundings of Algiers, particularly in the area around where he was staying, on the Champ de manoeuvres at Mustapha inférieur, just south of the city. Some of his paintings show the views from the hills over the sea, but *The Ravin de la Femme Sauvage* shows a more enclosed subject. The scene is unpeopled and seems remote and exotic, but the subject was within very easy reach – a narrow valley which led down towards the sea from Birmandrais (Bir Mourad Rais), a mile or so inland from where Renoir was staying. The valley's name, indeed, far from reflecting an exotic past, apparently commemorated 'a young lady, by no means shy, who kept a café restaurant in this ravine shortly after the French conquest' (R.L. Playfair, *Murray's Handbook for Travellers in Algeria and Tunis*, 1895 edition, p. 108). The valley itself was apparently overrun by buildings and a tramway the year after Renoir had painted it (Bazin 1946).

The main subject of the painting is the exotic foliage – presumably the 'mixture of

prickly pear and aloes' which he mentioned in his letter to Mme Berard. A free scatter of multicoloured touches conveys foliage and lighting, sometimes with soft dabs of paint, sometimes with crisp little dashes; rich blues suggest the shadows, with flashes of red and orange in the lights. But this surface activity is underpinned by a quite orthodox pictorial structure, framed by the foliage at top left and the hill on the right, and leading back into space in an arc from the boldly sketched aloes.

The painting was in Durand-Ruel's possession when he reorganized his stock in 1891, but it is unclear from his records when he first bought it; he sold it in April 1909 to Bernstein – presumably the actor Henry Bernstein whose portrait Renoir painted in 1910.

LITERATURE
Bazin 1946, pp.6–10
Callen 1978, p.79

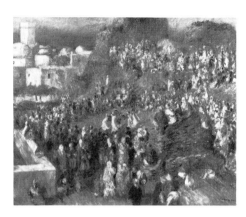

56

The mosque (*known as* Arab festival)

La Mosquée (dit *Fête arabe*)
1881
73 × 92 cm (28½ × 36 ins)
Signed and dated bottom right: Renoir 81.
Musée d'Orsay, Paris (Galerie du Jeu de Paume, Gift of the Fondation Biddle in memory of Margaret Biddle, 1957),
RF 1957–8

COLOUR *p. 99*

Arab festival is exceptional among the pictures Renoir brought back from Algeria; it is the only one to show any sort of local custom, rather than simply landscapes, views or local types. However, the subject has not been precisely identified. The painting was titled *La Mosquée, fête arabe* in Durand-Ruel's records when he bought it in 1892, and it has been assumed (London, Royal Academy, 1984) that it depicts a religious celebration. But it is the only painting which fits a description by Gustave Kahn of a canvas exhibited at Durand-Ruel's in 1888: 'A sketch of a swarm of Arabs at Algiers inadequately renders the polychrome movement of these oriental crowds;' the one painting in the exhibition catalogue to which this description can refer is titled *Saltimbanques à Alger* – which raises the possibility that the objects of the crowd's attention are itinerant performers, rather than religious fanatics. The painting was exhibited in 1906 with the title *Fête au camp*; it was later generally known as *La Casbah*.

The elevated viewpoint looking down on urban groups of figures is a cliché of impressionist pictorial composition, here translated into an exotic milieu. But the crowd here are themselves spectators, rather than passers-by. The performers are placed in the centre of the composition, but the viewer of the picture is so distant and so detached from them that its principal subject becomes the swirling ranks of the audience, a sea of dazzling colour into which their performance is absorbed. Viewing his subject at this range Renoir had little need, or little chance, to find a distinctive pictorial form to express the local dance movements.

In his reminiscences of Algeria, Renoir described how the sunlight transformed the humblest beggars into the semblance of legendary beings (Vollard 1938, p.267; Rivière 1921, p. 190) and spoke of the effect of the sun: 'In Algeria I discovered white. Everything is white, the burnouses, the walls, the minaret, the road' (J. Renoir 1962, p.228). More than the other pictures from his first visit, *Arab festival* uses white to create a pictorial structure within which, in painting the crowd, he could use his most virtuoso technique of sketching in full, impasted colour. However, this was not simply the result of his experience of the North African light; *Luncheon of the boating party* (no.52) completed and sold just before he left for Algiers, already shows a fresh sense of structure and an awareness of the possibility of using zones of light and dark to anchor a composition. The Algerian sun may have demanded a fresh luminosity in his palette, but it confirmed the direction his art was already taking.

Speaking to Vollard many years later, Renoir described one of his Algerian paintings, a 'Fantasia': 'When I delivered this picture to Durand-Ruel, it looked like a heap of crumbled plaster. Durand-Ruel trusted me, and several years later the colour had done its work, and the subject emerged from the canvas as I had conceived it.' Though Vollard dated this picture to Renoir's second visit, in 1882, *Arab festival* is the most likely candidate to be the canvas in question, since Renoir never painted an orientalist *fantasia* (a sort of equestrian exercise). The story shows how early in his career Renoir began to evolve means of compensating for what he most feared as a painter, the changeability of oil colours.

Though Renoir arrived in Algiers in 1881 eager to paint figures, it was only on his second visit, in spring 1882, that he was able to find a number of willing Arab models, from whom he made a few paintings and a number of thumbnail sketches in a notebook (this book, published in facsimile in 1955, contains a Venetian supplier's label; the Algerian drawings in it must thus belong to his second visit, not that of 1881 as suggested by White 1969, p.324). From neither of his Algerian trips, though, did Renoir derive any figure subject as ambitious as the orientalist costume pieces he had painted without leaving France (cf.nos.17 and 20).

Durand-Ruel bought *Arab festival* from Renoir in February 1892, but it had been on deposit in his gallery since December 1888 (while its colour settled?); in January 1900 he sold it to Claude Monet, who kept it until his death.

LITERATURE
? Kahn 1888, pp.544–6
Rey 1931, p.53
? Vollard 1938, p.207
Gaunt and Adler 1982, no.37
London, Royal Academy, 1984, no.109

EXHIBITIONS
? 1888, Paris, Durand-Ruel (19)
1906, Marseille (53)

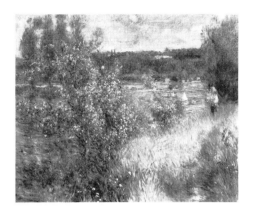

57

The Seine at Chatou

La Seine à Chatou
c. 1881
74 × 93 cm (29 × 36½ ins)
Signed bottom right: Renoir.
Museum of Fine Arts, Boston (Gift of
Arthur B. Emmons, 1919), 19.771

COLOUR *pp. 100, 101*

Renoir worked at Chatou in the late summer of 1880, concentrating on *Luncheon of the boating party* (no.52), and again in spring 1881, after his return from Algiers, when, with *Luncheon of the boating party* finished and sold, he was able to work without the pressure of a major project. At Easter 1881 he wrote from Chatou to Duret to explain his reasons for deferring a planned visit to London: 'I'm struggling with trees in flower, with women and children, and I don't want to see anything beyond that' (Florisoone 1938). *The Seine at Chatou* is very probably one of these paintings of 'trees in flower', together with two canvases of flowering chestnut trees (both dated '81'; Jeu de Paume and Nationalgalerie, Berlin).

The Seine at Chatou is one of Renoir's most ebullient landscapes, vibrant and variegated in colour and technique. The canvas is dominated by the varied greens of the foliage and the blues of water, sky and shadows, but the whole is threaded through with warm hues, orange-reds, pinks and dull carmines, which constantly enliven the scene. The brushwork has no overriding order to it: the hatching in the sky is comparable to Pissarro, while the hooks and dashes in the grass are similar to Monet's contemporary paintings of Vétheuil. But the more crisply, literally described flowering tree and the soft, feathery touches in the distance create a diversity quite unlike the more homogeneous pictorial textures which both Monet and Pissarro were already seeking. Within the next year, Renoir, too, was to begin working in a far more clearly structured way (cf. no.64).

The girl on the right of the picture and her bunch of flowers are also treated in free dabs and dashes of colour; she is absorbed into the textures of the rest, rather than differentiated as a point of human interest. But her presence, with the sailing boats and the houses suggested on the far bank, show that this is a suburban rather than a rural scene, evoking with its freshness of technique and colour a late spring day in one of the most famous playgrounds of Paris's outer suburbs (cf.no.52).

The painting was in Durand-Ruel's possession when he reorganized his stock in 1891; it was presumably one of the Chatou river scenes he bought from Renoir in 1881, and it was thus very probably one of the paintings by Renoir that the dealer included in the seventh impressionist group exhibition in 1882. The dealer sold it at auction in New York on 19 December 1894.

LITERATURE
? Florisoone 1938, p.40

EXHIBITION
? 1882, Paris, Septième exposition

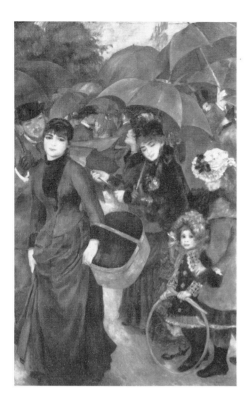

58

The umbrellas

Les Parapluies
c. 1881 and *c.* 1885
180 × 115 cm (71 × 45 ins)
Signed bottom right: Renoir.
The Trustees of The National Gallery,
London, 3268

COLOUR *p. 119*

Exhibited in London and Paris only

Though so popular and so widely reproduced since it entered the English national collections as part of the Lane Bequest in 1917, *The umbrellas* remains a puzzling picture, because of the clear discrepancy between its two halves, in handling and colour and in the female fashions depicted. The canvas belongs to Renoir's long sequence of ambitious vertical paintings of modern-life scenes – most of them virtually the same height – which began with *Lise with a parasol* (p. 181 fig. f) in 1867. Most relevant to *The umbrellas* is *Leaving the Conservatoire* of *c.* 1877 (Barnes Foundation, Merion), which depicts full-length groups of fashionably dressed men and women in the street, in a similarly informal and loosely structured composition. *The umbrellas* also recalls the types of figure grouping used in *Ball at the Moulin de la Galette* of 1876 (no. 40).

It seems virtually certain that the picture, in its present form, was executed at two dates, and that there was an interval of about four years between the painting of the group on the right (the child with a hoop and the woman beyond her, together with parts of the girl at far right and perhaps of the woman in profile in the centre) and the remainder of the picture. The umbrellas and background all belong to the second stage of execution, along with the couple at the left, whose appearance contrasts so markedly with the figures on the right. Three types of evidence support this conclusion: the picture's handling; the female fashions depicted; and technical examination and X-rays.

The figures on the right are treated with a soft, feathery touch; their features are not clearly modelled or crisply contoured, and their colour is rich and varied. By contrast, those on the left are painted more drily; their forms are more crisply silhouetted and features like the couple's eyes are far more precisely drawn. The colour is duller and, in the woman's dress, is treated in comparatively distinct zones, which follow its modelling and folds, rather than dissolving into a kaleidoscopic surface. Approximate dates can be suggested on these grounds, but it is to be hoped that the present exhibition will make such arguments far clearer, by showing the picture alongside many of the most relevant comparative examples. The earlier part shows the soft, pliant technique that Renoir used on occasion from around 1875 until 1881; it appears in 1880–1 in *Luncheon of the boating party* (no. 52), in 1881 in *On the terrace* (Art Institute of Chicago). Overall, the tonality of *The umbrellas* is cool, but the heightened orange in the hair of the girl on the right, together with the treatment of her lost profile, are reminiscent of *Young woman reading an illustrated journal* (no. 54) of *c.* 1880–1; similarly accentuated warm hues appear in *Luncheon of the boating party*. On the left, the drawing of the faces is comparable to *Child with a whip* of 1885 (no. 76), while the modelling of the dress relates to the treatment of the jacket in *Portrait of Aline Charigot* of *c.* 1885 (no. 78); the tree at top left resembles the foliage in *La Roche-Guyon*, also of *c.* 1885 (no. 77), with its echoes of Cézanne.

The female fashions depicted supply the most precise evidence for dating the picture (cf. London, National Gallery, 1970, and detailed discussions compiled by Stella M. Pearce in the National Gallery files). The figures on the right are wearing expensive clothes of a type which came into vogue in 1881 and remained fashionable in 1882; a date before 1881 seems impossible. The dress of the woman on the left – quite different in cut and far more severe in its lines – came into fashion only in 1885, and would have become outmoded by 1887. In his modern-dress paintings Renoir consistently depicted his sitters in the latest fashions; indeed, a coloured lithograph after *On the terrace* was used as a plate in the fashion magazine *L'Art de la mode* in 1882. There-

fore, over and above the evidence of technique, it seems most implausible that Renoir would have painted the woman and child on the right at the same time as the woman on the left, since her clothes would have been conspicuously out of date by 1885, the earliest possible date for the left figure.

According to the National Gallery catalogue, the canvas was originally somewhat larger at left and bottom: the present tacking margins on these edges are painted. But X-rays suggest that the arrangement of the figures within the composition was not greatly altered, and the picture may have been only slightly cut down. Nor do X-rays confirm the suggestion in the National Gallery catalogue that a band across the top was originally unpainted: they show no visible change in treatment at this point. The X-rays do, though, show underpainting of completely different types beneath the two main groups; their paint surfaces were clearly built up in quite different ways. Those on the right were only very loosely indicated below, and their forms were gradually refined, which suggests that work on the canvas only began around 1881; but beneath those on the left the forms were clearly and firmly defined. The man's face and arm here were originally a little further up, and the woman's features rather different, with a larger mouth, perhaps smiling, and curlier hair. Her dress was much changed: it originally had frilly or lacy cuffs and collar, and there are traces of a horizontal belt, or waistline, just to the left of the left end of the strap of her band box; however, it seems likely that Renoir scraped off much of the original painting of her dress before executing it in its present form. It remains unclear whether, in their original form, the figures on the left were painted at the same time as those on the right, or whether the X-ray reveals an intermediate stage, between 1881 and 1885. A number of drawings of related themes survive (Drucker 1944, pl. VIII; Daulte 1959, pls. 1, 4), but they do not help us to date the execution of *The umbrellas*, since none of them seems to have served directly as a study for it.

However Renoir arrived at the final result, he clearly decided that he could not, or did not want to, rework the right side to make it conform to the left. As the painting's early history shows (see below), this must have affected its saleability: to a contemporary eye, the discrepancy in the fashions would have been far more glaring than it is today – comparable, in late twentieth-century terms, to the contrast between a mini-skirt and a kaftan. One can only surmise why Renoir did not continue to work on it: very possibly each group seemed to him a success in its own terms; but it is also likely that, by the time he finished the figures on the left, he no longer wished to rework the rest of such a complex, loosely structured grouping of fig-

ures. In the early 1880s, he had increasingly been seeking simple, clear-cut figure groups, for instance in the three tall *Dance* canvases of 1882–3 (nos. 67–9) – exactly the same height as *The umbrellas*, and painted in the interval between its two stages. After these, *The umbrellas* would have seemed a throwback to the types of composition he had favoured before his trip to Italy in 1881–2. On their own, the two figures on the left are reminiscent of the *Dance* pictures: a couple, closely juxtaposed and interlocked in pictorial terms, whose personal relationship is left quite undefined – indeed, here we do not even know whether there is any relationship between them. This sort of open-ended presentation of modern types on parade in the streets or in places of entertainment had been a speciality of Renoir's until this date (cf. nos. 26, 40, 49). After 1885, Renoir painted no more monumental modern-life subject pictures. The state in which he left *The umbrellas* bears witness to the concerns which led to this crucial change in his career, seen in the *Bathers* (p. 241 fig. a), the manifesto picture of his phase of experiment.

The early history of the painting confirms that it presented problems. Renoir deposited it with Durand-Ruel in April 1890, and the dealer bought it from him in February 1892, for a price very modest for a painting of this size. Alone of Renoir's major paintings it was not rapidly exhibited in Paris – notably not in the important retrospective of Renoir's work which Durand-Ruel organized in May 1892, shortly after buying the painting; presumably the discrepancy in the fashions depicted would still have been far too apparent for the painting to carry conviction. This would presumably have been less worrying to Sir Hugh Lane when he bought the picture from Durand-Ruel in 1907, and to the Irish public when the painting was put on display in the Municipal Gallery in Dublin in 1908.

LITERATURE
Fry 1917, pp. 148–9
André 1928, pp. 20–1
Drucker 1944, p. 205 no. 76
Bell 1945
Demus, O., 'The Literature of Art, Auguste Renoir, Les Parapluies', *Burlington Magazine*, October 1945, pp. 258–9
Gowing 1947, p. 6
Pach 1950, pp. 68–9
London, National Gallery, *French School, Early 19th Century, Impressionists, Post-Impressionists etc.*, catalogue by M. Davies and C. Gould, 1970, pp. 119–120
Daulte 1971, no. 298
Gaunt and Adler 1982, no. 39
Information in the files of the National Gallery, London

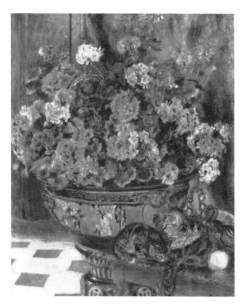

59
Geraniums and cats

Géraniums et chats
1881
91 × 73 cm (36 × 28½ ins)
Signed and dated bottom right: Renoir.81.
Private Collection, New York

COLOUR *p. 91*

Exhibited in Boston only

Around 1880, Renoir painted a number of elaborate, ambitious still lifes. It seems that, at this date, both he and Monet found that there was a more reliable market for still lifes than for their other work. Here Renoir chose an unusually complex arrangement. The upper half of the canvas is virtually filled with flowers, set against a curtain; but below this, the obliquely angled table, with sleeping cats, contrasts with the open spaces of the floor on the left. The huge bowl in which the flowers are growing stands on an elaborate pedestal, apparently just beyond the table. Renoir did at times include elements in his compositions which were cut off by the margin of the picture (cf. too no. 49), but, unlike Degas, he always arranged his compositions so that their principal subject was unequivocally their central focus. The lavish, high-key colour here complements the sumptuousness of the subject and its arrangement.

The picture was among the first for which Durand-Ruel found a buyer in the United States; he sold it at his 1886 New York exhibition to A.W. Kingman. It is presumably the picture that he bought from Renoir in October 1881 with the title *Géraniums* and included in the seventh impressionist group exhibition in 1882; the dealer sent this picture to London in April 1883 for the exhibition at the Dowdeswell Gallery, but it does not appear in the exhibition catalogue.

LITERATURE
New York, Wildenstein, 1969, no. 41

EXHIBITIONS
? 1882, Paris Septième exposition (156)
? 1883, London, Dowdeswell
1886, New York, American Art Association (284)

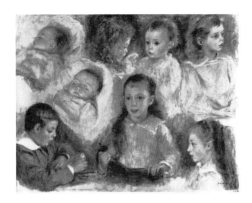

60

Sketches of heads (the Berard children)

Croquis de têtes (les enfants Berard)
1881
62 × 83 cm (24½ × 32½ ins)
Signed and dated bottom right: Renoir.81.
Sterling and Francine Clark Art Institute,
Williamstown, Massachusetts, 590

COLOUR *p. 102*

Between 1879 and 1884 Renoir painted a long sequence of pictures for Paul Berard, a diplomat and banker (see p. 22). He had met Berard through Charles Deudon, like him a frequent visitor at Cernuschi's house (cf. no. 53). For his first commission for Berard, a portrait of his eldest daughter Marthe (Museu de Arte, São Paulo), Renoir chose a deliberately restrained colour range (Duret 1924, p. 63), but the family liked the painting; Renoir quickly became a close friend of Paul Berard and a regular guest at their country house, the Château de Wargemont outside Dieppe. His later pictures of the Berard children include some of his most lively and unusual portraits (cf. also no. 74). During his stays at Wargemont Renoir also entered enthusiastically into the life of the household, striking up cordial relations with the chief servants and relishing their Saturday trip to market-day in Dieppe, where he appeared in a pointed canoeist's hat (Blanche 1937, pp. 35–8).

Renoir frequently juxtaposed sequences of heads on a single canvas or sheet of paper (cf. p. 242 fig. b), but these were generally private studies, not intended for public view; in 1892 he showed an interviewer some of these, pointing out the freedom that such little sketches allowed him, but insisting he did not exhibit them because he did not regard them as 'complete pieces' ([Anon.], *L'Eclair*, 1892). Exceptionally, though, he did regard the present picture as complete in its own terms, and he exhibited it in 1883 with the title *Croquis de têtes*; the heads in it are far more highly finished than most of his pictures with multiple images.

It shows all four of the Berard children: André (born 1868) at bottom left; Marthe (born 1870) at bottom centre and bottom right; Marguerite (born 1874) at top right and in profile at top centre; and Lucie (born 1880) twice at upper left, and probably again as the third head along the top row. The format allowed him to view the children informally from many angles without the demands of having to build a whole composition from a single pose. Perhaps, too, the juxtaposition of all these heads gives some idea of the house: as Blanche remembered, 'the Berard girls, unruly savages who refused to learn to write or spell, their hair wind-tossed, slipped away into the fields to milk the cows' (1937, pp. 37–8).

The faces are treated with great delicacy, while the soft brushing between them allows the eye to slip easily from one to the next; yet the whole is unobtrusively structured – anchored by the frontal figure with the red book at bottom centre, and held together at the top by the blue behind the profile head of Marguerite. The shaded parts of their skin are modelled by blues and also by soft yellows and even reds; their hair is treated in a wide range of colours – blues, purples, reds and yellows – which give the viewer no clear sense of the actual colour of their hair. But, alongside this play of colour, some of their features, particularly the eyes, are picked out with the skill of a miniaturist.

At the Paul Berard sale in 1905, the painting was bought by Albert Pra.

LITERATURE
Duret 1922, p. 100
Berard 1939, p. 12
Daulte 1971, no. 365
Daulte 1972, p. 91

EXHIBITION
1883, Paris, Durand-Ruel (11)

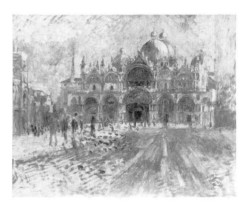

61

Piazza San Marco

La Place Saint-Marc
1881
65 × 81 cm (25½ × 32 ins)
Signed bottom right: Renoir.
The Minneapolis Institute of Arts
(The John R. Van Derlip Fund), 51.19

COLOUR *p. 104*

On his tour of Italy, Renoir made his first major stop in Venice in late October and early November 1881. His Venetian canvases focus on famous sites – readily saleable subjects. But, unlike those of the group which Renoir completed for immediate sale, *Piazza San Marco* was left in a sketch-like state, presumably without studio reworking. Durand-Ruel bought two of the most highly finished Venice paintings, including *The Grand Canal* (fig. a), on Renoir's return from Italy, and included them in the seventh impressionist group exhibition in 1882; *Piazza San Marco*, though, does not seem to have passed through the trade before it was acquired (before 1892) by the novelist and journalist Robert de Bonnières. Like many of the Impressionists' boldest sketches, it was seen as more suitable for an enlightened *amateur* than for a dealer's stock (cf. also no. 36); when it was exhibited in 1892, Alexandre characterized it in the catalogue preface as an *ébauche* (a lay-in). Only rarely did Renoir

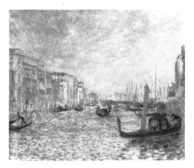

FIG a. Renoir, *The Grand Canal*, 1881. Museum of Fine Arts, Boston (Bequest of Alexander Cochrane, 19.173).

experiment with the virtuoso open-air sketch, the sort of painting which gave the impressionist group their reputation when Monet exhibited *Impression, sunrise* at their first exhibition in 1874.

The Grand Canal and its companion *The Doge's Palace* (Clark Art Institute, Williamstown) are quite tight and fussy in execution; when they were exhibited in 1882, Manet's brother Eugène thought them 'detestable, real failures' (Rouart 1950, p.104), and Armand Silvestre (1882, p.151) called them 'a thoroughly bad compromise between Ziem and Monticelli'. By contrast, *Piazza San Marco*, though it treats an equally hackneyed subject, is uncluttered by attendant details, scarcely hinting at the figures and birds in the Piazza. The church, its gilding and mosaic work glowing in direct and reflected sunlight, is the whole subject; rapid coloured touches, and bold contrasts of oranges and yellows against blues, capture its essential form. This may well be the canvas Renoir mentioned in a letter to Bérard from Venice as 'a study where I have stacked chrome yellow on top of brilliant yellow. You'll see how bad it is.' (Paris, Drouot, 16 February 1979, lot 69.)

In other letters from Venice Renoir joked about his very conventional response to its sights (cf. White 1969, pp.346–7); he showed no interest in exploring the pictorial possibilities of its back alleys, unlike Whistler, with whom Renoir had spent time the same spring, when the American was newly back from Venice (letter to Duret, Florisoone 1938, p.40). However, Renoir retained rich memories of San Marco: to Vollard (1938, p.202) he evoked the soft light and mosaics of its interior, and, in notes prepared around 1884 for his proposed Society of Irregularists (cf. p.13), he cited it as a prime example of his principle of irregularity within regularity – 'regular in its ensemble, but with no two details alike' (J. Renoir 1962, p.234).

Vollard bought the painting from de Bonnières; it was presented in 1912 by an art lover to the Munich Staatsgalerie in memory of H. von Tschudi; the gallery later sold it.

LITERATURE
Alexandre 1892, p.35
Munich, Staatsgalerie, *Katalog*, 1925, no.8645
Meier-Graefe 1929, p.156
Drucker 1944, pp.61, 204 no.72
Minneapolis Institute of Arts Bulletin, April 1952, pp.70–5
New York, Wildenstein, 1969, no.43
White 1969, p.345
Minneapolis, Institute of Arts, *European Paintings*, 1971, no.151
Chicago, Art Institute, 1973, no.35
Ann Arbor, Museum of Art, 1979–80, p.182 no.49

EXHIBITIONS
1892, Paris, Durand-Ruel (47)
1910 (Spring), Berlin, Secession (212)

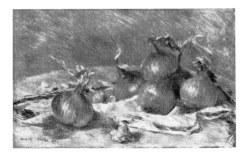

62

Onions

Oignons
1881
39×60 cm ($15\frac{1}{2} \times 23\frac{1}{2}$ ins)
Signed, dated and inscribed bottom left:
Renoir. Naples. 81.
Sterling and Francine Clark Art Institute, Williamstown, Massachusetts, 588

COLOUR *p.106*

Exhibited in Boston only

This small still life was painted during Renoir's stay in Naples late in 1881. He had recently painted a number of elaborate still life compositions (cf. no. 59), paintings which often matched the lavish ambiences in which he hoped they would hang. Here, by contrast, he treated onions and garlic with an ebullient informality, both in the arrangement of the forms and in the painting's execution. The touch, delicate in parts, is animated throughout, with soft and varied diagonal rhythms which complement the different directions in which the onions point; the energy of the whole composition is much enhanced by the red and blue coloured border which runs in vibrant serpentine curves around the cloth on which the onions are placed.

The simple setting and informal composition of *Onions* well complements the simple local produce that Renoir was painting. But its treatment may also reflect a personal sense of release. For the past three years, he had been heavily dependent on the patronage of fashionable wealthy collectors, but now he was his own master on a long Italian tour, with Aline Charigot for company. *Onions* was painted at much the same time as the *Bather* he painted with Aline as model in the Bay of Naples (no.63).

Durand-Ruel bought the painting from Dr Soubies in 1921. However, it is very probably the picture titled *Oignons* that the dealer had previously bought from the artist in May 1882, which was included in Renoir's one-man exhibition in 1883; Durand-Ruel put this on deposit along with many other impressionist pictures in 1883–4, but it was no longer in his possession when he reorganized his stock in 1891. Haviland (cf. no.73)

is recorded as an early owner of the picture (Williamstown, Clark Art Institute, 1956), but this cannot be firmly documented. More recently, it was Sterling Clark's favourite among the many Renoirs he gave to the Sterling and Francine Clark Art Institute, Williamstown.

LITERATURE
Williamstown, Clark Art Institute, 1956, no.150
Callen 1978, p.73

EXHIBITION
? 1883, Paris, Durand-Ruel (29)

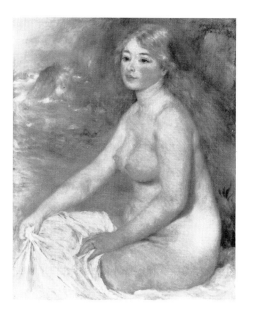

63

Bather (*known as* Blonde bather I)

Baigneuse (dit *Baigneuse blonde I*)
1881
82 × 66 cm (32 × 26 ins)
Signed, dated and inscribed top right: à Monsieur H. Vever / Renoir. 81 (partly overpainted) / Renoir. 81.
Sterling and Francine Clark Art Institute, Williamstown, Massachusetts, 609

COLOUR *p. 105*

Renoir brought this *Bather* back from his Italian trip of autumn and winter 1881, proudly telling his friends that he had painted it on a boat in full sunlight in the Bay of Naples (Blanche 1921; cf. Blanche 1931, Vollard 1938). It seems virtually certain that the model was Aline Charigot, who accompanied Renoir on part at least of his Italian trip (cf. Manet 1979, p.66); she had probably begun to model for Renoir during 1880 (cf. no.52).

When he first showed *Bather* to his friends in France, they at once realized that it marked a new departure in his art. Renoir himself recalled to Jacques-Emile Blanche (1949, p.435) many years later: 'Do you remember Paul Berard, Deudon and Charles Ephrussi when I brought back to Wargemont my Bather from Capri? And how afraid they were that I wouldn't do any more Ninis?' In the same conversation Renoir remembered the impact that Raphael's Villa Farnesina frescoes had made on him in Rome during that trip: 'Raphael broke with the schools of his time, dedicated himself to the antique, to grandeur and eternal beauty.'

Bather invites comparison with *Study*, his open-air nude of 1875 (no.36; the model for

this was Anna, or Nana; Nini reputedly modelled for *La Loge*, no.26). In place of the bold colour patches of *Study*, which fuse figure with surroundings and make her a part of the landscape, the model in *Bather* stands out distinctly from the background. The figure is still modelled with colour: soft blues and deeper reds suggest the shadows on her flesh, and fuller blues indicate the folds in her towel; but these nuances are subordinated to the dazzling whiteness of the sunlit flesh, with its distinct forms and contours. The whole figure has a powerful physical palpability and presence. The contours are not harsh or linear, but the form is clearly demarcated by contrast with the darker, cooler hues which lie beyond.

The pose of the figure, too, makes a change from *Study*. The positions of the hands are similar in both, and in *Girl with a cat* (no.50). But in the two earlier pictures the figure faces us, relaxed and available to our gaze; while in *Bather* she is turned to the side and looks out beyond us, distancing herself in a way from the viewer. The diagonal of her farther arm gives the figure a simple pyramidal shape which lends the whole a more monumental and timeless air.

The Raphael frescoes in the Villa Farnesina contributed to these changes, together with the wall paintings from Pompeii which he had admired in the Naples Museum (most of the Pompeian paintings discovered before 1881 had been transferred to the Naples Museum). Renoir described his immediate reaction to these discoveries in terms which relate closely to *Bather*; early in 1882 he wrote to Madame Charpentier about his search for 'the grandeur and simplicity of the ancients'. 'Raphael who did not work out of doors had still studied sunlight, for his frescoes are full of it. So, by dint of studying out of doors I have ended up by only seeing the broad harmonies without any longer preoccupying myself with the small details which dim the sunlight rather than illuminating it.' (Florisoone 1938, p.36.) However the example of Ingres was also relevant to this clarification of form in his oil painting. He wrote to Durand-Ruel from Naples in November 1881 praising the 'simplicity and grandeur' of Raphael's frescoes, but adding: 'I prefer Ingres in oil paintings' (Venturi 1939, I, pp.116–7); he had thus been looking seriously at Ingres before leaving for Italy.

Luncheon of the boating party (no.52) shows that Renoir had already begun to define his forms and his compositions more clearly before his Italian trip. During the previous summer, too, he had planned an ambitious composition of naked children on a Normandy beach (Blanche 1949, p.443) – a theme without specific modern-life attributes. But his discoveries in Italy and the treatment of *Bather* mark an important stage in his move towards a more classical con-

ception of art, based on the primacy of the human form, freed from the contingencies of modern-life details and from the search to capture ephemeral effects.

As the picture now stands, its background clearly does not represent the view from a boat in the Bay of Naples; the figure seems to be seated by the shore, but there is no clear relationship between her and the sea or the cliffs beyond. Beneath the present painting of the cliffs, there are clear signs of dense dried paintwork describing quite different forms, and some unexplained colour can be seen through the top paint layers, which suggests that the whole background may have been repainted, perhaps after Renoir's return from Italy.

In later years both Renoir and Aline said that they visited Italy together after their marriage (J. Renoir 1962, p.232; Manet 1979, p.66), since they concealed from their family the fact that they only married in 1890. She is wearing a wedding ring in *Bather*, but it would be rash to propose any particular personal significance for this, since several of his earlier nudes have rings on the same finger (e.g. nos.15 and 36). It has been suggested that such rings were added for reasons of propriety, with an eye to 'conservative buyers' (White 1969; Callen 1978), but they do not seem to have been a necessary convention in the depiction of the modern-life nude; so their exact purpose remains puzzling.

Aline remembered how, on their trip to Italy when she was twenty-two, she had still been very thin, though Julie Manet found this hard to believe (Manet 1979, p.66). The ample folds of flesh in *Bather* might confirm Julie's doubts (cf. also no.69), but this may, too, be an early example of the tendency which became so marked in Renoir's nudes after 1900, to enlarge his female figures. This reflected his desire to move beyond his immediate experience of the model towards a vision of female beauty as an ideal of physical amplitude. In this context, *Bather* invites comparison with paintings such as Rembrandt's *Bathsheba* (in the Louvre) or Titian's *Venus at her toilet* (several versions), and also with the robust forms he admired in the female deities in Raphael's spandrel decorations in the Villa Farnesina (cf. Vollard 1938, p.140).

On his return from Italy, Renoir either sold (Vollard) or gave the picture (Meier-Graefe) to the jeweller, Japoniste and modern art collector Henri Vever. It was presumably at this point that he erased its original signature, now partly visible, to leave more room for the addition of the presentation inscription to Vever. Durand-Ruel bought the painting at the sale of Vever's collection in February 1897.

LITERATURE
Meier-Graefe 1912, pp.106–9
Blanche 1921, p.37
Fosca 1921, p.102
Bell 1922, p.69
Fosca 1923, p.27
Jamot 1923, pp.330–1
Meier-Graefe 1929, pp.164–8
Blanche 1931, p.73
Rey 1931, p.55
Vollard 1938, p.203
Blanche 1949, p.435
Williamstown, Clark Art Institute, 1956, no.155
Perruchot 1964, pp.176–7
White 1969, pp.340, 342–4, 346
Daulte 1971, no.387
Callen 1978, p.74

EXHIBITIONS
1905, London, Grafton Galleries (260)
1917, Zurich (172)

64

Rocky crags at L'Estaque

Rochers à l'Estaque
1882
66 × 82 cm (26 × 32 ins)
Signed and dated bottom left: Renoir 82.
Museum of Fine Arts, Boston (Juliana
Cheney Edwards Collection, Bequest of
Hannah Marcy Edwards in memory of her
mother, 1939), 39.678

COLOUR *p.108*

On his return journey from Italy, Renoir stopped late in January 1882 at L'Estaque, on the coast just west of Marseille; here he met and worked with Cézanne. Though he fell seriously ill with pneumonia in February, he was able to paint a few landscapes of the place. He wrote with delight about L'Estaque to Berard: 'How beautiful it is! It's certainly the most beautiful place in the world, and not yet inhabited. . . . There are only some fishermen and the mountains . . . so there are no walls, no properties or few . . . here I have the true countryside at my doorstep.' (Paris, Drouot, 16 February 1979, lot 77.)

At L'Estaque he was able to combine what he had learned from his study of Raphael in Italy (cf. no.63) with the example of Cézanne's current work. The off-white highlights of the rocks, set against the flat blue sky, are more boldly handled than the rest of the hillside; they give the composition a clear structure, with the peaks seen frontally and almost symmetrically before the viewer. But within this framework the colour is richly nuanced, the brushwork soft and variegated. Alongside the varied greens of the foliage, blues are used throughout to suggest cast shadows, and a sequence of warm accents runs through the whole – some darker reds in the tree-trunks and dashes of orange-red on the sunlit terrain, sometimes placed without obvious naturalistic justification. The brushwork is delicate throughout the areas of foliage, but in certain parts, notably the left grassy slope and the tree below it, the strokes run diagonally and

parallel with each other, in a way which echoes the far more rigorous 'constructive stroke' that Cézanne was using at the time, for instance in his canvas of the rocks above L'Estaque, perhaps executed at the same time as Renoir's picture (repr. Rewald 1973, p.465). It is, though, in the simplicity and order of the picture's broader structure, seeking a clear framework within the natural scene, that Renoir here manages to bring together the lessons of Raphael and Cézanne.

The early history of this picture cannot be documented, but it was very possibly with Durand-Ruel in the 1880s. It may well be *La Montagne (L'Estaque)* deposited by Renoir with the dealer in March 1883, before his one-man show; the only L'Estaque canvas in the exhibition catalogue is listed as *Campagne de L'Estaque*, a possible misreading for *Montagne*.

LITERATURE
London, Royal Academy, 1979–80, no.171
Callen 1982, pp.118–121

EXHIBITIONS
? 1883, Paris, Durand-Ruel (58)

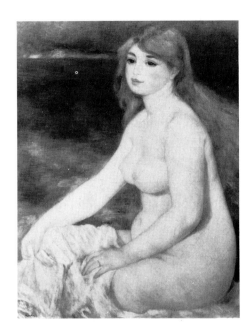

65

Bather (*known as* Blonde bather II)

Baigneuse (dit *Baigneuse blonde II*)
c. 1882
90 × 63 cm (35½ × 25 ins)
Signed bottom left: Renoir.
Private Collection

COLOUR *p. 107*

This painting is a second version, with variations, of no. 63, the *Bather* which Renoir had executed in Italy late in 1881, using Aline Charigot as his model. The second version was probably requested by Durand-Ruel because Renoir had committed the first to Vever, and it marks a development of tendencies which had begun to appear in Renoir's art in that work. Here, the background is reduced to an open expanse of blue sea, with only a narrow line of cliffs in the distance, which serves to emphasize the contour of the figure still more crisply. The ground on which she sits is virtually undefined, and the picture makes no pretence to a legible, consecutive spatial structure. The margins of the figures are more sharply defined, too, and the modelling of the flesh is flatter and less nuanced; her hair is blonde, rather than the reddish gold of the previous painting. The result of all these changes is to make the figure stand out still more monumentally, and virtually to eliminate the contingencies of location and specific light effect; Renoir thus further emphasized the 'broad harmonies' which, as he wrote to Madame Charpentier, he had come to seek through his discovery of the 'grandeur and simplicity of the ancients' (cf. entry for no. 63). The exhibition of the two versions

together in the present show – for the first time, it seems – will clarify the ways in which Renoir's ideas developed between the two.

The crisp silhouetting of the form against the sea can be compared with the treatment of the figure of Galatea in Raphael's *Triumph of Galatea*, which Renoir had so admired in the Villa Farnesina in Rome. Raphael's frescoes had long been models for academic painting; most recently, Bouguereau had exhibited a *Birth of Venus*, overtly based on the *Galatea*, at the 1879 Salon (Musée d'Orsay, Paris). Renoir's knowledge of Bouguereau's painting may well explain his surprise and delight when he saw the Raphael in the original and realized how different its solid, simple forms and vigorous composition were from Bouguereau's artful posturing and slick execution. The simplicity and timelessness of Renoir's *Blonde bathers*, particularly the second version, are in a sense his answer to the false classicism of academic painting, in their determination to create their vision of beauty from the close observation of the natural form.

The early history of this painting has been the subject of confusion. Vollard recorded Renoir saying that it was 'a copy which I did in Paris for Gallimard'. However, according to Meier-Graefe and subsequent sources, Renoir painted it for Durand-Ruel in spring 1882, and the dealer subsequently sold it to Gallimard. The painting is first firmly documented in 1892, when Gallimard lent it to Durand-Ruel's Renoir retrospective exhibition. Its earlier history cannot be definitively documented from Durand-Ruel's records. However, it is very probably the painting that Gallimard bought from the dealer, as late as December 1889, with the title *Torse de femme*; this canvas had just been returned to Paris by Durand-Ruel's New York branch, where it seems to have been sent in January 1888. The date at which Durand-Ruel bought this canvas from Renoir cannot be proved, but it is very likely that it was the same picture which Renoir deposited with the dealer in March 1883, just before his first one-man show, where it presumably featured; this in turn was bought by Durand-Ruel in August 1883, with the title *Baigneuse*, and sent by him to Gurlitt's Gallery in Berlin that September. The likelihood that this was the present painting is greatly increased by Jules Laforgue's description of a nude by Renoir which Gurlitt exhibited in Berlin late in 1883: 'solid, skilful and strange, but I do not like that smooth porcelain-like quality' (letter from Laforgue to Ephrussi, in Laforgue 1903, there misdated to late 1882). When the painting returned to Paris, Durand-Ruel transferred it to his personal possession; he very probably shipped it to New York early in 1886 along with most of his stock, but the export of works from his personal

holdings was not entered in his firm's records.

LITERATURE
? Laforgue 1903, p. 218
Vauxcelles 1908, pp. 26–7
Meier-Graefe 1912, p. 108
Barnes and de Mazia 1935, pp. 406–7 no. 131
Vollard 1938, p. 203
Drucker 1944, pp. 61, 204 no. 71
White 1969, p. 344
Daulte 1971, no. 393

EXHIBITIONS
? 1883, Paris, Durand-Ruel
? 1883, Berlin, Gurlitt
? 1886, New York, American Art Association
1892, Paris, Durand-Ruel (52)
1914, Copenhagen (176)

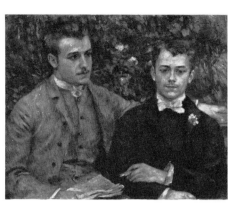

66

Portrait of Charles and George Durand-Ruel

Portraits de Charles et George Durand-Ruel
1882
65×81 cm ($25\frac{1}{2} \times 32$ ins)
Signed and dated top right: Renoir.82.
Durand-Ruel, Paris

COLOUR *p.112*

In 1882 the dealer Paul Durand-Ruel commissioned Renoir to paint portraits of all five of his children; the present painting shows his second and third sons, Charles (born 1865) and George (born 1866). With others of the group, it was painted that summer in the garden of the house which Durand-Ruel had rented in Dieppe. Jacques-Emile Blanche described the scene: 'The Durand-Ruel children posed for him in a garden on the *côte de Rouen*, beneath the moving leaves of the chestnut trees; the sun dappled their cheeks with reflections incompatible with the beautiful "flat modelling" of studio lighting' (Blanche 1927). This dappled outdoor light, had, of course, been one of Renoir's specialities in the mid-1870s (cf. nos. 36, 39 and 40), but by 1882 he was beginning to feel that it was incompatible with the adequate depiction of form (cf. no. 63). Here the distinct contours and clear delineation of the features pull the figures forward from their surroundings; the virtuoso display of coloured modelling in their hair and in the clothing of the left figure is subordinated to the sense of overall structure.

In autumn 1882 Renoir wrote to Berard, telling him that Durand-Ruel was not very happy with the portraits, and jokingly continued: 'I'm delighted by what's happening to me now. I'm going to return to the true path and I'm going to enter the studio of Bonnat [a leading academic portraitist]. In a year or two I'll be able to earn 30000000000000000 francs a year. Don't talk to me any more about portraits in sunlight. A nice dark background, that's the right thing.' (Archives Durand-Ruel; extracts, Paris, Drouot, 16

February 1979, lot 68.) Durand-Ruel's regrets at Renoir's changing style were to develop over the next few years (cf. p. 242 and no. 77).

This half-length double portrait bears a generic relationship to a tradition of Baroque court portraiture, seen for example in Van Dyck's *Portrait of Prince Charles Louis and Prince Rupert* (1637; in the Louvre). The conceit of treating Durand-Ruel's sons like princes painted *en plein air* might well have pleased both painter and dealer. Durand-Ruel bought the painting privately, presumably in 1882.

LITERATURE
Blanche 1927, p. 64
Blanche 1933, p. 292
Pach 1950, p. 80
Daulte 1971, no. 410
Chicago, Art Institute, 1973, no. 40

EXHIBITIONS
1912, Munich, Thannhauser (11)
1912 (February–March), Berlin, Cassirer (11)
1912 (June), Paris, Durand-Ruel (*Portraits*) (44)

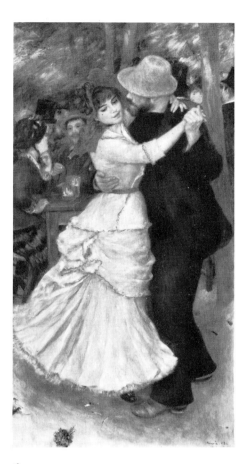

67

Dance at Bougival

La Danse à Bougival
1882–3
182×98 cm ($71\frac{1}{2} \times 38\frac{1}{2}$ ins)
Signed and dated bottom right: Renoir.83.
Museum of Fine Arts, Boston (Purchase, Picture Fund, 1937), 37.375

COLOUR *pp.114, 115*

In the summer or autumn of 1882, Renoir embarked on the theme of dancing couples: by spring 1883 he had completed three ambitious, virtually life-size canvases, the present painting and a matching pair (nos. 68–9). The paintings were never conceived as a trio; the present picture is wider in format and gives more importance to the background figures. Though they have been described as 'conceived as decorative panels' (Jamot), they were not executed for a particular patron and did not find an immediate buyer. But they were clearly intended to continue Renoir's sequence of major subject pictures of urban and suburban recreation (cf. nos. 40 and 52). In the event they were virtually his last ambitious explorations of this theme.

The subjects of the paintings have given rise to considerable confusion, because of the titles generally given to *Dance at Bougival*

and *Dance in the country* (no. 69). For convenience the traditional titles have been retained here, but all the documentary evidence suggests that Renoir himself made no clear distinction between their themes and did not see one as suburban, one as rural. When the paintings were first exhibited, *Dance in the country* was titled *Danseurs (Bougival)* at Durand-Ruel's in April 1883, while *Dance at Bougival* was called *Danseurs à Bougival* at Dowdeswell's in London later the same month. The situation is complicated by Durand-Ruel's records: *Dance in the country* was deposited with the dealer in March 1883 with the title *Danse à Chatou*, while *Dance at Bougival* was deposited the next month as *Danse à la campagne*. When registered in Durand-Ruel's stock lists late in 1886, both were called *Valse à la campagne*; when re-registered in August and September 1891 both were listed as *Danse à la campagne*. The fact that these titles could be used interchangeably further emphasizes the fact that the present picture is independent of the other two, since it would make no sense to have two paintings of the same theme within a trio.

By contrast with Renoir's apparent unconcern with distinguishing in his titles between Bougival and 'the country', the journalism and travel literature of the day attributed very specific social nuances to the various places of entertainment in Paris and its surroundings. In the present context the most relevant example of this writing is a series of articles by Renoir's brother Edmond, 'Un tour aux environs de Paris', published in *La Vie moderne* shortly after Renoir had finished these paintings. One essay (1 September 1883, pp. 556–7) contrasts the entertainments at Bougival and nearby La Grenouillère: Bougival is quite select and expensive, and girls go there without particular expectations, while La Grenouillère is the haunt of the old guard of professionals; in another (15 September 1883, p. 590) he describes the local girls (as opposed to Parisian girls) who frequent such entertainments for a single season – just long enough to find a husband and become *Madame*. Renoir's paintings cannot be decoded by using verbal material such as this: the documentary mode of the journalist is quite alien to the more open-ended possibilities of images like these. Renoir often reiterated his opposition to literary and narrative painting and consistently avoided using a precise language of signs in his paintings which might guide the viewer to any one 'correct' reading.

Renoir again showed his lack of concern for such precise details of ambience the same autumn, by using a drawing based on *Dance at Bougival* as an illustration to a short story by his friend Paul Lhote (who modelled for the man in the picture) entitled 'Mademoiselle Zélia', published in *La Vie moderne* (3 November 1883, pp. 707–8). The ball described in the story takes place not at Bougival, but at the Moulin de la Galette on Montmartre in Paris (cf. no. 40). One drawing of the composition bears an inscription in Renoir's hand: 'She was waltzing, deliciously abandoned, in the arms of a fair-haired man with the air of an oarsman.' This, though, has nothing to do with the conception of the painting *Dance at Bougival*; it is the passage from Lhote's story which he subsequently used the image to illustrate. The story itself is clearly based on Renoir's Montmartre days; it describes the painter Resmer, who works in a garden in rue Cortot (cf. nos. 38, 39), seeking ways of persuading a beautiful girl to model for him.

The painting *Dance at Bougival* creates a mood, rather than telling a story. The girl, wearing a ring on her wedding finger, seems momentarily to turn away from her companion's attentions, but we know no more of their relations. The grouping to the left, one girl with two men (one casually dressed, one top-hatted), cannot readily be interpreted, while the relationships between the cut-off figures at top right are quite illegible. The discarded matches and the bouquet of violets on the ground give the whole picture an added informality. In these respects *Dance at Bougival* is very similar in mood to *Ball at the Moulin de la Galette* (no. 40) and, in its social relationships, to *Luncheon of the boating party* (no. 52). But its central focus on a single couple is quite unlike the earlier paintings. With its background figures still prominent, it is a transitional picture between the multiple focuses of attention of its predecessors and the exclusive focus on the couple in the other two *Dance* pictures. In *Dance at Bougival*, the main forms, and particularly the woman's face, are crisply defined, but the secondary figures are treated with a softer focus, more like his handling of the later 1870s. However, clear colour-rhymes link front and back figures – from the reds of the dancer's bonnet to the ribbons at top right, and from the gold of her belt to the drink in the glasses. There is a slight conflict here between the creation of a total ambience, as in the earlier modern-life subjects, and the concentration of a single, simple theme, characteristic of his work after his trip to Italy in winter 1881–2 (cf. no. 63). Within the clear-cut contours of the main figures, colour is still used with much freedom to model the forms; the diagonal brushing in the background trees may reflect Cézanne's 'constructive stroke' (cf. nos. 64 and 77), but it is far more sketchily treated than the comparable trees in the background of *The umbrellas* (no. 58), painted around two years later.

Dance at Bougival and *Dance in the city* (no. 68) seem to have been the first two paintings in which Renoir used as a model the seventeen-year-old Marie-Clémentine Valadon – later well known as a painter under the name of Suzanne Valadon. In December 1883, she gave birth to Maurice Utrillo, whose father, she was to say on occasion, might, among others, have been Renoir.

Renoir deposited *Dance at Bougival* with Durand-Ruel in April 1883; Durand-Ruel had bought it by late 1886, but it is not clear whether the purchase took place before he shipped the painting to New York in February 1886. He re-registered it in his stock in September 1891 and sold it to François Depeaux in 1894; it was bought by Decap at the Depeaux sale in 1906 (cf. pp. 23, 28 n. 59).

LITERATURE
Meier-Graefe 1912, p. 110
Jamot 1923, p. 321
Drucker 1944, pp. 64, 205 no. 75
Pach 1950, p. 84
Perruchot 1964, p. 190
Daulte 1971, no. 438
Gaunt and Adler 1982, no. 38

EXHIBITIONS
1883, London, Dowdeswell (66)
1886, New York, American Art Association (204)
1892, Paris, Durand-Ruel (83)

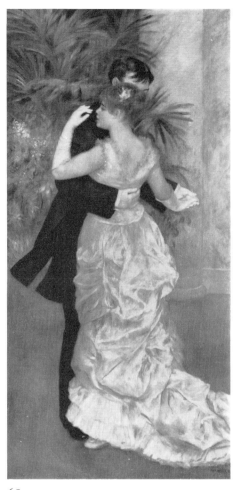

68

Dance in the city

La Danse à la ville
1882–3
180 × 90 cm (71 × 35½ ins)
Signed and dated bottom right: Renoir.83.
Musée d'Orsay, Paris (Galerie du Jeu de Paume), RF 1978–13

COLOUR *p.116*

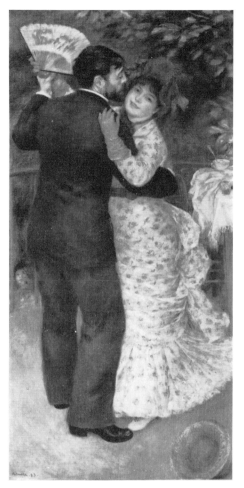

69

Dance in the country

La Danse à la campagne
1882–3
180 × 90 cm (71 × 35½ ins)
Signed and dated bottom left: Renoir.83.
Musée d'Orsay, Paris (Galerie du Jeu de Paume), RF 1979–64

COLOUR *p.117*

Dance in the city and *Dance in the country* were designed as a pair, and they have almost always been exhibited together since they were first shown at Durand-Ruel's gallery in April 1883. Durand-Ruel did not buy them immediately, but they were in his possession by late 1886 (cf. entry to no. 67); by 1892, they hung together in his salon (Lecomte 1892), where they remained until after Renoir's death.

The two paintings have been known by their present titles since 1892, but they were differently titled when first exhibited. They appeared in 1883 as *Danseurs (Paris)* and *Danseurs (Bougival)*, which shows, as with *Dance at Bougival* (no.67), that Renoir intended no clear distinction between Bougival and the 'country'. In 1886 at Les XX in

Brussels they were exhibited, on Renoir's explicit instructions, as *Panneaux de la Danse. I. L'Hiver* and *II. L'Eté* (Venturi 1939, II, pp. 227–8). This was the only occasion on which the city-country opposition in their titles was replaced by that between winter and summer.

From the first appearance of the pictures, critics characterized the figures and their surroundings. For de Marthold in 1883, they showed a 'dance of the demi-monde in a suburban cabaret (*guinguette*)' and a 'society dance in a salon'. Lecomte in 1892 did not see the former as explicitly demi-mondaine, but contrasted the impulsive passion which had led the country couple to dance without completing their meal with the casual unconcern of the couple in the city, brought together only by a social ritual and soon to go their separate ways. However, the paintings themselves give no such precise information about the couples. As Burty commented in 1883: 'One could add to them the literary commentary so dear to the French imagination, but I can see in them only an art that is skilled at painting faces flushed with pleasure, relaxed by delicious fatigue, an art which makes clothing that is cut well and worn well seem elegant and distinguished.' The girl in *Dance in the country* may equally well be seen as a demi-mondaine from Paris or a local country girl, since both types frequented the *guinguettes* around Paris (cf. entry to no. 67). Nor is the disinterest which Lecomte saw in the couple in *Dance in the city* explicit. Indeed, the couples in the two paintings are in virtually identical poses, but seen from different angles. It is the different viewpoint which most affects the spectator's relationship to each picture: we have active complicity with the smiling girl who looks at us in *Dance in the country*, while the girl in *Dance in the city* is quite unconscious of us: we can only admire her profile and the fall of her gown. These differences reflect the nature of each occasion – informal as against formal – rather than informing us about the nature of the personal relationships depicted; these we are left free to surmise, to complete as we choose.

The fact that the same male model (Paul Lhote) is used for both, but different women, suggests how separate, for the fashionable bourgeois male, were the rituals of the social season and the recreations of the summer. There is also a marked difference between the two female types depicted – the elegance of the seventeen-year-old Suzanne Valadon in *Dance in the city* in contrast with the already ample form of Aline Charigot in *Dance in the country* (cf. nos. 63 and 78); Lecomte in 1892 made much of her weightiness. A contrast between the *chic* of the city and the robustness of the country seems to be intended; this is complemented by the backgrounds of the pictures – the artifice of the potted hot-

house plants in the city, the natural chestnut trees in the country. The fact that Valadon had also modelled for the other country picture, *Dance at Bougival* is irrelevant here, for this canvas was not intended to belong with the others: it is the contrast between the models in the two pictures planned as a pair that is significant.

In these two pictures the eye can focus without distraction on the couples – on a single clear-cut group in marked contrast to the multiple focuses of Renoir's earlier major modern-life paintings (cf. nos. 40 and 52), and without the background incident of *Dance at Bougival*. Their simple formal structures and the clarity of the figures' contours reflect the lessons of Renoir's visit to Italy, and his subsequent concern with seeking broad harmonies rather than being waylaid by detail (cf. no. 63). But colour is still given free play within these distinct forms, as in the girl's gown in *Dance in the city*; its folds are modelled with blue, but nuances of yellow, green and red are added too, to create a rich interplay with the colours elsewhere in the picture. Her companion's evening dress is also modelled entirely with colour; at this period Renoir did not use black even for such an emphatically black actual subject as a tail coat.

LITERATURE
Burty 1883
de Marthold 1883
Morel 1883, pp. 1–2
Alexandre 1892, pp. 33–5
Lecomte, *Art impressionniste*, 1892, pp. 147–152
Lecomte 1907, pp. 244, 250–1
Meier-Graefe 1912, p. 110
Jamot 1923, p. 321
Coquiot 1925, p. 97
Meier-Graefe 1929, pp. 170–5
Paris, Orangerie, 1933, nos. 68–9
Barnes and de Mazia 1935 p. 408 nos. 135–6
Vollard 1938, pp. 182–3
Drucker 1944, pp. 63–4
Daulte 1959, pl. 5
Gimpel 1963, p. 181
Daulte 1971, nos. 440–1
Chicago, Art Institute, 1973, nos. 43–4
Paris, Grand Palais, 1974, nos. 39–40
H. Adhémar, 'La danse à la ville de Renoir', *Revue du Louvre*, 1978, 3, pp. 201–4
Manet 1979, p. 167
'La Danse à la campagne par Auguste Renoir', *Revue du Louvre*, 1980, 2, p. 123

EXHIBITIONS
1883, Paris, Durand-Ruel (25–6)
1886, Brussels (Renoir 1, I and II)
1892, Paris, Durand-Ruel (81–2)
1898, Paris, Durand-Ruel
1904, Brussels (131–2)
1905, London, Grafton Galleries (242–3)
1912, Paris, Société Nationale (105 – *Dance in the city* only)

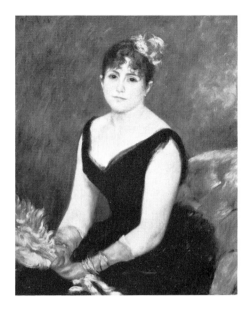

70

Portrait of Madame Clapisson

Portrait de Madame Clapisson
1883
82 × 65 cm (32½ × 25½ ins)
Signed and dated top left: Renoir 83.
The Art Institute of Chicago (Mr and Mrs Martin A. Ryerson Collection), 1933.1174

COLOUR *p.113*

Léon Clapisson bought three of Renoir's recently completed Algerian paintings from Durand-Ruel in May 1882 and commissioned Renoir to paint a portrait of his wife. Renoir first produced *Among the roses* (fig. a), showing Madame Clapisson full length on a bench in a garden. 'Done in very light tones and with flowers of vivid hue around the model', this was found too daring, and Renoir had to paint a second picture, 'in soberer tones, which was accepted' (Duret 1924). Renoir wrote to Berard in autumn 1882: 'I'm starting the portrait of Madame Clapisson over again; I've had a complete failure' (Archives Durand-Ruel; extracts, Paris, Drouot, 16 February 1979, lot 68). The second portrait, the present picture, was exhibited at the Salon in 1883 – Renoir's last Salon exhibit of the decade. Vollard's brief mention of the commissions, in which he quotes Renoir saying 'that charming Mme Clapisson, whose portrait I did twice, with what pleasure', suggests that, whatever the problems with the commission, Madame Clapisson may have been a sympathetic sitter.

The second picture is a remarkable synthesis of the conventions of Neo-Classical portraiture with a colourist palette. The pose is closely comparable to many of Ingres's female portraits, and the essential structure of the figure is crisp and distinct; the basic colour scheme is based on distinct zones of red, blue and yellow. But the wall behind the sitter, far from supplying the plain dark background which he had jokingly described as the recipe for success in his letters to Berard (cf. no. 66), is a kaleidoscopic combination of these three colours; as technical analysis has shown (Chicago, Art Institute, 1973), greens and whites enliven and model the blue dress; and the smaller details in the figure also show delicate colour nuances. Parts of the picture, too, are treated with very free brushwork, but this never threatens to disturb the overall equilibrium.

Durand-Ruel bought the portrait from Clapisson in 1908 and sold it to Ryerson of Chicago in 1913. The subsequent history of the first portrait of Madame Clapisson (misrecorded by Daulte 1971, no. 428) is a telling indication of the different outlets available for different types of picture. As Duret (1924) records, 'the rejected portrait, with the model fixed so that it would not be too recognizable, was sold as a picture and was one of the first works of Renoir to go to America'; since the model belonged to the bourgeoisie, her identity had thus to be disguised before the painting could be sold as a subject picture through the art trade. Renoir deposited it in April 1883 with Durand-Ruel, who sent it to the 1883 exhibition at Dowdeswell's in London; Renoir took it back from Durand-Ruel in 1884 and was still its owner when he sent it, with the title *Sur le banc*, to Les XX in Brussels early in 1886; Durand-Ruel shipped it to New York and exhibited it there later in 1886, but only bought it from Renoir when a buyer appeared in New York, Albert Spencer. Spencer then lent it to the World's Columbian Exhibition in Chicago in 1893, where it was the only work by Renoir to appear (in the Loan Collection, not the official French section).

LITERATURE
Duret 1924, pp. 70–1
Vollard 1938, p. 193
Chicago, Art Institute, 1973, no. 45 and pp. 209–14
New York, Wildenstein, 1974, no. 26

EXHIBITIONS
1883, Paris, Salon (2031)
1910, Paris, Durand-Ruel (43)

FIG a. Renoir, *Among the roses*, 1882. Present whereabouts unknown.

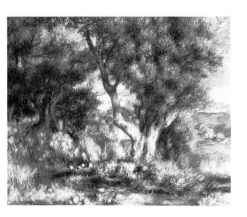

71

Landscape near Menton

Paysage près Menton
1883
66 × 81 cm (26 × 32 ins)
Signed and dated bottom right: Renoir 83.
Museum of Fine Arts, Boston (Bequest of
John T. Spaulding, 1948), 48.596

COLOUR *p.109*

Exhibited in Boston only

In December 1883 Renoir and Monet made a
trip along the Mediterranean coast between
Marseille and Genoa. Both were very en-
thusiastic about what they saw; Renoir wrote
to Berard: 'What lovely landscapes, with
distant horizons and the most beautiful
colours . . . the delicacies of hue are extra-
ordinary . . . alas, our poor palette can't
match up to it' (extracts, Paris, Drouot, 16
February 1979, lot 76). Though they were
away for less than a fortnight, both men
began to paint; *Landscape near Menton* is one
of Renoir's few paintings from this trip.
However, it is quite elaborately worked,
and its surface shows signs of quite exten-
sive minor modifications made during the
execution of the painting; given the brevity
of their tour, the picture was very probably
thoroughly reworked in the studio on Ren-
oir's return to Paris.

Renoir chose a natural subject which gave
the picture an ordered and fairly conven-
tional composition; the trees give strong
structural axes and create a gentle pro-
gression into space, quite unlike the dramatic
contrasts and jumps in space which Monet
adopted in many of his contemporary cliff-
top scenes. The brushwork varies according
to the natural textures depicted – sometimes
small flecks or dashes, sometimes broader
sweeps of paint – but it animates the whole
surface and creates a rippling movement up
the picture, which passes through grasses,
trunks and foliage. The colour, too, though
richly varied in its nuances, is given a cer-
tain internal order. A sequence of accentuated
oranges and reds runs through the painting,

from the foreground terrain and the tree
trunks to the far shoreline; the blues of sea
and sky are picked up in the foreground
shadows. These colours set off, and give a
framework to, the free play of lavish yellows
and greens which capture the effects of foli-
age and grasses in the Mediterranean sun-
light.

Durand-Ruel bought the present land-
scape from Renoir, probably in December
1884. It was re-entered in his stock lists in
1886 and again in 1891 and was transferred
to his New York branch in 1897, where it
seems to have remained until after Renoir's
death.

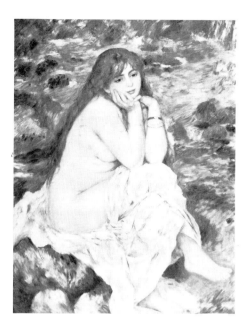

72

Seated bather

Baigneuse assise
c. 1883–4
121 × 91 cm (47½ × 36 ins)
Signed bottom left: Renoir.
Fogg Art Museum, Harvard University,
Cambridge, Massachusetts (Bequest –
Collection of Maurice Wertheim, Class of
1906)

COLOUR *pp.110, 111*

Exhibited in Boston only

Though generally dated to 1885, *Seated bather*
belongs more closely, as Barnes pointed out,
to Renoir's work of 1883. The figure stands
out distinctly from the background and sits
in an uncertain relationship to the space
beyond, as in the *Bather* paintings of 1881–2
(nos. 63, 65), but the handling is more supple
and the contours less harsh than those of
1885 (cf. no. 75). The brushwork can be
compared with that in the *Dance* pictures of
1882–3 (nos. 67–9). The background would
suggest a date of 1883–4, since the rocks in
the water correspond closely to those in the
outdoor sketches which Renoir made on the
island of Guernsey in autumn 1883 (particu-
larly to the canvas repr. Fosca 1961, p. 165).

Renoir wrote to Durand-Ruel from Guern-
sey on 27 September 1883: 'I hope to return
soon . . . with a few canvases [presumably
his finished Guernsey landscapes] and some
documents for making paintings in Paris . . .
I'll have a source of real, pleasing motifs
which I will be able to exploit' (Venturi
1939, I, pp. 125–6). The small sketches of
beaches were presumably these 'documents'
(e.g. fig. a); the present picture is very likely
to be one of the canvases which Renoir

worked up from them in Paris. Indeed the discrepancy between figure and background strongly suggests that it was executed in a composite fashion; the effect of the background space in *Seated bather* is quite unlike the beach studies, because in the large picture Renoir chose to omit the sky. Early in 1884, he wrote to Monet: 'I'm stuck in Paris where I'm getting very fed up, and I'm seeking the perfect model. But I am a figure painter. Alas! sometimes it is great fun, but not when one can only find figures that are not to one's taste.' (Geffroy 1924, II, pp. 24–5.) The present painting very probably belongs to this campaign of figure painting in winter 1883–4, which suggests that his search for the perfect model was not in vain; the result is one of the pictures of his whole career which best fuses monumental form with an easy informality of gesture and expression.

Renoir's experiences on Guernsey probably contributed, also, to the mood of *Seated bather*. In his letter to Durand-Ruel from the island, Renoir wrote: 'Here one bathes among the rocks which serve as bathing cabins, because there is nothing else; nothing can be prettier than this mixture of women and men crowded together on the rocks. One would think oneself in a Watteau landscape rather than in reality. . . . Just as in Athens, the women are not at all afraid of the proximity of men on the nearby rocks. Nothing is more amusing, while one is strolling through these rocks, than surprising young girls getting ready to bathe; even though they are English, they are not particularly shocked.' Even many years later, Renoir remembered the lack of modesty among the Guernsey bathers (Vollard 1938, p. 201). *Seated bather* is not, of course, a direct record of these strolls among the rocks; but his experiences on Guernsey may well have given Renoir the sanction for siting the timeless theme of female nude by the sea in a specific natural setting, based on outdoor studies – for re-creating a classic theme from direct experience.

The handling of the picture reflects the way in which it was executed. Fluent brushstrokes in the background absorb water and rocks alike into an animated coloured back-drop, while the figure is treated more smoothly. Though the drapery around her legs is modelled by crisp strokes of clear blue, her flesh is not modelled by strong colour variations, but mainly with soft duller pinks and yellows. The flesh passages in the painting are strongly differentiated from the rest of the painting both by their brushwork and by their more restricted colour. During the 1880s, Renoir deliberately explored such discrepancies between figure and ground as he sought means to reinstate the human figure as the unequivocal focus of his art, whilst retaining the freshness and mobility of the impressionist vision of landscape and nature.

Renoir deposited the picture with Durand-Ruel in January 1886, but it seems not to have been among the pictures that the dealer shipped to New York in February 1886; he finally bought it from Renoir in February 1892 and sold it to Mrs Potter Palmer the same April; she sold it back to Durand-Ruel in New York in November 1894. He kept the picture until his firm sold it to Jacques Balsan in 1930.

LITERATURE
Paris, Orangerie, 1933, no. 78
Barnes and de Mazia 1935, pp. 408–9 no. 142
Daulte 1971, no. 490

EXHIBITIONS
1913, Boston, Saint Botolph Club (5)
1914, New York, Durand-Ruel (19)
1917, New York, Durand-Ruel (12)

FIG a. Renoir, *Marine Guernsey*, 1883. Musée d'Orsay, Paris (Galerie du Jeu de Paume).

1884–1887

In December 1883, Renoir and Monet travelled together along the Mediterranean coast, delighted at the colours of sea, foliage and mountains. Monet's immediate response was to return to the south for several months, in order to master these natural effects. Renoir, by contrast, as he ruefully told Monet, stayed in Paris seeking 'the perfect model'; for, he insisted, 'I am a figure painter'. This was the prelude to three years of technical experimentation, which culminated with the exhibition of *Bathers* (fig. a) in spring 1887.

During this time Renoir travelled little, working mainly in Paris with occasional stays in the Seine valley or on the Channel coast, or in Aline Charigot's native village of Essoyes in southern Champagne. The stimulus of novel sites and effects was, for the moment, irrelevant to the pictorial problems he was exploring. For his major pictures, too, he rejected the vagaries of the ever-changing weather in favour of the controlled effects he could find in his studio. In *Bathers*, both figures and background were clearly painted indoors, with no attempt to suggest the play of outdoor light or a legible landscape space. His few landscapes of the period show that he was looking at the art of Cézanne in his search for means of structuring natural subjects (cf. no. 77).

He had come to feel, he later told Vollard, that he 'had reached the end of Impressionism, and had reached the conclusion that he could neither paint nor draw'. His letters record his dissatisfaction and his search for a solution to his technical

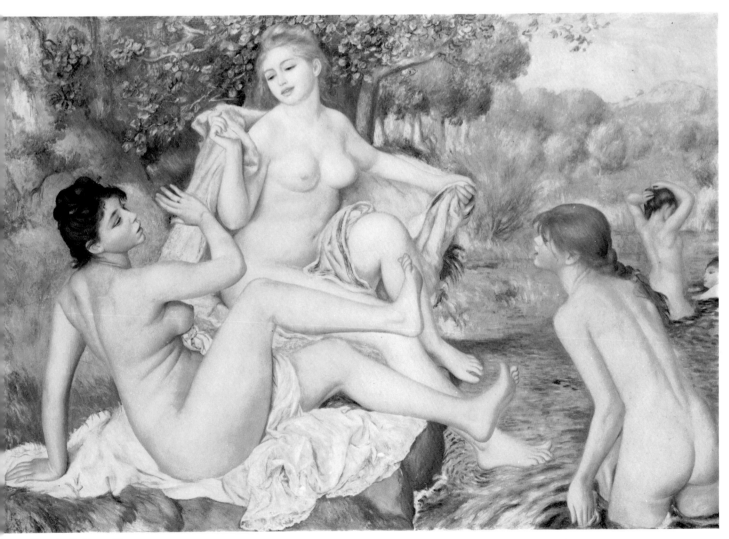

FIG a. Renoir, *Bathers*, 1887.
Philadelphia Museum of Art (The Mr and Mrs Carroll S. Tyson Collection, '63–116–13).

problems; he apparently destroyed many paintings from these years. His experiments developed from his discoveries in Italy in 1881 but during these years focused on one issue in particular, on the relationship of drawing to painting, of contour to colour. He worked out the compositions of paintings like *Bathers* in a long sequence of preparatory studies in different media (pencil, chalk, ink, watercolour), so that he could control as fully as possible the varied elements that he wanted to unite in the final painting. This was the only phase of his career in which he made such complex preparations and gave so important a role to drawing. Few preparatory drawings have survived from his earlier years, and he probably used them only sporadically; after 1890 his drawings, mainly in chalk, served primarily to rough out the general arrangement of his more important compositions, whose precise arrangement usually evolved as he painted the final canvases. Some preparatory studies of the mid-1880s, and some independent drawings, record in sharply focused detail the folds of drapery or outline individual leaves of trees in black ink. Some canvases, too, were begun with a similarly precise black ink scaffold before he began to paint; certain forms in others were meticulously outlined with the brush, such as the chair in *Maternity* (no. 79). In the linear drawings there are echoes of Ingres, and even of Dürer.

But these linear concerns were not an alternative to colour. He also made jewel-like watercolour studies in preparation for paintings such as *Bathers* (cf. fig. b), and in the final pictures luminous colour lies between even the sharpest contours. The forms in them are crisply defined at their margins, but their internal modelling is suggested by nuances of colour, not by chiaroscuro; Renoir thus starkly juxtaposed on the canvas the two basic conventions for representing form in paint, traditionally seen as opposites: by form and tone, and by colour (cf. no. 75).

The methods of oil painting were themselves causing him grave problems. Dissatisfied with its malleability and fluidity, he tried at times to give it an effect more like fresco, by eliminating as far as possible the use of oil as a medium, to produce opaque, matt surfaces. But the removal of oil prevented the paint layers from fully adhering, which has led to severe conservation problems in some paintings of this period, among them *Bathers*. In other paintings at just the same time, though, Renoir worked thinly with much medium on opaque white grounds, creating effects comparable to enamelling or to his first métier, porcelain-painting (e.g. no. 79).

In technique, composition and subject-matter Renoir was deliberately moving away from any suggestion of the fleeting or the contingent, away from the impressionist preoccupation with the captured instant, towards a more timeless vision of woman within nature. When Berthe Morisot visited him early in 1886, he told her that 'the nude seemed to him to be one of the most essential forms of art'. Even in such everyday subjects as *Maternity* Renoir suggested timelessness and permanence by fitting the forms into a stable pyramidal framework and by simplifying and generalizing their features.

But this process of idealization was quite different from the methods taught in academic art schools; Renoir repudiated the artificially rhetorical methods of expression they taught and lamented the loss of an inherited tradition of craftsmanship destroyed when school training took over from personal apprenticeship. In 1884 he proposed founding a Society of Irregularists and publishing a 'Summary of the Grammar of the Arts'; the project came to nothing, but Renoir's draft proposal survives. The arts, he argued, had lost their way when they began to impose an artificial regularity on to the irregularity of nature; this had resulted from the mechanical repetition of designs and could only be reversed by restoring the individual craftsman's direct contact with nature. In what he wrote, Renoir did not specifically relate these ideas to the development of his own art, but some of his most meticulous drawings of this period show that he was himself scrutinizing irregularities in nature – for instance the separate head to the right of fig. b. The irregularist project also reflected Renoir's belief that the arts (painting, sculpture, architecture and decoration) were inseparable, ideas he had first enunciated in his writings in *L'Impressionniste* in 1877. He had no chance of working on any decorative projects in these years, but revealed this concern by exhibiting *Bathers* in 1887 with the subtitle *Trial for decorative painting*: one of his drawings for the picture indicates a complex frame or surround, with nude figures and garlands.

Renoir continued in these years to execute the occasional commissioned portrait, though his stylistic experiments distanced him from many of his potential portrait patrons; only Bérard remained a regular close contact, and even he seems to have bought none of Renoir's paintings after 1884 (cf. no. 74). Though he continued to paint landscapes and still lifes, his attentions were focused on his major figure paintings, notably *Bathers*, and many of his smaller canvases remained unfinished.

Initial responses to Renoir's new linear style were mostly puzzled or hostile, regretting that he had abandoned the freshness and delicacy for which his earlier work was beginning to be recognized. Durand-Ruel, too, disliked his new manner and felt that it would harm his sales; he bought few of his latest

FIG b. Renoir, Page of sketches, *c.* 1885–6, watercolour, pencil and pen. Musée du Louvre, Paris (Cabinet des dessins).

oils in these years. Of his former colleagues, Monet seems best to have understood his enterprise. Renoir exhibited little during his period of experimentation. He did not submit to the Salon between 1883 and 1890, nor did he contribute to the final impressionist group exhibition in 1886. However, he did show at Georges Petit's *Expositions internationales* in 1886 and 1887; in this more fashionable milieu, alongside more widely accepted painters, he exhibited mainly earlier work in 1886 (e.g. no. 44, but also probably no. 79), but in 1887 he chose this forum for the first public display of *Bathers: Trial for decorative painting*.

The patterns of Renoir's social life changed greatly in the same years. Probably in 1884, he left his rue Saint-Georges studio and with it the informal circle of friends who had frequented it. His personal life now revolved around Aline Charigot, particularly after the birth of their first son in 1885, though only his closest friends knew of the ménage. In the same years Renoir began on occasion to appear at two new social rituals which sustained old friendships and forged new contacts: at the monthly impressionist dinners at the Café Riche from the end of 1884, which united impressionist painters with naturalist writers; and at the informal evenings which Berthe Morisot began to hold late in 1885, where Mallarmé, in particular, became a close comrade.

73

Portrait of Paul Haviland

Portrait de Paul Haviland
1884
57 × 43 cm (22½ × 17 ins)
Signed and dated bottom left: Renoir 84
The Nelson-Atkins Museum of Art,
Kansas City, Missouri (Nelson Fund)

COLOUR *p.118*

Paul Haviland, son of Charles and Madeleine
Haviland, was born in June 1880, and he
was thus three or four years old when Renoir
posed him in this orderly, formal composi-
tion, his left elbow on a small table. Madeleine
Haviland was the daughter of Philippe Burty,
the writer and critic, a friend and supporter
of the Impressionists. Her husband Charles
ran a porcelain factory in Renoir's birth-
place Limoges; in 1872 he founded an *atelier*
in Auteuil, on the south-western edge
of Paris, for which many associates of
the Impressionists worked, among them
Bracquemond, Chaplet and even Degas
(cf. d'Albis 1974). We do not know when
Renoir met the Havilands, but their mutual
acquaintances, and Renoir's lasting interest
in porcelain painting (his own first métier),
presumably brought them into contact soon
after Haviland set up his business in Auteuil.

Renoir's portrait is clear cut in its forms,
the blond hair and the white stripes of the
suit standing out boldly from the back-
ground. The combination of a formal pose,
echoing the conventions of Neo-Classical
portraiture, with the freely brushed model-
ling of clothes and background is remini-
scent of *Portrait of Madame Clapisson* (no. 70)
of the previous year; the forms and colours
are not so sharp here as in *Children's afternoon*

at Wargemont (no. 74), also of 1884. How-
ever, the drawing of Paul's eyes, in particular,
reflects the formal simplifications which
Renoir was exploring at the time – seen too
in the standing girl in *Children's afternoon at
Wargemont*.

The painting remained with the Haviland
family until after Renoir's death.

LITERATURE
New York, Wildenstein, 1969, no. 56
Daulte 1971, no. 454
J. and L. d'Albis, 'La Céramique impressionniste',
 L'Oeil, February 1974, p. 47

74

Children's afternoon at Wargemont

L'Après-midi des enfants à Wargemont
1884
127 × 173 cm (50 × 68 ins)
Signed and dated centre right: Renoir.84.
Staatliche Museen Preussischer
Kulturbesitz, Nationalgalerie, Berlin

COLOUR *pp.120, 121*

This was the largest commission that
Renoir undertook for Paul Berard, the dip-
lomat and banker, for whom he had first
worked in 1879 (cf. no. 60). Executed in the
summer of 1884, the painting shows an
interior in Berard's country house at Warge-
mont, outside Dieppe, with his three daugh-
ters: Marthe, now aged fourteen, seated on
the right; Marguerite, aged ten, on the left;
and Lucie, aged four, standing. Renoir seems
to have painted no more pictures for Berard
after 1884, but the two men remained close
friends and Renoir continued to visit
Wargemont.

In contrast to the vivacious little portrait
heads which Renoir had painted of the Berard
children three years earlier (no. 60), *Children's
afternoon at Wargemont* is monumental in
form and quiet in mood, with not a hint of
the children's impish nature (on which cf.
Blanche 1937). The picture is a deliberate
attempt to match the scale and ambitions of
the *Portrait of Madame Charpentier and her
children* (no. 44), but the contrast between
the two pictures could not be more marked
– in content, composition, colour and ex-
ecution. In Madame Charpentier's salon, the
children are the outsiders amid the sumptuous
japonaiseries, confined to the corner of the
picture; here the Berard children hold the
whole scene in the simple surroundings
of Wargemont. Madame Charpentier presides
over her salon, if rather abstractedly, while
here the oldest sister continues to sew, ap-
parently unconcerned by the attentions of
little Lucie and her doll. The compositions
of the two paintings echo these relation-
ships: Madame Charpentier is at the apex of
a triangle leading up the composition and
into space, while here the children are
spread, frieze-like, across a shallow fore-
ground space, without any one central focus.
But the composition in *Children's afternoon at
Wargemont* is just as carefully constructed as
in the earlier painting: it is balanced by the
figures at either side, and the girls' heads are
interlocked with the lines of the furniture,
windows and panels beyond them just as
tautly as in any seventeenth-century Dutch
interior.

What is so unusual in *Children's afternoon
at Wargemont* is the relationship of colour to
composition. Whereas in Dutch interiors,

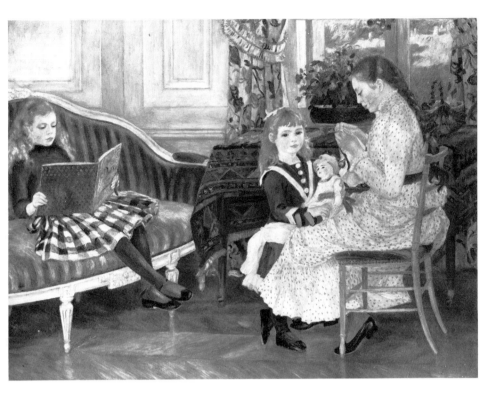

and in Renoir's own *Portrait of Madame Charpentier and her children*, the main focuses of the painting are created by contrasts between dark and light tones, here colour contrasts predominate. But these contrasts are not threaded throughout the picture to suggest the play of light and shade, as in *The swing* (no. 39), for example; instead, the left half is mainly cool and blue, its forms spare and mainly striped, punctuated only by Marguerite's face and golden hair, while the right side, richer and more varied in its patterning, is largely made up of warmer hues, set off by only a few sharp blue accents. Chiaroscuro is almost entirely abandoned, and, with the clear, diffused lighting there is little coloured modelling; individual forms, like the shoes and the flower-bowl, create a few darker blue accents, but the overall tone is very light and even. Forms are crisply set off against each other, most conspicuously in Marthe's profile seen against the flowers; though the drawing is not strictly linear, these clear-cut shapes mark a complete rejection of the integrated atmospheric ensemble of paintings like *The swing*. The brushwork is not fluent. Mostly quite opaque, it unobtrusively defines the forms, without giving the surface any strong rhythm or animation. Only in the little vignette of grass seen through the window is there an emphatic diagonal movement in the brushwork which recalls Cézanne (cf. no. 77).

The drawing is rather simplified, particularly in the faces on the right. As Meier-Graefe pointed out in 1912, the stylized faces of the girls on the right resemble the

doll – an analogy between faces and masks which is remarkable for its date. Such associations – in Ensor's work, for instance – generally evoke the shallowness and artificiality of human behaviour, but such ideas seem quite extraneous to Renoir. In the increasingly simplified contours of his faces at this period (cf. no. 79), he was moving away from the particular details of physiognomy to more generalized images of the prettiness of girls and children – from the individual towards the typical. This development was central to his art over the next few years and was clearly incompatible with portraiture's demands for specific likeness; Renoir was to paint few portraits between 1885 and the early 1890s.

Children's afternoon at Wargemont bears the imprint of Renoir's studies of the art of the past in many ways, but without closely resembling any previous painting. Composition and subject evoke echoes of the domestic interiors of seventeenth-century Holland or eighteenth-century France, while the clean modelling of the forms may reflect Ingres, whose *Portrait of Mademoiselle Rivière* (in the Louvre) seems a distant ancestor of the standing girl here. But the crisp, all-over focus and the blondness of the whole picture seem closer to Italian fifteenth-century fresco painting – to the sharply defined forms within simple interiors of artists such as Domenico Ghirlandaio. Generalized memories of frescoes of this type and of the tonalities of Pompeian mural painting may have played a part, as may the two Botticelli frescoes from the Villa Lemmi, which the Louvre acquired in 1882 from Renoir's friend

and patron Charles Ephrussi. But on to the painting's spare structure Renoir grafted a richness of colour which clearly reflected the lessons of Impressionism. In the mid-1880s Renoir became preoccupied with the textures of fresco painting (cf. no. 75), but *Children's afternoon at Wargemont* does not represent his technique at its driest, though it clearly rejects the fluid handling of much of his earlier work.

At the Berard sale in May 1905 the picture was bought by Bernheim-Jeune; it was given by Elise König to the Nationalgalerie, Berlin, in 1906.

LITERATURE
Paris, Petit, *Berard*, 1905, no. 15
Duret 1906, pp. 141–4
Meier-Graefe 1912, pp. 126–132
George 1922, p. 184
Fosca 1923, pp. 35–6
Jamot 1923, p. 338
Meier-Graefe 1929, pp. 201–213
Blanche 1933, p. 292
Barnes and de Mazia 1935, pp. 91–2, 409–412 no. 144
Blanche 1937, pp. 35–8
Berard 1939, p. 11
Drucker 1944, pp. 65–7, 205 no. 77
Rouart 1954, p. 69
Daulte 1971, no. 457
Chicago, Art Institute, 1973, no. 47

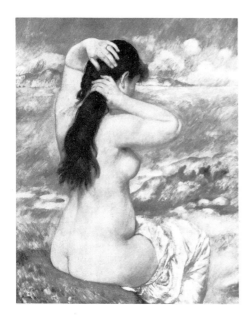

75

Bather (*known as* La Coiffure)

Baigneuse (dit *La Coiffure*)
1885
92 × 73 cm (36 × 28½ins)
Signed and dated bottom left: Renoir 85.
Sterling and Francine Clark Art Institute,
Williamstown, Massachusetts, 589

COLOUR *p. 122*

Exhibited in Boston only

La Coiffure is one of the most crisply drawn,
harshly contoured of all Renoir's nudes from
his period of technical experimentation dur-
ing the mid-1880s. Along with *Bathers* (p.
241 fig. a), completed in 1887, it marks the
extreme point of his rejection of the impres-
sionist technique of absorbing figures into
an ambient atmosphere.

The landscape in the background here is
comparable to the second version of the
Bather of 1881–2 (no. 65), with distant cliffs
seen across a bay; but its treatment is differ-
ent, crisply and stiffly brushed; like Renoir's
contemporary landscapes (cf. no. 77), it is
clearly reminiscent of Cézanne. However,
the figure is treated quite differently. Its
margins are not, in the main, defined by a
line, but are sharply differentiated from the
background by contrasts of colour and paint
texture; only around the buttocks and belly
is a soft blue line used to demarcate the
model. Strongly lit from the front, the model's skin
presents simple, quite flatly painted planes
of dense impasto, treated mostly in soft pinks
and creams, with only slight colour modu-
lations suggesting the play of light across
her form. These soft nuances of colour do
echo the richer colours of the landscape
beyond, but the simplicity of her colouring,
with her dark hair set against her light skin,

sets her apart from the kaleidoscopic hues
beyond. The very generalized lighting on
the figure and the illegibility of the space
show that the picture was composed in the
studio.

Renoir was here preoccupied by the con-
tour, at the expense, in places, of convincing
modelling within the figure. His uncertainties
about the outlines of the figure can be seen,
for instance, around her right elbow, where
the directions of the brushwork strongly
suggest that its margins have been shifted.

Renoir's fascination with the defining line
reflects his interest at this period in Ingres
and the tradition of linear drawing, though
the colour declares his allegiance to the alter-
native colourist tradition. This synthesis, in
some ways disconcerting, was analysed with
great sympathy by Meier-Graefe in 1912, in
the first monograph published on Renoir; a
drawing after this picture even appeared on
the front cover of his book. He saw the
figure as a modern Venus: 'This Venus Ana-
dyomene does not borrow her charms from
any antique sculpture. She testifies to her
origins in a way more credible to our mod-
ern ideas; she is truly woman born from the
waves. Renoir draws her brilliant enamel
out from the coloured beauty of the atmos-
phere which surrounds her, and thus avoids
the immobile isolation of painted modelling.'
(Meier-Graefe 1912, p. 114.)

The cracking in the painted surface of the
figure suggests that this was one of the
paintings in which Renoir tried to reduce
the quantity of medium he added to his
colour (cf. Vollard 1938, pp. 216–7); cer-
tainly the superimposed layers of paint did
not here fully bond themselves together.
The high-key, rather chalky tonality of the
picture, too, suggests his interest in the visual
qualities of fresco painting. However, viewed
from close to, the surface of the figure has a
sleekness and fullness of *matière* quite unlike
painting on plaster; comparisons with the
visual effects of painting on enamel or por-
celain may be more relevant. Soon after-
wards, as Renoir told Vollard, he realized
that 'oil painting must be executed with oil'
(1938, p. 216); from around 1888, he never
again had such problems with the bonding
of his materials.

Renoir deposited this picture with Durand-
Ruel in April 1885; the dealer sent it to New
York in 1886, where it was very probably
exhibited. He finally bought it from Renoir
in February 1892 and very probably included
it in the Renoir retrospective he organized
that May. His firm sold it to Sterling Clark
in 1938.

LITERATURE
Meier-Graefe 1908, I, p. 294
Meier-Graefe 1912, pp. 111–6
Fosca 1923, p. 36
Jamot 1923, pp. 331–2
Barnes and de Mazia 1935, p. 413 no. 152
Drucker 1944, pp. 74, 205 no. 77
Williamstown, Clark Art Institute, 1956, no. 138
Daulte 1971, no. 492
White 1973, p. 111

EXHIBITIONS
? 1886, New York, American Art Association
? 1892, Paris, Durand-Ruel
1912, Munich, Thannhauser (16)
1912 (February–March) Berlin, Cassirer (16)

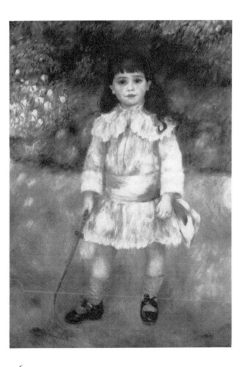

76

Child with a whip

L'Enfant au fouet
1885
105 × 75 cm (41½ × 29½ ins)
Signed and dated bottom right: Renoir. 85.
The State Hermitage Museum, Leningrad

COLOUR *p.123*
Exhibited in London and Paris only

Child with a whip shows Etienne, born 1880, youngest son of Dr Goujon; Goujon commissioned portraits of all four of his children from Renoir in 1885; *Child with a whip* is a pair to *Girl with a hoop* (Chester Dale Collection, National Gallery of Art, Washington, D.C.), which shows Étienne's sister Marie.

The work combines the rich colour of Renoir's open-air painting with a crisply drawn figure. The boldly brushed background is evoked by constant variations of hue and touch; even the dress (presumably of a white material) is modelled with blues, greens and yellows. But the composition is given a sharp tonal structure by the boy's hair and shoes (cf. the hair in the contemporary *Bather*, no. 75), and his face is treated smoothly, with its features almost harshly drawn. The face and hair stand out from the freely worked surrounds. Later (cf. no. 80), Renoir sought ways of reintegrating children's faces with their context in the picture.

Goujon sold the picture to Vollard, who sold it to Ivan Morosov in 1913.

LITERATURE
Paris, Musées Nationaux, 1965–6, no. 70
Daulte 1971, no. 471

77

La Roche-Guyon

La Roche-Guyon
c. 1885
47 × 56 cm (18½ × 22 ins)
Signed bottom left: Renoir
Aberdeen Art Gallery and Museums, 1974.12

COLOUR *p.126*

During the summers of 1885 and 1886, Renoir stayed at La Roche-Guyon, a village on the Seine between Paris and Rouen, a few miles upstream from Giverny, where Monet had recently settled. Cézanne joined Renoir there for a time in 1885. This painting cannot be firmly dated, but it may well belong to 1885, since its technique bears the imprint of Cézanne's influence.

The diagonal brushwork which runs through much of *La Roche-Guyon*, integrating foreground, distance and sky, reflects Cézanne's so-called 'constructive stroke' – his method of structuring a paint surface by sequences of parallel brushstrokes. Renoir had already toyed with this device on occasion (cf. nos. 64, 67), but *La Roche-Guyon* is one of his most extreme experiments with evenly weighted brushmarks unifying a whole painting. The strokes themselves, though, are quite unlike Cézanne's – less crisp, and tending to blend together. In Cézanne's paintings such strokes belong to the picture's two-dimensional fabric; their effect is flat, too, in parts of Renoir's picture, such as the sky and the bushes at bottom right, but elsewhere they act more illusionistically, suggesting the appearance of forms in space, as in the roofs and in some of the trees. At a few points, too, Renoir itemized particular details – some leaves on the left, and stones on a cottage wall. Renoir was reluctant to subordinate the natural elements in a scene to an overriding surface pattern.

The objects in the picture mask a legible perspective, but the eye can work its way from form to form back into space, and soft blues suggest atmospheric distance. The whole composition has a crisp structure of tones and colours, organized around the light accents of rocks and chimneys and the central red roof; around these are sequences of varied reds and mauves, set against greens which are animated by vivid emerald accents. Despite the apparent tensions between space and surface, the animated touch and rich colour give the picture a real presence.

In two letters from La Roche-Guyon in August 1885, Renoir wrote of his artistic uncertainties. He asked Durand-Ruel not to visit him, but reassured him that he had at last set his bungling behind him (Venturi 1939, I, pp. 130–1); to Berard, though, he admitted that he had forestalled the dealer because he had not resolved anything: 'I want to find what I am looking for before delivering myself' (Paris, Drouot, 16 February 1979, lot no. 74; letter of 17 August 1885, there misdated to August 1886, when Renoir was at Saint-Briac).

No details are known of the painting's early history.

LITERATURE
Callen 1978, pp. 94–5
London, Royal Academy, 1979–80, no. 172

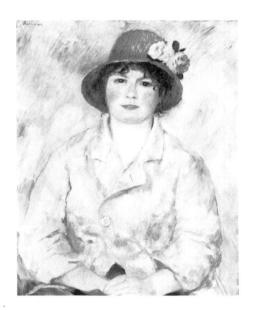

78

Portrait of Aline Charigot (Madame Renoir)

Portrait d'Aline Charigot (Madame Renoir)
c. 1885
65 × 54 cm (25½ × 21 ins)
Signed top left: Renoir
Philadelphia Museum of Art (Purchased:
The W.P. Wilstach Collection), W 57-1-1

COLOUR *p.124*

This is one of the few occasions when Renoir painted a portrait of Aline Charigot, whom he was to marry in 1890 (cf. also no. 114), rather than using her as his model for a subject picture. Though not precisely datable, the picture was probably painted in 1885, after the birth of their first son Pierre in March; its directness and specific observation thus makes a direct contrast to the far more generalized treatment of Aline in Renoir's contemporary canvases of *The child at the breast*, particularly the last two versions (cf. no. 79), where she becomes an archetype of rural motherhood.

Aline's robust form is accentuated here by the frontal viewpoint; the simple curves of her cheeks and jaw are echoed by her shoulders and arms. She is presented as a country girl, rather than fashionably dressed as she had appeared when Renoir first painted her (cf. no. 52). It seems to have been in the autumn of 1885, after Pierre's birth, that Renoir first visited her home village of Essoyes in southern Champagne; Aline always felt this place to be her home, and this picture may reflect Renoir's first encounter with her on her native soil.

Light blues and yellows dominate the composition, anchored by the dark blue of her eyes and skirt and the darker yellows and browns of her hat and hair; the warm

hues of her flesh and the rose provide a colour focus of a different sort. In the background, blue predominates over yellow, in her jacket yellow over blue, but these colours are kept reasonably distinct, not freely intermingled. The blues in the jacket suggest its modelling, with the help of the brushwork, in clusters of roughly parallel strokes running in varied directions. The paint layers are opaque and quite thick throughout, and fairly homogeneous in texture. The contours are clear, but only occasionally outlined, where a line is needed to demarcate two zones of very similar colour; otherwise form is primarily suggested by variations of colour.

The picture remained in Renoir's possession until his death.

LITERATURE
André and Elder 1931, I, pl. 9, no. 16
Barnes and de Mazia 1935, p. 412 no. 148
New York, Wildenstein, 1969, no. 60
Daulte 1971, no. 484
Chicago, Art Institute, 1973, no. 51
New York, Wildenstein, 1974, no. 32

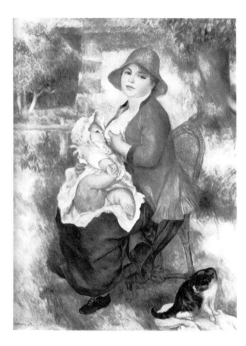

79

The child at the breast (*known as* Maternity)

L'Enfant au sein (dit *Maternité*)
1886
74 × 54 cm (29 × 21 ins)
Signed and dated bottom left: Renoir. 86.
Anonymous loan, Museum of Fine Arts,
St Petersburg, Florida

COLOUR *p.125*

Exhibited in Paris and Boston only

Renoir's first son Pierre was born in March 1885; that summer he began work on the theme of Aline feeding the baby, producing during the next year two elaborate sanguine drawings and three oil paintings, as well as a number of more informal drawings. All depict the same pose, with Pierre grasping his own foot, and all show much the same sized baby – very approximately six months old. One sanguine and one oil (Daulte 1971, no. 485) are dated '85' and were presumably executed (in part, at least) at Essoyes, Aline's home village in southern Champagne, which Renoir first visited that autumn (cf. no. 78). Renoir was working on the theme in Paris in winter 1885–6: on 11 January 1886 he showed Berthe Morisot several of his studies of the subject in his studio (Rouart 1950). The present oil alone is dated '86' and is presumably a studio reworking of the theme; another closely related but undated oil (Daulte 1971, no. 496) was very probably painted at much the same time. The unchanged size of the baby makes it implausible that these two latter oils were painted from life at Essoyes in June 1886, as suggested by Daulte. Indeed it is very likely that one of

them was already on exhibition: one of the paintings Renoir showed at Georges Petit's *Exposition internationale*, which opened on 15 June 1886, was titled *L'Enfant au sein*; this was very probably one of these two oils (fully finished works, unlike that dated '85') – perhaps the present one, since it is dated. Whichever version it was, it was the first painting exhibited by Renoir in Paris which revealed the results of his two years of technical experimentation; Octave Mirbeau commented on it in his review of the show: 'Admire his *Woman with child*, which, in its originality, evokes the charm of the Primitives, the precision of the Japanese and the mastery of Ingres.'

The figure composition is a combination of informality and timelessness. The gesture of the baby catching hold of his own foot gives it an air of immediacy, as well as showing off the sex of the baby to the proud father and to the viewer; but the simple pyramidal structure is deliberately monumental. Aline's features have been generalized and simplified; she is presented as a type, in contrast to the far more specific observation in the portrait that Renoir had painted of her shortly before (no. 78). She is shown in country clothes, placed in front of a typical rural background – a cottage with trees (cf. also no. 81). Figures and context alike make this an archetypal image of rural motherhood.

In theme and composition it invites comparison with Italian Renaissance paintings of the Madonna and Child. Renoir later remembered his delight at Raphael's *Madonna della Sedia* in the Pitti Palace in Florence: 'The most free, the most solid, the most marvellously simple and alive painting that one could imagine; the arms and legs have real flesh, and what a touching expression of maternal tenderness!' (Vollard 1938, p. 202). The parallel, though, is generic, not to any single Renaissance painting. On Renoir's Italian trip, Raphael's paintings came to represent for him the image of motherhood: in Italy, he remembered, 'every woman nursing a child is a Virgin by Raphael' (J. Renoir 1962, p. 225). When he wanted to re-create this theme in his own art, he adopted a Raphael-like combination of closely observed gesture with simple, balanced structure.

The technique of the painting reflects Renoir's experiments of the mid-1880s – free and luminous in some parts, very precise in others. It is executed on a thick white ground – very possibly with an opaque extra layer of priming added by the artist over a commercially primed canvas (cf. Callen 1978, pp. 86–7). Across this smooth white base, much of the background is freely and thinly brushed, allowing the white ground to lend its luminosity to the kaleidoscopic hues of grass, tree, house and the trees beyond. By contrast, the principal forms are opaquely

painted and clearly defined, some of them precisely outlined. There are no obvious traces here of the meticulous ink under-drawing which lies below some of Renoir's paintings of this period (cf. Vollard 1938, p. 217, André 1928, p. 72), but the chair, in particular, and some of the leaves in the tree have their margins carefully outlined – the chair in a dull red, the leaves in blue, apparently all drawn with a fine brush. Only a few details in the figures are similarly drawn – Pierre's penis and some of his fingers and toes – but the outlines of the whole group are crisply established by the contrast with what lies beyond them. The flesh is treated quite smoothly, with only the softest nuances of colour to suggest modelling; the baby's white dress is more freely brushed, while crisper strokes indicate the pattern of folds in Aline's clothes; soft orange-reds suggest the modelling of her blue skirt. The dominant colours of her hat, jacket and skirt, with the white of the baby's dress, stand out distinctly, in contrast to the constantly variegated colours of the background. Their clear colour structure, with their sharp contours and simple grouping of forms, draws the figure group decisively forward from the scene beyond, which serves merely as a backdrop, in marked contrast to the fusion between figures and ambience of the mid-1870s (cf. nos. 39 and 40).

In *Bathers* (p. 241 fig. a), the major composition on which Renoir was working between 1884 and 1887, as in *The child at the breast*, the figures are treated with great precision and clearly separated from the background; but in *Bathers* the paint layers are dense and opaque throughout (cf. no. 75), in contrast to the translucency of much of *The child at the breast*. This simultaneous exploration of two such different methods well shows Renoir's technical uncertainties of the mid-1880s.

The process of simplification and monumentalization had first appeared in the *Bather* painted in late 1881, during Renoir's trip to Italy (no. 63). But *The child at the breast* is also a sequel to that *Bather* in its theme. It repeats much the same pose, translating the earlier archetype of youthful beauty into the archetypal mother; whereas the nude *Bather* had looked out beyond the viewer into the distance, the young mother can look directly at us, to share with us the joys of motherhood – as she had shared the pleasures of the dance in *Dance in the country* (no. 69), three years before. Such repetitions characterize images which had particular significance for Renoir; his attachment to this mother and child grouping was poignantly revealed when, after Aline's death in 1915, he painted a further version of the composition and asked his assistant to base a sculpture on it (cf. Haesaerts 1947, p. 29).

Durand-Ruel bought the present painting from Renoir in June 1892, soon after

Renoir's one-man exhibition at Durand-Ruel's gallery had closed; it seems very possible that this was the painting shown in that exhibition as no. 75, with the title *L'Enfant qui tette*. Natanson's review of Durand-Ruel's 1896 Renoir exhibition shows that the picture appeared there, though it cannot be identified in the catalogue; it had been bought from the dealer just before the opening of this show by the Boston collector Henry Sayles.

LITERATURE (for present version)
? Mirbeau 1886
Natanson 1896, p. 549
New York, Duveen, 1941, no. 57
Pach 1950, p. 20
Daulte 1971, no. 497

LITERATURE (for related versions)
Meier-Graefe 1912, pp. 134–6
Fosca 1923, p. 36
Jamot 1923, pp. 338–9
Meier-Graefe 1929, pp. 238–9
Barnes and de Mazia 1935, pp. 93–5, 413–4 no. 162
Drucker 1944, pp. 75–6, 205–6 no. 79
Pach 1950, pp. 90–1
Rouart 1950, p. 128
Daulte 1971, nos. 485, 496
Daulte 1972, pp. 48–9
Chicago, Art Institute, 1973, no. 52

EXHIBITIONS
? 1886, Paris, Petit (126)
? 1892, Paris, Durand-Ruel (75)
1896, Paris, Durand-Ruel

1888 marks the end of Renoir's most hermetic phase of technical experimentation, but the dilemmas which had come to a head in the mid-1880s continued to preoccupy him: how could he reconcile the direct study of nature with his desire to belong to an artistic tradition and combine the definition of form with the free play of coloured brushwork?

He was again travelling widely between 1888 and 1898, as he had in the early 1880s, seeking fresh natural sites and also exploring the art of the museums. His painting trips took him to Normandy and to Essoyes, and particularly to the south of France and around the coasts of Brittany. To visit the museums he travelled to Madrid (1892), Dresden (1896, after a visit to Bayreuth), Amsterdam (1898) and London (probably during the same years); when in Paris he spent much time in the Louvre.

His interests in past art now focused less on the linearity of the Renaissance, but rather on Titian, Velasquez, Rubens, Rembrandt and Vermeer, and most particularly on the art of the French eighteenth century and on Corot. These artists, in their different ways, shared two qualities that were central to Renoir's concerns: they all modelled form and suggested space with the brush, rather than separating painting from drawing, colour from line; and all found ways of transforming their close observation of the world around them into lasting pictorial form. But he still felt that the masters of line were essential for study, instructing his young pupil Jeanne Baudot to copy from Poussin and Mantegna.

His espousal of the French eighteenth century and of Corot was central to his art and to the public image he projected; his essential Frenchness became a critical cliché. Watteau and Fragonard became especially important for him in the late 1880s, as he worked his way out of the harshness of contour and rigidity of design of his 1887 *Bathers* (p. 241 fig. a). In 1888 he cited Fragonard to explain his efforts to soften and variegate his technique (cf. no. 81); his brushwork of the 1890s retains Fragonard's imprint (cf. figs. a, c), in its increasingly rhythmic, cursive movements, which model form and create decorative pattern in the same gesture. At the same time many of his outdoor subjects look to Fragonard or to Watteau's *fêtes galantes*, in the ways in which outdoor figures and their surroundings are woven together by composition and touch, and figures in contemporary dress are made more timeless by their gestures and setting.

Corot's example was particularly relevant to his problems with landscape painting. Painting out of doors often made Renoir wish he had not spent so long working in the studio, but the changing weather and the physical difficulties of open-air work forced him back to the studio to execute his more ambitious projects. Likewise he sometimes described nature in terms of Corot's paintings, and he praised the 'extraordinary truthfulness' of his views of La Rochelle; but he also cited Corot in defence of his own practice of reworking his outdoor studies in the controlled environment of the studio.

These uncertainties about the ideal methods for executing paintings were reflected in their appearance. In some outdoor studies the touch remained emphatic and variegated, but in many more finished paintings it became far softer and more unified, even Corot-like in its delicacy. The colour range he adopted was similarly varied: in some pictures until the early 1890s the forms were modelled by rich colour with backgrounds treated in rainbow hues, but by 1888 he had already begun to use a far more restricted and muted palette for certain subjects – again echoing Corot. By the mid-1890s he had virtually ceased to use blues in the shadows in painting flesh, and he was modelling forms in a more traditional way, more by gradations of tone than by contrasts of warm and cool colours. At the same time he proudly declared that he had restored black as an essential colour to his palette – banished since the mid-1870s from all his paintings except a few commissioned portraits. He was preoccupied in the mid-1890s with finding a definitive, simple range of colours for his palette which would serve every need, in his obsessive concern with mastering the craft of painting.

On his travels Renoir painted many landscapes and informal outdoor subjects, but his more serious efforts were reserved for themes which tread the borderlines between everyday life and idyll – themes with obvious echoes of eighteenth-century art. He painted a long sequence of nudes, mainly of young girls in outdoor settings, whom in a letter he called his 'nymphs'. Mainly single figures at first, he brought them together in groups around 1897 in several pictures of girls playing (e.g.

FIG a. Jean-Honoré Fragonard, *L'Etude*. Musée du Louvre, Paris.

fig. b), which translate the subject of the 1887 *Bathers* into a fluent informality very reminiscent of Fragonard's *Bathers* (fig. c). Another favoured eighteenth-century theme – the young child – became a central concern after the birth of his second son Jean in 1894, in a long sequence of pictures which seek the archetypal images and gestures of childhood.

But his most often repeated subject of the 1890s was the fashionable modern costume piece – figures of girls, often wearing fancy hats, some head and shoulders, some half length, some full length, with single figures or pairs (e.g. fig. d). It was with pictures such as these, it seems, that he found a real market in the 1890s, particularly with Durand-Ruel. He joked in 1891 about painting a 'tableau de genre, genre vente' and was apparently wearied of executing pictures to please the dealer; but later in the decade Durand-Ruel seems to have tried, without success, to persuade Renoir to stop painting girls with elab-

orate hats, since these had gone out of fashion. Renoir had (as Suzanne Valadon remembered) a particular penchant for women's hats and had them specially made for his models.

His most important sale of the decade was a painting of this type (though without hats): as early as 1892 the French Government bought *Young girls at the piano* (no. 91), for the Musée du Luxembourg, a composition of which Renoir made several versions in the hope of such a purchase. At the same time, too, he began to find a wider circle of buyers and to gain real critical attention, largely through the efforts of Durand-Ruel, who remained his commercial mainstay, though later in the decade Vollard and Bernheim-Jeune began to buy from him.

His social life of the decade fell into two distinct parts. He cultivated acquaintances among potential patrons and built up once again a clientèle for portrait commissions – some more formal society portraits, some informal images of the families

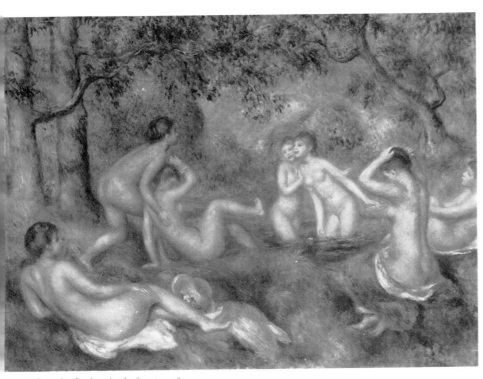

FIG b. Renoir, *Bathers in the forest*, c. 1897.
The Barnes Foundation.

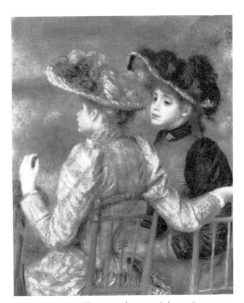

FIG d. Renoir, *Two seated young girls*, c. 1892.
Philadelphia Museum of Art (The Mr and
Mrs Carroll S. Tyson Collection, '63–116–15).

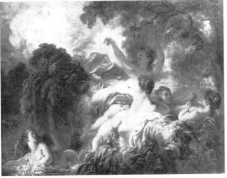

FIG c. Jean-Honoré Fragonard, *Bathers*.
Musée du Louvre, Paris.

and children of his friends. His warm friendship with Berthe Morisot and Mallarmé led to many of these commissions. He also painted a number of decorative schemes, some for Durand-Ruel's private residence and others in particular for Paul Gallimard, collector, bibliophile and director of the Théâtre des Variétés, who became a close friend. Gallimard's patronage drew Renoir to allegorical and Neo-Classical themes, with a reclining decorative nude entitled *La Source* (fig. e) and an un-realized project for a dining room decoration based on scenes from *Oedipus Rex*, which Renoir planned loosely along the lines of a Pompeian mural decoration.

The other side of his life was his own family. After they were married in 1890, Aline could be introduced to Renoir's more formal bourgeois friends such as Morisot, but their real social life as a family revolved around their home on Montmartre in the 'Château des Brouillards', where they built up a group of informal, bohemian friends, mainly much younger than Renoir, a circle comparable to the habitués at the rue

Saint-Georges in the late 1870s. Renoir made the family circle itself, with a neighbour's child, into the theme of one of his most monumental paintings of the period, exhibited with the title *Portraits* in 1896 (fig. f).

The responses of the critics reflected the duality of his art. Some continued to characterize him as a painter of modern life, painter par excellence of the modern Parisian girl. But during the decade, several critics began to explore his art from different angles, and to associate it with ideas current in symbolist circles: de Wyzewa discussed its emerging Classicism; Aurier saw his girls as artificial and puppet-like; but Geffroy focused on their innocence and instinctual life. It was Denis in 1892 who highlighted the issue that made this plurality of interpretations possible: 'Idealist? Naturalist? Whichever you please. With his own personal methods he has concentrated on translating his own emotions, encompassing the whole of nature and the whole of his dream. The joys of his eyes have enabled him to compose marvellous bouquets of women and flowers.'

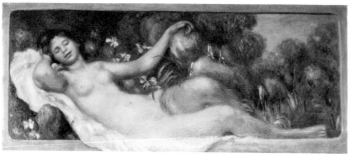

FIG e. Renoir, *La Source*, c.1895.
The Barnes Foundation.

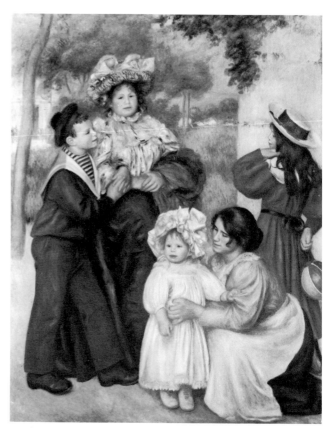

FIG f. Renoir, *Portraits*, 1896.
The Barnes Foundation.

80

Little girl carrying flowers

L'Enfant portant des fleurs
1888
66 × 54 cm (26 × 21 ins)
Signed and dated bottom left: Renoir 88.
Museu de Arte de São Paulo,
Assis Chateaubriand

COLOUR *p.127*

Renoir completed very few paintings in
1887, but in 1888 he began to explore a
number of possible ways out of the technical
impasse in which he found himself, seeking
means to reconcile drawing with colour and
the precise definition of form with the free
play of the brush. In this search he looked
back to the art of Corot and of the French
eighteenth century, to the Impressionism of
the 1870s, and to Cézanne's recent work (cf.
also nos. 81, 82 and 85). Durand-Ruel played
an important part in encouraging Renoir to
turn away from the dryness of his recent
work: Renoir wrote to Berard around this
date to tell him that he was taking up again
'my old manner of painting, the painting of
the geraniums, after much discussion with
Durand' (undated letter, Paris, Drouot, 11
June 1980, lot 102; the 'geraniums' refers to
a still life Renoir had painted for Berard in
1880); in several letters to Durand-Ruel he
eagerly reported on the progress he was
making (cf. no. 81).
 The free, varied brushwork of *Little girl
carrying flowers* marks a return to a more
typically impressionist handling, in contrast
to his tautly structured forms of the mid-
1880s (cf. nos. 75, 79). However, the land-
scape background is organized into distinct
zones, each with a dominant colour, in con-
trast to the more all-over variegation of
paintings such as *The Seine at Chatou* (no. 57)

of *c.* 1881. The figure too, though freely
brushed, is clearly distinguished from the
background. The format of the picture and
the rather ambiguous spatial relationship
between the girl and her setting are remi-
niscent of *Study* (no. 36), Renoir's open-air
nude of 1875; but in *Little girl carrying flowers*
the patches of colour do not invade the
figure but act as a foil for it, revolving
around the white of her dress and picking
up the strong accents of red, gold and blue
in her ribbons and hair and the shadows on
her dress and basket. A child carrying
flowers had appeared as one element in the
landscape in *The Seine at Chatou*; here she
becomes the central theme of the painting.
The analogy between the beauties of young
girls and flowers became a central theme in
Renoir's later paintings (cf. nos. 86, 116, 126).
 In its treatment, *Little girl carrying flowers*
belongs most closely with the group of river
scenes which Renoir painted at Argenteuil
in summer 1888. His return to the physical
site of some of his most experimental out-
door painting of the 1870s (cf. nos. 29 and
30) may have encouraged him to re-adopt a
more typically impressionist handling, but
more important may have been the example
of Caillebotte, with whom Renoir stayed at
Petit Gennevilliers (across the river from
Argenteuil) during the summer of 1888. In
his recent landscapes Caillebotte was com-
bining rich atmospheric colour and vigorous
broken brushwork with clearly structured
forms and compositions.
 Renoir deposited the picture with Durand-
Ruel in May 1890, but the dealer did not buy
it until February 1892, when he registered it
as *Enfant portant des fleurs*; it may well have
appeared in the dealer's May 1892 Renoir
exhibition, but cannot be identified from
the catalogue. Durand-Ruel showed it, with
the title *Little girl carrying flowers*, in London
in 1905; it is very possibly the same picture
which was exhibited in Montreal in 1909
and by Manzi, Joyant et Cie in Paris in 1912
with the title *Enfant portant des fleurs*.
Durand-Ruel sold it to the Berlin dealer
Cassirer (cf. no. 122) in October 1913.

LITERATURE
Meier-Graefe 1912, p.138
London, Arts Council, 1954, no. 55
Daulte 1971, no. 558

EXHIBITIONS
1905, London, Grafton Galleries (265)
? 1909, Montreal (273)
? 1912, Paris, Manzi-Joyant (173; lent by Durand-
 Ruel)

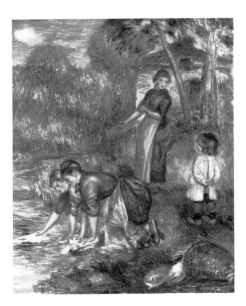

81

Washerwomen

Les Laveuses
c. 1888
56 × 47 cm (22 × 18½ ins)
Signed bottom right: Renoir.
The Baltimore Museum of Art (The Cone
Collection, formed by Dr Claribel Cone
and Miss Etta Cone of Baltimore,
Maryland), BMA 1950.282

COLOUR *p.129*

Painted at Essoyes (cf. Vollard 1918), this is
very probably the canvas depicting '*blan-
chisseuses*, or rather *laveuses*, beside the river'
which Renoir mentioned in a letter to Berthe
Morisot and Eugène Manet late in 1888
(Rouart 1950). 'I'm playing peasant in
Champagne in order to escape the expensive
models of Paris', he wrote in the same letter;
a few weeks later he told Eugène Manet
how reluctant he would be to get back to the
'stiff collars' of Paris; 'I'm becoming more
and more of a rustic.' On this visit he spent
around three months at Essoyes, Aline
Charigot's home village in southern Cham-
pagne, and undertook some of his most
important canvases of peasant life. His art
reflects his distaste for Paris's 'stiff collars',
as he created images which suggest a natural
harmony between country life and work. In
Washerwomen, the kneeling women are
treated with relaxed, easy rhythms, while
the standing woman turns aside to greet the
watching child – presumably Renoir's son
Pierre, born in March 1885. This gentle,
almost idyllic vision of country life bears
comparison with the more monumental,
solemn images of work which Pissarro was
painting at the same time; Pissarro's con-
cerns were with the role of labour within an
integrated rural society, Renoir's, as he pre-

sented them in *Washerwomen*, with the country as site for easy relations and healthy occupations. Many years later Renoir told his son Jean that women needed such physical exercise: 'The best thing for a woman is to stoop down to clean the floor, to light the fire or to do the washing; their bellies need these movements' (J. Renoir 1962, p. 89).

Though quite small, *Washerwomen* is elaborately executed, but without the dryness of some of his works of the mid-1880s. The background is mostly treated in loosely parallel strokes, but these, with their varied, curling rhythms, are less rigid and Cézanne-like than in some of Renoir's works of this period (cf. no. 82). The colour throughout is luminous and pastelly, with emphatic contrasts between warm and cool hues; orange-red accents were added in several parts of the picture late in its execution, to increase its overall warmth. Like the background, the figures are quite freely brushed, but Renoir suggested their modelling carefully; fluent strokes of varied colour follow the directions of the folds in their dresses, while their highlights are expressed by clear, light tones. Extensive layers of dried paint below the refinements of the final surface show that the painting was worked up over a considerable period of time; moreover, a number of related drawings survive, which reveal the careful planning that went into the compositional arrangement. The background, which carefully complements the positions of the figures, is more an archetypal rural setting than a particular location; a similar arrangement, without the stream, appears in *The child at the breast* (no. 79). It thus seems likely that *Washerwomen* was executed in the studio, not out of doors.

In a group of undated letters from Essoyes, Renoir wrote to Durand-Ruel about his search for a softer style of painting. These letters have been published as belonging to 1885 (Venturi 1939, I, pp. 131–4), but they very probably belong to autumn 1888. One of them may mention *Washerwomen*: 'I have some pictures under way in the manner of the *Woman with a fan* (Daulte 1971, no. 332) . . . I have begun some washerwomen . . . I think that it will work out all right this time. It is very soft and coloured, but luminous.' Another of this group of letters described this new manner more fully: 'I have taken up again, never to abandon it, my old style, soft and light of touch. . . . It is quite different from my recent landscapes and from the monotonous portrait of your daughter [presumably Daulte 1971, no. 549, dated '88']. It's like the *Fishergirls* [fig. a] and the *Woman with a fan*, but with a slight difference caused by a note which I could not find, which I have finally put my hand on. It's nothing new, but rather a follow-up to the paintings of the eighteenth century. . . . This is to give you some idea of my new and last manner of painting (like Fragonard,

only not so good). . . . I'm not comparing myself, believe me, to an eighteenth-century master. But I must explain the way I am working. Those fellows who give the impression of not painting nature knew more about it than we do.' This last phrase closely echoes Renoir's responses to Raphael in 1881 (cf. no. 63), but the idea is now reapplied to the art of the eighteenth century. *Washerwomen* does not closely resemble any particular eighteenth-century example, but suggests the lessons of French eighteenth-century art in a number of ways: in the increasing suppleness with which brushwork creates form; in the luminous, rather generalized backdrop (cf. no. 85); and in its idyllic, pastoral mood, so far from the mainstream of nineteenth-century peasant painting.

The early history of this painting cannot be firmly documented.

LITERATURE
Vollard 1918, I, p. 11 no. 42
? Venturi 1939, I, pp. 133–4
? Rouart 1950, p. 142
Daulte 1971, no. 572 and p. 54
Chicago, Art Institute, 1973, no. 56

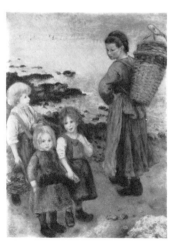

FIG a. Renoir, *Mussel-fishers at Berneval*, 1879. The Barnes Foundation.

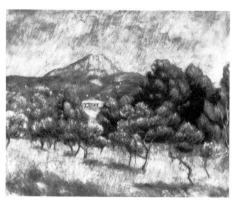

82

Montagne Sainte-Victoire

La Montagne Sainte-Victoire
c. 1888–9
53 × 64 cm (21 × 25 ins)
Signed bottom right: Renoir
Yale University Art Gallery, New Haven
(The Katharine Ordway Collection),
1980.12.14

COLOUR p. 128

Renoir stayed with Cézanne at Aix-en-Provence early in 1888, and on another occasion he rented a house near Aix, named Bellevue, from Cézanne's brother-in-law, where he painted at least three landscapes of subjects which Cézanne also painted – two showing the Montagne Sainte-Victoire and one the pigeon tower (cf. Rewald 1950). Though the date of this visit cannot be precisely documented (Cézanne's brother-in-law placed it in 1886), it very probably took place, as Rewald suggests, in 1889: one of the Montagne views bears this date, and the style of the pictures belongs to 1888–9. Two years later, after passing through Aix again on his way south early in 1891, he wrote to Berard of his delight at Aix and its countryside: 'That countryside which I already found so beautiful dazzled me even more. That aridness, with the olive tree which follows the weather – sad in grey weather, resonant in the sun and silvered in the wind. . . .' (Berard 1968, p. 7, letter of 5 March 1891.)

Cézanne's presence is felt in the present view of the Montagne Sainte-Victoire in the recurrent parallel brushstrokes. Orderly parallel strokes had been the basic unit in Cézanne's more highly worked paintings of the early 1880s, and Renoir had already explored this means of unifying his picture surfaces (cf. nos. 64 and 77). However, by the late 1880s even Cézanne's more finished paint surfaces were becoming less dense and their touch less regular, as he sought more flexible ways of translating his experiences of nature into coherent pictorial form. Renoir's parallel strokes in this version of

Montagne Sainte-Victoire create a thoroughly covered, opaque surface, but they vary in weight and direction; in the distance and foreground they are partially blended together, while in the foliage they tend to follow the directions of the foliage rather than imposing a single direction on it. The brushwork in Renoir's (presumably contemporary) view of the pigeon tower at Bellevue (Barnes Foundation, Merion) is more tightly parallel, while in the second version of *Montagne Sainte-Victoire* (dated '89'; fig. a) it is softer and more cursive. This second version is identical in its forms to the first, with the addition of two small figures working in the foreground field; it is not impossible that it might be a studio painting, based on the present picture.

In this version, form and space are primarily expressed by colour, with blues to suggest shadows and distance, while reds and red-oranges animate some of the sunlit zones. However, Renoir simultaneously used a more tonal type of modelling, bleaching his colours where the sun creates highlights on the trees, in a way more reminiscent of Corot than of the colourist tradition to which Impressionism belonged. He seems here, as in the figures in *Washerwomen* (no. 81), to be trying to reconcile two different conventions for the representation of sunlight. Renoir later returned to this problem, particularly in the landscape backgrounds of his last paintings (cf. no. 125).

Renoir's paintings of the Montagne Sainte-Victoire present a far more accessible, straightforward space and composition than most of Cézanne's. The eye here is gently led into the space along the row of trees, and can then move back step by step through the intervening space to the distant mountain; Cézanne rarely used such steady progressions from foreground to distance, creating far tauter rhymes of form and colour between objects in different planes of space.

Its early history is not documented.

LITERATURE
Drucker 1944, p. 80, pl. 100 (wrongly identified as the Barnes Foundation version)
Rewald, J., *Paul Cézanne*, London 1950, p. 142
J. Renoir 1962, p. 261
Information kindly communicated by Professor John Rewald

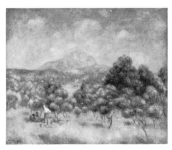

FIG a. Renoir, *Montagne Sainte-Victoire*, 1889. The Barnes Foundation.

83

Flowers and fruit

Fleurs et fruits
1889
65×53 cm ($25\frac{1}{2} \times 21$ ins)
Signed and dated lower left (above the table): Renoir 89
Private Collection

COLOUR *p. 130*

In September 1890 Durand-Ruel bought from Renoir this painting and another which shows the identical vase of flowers with a different grouping of fruit (New York, Wildenstein, 1969, no. 50, there misdated to 1882). Still lifes were one of the Impressionists' most readily saleable commodities. Durand-Ruel bought many still lifes from both Renoir and Monet when he began to purchase their work regularly in the early 1880s; from the late 1880s onwards still life became a regular part of Renoir's stock-in-trade, sometimes in the form of elaborated, fully worked compositions, like the present picture, but often with more casual informal studies (cf. no. 104).

Form and colour alike are carefully arranged here: above the nuanced light colours of the tablecloth, interwoven contrasts of red and green revolve around the blue and orange patterned vase. The forms are clear, mainly defined by contrast with what lies beyond them. The drawing, though, is not precise; the brushwork seeks out the internal rhythms of the various elements, setting their cursive patterns against the unobtrusively brushed verticals of the background. The second peach from the left is a textbook example of modelling by colour gradation – from the yellow on its lit side, through orange and various reds to duller mauves

and beiges and deeper purple; by contrast, the shinier surfaces of the grapes are modelled by off-white highlights.

Renoir was to use the same vase again in two versions of his *Young girls at the piano* (cf. no. 90).

The painting remained with Durand-Ruel until after Renoir's death.

LITERATURE
New York, Wildenstein, 1969, no. 71

EXHIBITION
1908 (April–May), Paris, Durand-Ruel (*Natures mortes*) (47)

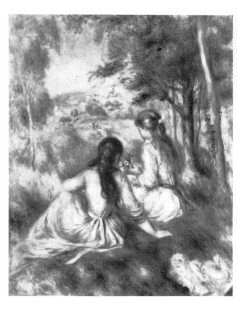

Durand-Ruel bought the picture as *La Leçon de piano* in January 1890 and sold it to P. Mellério in March 1892; it can thus be identified with the picture entitled *Jeunes filles au piano* which P. Mellério lent to Durand-Ruel's Renoir exhibition in May 1892 – presumably its title was changed to emphasize its relationship to the *Jeunes filles au piano* of 1892 recently purchased by the State, which appeared in the same show but not in its catalogue (cf. no. 91). It was in the Bernheim-Jeune stock in 1913.

LITERATURE
New York, Duveen, 1941, no. 49
Drucker 1944, pp. 81–2, 209 no. 104
Kálmán 1956, pp. 118–122
Daulte 1971, no. 561
Chicago, Art Institute, 1973, no. 55

EXHIBITION
1892, Paris, Durand-Ruel (24)

84

The piano lesson

La Leçon de piano
c. 1889
56 × 46 cm (22 × 18 ins)
Signed bottom right: Renoir.
Joslyn Art Museum, Omaha, Nebraska, 1944.20

COLOUR *p. 131*

Girls playing the piano were one of Renoir's favoured themes (cf. no. 35); the present picture is Renoir's first version of the grouping which he was to explore at length in 1892 for the picture which the French State purchased (cf. nos. 89–91). Indeed, the fact that Renoir chose this theme again for so important a project suggests that he felt it was a happy formulation.

The picture was painted from young models – presumably the same girls who posed for *The two sisters* (Daulte 1971, no. 562). It thus makes an interesting contrast with another painting of girls at a piano, the *Portrait of the daughters of Catulle Mendès* of 1888 (Walter H. Annenberg Collection), which Renoir showed at the 1890 Salon – his last Salon exhibit. There, the three girls are carefully posed to display their faces, as the conventions of portraiture demanded; here, by contrast, the individuals depicted are unimportant, but are presented as types. Their faces are less individualized, and the focus of the picture is their activity and the interrelationships of form and colour between figures and surroundings. A preparatory drawing for the picture (Longstreet 1965; discussed Kálmán 1956) shows how carefully its forms were composed. This sort of genre painting, evoking a mood of youthful harmony, has clear links with similar images by French eighteenth-century artists.

85

Gathering flowers (*known as* In the meadow)

La Cueillette des fleurs (dit *Dans la prairie*)
c. 1890
81 × 65 cm (32 × 25½ ins)
Signed bottom left: Renoir.
The Metropolitan Museum of Art, New York (Bequest of Sam A. Lewisohn, 1951), 51.112.4

COLOUR *p. 133*
Exhibited in London and Paris only

Alongside rural subjects such as *Washerwomen* (no. 81), Renoir painted many canvases between 1888 and 1892 depicting the recreations of young bourgeois girls – playing the piano, reading, talking, walking in the countryside, picking flowers. The girls often appear in couples and are tidily but informally dressed, frequently in summer frocks. Their poses are carefully worked out, often with the help of preparatory drawings; their gestures are typical, rather than suggesting a captured instant or incident, and their grouping presents their shared activity as something natural and harmonious, without a hint of psychological engagement or any more precise narrative. Pictures of this type seem to have found a ready market in the early 1890s.

The girls in the present painting are framed by the trees; they are turned away from us towards the sunny vista which opens out beyond them, but their attention is focused on the bunch of flowers which the blonde holds, which is carefully framed between the two figures in the centre of the canvas. The viewer has no direct access to their experience, but looks in from outside on to their self-contained world; at the same time

the whole picture – sunlit landscape, young girls and flowers – presents the viewer with a vision of harmony and integration.

The painting's execution complements this mood. It is soft and supple throughout; the figures of the girls are more densely painted, emphasizing their central role in the composition, but in places – particularly in the background – the paint is thin, allowing the white priming to show through and lend added luminosity. As in so many of Renoir's pictures of girls, the blonde wears white and blue, the brunette pink (cf. nos. 53, 86, 89–91), and the figures are woven into their surroundings by the repetition of similar colours throughout the landscape, with stronger hues in the foreground and the main tree, and luminous, pastelly tints in the distance.

The idyllic mood of this painting is reminiscent of the *fêtes champêtres* of French eighteenth-century painting, though drained of any nuance of courtship and eroticism. The supple brushwork and the generalized, though luminous, forms of the background also suggest the example of the eighteenth century, which Renoir had recently acknowledged in a letter to Durand-Ruel (cf. entry for no. 81); in 1896 he particularly praised the beauty of Watteau's landscape backgrounds (Manet 1979, p. 134). But these lessons must be seen alongside Renoir's admiration for Corot, which was at its height in the 1890s; indeed the softly brushed landscape here is a sort of coloured Corot. Renoir later attributed the truthfulness of Corot's vision to his insistence on reworking his canvases indoors; the rather unspecific lighting and the simplified forms of the landscape here, so closely dovetailed to the figure grouping, would suggest that the picture was a studio composition.

According to Daulte, this picture and no. 86 were painted using Berthe Morisot's models, while Renoir was staying with her at Mézy in summer 1890; but Morisot's daughter Julie Manet plausibly suggested (New York, Metropolitan, 1967) that the models are those who also posed for *Young girls at the piano* (nos. 89–91), which would indicate that they were regular models of Renoir's, and presumably based in Paris.

The early history of this painting and no. 86 has become confused (e.g., in Daulte 1971), as a result of a confusion between the two in the records of Durand-Ruel's New York branch in the 1890s. Durand-Ruel bought the present picture from Renoir in March 1892 and sold it at once to Mrs Potter Palmer; she sold it back to Durand-Ruel in New York in November 1894, when it was registered with the wrong photograph-number – that belonging to no. 86. The present picture was sold by Durand-Ruel to Arthur B. Emmons in February 1906 and was bought by Adolph Lewisohn at the Emmons sale in 1920.

LITERATURE
New York, Duveen, 1941, no. 61
Pach 1950, p. 90
New York, Metropolitan, 1967, pp. 158–9
Daulte 1971, no. 610 and p. 55

EXHIBITION
1900, New York, Durand-Ruel (30 or 32)

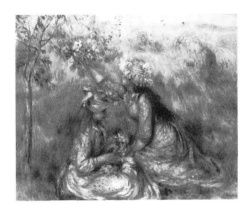

86

In the meadow

Dans la prairie
c. 1890
65 × 81 cm (25½ × 32 ins)
Signed bottom right: Renoir.
Museum of Fine Arts, Boston
(Juliana Cheney Edwards Collection,
Bequest of Hannah Marcy Edwards
in memory of her mother, 1939), 39.675

COLOUR *p. 132*

In the meadow was probably painted at much the same time as no. 85 and very possibly from the same models – the brunette again wearing pink, the blonde white with a blue sash. Though the general theme is very similar, the painting is conceived in a rather different way. Instead of placing the figures within the landscape, Renoir has here reduced the setting to little more than a freely brushed coloured backdrop, with only the merest hints of natural features. The figures are placed right at the front of the picture, treated in more detail than in no. 85, and with their profiles displayed. Their world, though, remains quite separate from that of the painting's viewer; their poses are carefully interlocked, creating a gentle circular movement through the centre of the picture. In natural terms, the gesture of the girl on the right is a little puzzling, since the tree must be remarkably small for its flowering branches to be within her reach as she kneels on the ground; however, this single tree plays a crucial role in the picture, framing its composition and creating an image of natural plenty. The juxtaposition of flowers and young girls, here mediated by the girls' flowering bonnets, creates a metaphor for beauty and innocence which Renoir often repeated (cf. nos. 80, 116).

Durand-Ruel bought this picture from Renoir in February 1892 and despatched it to his New York branch in October 1892; in his records there, the picture became confused with no. 85: both pictures – simultaneously in his New York stock – were registered with the same photograph

number. When the error was seen, the number of the wrong picture – the present one – was corrected. It was sold to Miss Grace Edwards in December 1912 and presented to the Boston Museum in the Edwards collection in 1939.

LITERATURE
New York, Duveen, 1941, no. 60
Daulte 1971, no. 609 and p. 55

EXHIBITION
1900, New York, Durand-Ruel (30 or 32)

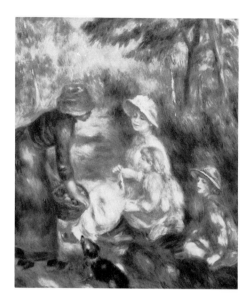

LITERATURE
New York, Wildenstein, 1969, no. 75
Daulte 1971, no. 585
Chicago, Art Institute, 1973, no. 57

EXHIBITION
1896, Paris, Durand-Ruel (18)

87

The apple seller

La Marchande de pommes
c. 1890
66 × 54 cm (26 × 21½ ins)
Signed bottom right: Renoir
The Cleveland Museum of Art, (Purchased Leonard C. Hanna, Jr Bequest), 58.47

COLOUR *p.134*

Exhibited in Boston only

In technique and colour, *The apple seller* is closely comparable with *Gathering flowers* (no. 85): its supple brushwork suggests the modelling of forms and creates cursive patterns which run through the picture, while rich colours suggest the rather generalized patterns of light and shade. The present picture was probably painted at Essoyes. The seated woman has plausibly been identified as Renoir's wife Aline, but the child beside her seems to be a girl with a ribbon in her hair, rather than Renoir's son Pierre, as Daulte suggests; Pierre (born in 1885) is likely, rather, to have been the model for the boy on the right.

The subject, like *Washerwomen* (no. 81), presents an idyllic vision of rural life. The pyramidal arrangement which encompasses all four figures draws them into a single harmonious ensemble; no reference is made to the labour of collecting the apple harvest, which Pissarro had recently made into the theme of several of his figure paintings of the later 1880s.

The apple seller is the most highly worked of three presumably contemporary versions of the subject (cf. Daulte 1971, nos. 584, 586).

Durand-Ruel bought this version from Renoir in November 1891, and sold it to Count von Kessler of Berlin in 1896.

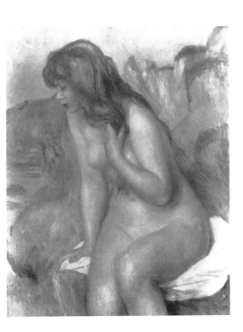

88

Bather

Baigneuse
1892
80 × 64 cm (31½ × 25 ins)
Signed and dated bottom right: Renoir.92.
Durand-Ruel, Paris

COLOUR *p.141*

The *Bather* which Renoir painted in Italy in 1881 (no. 63) was the beginning of a long sequence of single nude figures in outdoor settings. Unlike the figure in *Study* of 1875 (no. 36), these nudes are not absorbed into an overall play of light; instead, their forms stand out clearly from what lies beyond them.

The present *Bather* of 1892 and the others of this period mark a clear rejection of the harsh, linear treatment of Renoir's nudes of the mid-1880s (cf. no. 75). The form is softly brushed, in supple strokes which unobtrusively follow the forms of the figure. Nuances of pink, yellow and blue suggest the warm flushes on her skin and the play of light across it. The colours in the landscape echo and harmonize with the hues in the figure, but, as in the 1881 *Bather*, Renoir has not placed the model in a legible spatial relationship with the background. She does not exist in the same space as the cliffs which are suggested behind her and the river or shoreline on the left.

This break in the picture's space may well reflect the way in which Renoir executed the canvas, but such spatial discrepancies occur so often in his outdoor nudes that they cannot have been unintentional (cf. nos. 63, 72). We have no firm evidence about how this picture was painted, but it was very probably a studio work. Renoir did on occa-

sion consider posing his nude models out of doors during these years; he wrote in August 1891 to Marie Meunier to tell her that he had decided not to bring a model to pose nude on an islet in the river Oise (letter of 12 August 1891, Gachet 1957, pp. 105–6). He clearly found that the changeable weather conditions did not allow him to finish paintings as he wished; a few weeks before this letter, he had written to Berthe Morisot from Paris: 'I've just written to a model. I'm starting work again in the studio while waiting for something better. For a whole month I've been watching the sky and doing nothing else. . . . I'm going to do some open air in the studio' (Rouart 1950, p. 160). The present *Bather* was sold to Durand-Ruel in June 1892 and may well have been one of the studio open-air subjects that Renoir was planning in summer 1891; he did not spend a period at the seaside in the year before delivering the canvas. A few years later, he delightedly painted a nude in Jeanne Baudot's south-facing studio, with the sunlight diffused by a white curtain; 'Titian,' he said, 'must have worked in this way' (Baudot 1949, p. 14). The warm hues of this *Bather* may well have been achieved by similar means.

A second nude, also dated '92', shows probably the same model, in a similar pose (fig. a), but the setting and colour scheme are very different from the present picture: the figure is surrounded by foliage, implicitly seated by a riverside, and the whole is treated in a very restricted, cool colour range which is particularly reminiscent of Corot. Monet, who owned this picture, later criticized its background for being so conventionalized: 'It looks just like a photographer's décor' (Dauberville 1967, p. 202). But it would be wrong for us to impose Monet's preoccupation with the atmospheric ambience on to paintings such as these. Their backgrounds and their chosen colour schemes create a pictorial tone, rather than attempting to re-create a specific natural effect. The Impressionism of the mid-1870s, like Monet's more recent figure paintings, had fused figure with ground, treating it as if it was part of the landscape; in these *Bather* paintings, Renoir was deliberately rejecting this process, by reinstating the traditional humanistic view of the figure as the painter's prime object of attention, at the same time as he was re-establishing the links between his own art and the figurative tradition in European painting.

For all their differences in setting and colour scheme, the present *Bather* and fig. a view the nude model in very similar ways, with her head averted and one arm partly shielding her body from the viewer's gaze. Renoir's nudes of these years rarely engage the viewer directly; their poses sometimes suggest modesty, as here, and sometimes a complete unawareness of any possible aud-

ience (e.g. no. 94). Poses of these types complement the youthful girlish types which Renoir favoured for his models in these years, seeking to evoke a sense of innocence. Critical commentaries on Renoir's art between the early 1890s and around 1905 were to make much of this vision of female beauty – half child, half woman. After 1900, Renoir began again to paint more ample models; only then did his figures on occasion engage the viewer in a more direct relationship (cf. nos. 102, 103).

LITERATURE
Barnes and de Mazia 1935 p.418 no.199
Gaunt and Adler 1982, no.41

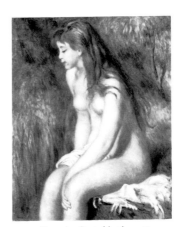

FIG a. Renoir, *Seated bather*, 1892.
The Metropolitan Museum of Art,
New York, Lehman Collection.

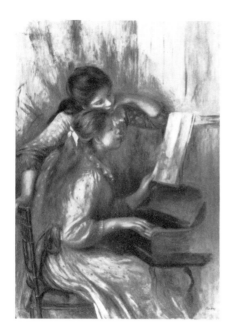

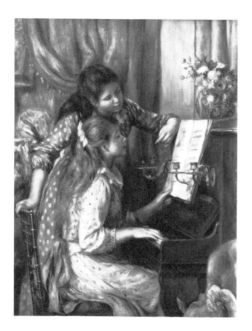

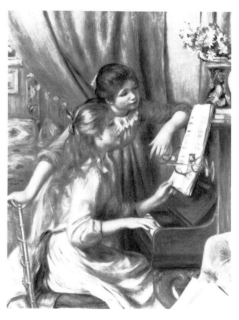

89

Young girls at the piano

Jeunes filles au piano
1892
116 × 81 cm (45½ × 32 ins)
Signed bottom right: Renoir.
Musée de l'Orangerie, Paris (Collection
Walter–Guillaume), RF1960–16

COLOUR *p.136*

90

Young girls at the piano

Jeunes filles au piano
1892
117 × 90 cm (46 × 35½ ins)
Signed and inscribed bottom right:
A mon ami G.Caillebotte / Renoir.
Private Collection

COLOUR *pp.138, 139*
Exhibited in Paris only

91

Young girls at the piano

Jeunes filles au piano
1892
116 × 90 cm (45½ × 35½ ins)
Signed bottom right: Renoir.
Musée d'Orsay, Paris (Galerie du Jeu de
Paume) RF755

COLOUR *p.137*
Exhibited in Paris only

Late in 1891 or early in 1892, Renoir was
asked by the French State, in the person of
the Minister of Fine Arts, Henri Roujon, to
paint a substantial picture to be purchased
by the Musée du Luxembourg, the museum
devoted to paintings by the leading living
artists. Roujon made this request on the
instigation of Mallarmé and Roger Marx (cf.
Mallarmé 1981, V); his first instinct, ap-
parently, was to buy an old work by Renoir
– presumably a major painting from the
1870s; but Mallarmé insisted he chose some-
thing new (cf. Natanson 1948). The trans-
actions have been described as a commission
from the State, but they seem to have begun
as a more informal request, for the painting
was only selected, and the purchase officially
authorized, in April 1892, after Renoir had
completed his work.
 Renoir took great pains over the project.
He chose a theme which he had recently
depicted (cf. no. 84), and seems quickly to
have settled on an approximate grouping,
which he explored in six large works, one
pastel and five oils, each around 45 inches
high; at no other moment in his career did
he work with such concentration on a single
project. He was adding paintings to the
sequence until the last minute. Early in April

1892 Mallarmé wrote to tell Roger Marx that Roujon's visit to select the picture was to be deferred, and he added: 'Renoir has taken advantage of this to paint a new version alongside, and you'll be spoiled for choice' (Mallarmé 1981, V, pp. 61–2). The choice was finally made on 20 April; Roujon gave official instructions for the purchase on 25 April, and it was decreed on 2 May, for 4000 francs.

Roujon gave authorization for the purchased picture (no. 91) to be exhibited in Renoir's one-man show at Durand-Ruel's in May; the Musée du Luxembourg was closed for reorganization until late in the year. On 12 May Mallarmé wrote to thank and congratulate Roujon: 'Renoir has used [the authorization] very discreetly, by setting apart, on an easel in a special room, the painting, one of his perfect works. For myself, and from the unanimous impression gathered around me, I cannot congratulate you enough for having chosen for a museum this definitive canvas, so calm and so free, a work of maturity' (Mallarmé V, 1981, pp. 77–8). Alexandre, in his preface to the May 1892 exhibition catalogue, hailed the picture as the resolution of Renoir's technical researches of the past decade.

But the State purchase was only the beginning of the discussions which have surrounded Renoir's versions of *Young girls at the piano* ever since. It was only when the other four oil versions began to be seen that their viewers, and Renoir himself, began to ask if the State had, in fact, acquired the finest version. Durand-Ruel bought one (fig. a) immediately after the official purchase of no. 91, but seems to have withheld it from the May 1892 Renoir exhibition, presumably so as not to detract from the Luxembourg picture; no version of the composition appears in the exhibition catalogue (cf. entry for no. 84). The dealer bought a second in June (fig.b). Renoir dedicated a third to Gustave Caillebotte, with whose family it remained (no. 90); the final oil was left in a sketch-like state, and remained in Renoir's possession until his death (no. 89).

Critics in Renoir's lifetime felt that the State's version was not the best (Mauclair, Meier-Graefe), but it seems to have been only after his death that Renoir's own feelings became public. In 1920, Alexandre described the anxieties which had surrounded the project in 1892: 'I remember the infinite pains he took in executing the official commission which a well-meaning friend had taken the trouble to gain for him. This was the *Young girls at the piano*, a painting delicate and supple in its execution, though its colour has yellowed somewhat. Renoir began this painting five or six times, each time almost identically. The idea of a *commission* was enough to paralyze him and to undermine his self-confidence. Tired of the struggle, he

finally delivered to the Beaux-Arts the picture which is today at the Museum, which immediately afterwards he adjudged the least good of the five or six.' Renoir later admitted to Durand-Ruel that he had overworked the Luxembourg version (Gimpel 1963).

There are minor compositional variations between the versions, in the position of the head and arms of the standing girl, and in details of dresses, vases, curtains and background. These suggest a putative sequence of execution. The present oil sketch (no. 89) and the pastel seem to come first, before the background space and the vase on the piano were defined; the sketch indicates the basic forms of the composition with great verve and freshness, but was presumably abandoned because Renoir wanted to change some of the detailed compositional relationships. The Caillebotte (no. 90) and Lehman (fig. a) versions probably come next and are closely related: the standing girl's head is a little higher than in the first two, and her left arm has been moved; the background curtain and the space beyond it have been defined, and there is a vase of flowers on the piano (cf. no. 83 for this vase). The Caillebotte version is fully resolved, but rather more fluently brushed than the Lehman one, with the girls' features less closely defined; the Lehman one, with its tighter finish, may be a first attempt at an 'official' version. In their tonality, both are clear and cool. The version from a private collection (fig.b) is more sketchily treated than either of these, but, unlike the initial sketch, was completed for sale by Renoir; it probably postdates them: the standing girl's head is moved to the right, though her left hand is returned to her chin, as in the first version. In the painting which the State bought (no. 91), her left hand hangs down again. This picture is treated with finesse and delicacy; the touch is soft throughout, sometimes feathery, sometimes flowing more freely, as in the fabrics and hair. The brushwork complements the patterns of the composition, in giving the whole painting a carefully conceived rhythmic structure, cursive and smoothly interlocked. The basic idea of the brunette wearing pink, the blonde wearing white with a blue sash (so common in Renoir's paintings, cf. nos. 53, 85, 86) remains unchanged, though the patterns of their dresses alter, along with the details of curtains and vases. A full-sized outline drawing survives for the final grouping, presumably used for its transfer to the final canvas (Daulte 1972, p. 56; on such drawings, cf. André 1928, p. 71), which shows how carefully the compositional changes were worked out.

However, the most marked change in the Luxembourg version is in its tonality and colour scheme: it is deliberately warmed and mellowed, to give it a softly golden glow, in place of the coolness and crisper tonal contrasts of the Caillebotte and Lehman ver-

sions. Specifically, in the final one Renoir virtually eliminated the use of blue to model shadows – an important move away from a technique which had been so closely associated with the Impressionists in their days of notoriety in the 1870s. Though in this case he may have done this in order better to please official tastes, he rarely used blue as an important means of modelling form in his pictures after this date; in his later paintings, as in the Luxembourg version of *Young girls at the piano*, blues are generally confined to individual accents which stand out against their dominant tonality.

In subject and composition, the picture relates closely to much of Renoir's recent work – to his pictures of the carefree recreations of pretty young bourgeois girls, presented in smooth and harmonious groupings (cf. nos. 85, 86). The subject is complemented by the theme of music, with its associations of harmony and sensory beauty; musical imagery recurs frequently in Renoir's later paintings (cf. nos. 96, 126). The music room theme also evokes reminiscences of old master prototypes, particularly from seventeenth-century Holland

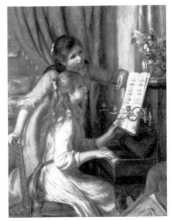

FIG a. Renoir, *Young girls at the piano*, 1892. The Metropolitan Museum of Art, New York, Lehman Collection.

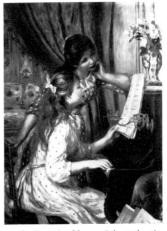

FIG b. Renoir, *Young girls at the piano*, 1892. Private Collection.

and eighteenth-century France, among them Fragonard's *Music lesson* (in the Louvre). But Renoir has drained the subject of all its familiar references to love or courtship; his imagery has no allegorical content or precise programme. But his chosen subjects also go beyond literal depiction; typical rather than specific, their slightly generalized forms are designed to evoke moods; it was this that enabled younger critics in symbolist circles to take up his art with such eloquent enthusiasm in the 1890s. Throughout the 1890s, the innocence and prettiness of youth were the central theme of his art, in pointed contrast to his erratic, often quirky personal behaviour; sometimes generous and expansive, sometimes querulous and misanthropic, he was always agitated and ill at ease, wholly lacking the serenity of which he created an image in paintings such as *Young girls at the piano*.

LITERATURE (for all versions)
Alexandre 1892, pp. 30–1
[Anon.], *L'Eclair*, 1892
Mauclair 1902, pp. 222–3
Meier-Graefe 1908, I, pp. 294–5
Meier-Graefe 1912, pp. 145–6
Alexandre 1920, p. 6
Fosca 1923, pp. 37–8
Jamot 1923, p. 342
Meier-Graefe 1929, pp. 250–5
Barnes and de Mazia 1935, pp. 418–420 no. 203
Jeanès 1946, p. 30
Natanson 1948, p. 27
Pach 1950, p. 98
Gimpel 1963, p. 180
Paris, Orangerie, 1966, no. 24
Daulte 1972, pp. 56–7
Mallarmé 1981, V, pp. 61–78, 149, 175
Gaunt and Adler 1982, no. 42
Paris, Orangerie, 1984, pp. 188–191

EXHIBITIONS
No. 91: 1892, Paris, Durand-Ruel (ex-cat.).
Displayed in Musée du Luxembourg, Paris, December 1892.
Neither no. 189 nor no. 90 seems to have been exhibited during Renoir's life.

92

Landscape at Beaulieu

Paysage de Beaulieu
1893?
65×81 cm ($25\frac{1}{2} \times 32$ ins)
Signed and dated bottom right: Renoir. 97
The Fine Arts Museums of San Francisco
(The Mildred Anna Williams Collection),
1944.9

COLOUR *p. 135*

In spring 1893 Renoir spent a period at Beaulieu, on the Mediterranean coast just to the east of Nice; despite the date it appears to bear, the present painting was very probably painted during this visit; he did not, it seems, travel south in 1897. He kept the picture until he deposited it with Durand-Ruel in 1914; the photograph which the dealer took of it at this time clearly shows that the picture was still unsigned. Durand-Ruel bought the canvas in 1917, and presumably asked Renoir to sign it at this point; the date '97' is probably a misdating by the aged artist, so many years after the picture was painted.

Towards the end of his stay at Beaulieu, Renoir wrote to Gallimard: 'I think I will bring you back a landscape. I will only be able to know its real value when I get to Paris and see it in good lighting. I haven't sent a case of paintings, because I have worked much too much at my studies over a period of months, which is not particularly profitable; but if I'm happy when I get back, the damage will be repaired' (letter of 27 April 1893, MS, Institut Néerlandais, Fondation Custodia, Paris). The present painting may well be the 'landscape' which Renoir appears to distinguish from his 'studies' in this letter; it seems to be his most substantial painting from Beaulieu. Since Renoir remained its owner, we must assume that any planned sale to Gallimard came to nothing.

Renoir painted few landscapes of this scale and ambition after 1890. The picture marks a return to the lavish, exotic foliage which had attracted him in his Algerian paintings of 1881–2 (cf. no. 55); in its brushwork,

too, it is bold and ebullient, like Renoir's southern landscapes of the early 1880s (cf. also no. 71), in contrast to the softer, more supple handling characteristic of his work of the early 1890s. Unlike *The Ravin de la Femme Sauvage* (no. 55), painted in Algeria in 1881, though, *Landscape at Beaulieu* shows nature ordered and tamed by man; the low wall across the foreground and the path with figures on it running into the centre of the pictorial space clearly present its lavish foliage as the results of cultivation. This harmonious interrelation of man and nature became a central theme in Renoir's late work (cf. e.g. nos. 109, 117, 125).

LITERATURE
Chicago, Art Institute, 1973, no. 68

EXHIBITION
1918, New York, Durand-Ruel (23)

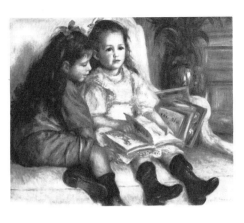

93

Portraits of children (the children of Martial Caillebotte)

Portraits d'enfants (les enfants de Martial Caillebotte)
1895
65 × 82 cm (25½ × 32 ins)
Signed and dated bottom right: Renoir.95.
Private Collection

COLOUR *p.142*

After the death of Gustave Caillebotte on 21 February 1894, Caillebotte's younger brother Martial and Renoir, the executors of his will, entered protracted negotiations with the French State over the acceptance of Gustave Caillebotte's collection as a bequest (see p. 23). In the midst of the controversies this aroused, Renoir painted this double portrait of Martial's children Jean and Geneviève. The two men became firm friends and a year later, in summer 1896, travelled together to Bayreuth and Dresden (Baudot 1949, p. 77; Manet 1979, p. 113).

Pairs of girls or children were one of Renoir's favourite themes (cf. nos. 53, 85, 89–91 etc.); here he has adapted it with great charm and wit. His viewpoint is close to the children, and the sofa on which they sit virtually fills the picture, with only the urn and panelled wall at top right to suggest the room beyond. Their poses are carefully interlocked, to form a simple pyramid, but within this ordered framework, details like the children's brown boots suggest an easy informality. Their interrelationship is wittily characterized: the girl in pink is not looking at the book she holds, and she holds it in such a way that her brother cannot easily see its pages; the other books, too, are tucked away beyond the boy's reach. The way in which the relationship is constructed hints at Renoir's declared view that, in the battle of the sexes, woman inevitably prevail; Rivière remembered Renoir emphasizing this belief as they together watched a little girl and a little boy arguing at Essoyes (Rivière 1928, p. 673).

This was the sort of portraiture at which Renoir excelled, when he could evoke childhood by combining its characteristic gestures with pretty young faces; less successful were portraits which demanded a penetration of character. Two or three years earlier, Renoir had painted the portrait of Mallarmé; Edmond Bonniot noted Mallarmé's comments on this: 'He showed us Renoir's oil portrait of him, which gives him, in his words, "the air of a prosperous financier", and in which he does not recognize himself. The truth is that the painter has given a concrete and material appearance to his dreaming features [*traits de rêve*], instead of veiling them in abstraction, which is what Whistler well understood in the little lithograph in his book.' (Mallarmé 1981, VI, pp. 22–3; Whistler's lithograph appeared as the frontispiece to Mallarmé's *Vers et prose* in 1893.) It was in child portraits like this painting that Renoir's concentration on 'concrete and material appearance' was so appropriate and so successful.

The picture's basic colour range is simple, with clear oppositions of dark and light tones, and sequences of pinks, reds and browns set off against the more neutral tones beyond; soft blues appear in some of the shadows. The brushwork is pliant and unobtrusive, softly brushing in the forms of the children.

The painting was exhibited at Durand-Ruel's in 1896 as *Portraits d'enfants*; it remained with the Caillebotte family.

LITERATURE
Drucker 1944, p. 88 and 210 no. 119
Berhaut 1978, p. 21 n. 92

EXHIBITION
1896, Paris, Durand-Ruel (32)

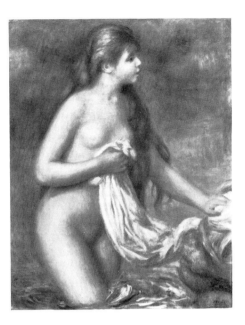

94

Bather

Baigneuse
c. 1895
82 × 65 cm (32 × 25½ ins)
Signed bottom right: Renoir.
Musée de l'Orangerie, Paris (Collection Walter–Guillaume), RF1963–23

COLOUR *p.140*

This is one of two closely related paintings of a young bather; the other is dated '95' (Barnes Foundation, Merion; repr. Barnes and de Mazia 1935, p. 310), and the present version was presumably painted at the same time. A preparatory sanguine drawing (Daulte 1959, pl. 21) relates more closely to this picture than to the Barnes version. Like no. 88 fig. a, of 1892, these paintings are set in a woodland setting, with a sketchily indicated, unspecific background which acts as a backdrop; space is only summarily suggested. The lighting is diffused; soft gradations of colour and tone suggest the modelling of the figure and the patches of foliage beyond. The colour harmony is quite restricted and subdued: only the pinks of the girl's face and her clothes on the rock set off the harmonies of beiges, yellows and muted greens that dominate the rest. This restricted palette and rather generalized treatment is particularly reminiscent of Corot, one of whose outdoor nudes, owned by his friend Gallimard, particularly aroused Renoir's enthusiasm (Vauxcelles 1908, p. 10; the painting, Robaut II, no. 379).

Late in his life Renoir told André: 'The simplest subjects are eternal. A nude woman getting out of the briny deep or out of her bed, whether she is called Venus or Nini, one can invent nothing better' (André 1928,

p. 32). His nudes of the 1890s are on the borderline between modernity and timelessness, between young model-girls and nymphs; indeed Renoir wrote to Geffroy at around this date about working at his 'nymphs' – presumably *Bather* pictures like the present one (undated letter, Paris, Librairie de l'Abbaye, catalogue no. 266, item 198). In a *Bather* composition in 1896 he once again posed his model (as he had before, cf. no. 15) in the Venus Pudica pose, with her hand modestly shielding her body (London, Christie, 30 March 1981, lot 40). The present *Bather*, by contrast, is wholly unaware of the viewer, her attention attracted, it seems, by something outside the picture to the right. Her gesture with the towel leaves her naked to our gaze, placing the viewer in the role of voyeur. Her apparent innocence is emphasized by the very youthful model Renoir chose for this picture and for his other nudes of the mid-1890s – a girl rather than a mature woman. Geffroy in 1896 evoked the 'young bodies of his bathing girls, little instinctive beings, at the same time children and women, to whom Renoir brings a convinced love and a malicious observation. They are a wholly individual idea, these young girls who are sensual without vice, oblivious without cruelty, irresponsible though gently woken into life. . . . They exist like children, but also like playful young animals, and like flowers which absorb the air and the dew.' Renoir was fascinated by the gestural language of young girls at this date. Natanson described him vividly miming the movements of a young girl walking through a forest, whose petticoat catches and tears on a twig (Natanson 1896, p. 546; 1948, p. 30). The light-hearted mood here, and in contemporary multi-figure bather compositions such as *Bathers in the forest* (p. 251 fig. b), is particularly reminiscent of French eighteenth-century painting – for instance Fragonard's *Bathers* in the Louvre (p. 251 fig. c).

Durand-Ruel bought the painting from Renoir in November 1896 and sold it to Oskar Schmitz of Dresden in November 1911.

LITERATURE
Paris, Orangerie, 1966, no. 26
Paris, Orangerie, 1984, pp. 194–5

EXHIBITIONS
? 1899, Paris, Durand-Ruel (? 101)

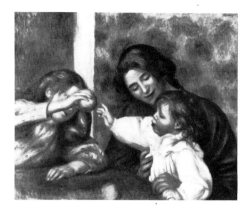

95

Gabrielle, Jean and a girl

Gabrielle, Jean et une petite fille
1895–6
65×80 cm ($25\frac{1}{2} \times 31\frac{1}{2}$ ins)
Signed top right: Renoir.
Private Collection represented by
Acquavella Galleries, Inc., New York

COLOUR *p.145*

Exhibited in Paris and Boston only

Renoir's second son Jean was born in September 1894. Earlier that summer Gabrielle Renard, a distant cousin of Aline Renoir, had joined the family to help in the household; she stayed with them for almost twenty years and became perhaps Renoir's most frequent model (cf. nos. 101, 115–6).

The present painting is the most ambitious of a group of related pictures which, from the age of the child, seem to belong to the later part of 1895 or early 1896. Some show just Gabrielle and Jean, others, like this one, include an older child. The care with which Renoir worked out the various groupings in these works is shown by the existence of many related drawings, including a full-sized tracing of this composition, presumably used for its transfer to the final canvas. Maurice Denis in 1897 noted Renoir's use of this technique (Denis 1957, I, p. 121).

Jean later remembered the secondary role that Gabrielle had played when Renoir had first painted her together with him as a baby, and he described his experience of posing: only rarely did Renoir ask him to sit quite still, so that he could capture a particular detail (J. Renoir 1962, pp. 391–2). This, together with the drawings, suggests that the overall arrangement of paintings such as *Gabrielle, Jean and a girl* was the result of careful compositional planning rather than simply the direct depiction of a posing group. Early in 1896 Renoir wrote to a friend: 'One must be personally involved in what one does. . . . At the moment I'm painting Jean pouting. It's no easy thing, but it's such a lovely subject, and I assure

you that I'm working for myself and myself alone' (letter to Congé[?], 1 February 1896; Paris, Drouot, 8 December 1980, lot 183). The colour, too, is carefully composed. In contrast to the restricted palette of the contemporary woodland *Bather* (no. 94), here clear colours are set against each other, with Gabrielle's red blouse standing out from the green wall behind her, and soft blues beyond the little girl's golden hair.

The focus of the composition is an apparently fleeting moment, as Jean reaches for the apple, but the figures are locked into a smooth sequence of relationships: all three figures are fitted within a semicircle, and Jean is protected by Gabrielle – only his hand reaches beyond her encompassing presence. Geffroy in 1896 described some of this group of paintings: 'Masterpieces which tell of the patience and solicitude of the woman without any sentimental *mise-en-scène*, simply by the posture and gesture of the arms which surround the child.'

The composition has clear echoes of many old master paintings, among them two which Renoir knew well in the Louvre: Correggio's *Mystic marriage of St Catherine* and Rubens's *Hélène Fourment and her children* (fig. a). But such resemblances are generic, not specific; the conventions of such paintings suggested a format which Renoir chose to adopt here. The Rubens (which Renoir had copied in his youth) may have had a more particular relevance for him in the 1890s, for its technique: Jeanne Baudot remembered how Renoir examined the Louvre's paintings by Rubens in these years, 'seeking to discover the procedure he used when he laid in the beginnings of his paintings'. The thinly worked, freely brushed surfaces of *Hélène Fourment and her children* can well be compared with *Gabrielle, Jean and a girl*, where the brush fluently suggests forms and highlights without tight contours or loaded impasto.

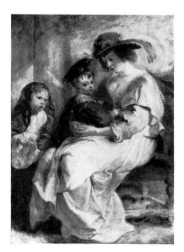

FIG a. Peter Paul Rubens, *Hélène Fourment and her children*
Musée du Louvre, Paris.

The picture was in Renoir's possession when he died (André and Elder 1931), but it had reputedly belonged to Cézanne.

LITERATURE
André and Elder 1931, I, pl. 23, no. 56
New York, Duveen, 1941, no. 70
Pach 1950, p. 92
New York, Wildenstein, 1974, no. 50

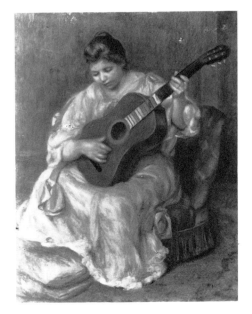

96

Woman playing the guitar

Femme jouant de la guitare
1896–7
81 × 65 cm (32 × 25½ ins)
Signed bottom right: Renoir.
Musée des Beaux-Arts, Lyon, B 624

COLOUR *p.147*

Exhibited in Paris only

Woman playing the guitar seems to be one of the first of the group of paintings Renoir executed in the late 1890s of men and women playing the guitar. It must be the picture that Julie Manet saw underway in Renoir's studio on 1 February 1897: 'He's doing some ravishing things with a guitar; a woman with a white muslin dress, held by pink bows, leans gracefully over a large brown guitar, with her feet on a yellow cushion. . . . It's all coloured, soft, delicious.' Julie Manet saw further paintings from this sequence in Renoir's studio in November 1897 (Manet 1979, pp. 123, 141). Renoir sold two paintings of similar subjects to Durand-Ruel early in 1897, but seems to have retained the present picture. It was bought by the Musée des Beaux-Arts, Lyon, in January 1901 with Durand-Ruel as an intermediary, but Renoir's letters to the dealer about the despatch of the picture to Lyon suggest that he was still its owner. The dealer had the canvas photographed while it was in his hands, but it was not entered in his stock records. The painting, or another of its type, was exhibited by Durand-Ruel in 1899 as *Femme jouant de la guitare, 1896.*

These paintings mark an important change in Renoir's treatment of costumed figures. His young girls of the early 1890s had worn informal modern dresses (cf. nos. 85, 86,

89–91), while his guitarists wear costumes – sometimes explicitly Spanish – rather than everyday clothes; the pink bows on the dress in *Woman playing the guitar* are clearly Spanish in style. According to Jeanne Baudot (1949, p. 70), he was inspired to paint girls playing guitars (using a model called Germaine) by his delight at a celebrated dancer at the Folies-Bergère, 'La Belle Otéro' – the incarnation of 'Spanish seduction'. Though such pictures recall his earlier orientalist costume pieces (cf. nos. 17, 20), his rejection of contemporaneity in the later 1890s was an aspect of a general shift towards a more classicizing form of art. In *Woman playing the guitar* and later paintings, the figure types become larger, the compositional structures more monumental; he did not return to modern French dress in his later costume pieces (cf. nos. 115, 126), preferring to retain this more timeless mood, with its overtones of exoticism.

Around the girl's white dress, the composition is carefully divided into warm and cool zones, with soft warm accents amid the cool tones, and cool amid the warm. The forms are softly brushed, but stand out by contrast with what lies behind them. The white dress is modelled primarily by gradations of tone, with quite densely painted highlights; yellows, and soft nuances of blue amid the greys, help to suggest its folds and the play of light and shade across it. The crisp verticals on the background wall at top right serve as anchor to a composition otherwise dominated by the undulating lines of dress, guitar, chair and cushion; Degas used verticals alongside the line of the frame in a similar way (cf. also no. 98).

Compositions such as this reflect Renoir's great admiration, in these years, for Corot's figure subjects, which create a similarly timeless, harmonious mood, often complemented, as in Renoir's picture, by showing women playing musical instruments. Julie Manet noted in 1898 the delight he took at the Corot figures in the Rouart collection (Manet 1979, p. 150), and apparently Renoir was conducting a campaign at this time for the Louvre to acquire one of Corot's figure paintings (Alexandre 1913; Alexandre 1920, p. 5). However, the amplitude of the form in *Woman playing the guitar* suggests that he was also looking at this point to a more monumental figurative tradition, that of Titian and Rubens: the treatment of the model's form is comparable with the mother in Rubens's *Hélène Fourment and her children* (no. 95 fig.a), which Renoir greatly admired.

LITERATURE
Venturi 1939, I, pp. 162–3, 167
M. Vincent, *Catalogue du Musée de Lyon, VII,
 La Peinture des XIXe et XXe siècles*, Lyon
 1956, pp. 242–4
Manet 1979, p. 123

EXHIBITION
? 1899 Paris, Durand-Ruel (108)

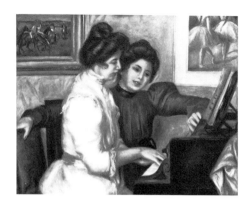

97

Yvonne and Christine Lerolle at the piano

Yvonne et Christine Lerolle au piano
1897
73 × 92 cm (28½ × 36 ins)
Signed bottom right: Renoir.
Musée de l'Orangerie, Paris (Collection Walter–Guillaume), RF 1960–19

COLOUR *p.144*

This canvas shows Yvonne (on the left) and Christine, the daughters of Henri Lerolle, painter, collector and musical amateur. Julie Manet saw the picture, apparently completed, in Renoir's studio on 25 October 1897, and commented: 'It's ravishing, Christine has a delicious expression, Yvonne is not a very good likeness, but her white dress is beautifully painted; the background with Degas's little Dancers in pink with their plaits and the Races is lovingly painted.' Though closely related to Renoir's previous pictures of girls at pianos, this is different in so far as the girls were the daughters of a friend, not professional models, and posed in their own home, with two works by Degas from their father's collection beyond them (Lemoisne nos. 702 and 486). However, Lerolle does not seem to have bought the picture: it was hanging in Renoir's salon in 1899 (Manet 1979, p. 215); Renoir deposited it with Durand-Ruel from 1914 until 1917 and still owned it at his death. The Lerolles did, though, acquire some of the preparatory drawings by which Renoir worked out the composition; a group of seven of these was sold by Christine Lerolle's husband Louis Rouart to Durand-Ruel in 1937.

In its composition the picture is particularly reminiscent of the conventions of the Dutch seventeenth-century interior, with its figures carefully set off against the rectangles of the piano and the frames on the wall. Renoir was studying Dutch genre painting with much pleasure at this date (cf. Baudot 1949, p. 29); he was to pay his one visit to Holland very soon after painting this picture, in 1898. The white and red of the dresses contrast sharply with the piano and the other dark accents; this simplified structure of red, black and white is set against a soft yellowish wall, while warmer accents in the pictures on the wall and the drapery at bottom right echo the central red dress. In paintings such as this, Renoir had largely abandoned the coloured modelling of the Impressionists, reintroducing black to his palette as a declaration of his return to traditional methods. Soon after painting this picture he told Julie Manet that 'in painting there is nothing but black and white' and added that 'one should give the white its intensity by the values of what surrounds it, rather than by adding more white', citing Titian, Manet and Corot as his examples (1979, p. 191; cf. p. 248).

LITERATURE
André and Elder 1931, I, pl. 65, no. 201
Baudot 1949, p. 67
Paris, Orangerie, 1966, no. 31
Manet 1979, p. 138, 215

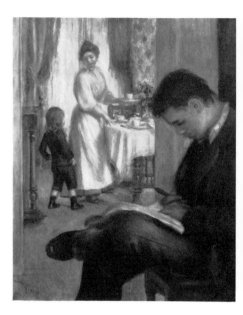

98

Breakfast at Berneval

Déjeuner à Berneval
1898
82 × 66 cm (32 × 26 ins)
Stamped bottom right: Renoir.
Private Collection

COLOUR *p.143*

Breakfast at Berneval was painted at the chalet which the Renoir family rented in July 1898 at Berneval, on the coast to the east of Dieppe. Julie Manet accompanied them on their trip to the coast and recorded in her diary: 'M. Renoir did not want to rent one of those awful chalets here, but Mme Renoir wanted to, so they rented one;' when she left Berneval, 'a charming place for the first day, too small the second, and intolerable on the third', Renoir told her: 'You are lucky to know that you'll never come here again' (Manet 1979, p. 169). Early in September, though, Renoir seemed 'content with his stay at Berneval' (Manet 1979, p. 186).

Breakfast at Berneval perhaps suggests some of Renoir's feelings about the chalet and the place. Its composition is unusually compressed for Renoir's work at this date, with the figure of his eldest son Pierre (now aged thirteen) wedged into the foreground and cut by the frame, while Gabrielle and Jean (now almost four years old) are tightly enclosed by the elaborate curtains and polished furniture – such a contrast to the simple, airy interiors Renoir favoured in his own home. Pierre's cut-off figure and the abrupt changes of scale between him and the scene beyond are clearly reminiscent of Degas's compositional techniques, as are the grids of verticals which frame the sides of the picture. The composition of the picture is particularly similar to Degas's *Dancing lesson* (fig. a),

which Renoir selected from Gustave Caillebotte's collection after his death in 1894, in accordance with the terms of his will. These compositional devices allowed Renoir to suggest the constricted space of the chalet, but he did not use the contrasts of scale, as Degas so often did, to suggest a rupture between the elements in the picture. Instead, Pierre's figure frames the scene beyond, and there seems no barrier between the reading teenager and the child and maid by the table; the forms of the three figures together encircle the central focus of the picture, the laid table. Ironically, soon after painting the present picture, Renoir sold the Degas to Durand-Ruel, in December 1898, almost at once buying from Durand-Ruel one of Corot's views of La Rochelle (Robaut II, no. 674). Though Caillebotte had declared that Renoir was free to sell whichever painting he selected, his sale of the picture precipitated a bitter row with Degas.

Long curls were in fashion for young boys at this date (cf. no. 93), but Renoir wanted to preserve those of his own children as long as possible. Jean Renoir later remembered his acute embarrassment at the curls he was forced to wear until he went to school, although he was taunted with the nicknames 'girl' and, still worse, 'wall-mop' (*tête de loup*; J. Renoir 1962, pp. 317, 367, 393–4, 397). After the children's curls were cut, Renoir rarely used them as models; this is one of very few images of Pierre after about the age of five, and Jean, in turn, went out of favour as a model when his hair was cut around 1901, to be replaced by Claude (cf. no. 110).

Softly varied colours appear throughout the picture, but its basic structure is simple and clear-cut, built around distant areas of dark, light and brown, in marked contrast to the diffused coloured atmosphere of Renoir's interiors of the mid to later 1870s (cf. nos. 35, 41).

The picture remained in Renoir's possession until his death.

LITERATURE
André and Elder 1931, I, pl. 60, no. 183
Drucker 1944, p. 88, 211 no. 124
London, Christie, 30 November 1976, lot 16

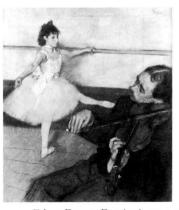

FIG a. Edgar Degas, *Dancing lesson*, c. 1878, pastel. The Metropolitan Museum of Art, New York.

Around 1900 the patterns of Renoir's life changed again: from then until the end of his life he and his family spent long periods each winter and spring on the Mediterranean coast and much of the summer at Essoyes, where they now owned a house, with only limited spells in Paris. From 1903 onwards, in the south they went always to Cagnes, just west of Nice, where in 1907 they bought land and began to build a house. The immediate reason for these changes was Renoir's health, undermined by the onset of arthritis, but they reflected a more general change in his art, towards the Classicism of the Mediterranean and, more particularly, towards ideas then associated with the revival of Provençal culture.

In 1895 Renoir's friend de Wyzewa summed up the timeless qualities which were seen as essentially southern, in contrast with the north. The north is for the young, for people 'eager for movement and struggle. . . . But sooner or later the sun attracts them . . . calms their nerves . . . and opens their eyes to the splendour of eternal things.' They lose their taste for the beguiling fairies of the north, daughters of the night, and give themselves instead to the 'daughters of the sun', who beget beautiful dreams in the Mediterranean lands, and particularly amid the characteristic landscapes of Provence. Self-consciously poetic though it is, de Wyzewa's characterization of the south parallels the qualities which emerged in Renoir's art after he made a regular home there; and Renoir himself spoke about the south in similar terms: 'In this marvellous country, it seems as if misfortune cannot befall one; one is cosseted by the atmosphere.'

From his conversations with his father, Jean Renoir concluded that it was around 1900 that Renoir finally resolved his uncertainties as an artist, and that, with this, he no longer needed to immerse himself in the art of the museums; he did, indeed, stop travelling outside France at this point, apart from a single trip to Munich in 1910. But this in no sense involved a rejection of tradition; it seems, rather, to mark Renoir's emergence into a wider sense of his own artistic heritage. He continued until the end of his life to voice his love for French eighteenth-century art, but his own painting now seems to match itself against the mainstream of the European classical tradition, and in particular Titian and Rubens, the great manipulators of oil paint within that tradition. He spoke of his 'quivers of joy' in front of Rubens's art in 1903 and was deeply enthusiastic about the Rubens in Munich in 1910; he spoke, too, of his endless delight in the mysteries of Titian's technique.

In the early years of the century Renoir used little bright colour; at times his palette was cool and austere, at times soft and pastelly. He varied his range of tones and colours according to the mood he sought in a painting: a pale, delicately nuanced scheme – a sort of coloured Corot – might be appropriate for a fashionable portrait (e.g. fig. b), while sharper tonal contrasts,

punctuated by a few colour accents, better suited a monumental figure composition. Such paintings were carefully conceived as colour compositions; executing a portrait in 1901, he placed a pink ribbon in his sitter's hair and commented: 'Now I've got hold of my composition. All the colours will act in relation to that pink, the problem of colour is resolved.' He much admired Velasquez's use of a similar hair ribbon in one of his Infanta portraits.

In his nudes up to around 1905, too, he used a very restricted range of colour. He generally avoided the use of blue to model shadows in the figure, and he treated areas of skin quite simply and broadly, without subdividing them into myriad coloured nuances; Renoir was deliberately rejecting, it seems, some of the most notorious aspects of Impressionism. Backgrounds were often brushed in thinly over the white priming, but the principal areas of the figure were normally treated more opaquely. His touch remained fluent and supple, modelling forms with the loaded brush without any return to the linearity of his experimental work of the 1880s. After 1905, his colour schemes began to grow warmer and his touch more mobile. Soft varied nuances were threaded through his figures, and his backgrounds began to be treated, at times, with a more emphatic touch, which draws them into an active relationship with the main subject. This process of surface enrichment ushered in the ebullience of his last works.

By this time he no longer felt a conflict between open air and the studio, between 'objective' and 'subjective'. 'I could not do without a model,' he told Besson, 'but one has to know how to forget the model, otherwise the work will smell of armpits', like a particular Rodin bust he cited. Monet, he said, painted 'times of the day' rather than 'une heure éternelle'. Art should transcend fleeting natural appearances. 'I am a poet,' he jokingly wrote to André in 1909, 'I'm told that every day. Poets dream.'

After 1900 Renoir virtually stopped painting the fashionable costume pieces he had favoured in the 1890s. His later draped figures are clad in unspecific or vaguely exotic garb. A few *Bather* subjects include discarded modern clothes, but these are quite subordinated to the classicizing order of the compositions; in *Toilet of the bather* (fig. a) of 1900–1 this theme is transformed into one of the grandest and most monumental of his compositions. At the same time, Renoir began to paint fuller, more mature female forms, in place of the soft young girls of the 1890s – a further indication that his allegiance was now to Titian and Rubens. The birth of his third son Claude (Coco) in 1901 led to a further series of paintings of childhood.

As Renoir's physical strength declined, he undertook fewer ambitious paintings. He had always produced casual sketches as a sort of recreation, but now came to produce these in ever

greater numbers. Some of them were just fragments, like quickly brushed studies of heads, breasts or flowers scattered across a larger canvas; but he also produced many modest and informal pictures – mainly landscapes and still lifes – which he sold through Durand-Ruel and other dealers. In these small paintings he found a freedom to improvise and experiment outside the constraints of conventional notions of composition and finish; but their apparent casualness and shapelessness soon began to arouse criticism. The emergence on to the art market of many of his most fragmentary scraps from his studio after his death has further distracted critical attention from the small number of fully resolved canvases on which his concentration did not flag.

Renoir first gained real fame during these years. He became Chevalier de la Légion d'Honneur in 1900, but it was the retro-spective of his work included in the 1904 Salon d'Automne which sealed his reputation. Durand-Ruel and Bernheim-Jeune regularly exhibited his work in Paris, and, largely through the efforts of Durand-Ruel, his paintings appeared in exhibitions all over Europe and North America. Much of this acclaim, though, was given to his earlier work; by around 1905 even official circles in France recognized the Impressionism of the 1870s as an integral part of the French tradition. His recent work, as the critics clearly saw, had distanced itself from the naturalistic tenets of early Impressionism. They recognized the idealizing process in his working methods and described the vision of the world that the pictures presented with phrases like 'rêve de bonheur' and the 'éternel féminin'. The classicism that emerged in his art around 1900 only gained a full recognition after his death.

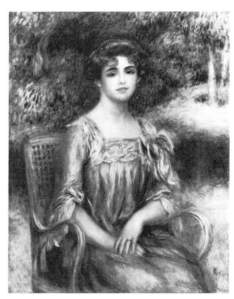

FIG b. Renoir, *Portrait of Mme G. Bernheim*, 1901. Musée d'Orsay, Paris (Galerie du Jeu de Paume).

FIG a. Renoir, *Toilet of the bather*, 1900–1. The Barnes Foundation.

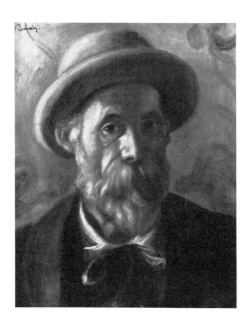

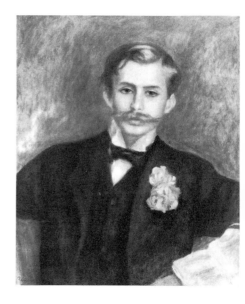

jacket, with only occasional warmer touches and nuances of blue in the modelling.

The painting was, it seems, in Renoir's possession at his death (cf. André and Elder 1931), although the records of the Sterling and Francine Clark Art Institute contain a note that it was purchased in 1914 by Charles Farrel, Paris.

LITERATURE
André and Elder 1931, I, pl. 59, no. 182
Williamstown, Clark Art Institute, 1956, no. 169
Manet 1979, p. 249
Information by courtesy of David B. Cass

99

Self-portrait

Autoportrait
1899?
41 × 33 cm (16 × 13 ins)
Signed top left: Renoir.
Sterling and Francine Clark Art Institute,
Williamstown, Massachusetts, 611

COLOUR *p.146*

Though normally dated to 1897–8, this painting is the only known one which can be identified with the self-portrait that Julie Manet described him painting at Saint-Cloud in summer 1899: 'He is finishing a self-portrait that is very nice, but he had made himself look rather harsh and wrinkled; we insisted that he suppress some wrinkles, and now it's more like him. "I think it more or less catches those calf's eyes," he says.'

The picture's original appearance may well have been closer to reality: photographs taken the previous summer after Mallarmé's funeral show his face already deeply creased and furrowed, and in the interim, in winter 1898–9, he had suffered an acute rheumatic attack, prelude to the arthritis which was to cripple him in later years. A later self-portrait, of 1910, was similarly idealized (no. 112). The present portrait smooths out his deep creases, bringing them into harmony with the cursive patterns which the brushwork emphasizes throughout the picture – in his tie and beard, and on the wall behind him. The face, turned slightly away from the light, perhaps suggests an elegiac mood, with a trace of melancholy – perhaps a reflection of his awareness of his own physical frailty. The colour range is quite restricted, in gradations from beiges and browns through greys to the dark blue

100

Portrait of Monsieur Germain

Portrait de Monsieur Germain
c. 1900
55 × 46 cm (21½ × 18 ins)
Signed bottom left: Renoir
Norton Gallery & School of Art, West
Palm Beach, Florida, 47.26

COLOUR *p.149*

After a brief interruption in the later 1880s, Renoir continued regularly to paint society portraits – generally of women – though at times he voiced his dislike of such commissions. The exact circumstances of the *Portrait of Monsieur Germain* are not known; however, the sitter can be identified with the 'young Germain', son of a great financier, whose unlikely friendship with Renoir around 1900 was later described by Jean Renoir: 'Germain was precious, with an unhealthy, perfumed coquettishness. He spoke with a slight Oxford accent and was so effeminate that it seemed a pose.' Germain's response to everything was deliberately unexpected and paradoxical; Jean remembered his saying that, as a boy, he had particularly liked not games, but flowers. The sitter's name remains uncertain. Often described as Germain Seligmann, he is, however, identified in the records of the Norton Gallery & School of Art as the grandson of the founder of the Crédit Lyonnais, whose name was Henri Germain.

With his long hair and remarkable moustache, his foppish character comes over well in the portrait, which reminded Drucker of the world of the young Proust. Appropriately enough, given his love of flowers, the carnations in his buttonhole become a prime focus in the composition, with their colour and florid brushwork set off by the

blacks of the jacket and the soft greens beyond. The way in which Renoir used this flower here is reminiscent of a comment he made a few years later about a Velasquez Infanta portrait: 'Renoir claimed that . . . Velasquez had fixed on to this pink bow, without which the picture didn't exist' (Robida 1959, p. 48). Though the sitter here faces the viewer, the casually held book at bottom right creates the illusion that we have momentarily interrupted his reading.

The painting was first recorded in the collection of Georges Viau.

LITERATURE
Drucker 1944, pp. 88, 212 no. 131
J. Renoir 1962, pp. 86–7
Chicago, Art Institute, 1973, no. 70
New York, Wildenstein, 1974, no. 48
Information by courtesy of Pamela S. Parry, Norton
 Gallery & School of Art

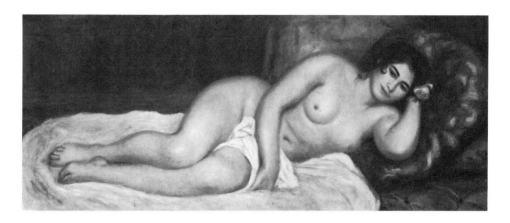

101

Reclining nude

Femme nue couchée
1903
65 × 156 cm (25½ × 61½ ins)
Signed and dated bottom right: Renoir. 03.
Private Collection

COLOUR *p.152*

Exhibited in London and Paris only

Renoir painted a sequence of monumental horizontal canvases of nude figures reclining on cushions between 1903 and 1907; this appears to be the first of them. At the same time he was also painting further large canvases of a nude out of doors personifying *La Source*, reworking a theme he had treated in a canvas painted for Gallimard around 1895 (p. 252 fig. e). His concentration on reclining figures for his largest works in these years was in part the result of his physical frailty, which, Lecomte reported in 1907, made it difficult for him to raise his right arm (1907, p. 252); presumably Lecomte's was one of the reports which challenged Renoir, in 1909, once again to undertake large vertical canvases with his chair on trestles (André 1928, pp. 45–6; cf. no. 110).

These paintings are Renoir's most sustained exploration of the theme of the reclining female nude. The two groups of paintings – outdoor and indoor – use two of the most traditional pretexts for treating such a subject: woman personifying a spring of water, a metaphorical fusion of woman and nature; and, in the indoor pictures, the reclining odalisque, given a hint of exoticism by the elaborate cushions and the rose in her hair. The timelessness of the theme declares Renoir's allegiance to the tradition of Ingres, rather than to the overtly modern odalisque which Manet had pioneered with *Olympia* at the 1865 Salon; indeed the present painting was exhibited at the Salon d'Automne in 1905 at the same time as an Ingres retrospective exhibition. *Odalisque with a slave* is the painting among Ingres's nudes which most closely resembles Renoir's reclining nude. However, his debt to Ingres was generic, rather than to any specific painting. This period was a phase of deliberate classicism in Renoir's work, as he replaced the soft handling of the 1890s, so reminiscent of the French eighteenth century, with more restrained brushwork and adopted a particularly restricted palette; he did not, though, return to the harshness of drawing and contour of his experimental work of the mid-1880s.

The present version of the theme is modelled in a particularly traditional way, with little free play of the brush except in the cushion; otherwise the brushwork softly follows the cursive rhythms of the figure and the drapery; the colouring of cushions and background sets off the largely tonal modelling of the figure. Reviewing the 1905 Salon d'Automne, where this painting appeared, Maurice Denis wrote: 'Renoir, who is no longer remotely an Impressionist, triumphs here with his astonishing latest manner, with robust, abundant nudes like the Raphaels of the *Fire in the Borgo* and the Farnesina: note how his knowledge of tonal gradations and modelling has in no way compromised his freshness or his simplicity' (Denis 1912, 1920 ed., p. 204).

The model for *Reclining nude* was Gabrielle Renard, who had come into the Renoirs' household in 1894 to help in the house and to look after baby Jean. Her first appearance as model was as Jean's nurse, as in no. 95; by 1900, she was modelling for ambitious subject pictures, appearing as the attendant maid in *Toilet of the bather* (p. 269 fig. a). But around this date, while staying at Grasse, Renoir found himself without a model to pose nude, and Gabrielle agreed to pose (cf. J. Renoir 1962, p. 391); until around 1912 she was his most regular nude model (cf. also nos. 115, 116), proving ideally relaxed as she posed.

A second very closely related version of this composition is in the Walter–Guillaume collection in Paris (cf. Paris, Orangerie, 1984). Though there is no clear evidence for their respective dates, it seems very probable that the present one was painted first; it

marks the extreme point of Renoir's disciplined handling and restrained colour during these years. The flesh painting in the other is rather more fluid and animated, its background treated more vigorously, which suggests that it was painted around 1906, at the beginning of the development towards richer colour and more lively surface textures which spanned Renoir's last fifteen years. A further version of a similar arrangement, with a different model, is probably the last of the three; it appears here as no. 106.

Durand-Ruel bought the present painting from Renoir in July 1907 and sold it in January 1917, during the exhibition of French art held at The Hague, to an unnamed buyer.

LITERATURE
Meier-Graefe 1912, p.176n
André, October 1936, p.21
New York, Duveen, 1941, no.72
Baudot 1949, p.66
Paris, Orangerie, 1984, pp.212–3

EXHIBITIONS
1905, Paris, Salon d'Automne (32)
1916, The Hague

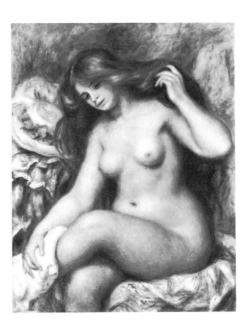

102

Bather

Baigneuse
c. 1903
92 × 73 cm (36 × 28½ ins)
Signed bottom right: Renoir.
Kunsthistorisches Museum, Vienna

COLOUR *p.150*

Exhibited in London only

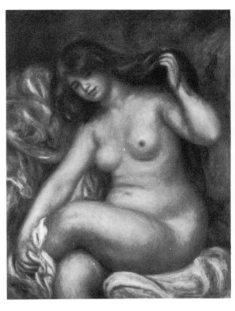

103

Bather

Baigneuse
1905
97 × 73 cm (38 × 28½ ins)
Signed and dated bottom right: Renoir. 05.
Private Collection

COLOUR *p.151*

Exhibited in Boston only

Renoir painted at least four canvases of a seated female nude in the same position between *c.* 1902 and 1905. One (Detroit Institute of Arts) shows the figure full length, including both of her feet and more discarded clothes at the left; the other three are very similar in arrangement, with only slight changes in the angle of head and arms (these two and the version repr. Florisoone 1937, pl.129). No.103, the only one dated on the canvas, seems to be the last of the four: the patterns in the drapery and the clothing are more flowing and their treatment is more generalized, and the figure's forms are rather softer. In no.102, by contrast, the drapery is modelled with shorter, crisper strokes, and the figure is slightly more simply, solidly modelled.

The pictures are among the last where Renoir depicted the nude with discarded modern clothing, but the clothes in them act more as a coloured adjunct to the figure than as a specific sign of modernity. The pose is related to Renoir's monumental two-figure composition, the *Toilet of the bather* of 1900–1 (p.269 fig.a), where, as here, the nude figure holds out a swathe of her own hair with her left hand. However, by removing the attendant maid in these later canvases, and by reducing the background to the sketchiest indication of a natural setting

Renoir made the massive single figure into the sole focus of the composition. In a picture of a similar theme of *c.* 1910, *Bather drying her leg* (no. 111), the nude seems wholly unaware of the spectator; here, though, the model does seem, with her gesture, to acknowledge the viewer's presence, and her gesture presents her figure to our gaze. Such manifest self-display is unusual in Renoir's many pictures of the nude.

Meier-Graefe in 1912 described this 'grandiose *Bather*' as painted by 'a transfigured Rubens'; in 1903, indeed, while engaged on this sequence of paintings, Renoir had spoken to de Wyzewa 'of the genius of Rubens, of the quivers of joy one feels in front of his painting' (de Wyzewa, diary for 29 January 1903, in Duval 1961, p. 138). The female types which Renoir came to favour around this date certainly reflect a Rubensian ideal of beauty.

In 1903, just before Renoir painted this picture, Camille Mauclair described his nudes in these terms: 'Renoir's woman comes from a primitive dreamland; she is an artless, wild creature, blooming in perfumed scrub. . . . She is a luxuriant, firm, healthy and naïve woman with a powerful body, a small head, her eyes wide open, thoughtless, brilliant and ignorant, her lips blood-red and her nostrils dilated; she is a gentle being, like the women of Tahiti, born in a tropical clime where vice is as unknown as shame, and where entire ingenuousness is a guarantee against all indecency. One cannot but be astonished at this mixture of "Japanism", savagism and eighteenth-century taste.' (Mauclair, *Impressionists*, 1903, pp. 116–8.) This evocation shows how far by this date younger critics could distance Renoir's art from his past association with the Impressionists. Such discussions of Renoir's view of woman had emerged from symbolist critical circles during the 1890s, but the 'golden age' theme implicit in Mauclair's account emerged more clearly in writings about him after 1900, as Renoir's own search for a more classicizing form of art coincided with a revival of classical ideas among the literary avant-garde.

Durand-Ruel bought no. 103 from Renoir in November 1906, and immediately sold it to Adrien Hébrard (cf. pp. 25–6), presumably for the collection of the Prince de Wagram; by 1917 it was in the possession of Emil Staub of Zurich. No. 102 was still in Renoir's possession at his death.

LITERATURE (for both versions)
Meier-Graefe 1912, pp. 170–3
André and Elder 1931, I, pl. 83, no. 269 (no. 102)
Drucker 1944, pp. 102, 213 no. 147
Chicago, Art Institute, 1973, no. 74 (no. 103)

EXHIBITIONS
No. 102: ? 1913, Paris, Bernheim-Jeune (ex-cat: the painting is reproduced in Mirbeau 1913, the volume accompanying the exhibition)
No. 103: 1917, Zurich (214)

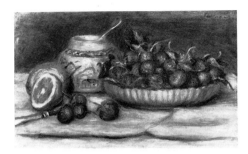

104

Strawberries

Fraises
c. 1905
28 × 46 cm (11 × 18 ins)
Signed top right: Renoir.
Musée de l'Orangerie, Paris (Collection Walter–Guillaume), RF 1963–17

COLOUR *p.154*

LITERATURE
Meier-Graefe 1912, p.187
Meier-Graefe 1929, p.381
Paris, Orangerie, 1966, no. 34
Paris, Orangerie, 1984, p. 210

EXHIBITION
? 1917, Zurich (212)

In his later years, Renoir painted and sold small informal paintings – landscapes, still lifes and figures – in very large numbers. *Strawberries* is characteristic of these works in its small scale and its simple, frontal composition, with the forms laid out across a shallow table top, rather than arranged in a more complex space. However, it is far more complete and more resolved in its execution than most of Renoir's small oils; the strawberries are modelled with great delicacy. Fruit and vase give the picture a fresh colour scheme of yellow, red and blue against the white cloth.

Renoir recommended still-life painting to Julie Manet in the late 1890s 'in order to teach yourself to paint quickly' (Manet 1979, p. 190); he told André that it was in his small *croquis* that 'he put the whole of himself, that he took every risk' (André 1928, p. 49). Alexandre, though, realized that his multitudes of small studies were often the result of his anxiety, painted at moments when he could not concentrate on sustained work (Alexandre 1920, p. 9). Indeed, the numbers of paintings which Renoir sold, many of them far less highly worked and far less carefully conceived than *Strawberries*, were already harming his reputation by the time he painted the present picture. As he tersely told Durand-Ruel in 1901, 'if I only sold good things, I would die of hunger' (letter of 25 April 1901; Venturi 1939, I, pp. 166–7). The facility which, when combined with care, could produce paintings like *Strawberries*, could at the same time produce the scrappy, unresolved works by which he is all too often known today.

The early history of the painting cannot be precisely documented; it is possibly the canvas which was exhibited in Zurich in 1917 with the title *Fraises, sucre, citron.*

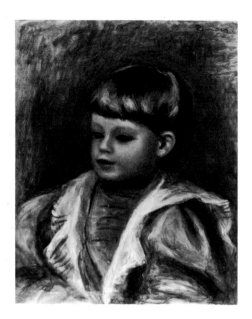

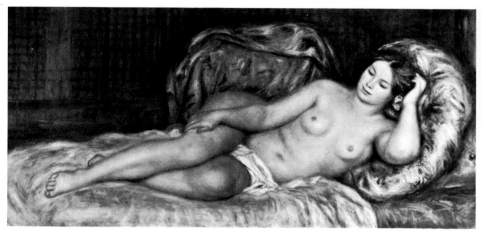

105

Portrait of a child (Philippe Gangnat)

Portrait d'enfant (Philippe Gangnat)
1906
41 × 33 cm (16 × 13 ins)
Signed top right: Renoir.
Private Collection

COLOUR *p.148*

Exhibited in Paris only

This portrait depicts Philippe, son of Maurice Gangnat (cf. no. 124), one of Renoir's principal friends and patrons in his last years, whom he had met through Paul Gallimard. The portrait seems to have been his first direct commission to Renoir and among the first paintings by Renoir that he acquired; he seems to have begun to buy his work in 1905 (cf. p. 25). Philippe, approximately the same age as Renoir's youngest son Claude (cf. no. 110), provided him with the sort of sitter he particularly enjoyed painting – a child's face not yet marked by adult experience.

After his father's death, Philippe Gangnat presented *Gabrielle with a rose* (no. 116) to the French State in 1925.

LITERATURE
London, Marlborough Fine Art, *Renoir*, 1956, no. 27

106

Nude on the cushions

Nu sur les coussins
1907
70 × 155 cm (27½ × 61 ins)
Signed and dated centre left: Renoir.1907.
Musée d'Orsay, Paris (donation subject to life interest), RF 1975–5

COLOUR *p.153*

Exhibited in Paris only

This picture is the third and last of the sequence of reclining nudes which Renoir painted between 1903 and 1907, of which the first was no. 101. Unlike the first two, the present picture seems not to use Gabrielle as a model, choosing instead a girl with warm brown hair. Overall its tonality is warmer and the handling freer; in the cushions and draperies Renoir sought more lavish patterns. These changes reflect Renoir's gradual move from the comparative austerity of his art of *c*. 1900–4 towards the sumptuous vision of his final years.

The pose of the model here is less reminiscent of Ingres than in no. 101. Her pose here, like the rich colour and brushwork, show that Renoir's main allegiance was now rather to Titian, whose *Venus and the organist*, with a similarly posed nude figure, he had so admired in Madrid in 1892; he later talked to Vollard about this Titian: 'The limpidity of the flesh, one wants to caress it. In front of this painting one feels all the joy that Titian felt when painting. When I see in a painter all the passion which he felt when painting, he makes me feel all the pleasure he felt' (Vollard 1938, p. 222). The model here, with her lavish surrounds, is put on display for the painter and for the viewer; her averted eyes and relaxed pose prevent her from any direct engagement with us; she is the passive object of our admiration.

The picture was in the possession of Mlle Diéterle in Paris by 1912; she lent it to the 1913 Bernheim-Jeune Renoir exhibition.

LITERATURE
Meier-Graefe 1912, p.176n
H. Adhémar, 'La donation Kahn-Sriber', *Revue du Louvre*, 1976, 2, pp.102–4
Paris, Orangerie, 1984, pp.212–3

EXHIBITION
1913, Paris, Bernheim-Jeune (48; *Nu sur les coussins*)

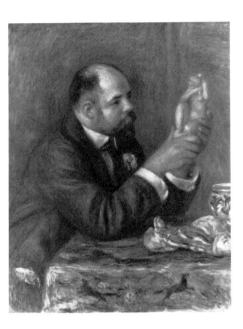

107

Portrait of Monsieur Ambroise Vollard

Portrait de Monsieur Ambroise Vollard
1908
82 × 65 cm (32 × 25½ ins)
Signed and dated top left: Renoir. 08.
Courtauld Institute Galleries, London
(Samuel Courtauld Collection), H.H.15

COLOUR *p.158*

Exhibited in London only

Renoir met the young dealer Ambroise Vollard in 1894 or 1895 (Vollard 1938, p. 139; J. Renoir 1962, p. 303). Vollard, born on the island of Réunion, off the east coast of Mozambique, had recently set himself up as an art dealer in rue Laffitte and began to buy paintings from Renoir; after 1900, along with Durand-Ruel and Bernheim-Jeune, he became one of the three principal dealers to whom Renoir sold his work, though his relations with the artist seem not always to have been easy (cf. p. 13).

Of the many portraits of Vollard which the dealer commissioned from the artists with whom he dealt, Renoir's is among the least acute either as a record of physiognomy or as an evocation of character. The smoothed, almost prettified image catches little of his bulldog features – so ugly, though he longed to be handsome (J. Renoir 1962, p. 318); even Picasso's cubist portrait of 1910 seems more revealing. Renoir, by contrast, was always more drawn to surface attractiveness than to inward expression (cf. entry for no. 93); his Vollard becomes the image of an archetypal connoisseur, rather than the evocation of the cunning, quirky entrepreneur who managed and disposed of the art treasures amassed in his legendary little shop.

Vollard is shown holding a statuette by Maillol, the *Crouching woman* of 1900, apparently in its original plaster form. In one sense this serves to place the picture within the long tradition of portraits of connoisseurs of art; but the reference to Maillol had a more specific significance. In 1907 or 1908, at Vollard's request, Maillol visited Renoir at Essoyes to execute a bust of him (for the dating, cf. Chronology: 1908, p. 310; for a description of the visit, cf. J. Renoir 1962, pp. 363–4; Frère 1956, pp. 237–8; Rivière 1921, pp. 247–8; the bust repr. New York, Duveen, 1941, no. 89); the present portrait may well reflect this project, as well as Renoir's interest in Maillol's art.

The simplified, monumental classicism which Maillol had evolved in his sculpture after 1900 is relevant to Renoir's painting at this period. Details of his personal relationship with Maillol are confused. Vollard recorded Renoir describing his first meeting with Maillol in the sculptor's studio at Marly, where Jeanne Baudot had taken him, and Renoir's enthusiastic praise for the truly antique spirit of Maillol's sculpture, achieved not by copying the ancients, but by carving freely and without precise measurements: 'I thought I was transported to Greece' (Vollard 1938, p. 291). According to Baudot herself, though, Renoir had initially met Maillol at Vollard's, and had felt some mistrust of him until his visit to Essoyes in 1907 or 1908 to execute the bust (Baudot 1949, p. 114). When Renoir himself embarked on large classicizing sculptures in 1913, Maillol's example, as well as Vollard's encouragement, may well have been important. However, it remains unclear whether Renoir had looked closely at Maillol's art before 1907/8. The likelihood is that he had, since Maillol's *La Méditerrannée* had been one of the most discussed exhibits at the 1905 Salon d'Automne, at which Renoir also showed. The pose of *La Méditerrannée* is close to that of the statuette which Renoir shows Vollard holding; with its monumental scale and its title evoking the south, the statue expresses the idea of timeless classicism, which Renoir, too, was pursuing at the time (cf. nos. 101, 103, 111).

In its technique, the portrait shows the increasing freedom which began to emerge in Renoir's painting around 1905. Mobile threads of white and pink animate Vollard's face and hands and suggest their modelling, replacing the simpler, more opaque flesh painting of pictures such as no. 101. The white highlights on his clothes and on the pottery on the table are fluently handled, and flowing rhythms run throughout the brushwork. These tendencies became far more marked in later paintings (cf. nos. 115, 125). Blue is no longer used to model forms, and Vollard's dark jacket is treated in gra-

dations of grey. Only the blues in the pottery on the table and the soft greens on the tablecloth contrast with the dominantly warm tonality, emphasized by the background wall.

Vollard sold the painting in 1927 to Samuel Courtauld, who gave it to the Courtauld Institute of Art, University of London, in 1932.

LITERATURE
Vollard 1938, p. 266
Cooper 1954, p. 111 no. 56
J. Renoir 1962, p. 399
Gaunt and Adler 1982, no. 44

EXHIBITIONS
1912 (June), Paris, Durand-Ruel (*Portraits*) (48)
? 1913, Paris, Manzi-Joyant (143)

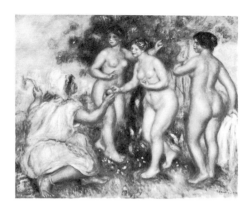

108

The Judgment of Paris

Jugement de Paris
1908
81 × 101 cm (32 × 40 ins)
Signed and dated bottom right:
Renoir. 1908.
Private Collection, Japan

COLOUR *p.166*
Exhibited in Boston only

Renoir had painted occasional mythological subjects in his earlier career, including *Diana the huntress* (p. 180 fig. d), rejected at the 1867 Salon, and a group of decorative pictures in 1879: for Berard *The Festival of Pan*, and for Dr Blanche two canvases of Venus and Tannhäuser (cf. Daulte 1971, nos. 314–8). But in all these cases he had special reasons for choosing such themes – in 1867 an unsuccessful attempt to make a study of a nude more acceptable to the Salon jury (cf. Vollard 1938, p. 155), in 1879 in response to the requirements of his patrons. Only at the end of his life does he seem to have felt that he could freely tackle a subject from classical mythology. This marks the extreme of his rejection of the modern-life aesthetic which had dominated his work in the 1870s, a rejection closely in line with the ideas of the leaders of the current renaissance of Provençal culture, who sought a living continuity with the classical heritage of their land (cf. pp. 16, 268). When after 1900 Renoir began to spend long periods every year on the Mediterranean coast, he came to conceive his art as a part of this long tradition.

The general arrangement of Renoir's *Judgment of Paris* can be compared to Rubens's treatment of the theme (especially fig. a, which Renoir would have seen in Madrid in 1892), but the details of Renoir's version of the subject show how far away he was from the complex languages of symbol and emblem, and of rhetorical gesture, which informed Rubens's dramatic narrative. In Renoir's treatment there is little tension or drama in Venus's gesture as she receives the apple from Paris, and the poses of her dis-

appointed rivals Hera and Athena do little more than frame her gesture of acceptance; the moment of Paris's choice carries little significance. Renoir's interest is on the sumptuous surface, not on Paris's decision as the root of discord. His vision of antiquity was as an earthly paradise (cf. p. 279), within which the theme of the Judgment of Paris seems to carry no significance beyond the simple selection of the most beautiful woman and the celebration of her beauty. The site for this celebration was a generalized vision of his own surroundings; in 1908, the year he painted this picture, Renoir moved into the house he had built himself on the estate of Les Collettes at Cagnes, where he lived amid a seemingly timeless grove of olives.

Jean Renoir recalled that his father had initially used the actor Pierre Daltour as model for Paris, but completed the figure from Gabrielle Renard (cf. nos. 95, 101, 115, 116), since he felt more at ease using her as model than the athletic Daltour. Vollard remembered seeing Gabrielle wearing a Phrygian cap, and quoted Renoir's explanation: 'See how like a boy she is! I always wanted to do a Paris, but I've never been able to find a model. What a Paris she will make!' Gabrielle was probably also the model for the right hand figure; the models for the other two goddesses were, Jean Renoir recalled, Georgette Pigeot and La Boulangère, two of his most regular models from these years.

Renoir exerted great efforts on the theme, treating it in two large chalk drawings (Louvre, Paris and Phillips Collection, Washington), and in a second large oil (no. 119). He had sold the present painting before his death, but its early history cannot be firmly documented.

LITERATURE
Duret 1924, p.98
Paris, Orangerie, 1933, no.114
Barnes and de Mazia 1935, pp.126, 190–1
Vollard 1938, p.251
Drucker 1944, pp. 104–5, 214 no.148
J. Renoir 1962, p.355
New York, Wildenstein, 1969, no. 87

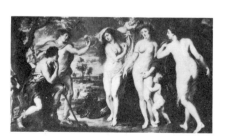

FIG a. Peter Paul Rubens, *The Judgment of Paris*. Museo del Prado, Madrid.

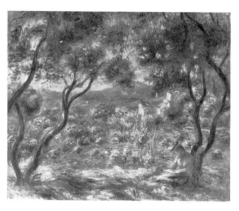

109

Vines at Cagnes

Les Vignes à Cagnes
c. 1908
46 × 55 cm (18 × 21½ ins)
Signed bottom right: Renoir.
The Brooklyn Museum (Gift of Colonel and Mrs E. W. Garbisch), 51.219

COLOUR *p.156*

Renoir's late landscapes, like his still lifes (cf. no. 104), are mostly quite small, treated freely and informally, and quite different from the few more ambitious canvases that he finished during the same years (e.g. nos. 106, 108). Many of the landscapes, like many still lifes and figure studies (cf. entry for no. 104), are no more than a quick notation of a single feature, without any claim to be a complete picture. However, other paintings, like *Vines at Cagnes*, are complete and resolved in their own terms, carefully composed and with all parts of the canvas taken to a similar degree of finish, though they are not large and are executed in a rapid, sketch-like technique. *Vines at Cagnes* was one of the vast collection of Renoir's paintings – many of them small, informal canvases – made by Maurice Gangnat in the last years of Renoir's life (cf. no. 124).

Dated to 1908 in the Gangnat sale catalogue, *Vines at Cagnes* shows a typical Cagnes hillside, with a vista framed by olive trees; the terrain is not, though, immediately recognizable as a view from the estate of Les Collettes, which Renoir bought in 1907 and where he moved on the completion of his house in 1908; it may well represent a scene from the hilly countryside around Cagnes. But paintings like *Vines at Cagnes* are not essentially topographical. Even if it depicts a specific site, the viewpoint has been carefully chosen to present an archetypal image of the area as Renoir saw it – a coloured, sun-drenched vista, with old houses amid the trees, framed by the curling trunks of olive trees, in whose shade a young woman sits reading. The whole scene is carefully integrated in touch and colour.

Renoir talked to Gimpel in 1918 about his Cagnes landscapes (1963, p. 34): 'The olive tree, what a brute! If you realized how much trouble it has caused me. A tree full of colours. Not great at all. Its little leaves, how they've made me sweat! A gust of wind, and my tree's tonality changes. The colour isn't on the leaves, but in the spaces between them. I know I can't paint nature, but I enjoy struggling with it. A painter can't be great if he doesn't understand landscape. Landscape, in the past, has been a term of contempt, particularly in the eighteenth century; but still, that century that I adore did produce some landscapists. I'm one with the eighteenth century. With all modesty, I consider not only that my art descends from a Watteau, a Fragonard, a Hubert Robert, but also that I am one with them.' The distant mountains at Cagnes, he told André, reminded him of Watteau's backgrounds (1928, p. 29). Fosca in 1923 commented on the transparent touches, daringly threaded through with carmine, in the shadows of the trees in paintings such as this (1923, p. 50).

J. F. Schnerb, who knew Renoir, described the qualities of his recent southern landscapes in a review of Durand-Ruel's 1908 exhibition of Renoir's and Monet's landscapes (1908, p. 596): 'M. Renoir more and more loves his canvas being full and sonorous. He loathes empty spaces. Every corner in his landscapes offers a relationship of colours and values chosen with a view to the embellishment of the surface.' His recent studies of the Provençal landscape have led him 'to transpose the themes furnished by nature into the most sonorous colour range and to assemble the largest possible number of elements in the canvas, like a musician who ceaselessly adds new elements to his orchestra.'

This type of picture is an unusual combination of classicism and Impressionism. The careful compositional framing and the combination of all the elements into a harmonious ensemble clearly belongs to the heritage of Claude, while the small scale, the broken touch and the summary description of objects closely ally the picture with the tradition of the impressionist sketch. This unified yet animated vision of landscape complements the vision of woman within nature which emerged in the major outdoor figure paintings of his last years (cf. nos. 121, 125).

LITERATURE
Paris, Drouot, *Gangnat*, 1925, no. 92

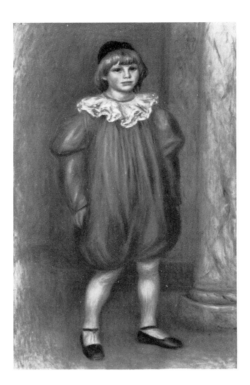

110

The clown

Le Clown
1909
120 × 77 cm (47 × 30½ ins)
Signed and dated lower right (on base of column): Renoir.09.
Musée de l'Orangerie, Paris (Collection Walter–Guillaume), RF 1960–17

COLOUR *p. 155*

In *The clown*, Renoir's youngest son, Claude (Coco), born in August 1901, is shown wearing a red clown suit, but the subject is treated on the scale of, and with all the panoply of, the baroque court portrait, complete with marble column and Velasquez-like indeterminate background. The picture delicately treads the borderline between homage and parody. Jean Renoir later remembered a comparable portrait of himself and wondered if Renoir had been thinking of Van Dyck (1962, p. 396; the picture in Drucker 1944, p. 123); the conception of *The clown*, too, certainly echoes Veronese. Renoir may have undertaken tall vertical pictures such as this in part because of his physical frailty: André (1928, pp. 45–6) reported that, eager to disprove the allegation that he could now paint only horizontal reclining figures, he had his chair installed on trestles, so that he could execute pictures like the portrait of Jean in hunting costume (another neo-baroque extravaganza; cf. Chicago, Art Institute, 1973, no. 76) and the 1909 dancing girl decorations painted for Gangnat (National Gallery, London). Renoir kept *The*

clown until his death, despite its apparently public scale.

In later years, Claude well remembered posing for this picture: 'The costume was completed with white stockings which I obstinately refused to put on. My father demanded the stockings in order to finish the picture, but he could do nothing: they pricked me. So my mother bought some silk stockings; they tickled me. Threats followed, and then negotiations; one after the other I was promised a spanking, an electric railway, being sent to a boarding school, and a box of oil colours. Finally I agreed to put on cotton stockings for a few moments; my father, holding back a rage which was ready to burst out, finished the picture despite the contortions I was making to scratch myself. The railway and the box of colours rewarded so much effort.' Renoir was, in turn, to benefit from his generosity, Claude remembered, executing a delightful portrait of the boy at work with his new painting set, though the fact that this painting seems to show a younger Claude than *The clown* may cast doubt on the literal truth of his recollections.

LITERATURE
André and Elder 1931, II, pl. 120, no. 374
C. Renoir 1948, pp. 6–7
Paris, Orangerie, 1966, no. 38
Paris, Orangerie, 1984, p. 218

EXHIBITION
? 1913, Paris, Bernheim-Jeune (ex-cat: the painting is reproduced in Mirbeau 1913, the volume accompanying the exhibition)

1910–1919

During his last decade, Renoir worked under increasingly acute physical handicaps as a result of his arthritis. He was himself virtually immobilized and felt more and more cut off from the world around him. His two elder sons were both wounded in the early months of the war, and Aline died in 1915. It was after her death that Renoir and his second son Jean began their joint exploration of the painter's life and world, which Jean recreated in *Renoir, My Father*.

However, he retained full control of the mechanics of painting until the end of his life. He acknowledged that he could now 'only paint broadly', but, like Monet in his last paintings, he was able to work within his physical limitations to combine breadth with extreme delicacy of effect. His technique in these late works uses the full potential of the oil medium. 'I love greasy oily painting, as smooth as possible,' he said, 'that is why I love painting in oils. . . . I love to paw a painting, to run my hand across it.' At times he painted very thinly and with much medium over a white priming, particularly in his backgrounds, allowing the tone and texture of the canvas to show through, and creating effects almost like watercolour. His figures tend to be more thickly painted, but not with single layers of opaque colour; instead fine streaks of varied hue are built up, which create a mobile, almost vibrating surface. 'I look at a nude;' he said, 'there are myriads of tiny tints. I must find the ones that will make the flesh on my canvas live and quiver.' Those who watched him paint in these years spoke of the forms emerging from the canvas as he worked, coming to life as he painted them.

But the backgrounds in these late paintings are not mere backdrops. In his portraits they are integral to the whole composition; in his outdoor figures, though thinly painted, they pulse with life. 'I'm trying to fuse the landscape with my figures,' he said in 1918, 'the old masters never attempted this.' Or, as he put it on another occasion: 'I'm struggling with my figures, to make them one with the landscape which acts as their background, and I want people to feel that neither my figures nor my trees are flat.'

To achieve this vision Renoir took increasing liberties with natural appearances, in figures and backgrounds. As one of his late models disarmingly remarked, he made her larger than she was; to give a sense of fullness and roundness to his forms, he often fused into the single image varied angles of vision, creating a sense of the physical totality of the figure. In his backgrounds, the space is rarely legible; trees, grasses and flowers fold themselves around the figures and complement their rhythms. As Renoir succinctly put it to Bonnard, 'One must embellish.'

The colour schemes of these last paintings are very warm, dominantly pink and orange; these hues are further emphasized by being set off against economically used zones of green and blue, whose coolness emphasizes the overall warmth. In part these colour schemes were a practical expedient: throughout his career Renoir had been very preoccupied with the lasting qualities of his pigments, but he felt that even his recent work was becoming duller; so, he told Gimpel in 1918, 'he paints brick red so that, later, his colours may become a milky pink.' One critic in the early 1930s thought that time was doing its job, but, after more than sixty years, the colours still seem unusually hot and heightened. Renoir must have intended that, even after any darkening, they should remain as rich and sonorous as possible; their colour is integral to the vision of the world they present, of figures fused with nature in a timeless southern light.

Titian and Rubens remained Renoir's most important mentors in his last years, both for the splendour of their vision of the physical world and for their technique; his long love of Veronese, too, seems to have come into its own – particularly for the *Marriage feast at Cana* (no. 52 fig. a), with its resplendent coloured surfaces, which Renoir hailed on his final visit to the Louvre in 1919. The vibrating enrichment of the surfaces of Titian's late figures shares much with Renoir's last paintings: 'That old Titian,' Renoir joked, 'he even looks like me, and he is forever stealing my tricks.' With Rubens, Renoir most appreciated the fullness of colour and form that he could obtain with thin, sometimes translucent, layers of paint; it was in this context that he quoted, with much enthusiasm, Cézanne's comment: 'It took me forty years to realize that painting is not the same thing as sculpture.'

However, at the same time as he was developing the full potential of painting in oils, Renoir also made his first serious experiments in sculpture. He had executed a relief medallion of Claude's head in 1907, but by 1913, when Vollard persuaded him to consider executing sculpture in the round, he was unable to manipulate the materials himself, and he worked through the hands of an assistant. Two bronze sculptures executed in this way were exhibited at the Triennale in Paris in spring 1916, including *Venus victorious*, the piece on whose details Renoir had worked most closely (fig. a; no. 127). In his last years he also conceived projects for branching out into other media. He did designs for a tapestry cartoon for the city of Lyon, representing *The Saône embraced by the Rhône*, which Albert André would have executed to his specifications; he turned again, with his youngest son Claude, to his first skill, ceramics; and in his last year he planned a fresco decoration for the staircase of Les Collettes, his Cagnes house.

It was only in his late work that he began to treat specifically mythological themes, apart from a few decorative commissions in earlier years. The Venus sculpture and successive versions

of *The Judgment of Paris* from 1908 onwards (nos. 108, 119) were his most ambitious attempts at such subjects. Only in the timeless world, the earthly paradise, that he imagined around him in the south of France could such ideas become viable; shortly before he died, he commented: 'What admirable people the Greeks were. Their existence was so happy that they imagined that the gods came down to earth to find their paradise and to make love. Yes, earth was the paradise of the gods. That is what I want to paint.'

The nude was his prime subject, but he continued to paint portraits and costume pieces. His portrait sitters became increasingly monumentalized; his costume pieces were not images of fashionable modern dress, but rather the pretext for the lavish display of coloured finery. In these last years, he also went on producing myriad small informal oil studies when tired or anxious or unable to sustain concentration on anything more substantial; but, after he resigned himself to being unable to walk again, he was able to focus his remaining energies on his painting, producing works of a scale and ambition which belied his physical state.

His final paintings were only exhibited after his death, notably at the Salon d'Automne in 1920. In the years immediately after he died, their glowing humanistic vision was felt by many to be in tune with the need, after the First World War, to seek a new physical and moral order. Renoir's healthy *volupté* and Cézanne's more intellectual sense of order were paired by many critics as the twin inspirations for modern art. As Elie Faure wrote in 1925, the ideas that Renoir's art suggested well suited an epoch which 'seeks to rebuild a spiritual architecture that is in ruins, and, if possible, to build one different from that which existed before.' This confidence in Renoir's healthy, physical vision was later undermined by the challenge of Surrealism, on the one hand, and also by the uses to which classicism was put in Nazi Germany. His subsequent reputation has depended more on his work from the early years of Impressionism than on the timeless humanistic vision of his last years.

FIG a. Renoir and Richard Guino, *Venus Victorious*, 1914. h. 182cm (no. 127 in London exhibition only). The Trustees of the Tate Gallery.

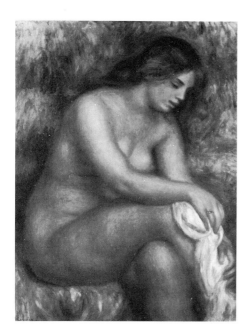

111

Bather drying her leg

Baigneuse s'essuyant la jambe
c. 1910
84×65 cm ($33 \times 25\frac{1}{2}$ ins)
Signed bottom left: Renoir.
Museu de Arte de São Paulo,
Assis Chateaubriand

COLOUR *p.157*

More perhaps than in any other of his long sequence of paintings of seated nudes, Renoir here focused on the figure alone, virtually filling the canvas with her form and reducing the background to an absolute minimum – just rapidly brushed suggestions of foliage, with a blue zone half way up the right side to hint at the presence of a stream. The colour is quite restricted, dominated by the pinks and whites of the flesh; this is modelled tonally, with dull, largely colourless shadows which set off the colours. Maurice Denis recorded Renoir's preoccupation with 'neutral tones, the greys which connect the tints and make the most of their brilliance' (Denis 1922, p. 113). The brush is used with great finesse, creating undulating movements within the figure's form; these suggest the roundness and fullness of her flesh and the play of light on it and at the same time create sequences of interrelated curves and highlights on the surface of the picture across which the eye moves.

The model's massive form is reminiscent of Titian's and Rubens's vision of female beauty, while its delicate treatment recalls their techniques of painting the nude. It was around this date that Renoir praised to Pach the paintings by Rubens that he had seen in Munich in 1910: 'There is the most glorious

fullness and the most beautiful colour, and the paint is very thin.' He also described Titian's painting of flesh and the way in which he made his forms seem to be radiating light (Pach 1938, pp.109, 111).

Renoir's bathers in outdoor settings from these years fall into two groups. Some, like nos. 102 and 103, seem to display themselves for the viewer's admiration, while the present picture belongs to a sequence in which the model is wholly absorbed in drying herself, without her attention being distracted by any implied outside presence. Her pose here is seemingly quite unselfconscious, in contrast to the hint at modesty and self-concealment in the pose of the 1892 *Bathers* (no. 88 and no. 88 fig. a). In one of the paintings in the same group as the present one, the apparent tranquillity of the composition is unexpectedly questioned by the bather's action, wiping blood from a cut on her leg (*The wounded bather*, 1909, repr. Drucker 1944, pl. 146).

The painting was in the Bernheim-Jeune collection at the time of Renoir's death.

LITERATURE
Paris, Bernheim-Jeune, 1919, II, pl. 125
London, Arts Council, 1954, no. 56
Rouart 1954, pp. 92–3

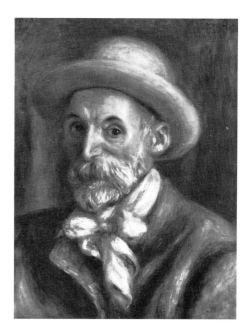

112

Self-portrait

Autoportrait
1910
47×36 cm ($18\frac{1}{2} \times 14$ ins)
Signed top right: Renoir
Dated top left: 1910.
Private Collection

COLOUR *p.161*

As in his self-portrait of *c.* 1899 (no. 99), Renoir here presented an idealized vision of himself, smoothing out the deep furrows which by 1910 covered his face. In contrast to the earlier portrait, though, the colour here is warmer and the brushwork more vigorous. The cool-toned jacket acts as a foil to the head and the background; the brushwork varies from the broader sweeps of the cravat to the finer drawing of the beard and the softer nuances worked into the face.

Marc Elder was presumably referring to the present picture in 1931 when he wrote of a self-portrait which expressed Renoir's restlessness and anxiety, comparing it with El Greco's portraits. Renoir would have known El Greco's paintings well at this period, since Durand-Ruel had held many in his stock; the Salon d'Automne had also organized an El Greco retrospective in 1908. El Greco's example seems to be reflected in the present self-portrait in the treatment of the features, and also in the rippling movements which run through the composition and the flickering, rather generalized lighting.

The painting remained in Renoir's possession until his death. Either it, or the profile self-portrait which he painted for

Durand-Ruel around the same date (New York, Wildenstein, 1969, no. 91), was exhibited in 1912 as *Portrait de l'artiste, 1910*.

LITERATURE
André and Elder 1931, I, pl. 102, no. 330, and ? II, preface, p. 14

EXHIBITION
? 1912, Paris (June), Durand-Ruel (*Portraits*) (19)

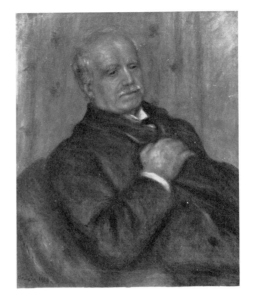

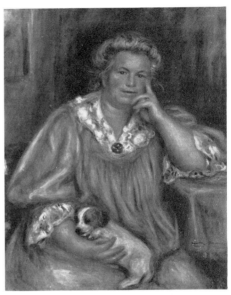

113

Portrait of Paul Durand-Ruel

Portrait de Paul Durand-Ruel
1910
65 × 54 cm (25½ × 21 ins)
Signed and dated bottom left:
Renoir 1910.
Durand-Ruel, Paris

COLOUR *p. 159*

Renoir had painted Paul Durand-Ruel's children several times (cf. no. 66), but this was the first and only occasion on which he painted the man who did more than anyone else to win commercial success for Renoir and the impressionist group. Durand-Ruel, born in 1831, was in his late seventies when Renoir painted him; he died in 1922. A contemporary photograph of him (Daulte 1972, p. 68) suggests that Renoir did not, here, have to embellish his elderly sitter; both photograph and portrait show the same soft, benevolent lines.

The picture is organized into distinct zones, with the warm hues in the dealer's face picked up by the floral pattern on the wall and by the red chair and set against the cooler hues of the wall; his jacket and shirt set up a crisp tonal contrast. The whole canvas is softly and thinly brushed, allowing the canvas grain to show through over large parts of the picture, with the thickest impasto on the white collar and cuff.

Durand-Ruel bought the painting privately, presumably in 1910.

LITERATURE
Pach 1950, p. 104
Chicago, Art Institute, 1973, no. 78

EXHIBITIONS
1912, Munich, Thannhauser (41)
1912 (February–March), Berlin, Cassirer (41)
1912 (June), Paris, Durand-Ruel (*Portraits*) (38)

114

Portrait of Madame Renoir with Bob

Portrait de Madame Renoir avec Bob
c. 1910
81 × 65 cm (32 × 25½ ins)
Signed bottom left: Renoir.
Wadsworth Atheneum, Hartford
(The Ella Gallup Sumner and Mary Catlin Sumner Collection), 1953.251

COLOUR *p. 160*

Of the few formal portraits that Renoir painted of his wife, this is the largest and the most ambitious (cf. no. 78). She had rarely posed for him since the mid-1880s; she had rapidly become very overweight after the birth of her children and was already in poor health in Jean's childhood in the later 1890s; she was later diagnosed as diabetic and died in 1915. Though she was aged only about fifty when Renoir painted the present portrait, Aline appears as an elderly woman, heavy and with greying hair, her size emphasized by the little sleeping puppy she holds. A contemporary photograph suggests that Renoir depicted his sitter without idealization (J. Renoir 1962, English edition, facing p. 249). Her pose is a very traditional one in the history of portraiture, and particularly convenient, because it makes it easier for the model to pose for long periods; it had often been used to suggest pensiveness or melancholy, but here the mood is perhaps one of weariness.

The colour in the picture is very restricted; reds, pinks and yellows dominate, with crisp white accents. The dress is modelled by gradations from yellow to grey, the flesh animated by fine streaks of white and red, its shadows modelled by duller tones rather

than contrasts of colour. The brushwork, flowing down her dress in cursive sweeps, suggests the folds and the weight of her figure below them. By contrast, the highlights in the picture seem weightless: her collar and cuffs are treated in rippling streaks and dabs of white, while fine yet fluent strokes describe her hair. The puppy's white coat anchors the base of the composition; it is enfolded by Aline's hand and dress, in a gesture reminiscent of Renoir's earlier images of motherhood and the protective care of children (cf. nos. 79, 95).

The painting remained in Renoir's possession until his death.

LITERATURE
André and Elder 1931, II, pl. 126, no. 391
New York, Wildenstein, 1969, no. 90
Chicago, Art Institute, 1973, no. 79
Callen 1978, pp. 98–9

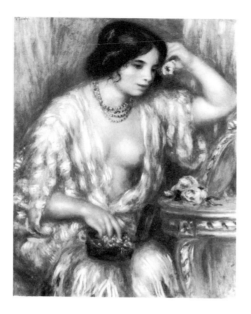

115

Gabrielle with jewellery

Gabrielle aux bijoux
c. 1910
81 × 65 cm (32 × 25½ ins)
Signed top left: Renoir.
Private Collection

COLOUR *pp. 162, 163*

Between about 1907 and 1911, Gabrielle Renard (cf. no. 95) served as Renoir's model for a sequence of canvases in which she is shown loosely clothed in semi-transparent materials, with her blouse opened to reveal her breasts. Some of these, like no. 116, treat the theme quite simply, but in paintings like *Gabrielle with jewellery* it becomes the pretext for a lavish display of finery. Composition, colour and touch unite the elements in the picture. The brushwork is animated throughout, with the more delicately worked areas of the skin framed by the fluent highlights of costume, jewels and dressing table. The colours, too, revolve around her skin: its soft whites, pinks, yellows and reds are picked up in the closely related but brighter colours in the rest of the canvas.

Her costume does not belong to a specific time or place: not modern nor ethnic, it is deliberately timeless, suggesting a generalized splendour and exoticism rather than the particular associations of orientalist or Hispanic garb (cf. nos. 96, 126). The ostensible theme of the picture is self-adornment and woman's preoccupation with appearances; but the vision that is being realized is of course Renoir's own: while Gabrielle prepares herself for display, she displays herself to the painter, who posed her thus, and to the viewer of the picture. The theme of women at their toilette has a long history in paint-

ing; one example, Willem Drost's *Bathsheba receiving David's letter*, a semi-nude half-length very comparable to Renoir's, had been acquired by the Louvre in 1902 (no. 2359A) and may perhaps have been relevant to his choice of the theme at this date.

This seems to have been one of the last group of paintings for which Renoir used Gabrielle as model. As Pach pointed out (1950, p. 102), he treated her face quite differently in subject paintings like this than in contemporary portraits of her; in the portraits, he particularized her features far more closely, while in subject pictures he transformed his model, now aged around thirty, into a generalized type of a dark-haired beauty. As he told Besson, he could not do without a model, but one needed also to be able to forget the model (Besson 1920, p. 50).

Gabrielle left the Renoir household around 1914, shortly before her marriage to the American painter Conrad Slade; according to some accounts, Madame Renoir asked her to leave, because, with her own increasing infirmity, she had become jealous of the painter's dependence on his maid and model (Frère 1956, p. 134; Dauberville 1967, p. 215).

The picture remained in Renoir's possession until his death.

LITERATURE
André and Elder 1931, II, pl. 116, no. 365

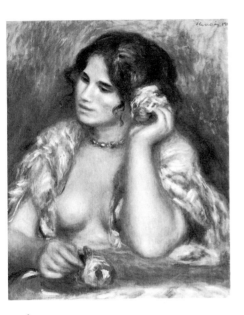

116

Gabrielle with a rose

Gabrielle à la rose
1911
55 × 47 cm (21½ × 18½ ins)
Signed and dated top right: Renoir.1911
Musée d'Orsay, Paris (Galerie du Jeu de
Paume, Gift of Philippe Gangnat, 1925),
RF 2491

COLOUR *p.165*

This is among the last of the sequence of
paintings of Gabrielle with an open blouse.
Smaller and less lavish than no. 115, it is
simple in its composition: the warm hues of
figure and table are set against a cooler
background, and clear contrasts are made
between her dark hair and the highlights on
her blouse and skin. The handling of blouse
and roses is particularly vigorous, creating
bold drawing and crisp highlights with one
and the same brushstroke; even within
the figure, a web of fine, separate strokes
animates the surface, introducing subtle
gradations between white and red. The white
highlights on her skin – on cheeks, breast,
belly, forearm and fingers – create a set of
equally weighted accents; but on her face
they are put alongside an alternative system
of accentuation – the warm reds which link
her cheeks and lips to the roses and the table
top. But the colour in the picture, rich
though it is, is limited in its range; the
shadows in her blouse are treated in dull
greys, rather than modelled by colour as
they would have been in Renoir's earlier
work.

At around this time he described his
methods to Pach: 'I arrange my subject as I
want it, then I go ahead and paint it, like a
child. I want a red to be sonorous, to sound
like a bell; if it doesn't turn out that way, I
put more reds or other colours till I get it.
I am no cleverer than that' (Pach 1938,
p.108). On other occasions, he made more
of the artfulness of his effects. He pointed
out to Schnerb in 1909, probably with refer-
ence to one of his paintings of Gabrielle,
how he had given the picture its colour
'with just a single tone' (Schnerb 1983,
p. 176). He used to emphasize how he was
seeking the richest possible effects with the
simplest possible means, reducing his pal-
ette as far as possible, so as to retain the
greatest control over his materials and over
the results he achieved with them (André
1928, pp. 34–5; J. Renoir 1962, pp. 386,
445, 456).

The roses in the picture serve several
functions. Their colour gives it a keynote,
of the sort he had so admired in a Velasquez
Infanta portrait (cf. entry for no. 100). Studies
of roses might also, he told Vollard, act as
'researches in flesh tones which I make for a
nude' (Vollard 1938, p. 224). But their role
was not purely formal; Renoir associated
them with the physical beauties of women.
In earlier years he had often juxtaposed
young girls and flowers (cf. nos. 80, 86); it
seems to have been after 1900, as he adopted
a fuller, more mature vision of female beauty,
that he focused on the rose, with its fullness
of form, as an attribute to this beauty (cf.
nos. 101, 126).

This picture was part of Maurice Gangnat's
vast collection of Renoir's late work. His
son Phillippe presented it to the French
State before the sale of the collection in
1925.

LITERATURE
Paris, Drouot, *Gangnat*, 1925, no. 23
Pach 1950, p.112
Gaunt and Adler 1982, no. 47

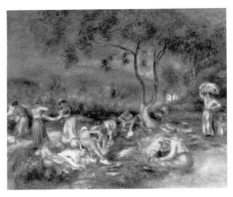

117

Washerwomen at Cagnes

Les Laveuses à Cagnes
c. 1912
73 × 92 cm (28½ × 36 ins)
Signed bottom left: Renoir.
Private Collection

COLOUR *p.168*

Renoir had previously painted washer-
women, notably at Essoyes around 1888
(no. 81); he returned to the theme in his last
years, particularly in two ambitious canvases
around 1912, the present picture and no.
118. In no. 118 he focused on two monu-
mentalized figures, while here he placed
many smaller figures within a landscape.

In the 1888 *Washerwomen* Renoir had given
little sense of physical toil; here the theme of
labour is played down still further. The fig-
ures are treated with soft, flowing rhythms,
and similarly smooth, cursive patterns knit
the whole composition together. The forms
of the two women wringing a sheet on the
left suggest dance movements more than
physical effort; the women at work are treated
in the same way as the resting, seated figures
which frame the composition. No single
figure or group is the principal focus; all are
part of a single harmonious interplay. The
two children in the picture are wittily con-
trasted. The woman and child at bottom
right are the only figures not involved with
the washing; as they sit and watch, the
woman's form enfolds and protects the
child. By contrast, the ragged little child on
the far right, holding on to the woman's
apron, assumes a pose which is a miniature
reproduction of hers, as she carries the basket
of washing on her head.

The forms of the landscape complement
the figures; the curling rhythms which run
up the stream and continue up the tree trunks
are softly echoed in the patterns of the
foliage. The composition is very traditional
in form, with an off-centre Claudian tree
punctuating a gently winding recession from
foreground to distance. This 'jewelled string
of ideal washerwomen curling among the
trees' reminded Gowing of Watteau's *Em-*

barkation for the Isle of Cythera in the Louvre (fig. a); the mood of the picture is clearly reminiscent, in general terms, of the *fête champêtre* of the early eighteenth century, translated into an image of timeless sunlit peasantry. But, despite the generalized forms and mood, the stream and its setting are reminiscent of the little river which flows through the valley between Renoir's house in Les Collettes and the old town of Cagnes. The geographical south here becomes the site for an idyllic vision of country women working in harmony within a natural paradise.

The colour enhances the picture's mood. Trees and landscape are suffused with soft pinks, which echo the stronger reds of some of the costumes; there are clear blues, too, in their clothes and in the stream and distance – and, more puzzlingly, on the ground beyond the seated figures on the right. These colour hues act as a foil to the dominantly warm key of the painting. The paint layers are mostly thin, with the texture of the canvas clearly felt throughout, and the brushwork is generally soft and unemphatic; at certain points in the landscape the touch is more animated – in grasses, foliage and flowers – and generates pockets of visual activity throughout the picture.

The picture was in Renoir's possession until his death; he deposited it with Durand-Ruel between 1914 and 1917.

LITERATURE
André and Elder 1931, II, pl.115, no.364
New York, Duveen, 1941, no.79
Drucker 1944, p.95, 214–15 no.157
Gowing 1947, p.7

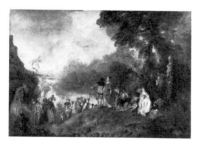

FIG a. Antoine Watteau, *Embarkation for the Isle of Cythera*.
Musée du Louvre, Paris.

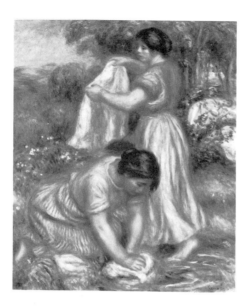

118

Washerwomen

Les Laveuses
c. 1912
65 × 55 cm (25½ × 21½ ins)
Signed bottom right: Renoir.
The Metropolitan Museum of Art, New York (Gift of Raymonde Paul, in memory of her brother, C. Michael Paul, 1982), 1982.179.3

COLOUR *p.169*

Exhibited in London and Paris only

Whereas *Washerwomen at Cagnes* (no. 117) presents its subject in a panoramic composition with many figures, *Washerwomen* builds a single, emphatic pyramidal group out of the figures of only two washerwomen, whose forms dominate the picture and the landscape beyond them. Their forms are weighty, but their gestures give no impression of toil, but lock the composition together; their rhythmic curves connect the figures and harmonize them with their background. The richly brushed highlights emphasize these interconnections.

Though very different in conception, the present picture has much in common with *Washerwomen at Cagnes* in its treatment – in the way in which the compositions revolve around the reds in the costumes, and in the treatment of the ripples in the water; in both, too, the brushwork in the background is animated in parts, rather than acting simply as a more neutral backdrop. Here the recession between foreground and background is less clearly legible; distant hills are suggested on the left, but the arrangement of trees, and foliage beyond the figures serves primarily to complement and frame their grouping.

There is no clear evidence for dating this picture. The ribbon-like highlights are comparable to those in *Gabrielle with a rose* of 1911 (no. 116); the faces of both washerwomen, too, are quite similar to Gabrielle as she is depicted in that picture. Renoir made an ambitious chalk drawing in preparation for the present painting (Daulte 1959, pl. 28, where it is wrongly described as a study for no. 117).

The early history of the picture cannot be precisely documented.

LITERATURE
New York, Wildenstein, 1969, no. 83

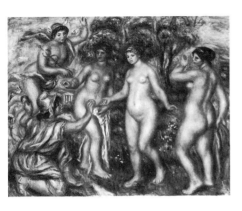

119

The Judgment of Paris

Jugement de Paris
c. 1913–14
73 × 92 cm (29 × 36 ins)
Signed bottom right: Renoir.
Hiroshima Museum of Art, Hiroshima, Japan

COLOUR *p.167*

Exhibited in London and Paris only

Renoir had recently finished this second version in oils of *The Judgment of Paris* when Jacques-Emile Blanche visited him at Cagnes in April 1914. The composition is more densely packed than the first version of 1908 (no. 108), with the addition of the bulky flying figure of Mercury at top left and the added enrichment and animation of the surface; this avoidance of open spaces in the composition was one of the key characteristics of his last works (cf. nos. 125, 126).

In this version Mercury's attributes, and the miniscule temple in the distance beneath him, further emphasize the painting's Classical subject. Otherwise the main change is in the pose of Venus: instead of reaching forward for the proffered apple, she stands with arms apart, on display before Paris her judge, and before the viewer of the painting. This pose was to become the basis of the sculpture *Venus victorious* (no. 127) which Guino executed to Renoir's instructions in 1914–16. Guino also made a relief based on this painted version of *The Judgment of Paris*; a bronze version of it was exhibited at the Paris Triennale in 1916 and in Zurich in 1917.

Renoir deposited this painting with Durand-Ruel between August 1914 and 1917; it was still in his possession at his death.

LITERATURE
Blanche 1919, p.241
André and Elder 1931, I, pl.131, no.405
New York, Duveen, 1941, no.83
Pach 1950, p.118
Chicago, Art Institute, 1973, no.83

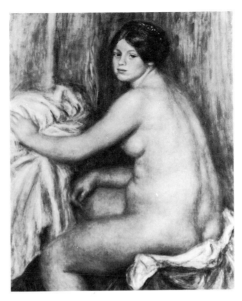

120

Bather

Baigneuse
1913
81 × 65 cm (32 × 25½ ins)
Signed and dated bottom left:
Renoir 1913.
Mr and Mrs Alexander Lewyt

COLOUR *p.172*

In his later years Renoir executed sequences of paintings of the female nude in both outdoor and indoor settings. Bathing or dressing may remain the ostensible pretext for these pictures, but the situation depicted became more and more unspecific, the nude in its own right more and more the focus of the composition.

The *Bather* of 1913 is particularly simple in subject, with only her head-band – vaguely oriental in style – supplying any particularity of detail. But this band plays an essential role in the composition: the blues and greens in it, together with the drapery in the bottom right corner, are the only cool tones in the picture, setting off the reds, pinks, beiges and whites which dominate the rest. The modelling in the white drapery on the left is suggested not by colour but by dull grey tones, some of them crisply added late in the execution of the painting, after the free-flowing white highlights; as Renoir often said in later years, black became a very important element in his palette from the 1890s onwards (cf., e.g., Alexandre 1920, p. 9).

Throughout the painting of the flesh the form of the model is suggested by soft movements of the brush and delicate variations of colour – sometimes lighter, sometimes warmer; the open areas of the body are constantly enlivened by the 'myriads of tiny tints' which Renoir sought in order to 'make

the flesh on my canvas live and quiver' (Pach 1938, p. 108). The fullness of form is achieved by the thinnest layers of paint, in the way that he had so admired in Rubens's work (cf. entry for no. 111, and also no. 121).

In paintings like this, Renoir seems to incorporate into a single figure several angles of vision. Certainly there are reminiscences of Rubens's favoured physical types, but the bulk of the model's hips seems to be further magnified by a combination of profile and back view. This may in part be the result of the fact that Renoir encouraged his models to pose quite freely: 'The model is only there to inspire me, to allow me to dare things which I would not be able to invent without her' (André 1928, p. 46). But the way in which he used this freedom clearly reflects a desire to maximize the physical presence of the nudes he depicted – to create a vision of woman which was both idealized and palpably physical. In 1920, Elie Faure described his use of these multiple view-points (Faure 1922, p. 90); at the same time, Renoir's last works were attracting great attention from younger painters of the Parisian avant-garde, among them Picasso, whose monumental nudes of the early 1920s are a remarkable fusion of the lessons of Ingres and Renoir with the possibilities of a post-cubist space.

The present painting was bought from Renoir by Durand-Ruel in August 1913.

LITERATURE
New York, Wildenstein, 1969, no.89
New York, Wildenstein, 1974, no.59

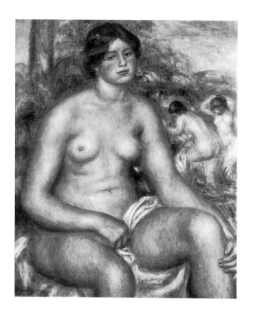

121

Seated bather

Baigneuse assise
1914
81×67 cm ($32 \times 26\frac{1}{2}$ ins)
Signed and dated bottom left:
Renoir. 1914.
The Art Institute of Chicago (Gift of
Annie Swan Coburn to the Mr and Mrs
Lewis Larned Coburn Memorial), 1945.27

COLOUR *p.173*

This canvas occupies an unusual halfway
stage between figure and bathing group. In
earlier *Bather* compositions, notably the
Bathers of 1887 (p. 241 fig. a), Renoir had
juxtaposed foreground and background
figures, but this painting, it seems, was the
first time that he had combined a single
monumental figure with small nudes be-
yond. The result of this is that the space in
the picture becomes still more illegible: the
background foliage and nudes alike act as an
attributive backdrop to the principal figure.
The same ambiguous figure-ground rela-
tionship was explored again in *The bathers* of
Renoir's last year (no. 125).

Seated bather is particularly thinly painted.
In many of Renoir's late paintings the grain
of the canvas is sensed beneath most of the
surface; often around the sides of the picture
the paint is so thin that it sinks into the
canvas, leaving the minute white-primed
peaks of the canvas-weave bare of paint. In
this picture, these areas extend even into the
principal figure; through much of the flesh
painting, the ridges of the canvas and tiny
flecks of white priming can be seen. Surfaces
such as this have caused much debate. Renoir
was, as he often said, seeking to suggest the
fullness of forms with the thinnest paint (cf.
entry for no. 120), but did he intend the

effect of the present painting? Or did the
thin paint layers sink further into the canvas
after he had completed work on it? Or are
such effects partly the result of subsequent
surface abrasion which has rubbed away
parts of the paint layer where it was thinnest?
Technical analysis of the present picture
(Chicago, Art Institute, 1973, p. 214) has
suggested that, at least in the background,
Renoir rubbed, rather than brushed, some
of the colour across the canvas, which would
suggest that such effects are, at least in part,
wholly deliberate. Anthea Callen has isolated
similar techniques in some of his earlier
work as well (Callen 1978, pp. 15, 51–3, and
cf. pp. 100–3). But on some occasions – for
instance in parts of the figure here – the
effect of the canvas grain is so insistent that
it begins to challenge the apparent round-
ness of the form in a way which Renoir
seems unlikely to have intended. It is much
to be hoped that further technical analysis –
perhaps occasioned by the present exhibition
– will help to resolve these questions and
will explain the causes of this effect, which
appears so frequently in Renoir's later
paintings.

The figure here is fully modelled, with
fine juxtaposed strokes of varied hue which
give the flesh a shimmering surface (cf.
Chicago, Art Institute, 1973, p. 214). By
contrast, the trees and the little figures be-
yond are treated in free strokes which ap-
proximate only very roughly to their natural
forms. These are very like the small oil
sketches of which Renoir painted so many
in his later years. It was in these, he said, that
he was able to express himself most freely
(cf. André 1928, p. 49); at the same time,
they occupied his time, and his hand, when
he could not sustain concentration on a
major work. But they also played a role in
preparing for his larger works, as André
described: 'Once he has found a subject, he
executes small canvases in the spirit of this
subject. Sometimes it is an isolated figure,
sometimes several figures. This work acts
for him as a sort of practice for the definitive
work' (André 1928, pp. 39–40). Rivière
remembered him using just such a quick
study, painted without a model, to help him
solve problems he was facing in the execu-
tion of one of his last nudes (Rivière 1925,
p. 1). In the present painting, by combining
an elaborated foreground figure with a freely
improvised background, Renoir found a
way of combining these two facets of his
own art, and also of bringing together in a
single image the sketch and the finished
painting, thereby reconciling the types of
painting whose rival claims had launched
the debates about the 'impression' half a
century earlier.

With its warm, luminous tonality, *Seated
bather* may well have been executed in the
glazed open-air studio which Renoir had
built at Les Collettes, whose shutters and

curtains could control the light inside, where
he worked, protected from cool breezes,
while the model could pose in full sunlight
outside (fig. a; cf. J. Renoir 1962, pp. 452–3).
Albert André evoked the aged Renoir's
rhapsodies about the subjects like this which
he painted in the south: 'Look at the light on
the olive trees . . . it shines like a diamond. . . .
It's pink, it's blue. . . . And the sky which
plays across them. . . . It drives you mad.
And those mountains which pass with the
clouds . . . they're just like Watteau's back-
grounds. Ah! this breast! Is it soft and
weighty enough! the pretty fold beneath it
with its golden tone. . . . It's something to
get down on one's knees in front of. If there
hadn't been any breasts, I think I'd never
have painted figures' (André 1928, p. 29).

The model here resembles Madeleine
Bruno, who posed for a related bather
composition in 1916 (Chicago, Art Institute,
1973, no. 85), though there she was depicted
with dark hair. In these years, Renoir nor-
mally so generalized the features of his
models, sometimes combining elements from
different sitters in a single figure, that it is
often impossible to identify particular sitters.
Madeleine Bruno found it hard to recognize
her own slight figure in the massive forms
that Renoir painted using her as a model
(Clergue 1976). Here the hips are given
particular breadth, which emphasizes the
figure's pyramidal form, but also creates a
form which seems implausible in naturalistic
terms; as in no. 120, more than one view-
point seems to have been fused into a single
image.

Though the date of this painting has often
been read as '1916', it must be '1914', since
Renoir put the canvas on deposit with
Durand-Ruel in August 1914 at the outbreak
of war; the dealer purchased it from him in
1917.

LITERATURE
Chicago, Art Institute, 1973, no. 84 and pp. 211–4

EXHIBITION
1918, New York, Durand-Ruel (16)

FIG a. The studio at Les Collettes, photograph.

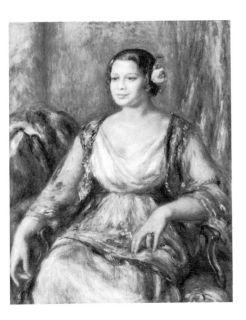

122

Portrait of Tilla Durieux

Portrait de Tilla Durieux
1914
92 × 74 cm (36 × 29 ins)
Signed and dated bottom left:
Renoir. / 1914.
The Metropolitan Museum of Art, New
York (Bequest of Stephen C. Clark, 1960),
61.101.13

COLOUR *p.171*

Exhibited in London and Paris only

This is the finest and most ambitious of
Renoir's late portraits. It depicts the German
actress Tilla Durieux, wife of the Berlin art
dealer Paul Cassirer, who had handled and
exhibited many of Renoir's paintings over
the previous fifteen years. The couple
travelled to Paris in July 1914, just before
the outbreak of the war, for Renoir to paint
Durieux's portrait; she later remembered
posing for two hours every morning and
every afternoon for two weeks. She is de-
picted wearing the costume that Poiret had
designed for her to wear in the last act of
Pygmalion.
 In the portrait, Renoir adopted the
rhetorical devices of High Renaissance por-
traiture: a simple, monumental pyramidal
arrangement, with its simplicity set against
the lavish textures and flowing movements
of the sitter's clothing and the drapery
around her. The painting has a clear generic
relationship with portraits such as Titian's
Isabella of Portugal in the Prado in Madrid, or
Raphael's *Joanna of Aragon* in the Louvre.
The face is not sharply characterized, but
contemporary photographs of the sitter show
that she closely resembled Renoir's image of
her smooth, regular features with wide cheek-

bones. Photographs survive of Renoir and
his sitter while the sessions for this portrait
were under way (one is reproduced in Rewald
1973, p. 584; another in Drucker 1944, facing
p. 58).
 The tonality of the picture is warm
throughout, with only the curtains at top
right and the narrow sashes down the side
of her skirt to provide a cool foil to the rest.
The wide areas of her white dress are mod-
elled with soft greys, by tonal gradations
rather than coloured nuances. Durieux de-
scribed how Renoir asked her to pin a rose
to her hair, which supplies a warm keynote
for the whole composition. In his later paint-
ings of women Renoir often used roses as an
attribute of their beauty (cf. nos. 101, 115,
116). Though he often said in his later years
that he disliked painting portraits, he told
Durieux that he was glad to have under-
taken this commission.
 Paul Cassirer left the portrait on deposit
with Durand-Ruel on 31 July 1914, just
after its completion; it was later returned to
him, though the date of this is not clear.

LITERATURE
Duret 1922, pp. 110–1
New York, Duveen, 1941, no. 81
Drucker 1944, p. 96 and facing p. 58
Pach 1950, p. 120
T. Durieux, 'Renoir', in *Eine Tür steht offen*, 1954
 (reprinted in *Meine ersten neunzig Jahre*, Munich and
 Berlin, 1971, pp. 205–211)
New York, Metropolitan, 1967, pp. 161–3
Rewald 1973, pp. 584–5

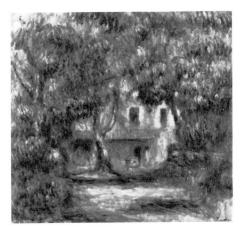

123

The farm at Les Collettes

La Ferme des Collettes
c. 1915
46 × 51 cm (18 × 20 ins)
Stamped bottom right: Renoir
Musée Renoir "Les Collettes",
Cagnes-sur-mer

COLOUR *p.164*

Exhibited in London only

Renoir purchased the estate of Les Collettes
at Cagnes, on the Mediterranean coast just
west of Nice, in 1907, and in autumn 1908
he moved into the house he built himself
there. After this, the estate provided him
with his principal subjects for landscape; he
focused sometimes on the panoramic views
from it of the coast and the old town of
Cagnes, sometimes on its ancient, twisting
olive trees, and often on the old farmhouse
on the estate. The estate's previous owner
had lived in the farm, and Renoir in his
pictures of it presented it as the continuing
focus of life there; never did he paint his
own massive new house. The farm com-
plemented the atmosphere that he was at
pains to maintain at Les Collettes. Claude
Renoir remembered how he had to 'struggle
to preserve the estate's rural character; he
wanted neither a "villa" nor a "garden"'
(C. Renoir 1960); indeed he had to stop his
gardeners from removing the grass that
grew out of the paths (Rivière 1928, p. 673).
 Almost like Monet, who built his water
garden as his ideal pictorial subject in his
last years, Renoir could construct at Les
Collettes a physical world which fulfilled his
pictorial vision. But it was quite different in
two crucial ways: Monet built his anew, to
his own aesthetic specifications, while
Renoir's was old, preserved as an idealized
vision of past society; and Monet's was an
elaborately cultivated garden, conceived as
an object of solitary contemplation, whereas
Renoir's view of nature necessarily implied
the human presence, which the olives and

the old farm evoked so richly; often, though not in the present picture, figures beside the house and beneath the trees enliven the scene still further. This harmonious interrelationship between nature and the traces of man became the vision of the 'earthly paradise' which he sought in his art in his last years. As Grappe put it in 1933, 'the farm at Les Collettes is the décor of his flamboyant fantasy' (1933, p. 285).

The present painting is one of the informal, freely brushed landscapes of Renoir's last years. The animated touch by which Renoir evoked the foliage suggests that it was painted around 1915, though it cannot be precisely dated. Though not formally finished, it is carefully, almost classically composed, with the principal tree, off-centre in front of the farm, leading the eye from foreground into middle distance, in a way very reminiscent of Claude and the classical landscape tradition, thus complementing the timeless, classical mood Renoir found in the southern landscape (cf. no. 109).

The painting was in Renoir's studio at his death; it was recently acquired by the Musée des Collettes, housed in Renoir's home at Les Collettes.

LITERATURE
André and Elder 1931, II, pl. 151, no. 469

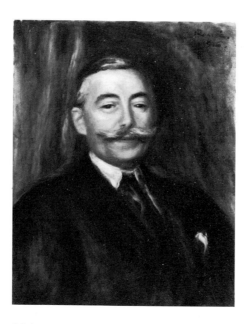

124

Portrait of Maurice Gangnat

Portrait de Maurice Gangnat
1916
47 × 38 cm (18½ × 15 ins)
Signed and dated top right: Renoir./1916.
Inscribed on reverse: Cagnes 1916
Private Collection

COLOUR *p. 170*

Maurice Gangnat began to collect Renoir's work around 1905 (cf. no. 105 and p. 25); between then and Renoir's death he acquired over one hundred and fifty paintings by the artist and became a close friend, regularly visiting him at Cagnes, where the present portrait was painted. His collection concentrated for the most part on Renoir's smaller, more informal late works (e.g. no. 109), but he also commissioned the two monumental *Dancer* figures of 1909 (National Gallery, London). Renoir himself acknowledged Gangnat's unerring eye: 'When he entered the studio, his glance always fell on the canvas which Renoir considered the best. "He has an eye!" my father stated. Renoir said also that the collectors who understood something about painting are more infrequent than good painters.' (J. Renoir 1962, p. 448.)

In his portrait of the collector, painted ten years after that of his son (no. 105), Renoir used his sitter's moustaches as the keynote of the flowing rhythms which run throughout his face and head.

LITERATURE
Rivière 1921, pp. 210–1
Paris, Drouot, *Gangnat*, 1925, frontispiece

125

The bathers

Les Baigneuses
c. 1918–19
110 × 160 cm (43½ × 63 ins)
Not signed
Musée d'Orsay, Paris (Galerie du Jeu de Paume, Gift of the artist's sons, 1923), RF 2795

COLOUR *pp. 174, 175*

Renoir intended *The bathers* as his final pictorial statement. It was in recognition of this that his sons presented the picture to the French State. It is a résumé of the most important theme of his career, the female nude in landscape, and in particular a recapitulation, after an interval of over thirty years, of the *Bathers* (p. 241 fig. a) on which he had worked for so long in the mid-1880s. The two canvases are virtually identical in size and similar in format, with small figures beyond the monumental foreground group. But here the resemblance ends: in the earlier one, the forms are harsh in contour and the touch is dry, while here fluid touches of varied colour model the figures and fuse them with the ambient landscape.

Michel Georges-Michel remembered seeing Renoir at work on the picture in his garden studio (cf. no. 121), using the special adjustable easel, with the canvas on rollers, which allowed him to reach all parts of even a large canvas as he sat (cf. J. Renoir 1962, p. 453). The most eloquent testimony to his work on the canvas comes from Matisse, as recorded, or embroidered, by Frank Harris. Renoir described why he wanted to continue working at this picture of two young girls, 'God's best works.... His supreme achievement'. ... 'The pain passes . . . but the beauty remains. I'm quite happy, and I shall not die till I have completed my masterwork. Yesterday I thought it was finished, that I could not put on another brushstroke to better it, but *la nuit porte conseil*; and now I see that three or four days' more work on it will give it a deeper touch.' Jean Renoir recorded that his father 'considered it as a final achievement. He thought that he had summed up in it the research of his whole life, and that he had prepared a good springboard for his future investigations.'

The picture also reflects Renoir's delight at the model he used in his last years, Andrée (Dédée) Hessling, whom Jean was to marry after his father's death. According to Albert André, the beauty of this 'superb redhead' was the incentive he needed to undertake his last paintings; she presumably posed for the lower figure in *The bathers*. But the picture is far more than a celebration of a particular model. The two figures, like Renoir's other late nudes, are given a scale and a fullness

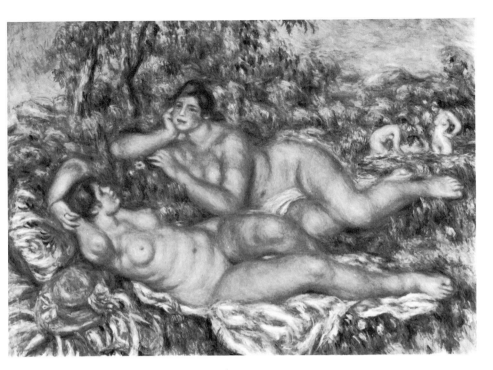

which transcends the specific individuals who posed for them or the specific viewpoint from which they were seen. With their arbitrary forms, apparently immunized against mortal sufferings, they reminded Robert Rey of Ingres's *Grande odalisque* (Louvre) or the *Diana of Anet* from the School of Fontainebleau.

But Renoir's figures are unlike those previous visions of the 'eternal feminine' in the way in which they are linked to the landscape. The cushion on the left dissolves into the foliage; figures, grasses and trees alike seem to be stacked on top of each other in a single mobile surface plane, as the eye scans the canvas. He told Gimpel in 1918: 'My landscape is only an accessory; at the moment I'm trying to fuse it with my figures' (Gimpel 1963, p. 27). André described Renoir's loathing for open spaces in his compositions: 'More and more he loves compositions which fill the canvas "to bursting point", he says – on the picture surface and in depth' (André 1928, pp. 44–5). To André he cited Veronese's *Marriage feast at Cana* (no. 52 fig. a) as his prime example of this fullness of composition. But the fusion of bathing figures with the landscape which surrounds them can also be compared with the very last *Bather* canvases of Cézanne, the smaller pictures which seem to postdate his large *Bathers*.

The technique of Renoir's picture complements its theme. The landscape is animated throughout with distinct coloured touches – softer in the distance, very vigorous in the trees. At times the background is very thinly painted; the oil paint is diluted in places with so much medium that it resembles watercolour – it even trickled down the canvas at certain points, for instance in the

lower left corner. As in no. 121, the background figures are treated with the freedom of Renoir's most summary improvisations in oil. The main figures are more opaquely painted, in soft cursive streaks of paint which follow their forms and model their volumes with delicate variations of colour and tone. The delicacy of painting in the main figures shows that the breadth of treatment in the background was deliberate and not a by-product of Renoir's physical disabilities.

The colour is warm throughout. Pinks and reds suffuse the grasses and trees as well as the figures, linking to the strong reds and oranges in the discarded clothing at bottom left. Blues are used in the distances and in the water at the right, but only very sparingly in the foliage and not at all in the figures. Renoir's use of colour here is particularly unusual in the way in which this lavish display of intense hues is combined with white and off-white highlights. In figures and trees alike, accents of hot colour are juxtaposed with tonal highlights. This is particularly marked in the foreground figure, whose whole body is built up of soft, swelling forms. Her hand, arms and elbows, cheek, neck and breasts, belly, thighs and knees are animated by a succession of equally weighted hot touches and highlights, sometimes with clear whites and rich reds closely juxtaposed, as in the area of her elbow, neck and breast where form virtually dissolves into a vibrating alternation of light and colour. This free synthesis of tonal and coloured accentuation is a sort of resolution to the traditional opposition between chiaroscuro and colour – to the debate between Ingres and Delacroix with which so much of Renoir's career had been engaged.

The *bathers* has, ever since its first appearance, been the central focus of the debates about Renoir's late work. The French National Museums were initially, it seems, reluctant to accept the gift of the painting, though from Renoir's supporters it won paeans of praise. During the 1920s Renoir's late work was widely fêted, but when in 1933 the National Museums organized a major Renoir retrospective at the Musée de l'Orangerie, the last paintings were scantily represented in comparison with earlier periods of his work. Amid the approbation given to Renoir's final style in the 1920s, Georges Duthuit's perceptive booklet of 1923 struck a note of caution; contrasting Renoir with Rubens, Duthuit concluded: 'Short of imagination, and deprived of any dramatic sense, without real fire or pungency, Renoir's marvellous facility did not reveal to him the secret of movement; in his largest compositions one finds something slack and overblown which distances them once and for all from monumental architecture' (Duthuit 1923, pp. 25–6).

LITERATURE
Jamot 1923, p. 344
Harris 1924, pp. 139–141
Meier-Graefe 1929, pp. 417–9
André and Elder 1931, I, p. 12
Rey 1931, pp. 58–9
Alexandre 1933, p. 8
Barnes and de Mazia 1935, pp. 144, 435–6 nos. 304
André, October 1936, p. 21
Drucker 1944, pp. 106–8, 215 no. 162
Georges-Michel 1954, p. 30
J. Renoir 1962, p. 455
Perruchot 1964, pp. 354, 359
Chicago, Art Institute, 1973, no. 87

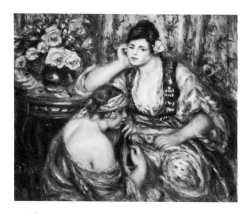

126

The concert

Le Concert
c. 1919
75 × 93 cm (29½ × 36½ ins)
Not signed
Art Gallery of Ontario, Toronto (Gift of
Reuben Wells Leonard Estate, 1954),
53/27

COLOUR *p.176*

If *The bathers* (no. 125) was Renoir's most
ambitious final testament, *The concert* is a
last synthesis of several themes which he
had often tackled: leisured young girls
with flowers (cf. nos. 85, 86); music-
making (cf. nos. 35, 89–91, 96) and women in exotic
costumes (cf. nos. 17, 20). The right figure
is particularly reminiscent of the *Woman of
Algiers* in orientalist garb that Renoir had
shown at the 1870 Salon (no. 15 fig. b).

The whole canvas is densely packed;
more perhaps than any of his major paintings
it reflects the dislike of empty spaces which
Renoir felt increasingly in his last years and
his delight in compositions which fill the
canvas (cf. entry for no. 125). This must
have been one of the things which constantly
drew him back to Veronese's *Marriage feast
at Cana* in the Louvre (no. 52 fig. a). He told
André late in life that he dreamed of nothing
but this picture (André 1928, p.45), and he
extolled it to Pach in terms which are clearly
relevant to *The concert*, praising 'the way in
which [Veronese] has controlled the archi-
tecture of that enormous picture, and the
way all those brilliant, even violent colours
work together without a break' (Pach 1938,
p. 111).

The concert is locked together on the
picture surface by successions of rhyming
rounded forms: the roses in the vase, on the
wall-hanging and in the girl's hair; the
rippling white highlights of their dresses,
and the gold of table, mandolin, hair-band
and the brunette's outer cloak. Within these
interwoven patterns, smaller accents animate
every area – dabs and dashes of red, yellow,
green and blue. These rich curves are set off

against the soft verticals of the background
hangings. The dominant colour is a warm
orange or brick red. Blues are virtually re-
stricted to the brunette's jacket and a single
narrow strip of the background hangings;
but the few cool colours in the picture serve
to accentuate the warmth of the rest. The
paint surfaces are generally thin; only the
densest highlights are wholly opaque.

Renoir achieved this dense surface pat-
terning at the expense of any credible sense
of three-dimensional space. But this con-
flation of the world on to a single decorative
surface was in no sense a manifesto of 'pure
painting'; rather it represented a fervent
affirmation of the value of sensory experi-
ence. In a ribald mood late in his life, he
compared the flowers of anemones to
women's sexes (Georges-Michel 1954,
p. 29); he particularly associated roses, too,
with the beauties of the female body (cf. no.
116). In pictures like this, the rhymes and
echoes between the objects create a series of
metaphorical associations; no one object is
simply equated with another, but all become
part of a single chain of connections, and all
celebrate a set of interrelated values: the
physical splendour of young women; the
richness of materials and gilded surfaces; the
lavishness of flowers, with their associations
with the sense of smell; and the musical
instrument, evoking hearing. Painting be-
comes a vehicle for suggesting the corres-
pondence of the senses, and in this fantasy
of an old man the elements all combine to
express youth, growth, beauty and colour –
a vision of an earthly paradise.

The models for the figures were presum-
ably the same two girls who posed for *The
bathers* (no. 125), with Andrée in the fore-
ground. The painting was in Renoir's studio
at his death.

LITERATURE
Meier-Graefe 1929, pp. 417–9
André and Elder 1931, II, pl. 216, no. 685
Drucker 1944, p. 215 no. 163
Chicago, Art Institute, 1973, no. 88

Renoir and Richard Guino

127

Venus victorious

Vénus victorieuse
1914/6; cast made by 1950
Bronze: 182 × 102 × 77 cm
(71½ × 44 × 30½ ins)
Signed and dated on upper surface of base:
Renoir/1914
Inscribed on back of base: Alexis Rudier./
Fondeur. Paris
The Trustees of the Tate Gallery, London,
5934

REPRODUCED *p.279*
Exhibited in London only

Venus victorious was the only substantial
sculpture to be closely supervised by Renoir,
and it is the one which most closely reflects
his intentions.

He had executed his first works in three
dimensions around 1907, a small relief
medallion and a little bust, both of Claude;
these he made with his own hands. Apparent-
ly he wished at once to do further sculptural
work, but it was not until 1913 that, at
Vollard's urging, he decided to implement
his projects. By then, his arthritis was so
severe that he could not manipulate the clay
himself; he employed a succession of assist-
ants to work to his instructions – notably
Richard Guino, the young pupil of Maillol
who worked for him, paid by Vollard, from
1913 until the end of 1917. After a lawsuit
which Guino took out against Renoir's heirs
in 1973, judgment was passed that the
sculptures which he executed to Renoir's
designs should be attributed to the joint
authorship of the two men; accordingly
Venus victorious is so credited here.

A small full-length *Venus* was the first
sculpture which Guino made for Renoir,
apparently at Essoyes in summer 1913. Soon
afterwards, Renoir had the idea of turning
this subject into a monumental sculpture.
This was under way by spring 1914, when
both Mary Cassatt and K.E. Osthaus saw
it at Cagnes (Venturi 1939; London, Tate
Gallery 1981); on 19 April 1914 Renoir
authorized Vollard to 'reproduce [it] in any
material' (Johnson 1977, p.41). Apparently,
though, he was annoyed when Vollard in-
cluded a cast of it as a work by him at the
Triennale exhibition in Paris in spring 1916
(Roux-Champion 1955). The date on the
present version suggests that it was cast in
1914; however, as Alley points out, the large
version is often dated to 1915–6; it seems
very probable that work on the figure did
continue after its first casting, for the version
exhibited in spring 1916 was described as

'second cast [*épreuve*] of the first state', while that in the collection of the Petit Palais in Paris, though apparently identical to the present version, is inscribed 'ETAT D.TIF VI'.

Various accounts describe the processes by which it was made and the alterations which Renoir instigated during its execution, first making the pelvis and the hips thicker, then raising the breasts a little. The accounts differ as to when these changes were made, Haesaerts reporting that it was the small version that was altered, while Meier-Graefe states that they were made after the first casting of the large version (cf. London, Tate Gallery, 1981); according to Vollard, the first alterations were made to the small version, while the breasts were raised in the large one a full year after this version was made. There are several descriptions of the way in which Renoir and Guino worked together. Pierre Renoir remembered: 'A sketch on paper or canvas by Renoir would furnish the general set-up of the mass of clay. With a light wand the old man would indicate how the work was to continue, at one place making a mark on the *maquette* where the ready modelling tool of the young sculptor was to cut away an excessive volume, at another place showing by a pass through the air how the contour was to swell out by the addition of more material. . . . Then the figure would be turned on its pedestal and would need trimming down to compensate for an excess invisible from the other angle. They communicated by grunts when the thing got so close to the definitive result that it got exciting . . . the sculptor would be making his little jabs with the tool, so much like my father's brushstrokes that you'd think the work came from his hand, as indeed it almost did.' (Pach 1938, p. 106; cf. Warnod 1934, p. 8.) Roux-Champion quoted Renoir's instructions: 'Remove those muscles! Round out those thighs! Add some clay here! More, more! But there, you must take some off! Above all, no dryness! give it *enveloppe*!'

According to Besson, 'Renoir explained that only one sculpture . . . could really be attributed to him: the standing nude in its original format: "I had modelled it when I could still manipulate a chisel. I agreed to allow it to be enlarged at Vollard's request, and, from my armchair, I directed Guino's work. But one statue succeeded another."' (Besson 1939.) Haesaerts's account, though, suggests that Guino had also worked on the smaller version, whose head alone Renoir had been able to model with his own hands. Besson, who was always hostile to Vollard, recorded the circumstances in which the collaboration with Guino ended at the end of 1917, because Guino, encouraged by Vollard, was making sculptures at will from Renoir's old sketches. However, it is clear that their collaboration still had Renoir's active consent in summer 1916, when Renoir invited Guino to come to Essoyes to make a bust of Aline, who had died the year before, from a painted study (Haesaerts 1947, p. 29). It seems likely that Renoir himself felt deeply ambivalent about his arrangements with Guino and Vollard, and that the conflicting stories which have come down to us reflect his ambivalence; the letter that he wrote to Vollard in January 1918 on Guino's departure from Cagnes shows that he felt no ill-will towards 'this charming man whom I would not hurt at any price' (Paris, Drouot, 6 June 1975, lot 45). The arguments have, however, continued in the various subsequent accounts of their relationship, culminating in Guino's lawsuit.

The figure of Venus in the sculpture is based on the image of the goddess in Renoir's second oil version of *The Judgment of Paris* (no. 119); the figure is very similarly posed, but in the sculpture she has now received the apple and stands alone, holding the token of her victory. Renoir also looked to antique sculpture when he began working on the project; he wrote to André from Cagnes in February 1914 asking him to find out some measurements from a statue of a Greek woman, 'not the Venus de Milo, who is an old gendarme, but the Venus of Arles or the Medici Venus or some other' (Paris, Braun, *Renoir*, 1932, p. 14). Aside from such small details as this, his memories of antique sculpture clearly also played a part in the *Venus*, in helping him to see how to translate into three dimensions and on to a monumental scale an idea originally conceived within a richly patterned two-dimensional surface. The two stages of the translation bear witness to the problems it caused. In the small version the forms are comparatively soft; the parts of the figure dissolve into each other, and the surfaces are variegated with the visible imprint of the tools used. In the large, by contrast, the separate parts of the figure are more clearly distinguished – notably the breasts and the curls of the hair – and the flesh is smoother. These changes displace attention from surface to form, highlighting the purely sculptural, as opposed to the pictorial, qualities of the figure; the figure of the *Venus victorious* clearly belongs to the family of Renoir's female types, but the simplification and clarity of her final form ally her with the sculptural heritage of Maillol (cf. no. 107), and, through Maillol, to a particular version of the Greek ideal.

Slightly larger than life size, and modelled as she is, *Venus victorious* is immediately presented to us as the image of a superhuman being. Moreover, Renoir hoped to enhance her effect by the way she was installed; he explored various ideas about the installation of the large figure. A watercolour (Petit Palais, Paris; cf. Daulte 1959, pl. 30), perhaps from an early stage in the project, shows her standing in water amid greenery; it is inscribed: 'The base of the statue should be on the level of the water, with some small rocks and aquatic plants'. Later he revised this plan, envisaging the statue with, on its base, the bas-relief which Guino had executed from his painting of *The Judgment of Paris*. Finally, in 1918 or 1919, he had the idea of making it the central focus of a Temple of Love, to be executed in his garden at Cagnes by Marcel Gimond, with a hemicycle of columns around the figure. Like the other decorative projects of Renoir's last years (cf. p. 278), none of these plans was realized; the cast which now stands in front of Renoir's house at Les Collettes is set on a simple rectangular base.

LITERATURE

George 1924, pp. 329, 332
André 1928, p. 51
Meier-Graefe 1929, pp. 351–365, 370–1
Vollard 1934, p. 1
Venturi 1939, II, p. 135
Besson 1939, p. 137
Drucker 1944, pp. 114–5
Haesaerts 1947, pp. 21, 24–6, 33, 37–8, 39–40 no. 6
Roux-Champion 1955, p. 5
Daulte 1959, pl. 30
Johnson 1977, pp. 41, 170
London, Tate Gallery, *Catalogue of the Tate Gallery's Collection of Modern Art other than works by British Artists*, catalogue by R. Alley, 1981, pp. 625–6

EXHIBITION (another cast)
1917, Paris, Triennale (152)

Maps

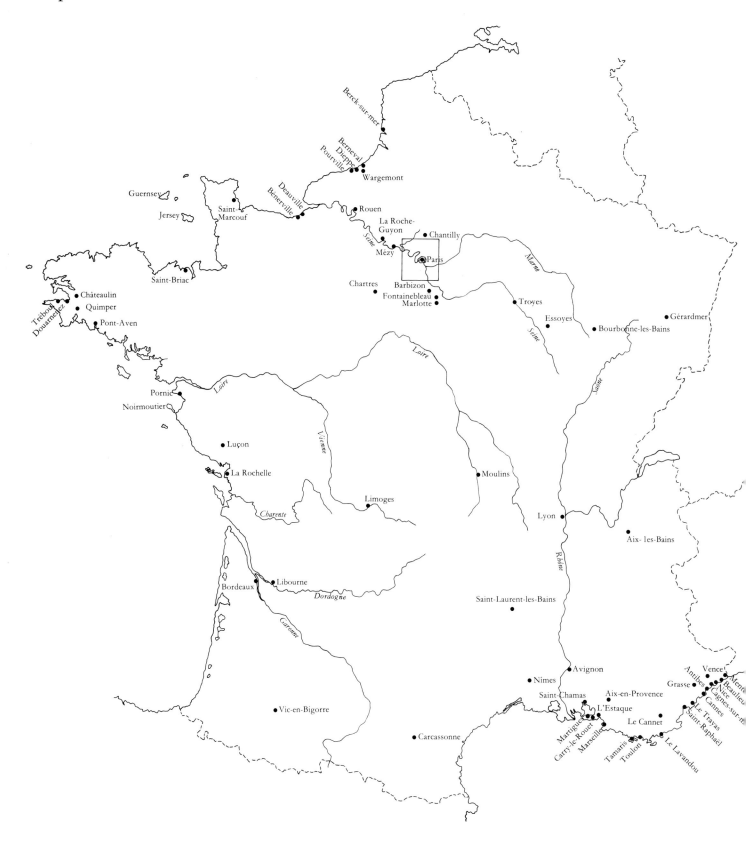

Berck-sur-mer

Berneval
Dieppe
Pourville
Wargemont

Guernsey

Jersey

Saint-Marcouf

Deauville
Bénerville

Rouen

La Roche-Guyon

Mézy

Chantilly

Paris

Saint-Briac

Chartres

Barbizon
Fontainebleau
Marlotte

Troyes

Châteaulin
Quimper

Essoyes

Gérardmer

Bourbonne-les-Bains

Trébou
Douarnenez

Pont-Aven

Loire

Pornic

Noirmoutier

Loire

Vienne

Luçon

Moulins

Limoges

Lyon

Charente

Aix-les-Bains

Libourne

Bordeaux

Dordogne

Saint-Laurent-les-Bains

Garonne

Rhône

Vic-en-Bigorre

Avignon

Vence
Menton
Antibes
Beaulieu
Grasse
Nice-sur-m
Cagnes-sur-m
Cannes

Nîmes

Saint-Chamas

Aix-en-Provence

L'Estaque

Le Trayas
Saint-Raphaël

Le Cannet

Carcassonne

Martigue
Carry-le-Rouet
Marseille

Tamaris
Toulon

Le Lavandou

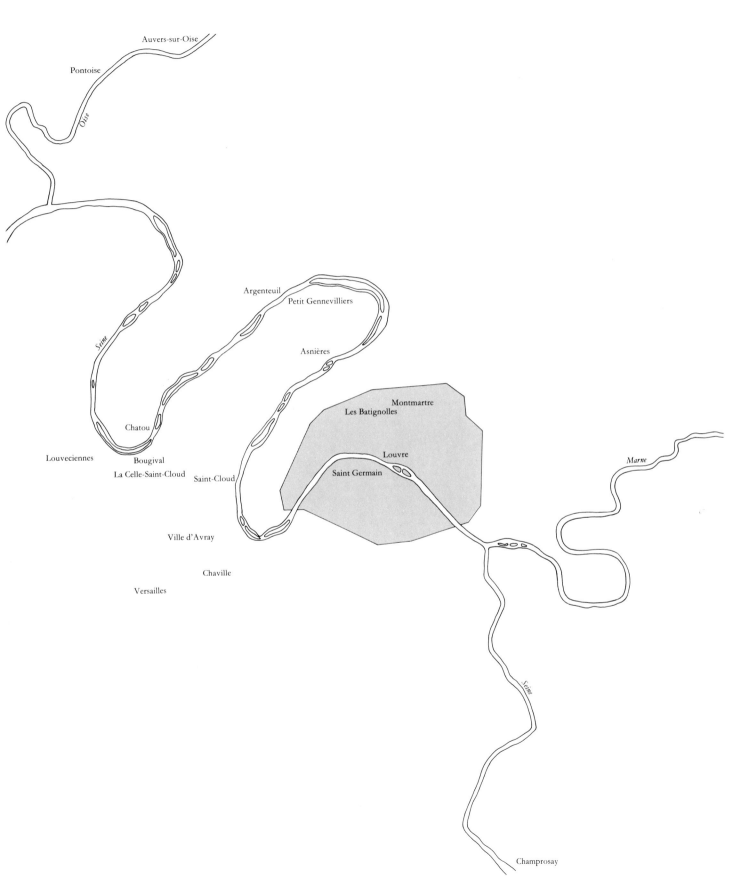

Auvers-sur-Oise

Pontoise

Oise

Seine

Argenteuil

Petit Gennevilliers

Asnières

Montmartre

Les Batignolles

Chatou

Louvre

Louveciennes

Bougival

Saint Germain

La Celle-Saint-Cloud

Saint-Cloud

Ville d'Avray

Marne

Chaville

Versailles

Seine

Champrosay

Chronology

This chronology attempts to bring together as fully as possible the existing documentation on the significant events of Renoir's life. The sources for the information are given throughout. Although the compilers have included only information which seemed to be sufficiently well established, it will be seen that not all information comes from equally specific or equally reliable sources.

1841

25 February Birth of Pierre-Auguste Renoir at 35 boulevard Sainte-Catherine (now 71 boulevard Gambetta), Limoges. His father Léonard Renoir (1799–1874) is a tailor, his mother Marguerite Merlet (1807–96) a dressmaker. Pierre-Auguste is the sixth of seven children, two of whom died in infancy. He is baptized the day of his birth at the church of St Michel-des-Lions.
Birth certificate; Hugon 1935, pp. 453–5.

1844

The family moves to Paris.
Rivière 1921, p. 3.

1848–54

Renoir attends a primary school run by the Frères des Ecoles chrétiennes.
Rivière 1921, p. 5.

1849

12 May Birth of his younger brother Edmond Victor at 16 rue de la Bibliothèque, Paris (the street, which ran from the place de l'Oratoire to the rue Saint-Honoré, was later demolished to make way for the rue de Rivoli).
Birth certificate.

1854–8

He is apprenticed to a porcelain painter, M. Levy of Levy frères et Compagnie, 76 rue des Fossés-du-Temple. During his apprenticeship he takes drawing lessons from the sculptor Callouette, who is director of the Ecole gratuite de dessin de IIIᵉ arrondissement de Paris in the rue des Petits-Carreaux (in 1862 he will describe himself as Callouette's pupil). The school also teaches decorative arts.
E. Renoir 1879, in Venturi 1939, II, p. 335; Vollard 1918, *Jeunesse*, pp. 17–18; E. Renoir in Rewald 1945, p. 174; Didot-Bottin, *Annuaire*, 1855; Archives Nationales A J⁵² 235; Tuleu 1915, p. 34.

1855

The land register describes 'Raynouard' of 23 rue d'Argenteuil (Iᵉʳ) as a bespoke tailor. The Raynouard family rents an apartment on the fifth floor. From 1858 onwards, they also rent additional rooms on the sixth floor. The family stays at this address until 1868, although Renoir lives and has studios at a number of other Paris addresses from 1862; he continues to give the address of the family home on his admission cards to the Louvre and on his Salon entries until 1864, and he appears there on the electoral registers until 1866; a note in the 1867 register states that Renoir is 'no longer at this address'.
Archives de Paris, calepins cadastraux Dᴵ P⁴ A/5, 1852; listes électorales Dᴵ M², 1er arrondissement, quartier du Palais Royal, 1866–7; Archives du Musée du Louvre, LL16; Salon catalogues.

c. 1858–9

He paints fans and colours heraldic designs for his eldest brother Henri, who is a medallist. At the end of his apprenticeship he starts working as a decorator for a manufacturer of blinds, M. Gilbert, 63 rue du Bac: 'Manufacturer of blinds of all types for apartments, shops, steamboats, etc. . . . Specialist maker of religious blinds, perfect imitation stained glass for churches . . . Waterproof blinds, monumental and artistic blinds. Commissions undertaken, export orders accepted.'
Vollard 1918, *Jeunesse*, pp. 18–20; Didot-Bottin, *Annuaire*, 1859.

1860

24 January Renoir is granted permission to work in the Louvre; his admission card is no. 320; his application is sponsored by Abel Terral, a picture restorer in the Musée de Versailles. This permission is renewed in 1861 (5 March; card no. 128), 1862 (21 January; card no. 67), 1863 (9 April; card no. 247), 1864 (1 June; card no. 313).
Archives du Musée du Louvre, LL 16, 0³⁰ 104.

1861

8 November Gleyre, whose studio he attends, asks for him to be given permission to work in the print department of the Bibliothèque Impériale.
Bibliothèque Nationale Estampes, Yᵉ 118, t1.

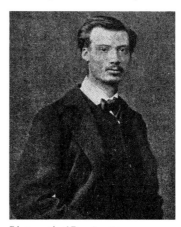

Photograph of Renoir, 1861.

1862

1 April

Admitted to the Ecole Impériale et Spéciale des Beaux-Arts; he comes 68th in the entrance examination (out of 80 candidates); his card is no. 3325. His address at 29 place Dauphine (Ier) is also that of Emile Laporte, one of the friends he made at the school in the rue des Petits-Carreaux. Laporte also attends Gleyre's studio and the Ecole des Beaux-Arts.
Archives Nationales, A J^{52} 76–77; A J^{52} 235; Archives de Paris, calepins cadastraux D^1 P^4 D/2, 1862; Tuleu 1915, pp. 33–4.

18 April

Comes 5th (out of 27) in the perspective drawing examination and is awarded the *quatrième mention*; the subject is: 'perspective drawing of four steps of a Classical temple, of the shaft of a Doric column and of an oblique inclined stone block'.
Archives Nationales, A J^{52} 76–77.

Summer

According to Meier-Graefe, Renoir works in the Forest of Fontainebleau with other pupils from Gleyre's studio. There he meets Diaz, who gives him advice and offers him credit with a colour merchant.
Meier-Graefe 1912, p. 16; Vollard 1918, *Jeunesse*, p. 22; E. Renoir 1879, in Venturi 1939, II, p. 336; André 1928, p. 34.

16 August

Comes 10th in the composition examination (a preliminary for admission to the figure-painting and modelling examination); the subject is: 'Joseph sold by his brothers'. Renoir's is the last of the ten sketches accepted.
Archives Nationales, A J^{52} 76–77.

1 October–31 December

Called up for military service as a soldier in the second part of the annual contingent.
Service Historique de l'Armée de Terre, dossier no. 2233.

1863

21 March

Comes 20th (out of 80) in the figure-drawing examination.
Archives Nationales, A J^{52} 76–77.

April

According to Arsène Alexandre, his painting *Une Nymphe avec un faune* is rejected by the Salon, and he destroys it.
Alexandre 1892, p. 12.

14 August

Comes 9th (out of 12) in the composition examination (a preliminary for admission to the figure-painting and modelling examination); the subject is 'Ulysses in the palace of Alcinous'.
Archives Nationales, A J^{52} 76–77.

7 October

'Renouard' is placed 28th out of 80 students in the winter semester examination.
Archives Nationales, A J^{52} 76–77.

1864

5 January–5 March

Second period of military service.
Service Historique de l'Armée de Terre, dossier no. 2233.

5 April

'Renouard', described as a pupil of Gleyre, comes 10th (out of 106 candidates) in the examination for draughtsmen and sculptors.
Archives Nationales, A J^{52} 77.

May–June

Exhibits at the Salon:
no. 1618 *La Esmeralda*.
Destroys the painting after the exhibition.
Catalogue; Vollard 1918, *Jeunesse*, p. 22.

Gleyre's studio has financial difficulties.
Bazille, letter [1864] to his father, in Chicago, Art Institute, 1978, p. 195.

1865

May–June

Exhibits at the Salon:
no. 1802 *Portrait de M.W.S...* [William Sisley, no. 2]
no. 1803 *Soirée d'été*.
His address is given as 43 avenue d'Eylau (now avenue Victor Hugo, 16e).
Catalogue.

July

Plans a boat trip down the Seine with 'Henri' Sisley and a young model known as 'le petit Grange'. They intend to be towed to Rouen by the 'Paris et Londres', and then go to see the regatta at Le Havre. Writes to Bazille from Sisley's apartment (31 avenue de Neuilly) inviting him to join them.
Renoir, letter of 3 July 1865 to Bazille, in Daulte 1952, p. 47.

Stays frequently with his friend the painter Jules Le Coeur, who bought a house in Marlotte in April 1865. It is here that he meets Le Coeur's mistress Clémence Tréhot and her sister Lise, who becomes his mistress and frequent model from 1866 until shortly before her marriage in 1872 [cf. entry on no. 8].
Cooper 1959, pp. 164, 171.

1866

January–March

Exhibits three paintings with the Société des Amis des Beaux-Arts in Pau:
no. 211 *Baigneuses (paysage)*
no. 212 *La Mare aux fées*
no. 213 *Nymphe se mirant dans l'eau*.
His address is given as 20 rue Visconti (6e).
Catalogue.

February

Renoir, Sisley and Le Coeur [cf. no. 5] visit Milly and Courances, crossing the Forest of Fontainebleau on foot.
Jules Le Coeur, letter of 17 February 1866, in Cooper 1959, p. 322 n. 5.

March–April

Stays frequently at Marlotte with Sisley and Le Coeur [cf. no. 4].
Marie Le Coeur (Madame F.), letters, in Cooper 1959, p. 164.

April

Renoir submits a landscape with two figures [cf. pp. 179–180] and a 'quick sketch' he made at Marlotte to the Salon Jury; the sketch is accepted but the painting is rejected, despite the favourable opinions expressed by Corot and Daubigny. They encourage Renoir to demand a Salon des Refusés. He withdraws his painting from the Salon, because he does not want his sketch to appear alone.
Marie Le Coeur (Madame F.), letter of 6 April 1866, in supplement to *Cahiers d'aujourd'hui*, no. 2, January 1921.

August

Stays with Sisley, Charles Le Coeur and his sister Marie in Berck.
Charles and Marie Le Coeur, letters to Mme J. Le Coeur, in Cooper 1959, p. 322 n. 5.

1867

During the winter, Bazille takes over the flat at 20 rue Visconti. He and Renoir are joined shortly afterwards by the penniless Claude Monet; they probably stay there until late 1867.

Bazille, letter [1867] to his mother, in Chicago, Art Institute, 1978, p. 203; Renoir, *Portrait of Bazille* [no. 6], dated 1867; Bazille's father, letter of 28 November 1867 to Bazille (lot 12 in Paris, Drouot, 7–8 December 1982).

March

His painting of *Diana the huntress* [p.180 fig.d] is rejected by the Salon. On 30 March, he signs a petition drawn up by Bazille calling for the rejected paintings to be exhibited.

Meier-Graefe 1912, p. 6; Archives du Musée du Louvre, Salons, 1867.

July–August

Stays in Chantilly.

Maître, letter of 23 August 1867 to Bazille, in Daulte 1971, p. 34.

1868

Early in the year, he moves with Bazille to 9 rue de la Paix, aux Batignolles (now 17ᵉ) (officially re-named rue de La Condamine in late 1868); their rooms on the third floor consist of a studio and one heated room, and they remain there until spring 1870. They are near the Café Guerbois (11 Grand-Rue) which is a meeting place of the group of artists centred around Manet.

Renoir, letter [1868] to Bazille in Poulain 1932, pp. 153–4; Archives de Paris, calepins cadastraux Dⁱ P⁴ L/1, 1862; Salon catalogues, 1868, 1869; Annuaire de la Gazette des Beaux-Arts, 1869; Bazille's *Atelier de la rue de La Condamine* [p. 179 fig.a], dated 1870; Hillairet 1963, II, p. 11.

Around March

Thanks to the intervention of the architect Charles Le Coeur, brother of the painter Jules, Renoir obtains a commission to decorate the town house of Prince Georges Bibesco (22 avenue de Latour-Maubourg).

Cooper 1959, p. 326.

May–June

Exhibits at the Salon:
no. 2113 *Lise* [p. 181 fig. f]
His success is attested by the publication of numerous articles and caricatures: Castagnary in *Le Siècle*, 10 May and 26 June: Fouquier in *L'Avenir National*, 23 May; Zola in *L'Evénement*, 24 May; Chesneau in *Le Constitutionnel*, 16 June; Lasteyrie in *L'Opinion Nationale*, 20 June; Chaumelin in *La Presse*, 23 June; Harmant in *L'International*, 25 June; Astruc in *L'Etendard*, 27 June; Chassagnol in *Le Tintamarre*; Gill in *Le Salon pour rire*; Oulevay in *Le Monde pour rire*; Bürger in *Salons de 1861 à 1868*, Paris 1870 [cf. p. 181 figs g,h,i].
Catalogue.

Summer

His parents move to Voisins-Louveciennes.

Léonard Renoir states he has been living eighteen months in Louveciennes when he registers for the electoral roll on 15 January 1870 (Archives Municipales de Louveciennes, listes électorales, 1870).

Summer

He stays at Ville d'Avray.

Renoir, letters [1868] to Bazille, in Poulain 1932, pp. 153–4.

1869

May–June

Exhibits at the Salon:
no. 2201 *En été (étude)* [no. 8].
Catalogue.

July–September

Lives with his parents at Voisins-Louveciennes, travelling almost daily to Monet's home at Saint-Michel, near Bougival. They both paint at 'La Grenouillère' [see nos 12,13].

Renoir, letter [1869] to Bazille, in Poulain 1932, pp.155–6; Monet, letters of 9 August [1869] and 25 September 1869 to Bazille, in Wildenstein 1974, I, pp. 426, 427.

Autumn

Exhibits several paintings at Carpentier's shop (colours and frames) at 8 boulevard Montmartre [cf. entry on no.9].

Renoir, letter [October 1869] to Bazille (lot 12 in Paris, Drouot, 19 February 1982); Didot-Bottin, *Annuaire*, 1870.

1870

Fantin-Latour paints *A Studio in Les Batignolles*, which depicts Manet, Scholderer, Renoir, Astruc, Zola, Maître, Bazille and Monet.

Paris, Grand Palais, 1982–3, pp. 205ff., no. 73.

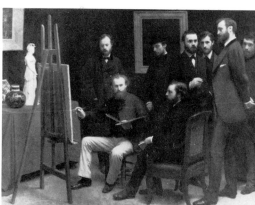

Henri Fantin-Latour, A Studio in Les Batignolles, *1870. Musée d'Orsay, Paris (Galerie du Jeu de Paume).*

Spring

According to both the Salon catalogue and his military record, his address is 8 rue des Beaux-Arts (6ᵉ), where he shares rooms with Bazille, who rented the apartment from April. The apartment is very small, and, according to Daulte, he is mostly living with Edmond Maître at 5 rue Taranne (a nearby street destroyed in the construction of bvd Saint-Germain).

Salon catalogue; Service Historique de l'Armée de Terre, dossier no. 2233; Bazille, letter of 26 May 1870 to his mother, in Chicago, Art Institute, 1978, p. 209; lease of rue des Beaux-Arts apartment from April 1870 (lot 11 in Paris, Drouot, 7–8 December 1982); Daulte 1971, p. 36.

May–June

Exhibits at the Salon:
no. 2405 *Baigneuse* [no.15]
no. 2406 *Femme d'Alger* [no.15 fig.b]
Catalogue.

26 August

Following France's declaration of war on Prussia (19 July), Renoir is mobilized in the Tenth Cavalry Regiment.

Service Historique de l'Armée de Terre, dossier no. 2233.

Taille : 1 mètre *69* ᶜ mil.

visage *Ovale*

front *ordinaire*

yeux *bruns*

nez *long*

bouche *grande*

menton *rond*

cheveux *cl*

sourcils *blonds.*

Description of Renoir on his military record, 1870.
Service Historique de l'Armée de Terre.

1871

Posted to Libourne. He suffers a severe attack of dysentry. His uncle takes him to Bordeaux, where he is treated and cured. The armistice is signed on 28 January, and in late February he rejoins his regiment in Vic-en-Bigorre, near Tarbes. He is demobilized on 10 March; his record states that he 'conducted himself well for the duration of the war'. He later reported to Julie Manet that 'while he was a soldier after the war he spent two months in a château, where he was treated like a prince. He gave drawing lessons to a young girl and spent his days riding. They did not want to let him go for fear that he might be killed in the Commune.' (Despite this reference to the Commune, it seems more likely that this took place during his convalescence in January-February.)
Renoir, letter of 1 March 1871 to C. Le Coeur, in Cooper 1959, p. 327; Service Historique de l'Armée de Terre, dossier no. 2233; Manet 1979, p. 132.

Spring Returns to Paris by April and rents a room in the rue du Dragon (6ᵉ). Thanks to Raoul Rigaud, the Préfet de Police, he obtains a pass and is able to travel during the Commune period between Paris and Louveciennes, where his parents are living.
Portrait de Rapha [no.19], dated 'avril. 71.'; Vollard 1938, p. 168; Vollard 1919, p. 54; Rivière 1921, p. 14.

August Spends several days with Jules Le Coeur in Marlotte and then at the Maison de la Treille in La Celle-Saint-Cloud, near Bougival.
Jules Le Coeur, letter of 13 August 1871 to his mother, in Cooper 1959, p. 325; Renoir, letter [1871] to Duret, in Florisoone 1938, p. 39.

Autumn Rents an apartment and studio at 34 rue Notre-Dame-des-Champs (6ᵉ), where he lives until summer 1873.
Vollard 1919, p. 57; Rivière 1921, p.14; Catalogue, Salon des Refusés, 1873.

1872

Durand-Ruel buys paintings from Renoir for the first time: *Vue de Paris (Pont des Arts)* [p.181 fig.j], bought on 16 March for 200 francs; *Fleurs (Pivoines et coquelicots)*, bought on 23 May for 300 francs.
Archives Durand-Ruel: *Livres d'achats* and *Grand Livre*.

24 April Lise Tréhot marries the architect George Brière de l'Isle.
Cooper 1959, p.171.

April His painting *Parisiennes habillées en Algériennes* [no. 20] is rejected by the Salon.
Duret 1906, pp.131–2.

18 June Signs the petition drawn up by Charles Blanc asking the Minister responsible for fine arts for a Salon des Refusés. Others who sign include Manet, Fantin-Latour, Jongkind, Pissarro and Cézanne.
Archives Nationales, F²¹ 535.

November His painting *Vue de Paris (Pont des Arts)* [page 181 fig. j] is included in the fifth exhibition of the Society of French Artists organized by Durand-Ruel at the German Gallery, 168 New Bond Street, London. This is the first time a work of Renoir's has been shown there.
Catalogue.

1873

March–April Meets Théodore Duret, who has just returned from a round-the-world trip with Cernuschi, in Degas's studio. Duret buys *Summer* [no.8] from a dealer in rue La Bruyère for 400 francs. After a subsequent visit to Renoir's studio in the rue Notre-Dame-des-Champs, Duret also buys *Lise with a parasol* [p.181 fig.f] for 1,200 francs.
Meier-Graefe 1912, p. 6 n.**; Duret 1924, pp. 13, 14–15.

May–June Exhibits at the Salon des Refusés:
no. 90 *Allée cavalière au Bois de Boulogne* [p. 196 fig. a]
no. 91 *Portrait.*
Catalogue.

Summer Stays with Claude Monet in Argenteuil [cf. no. 23].
Monet, letter of 12 September 1873 to Pissarro, in Wildenstein 1974, I, p. 429.

Autumn Rents an apartment and studio at 35 rue Saint-Georges (9ᵉ); while he rents other studios in the neighbourhood from time to time, this remains his permanent residence until at least 1882 and probably (according to Rivière) 1883–4.
Archives de Paris, calepins cadastraux, D¹ P⁴ S/3, 1876; listes électorales D¹ M², 9ème arrondissement, quartier Saint-Georges, 1882; Rivière 1921, p. 88.

Autumn Takes part in meetings of what will become the Société anonyme coopérative des artistes peintres, sculpteurs, graveurs, etc. The Société is founded on 27 December 1873. Several of its meetings are held at 35 rue Saint-Georges.
Monneret 1979, II, p.167.

Winter 1873/4 Quarrels with the Le Coeur family.
Cooper 1959, p. 328.

1874

April–May Takes part in the first group exhibition organized by the Société anonyme coopérative des artistes peintres, sculpteurs, graveurs etc. at 35 boulevard des Capucines, showing six paintings [cf. nos. 26 (*La Loge*), 28 (*La Parisienne*)] and one pastel.
Catalogue.

Two of his paintings are included in the ninth exhibition of the Society of French Artists organized by Durand-Ruel at the German Gallery, 168 New Bond Street, London.
Catalogue.

Summer

Visits Monet in Argenteuil [cf. nos. 29, 30]. Manet, who is staying in Gennevilliers sometimes joins them.
Rewald 1973, pp. 341–3.

During the seventies, frequents the Nouvelle-Athènes café, together with Manet, Marcellin Desboutin, Duranty, Duret, Charles Cros, Jules de Marthold, Villiers de l'Isle Adam, Richepin, Armand Silvestre, Franc-Lamy, Rivière, Goeneutte, Cabaner; they are sometimes joined by Burty and Cézanne.
Rivière 1921, pp. 23, 25–32.

Café de la Nouvelle Athènes, Montmartre.
Bibliothèque Nationale, Paris.

17 December

The General Meeting of the Société anonyme coopérative des artistes peintres, sculpteurs, graveurs etc. is held in Renoir's apartment, with Renoir in the chair. The meeting decides to wind up the Société because of its liabilities.
Minutes of Société anonyme (lot 82, Paris, Drouot, 21 November 1975).

22 December

His father, Léonard Renoir, dies in Louveciennes (rue de Voisins).
Death certificate; Archives Municipales, Louveciennes, census 1872, 1876.

During 1874, Père Martin buys La Loge [no. 26] from him for 425 francs.
Vollard 1938, p.177.

1875

Early in the year, according to Vollard, he is commissioned to paint a portrait, Lady with her two daughters (Daulte 1971, no. 111), for which he is paid 1,200 francs; this encourages him to propose a public auction of paintings by himself and his friends. He uses the money from this commission to rent a studio in rue Cortot (18ᵉ) [cf. no. 38], though he continues to live at 35 rue Saint-Georges.
Vollard 1938, pp.181–3; Rivière 1921, p.129 (who dates the renting of rue Cortot to May 1876 without mentioning a connection with the portrait commission).

23–24 March

Renoir having persuaded his friends Monet, Sisley and Morisot to hold an auction of their work [cf. pp. 19–20], there are public demonstrations when the paintings go on show (on 23 March). The auction is held the following day at the Hôtel Drouot; the auctioneer is Charles Pillet, the assessor Durand-Ruel; the preface to the sale catalogue is by Philippe Burty. Renoir sells twenty paintings

for 2,251 francs; the prices range from 50 to 300 francs.
Vollard 1938, p. 183; Meier-Graefe 1912, p. 53 n.*; Archives de Paris, procès-verbal of the sale, D⁴⁸ E³ art. 65; Bodelsen 1968, pp. 333–6.

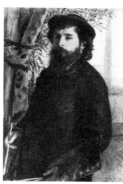 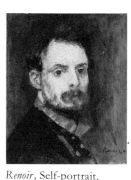

Renoir, Claude Monet, 1875.
Musée d'Orsay, Paris (Galerie du Jeu de Paume).

Renoir, Self-portrait, c.1875.
Sterling and Francine Clark Art Institute, Williamstown.

April

According to Duret and Maître, a painting by Renoir is rejected by the Salon.
Duret 1878, p. 27; Maître in Daulte 1952, p. 60 n.1.

Summer

Visits Père Fournaise on the Ile de Chatou.
Portraits of Fournaise (Clark Art Institute, Williamstown) and Alphonsine Fournaise (Museu de Arte, São Paulo) dated 1875.

During 1875 he meets the collector Victor Chocquet, perhaps as a result of the impressionist auction. In 1875–6 he executes several portraits of the Chocquet family.
Rewald 1969, pp. 38–9; cf. p. 21 of present catalogue.

He is commissioned by Dollfus to make a copy of Delacroix's Jewish wedding in Morocco.
Meier-Graefe 1912, p. 28; Daulte 1971, no. 139.

1876

February–March

Exhibits two paintings in the exhibition organized by the Société des Amis des Arts in Pau:
no. 280 Couseuse
no. 281 Jeune fille jouant avec un chat.
Catalogue.

April

Shows fifteen paintings in the Deuxième exposition de peinture organized by the impressionist group at 11 rue Le Peletier.
Catalogue.

Summer

Working on Montmartre in the garden of his studio in rue Cortot [cf. nos. 38, 39] and at the Moulin de la Galette [cf. no. 40].
Rivière 1929, pp.129–130.

September

Stays in Champrosay with Alphonse Daudet, whom he had met through the Charpentiers. Visits Delacroix's grave.
Vollard 1938, p.185; Robida, Salon Charpentier, 1958, p.53.

In 1876–7 the Charpentiers commission portraits [cf. no. 44] and, later, decorations for the grand staircase in their town house in the rue de Grenelle in Paris.
Vollard 1919, p.97.

1877

April

In response to hostile press criticism of the Impressionists, Renoir suggests to Rivière that they should publish a review entitled *L'Impressionniste*; four issues appear during April. Renoir himself publishes a letter signed 'un peintre' (14 April) and an article, 'Art décoratif et contemporain' under the same signature (28 April).

Rivière 1921, p.154; Venturi 1939, II, pp. 305–329.

April

Shows twenty-one paintings in the *Troisième exposition de peinture* organized by the impressionist group at 6 rue Le Peletier.

Catalogue.

28 May

Renoir organizes a second auction at the Hôtel Drouot; Caillebotte, Pissarro and Sisley take part. Renoir sells fifteen paintings and a pastel for 2,005 francs.

Bodelsen 1968, p. 336.

October

During a costume ball given by Cernuschi, Renoir meets Gambetta and requests an appointment as curator of a provincial museum.

Kolb and Adhémar 1984, p. 30.

During the later 1870s, Renoir attends the Wednesday dinners given by Murer at his restaurant at 95 boulevard Voltaire together with a number of writers, journalists and painters.

Renoir, letters to Murer, in Gachet 1957, pp.89–91.

1878

May

Publication of Duret's *Les Peintres impressionnistes*, illustrated with a drawing by Renoir after *Lise with a parasol* [p. 181 fig. f].

May–June

Exhibits at the Salon:
 no. 1883 *Le Café* [Daulte 1971, no. 272].
Catalogue.

5–6 June

Hoschedé's collection is auctioned at the Hôtel Drouot after he is declared bankrupt. Renoir's three paintings make only 157 francs.

Archives de Paris, *Procès-verbal de la vente judiciaire Hoschedé*, D⁴⁸ E³ art. 3; Bodelsen 1968, pp.339–341.

Publication of the illustrated edition of Zola's *L'Assommoir* with woodcuts after drawings by Bellenger, Butin, Castelli, Clairin, Garnier, Gill, Goeneutte, Leloir, Monillon, Regamey, Renoir . . .

E. Zola, *Correspondance*, edited by B.H. Backer, 1982, III, p. 173.

1879

February

Death of Alma-Henriette Leboeuf, a young model who has posed for Renoir [cf. entry on no. 36]. Despite several references (including one by Renoir himself) to this model as 'Margot', there can, in view of the death certificate, be little doubt as to her identity.

Renoir, letters posted to Gachet and to Murer on 25 February 1879, in Gachet 1957, pp. 85, 89–90; death certificate.

10 April

First issue of *La Vie moderne*, a journal founded by Charpentier and edited by Emile Bergerat. Edmond Renoir takes over as editor in 1884–5.

E. Renoir in Rewald 1945, pp.183–4.

April–May

Like Cézanne and Sisley, Renoir refuses to take part in the *Quatrième exposition de peinture* organized by the impressionist group at 28 avenue de l'Opéra.

Catalogue.

May–June

Exhibits at the Salon:
 no. 2527 *Portraits de Mme. G. C. . . . et de ses enfants* [Mme Georges Charpentier, no. 44].
 no. 2528 *Portrait de Mlle Jeanne Samary, sociétaire de la Comédie-Française*.
 no. 4476 *Portrait de Paul C. . . .* (pastel).
 no. 4477 *Portrait de Théophile B. . . .* (pastel).
The portrait of Madame Charpentier is hung 'in the centre of the wall', thanks to the combined influence of the model and of Ephrussi.

Catalogue; Kolb and Adhémar 1984, p. 30.

June

The fifth exhibition at the Galerie de la Vie moderne is devoted to Renoir (probably only pastels). Works by him are also included in the exhibition of drawings (first series) held at the same gallery in July, and one work in the exhibition *Les Tambourins de la Vie moderne* there in December. Edmond Renoir publishes a letter to Emile Bergerat about his brother as an article in *La Vie moderne* on 19 June.

La Vie moderne, 19 June 1879, pp. 174–5; 17 July 1879, p. 239; 20 December 1879, p. 581.

Summer

Renoir stays at the home of the Berards in Wargemont on the Normandy coast [cf. nos. 45, 46]; he was introduced to them in Mme Charpentier's *salon* by Deudon [cf. p. 22].

Perruchot 1964, p. 364; Berard 1938, p. 9.

Château de Wargemont (top), and a door and chimney-breast painted by Renoir in the château.

September | Visits Jacques-Emile Blanche at his mother's house in Dieppe, where he executes decorative paintings with Wagnerian themes.
Blanche 1949, p. 440; Meier-Graefe 1912, p. 108.

Jacques Spuller, Under-secretary of state in the Gambetta Cabinet (whose portrait by Renoir had been exhibited in the third impressionist group exhibition in 1877), tries to obtain a State commission for Renoir.
Renoir, letters to Charpentier, in Florisoone 1938, pp. 32–4; Caillebotte, letter [summer 1879] to Pissarro, in Berhaut 1978, p. 245.

1880

January | Breaks his right arm and plays at 'working left-handed'.
Renoir, letter of 13 February 1880 to Duret, in Paris, Braun, L'Impressionnisme, 1932, pp. 10–11.

April | Does not take part in the Cinquième exposition de peinture organized by the impressionist group at 10 rue des Pyramides.
Catalogue.

16 April | Attends Duranty's funeral, together with many other personalities.
Crouzet 1964, p. 394.

May–June | Exhibits at the Salon:
no. 3195 Pêcheuses de moules à Berneval (côte normande) [no. 75 fig. a]
no. 3196 Jeune fille endormie [no. 50]
no. 5703 Portrait de Lucien Daudet (pastel)
no. 5704 Portrait de Mlle M.B. (pastel).
On 10 May Renoir and Monet write to the Minister responsible for fine arts to protest at the hanging of their paintings and to ask for better treatment the following year. Cézanne asks Zola to arrange for the letter to be published in Le Voltaire. Between 18 and 22 June, Zola publishes a series of articles on 'Naturalism in the Salon', in which he describes the hanging of Renoir's paintings 'in the circular gallery which runs around the garden. The harsh daylight and the dancing sunlight show them to very poor advantage.' A plan to reform the Salon drawn up by Renoir and written by Murer is published in La Gazette des tribunaux (23 May).
Catalogue; Zola 1880, in Zola 1970, p. 341; Cézanne, letter of 10 May 1880 to Zola, in Cézanne 1978, pp. 191–2; Gachet 1956, pp. 166–7.

June–July | Visits the Berards in Wargemont, where he sees Zola's articles in Le Voltaire.
Renoir, letter to Chocquet, in Joëts 1935, p. 121.

July | 'I hear that Renoir has some good commissions for portraits' (Cézanne): He has in fact received commissions from Mme Cahen d'Anvers [cf. no. 53], to whom he had been introduced by Charles Ephrussi, and from M. Turquet, the former Under-secretary of state for fine arts. He works on these in Paris during July.
Cézanne, letter of 4 July 1880 to Zola, in Cézanne 1978, pp. 193–4; Duret 1924, p. 62; Renoir, letter [July 1880] to Berard, in Daulte 1974, p. 12.

14 July | Attends the grand dinner given by Murer in his restaurant to mark the Third Republic's first official '14 July' celebration.
Gachet 1956, p. 162.

Around September–October | Stays with Fournaise on the Ile de Chatou, beginning work on Luncheon of the boating party [no. 52].
Renoir, letters [late summer 1880] to Berard, in Berard 1968, pp. 3–5.

Probably during summer or autumn, meets his future wife Aline Charigot (born Essoyes, 23 May 1859, died Nice, 27 June 1915). She is a young seamstress and poses for him [cf. no. 52 etc.].

1881

January | Durand-Ruel begins to buy paintings from Renoir on a regular basis.
Archives Durand-Ruel.

March–April | Travels in Algeria [cf. nos. 55, 56], where he meets up with his friends Lestringuez, Lhote and Cordey. He thinks of going to London with Duret, but abandons the plan.
Rivière 1921, p. 189; Renoir, letter of 4 March 1881 to Duret, in Paris, Braun, L'Impressionnisme, 1932, p. 11; letter dated 'Easter Monday 1881' [i.e. 19 April] to Duret, in Florisoone 1938, p. 40.

March–April | Ephrussi takes responsibility for his submission to the Salon. In a letter to Durand-Ruel, he explains why he wants to take part in the Salon: 'There are barely fifteen collectors in Paris who are capable of liking a painter they have not seen at the Salon.'
Renoir, letter of 4 March 1881 to Duret, in Paris, Braun, L'Impressionnisme, 1932, p. 11; letter of March 1881 to Durand-Ruel, in Venturi 1939, I, p. 115.

April | On his return to France, he rents a studio in the rue Norvins (18e).
Vollard 1919, p. 106.

April | He paints in Chatou, where Whistler visits him [cf. no. 57].
Renoir, letter dated 'Easter Monday 1881' [i.e. 19 April] to Duret, in Florisoone 1938, p. 40.

April–May | Does not participate in the Sixième exposition de peinture organized by the impressionist group at 35 boulevard des Capucines.
Catalogue.

May–June | Exhibits at the Salon:
no. 1986 Portrait de Mlle XXX
no. 1987 Portrait de Mlle XXX.
Catalogue.

July | Stays with the Berards in Wargemont [cf. no. 60]. While he is there, Mme Blanche reluctantly gives him hospitality in Dieppe. He is at Wargemont again in September.
Renoir, letter of 27 July 1881 to Durand-Ruel, in Venturi 1939, I, p. 116; Mme Emile Blanche, letter of 20 July 1881 to Dr Blanche, in Blanche 1949, pp. 443–4; J.-E. Blanche, letter of 20 July 1881 to Dr Blanche, in Blanche 1949, pp. 444–5; Portrait of Albert Cahen d'Anvers signed and dated 'Renoir, Wargemont, 9 septembre 81' [Daulte 1971, no. 362].

October–November | Leaves for Italy at the end of October: 'I have suddenly become a traveller and I am in a fever to see the Raphaels. . . . I have started in the north, and I am going to go to the toe of the boot.' He is in Venice on 1 November [cf. no. 61]. He visits Padua (according to Coquiot) and Florence (ac-

cording to Coquiot and Vollard); then travels to Rome, where he admires the Raphaels, especially his frescoes. In late November he is in Naples (Albergo Trinacria), where he studies the paintings from Pompeii in the museum. He visits Calabria in December, and at the end of the year is in Capri (Hôtel du Louvre), from where he writes to Manet to congratulate him on being made Chevalier de la Légion d'Honneur. Aline Charigot accompanies him for at least part of the trip [cf. no. 63].

Renoir, letter to Mme Charpentier in Florisoone 1938, p. 36; letter of 1 November 1881 to Berard (lot 69 in Paris, Drouot, 16 February 1979); Coquiot 1925, p. 84; Vollard 1938, p. 202; Renoir, letter of 21 November 1881 to Durand-Ruel, in Venturi 1939, I, pp. 116–7; letter [? December 1881] to Deudon, in Schneider 1945, pp. 97–8; J. Renoir 1962, pp. 224–8, 231; Renoir, letter of 28 December 1881 to Manet, in E. Moreau-Nélaton, *Manet raconté par lui-même*, Paris 1926, p. 88; Manet 1979, p. 66.

1882

January

Attempts to obtain a letter of introduction to Wagner, who is completing his opera *Parsifal* in Palermo, and, in the meantime, visits Monreale. Wagner receives him on 14 January and the following day agrees to sit for thirty-five minutes for a portrait.

Renoir, letter [January 1882], in Drucker 1944, pp. 132–4.

17 January

In Naples; he plans to return to France via Marseille.

Renoir, letter of 17 January 1882 to Durand-Ruel, in Venturi 1939, I, pp. 117–8.

23 January

Stays at L'Estaque (Hôtel des Bains) and works with Cézanne [cf. no. 64].

Renoir, letter of 23 January 1882 to Durand-Ruel, in Venturi 1939, I, p. 118.

February

Catches pneumonia.

Renoir, letters of 14 and 19 February 1882 to Durand-Ruel, in Venturi 1939, I, pp. 118–9.

March

Refuses to take part in the *Septième exposition des artistes indépendants* held in Salons du Panorama de Reichshoffen, 251 rue Saint-Honoré: 'The main reason is that I am exhibiting at the Salon, and the two do not really go together.' He cannot, however, prevent Durand-Ruel from exhibiting the paintings he owns. The dealer shows twenty-five paintings by Renoir.

Renoir, letter of 26 February 1882 to Durand-Ruel, in Venturi 1939, I, p. 121; Catalogue.

March–April

On his doctor's advice, he goes to Algeria, planning to spend a fortnight in Algiers, but stays there about six weeks, renting an apartment at 30 rue de la Marine. He paints mainly figures.

Renoir, letter of 2 March 1882 to Chocquet, in Joëts 1935, pp. 121–2; letter to Paul Berard (Archives Durand-Ruel); letters of March 1882 and 4 April 1882 to Durand-Ruel, in Venturi 1939, I, pp. 122–5.

May–June

Having asked Paul Berard to look after his Salon submission, he exhibits:
 no. 2268 *Portrait of Mlle Y.G.* [Yvonne Grimprel].

Renoir, letter to Berard (Archives Durand-Ruel); Catalogue.

July

Included in an exhibition of impressionist paintings organized by Durand-Ruel at 13 King Street, London.

Cooper 1954, p. 23.

Summer

Renoir probably stays at Wargemont with the Berards. With Durand-Ruel he visits Monet in Pourville. He makes frequent visits to Jacques-Emile Blanche in Dieppe.

Wildenstein 1979, II, p. 220; Monet, letter of 16 September 1882 to Pissarro, in Wildenstein 1979, II, p. 8; J.-E. Blanche, letter of 13 August 1882 to Dr Blanche, in Blanche 1949, p. 441.

1883

April

Renoir exhibition (70 works), one of a series of one-man shows (Boudin, Monet, Renoir, Pissarro, Sisley) organized by Durand-Ruel between February and June at 9 boulevard de la Madeleine. The preface to the Renoir catalogue is by Duret: 'I regard M. Claude Monet as the impressionist group's most typical landscape painter and M. Renoir as its most typical figure painter.'

Catalogues.

April–July

Ten paintings by Renoir are shown in an exhibition organized by Durand-Ruel at a London gallery, Dowdeswell and Dowdeswell, 133 New Bond Street.

Catalogue.

May–June

Exhibits at the Salon:
 no. 2031 *Portrait of Mme C.* [Mme Clapisson, no. 70].

Catalogue.

May

Durand-Ruel sends three paintings by Renoir to Boston for the *American Exhibition of Foreign Products, Arts and Manufactures*.

Catalogue.

Summer

Visits Caillebotte in Petit-Gennevilliers, near Argenteuil, where he paints a portrait of Caillebotte's mistress Charlotte Berthier.

Berhaut 1978, pp. 18 n. 91, 21.

Early September

Visits Jersey and then spends a month on Guernsey [cf. no. 72].

Renoir, letter of 5 September 1883 to Berard, in Berard 1968, p. 4; letter of 27 September 1883 to Durand-Ruel, in Venturi 1939, I, p. 126.

Autumn

Included in exhibition of impressionist paintings at Gurlitt's gallery, Berlin.

Pissarro 1950, p. 66; Rewald 1973, pp. 498–500.

16 December

Renoir and Monet begin a brief trip to the Riviera [cf. no. 71]; they travel by stages from Marseilles to Genoa, visiting Hyères, Saint-Raphaël, Monte Carlo and Bordighera. On their return journey, they visit Cézanne.

Monet, letter of 16 December 1883 to de Bellio, in Wildenstein 1979, II, p. 232; Renoir, letter to Durand-Ruel, in Venturi 1939, I, pp. 126–7; Cézanne, letter of 23 February 1884 to Zola, in Cézanne 1978, p. 214.

Around this time, in 1883–4, according to Georges Rivière, Renoir leaves his apartment in the rue Saint-Georges [see 1873: September]. By March 1885 the Renoirs have moved to 18 rue Houdon (18e).

Rivière 1921, p. 88; birth certificate of Pierre Renoir.

1884

January

Exhibits two paintings at the Cercle artistique de la Seine, 3 bis rue de la Chaussée d'Antin.

F. Fénéon, 'Exposition du Cercle artistique de la Seine', *La libre revue*, 16 January 1884, in Fénéon 1970, I, p.22.

January

Manet retrospective at the Ecole Nationale Supérieure des Beaux-Arts. Renoir is delighted with the exhibition's success.

Renoir, letter to Monet, in Geffroy 1924, II, pp. 24–5.

4–5 February

Manet sale at the Hôtel Drouot. Renoir cannot 'afford to buy a souvenir of our late friend'.

De Bellio, letter of 24 February 1884 to Monet, in Wildenstein 1979, II, p. 27 n. 262.

February

Helps his brother Victor, who has returned bankrupt from Russia.

Renoir, letter [February 1884] to Monet, in Baudot 1949, p. 59.

May

Durand-Ruel faces bankruptcy as a result of the collapse of the Union Générale. Renoir and Monet urge him to sell their paintings at low prices.

Wildenstein 1979, II, p. 30; Monet, letter of 15 May [1884] to Durand-Ruel in Wildenstein 1979, II, p. 252; Renoir, letter of May 1884 to Durand-Ruel, in Venturi 1939, I, p. 127.

May

He plans a new painters' association: the 'Société des irrégularistes'. Its aesthetics are to be based upon 'irregularity'. He also plans to publish an 'Abrégé de la Grammaire des Arts'. Lionel Nunès, a distant relative of Pissarro, does some research for Renoir to write a first draft.

Venturi 1939, I, pp. 127–9 (draft, Archives du Musée du Louvre); Monet, letter to Pissarro, in Wildenstein 1979, II, pp. 252–3; Pissarro 1980, pp. 299–300 n. 2; cf. pp. 13, 18 n. 33, 242 of present catalogue.

Summer

Stays with the Berards at Wargemont.

The children's afternoon at Wargemont [no. 71], dated 1884.

Summer

According to Venturi, he then goes to La Rochelle (Hôtel d'Angoulême): 'The last painting I saw by Corot made me want desperately to see this port.'

Renoir, letter [undated] to Durand-Ruel, in Venturi 1939, I, pp. 129–130.

October–December

Renoir is in Paris. Monet suggests the institution of monthly dinners to give an opportunity to the impressionist group to meet regularly.

Pissarro, letters of 9 October 1884 to Monet, in Pissarro 1980, p. 314; Monet, letters of 11 November and 12 December 1884 to Pissarro, in Wildenstein 1979, II, pp. 256–7.

8 December

Mirbeau publishes a favourable article on Renoir in *La France*.

1885

5 January

Attends the banquet organized by the Manet family and Antonin Proust at Père Lathuille's to mark the anniversary of the Manet exhibition at the Ecole des Beaux-Arts. Pissarro does not attend.

Pissarro 1980, I, p. 322; Monet, letter to Pissarro, in Wildenstein 1979, II, p. 257.

22 January

Attends opening of the Eva Gonzalès exhibition at the offices of *La Vie moderne*.

La Vie moderne, 24 January 1884, p. 60.

21 March

Birth of Pierre, the painter's first son. The address given on the birth certificate is 18 rue Houdon. His godfather is Gustave Caillebotte.

Birth certificate; J. Renoir 1962, p. 259.

June

Paintings by Renoir included in an exhibition organized by Durand-Ruel in the Hôtel du Grand-Miroir, Brussels.

Fénéon 1970, I, p.38; Verhaeren 1927, pp.177–181.

Summer

Goes in June to La Roche-Guyon [cf. no.77], near Giverny, with his family and rents a house in the Grande Rue. Cézanne, Hortense Fiquet and their son Paul stay there with the Renoirs (15 June–11 July). In July he visits the Berards in Wargemont, but returns to La Roche-Guyon in August.

Cézanne, letter of 6 July 1885 to Zola, in Cézanne 1978, pp. 218–220; J. Rewald, *Paul Cézanne*, London 1950, p.119; Renoir, letters [July, August 1885] to Durand-Ruel, in Venturi 1939, I, pp. 130–1; letter of 17 August [1885] to Berard (lot 74 in Paris, Drouot, 16 February 1979).

September–October

His first visit to Essoyes, Aline Charigot's home village in southern Champagne [cf. no. 78].

Renoir, letters [September, October 1885] to Durand-Ruel, in Venturi 1939, I, p.133.

November

Stays with the Berards in Wargemont. Writes to Durand-Ruel to congratulate him on his letter to *L'Evénement* (5 November) about the action taken against Goupil in connection with art forgeries.

Renoir, letter [November 1885] to Durand-Ruel, in Venturi 1939, I, p.134; Venturi 1939, II, pp. 249–252; Monet, letter of 30 October [1885] to A. Hoschedé, in Wildenstein 1979, II, pp. 263–4; Venturi 1939, I, pp. 72–3.

The electoral register for 1885 gives Renoir's address as 37 rue Laval (9ᵉ) (now rue Victor Massé). This address also appears on a letter of 30 November from Renoir to Octave Maus and again on his submission to the exhibition of Les XX in Brussels in February 1886.

Archives de Paris, listes électorales D¹M², 9ème arrondissement, quartier Saint-Georges, 1885; Renoir, letter of 30 November 1885 to O. Maus, in Venturi 1939, II, p. 227; Catalogue.

During the winter of 1885/6, Berthe Morisot begins to entertain her friends regularly at her home. Renoir is one of her frequent visitors.

Rouart 1950, pp.127–8.

1886

11 January

Berthe Morisot visits Renoir in his studio and admires his *Maternity* paintings and his *Bathers*.

Rouart 1950, p.128.

February

Sends eight paintings to the third exhibition of the Cercle des XX in Brussels.

Renoir, letters [5, 10 January 1886] to O. Maus, in Venturi 1939, II, pp. 228–9; Catalogue.

April–June

Durand-Ruel organizes a New York exhibition sponsored by the American Art Association, which includes 38 works (oils and pastels) by Renoir; the preface to the catalogue is by Théodore Duret. It is shown at the American Art Galleries (April) and the National Academy of Design (May-June).

Venturi 1939, II, p. 216; Catalogues.

May

Refuses to take part in the eighth and final *Exposition de peinture* organized by the impressionist group at 1 rue Laffitte.

Pissarro, letter [5 April 1886] to his son Lucien, in Pissarro 1950, p.102.

June–July

Exhibits five works in the fifth international exhibition held at the Galerie Georges Petit in rue de Sèze. On his return from New York on 18 July,

Paul Durand-Ruel visits the Galerie Petit where 'he saw the Renoirs, but did not like his new style at all, not at all.'
Catalogue; Pissarro, letter of 27 July 1886 to his son Lucien, in Pissarro 1950, p.108.

16 June
Mirbeau publishes a favourable article on Renoir in *Le Gaulois*, for which Renoir thanks him.
Renoir, letter of 18 June 1886 to Mirbeau (lot 138 in Paris, Drouot, 19 June 1979).

July
He again visits La Roche-Guyon, returning to Paris at the end of the month.
Renoir, letters [3 July 1886, July 1886] to J. Durand-Ruel, in Venturi 1939, I, pp.134–5.

August–September
He tours in northern Brittany, deciding to stay in La Chapelle-Saint-Briac, on the coast, where he rents 'La Maison Perrette' for two months. He invites Monet to join him there, commending the ruined castle of Le Guildo, near Saint-Briac, which had particularly impressed him. He is planning to return to Paris on 25 September, but is willing to postpone this if Monet will join him.
Renoir, letter [August 1886] to Berard (lot 73 in Paris, Drouot, 16 February 1979); letters [August 1886] to Durand-Ruel, in Venturi 1939, I, pp.135–7; Monet, letters of 21, 29 September 1886 to A. Hoschedé, in Wildenstein 1979, II, pp. 277–8; Renoir, letter to Monet in Geffroy 1924, II, pp. 23–4.

15 October
Moves to 35 boulevard Rochechouart (9e), where he stays for at least a year.
Archives de Paris, listes électorales D¹M², 9ème arrondissement, quartier Saint-Georges, 1887; Renoir, letter [September 1886] to Durand-Ruel, in Venturi 1939, I, p.137; letter of 15 October 1886 to Monet (lot 770 in Paris, Charavay, October 1980); letter of 24 September [1887] to Berard (lot 94 in Paris, Drouot, 11 June 1980).

December
With his family stays in Essoyes for Christmas and New Year.
Renoir, letter of 30 December 1886 to Murer, in Gachet 1957, p. 98.

1887

5–6 May
Durand-Ruel organizes an auction at Moore's Art Galleries, 290 Fifth Avenue, New York, which includes five paintings by Renoir.
Sale catalogue (Archives Durand-Ruel).

May–June
Durand-Ruel organizes a second exhibition at the National Academy of Design of New York, sponsored by The American Art Association, including five paintings by Renoir.
Catalogue; Venturi 1939, II, p. 218.

May–June
Takes part in the sixth international exhibition held at the Galerie Georges Petit. He shows five paintings, among them *Bathers* [p. 241 fig. a.]
Catalogue.

August
In Le Vésinet, where he lodges at 35 rue de la Station.
Renoir, letter of Thursday 4 August [1887] to Murer, in Gachet 1957, p. 94.

September
Travelling back and forth between Paris and Louveciennes.
Renoir, letter of 24 September [1887] to Berard (lot 94 in Paris, Drouot, 11 June 1980).

September–October
Visits Murer in Auvers-sur-Oise and meets Pissarro there.
Pissarro 1950, pp.162–3.

1888

15 January
Mallarmé announces the he has taken the manuscript of his prose poem *Le Tiroir de laque* to Dentu to be illustrated with four coloured etchings by John Lewis Brown (cover), Degas, Renoir and Morisot. (It was finally published in 1891 by Deman as *Pages*, the only illustration being Renoir's etching for *Le Phénomène futur*, which appeared as the frontispiece.)
Mallarmé, letter of 15 January [1888] to Verhaeren, in Mallarmé 1969, III, pp.161,162 n.3, 163.

1 February
Durand-Ruel sends money to Renoir at Jas de Bouffan, where he is staying with Cézanne and his family. But 'the household is so wretchedly mean' that he moves into the Hôtel Rouget in Martigues, 'the Venice and the Constantinople of the pictures by Ziem and the Swedish painters'.
Archives Durand-Ruel, *livre de comptes*; Renoir, letter [February 1888] to Monet in Baudot 1949, pp. 53–4; Monet, letters [21 January 1888, 13 February 1888] to A. Hoschedé, in Wildenstein 1979, III, pp. 225–9.

March
Suddenly leaves Martigues for Louveciennes, where his mother is ill.
Renoir, letter [March 1888] to Durand-Ruel, in Venturi 1939, I, pp.139–140.

May–June
Mixed exhibition at Durand-Ruel's gallery, rue Le Peletier, includes 19 paintings and 5 pastels and gouaches by Renoir.
Catalogue.

Summer
Works in Argenteuil and makes brief visits to Essoyes.
Renoir, letter to Murer, in Gachet 1957, p.99.

September
Stays with Caillebotte in Petit-Gennevilliers, near Argenteuil.
Renoir, letter postmarked 29 September 1888 to Murer (Université de Paris, Bibliothèque d'Art et d'Archéologie, Fonds Doucet).

September
'I had a long talk with Renoir. He told me that everyone, from Durand-Ruel to his old collectors, is criticizing him and attacking his attempts to break with his romantic period' (Pissarro).
Pissarro, letter of 1 October 1888 to his son Lucien, in Pissarro 1950, p.178.

Autumn
Stays in Essoyes until the end of the year, 'in order to get away from expensive Parisian models . . . [and to paint] laundresses, or rather washerwomen on the riverbanks' [cf.no.81].
Renoir, letter to E. Manet, in Rouart 1950, p.142.

Late December
Catches a chill and develops facial paralysis.
Renoir, letter of 29 December 1888 to Charpentier, in Florisoone 1938, p.38; letter to E. Manet, in Rouart 1950, p.143; letter [31 December 1888] to Durand-Ruel, in Venturi 1939, I, pp.140–1.

1889

The electoral register gives his address as 11 boulevard de Clichy (9ᵉ). Renoir has two studios which face one another across the second floor landing. It is the address given on his marriage certificate in April 1890, but by October of that year he has moved his residence to 13 rue Girardon (18ᵉ). He is still using the studios in 1894.

Archives de Paris, listes électorales D¹M², 18ème arrondissement, 1889, 1890; calepins cadastraux D¹ P⁴ C/10, 1876; marriage certificate; Renoir, letter of 30 October 1890 to Murer, in Gachet 1957, p.101; Archives du Musée du Louvre, P8.

24 April Tells Dr Gachet that his health is improving and that he intends to come and see him in Auvers after a brief visit to his brother in Villeneuve.

Renoir, letter of 24 April 1889 to Gachet, in Gachet 1956, p. 84.

July Refuses to take part in the Centennale (retrospective exhibition of nineteenth-century French art) planned for the 1889 Exposition Universelle. He writes to Roger Marx: 'When I next have the pleasure of seeing you I will explain something very simple; I think that everything I have done is bad and it would cause me a great deal of pain to see it exhibited.'

Renoir, letter [10 July 1889] to R. Marx (Paris, Louvre, Cabinet des Dessins).

Summer According to Rewald, he spends the summer near Aix-en-Provence, where he rents a house from Cézanne's brother-in-law. He paints landscapes.

J. Rewald, *Paul Cézanne*, London 1950, p.142; cf. entry for no.82.

11 August Writes to Monet about the fund that has been launched to buy *Olympia*: 'Impossible to find the money. . . . I hope Manet will go to the Louvre, but it will have to be without my help. All I can do is say that I hope you will succeed in what you are trying to do.' He eventually sends 50 francs on 10 January 1890.

Renoir, letters of 11 August [1889] and 10 January 1890 to Monet, in Geffroy 1924, I, p. 245.

1890

January Having initially refused (20 November) an invitation to participate in the forthcoming seventh exhibition of Les XX in Brussels, on the advice of Blanche, believing that it is dominated by the 'système pointilleux', he is persuaded by de Wyzewa to change his mind. He turns down (17 January) Octave Maus's invitation to go to Brussels to see the exhibition (held February-March), but he does send five works.

Renoir, letter of 20 November 1889, and de Wyzewa, letter of December 1889 to Maus, in Venturi 1939, II, p. 230; de Wyzewa, letter [November-December 1889] to Maus, in Delsemme 1967, p. 37; Renoir, letters of 25 December 1889 and 17 January 1890 to Maus, in Venturi 1939, II, pp. 230-1.

14 April Marries Aline Charigot at the Mairie du 9ème arrondissement, Paris. Their witnesses are: Franc-Lamy, Lhote, Lestringuez and Zandomeneghi. By marrying, they recognize Pierre as their legitimate child.

Marriage certificate.

May He refuses to be decorated. Monet writes to Caillebotte: 'I congratulate him . . . true, it would have been useful, but he has to succeed without that. It's smarter that way.'

Monet, letter of 12 May 1890 to Caillebotte, in Berhaut 1978, p. 248.

May–June Exhibits at the Salon for the last time:
no. 2024. *Portraits of Mlles M. . .* [the daughters of Catulle Mendès at the piano, Daulte 1971, no. 545].

Catalogue.

May–June Visits La Rochelle (until at least 20 June), from where he thanks Arsène Alexandre for his article protesting at the hanging of his picture at the Salon.

Alexandre 1913; Alexandre 1933, p.8; Archives Durand-Ruel.

September Stays in Mézy with Berthe Morisot and Eugène Manet.

Renoir, letter of 17 September 1890 to Gachet, in Gachet 1957, p. 87.

30 October In a letter to Murer he gives the address of his studio as 'Villa des Arts, impasse Hélène (Avenue de Clichy)' (17ᵉ), and his home address as '13 rue Girardon' (18ᵉ) (the 'Château des Brouillards'); they are still living here in September 1894 when their son Jean is born.

Renoir, letter of 30 October 1890 to Murer, in Gachet 1957, p.101; birth certificate.

The private gardens of old Montmartre: alley of the 'Château des Brouillards', 13 rue Girardon, June 1904. Bibliothèque Nationale, Paris.

6 December Téodor de Wyzewa publishes an essay on Renoir in *L'Art dans les deux mondes*.

1891

January Aline tells Murer that they are leaving for Toulon on 17 January: 'We are not going to Algiers, as Renoir is afraid that the crossing might be too much for the boy.' But they are still in Paris on 28 January, hoping to leave on the 31st.

Aline Renoir, letter of 8 January 1891 to Marie Doucet (no.279 in Paris, Bodin, spring 1980); Renoir, letter of 28 January 1891 to Mallarmé, in Mallarmé 1973, IV, p.197.

February–April Travels south by way of Aix-en-Provence, staying with de Wyzewa in the Villa des Roses, Tamaris-

sur-Mer, until April. He invited Murer to visit Tamaris on his way back from Algeria.

Renoir, letter of February 1891 to Durand-Ruel, in Venturi 1939, I, p.142; letter of 5 March 1891 to Berard, in Berard 1968, p.7; letter to Murer, in Gachet 1957, pp.103–4.

Early April
Moves into the Hôtel des Etrangers in Le Lavandou and remains there until the end of the month. It is there that he learns of the death (on 7 April 1891) of Victor Chocquet.

Renoir, letter to Durand-Ruel, in Venturi 1939, I, p.146; letter of 15 April 1891 to Durand-Ruel, in Venturi 1939, I, p.147; letter of 20 April 1891 to Mme Chocquet (no. 207 in Paris, La Librairie de l'Abbaye, Bulletin no. 238, n.d.).

Late April
Interrupts his return journey to Paris to see the Maison Carrée in Nîmes.

Renoir, letter of 23 April 1891 to Durand-Ruel, in Venturi 1939, I, p.148

July
Exhibition at Durand-Ruel's gallery of his recent work (paintings of 1890–1).

Pissarro 1950, pp.259–260.

Summer
In Paris, but in July and August he makes several visits to Mézy to see Berthe Morisot and Eugène Manet. Introduces Aline to them for the first time.

Renoir, letter of 17 August [1891] to Morisot, in Rouart 1950, p.161; Morisot, letter [? October 1891] to Mallarmé, in Rouart 1950, p.163.

9 September
Goes to spend a week at Caillebotte's home in Petit-Gennevilliers.

Renoir, letter of 28 September 1891 to Murer, in Gachet 1957, pp.106–7.

1892

He has a studio at 15 rue Hégésippe Moreau (18ᵉ), which is the address given for him in the electoral register.

Archives de Paris, listes électorales DⁱM², 18ème arrondissement, 1892.

January
Boussod and Valadon buy their first painting from Renoir, but do not become regular buyers.

J. Rewald, 'Theo van Gogh, Goupil and the Impressionists', Gazette des Beaux-Arts, January-February 1973, pp. 79, 104.

April
Thanks to the intervention of his friend Roujon (Directeur des Beaux-Arts), Mallarmé persuades the State to buy a version of *Young girls at the Piano* [no. 91].

Mallarmé, letter [4 April 1892] to R. Marx, in Mallarmé 1981, V, p. 61.

May
Renoir retrospective at Durand-Ruel's gallery (110 works); the preface to the catalogue is by Arsène Alexandre.

Catalogue.

6 May
Renoir gives a dinner at the Café Riche – the traditional setting for the impressionist 'Thursdays' – to celebrate the exhibition. Mallarmé, Monet, Caillebotte, Duret, de Bellio are present, and Mallarmé sends invitations to Roujon, Marx and 'his young friends'.

Mallarmé, letter [5 May 1892] to Renoir, in Mallarmé 1981, V, p. 76.

Late May–June
Goes to Spain with Gallimard; visits Madrid, where he particularly admires the Velasquezs in the Prado, and also Seville.

[Anon.], L'Eclair, 1892; Vollard 1919, p.137; Morisot, letter [1892] to L. Riesener, in Rouart 1950, p.169; André and Elder 1931, I, p.11.

July–October
Goes to Brittany with his family for the summer. In August-September they are in Pornic (Hôtel du Lion d'or, then the Châlet des Rochers), where he is bored, though he is impressed by Noirmoutiers ('superb and very southern'). In late September-October they are in Pont-Aven (Hôtel des Voyageurs), where he meets Armand Seguin and Emile Bernard.

Renoir, letter of 14 July [1892] to Murer, in Gachet 1957, p.104; letters of 29 August 1892 and 18 September 1892 to Durand-Ruel, in Venturi 1939, I, p.148; letter [summer 1892] to Morisot, in Rouart 1950, p.170; letter of 13 October 1892 to Durand-Ruel, in Venturi 1939, I, p.149; E. Bernard, Souvenirs inédits sur l'artiste peintre Paul Gauguin et ses compagnons lors de leur séjour à Pont-Aven et au Pouldu, Morbihan, n.d., p.18.

End of year
Paints portrait of Mallarmé.

Mallarmé 1981, V, pp.22–3; Renoir, letter [November 1892] to Mallarmé (lot 177 in Paris, Drouot, 19 December 1977 – there misdated to 1894).

1893

April
In Beaulieu (Villa Quincet), near Nice [cf. no. 92].

Renoir, letter of 27 April 1893 to Gallimard (Paris, Institut Néerlandais, Fondation Custodia); letter of 30 April 1893 to Durand-Ruel, in Venturi 1939, I, p.149.

June
Visits Gallimard in Bénerville, near Deauville; then travels to Essoyes through Falaise, Domfront and Chartres.

Renoir, letter to Gallimard (Archives Durand-Ruel); letter [1893] to Morisot, in Rouart 1950, pp.173–4.

July
Stays for a week in Saint-Marcouf on the Channel coast in western Normandy.

Renoir, letter [around 20 July 1893] to Maître (?) (Université de Paris, Bibliothèque d'Art et d'Archéologie, Fonds Doucet).

August
Second visit with his family to Pont-Aven.

Renoir, letter to Murer, in Gachet 1957, pp.107–9; letters [August 1893] to Durand-Ruel, in Venturi 1939, I, pp.150–1.

Letter from Renoir to Paul Durand-Ruel, 31 August 1893. Collection Durand-Ruel.

November
Dislikes Gauguin's exhibition at Durand-Ruel's.

Pissarro 1950, p.317.

During 1893 he meets Jeanne Baudot, and she becomes his pupil.

Baudot 1949, pp. 8–11.

1894

February–March

Shows two works in the first exhibition of La Libre Esthétique in Brussels.
Catalogue.

The catalogue for the Libre Esthétique exhibition gives Renoir's address as 7 rue de Tourlaque (18ᵉ), evidently a new studio, and this address reappears on the electoral register for 1896.
Catalogue; Archives de Paris, listes électorales D¹M², 18ème arrondissement, 1896.

21 February

Death of Caillebotte. In his original will (1876) he names Renoir as his executor: 'I ask Renoir to be my executor and to accept a painting of his choice; my heirs will insist that he takes a major painting.' Renoir chooses Degas's *Dancing lesson* [see 1898: 12 December]. In March he writes to Roujon, Directeur des Beaux-Arts, in connection with the bequest of the Caillebotte collection to the Musée du Luxembourg and the Musée du Louvre (some sixty paintings); he arranges for the paintings to be moved from Petit-Gennevilliers to his Paris studio at 11 boulevard de Clichy. On 19 March the commission that has been appointed examines them there.
Wills dated 3 November 1876 and 23 November 1883; Renoir, letter of 11 March 1894 to Roujon (all, Archives du Musée du Louvre, P8).

19 March

Duret sale [see p. 27 n. 11].
Sale catalogue.

April

While staying at Saint-Chamas (Hôtel de la Croix-Blanche) 'for health reasons', he asks Martial Caillebotte to draw up the papers needed for the State's acceptance of his brother's bequest. Invites Berthe Morisot to visit the region: 'This is the most beautiful place in the world; a combination of Italy, Greece and Les Batignolles, with the sea too.'
Renoir, letter of 18 April 1894 to Roujon (Archives du Musée du Louvre, P8); letter [1894] to Morisot, in Rouart 1950, p. 173.

4 May

The Musées Nationaux agree to accept Caillebotte's *Carpenters planing floor boards*. Renoir thanks Roujon and the Minister responsible for fine arts.
Renoir, letter of 5 May 1894 to Roujon; letter of 7 May 1894 to the Ministre de l'Instruction Publique, des cultes et des Beaux-Arts (Archives du Musée du Louvre, P8).

August

Visits the Gallimards at Villa Lucie, Bénerville, but does not accept Berthe Morisot's invitation to visit her in Brittany.
Renoir, letter to Durand-Ruel (Archives Durand-Ruel); letter of August 1894 to Morisot, in Rouart 1950, pp. 180–1; Morisot, letter of 13 September [1894] to Mallarmé, in Rouart 1950, p. 181.

August

While Renoir is staying with the Gallimards, Gabrielle Renard, a distant cousin of Aline's, joins the Renoir family in Paris from Essoyes [cf. no. 95].
J. Renoir 1962, pp. 284–6.

15 September

Birth of Renoir's second son Jean at 13 rue Girardon. Jean is baptized at Saint Pierre de Montmartre in 1896; his godfather is George Durand-Ruel and his godmother Jeanne Baudot.
Birth certificate; Renoir, letter to G. Durand-Ruel (Archives Durand-Ruel); J. Renoir 1962, pp. 271, 276.

September–October

Renoir painting at Versailles. An attack of rheumatism prevents him from attending the funeral of Norbert Goeneutte, who has died in Auvers-sur-Oise on 9 October.
Renoir, letter [October 1894] to Dr Gachet, in Gachet 1957, p. 88.

December

Dreyfus found guilty. Throughout the 'Affair', Renoir remains a convinced anti-Dreyfusard.
Manet 1979, pp. 148–151.

In 1894, according to Vollard, or 1895, according to Jean Renoir, Renoir meets the dealer Vollard.
Vollard 1919, pp. 9–14; J. Renoir 1962, pp. 302–3.

1895

January

Renoir is at Carry-le-Rouet, near Martigues, with his pupil Jeanne Baudot and her parents.
Renoir, letter [1895] to Morisot, in Rouart 1950, pp. 183–4.

3 March

Death of Berthe Morisot. According to Jean Renoir, Renoir is working at this time with Cézanne at the Jas de Bouffan (not confirmed by any other source). He returns to Paris for her funeral on 5 March.
J. Renoir 1962, p. 299; Renoir, letter of 3 March 1895 to Portier (lot 119 in Paris, Drouot, 16 April 1974).

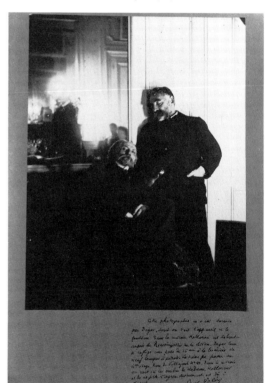

Photograph of Renoir and Mallarmé by Degas, 1895.
Bibliothèque littéraire Jacques Doucet, Paris.

May

Renoir admires the exhibition of Monet's *Rouen Cathedral* series at Durand-Ruel's gallery.
Pissarro, letter of 1 June 1895 to his son Lucien, in Pissarro 1950, p. 382.

August

Travels in Brittany. On 8 August Julie Manet and Paule and Jeannie Gobillard join Renoir in Châteaulin, and they visit Quimper, Bénodet and Douarnenez together. Two days later they join Mme Renoir and her sons in Pont-Aven (Hôtel

des Voyageurs). They then go to Tréboul, near Douarnenez, where Renoir rents the Maison Lemaître.

Manet 1979, pp. 57–70; Renoir, letter of September 1895 to Durand-Ruel (Archives Durand-Ruel).

Summer–Autumn Visits Jacques-Emile Blanche in Dieppe (perhaps while staying with the Berards), at the time Blanche is working on a portrait of Thaulow and his family.

Blanche 1949, p. 246.

November Renoir expresses his admiration of Cézanne's recent paintings, which he has seen at Vollard's gallery: 'There is something similar to the things from Pompeii, so rough and so admirable.'

Pissarro, letter of 21 November 1895 to his son Lucien, in Pissarro 1950, pp. 388–390.

December Renoir goes to Essoyes to buy a house.

Manet 1979, p. 76.

Renoir's house at Essoyes.

December–January 1896 Cézanne quarrels with Renoir.

Pissarro 1950, pp. 396–7.

1896

January–February Renoir dislikes the Bonnard exhibition at Durand-Ruel's gallery.

Pissarro, letter of 6 February 1896 to his son Lucien, in Pissarro 1950, p. 398.

March Renoir, Monet and Degas install the restrospective exhibition of Berthe Morisot at Durand-Ruel's. Renoir has taken a close interest in its organization.

Manet 1979, pp. 77–80.

May Thirty paintings by Renoir, many from Murer's collection, are exhibited at Murer's Hôtel du Dauphin et d'Espagne in Rouen.

Gachet 1956, p. 164.

May–June Renoir exhibition at Durand-Ruel's gallery (42 works).

Catalogue.

15 June Thadée Natanson publishes an article on Renoir in *La Revue blanche*.

15 July Leaves for Germany. Martial Caillebotte accompanies him to Bayreuth. Wagner's music bores him, and he cannot bear to stay for the four days of the performances. Leaves for Dresden, where he visits the museums.

Renoir, letter of 10 July 1896 to Geffroy (lot 257 in Paris, Drouot, 6 April 1981); Vollard 1919, p. 112; Manet 1979, p. 113; Baudot 1949, p. 77.

October Rents a studio in rue de la Rochefoucauld (9e).

Manet 1979, p. 116.

11 November His mother, Marguerite Merlet, dies at the age of eighty-nine in Louveciennes (18 route de Versailles), where she has been living with her daughter Elisa (Mme Charles Leray) and her son Victor.

Death certificate; Archives Municipales, Louveciennes, census 1896.

1897

Early in the year, he gives his address as 64 rue de La Rochefoucauld (9e), but plans to move from Montmartre in the spring.

Renoir, letter of 4 February 1897 to Murer, in Gachet 1957, pp. 109–110.

February The Caillebotte bequest is, at last, exhibited in the Musée du Luxembourg.

Pissarro 1950, p. 432.

Summer–Autumn In Essoyes. In August he falls from his bicycle, breaking his arm for the second time. Julie Manet and Paule and Jeannie Gobillard stay in Essoyes from September to mid-October. He advises Julie on her painting.

Manet 1979, pp. 130–7; J. Renoir 1962, pp. 337, 347.

1898

February Stays in Cagnes, probably for the first time, and returns enthusiastic about the place.

Manet 1979, pp. 152–3.

May–June Exhibition (Monet, Renoir, Pissarro, Sisley) at Durand-Ruel's gallery; one room is devoted to Renoir.

Manet 1979, pp. 166–7; Pissarro, letter of 29 May 1898 to his son Lucien, in Pissarro 1950, p. 454.

July–September Rents a chalet in Berneval [cf. no. 98] and spends the summer there. Julie Manet and Paule and Jeannie Gobillard spend several days there with him.

Manet 1979, pp. 168–9.

September In Essoyes.

Manet 1979, p. 186.

9 September Death of Mallarmé. Renoir attends his funeral in Valvins on 11 September.

Jeannie Gobillard, letter, in Baudot 1949, p. 84; Manet 1979, p. 186.

22 October Travels to Holland with Faivre, George Durand-Ruel, Berard and 'e'. Visits The Hague and Amsterdam, where there is a major Rembrandt exhibition.

Manet, 1979, p. 198; André 1928, pp. 57–8; Vollard 1938, pp. 226–7; Renoir, letter from Amsterdam to Durand-Ruel (Archives Durand-Ruel).

November Painting sketches for a series of decorative panels for Gallimard on the theme of Oedipus, but does not execute them.

Manet 1979, pp. 168, 204; Meier-Graefe 1929, p. 386 (misdated to 1895).

12 December	Sells Durand-Ruel Degas's *Dancing lesson* [no. 98 fig. a], the work he chose as a gift from Caillebotte's collection. This leads to a quarrel with Degas. Archives Durand-Ruel; Manet 1979, pp. 279, 282; Baudot 1949, p. 23.

1899

February–May	Departs for Cagnes (Hôtel Savournin) on 12 February, where he undergoes treatment for his rheumatism. Jeanne Baudot accompanies him for the first two weeks of his stay. He pays several visits to Deudon in Nice and sends Durand-Ruel an inventory of Deudon's collection, which is for sale. Manet 1979, p.216; Renoir, letter of 11 February 1899 to Durand-Ruel (Archives Durand-Ruel); letter of 20 February 1899 to Berard (lot 78 in Paris, Drouot, 16 February 1979); letters [February, March, April 1899] to Durand-Ruel, in Venturi 1939, I, pp.151–3.
April	Exhibition (Monet, Pissarro, Renoir, Sisley) at Durand-Ruel's gallery; 42 works by Renoir are included. Catalogue.
1 May	Following the death of Sisley on 29 January, Monet organizes an auction on behalf on his children. Renoir donates a painting. Pissarro, letter of 12 April 1899 to his son Lucien, in Pissarro 1950, p. 467.
4–9 May	Doria sale [see p.21]. Catalogue
1, 3–4 June	Chocquet sale [see p.27 n.19]. Catalogue.
June–August	In Saint-Cloud, where he is visited by de Wyzewa and Vollard. Manet 1979, pp. 234, 240, 250.
13 August–September	Treatment in Aix-les-Bains on the advice of Dr Baudot. Manet 1979, pp.248–9; Renoir, letter of 29 August 1899 to Durand-Ruel, in Venturi 1939, I, p.156.
22 December	Leaves for the south, where he stays in Grasse (Hôtel Muraour). Manet 1979, p. 285; Renoir, letters of 29 and 31 December 1899 to Durand-Ruel, in Venturi 1939, I, p.156.
Late December	Asks Durand-Ruel to send his *Portrait of Jean Renoir as a child* to the Museum in Limoges. It is registered as no. 58 on 24 February 1900. Renoir, letter of 29 December 1899 to Durand-Ruel, in Venturi 1939, I, p.156; inventory of Musée Municipal de Limoges.

1900

5 January–mid-May	Aline joins him in the south. They rent a house (Villa Raynaud) near Magagnosc. Renoir, letter of 13 January 1900 to Durand-Ruel, in Venturi 1939, I, p.158.
January–February	Renoir exhibition at Bernheim-Jeune, Paris (68 works). Catalogue.
April	Exhibition (Monet and Renoir) in Durand-Ruel's New York galleries (21 works). Catalogue.
May–June	Spends several days in Avignon (Hôtel Crillon) on his way to Saint-Laurent-les-Bains (Hôtel

	Dalverny), near Aix-les-Bains, where he has treatment for his rheumatism. Renoir, letters of 24 May and 12 June 1900 to Durand-Ruel, in Venturi 1939, I, pp.160–1.
May–June	Eleven paintings by Renoir are eventually shown in the Centenale de l'Art Français at the Exposition Universelle, though Renoir initially refused to exhibit, as did Monet and Pissarro. Catalogue; Monet, Pissarro, Renoir, letters [January-April 1900] to R. Marx, in Paris, Louvre, Cabinet des Dessins, *Donation Roger Marx*, 1980–1, pp. 92–3, nos. 78–81.
August	At Louveciennes. Renoir, letter of 18 August 1900 (lot 121 in Paris, Drouot, 16 April 1974); letter of 20 August 1900 to Durand-Ruel, in Venturi 1939, I, p.161.
16 August	Given the order of Chevalier de la Légion d'Honneur. He tells Monet: 'I have let them give me a decoration . . . whether or not I have done something stupid, your friendship still means a lot to me.' On 17 June 1901, Paul Berard presents him with his insignia. Archives Nationales, LH 2300/69; Renoir, letter of 20 August 1900 to Monet, in Geffroy 1924, II, pp. 25–6.
November–April 1901	In Magagnosc, near Grasse. Renoir, letters to Durand-Ruel, November 1900 – March 1901, in Venturi 1939, I, pp.161–5; letter of 17 December 1900 to Gallimard (no.7191 in Paris, Saffroy, catalogue 74, June 1971).

1901

25 January	Asks Durand-Ruel to dispatch *Woman playing the guitar* [no. 96], which has been purchased by the Musée de Lyon. Renoir, letter of 25 January 1901 to Durand-Ruel, in Venturi 1939, I, p.162.
April	Spends several days in Le Trayas (Hôtel A la Réserve), near Saint-Raphaël, with his son Pierre; Pierre is a boarder at Sainte-Croix de Neuilly and spends the Easter holidays with his parents. Aline leaves for Essoyes, while Renoir returns to Magagnosc, then moves to Cannes (Grand Hôtel des Colonies et des Négociants), to wait for the opening of the thermal season. Renoir, letters of 13, 17, 25 April 1901 to Durand-Ruel, in Venturi 1939, I, pp.165–7.
May	Further treatment at Aix-les-Bains (Hôtel de la Paix, Guichard Garin). Renoir, letters of 3 and 5 May 1901 to Vollard, in Drucker 1944, pp.140–1,144.
6 May	Abbé Gaugain's collection auctioned at Hôtel Drouot [see p.24]. Catalogue.
June	Rejoins his wife in Essoyes. Renoir, letters of July 1901 to Durand-Ruel, in Venturi 1939, I, p.167.
4 August	Birth of his third son Claude in Essoyes. Birth certificate.
Early September	Visits the Adlers in Fontainebleau in order to paint Adler's sisters, the fiancées of Joseph and Gaston Bernheim [cf. p.269 fig. b]. Renoir, letter of 4 September 1901 (Archives Durand-Ruel); letter of 7 September 1901 to Durand-Ruel, in Venturi 1939, I, p.168.

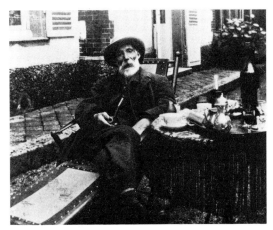

Renoir at the Pavillon de Bellune in Fontainebleau, August 1901.

October	Rents an apartment at 43 rue Caulaincourt (18ᵉ) and a studio at 73 rue Caulaincourt. J. Renoir 1962, p.368; Renoir, letter of 13 April 1902 to Durand-Ruel (Archives Durand-Ruel).
October–November	Mixed exhibition at Paul Cassirer's gallery in Berlin (23 works by Renoir). Catalogue.

Renoir at Le Cannet, c.1901–2. Collection Durand-Ruel.

1902

January–end April	In Le Cannet (Villa Printemps), where he is joined by Aline, Jean and Claude. Albert André works with him. Renoir, letter of 3 February 1902 to Durand-Ruel, in Venturi 1939, I, pp.168–9.
June	Renoir exhibition at the Durand-Ruel gallery in Paris (40 works). Catalogue.
June	Extends his house in Essoyes by incorporating the house next to it. From 1902 onwards, Renoir's health deteriorates seriously: partial atrophy of a nerve in the left eye, severe attacks of rheumatism. Renoir, letter of 13 June 1902 to Durand-Ruel, in Venturi 1939, I, p.171; J. Renoir 1962, pp.345, 349–350.

1903

February–March	Spends the winter in Le Cannet and, from March onwards, in Cagnes (Maison de la Poste). Renoir, letters of February–April 1903 to Durand-Ruel, in Venturi 1939, I, pp.171–3.

25 May	Leaves Cagnes. On his way to Paris, he stays with Albert André in Laudun (Gard). Renoir, letter of 24 May 1903 to Durand-Ruel (Archives Durand-Ruel).
August–October	In Essoyes. Renoir, letter of 31 August 1903 to Jeanne Baudot, in Baudot 1949, p.100; letter of 22 September 1903 to Paul Berard (lot 33 in Paris, Drouot, 16 February 1979).
November	Travels south to Marseille (Grand Hôtel Beauvau), and then to Cagnes. Renoir, letters of 13 and 24 November 1903 to Durand-Ruel, in Venturi 1939, I, p.174.
December	The collector Viau [see p.23] is accused of having forgeries of paintings and pastels by Renoir. The painter suspects his studio neighbour. Renoir, letters of 24 and 28 November, 16, 24 and 26 December 1903 to Durand-Ruel, in Venturi 1939, I, pp.174–6; letter of 24 December 1903 to Albert André (Paris, Institut Néerlandais, Fondation Custodia).
December	The Valtats visit Renoir in Cagnes. Renoir, letter of 8 December 1903 to Albert André (Paris, Institut Néerlandais, Fondation Custodia).

1904

January	Registers a complaint with the Procureur de la République in the fakes affair, but withdraws it the following month on the advice of a lawyer. Renoir, letters of 13 January and 10 February 1904 to Durand-Ruel, in Venturi 1939, I, pp.177, 179–180.

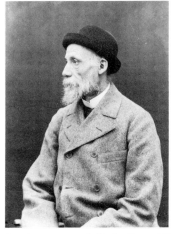

Renoir, c.1900–5. Collection Durand-Ruel.

February–April	Twelve paintings included in the Libre Esthétique exhibition devoted to Impressionism in Brussels. Catalogue.
April or May	Leaves south of France to spend the summer in Essoyes. Renoir, letters of 18 April and 11 August 1904 to Durand-Ruel, in Venturi 1939, I, p.181.
August–September	Thermal treatment at Bourbonne-les-Bains, after which he returns to Essoyes. Renoir, letters of 11 August and 4 September 1904 to Durand-Ruel, in Venturi 1939, I, pp.181–2.
October–November	One room at the Salon d'Automne in Paris is devoted to Renoir (35 works): 'They ask me why I have decided to take part in the autumn exhibition even though I never exhibit. I tell them that I do not exhibit when no one wants anything to do

with me, but that I do not hide my paintings on principle and that I was very politely asked if I would like to exhibit.'
Catalogue; Renoir, letter of 19 October 1904 to Durand-Ruel, in Venturi 1939, I, p.184.

1905

Winter	In Cagnes, where he is visited by Valtat and d'Espagnat. Renoir, letter to Durand-Ruel, in Venturi 1939, I, p.184; letters of [December 1904], February 1905 to Albert André (Paris, Institut Néerlandais, Fondation Custodia).
January–February	Durand-Ruel organizes an impressionist exhibition at the Grafton Galleries, London (59 Renoirs). Catalogue.
8–9 May	Berard sale [see p. 22]. Catalogue.
Summer	Has a new studio built at Essoyes. J. Renoir 1962, pp. 345–6.
October–November	Exhibits at the Salon d'Automne (9 works). He is Honorary President of the Salon. Catalogue.

1906

Winter	Spends the winter in Cagnes. Renoir, letters of December 1905, February, March 1906 to Durand-Ruel, in Venturi 1939, I, pp.185–6.

Renoir and Albert André at Laudun (Gard), 1906. Collection Durand-Ruel.

February	Maurice Denis visits him. Denis 1957, II, pp.34–5.
August	In Essoyes. Renoir, letter of 9 August 1906 to Durand-Ruel, in Venturi 1939, I, pp.186–7.
October–November	Exhibits five paintings at the Salon d'Automne. Catalogue.
October	Renoir meets Monet in Paris and plans to do a drawing of him for Vollard. Alice Monet, letters of 23–26 October 1906 to G. Salerou, in Paris, Centre Culturel du Marais, 1983, p. 281.
November–May 1907	In Cagnes. Renoir, letters of 4 December 1906–2 May 1907 to Durand-Ruel, in Venturi 1939, I, pp. 187–8.

Renoir painting at the Villa de la Poste, Cagnes. Collection Durand-Ruel.

1907

February	The painter and art critic Jacques-Félix Schnerb visits him in Cagnes (Maison de la Poste). Schnerb 1983, p. 175.
11 April	Charpentier sale [see p. 20]. *Portrait of Madame Charpentier and her children* [no. 44] bought for Metropolitan Museum of Art, New York. Catalogue.
20 June	Frantz Jourdain writes to the Minister to propose that Renoir be made an Officier de la Légion d'Honneur. Archives Nationales, F²¹ 4103.
28 June	Buys Les Collettes, an estate in Cagnes, and has a house built there in 1907–8. C. Renoir 1960.
October	Renoir is Honorary President of the Salon d'Automne, but does not exhibit. Catalogue.
Autumn–Spring 1908	In Cagnes. Rents a villa on the road to Vence while his house is being constructed. C. Renoir 1960; Renoir, letters of 15 December 1907–29 April 1908 to Durand-Ruel, in Venturi 1939, I, pp. 189–191.

1908

March	Planting of the garden at Les Collettes. Renoir, letter of 20 March 1908 to Julie Manet, in Paris, Braun, *Renoir*, 1932, p. 12.
April–May	Exhibition of still lifes (Monet, Cézanne, Renoir, Pissarro, Sisley, A. André, d'Espagnat, Lerolle) at Durand-Ruel's gallery in Paris (42 works by Renoir). Catalogue.
May–June	Exhibition of landscapes by Monet and Renoir (37 works) at Durand-Ruel's gallery in Paris. Catalogue.
Mid-July	In Essoyes. According to Rivière, the sculptor Maillol visits him and models a bust of the painter. (Maillol's biographers place this visit in 1907.) Rivière 1921, pp. 247–8; W. George, *Aristide Maillol*, London 1965, p. 221.

Autumn — Moves into the house he has had built at Les Collettes.
Renoir, letter of 15 November 1908 to Durand-Ruel, in Venturi 1939, I, p. 192.

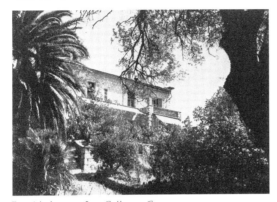

Renoir's house at Les Collettes, Cagnes.

14 October — Draws up a will; it is mainly concerned with provisions for Les Collettes in the event of his death.
Will (lodged with Maître Duhau, Paris).

November–December — Renoir exhibition at Durand-Ruel Galleries, New York (41 works).
Catalogue.

Autumn–June 1909 — In Cagnes, where he is visited in December by Monet.
Paris, Centre Culturel du Marais, 1983, pp. 139–140; J.-P. Hoschedé, *Claude Monet, ce mal connu*, Paris 1960, I, p. 128; Renoir, letters of 15 November 1908–2 June 1909 to Durand-Ruel, in Venturi 1939, I, pp. 192–5.

1909

Spring — Jacques-Emile Blanche visits him in Cagnes.
Blanche 1921, p. 38.

June — Durand-Ruel arranges to meet Renoir in Paris the day before the exhibition of Monet's *Waterlily* paintings closes.
Alice Monet, letter of 11 June 1909 to G. Salerou, in Paris, Centre Culturel du Marais, 1983, p. 273.

Summer — Presumably spent at Essoyes.

Renoir with parasol. Collection Durand-Ruel.

December — Objects to plans for a commemorative monument to Cézanne, who had died in 1906: 'A painter should be represented by his paintings.'
Renoir, letter of 6 December 1909 to Monet, in Geffroy 1924, II, pp. 26–7.

6–7 December — Second Viau sale [see p. 23].
Catalogue.

Autumn–June 1910 — In Cagnes.
Renoir, letter of 6 December 1909 to Monet, in Geffroy 1924, II, pp. 26–7; letters of 20 February–28 May 1910 to Durand-Ruel, in Venturi 1939, I, pp. 196–8.

1910

10 March — Maurice Denis visits him in Cagnes.
Denis 1957, II, p. 118.

April–October — Renoir retrospective at the Ninth Venice Biennale (37 works).
Catalogue.

June — Exhibition (Monet, Pissarro, Renoir, Sisley) at Durand-Ruel's gallery in Paris (35 works by Renoir).
Catalogue.

Summer — Goes to Germany and stays with Edouard Berard's daughter Mme Thurneyssen. When he returns, he finally has to give up walking.
Duret 1924, p. 74; Pach 1958, pp. 280–2; Brüne 1958, pp. 7–12; J. Renoir 1962, pp. 421–3.

Autumn — Writes an open letter to Henri Mottez, which is published as the preface to a new edition of the painter Victor Mottez's translation of Cennino Cennini's *Le Livre de l'art*.
Rivière 1921, p. 226.

October–November — Exhibits one painting at the Salon d'Automne.
Catalogue.

Autumn–Spring 1911 — In Cagnes.
Renoir, letters of 26 November 1910–31 March 1911 to Durand-Ruel, in Venturi 1939, I, pp. 198–201.

1911

January — Mme Cézanne and her son stay with the Renoirs in Cagnes.
Renoir, letter of 11 January 1911 to Durand-Ruel, in Venturi 1939, I, p. 199.

31 March — Contributes 500 francs to the Sisley memorial fund.
Renoir, letter of 31 March 1911 to Durand-Ruel, in Venturi 1939, I, p. 201.

Renoir in his studio. Bibliothèque Nationale, Paris.

June–July	Attends a performance by the Ballets Russes in Paris with Alfred Edwards and Misia Godebska. Blanche 1919, p. 240; J. Renoir 1962, pp. 405–7; June 1911: first Paris performances of *Petrouchka* and *Spectre de la Rose* by Diaghilev's Ballets Russes.
October	Rents a studio at 38 bis boulevard Rochechouart (18ᵉ). Archives de Paris, listes électorales DᴵM², 18ème arrondissement, 1911.

Renoir at home (boulevard Rochechouart?).
Bibliothèque Nationale, Paris.

20 October	Renoir is made an Officier de la Légion d'Honneur. Léon Dierx presents him with his insignia on 12 November. Rodin sends his congratulations. Archives Nationales, L H 2300/69; Rodin, letter of 25 October 1911 to Renoir (lot 152 in Paris, Drouot, 25 June 1975).
November	Renoir presents Signac with the insignia of a Chevalier de la Légion d'Honneur. Renoir, letter of 15 November 1911 to Signac (lot 148 in Paris, Drouot, 25 June 1975, there misdated to 1915).
Autumn– June 1912	In the south of France. Renoir, letters of 21 December 1911–15 June 1912 to Durand-Ruel, in Venturi 1939, I, pp. 201–3. Meier-Graefe's monograph on Renoir is published; a French edition appears in 1912.

1912

January– March	Moves into an apartment in Nice because his rheumatism prevents him from using his studio at Les Collettes. Renoir, letter of 12 January 1912 to Durand-Ruel, in Venturi 1939, I, pp. 201–2.
January– February	Renoir exhibition at Galerie Thannhauser, Munich (41 works). It transfers in February–March to Paul Cassirer's gallery in Berlin. Catalogues.
February– March	Renoir exhibition at the Durand-Ruel Galleries, New York (21 works). Catalogue.
Early in year	Exposition Centennale d'Art Français (1812–1912) at the Institut Français, St Petersburg (24 works by Renoir). Catalogue.
April–May	Renoir exhibition at Durand-Ruel's gallery in Paris (74 works). Catalogue.
May	Becomes Honorary President, with Rodin, of Salon de Mai in Marseille. Catalogue.

June	Exhibition of portraits by Renoir at Durand-Ruel's gallery in Paris (58 works). Catalogue.
June	Suffers an attack of paralysis. During a visit to Paris, the Bernheims introduce him to a Viennese doctor. He tries to walk, but accepts he will never walk again. Renoir, letter of 15 June 1912 to Durand-Ruel, in Venturi 1939, I, p. 203; J. Renoir 1962, pp. 443–4.
August	Undergoes an operation and spends several days convalescing in Chaville. Rivière 1921, pp. 228–9.
Summer(?)	Exhibition of modern art at Manzi-Joyant gallery in Paris (28 works by Renoir). Catalogue.
October– November	Exhibits two paintings at the Salon d'Automne. Catalogue.
December	Henri Rouart sale [cf. p. 20]. Catalogue.
Autumn– Spring 1913	In the south of France. Renoir, letter of 28 January 1913 to G. Durand-Ruel, in Venturi 1939, I, p. 204; letter of 19 March 1913 to Durand-Ruel (Archives Durand-Ruel).

1913

February	Maurice Denis visits him in Cagnes. Denis 1957, II, pp. 150–1; Baudot 1949, p. 131.

Renoir in Cagnes, 1913. Collection Durand-Ruel.

February– March	Five paintings by Renoir are exhibited in the Armory Show, New York. Catalogue.
17 February	His son Jean enlists in the First Regiment of Dragoons for a period of three years. Service Historique de l'Armée de Terre, dossier 41/9912.
March	Renoir exhibition at Bernheim-Jeune gallery in Paris (52 works); catalogue preface by Octave Mirbeau. Catalogue.
June–July	Exhibition of modern art at Manzi-Joyant gallery in Paris (30 works). Catalogue.
Summer	At Vollard's suggestion, Renoir takes up sculpture while spending the summer at Essoyes: 'When Vollard first mentioned sculpture, I told him to go to the devil, but on reflection I let myself be persuaded'. Vollard engages Richard Guino, a

pupil of Maillol, to implement Renoir's ideas for sculpture.
Haesaerts 1947, pp. 16, 24; Renoir, letter of 28 April 1914 to Albert André (Paris, Institut Néerlandais, Fondation Custodia).

Winter 1913/14 Spends part of the winter at Les Collettes, part in his apartment in Nice (Place de l'Eglise du Voeu).
Renoir, letters of November 1913 and January 1914 to Durand-Ruel, in Venturi 1939, I, pp. 204–5.

1914

February Renoir exhibition at Durand-Ruel Galleries, New York (30 works).
Catalogue.

March Working on a tapestry cartoon for the Gobelins factory representing Neptune caressing Venus at her birth.
F. Fénéon, *Bulletin*, 1 March 1914, in Fénéon 1970, I, p. 277.

March Publication of Vollard's volume on Cézanne. Renoir comments: 'It is a monument which will have a strong influence on young painters. The reproductions are superb.'
F. Fénéon, *Bulletin*, 1 March 1914, in Fénéon 1970, I, p. 279.

End of winter Rodin visits Renoir in Cagnes.
Coquiot 1925, p. 130; Vollard 1938, p. 279.

April Jacques-Emile Blanche visits Renoir in Cagnes.
Blanche 1919, pp. 235–243.

4 June Three paintings by Renoir enter the Louvre, part of the bequest to the State of Isaac de Camondo, who had died in 1911 [see p. 24].
Archives du Musée du Louvre, Z8 1912 17 December.

Summer In Essoyes and Paris.
Renoir, letter [July 1914] to Marguerite André (Paris, Institut Néerlandais, Fondation Custodia).

3 August Germany declares war on France.

September J.-E. Blanche meets Renoir, who has stopped in Moulins (Hôtel de Paris) on his way to Cagnes.
Blanche 1915, pp. 183–4; Blanche 1949, p. 435.

October Pierre and Jean are wounded and are hospitalized in Carcassonne and Luçon respectively.
Renoir, letter [October 1914] to Albert André (Paris, Institut Néerlandais, Fondation Custodia); letter of 29 October 1914 to Durand-Ruel, in Venturi 1939, I, p. 206.

October–June 1915 In Cagnes.
Renoir, letters of 29 October 1914–28 June 1915 to Durand-Ruel, in Venturi 1939, I, pp. 206–8.

1915

April Jean is severely wounded in the leg.
J. Renoir 1962, p. 9.

27 June On her return from Gérardmer, where Jean has been hospitalized, Aline Renoir dies in Nice.
Renoir, letter of 26 June 1915 to Marguerite André (Paris, Institut Néerlandais, Fondation Custodia); letter of 28 June 1915 to Durand-Ruel, in Venturi 1939, I, pp. 207–8; death certificate.

December Asks Durand-Ruel and Vollard to take an inventory of the paintings that are still in Paris.
Renoir, letter of 17 December 1915 to Durand-Ruel, in Venturi 1939, I, p. 208.

Autumn–Spring 1916 In Cagnes.
Renoir, letters of 12 December 1915–12 March 1916 to Durand-Ruel, in Venturi 1939, I, p. 208.

1916

June In Paris.
Renoir, letter [24 June 1916] to J. Durand-Ruel, in Venturi 1939, I, p. 209.

15 June He gives a *Portrait of Colonna Romana* to the museum in Limoges.
Musée Municipal de Limoges.

Summer Asks the sculptor Guino to come to Essoyes and model a bust of his wife from a seated study.
Renoir, letter of 23 July 1916 to Guino, in Haesaerts 1947, p. 29.

Photograph of Jean and Auguste Renoir by Bonnard, 1916. Collection Antoine Terrasse.

Autumn–Summer 1917 In Cagnes.
Renoir, letters of 29 November 1916–21 May 1917 to G. Durand-Ruel, in Venturi 1939, I, pp. 209–211.

1917

January Renoir exhibition at the Durand-Ruel Galleries, New York (18 works).
Catalogue.

January Albert and Marguerite André stay with Renoir in Cagnes.
Renoir, letter of 28 January 1917 to G. Durand-Ruel, in Venturi 1939, I, p. 210.

Photograph of Adèle Besson, Albert André and Renoir at Cagnes by George Besson, 1917. Collection Jacqueline George Besson.

June–July | Sixteen paintings shown in the exhibition of nineteenth-century French art at the Galeries Paul Rosenberg, Paris. Profits from the exhibition go to the war wounded.
Catalogue.

July | Stops in Beaune on his way to Paris.
Renoir, letter of 15 July 1917 to Durand-Ruel, in Venturi 1939, I, p. 212.

August | In Essoyes.
Renoir, letter of 20 August 1917 to G. Durand-Ruel, in Venturi 1939, I, p. 212.

27 September | While in Cagnes, Renoir hears the news of Degas's death.
Renoir, letter of 30 September 1917 to G. Durand-Ruel, in Venturi 1939, I, p. 212–3.

Autumn | Begins to teach his son Claude to make pottery at Cagnes.
C. Renoir 1948, pp. 7–8.

October–November | Exhibition of nineteenth- and twentieth-century French art at the Kunsthaus, Zurich (60 works by Renoir).
Catalogue.

Late December | Disenschanted with his collaboration with the sculptor Guino, who leaves Cagnes in January.
Besson 1939, p. 137; Renoir, letter of 7 January 1918 to Vollard (lot 45 in Paris, Drouot, 6 June 1975).

31 December | Matisse visits Renoir for the first time in Cagnes.
Besson 1939, p. 137.

1918

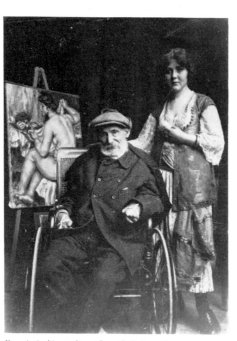

Renoir in his studio at Les Collettes, Cagnes.
Collection Durand-Ruel.

February–March | Renoir exhibition at the Durand-Ruel Galleries, New York (28 works).
Catalogue.

3 March | Congratulates Vollard on the reproductions chosen to illustrate his monograph.
Renoir, letter of 3 March 1918 to Vollard, in Vollard 1918, I, p. v.

End March | The dealer René Gimpel visits Renoir in Cagnes. Renoir refuses to sell him any paintings.
Gimpel 1963, pp. 26–30.

Spring | As the Germans advance, Renoir entrusts the remaining paintings in Paris and Essoyes to friends. Pierre brings back several large rolled canvases to the apartment in Nice (rue Palermo).
Rivière 1921, pp. 262–3; Gimpel 1963, p. 32.

13 April | *Portrait of Colonna Romano* goes on display in the Musée du Luxembourg.
Galerie du Jeu de Paume, Musée d'Orsay, Paris, R.F. 2796.

13 April | René Gimpel visits Renoir on this and the following days in his apartment in the rue Palermo, Nice. His health is deteriorating, and there are fears that his foot is becoming gangrenous.
Gimpel 1963, pp. 32–5.

1919

19 February | Renoir is made a Commandeur de la Légion d'Honneur. General Corbillet presents him with his insignia in Nice on 25 March.
Archives Nationales, L H 2300/69.

April | Renoir exhibition at Durand-Ruel Galleries, New York (35 works).
Catalogue.

May | Congratulates André on the publication of his monograph.
Renoir, letter of May 1919 to Albert André (Paris, Institut Néerlandais, Fondation Custodia).

July | In Essoyes.
Renoir, letter of 1 July and 7 August 1919 to G. and P. Durand-Ruel, in Venturi 1939, I, p. 214.

August | Visits the Louvre at the invitation of Paul Léon, the Directeur des Beaux-Arts; his *Portrait of Madame Charpentier* is on display in the Salle La Caze, where the museum's most recent acquisitions have been on show since February.
Archives du Musée du Louvre.

Mid-September | Paul Léon visits Renoir in Essoyes and plans an exhibition for spring 1920.
Rivière 1921, pp. 264–5.

3 December | Renoir dies in Cagnes of congestion of the lungs. He is buried on 6 December.
J. Renoir, letter of 20 December 1919 to Durand-Ruel (Archives Durand-Ruel); death certificate.

Exhibition history

The exhibition history aims to provide as full a listing of exhibitions in which Renoir's work was included during his lifetime as possible. The principal list includes those exhibitions in which the compilers have been able to confirm his participation. Exhibitions known only through secondary sources are listed separately at the end.

The list is arranged in chronological order. Exhibitions for which no month or season is known are placed in the middle of the relevant year.

Where the number of works exhibited by Renoir is known, this is indicated in parentheses at the end of the entry.

1864
May onwards: Paris, *Salon* (1 work)

1865
May onwards: Paris, *Salon* (2 works)

1866
January–March: Pau, Société des Amis des Beaux-Arts (3 works)

1868
May onwards: Paris, *Salon* (1 work)

1869
May onwards: Paris, *Salon* (1 work)
Autumn: Paris, 8 boulevard Montmartre, chez Carpentier

1870
May onwards: Paris, *Salon* (2 works)

1872
November: London, 168 New Bond Street, The Society of French Artists, *Fifth Exhibition* (1 work)

1873
May–June: Paris, *Salon des Refusés* (2 works)

1874
April–May: Paris, 35 boulevard des Capucines, Société anonyme des artistes peintres, sculpteurs, graveurs, etc., *Première exposition* (6 paintings, 1 pastel)
London, 168 New Bond Street, The Society of French Artists, *Ninth Exhibition* (2 works)

1876
February–March: Pau, Société des Amis des Beaux-Arts (2 works)
April: Paris, 11 rue Le Peletier, *Deuxième exposition de peinture* (15 works)

1877
April: Paris, 6 rue Le Peletier, *Troisième exposition de peinture* (21 works)

1878
May onwards: Paris, *Salon* (1 work)

1879
May onwards: Paris, *Salon* (2 paintings, 2 pastels)
June: Paris, La Vie moderne, *Cinquième exposition de la Vie moderne, P.-A. Renoir* (? only pastels)
July: Paris, La Vie moderne, *Les Dessins de la Vie moderne – première série* (with Renoir drawings)
December: Paris, La Vie moderne, *Les Tambourins de la Vie moderne* (1 work)

1880
May onwards: Paris, *Salon* (2 paintings, 2 pastels)

1881
May onwards: Paris, Société des artistes français, *Salon* (2 works)

1882
March: Paris, 251 rue Saint-Honoré, Salons du Panorama de Reichshoffen, *7me exposition des artistes indépendants* (25 works)

May onwards: Paris, Société des artistes français, *Salon* (1 work)
July: London, 13 King Street, exhibition of impressionist paintings lent by Durand-Ruel

1883
April: Paris, 9 boulevard de la Madeleine, Durand-Ruel, *Exposition des oeuvres de P. A. Renoir* (70 works)
April–July: London, Dowdeswell and Dowdeswell, *La Société des Impressionnistes* (10 works)
May onwards: Paris, Société des artistes français, *Salon* (1 work)
Boston, *American Exhibition of Foreign Products, Arts and Manufactures*, Art Department (3 works)
Autumn: Berlin, Gurlitt, exhibition of impressionist paintings

1884
January: Paris, 3*bis* rue de la Chaussée d'Antin, *Exposition du Cercle artistique de la Seine* (2 works)

1885
June: Brussels, Hôtel du Grand-Miroir, *Exposition de MM. Degas, Monet, Pissarro, Renoir et Sisley* (organized by Durand-Ruel)

1886
February–March: Brussels, Les XX, [*3e exposition*] (8 works)
April: New York, Madison Square South, American Art Galleries, American Art Association, *The Impressionists of Paris, Works in Oil and Pastel* (38 works)
April–June: New York, National Academy of Design, American Art Association, *The Impressionists of Paris, Works in Oil and Pastel* (transferred from the American Art Galleries) (38 works)
June–July: Paris, Galerie Georges Petit, *5e Exposition internationale de peinture et de sculpture* (5 works)
Autumn: Nantes, cours Saint-Pierre, *Exposition des Beaux-Arts* (2 works)

1887
May–June: New York, National Academy of Design, American Association for the Promotion and Encouragement of Art, *Celebrated Paintings by Great French Masters* (5 works)
May–June: Paris, Galerie Georges Petit, *6e Exposition internationale de peinture et de sculpture* (5 works)

1888
May–June: Paris, Galeries Durand-Ruel, *Exposition* (24 works)

1890
February–March: Brussels, Les XX, *VIIe Exposition annuelle* (5 works)
May onwards: Paris, Société des artistes français, *Salon* (1 work)
September–October: Chicago, Inter-State Industrial Exposition, *18th Annual Exhibition, Paintings* (3 works)

1891
April: Nantes, Société des amis des arts, *2me exposition* (2 works)
July: Paris, Galeries Durand-Ruel, *Renoir, tableaux de 1890–91*

1892
May: Paris, Galeries Durand-Ruel, *Exposition A. Renoir* (110 works)

1893
February: New York, American Fine Arts Society, Loan Exhibition, *Paintings: Modern Masters* (1 work)
Chicago, World's Columbian Exposition, *Loan Collection, Foreign Masterpieces owned in the United States* (1 work)

1894
February–March: Brussels, La Libre Esthétique, *Première Exposition* (2 works)
February: Buffalo, Fine Arts Academy, *Loan Exhibition* (1 work)
Saint Louis Exposition, *11th Annual Exhibition*, Art Department (2 works)

1895
Saint Louis Exposition, *12th Annual Exhibition*, Art Department (1 work)

1896
February–March: Brussels, La Libre Esthétique, *3e Exposition* (1 work)
May: Rouen, Hôtel du Dauphin et d'Espagne, *Magnifique collection d'Impressionnistes* (30 works, including Murer's collection)
May–June: Paris, Galeries Durand-Ruel, *Exposition Renoir* (42 works)
Saint Louis Exposition, *13th Annual Exhibition*, Art Department (1 work)

1897
Saint Louis Exposition, *14th Annual Exhibition*, Art Department (1 work)
November–1898 January: Pittsburgh, Carnegie Institute, *Second Annual Exhibition* (1 work)

1898
March: Boston, Copley Hall, Art Students Association, *Modern Painters* (2 works)
May–June: Paris, Galeries Durand-Ruel, *Monet, Renoir, Pissarro, Sisley* (more than 10 works)
Summer: London, Knightsbridge, International Society of Sculptors, Painters and Gravers, *Exhibition of International Art* (1 etching)

1899
April: Paris, Galeries Durand-Ruel, *Exposition de tableaux de Monet, Pissarro, Renoir et Sisley* (42 works)
Spring: Dresden, *Kunst-Salon Ernst Arnold* (4 works)
May–July: London, Knightsbridge, International Society of Sculptors, Painters and Gravers, *Second Exhibition* (2 works)
November–1900 January: Pittsburgh, Carnegie Institute, *4th Annual Exhibition* (2 works)

1900
January–February: Paris, Galeries Bernheim-Jeune et Fils, *Exposition A. Renoir* (68 works)
April: New York, Durand-Ruel Galleries, *Exhibition of Paintings by Claude Monet and Pierre Auguste Renoir* (21 works)
June: Munich, Secession, *Internationale Kunst-Ausstellung* (1 work)
Paris, Exposition International Universelle de 1900, *Exposition centennale de l'art français (1800–1889)* (11 works)
Berlin, Secession, *Zweite Kunstausstellung* (2 works)
November: New York, The Union League Club, *Loan Exhibition* (1 work)

1901
January: Chicago, Art Institute, *Loan Collection of Selected Works of Modern Masters* (1 work)
Early: London, Hanover Gallery, *Pictures by French Impressionists and other Masters* (9 works)
March: Brussels, La Libre Esthétique, *Huitième exposition* (2 works)
Spring: Berlin, Secession, *Dritte Kunstausstellung* (2 works)
Boston, Copley Society, Copley Hall, *Loan Collection of Pictures of Fair Children* (1 work)
Glasgow: International Exhibition, *Fine Art Loan Collection* (1 work)
October–December: Berlin, Paul Cassirer, *IV. Jahrgang der Kunst-Ausstellungen, Ausstellung von Werken von Auguste Renoir, Max Slevogt, Wilhelm Trübner, Eugène Carrière, Fritz Klimsch, R. Carabin* (23 works)
October–December: London, The Galleries, 191 Piccadilly, International Society of Sculptors, Painters and Gravers, *Third Exhibition* (1 work)

1902
February–May: Glasgow, Royal Glasgow Institute of Fine Arts, *Forty-first Exhibition of Works of Modern Artists* (1 work)
June: Paris, Galeries Durand-Ruel, *Tableaux par A. Renoir* (40 works)
August–November: Prague, Société Manès, *Moderní Francouz. Umění* (2 works)
September: Dresden, Kunstsalon Ernst Arnold, *Gemälde französischer Künstler* (3 works)
Winter–1903: Berlin, Secession, *VI. Kunstausstellung, Zeichnende Künste* (1 lithograph)

1903
January–February: Vienna, Oesterreichs-Secession, *XVI. Ausstellung; Entwicklung des Impressionismus in Malerei und Plastik* (6 works)
April: Paris, Bernheim–Jeune, *Exposition d'Oeuvres de l'Ecole Impressionniste* (9 works)
April–October: Venice, *V Esposizione Internazionale d'Arte (Biennale)* (1 work)
May–July: London, Grafton Galleries, *French Masters* (4 works)
Budapest, *Tavaszi Nemzetközi Kiállítás* (1 work)
Berlin, *Grosse Berliner Kunst-Ausstellung* (2 works)

1904
February–March: Brussels, La Libre Esthétique, *Exposition des peintres impressionnistes* (12 works)
Dresden, *Grosse Kunstausstellung, Retrospektive Abteilung* (2 works)
Dublin, Royal Hibernian Academy, *Pictures presented to the City of Dublin to form the Nucleus of a Gallery of Modern Art, also Pictures lent by the Executors of the late Mr. J. Staats Forbes, and others* (1 work)
April–May: Paris, Musée National du Luxembourg, *Exposition temporaire de quelques chefs-d'oeuvre de maîtres contemporains* (3 works)
May–October: Düsseldorf, *Internationale Kunstausstellung* (2 works)
Saint Louis, *Universal Exhibition*, Department of Art (2 works)
Weimar [no precise location], *Monet, Manet, Renoir, Cézanne* (10 works)
October–November: Paris, Grand Palais, *Salon d'Automne* (Salle Renoir, 35 works)
November–December: New York, American Fine Arts Society, *Comparative Exhibition of Native and Foreign Art* (1 work)
?December: Berlin, Paul Cassirer, *VII. Jahrgang, III. Ausstellung* (1 work)

1905
January–February: London, Grafton Galleries, *Pictures by Boudin, Cézanne, Degas, Manet, Monet, Morisot, Pissarro, Renoir, Sisley, Exhibited by Messrs. Durand-Ruel and Sons of Paris* (59 works)
June: Boston, Messrs. Walter Kimball and Company, *Summer Exhibition of Paintings*
Venice, *VI Esposizione Internazionale d'Arte (Biennale)*, Sala Francese (2 works)
October–November: Paris, Grand Palais, *Salon d'Automne* (9 works)

1906
January–February: London, New Gallery, International Society of Sculptors, Painters and Gravers, *Sixth Exhibition* (2 works)
February–March: Bremen, *Internationale Kunstausstellung* (3 works)
February: Montreal, Art Gallery, *Works of Some French Impressionists* (3 works)
March–April: Basel, Kunsthalle, *Exposition d'art français* (5 works)
April–May: Belfast, Municipal Art Gallery, First Exhibition, *Modern Paintings*, (1 work)
Marseille, Exposition Nationale Coloniale, *L'Exposition rétrospective des Orientalistes français* (3 works)
October–November: Paris, Bernheim-Jeune, *Exposition d'Aquarelles, Pastels, Gouaches et Dessins*
October–November: Paris, Grand Palais, *Salon d'Automne* (5 works)

1907
March–April: Strasbourg, Château des Rohan, *Art Français contemporain* (3 works)
April–June: Pittsburgh, Carnegie Institute, *11th Annual Exhibition* (1 work)
May–July: Krefeld, Museum Kaiser Wilhelm, *Exposition d'Art Français* (4 works)
May–October: Mannheim, *Internationale Kunst-Ausstellung* (1 work)
Barcelona, *V Exposición International de Bellas Artes y Industrias Artísticas* (8 works)
Stuttgart, Museum der Bildenden Künste, *Ausstellung Französischer Kunstwerke* (3 works)
October–December: Buffalo, Fine Arts Academy, Albright Art Gallery, *Exhibition of Paintings by the French Impressionists* (8 works)
October–November: Prague, Société Manès, *Francouzští Impressionisti* (7 works)
November: Paris, Bernheim-Jeune, *Fleurs et natures mortes* (7 works)
December: Saint Louis, Museum of Fine Arts, *A Special Exhibition of Paintings by the French Impressionists* (8 works)
December: Budapest, Nemzeti Salon, *Modern Francia Nagymesterek Tárlata* (11 works)
December–1908: Manchester, City Art Gallery, *Exhibition of Modern French Painting* (14 works)
December–1908 January: Paris, Bernheim-Jeune, *Portraits d'hommes* (4 works)
December: Paris, Galerie E. Blot, *Exposition de Cent Vingt tableautins . . .* (7 works)

1908
January–February: London, New Gallery, International Society of Sculptors, Painters and Gravers, *Eighth Exhibition* (2 works)
February: Columbia, Missouri, Art Lovers Guild, *Second Annual Exhibition* (1 work)

February–March: London, New Gallery, International Society of Sculptors, Painters and Gravers, *Exhibition of Fair Women* (2 works)
February–March: Pittsburgh, Carnegie Institute, *Exhibition of Paintings by the French Impressionists* (10 works)
February–June: Rome, Società di Amatori e Cultori di Belle Arti, *LXXVII esposizione* (graphic work)
March–April: Brussels, La Libre Esthétique, *Salon jubilaire* (8 works)
March–April: Cincinnati, Museum, *Exhibition of Paintings by the French Impressionists* (4 works)
April–May: Brussels, Musée moderne, Cercle d'Art Vie et Lumière, *IVe Exposition* (4 works)
April–May: Minneapolis, Society of Arts, *Special Exhibition of Paintings by the French Impressionists* (4 works)
April–May: Moscow, Golden Fleece, *First Exhibition* (1 work)
April–May: Paris, Galeries Durand-Ruel, *Exposition de Natures mortes* (42 works)
April–June: Pittsburgh, Carnegie Institute, *12th Annual Exhibition* (1 work)
May–June: Paris, Galeries Durand-Ruel, *Exposition de paysages par Claude Monet et Renoir* (37 works)
Summer: Paris, Bernheim-Jeune, *Exposition permanente* (1 work)
London, *Franco-British Exhibition* (3 works)
October–November: Zurich, Künstlerhaus, *VIII. Serie, Französische Impressionisten* (4 works)
November–December: New York, Durand-Ruel Galleries, *Exhibition of Paintings by Pierre Auguste Renoir* (41 works)

1909
January–February: Montreal, Art Association, *Exposition d'art français* (3 works)
February–March: London, New Gallery, International Society of Sculptors, Painters and Gravers, *Exhibition of Fair Women* (2 works)
March–April: Brussels, La Libre Esthétique, *Seizième exposition* (1 work)
April–June: Pittsburgh, Carnegie Institute, *13th Annual Exhibition* (1 work)
Liège, *Salon International* (2 works)
July–September: Kassel, Kunstverein, *Französische Kunstausstellung* (1 work)
August–September: Hagen, Museum Folkwang, *Sonderausstellung, Graphische Arbeiten* (5 lithographs)
November: Munich, Moderne Galerie, *Impressionisten-Ausstellung* (8 works)
November–December: Paris, Galerie E. Blot, *Natures mortes et fleurs* (1 work)
December: Mannheim, Kunsthalle, *Ausstellung von Werken der Malerei des 19 Jahrhunderts* (6 works)
December–1910 January: Berlin, Secession, *XIX. Ausstellung, Zeichnende Künste* (2 graphic works)

1910
January: Brooklyn, Art Gallery, Pratt Institute, *Exhibition of Modern French Paintings* (1 work)
March–April: Brussels, La Libre Esthétique, *L'Evolution du paysage* (3 works)
April–May: Budapest, Müvészház, *Nemzetközi Impresszionista Kiállítás* (4 works)
April–May: Florence, Lyceum Club, *Prima Mostra Italiana dell' Impressionismo* (2 paintings, 3 lithographs)
April: Paris, Bernheim-Jeune, *D'après les maîtres* (1 work)
April–October: Venice, *IX Esposizione Internazionale d'Arte (Biennale), Sala 6, Mostra individuale di Pierre-Auguste Renoir* (37 works)
Spring: Berlin, Secession, *Zwanzigste Ausstellung* (1 work)
May: Paris, Bernheim-Jeune, *Nus* (7 works)
May–June: Pittsburgh, Carnegie Institute, *14th Annual Exhibition* (1 work)
June–August: Brighton, Public Art Galleries, *Exhibition of the Works of Modern French Artists* (2 works)
June: Paris, Galeries Durand-Ruel, *Tableaux par Monet, C. Pissarro, Renoir et Sisley* (35 works)
Brussels, Exposition universelle et internationale, Section II, *Oeuvres d'art modernes* (3 works)
Chicago, Art Institute, *The Potter Palmer Collection*
Paris, Palais du Domaine de Bagatelle, Société Nationale des Beaux-Arts, *"Les Enfants", leurs portraits, leurs jouets, Exposition rétrospective 1789 à 1900* (1 work)

October–November: Leipzig, Kunstverein, *Ausstellung Französischer Kunst* (3 works)
October–November: Paris, Grand Palais, *Salon d'Automne* (1 work, in Bazille Exh.)
November–1911 January: Berlin, Secession, *XXI. Ausstellung, Zeichnende Kunst* (1 work)
November–December: New York, Photo-Secession Gallery, *Loaned Collection of some Lithographs etc.*
December: New York, Lotos Club, *Exhibition of Paintings by French and American Luminists* (3 works)
December: Paris, Bernheim-Jeune, *La Faune* (5 works)

1911
February–April: Hannover, Kunstverein, *Grosse Kunst-Ausstellung* (1 work)
February–March: Paris, Bernheim-Jeune, *Collection Maurice Masson* (2 works)
May–June: Wiesbaden, Hotel Vier Jahreszeiten, Dr. F. Graefe, Kunstsalon, *Moderne Französische Künstler* (2 works)
June–July: London, Grafton Gallery, International Society of Sculptors, Painters and Gravers, *Century of Art Exhibition 1810–1910* (1 work)
June–July: Paris, Bernheim-Jeune, *L'Eau* (2 works)
Munich, Alte Pinakothek, *Gemälde aus der Sammlung von Nemes* (2 works)
Rome, *Esposizione Internazionale di Roma, Mostra di Belle Arti* (1 work)
Warsaw, *Artystów Francuskich* (2 works)
August: Belfast, Municipal Art Gallery, *Loan Exhibition of Modern Paintings* (1 work)
October–November: Vienna, Galerie Arnot, *Französische Impressionisten* (1 work)
November–December: Berlin, Secession, *XXIII. Ausstellung, Zeichnende Künste* (3 lithographs)

1912
Early: St Petersburg, Institut français, *Exposition Centennale d'art français* (24 works)
January–February: Munich, Moderne Galerie Heinrich Thannhauser, *Auguste Renoir* (41 works)
January–February: Toledo, Museum of Art, *Inaugural Exhibition* (1 work)
January–February: Vienna, Galerie Miethke, *Französische Meister* (10 works)
February–March: Berlin, Paul Cassirer, *VI. Ausstellung* (41 works, the same works as exhibited Munich, January–February 1912)
February–March: New York, Durand-Ruel Galleries, *Exhibition of Paintings by Renoir* (21 works)
March: Boston, Brooks Reed Galleries, Exhibition organized by Durand-Ruel
April–July: Amsterdam, Stedelijk Museum, *Exposition Internationale des Beaux-Arts* (1 work)
April–June: Leipzig, Verein LIA, *Leipziger Jahresausstellung 1912* (2 works)
April–May: London, Grafton Galleries, International Society of Sculptors, Painters and Gravers, *Twelfth Exhibition* (1 work)
April–May: Paris, Galeries Durand-Ruel, *Exposition de tableaux par Renoir* (73 works, 1 ex catalogue)
April–June: Pittsburgh, Carnegie Institute, *16th Annual Exhibition* (1 work)
May: Marseille, Ateliers du Quai Rive-Neuve, *Salon de mai, Première Exposition* (3 works)
May–October: Dresden, Städtischer Ausstellungspalast, *Grosse Kunstausstellung* (2 works)
May–July: Paris, Palais du Domaine de Bagatelle, Société Nationale des Beaux-Arts, *La Musique, La Danse, Exposition rétrospective* (2 works)
June: Paris, Galeries Durand-Ruel, *Portraits par Renoir* (49 oils; 9 pastels)
?Summer: Paris, Manzi, Joyant & Cie, *Exposition d'Art Moderne* (28 works)
July–August: Zürich, Kunstsalon Wolfsberg, *Gemälde-Ausstellung Französischer Meister*
July–December: Düsseldorf, Städtische Kunsthalle, *Sammlung Marczell von Nemes* (4 works)
July–September: Frankfurt-am-Main, Frankfurter Kunstverein, *Die Klassische Malerei Frankreichs im 19 Jahrhundert* (9 works)
July: Hagen, Museum Folkwang, *Moderne Kunst* (6 oils, one lithograph)
October–November: Berlin, Paul Cassirer, *XV. Jahrgang, I. Ausstellung* (11 works)

October–November: Paris, Grand Palais, *Salon d' Automne, Exposition de portraits du XIXe Siècle* (2 works)
December: Vienna, Galerie Arnot, *Ausstellung von Werken moderner Franzosen* (3 works)

1913
January: Berlin, Paul Cassirer, *XV. Jahrgang, III. Ausstellung, Sammlung Reber* (2 works)
January: Boston, Saint Botolph Club, *Impressionist paintings, lent by Messrs Durand-Ruel and Sons* (4 works)
?January: Budapest, Ernst-Museum, *Francia Impresszionisták* (1 work)
January–February: Vienna, Galerie Miethke, *Die Neue Kunst* (1 work)
February–March: New York, Armory of the Sixty-ninth Regiment, *Armory Show* (5 works)
February–March: New York, Association of American Painters and Sculptors, Inc., *International Exhibition of Modern Art* (4 works)
February–March: Zurich, Kunsthaus, *Französische Kunst* (2 works)
March: Berlin, Paul Cassirer, *XV. Jahrgang, VI. Ausstellung* (2 works)
March–April: Brussels, La Libre Esthétique, *Interprétations du midi* (4 works)
March–April: Chicago, Art Institute of Chicago, *Armory Show* (11 lithographs)
March–June: Rome, Secession, *Prima Esposizione Internazionale d' Arte* (2 works)
March: Paris, Bernheim-Jeune et Cie, *Exposition Renoir* (52 works)
March: Vienna, Galerie Miethke, *Französische Impressionisten* (10 works)
April–May: Boston, Copley Hall, Copley Society of Boston, *Armory Show* (lithographs)
?April–May: London, Grosvenor Gallery, International Society of Sculptors, Painters and Gravers, *Spring Exhibition* (1 work)
April: Munich, Galerie Heinemann, *Französische Kunst des XIX. Jahrhunderts* (4 works)
April–June: Pittsburgh, Carnegie Institute, *17th Annual Exhibition* (1 work)
Spring: Berlin, Secession, *XXVI. Ausstellung* (10 works)
May–October: Düsseldorf, Städtischer Ausstellungspalast, *Grosse Kunstausstellung* (2 works)
May–October: Stuttgart, Kgl. Kunstgebäude, *Grosse Kunstausstellung* (7 works)
June–July: Paris, Galerie Manzi, Joyant & Cie, *Exposition d' Art Moderne de 1913* (30 works)
Summer: Berlin, Paul Cassirer, *XV. Jahrgang, Sommerausstellung* (3 works)
?Summer: Ghent, Exposition Universelle, *Beaux-Arts: Oeuvres Modernes* (2 works)
?Autumn: Budapest, Ernst-Museum, *A XIX. Szazad Nagy Francia Mesterei* (3 works)
October–November: Berlin, Neue Galerie, *Erste Ausstellung* (1 work)
November: Berlin, Paul Cassirer, *Degas/Cézanne* (10 works)
December–1914 January: New York, Durand-Ruel Galleries, *Exhibition of Paintings representing Still Life and Flowers* (8 works)

1914
January–February: Vienna, Kunstsalon Pisko, *Konkurrenz C.R.* (3 works)
February: New York, Durand-Ruel Galleries, *Exhibition of Paintings by Renoir* (30 works)
February–March: Bremen, Kunsthalle, *Internationale Ausstellung* (8 works)
April–September: Berlin, Secession Ausstellungshaus, *Erste Ausstellung der freien Secession* (2 works)
April–May: Dresden, Galerie Ernst Arnold, *Ausstellung Französischer Malerei des XIX. Jahrhunderts* (11 works)
May–June: Copenhagen, Statens Museum for Kunst, *Fransk Malerkunst fra det 19nde Aarhundrede* (12 works)
June: Paris, Bernheim-Jeune, *Le Paysage du midi* (5 works)
Summer: Berlin, Paul Cassirer, *XVI. Jahrgang, Sommerausstellung* (5 works)
Summer: Munich, Hans Goltz, *Neue Kunst Sommerschau* (2 works)
London, Grosvenor House, *Exposition d' Art décoratif contemporain 1800–1885* (10 works)

1915
Summer: San Francisco, *Panama–Pacific International Exhibition, Department of Fine Arts* (5 works)
Rome, Secessione, *III Internazionale* (1 work)

November: Detroit, Museum of Art, *Exhibition of Paintings by French Impressionists* (7 works)
December: New York, Durand-Ruel Galleries, *Exhibition of Paintings by Claude Monet and Pierre Auguste Renoir* (10 works)

1916
January: New York, M. Knoedler and Co., *Exhibition of Paintings by Contemporary French Artists* (4 works)
March–April: Buffalo, Albright Art Gallery, *Exhibition of French and Belgian Art* selected from the Panama–Pacific International Exhibition (1 work)
March–April: Paris, Jeu de Paume, La Triennale, *Exposition d'art français au profit de la Fraternité des artistes* (3 works, inc. 2 bronzes)
October–December: Buffalo, Fine Arts Academy, Albright Art Gallery, *Retrospective Collection of French Art, 1870–1910*, lent by the Luxembourg Museum, Paris, France (4 works)
October–November: Winterthur, Kunstverein, *Peinture française* (26 works)
November–early 1917: The Hague, exhibition of French art

1917
January: New York, Durand-Ruel Galleries, *Exhibition of Paintings by Renoir* (18 works)
April–July: Barcelona, Palau de Belles Artes, *Exposició d'art francès contemporani* (5 works)
March–April: Stockholm, Nationalmuseum, *Fransk Konst fran 1800–talet* (8 works)
April: Paris, Galeries Georges Petit, *Exposition de Tableaux . . . au profit de la Fraternité des artistes* (1 work)
June: Paris, Berheim-Jeune, *Essai d'une collection* (3 works)
June–July: Paris, Galeries Paul Rosenberg, *Exposition d'art français du XIXe Siècle*, au profit de l'association générale des mutilés de la guerre (16 works)
October–November: Zurich, Kunsthaus, *Französische Kunst des XIX und XX Jahrhunderts* (57 paintings, 3 bronzes)
December: Worcester, Art Museum, *Exhibition of Paintings by Modern French Masters* (5 works)

1918
January–February: Oslo, I Kunstnerforbundet, *Den Franske Utstilling* (13 works)
February–March: New York, Durand-Ruel Galleries, *Exhibition of Paintings by Renoir* (28 works)

1919
March: Paris, Bernheim-Jeune, *Dessins, Aquarelles et Pastels*
April: New York, Durand-Ruel Galleries, *Exhibition of Recently Imported Works by Renoir* (35 works)
?New York and elsewhere in USA, *Exhibition of French Modern Art*, organized by the French Ministry of Public Instruction . . . (1 work)

Unverified Exhibitions

1897
Stockholm, Exhibition organized by Durand-Ruel

1898
Vienna, Exposition internationale des beaux-arts

1899
January–February: St Petersburg, Exposition de peinture française *(12 works)*
Autumn: Vienna, Secession, Studies and Products of Modern Drawing

1900
April: Nantes, Société des amis des arts
Amsterdam, Arti et amicitiae

1905
Summer: Buffalo, Albright Art Gallery, Inaugural Loan Exhibition

1909–10
Winter: Bremen, Internationale Kunstausstellung

1911
Cambridge, Mass., Fogg Art Museum, Harvard University, French Painting

1913
Dresden, Galerie Arnhold, Ausstellung Graphischer Kunst

1914
July: Dresden, Galerie Arnhold, Ausstellung Französischer Malerei
(collections allemands)

? c. 1915
Toronto, Canadian National Exhibition Fine Arts

1919
Paris, Petit Palais, Exposition de maîtres illustrés depuis le XVIIIe Siècle
jusqu' à nos jours

Selected bibliography

The bibliography makes no claim to be comprehensive. It aims to include all material which the compilers have found to be informative and of interest.

The bibliography is arranged in alphabetical order by author and, for exhibition or museum catalogues and sales, by city. Works by the same author are listed in chronological order.

[Adam, P., and Moréas, J.], *Petit Bottin des Lettres et des Arts*, Paris 1886

Adhémar, J., 'Schnerb, Cézanne et Renoir', *Gazette des Beaux-Arts*, April 1982

Alexandre, A., 'Renoir', in catalogue of *Exposition A. Renoir*, Durand-Ruel, Paris 1892

Alexandre, A., *La Collection Henri Rouart*, Paris 1912

Alexandre, A., 'Billet à Renoir', unidentified press cutting, 1913 (in Fonds Vauxcelles, Bibliothèque d'Art et d'Archéologie, Université de Paris)

Alexandre, A., 'Renoir sans phrases', *Les Arts*, March 1920

Alexandre, A., *La Collection Canonne, Une Histoire en action de l'impressionnisme et de ses suites*, Paris 1930

Alexandre, A., 'Propos inédits de et sur Renoir', *Les Nouvelles littéraires*, 26 August 1933

Alexis, P., 'Les Impressionnistes de la collection Murer', *Le Cri du peuple*, 21 October 1887

André, A., *Renoir*, Paris 1919; enlarged editions, 1923, 1928

André, A., 'Les Dessins de Renoir', *Cahiers d'aujourd'hui*, May 1921; reprinted in André 1928, and as *Renoir, dessins*, Paris 1950

André, A., and Elder, M., *L'Atelier de Renoir*, 2 volumes, Paris 1931

André, A., 'Renoir et ses modèles', *Le Point*, January, March, May and October 1936

André, A., 'Les Modèles de Renoir', *Les Lettres françaises*, 20–27 August and 27 August–3 September 1953

Ann Arbor, University of Michigan, Museum of Art, *The Crisis of Impressionism 1878–1882*, exhibition catalogue by J. Isaacson and others, 1979–80

[Anon.], 'Renoiriana', *Bulletin de la vie artistique*, 15 December 1919

[Anon.], 'L'Eternel Jury', *Cahiers d'aujourd'hui*, January 1921

[Anon.], 'Nos Artistes: Le peintre P.-A. Renoir chez lui', *L'Eclair*, 9 August 1892

[Anon.], 'Les Hommes de jour: M. Renoir, artiste peintre', *L'Eclair*, 12 May 1899

[Anon.], *La Maison de Renoir, Musée Renoir du Souvenir (Renoir à Cagnes et aux Collettes*, 6, Cagnes 1976

[Anon.], 'Le Jour et la nuit', *Le Moniteur universel*, 8 April 1877

[Anon.], *Renoir aux Collettes*, 1, Cagnes 1960; 2, Cagnes 1961

[Anon.], 'Le Peintre A. Renoir et son oeuvre', *Le Temps*, 12 May 1892

[Anon.], 'Renoir as sitter, a family portrait', *Times Literary Supplement*, 30 November 1962, with correspondence 14 and 28 December 1962

Aurier, A., 'Renoir', in *Oeuvres posthumes*, Paris 1893

Baignières, A., 'Le Salon de 1879', *Gazette des Beaux-Arts*, 1 July 1879

Banville, T. de, 'Salon de 1879, III', *Le National*, 16 May 1879

Barotte, R., 'Dans sa guinguette de la forêt, Edmond Renoir évoque la belle figure de son frère', *Paris-Soir*, 25 June 1933

Baudot, J., *Renoir, ses amis, ses modèles*, Paris 1949

Bazin, G., 'Un Tableau de Renoir: Le Ravin de la femme sauvage', *Bulletin des Musées de France*, December 1946

Bazin, G., Florisoone, M., Leymarie, J., 'L'Impressionnisme', *L'Amour de l'art*, 1947

Bell, C., 'Renoir', in *Since Cézanne*, London 1922

Bell, C., *Auguste Renoir, Les Parapluies*, London [1945]

Bénédite, L., *L'Art au XIXe siècle*, Paris [c. 1902]

Bénédite, L., 'Madame Charpentier and her Children, by Auguste Renoir', *Burlington Magazine*, December 1907

Berard, M., 'Renoir en Normandie et la famille Berard', *L'Amour de l'art*, February 1938

Berard, M., *Renoir à Wargemont*, Paris [1939]

Berard, M., 'Un Diplomate ami de Renoir', *Revue d'histoire diplomatique*, July–September 1956

Berard, M., 'Lettres de Renoir à Paul Berard', *La Revue de Paris*, December 1968

Berhaut, M., *Caillebotte, sa vie et son oeuvre*, Paris, 1978

Bernac, J., 'The Caillebotte Bequest to the Luxembourg', *Art Journal*, August, October, December 1895

Bernier, R., 'Dans la lumière impressionniste', *L'Oeil*, May 1959

Bertall, 'Souvenirs du Salon de 1879', *L'Artiste*, August 1879

Besson, G., 'Renoir à Cagnes', *Cahiers d'aujourd'hui*, November 1920

B[esson], G., 'Renoir, par Ambroise Vollard', *Cahiers d'aujourd'hui*, July 1921

Besson, G., *Renoir*, Paris 1929

Besson, G., 'Arrivée de Matisse à Nice, Matisse et quelques personnages', *Le Point*, July 1939

Besson, G., 'Renoir aux Collettes, Douleur et Génie', *Les Lettres françaises*, 30 June–7 July 1955

Blanche, J. E., *Cahiers d'un artiste*, I, Paris 1915

Blanche, J. E., 'Sur les routes de la Provence, de Cézanne à Renoir', *Revue de Paris*, 15 January 1915; reprinted in *Propos de peintre, I, de David à Degas*, Paris 1919

Blanche, J. E., 'La Technique de Renoir', *L'Amour de l'art*, February 1921

Blanche, J. E., *Dieppe*, Paris 1927

Blanche, J. E., *Les Arts plastiques, La troisième république, 1870 à nos jours*, Paris 1931

Blanche, J. E., 'Renoir portraitiste', *L'Art vivant*, July 1933

Blanche, J. E., *Portraits of a Lifetime*, London 1937

Blanche, J. E., *La Pêche aux souvenirs*, Paris 1949

Blémont, E., 'Les Impressionnistes', *Le Rappel*, 9 April 1876

Bodelsen, M., 'Early Impressionist Sales 1874–94 in the light of some unpublished "procès-verbaux"', *Burlington Magazine*, June 1968

Boime, A., *The Academy and French Painting in the Nineteenth Century*, London 1971

Boime, A., 'Entrepreneurial Patronage in Nineteenth-Century France', in *Enterprise and Entrepreneurs in Nineteenth- and Twentieth-Century France*, edited by E. C. Carter, R. Forster and J. N. Moody, Baltimore 1976; modified version in French: 'Les Hommes d'affaires et les arts en France au 19ème siècle', *Actes de la recherche en sciences sociales*, June 1979

Bonnard, P., 'Souvenirs sur Renoir', *Comoedia*, 18 October 1941; original version in F. Bouvet, *Bonnard, l'oeuvre gravé*, Paris 1981

Brahm, C., 'Two copies of Delacroix's Noce juive dans le Maroc', *Gazette des Beaux-Arts*, November 1952

Brüne, H., 'Erinnerung an Renoir', in Munich, Städtische Galerie, *Auguste Renoir*, 1958

Burty, P., 'Exposition de la Société Anonyme des artistes', *La République française*, 25 April 1874

Burty, P., 'Exposition des impressionnistes', *La République française*, 25 April 1877

Burty, P., 'L'Exposition des artistes indépendants' and 'Salon de 1879', *La République française*, 16 April and 27 May 1879

Burty, P., 'Les Peintures de M.P. Renoir', *La République française*, 15 April 1883

Callen, A., 'Faure and Manet', *Gazette des Beaux-Arts*, March 1974

Callen, A., *Renoir*, London 1978

Callen, A., *Techniques of the Impressionists*, London 1982

Castagnary, J., 'L'Exposition du boulevard des Capucines, Les Impressionnistes', *Le Siècle*, 29 April 1874

Castagnary, J., *Salons, 1857–1879*, 2 volumes, Paris 1892

Catinat, M., *Les Bords de la Seine avec Renoir et Maupassant*, London 1952

Cennino Cennini, *Le Livre de l'art, ou Traité de la Peinture*, translated by V. Mottez, new edition with a letter from Renoir, Paris 1911

Cézanne, P., *Correspondance*, edited by J. Rewald, Paris 1978

Champa, K. S., *Studies in Early Impressionism*, London and New Haven 1973

Champier, V., 'Le Salon-Portrait', *L'Année artistique*, 1879

Chaumelin, M., 'Le Salon de 1870, VII', *La Presse*, 17 June 1870

Chesneau, E., 'A côté du Salon, II, le plein-air, Exposition du boulevard des Capucines', *Paris-Journal*, 7 May 1874

Chesneau, E., 'Le Salon de 1879 – Peinture', *Le Moniteur Universel*, 13 June 1879

Chicago, Art Institute of Chicago, *Paintings by Renoir*, exhibition catalogue by J. Maxon and others, 1973

Chicago, Art Institute of Chicago, *Frédéric Bazille and Early Impressionism*, exhibition catalogue by J. P. Marandel and others, 1978

Clergue, D. J., 'Madeleine modèle de Renoir', in [Anon.], *La Maison de Renoir*, 1976

Comte, J., 'Exposition d'art', *L'Illustration*, 28 April 1883

Cooper, D., *The Courtauld Collection*, London 1954

Cooper, D., 'Renoir, Lise and the Le Coeur Family: A Study of Renoir's Early Development', *Burlington Magazine*, May, September–October 1959

Coquiot, G., *Renoir*, Paris 1925

Crouzet, M., *Un Méconnu du Réalisme: Duranty*, Paris 1964

Dauberville, H., *La Bataille de l'Impressionnisme*, Paris 1967

Daulte, F., *Frédéric Bazille et son temps*, Geneva 1952

Daulte, F., *Pierre-Auguste Renoir, Watercolours, Pastels and Drawings in colour*, London 1959

Daulte, F., *Auguste Renoir, Catalogue raisonné de l'oeuvre peint, I, Figures 1860–1890*, Lausanne 1971

Daulte, F., *Renoir*, Milan 1972; French and English translations 1973

Daulte, F., 'Renoir et la famille Bérard', *L'Oeil*, February 1974

Delage, R., 'Chabrier et ses amis impressionnistes', *L'Oeil*, December 1963

Delsemme, P., *Téodor de Wyzewa et le cosmopolitisme littéraire en France à l'époque du symbolisme*, Brussels 1967

Denis, M., 'Le Salon du Champ-de-Mars, l'Exposition Renoir', *La Revue blanche*, 25 June 1892; reprinted in *Théories (1890–1910); du symbolisme et de Gauguin vers un nouvel ordre classique*, Paris 1912

Denis, M., 'Renoir', *La Vie*, 1 February 1920; reprinted in *Nouvelles théories, sur l'art moderne, sur l'art sacré (1914–1921)*, Paris 1922

Denis, M., *Journal*, 3 volumes, Paris 1957–9

Dewhurst, W., *Impressionist Painting, its Genesis and Development*, London 1904

Drucker, M., *Renoir*, Paris 1944

Dumas, P., 'Quinze tableaux inédits de Renoir', *La Renaissance de l'art français*, July 1924

Duranty, 'Salon de 1870, XII, erratum', *Paris-Journal*, 19 May 1870

Duret, T., *Les Peintres impressionnistes*, Paris 1878; reprinted in *Critique d'avant-garde*, Paris 1885

Duret, T., preface to *Catalogue de l'exposition des oeuvres du P.-A. Renoir, 9, Boulevard de la Madeleine*, April 1883; reprinted in *Critique d'avant-garde*, Paris 1885

Duret, T., *Histoire des peintres impressionnistes*, Paris 1906; enlarged edition, Paris 1922

Duret, T., *Manet and the French Impressionists*, London 1910

Duret, T., *Renoir*, Paris 1924; English translation 1937

Duthuit, G., *Renoir*, Paris 1923

Duval, E. L., *Téodor de Wyzewa, Critic without a Country*, Geneva and Paris 1961

Enault, L., 'L'Exposition des intransigeants de la galerie Durand-Ruel', *Le Constitutionnel*, 10 April 1876

Faison, S. L., 'Renoir's Hommage à Manet', in *Intuition und Kunstwissenschaft, Festschrift Hanns Swarzenski*, Berlin 1973

Faure, E., *Histoire de l'Art, IV, L'Art Moderne*, Paris 1920

Faure, E., 'Renoir', *Revue hebdomadaire*, 17 April 1920; reprinted in *L'Arbre d'Eden*, Paris 1922

Faure, E., 'A propos d'une collection célèbre, La collection Gangnat', *La Renaissance de l'art français*, April 1925

Fénéon, F., 'Les grands collectionneurs, I, Isaac de Camondo', *Bulletin de la vie artistique*, 1 April 1920

Fénéon, F., 'Les grands collectionneurs, II, Paul Durand-Ruel', *Bulletin de la vie artistique*, 15 April 1920

Fénéon, F., *Oeuvres plus que complètes*, edited by J. O. Halperin, Paris 1970

Fezzi, E., *L'opera completa di Renoir nel periodo impressionista, 1869–1883*, Milan 1972

Flor O'Squarr, C., 'Les Impressionnistes', *Le Courrier de France*, 6 April 1877

Florisoone, M., *Renoir*, Paris 1937; English translation 1938

Florisoone, M., 'Renoir et la famille Charpentier', *L'Amour de l'art*, February 1938

Fontainas, A., *Histoire de la Peinture française au XIXe siècle*, Paris 1906

Forge, A., 'Renoir at the Tate', *The Listener*, 1 October 1953

Fosca, F., 'Les Dessins de Renoir', *Art et décoration*, October 1921

Fosca, F., *Renoir*, Paris 1923

Fosca, F., *Renoir*, London and Paris 1961

Francastel, P., *L'Impressionnisme*, Paris 1937; reprinted 1974

Frère, H., *Conversations de Maillol*, Geneva 1956

Fry, R., 'The Sir Hugh Lane Pictures at the National Gallery', *Burlington Magazine*, April 1917

Fry, R., 'Renoir', in *Vision and Design*, London 1920 and later editions

Gachet, P., *Deux amis des impressionnistes, Le Docteur Gachet et Murer*, Paris 1956

Gachet, P., *Lettres impressionnistes*, Paris 1957

Gasquet, J., 'Le Paradis de Renoir', *L'Amour de l'art*, February 1921

Gaunt, W., *Renoir*, with notes by K. Adler, Oxford 1982

Gauss, C. E., *The Aesthetic Theories of French Artists, from Realism to Surrealism*, Baltimore 1949

Geffroy, G., 'Salon de 1890, V, Fantin-Latour – Renoir', in *La Vie artistique*, I, Paris 1892

Geffroy, G., 'L'impressionnisme, III, Auguste Renoir', *L'Encyclopédie*, 15 December 1893

Geffroy, G., *La Vie artistique*, III, Paris 1894

Geffroy, G., 'Renoir', *Le Journal*, 20 June 1896; reprinted in *La Vie artistique*, VI, Paris 1900

Geffroy, G., 'Au Luxembourg', *Le Journal*, 16 February 1897

Geffroy, G., *Claude Monet, sa vie, son oeuvre*, 2 volumes, Paris 1924

George, W., 'Renoir et Cézanne', *L'Amour de l'art*, February 1921

George, W., 'Renoir', in *Histoire générale de l'art français de la Révolution à nos jours*, by A. Fontainas, L. Vauxcelles and others, Paris 1922

George, W., 'L'Oeuvre sculpté de Renoir', *L'Amour de l'art*, November 1924

Georges-Michel, M., *De Renoir à Picasso*, Paris 1954

Gimpel, R., *Journal d'un collectionneur, marchand de tableaux*, Paris 1963

Gold, A., and Fizdale, R., *The Life of Misia Sert*, New York and London 1980

Gordon, D. E., *Modern Art Exhibitions, 1900–1916*, Munich 1974

Goujon, J., *Salon de 1870, propos en l'air*, Paris [1870]

Goulinat, J. G., 'Technique picturale, les sources du métier de Renoir', *L'Art vivant*, 1 April 1925

Gowing, L., *Renoir, Paintings*, London 1947

Grappe, G., 'Renoir', *L'Art vivant*, July 1933

Grimm, Baron, 'Lettres anecdotiques, Les Impressionnistes', *Le Figaro*, 5 April 1877

Groschwitz, G. von, 'Renoir's Garden in Montmartre', *Carnegie Magazine*, March 1966

Guenne, J., 'La Religion de Renoir', *L'Art vivant*, July 1933

Guillemot, M., 'Dans l'atelier de Renoir', *Gil Blas*, 6 October 1911

Haesaerts, P., *Renoir: Sculptor*, New York 1947

Hamerton, P. G., *The Present State of the Fine Arts in France*, London 1892

Harris, F., 'Henri Matisse and Renoir: Master Painters', in *Contemporary Portraits, Fourth Series*, London 1924

Hervilly, E.d', 'L'Exposition du boulevard des Capucines', *Le Rappel*, 17 April 1874

Hillairet, J., *Dictionnaire historique des rues de Paris*, 2 volumes, Paris 1963

Hoppe, R., *Städer och Konstnärer*, Stockholm 1931

Hugon, H., 'Les Aïeux de Renoir et sa maison natale', *Le Vie Limousine*, 25 January 1935

Huneker, J., *Promenades of an Impressionist*, London and New York 1910

Huysmans, J. K., *L'Art moderne*, Paris 1883

Huysmans, J. K., 'Chronique d'art, l'Exposition internationale de la rue de Sèze', *Revue indépendante*, June 1887

Isaacson, J., 'Impressionism and Journalistic Illustration', *Arts Magazine*, June 1982

Jacques, 'Menus propos, Salon impressionniste, II', *L'Homme libre*, 12 April 1877

Jamot, P., 'Renoir', *Gazette des Beaux-Arts*, November and December 1923

Jean-Pascal, *Le Salon d'Automne en 1904*, Paris 1904

Jeanès, J. E. S., *D'après nature, souvenirs et portraits*, Besançon 1946

Joëts, J., 'Les Impressionnistes et Chocquet, lettres inédites', *L'Amour de l'art*, April 1935

Johnson, U. E., *Ambroise Vollard, Editeur*, new edition, New York 1977

Jourdain, F., *Les Décorés, Ceux qui ne le sont pas*, Paris 1895

Jourdain, F., *Renoir: Le Moulin de la Galette*, Paris [c. 1947]

Kahn, G., 'Exposition des impressionnistes', *Revue indépendante*, June 1888

Kálmán, M., 'Les Dessins de Renoir au Musée des Beaux-Arts', *Acta Historiae Artium Academiae Scientiarum Hungaricae* (Budapest), IV, 1956

Kolb, P., and Adhémar, J., 'Charles Ephrussi (1849–1905), ses secrétaires: Laforgue, A. Renan, Proust, "sa" Gazette des Beaux-Arts', *Gazette des Beaux-Arts*, January 1984

Laforgue, J., *Mélanges posthumes*, Paris 1903

Laporte, P. M., 'The Classic Art of Renoir', *Gazette des Beaux-Arts*, March 1948

Lecomte, G., 'L'Art contemporain', *Revue indépendante*, April 1892

Lecomte, G., *L'Art impressionniste, d'après la collection privée de M. Durand-Ruel*, Paris 1892

Lecomte, G., 'L'Oeuvre de Renoir', *L'Art et les artistes*, August 1907

Lecomte, G., 'Figures et souvenirs: le Paris de ma jeunesse', *Revue Universelle*, 1 March 1933

Lecoque, *Renoir, mon ami*, Paris 1962

Léger, C., 'Renoir illustrateur', *L'Art vivant*, January 1933

Leroy, L., 'Exposition des impressionnistes', *Le Charivari*, 11 April 1877

Lethève, J., *Impressionnistes et symbolistes devant la presse*, Paris 1959

Leymarie, J., *Impressionism*, Geneva 1955

Lhote, A., 'Renoir', *Nouvelle revue française*, 1 February 1920

Lhote, A., 'Renoir (à l'Orangerie)', *Nouvelle revue française*, 1 November 1933

Lhote, P., 'Mademoiselle Zélia', *La Vie moderne*, 3 November 1883

London, Arts Council of Great Britain, *Masterpieces from the São Paulo Museum*, 1954

London, Royal Academy of Arts, *Impressionism, its Masters, its Precursors, and its Influence in Britain*, exhibition catalogue by J. House, 1974

London, Royal Academy of Arts, *Post-Impressionism, Cross-Currents in European Painting*, exhibition catalogue by J. House, MA. Stevens and others, 1979–80

London, Royal Academy of Arts, *The Orientalists*, exhibition catalogue by MA. Stevens and others, 1984

London, Tate Gallery, *Renoir*, 1953

Longstreet, S. (intro), *The Drawings of Renoir*, Alhambra (Calif.) 1965

Lora, L. de, 'Petites nouvelles artistiques, exposition libre des peintres', *Le Gaulois*, 18 April 1874

Maillard, G., 'Les Impressionnistes', *Le Pays*, 9 April 1877

Mallarmé, S., 'The Impressionists and Edouard Manet', *Art Monthly Review*, September 1876, reprinted in *Documents Stéphane Mallarmé I*, edited by C. P. Barbier, Paris 1968

Mallarmé, S., *Correspondance*, edited by H. Mondor and L. J. Austin, III, Paris 1969; IV, 1973; V, 1981; VI, 1981; VII, 1982

Manet, J., *Journal (1893–1899)*, Paris 1979

Mantz, P., 'L'Exposition des peintres impressionnistes', *Le Temps*, 22 April 1877

Marthold, J. de, [review of Renoir exhibition], *La Ville de Paris*, 3 April 1883

Marx, R., 'Renoir', *Le Voltaire*, 26 April 1892; reprinted in *Maîtres d'hier et d'aujourd'hui*, Paris 1914

Mauclair, C., 'Beaux Arts, Exposition Renoir – Durand-Ruel', *Revue indépendante*, May 1892

Mauclair, C., 'L'Oeuvre d'Auguste Renoir', *L'Art décoratif*, February and March 1902

Mauclair, C., *The Great French Painters*, London 1903

Mauclair, C., *The French Impressionists*, London 1903 (French edition, *L'Impressionnisme*, Paris 1904)

Mauclair, C., 'De Fragonard à Renoir (un leçon de nationalisme pictural)', in *De Watteau à Whistler*, Paris 1905

Maus, M. O., *Trente années de lutte pour l'art, 1884–1914*, Brussels 1926

Max, C., 'Le Peintre Auguste Renoir', *Revue méridionale*, June, September and October–November 1907

Meier-Graefe, J., *Modern Art*, London 1908

Meier-Graefe, J., *Auguste Renoir*, Paris 1912

Meier-Graefe, J., *Renoir*, Leipzig 1929

M[ellério], A., 'Les Artistes à l'atelier, Renoir', *L'Art dans les deux mondes*, 31 January 1891

Mézin, B. de, *Promenade en long et en large au Salon de 1870*, Paris [1870]; published also in *Le Vélocipède illustré*

Mirbeau, O., 'Notes sur l'art, Renoir', *La France*, 8 December 1884

Mirbeau, O., 'Impressions d'art', *Le Gaulois*, 16 June 1886

Mirbeau, O., and others, *Renoir*, Paris 1913

Mithouard, A., 'M. Renoir et le printemps', in *Les Pas sur la terre*, Paris 1908

Moncade, C. L., de, 'Le Peintre Renoir et le Salon d'Automne', *La Liberté*, 15 October 1904

Monneret, S., *L'Impressionnisme et son époque*, I, Paris 1978; II, 1979; III, 1980; IV, 1981

Montifaud, M. de, 'Exposition du boulevard des Capucines', *L'Artiste*, 1 May 1874

Montifaud, M. de, 'Salon de 1877', *L'Artiste*, May 1877

Moore, G., *Reminiscences of the Impressionist Painters*, Dublin 1906

Moreau-Vauthier, C., *Comment on peint aujourd'hui*, Paris 1923

Morel, H., 'P.-A. Renoir', *Le Réveil*, 2 July 1883

Muther, R., *Modern Painting*, 3 volumes, London 1895–6

Natanson, T., 'Renoir', *Revue blanche*, 15 June 1896; partly reprinted as 'Renoir il y a cinquante ans', in *Peints à leur tour*, Paris 1948

Natanson, T., 'De M. Renoir et de la Beauté', *Revue blanche*, 1 March 1900

Natanson, T., 'Renoir', in *Peints à leur tour*, Paris 1948

New York, Duveen Galleries, *Renoir Centennial Loan Exhibition*, 1941

New York, Metropolitan Museum of Art, *French Paintings, III, XIX–XX Centuries*, catalogue by C. Sterling and M. M. Salinger, 1967

New York, Wildenstein, *Renoir*, exhibition catalogue by D. Wildenstein, 1950

New York, Wildenstein, *Renoir*, foreword by C. Durand-Ruel, 1969

New York, Wildenstein, *Renoir, the Gentle Rebel*, 1974

Niculescu, R., 'Georges de Bellio, l'ami des impressionnistes', *Paragone*, nos. 247 and 249, 1970

Noutous, J., 'Histoire anecdotique de la semaine', *La Vie moderne*, 7 April 1883

Pach, W., 'Pierre Auguste Renoir', *Scribner's Magazine*, May 1912; largely reprinted in *Queer Thing, Painting*, New York 1938

Pach, W., *Renoir*, New York 1950

Pach, W., 'Renoir, Rubens and the Thurneyssen Family', *Art Quarterly*, Autumn 1958

Paris, Bernheim-Jeune, *L'Art Moderne et quelques aspects de l'art d'autrefois, 163 planches d'après la collection privée de MM. J. et G. Bernheim-Jeune*, with poems by H. de Régnier and texts by other authors, Paris 1919

Paris, Centre Culturel du Marais J.-M. G., *Claude Monet au temps de Giverny*, 1983

Paris, Galerie d'art Braun & Cie, *L'Impressionnisme et quelques précurseurs, Bulletin des expositions, III*, 1932

Paris, Galerie d'art Braun & Cie, *Renoir, Bulletin des expositions, 2me année, I*, 1932

Paris, Galerie Georges Petit, *Collection H. V[ever] Catalogue de Tableaux Modernes*, sale catalogue with preface by L. Roger-Milès, 1–2 February 1897

Paris, Galerie Georges Petit, *Collection du feu M. Paul Berard, Tableaux modernes*, sale catalogue with preface by L. Roger-Milès, 8–9 May 1905

Paris, Galerie Georges Petit, *Collection Jules Strauss*, sale catalogue, 15 December 1932

Paris, Grand Palais, *Centenaire de L'Impressionnisme*, preface by H. Adhémar and R. Huyghe, exhibition catalogue by A. Distel, M. Hoog, C. S. Moffett, 1974

Paris, Grand Palais, Ottawa, National Gallery of Canada, and San Francisco, Palace of the Legion of Honor, *Fantin-Latour*, exhibition catalogue by D. Druick and M. Hoog, 1982–3

Paris, Grand Palais, and New York, Metropolitan Museum of Art, *Manet*, exhibition catalogue by F. Cachin, C. S. Moffett and J. W. Bareau, 1983

Paris, Hôtel Drouot, *Tableaux composant la Collection Maurice Gangnat*, sale catalogue with essays by R. de Flers and E. Faure (reprinting Faure 1925), 24–25 June 1925

Paris, Hôtel Drouot, Rive gauche, *Vente de manuscrits*, 16 February 1979, 11 June 1980 (letters from Renoir to Berard)

Paris, Musée National du Louvre, *Catalogue des peintures, pastels, sculptures impressionnistes*, preface by G. Bazin, catalogue by H. Adhémar, M. Dreyfus-Bruhl, M. Sérullaz, M. Beaulieu, 1958

Paris, Musée de l'Orangerie, *Renoir*, exhibition catalogue by C. Sterling, 1933

Paris, Orangerie des Tuileries, *Collection Jean Walter – Paul Guillaume*, 1966

Paris, Musée de l'Orangerie, *Catalogue de la collection Jean Walter et Paul Guillaume*, catalogue by M. Hoog and H. Guicharnaud, 1984

Paris, Réunion des Musées Nationaux, *Chefs d'oeuvre de la peinture française dans les Musées de Leningrad et de Moscou*, 1965–6

Perruchot, H., *La Vie de Renoir*, Paris 1964

Pickvance, R., 'Monet and Renoir in the mid-1870s', in *Japonisme in Art, an International Symposium*, edited by Yamada Chisburō, Tokyo 1980

Pissarro, C., *Lettres à son fils Lucien*, edited by J. Rewald, Paris 1950

Pissarro, C., *Correspondance, I, 1865–1885*, edited by J. Bailly-Herzberg, Paris 1980

Pothey, A., 'Exposition', *La Presse*, 31 March 1876

P[othey], A., 'Beaux-Arts', *Le Petit parisien*, 7 April 1877

Poulain, G., *Bazille et ses amis,* Paris 1932

Prouvaire, J., 'L'Exposition du boulevard des Capucines', *Le Rappel,* 20 April 1874

Py, B., letter in *La Peinture,* 15 March 1972

Reff, T., 'Copyists in the Louvre, 1850–1870', *Art Bulletin,* December 1964

Régnier, H. de, *Renoir, peintre du nu,* Paris 1923

Reiley Burt, M., 'Le pâtissier Murer', *L'Oeil,* December 1975

Reinach, S., 'L'Aphrodite de Cnide et la Baigneuse au Griffon', *Revue archéologique,* May-June 1913

Renoir, C., 'Souvenirs sur mon père', in *Seize aquarelles et sanguines de Renoir,* Paris 1948

Renoir, C., 'Adieu à Gabrielle de notre enfance', *Paris-Match,* 14 March 1959

Renoir, C., 'Renoir, sa toile à l'ombre d'un parasol', in [Anon.], *Renoir aux Collettes,* I, Cagnes 1960 and subsequent editions

Renoir, C., 'En le regardant vivre', in *Renoir,* by P. Cabanne and others, Paris 1970

Renoir, E., 'Cinquième exposition de la Vie moderne', letter addressed to M. Emile Bergerat, *La Vie moderne,* 19 June 1879; reprinted in Venturi 1939, II

Renoir, E., 'Un tour aux environs de Paris', *La Vie moderne,* 25 August, 1, 15, 29 September, 6, 13 October 1883

Renoir, J., *Renoir,* Paris 1962 (English edition, *Renoir, My Father,* London 1962)

Renoir, P.-A., *Carnet de dessins, Renoir en Italie et en Algérie (1881–1882),* preface by A. André, introduction by G. Besson, Paris 1955

Rewald, J., 'Auguste Renoir and his Brother', *Gazette des Beaux-Arts,* March 1945

Rewald, J., *Renoir Drawings,* New York 1946

Rewald, J., 'Extraits du journal inédit de Paul Signac, II, 1897–1898', *Gazette des Beaux-Arts,* April 1952

Rewald, J., 'Chocquet and Cézanne', *Gazette des Beaux-Arts,* July–August 1969

Rewald, J., *The History of Impressionism,* 4th edition, New York and London 1973

Rey, R., 'Renoir à l'Ecole des Beaux-Arts', *Bulletin de la Société d'Histoire de l'Art Français,* 1926

Rey, R., *La Renaissance du sentiment classique,* Paris 1931

Rivière, G., 'A M. le Rédacteur du Figaro', *L'Impressionniste,* I, 6 April 1877; reprinted in Venturi 1939, II

Rivière, G., 'L'Exposition des impressionnistes', *L'Impressionniste,* I, 6 April 1877; reprinted in Venturi 1939, II

Rivière, G., 'Les Intransigeants et les impressionnistes, souvenirs du Salon Libre de 1877', *L'Artiste,* 1 November 1877

Rivière, G., *Renoir et ses amis,* Paris 1921

Rivière, G., 'Renoir', *L'Art vivant,* 1 July 1925

Rivière, G., 'Les Impressionnistes chez eux', *L'Art vivant,* 15 December 1926

Rivière, G., 'Les Enfants dans l'oeuvre et la vie de Cézanne et de Renoir', *L'Art vivant,* 1 September 1928

Rivière, G., *Mr. Degas, bourgeois de Paris,* Paris 1935

Robida, M., *Le Salon Charpentier et les impressionnistes,* Paris 1958

Robida, M., *Les grandes heures du Salon Charpentier,* Paris 1958

Robida, M., *Renoir, enfants,* Lausanne 1959

Roger-Ballu, 'L'Exposition des peintres impressionnistes', *Les Beaux-Arts Illustrés,* 22–23 April 1877

Roger-Ballu, 'Le Salon de 1879, II, La Peinture', *Revue Politique et Littéraire, revue des cours littéraires (2ème série), (La Revue Bleue),* 7 June 1879

Roger Marx, C., *Renoir,* Paris 1937

Rouart, D., *Correspondance de Berthe Morisot,* Paris 1950

Rouart, D., *Renoir,* Geneva 1954

Rouart, D., *The Unknown Degas and Renoir in the National Museum of Belgrade,* London and New York 1964

Rouault, G., *Souvenirs intimes,* Paris 1926; reprinted in *Sur l'art et sur la vie,* Paris 1971

Roux-Champion, J. V., 'Dans l'intimité de Renoir aux Collettes', *Figaro littéraire,* 9 July 1955

Scheyer, E., 'Jean Frédéric Bazille – The Beginning of Impressionism', *Art Quarterly,* Spring 1942

Schneider, F., 'Lettres de Renoir sur l'Italie', *L'Age d'or,* I, 1945

Schnerb, J. F., 'Paysages par Claude Monet et Renoir', *La Grande Revue,* 10 June 1908

Schnerb, J. F., 'Visites à Renoir et à Rodin, extraits des carnets inédits', *Gazette des Beaux-Arts,* April 1983

Sébillot, P., 'L'Exposition des impressionnistes', *Le Bien public,* 7 April 1877

Sert, M., *Misia,* Paris 1952

Silvestre, A., 'Exposition de la rue Le Peletier', *L'Opinion,* 2 April 1876

Silvestre, A., 'Demi-Dieux et simples mortels au Salon de 1879', *La Vie moderne,* 29 May 1879

Silvestre, A., 'Septième exposition des artistes indépendants', *La Vie moderne,* 11 March 1882

Silvestre, A., 'Exposition des oeuvres de P. A. Renoir', *La Vie moderne,* 14 April 1883

Silvestre, A., *Au pays des souvenirs,* Paris 1892

Sisley, C., 'The Ancestry of Alfred Sisley', *Burlington Magazine,* September 1949

Stein, L., *A. Renoir,* Paris 1928

Sutton, D., 'An Unpublished Sketch by Renoir', *Apollo,* May 1963

Syène, F. C. de, 'Salon de 1879, II', *L'Artiste,* July 1879

Tabarant, A., 'Le Peintre Caillebotte et sa collection', *Bulletin de la vie artistique,* 1 August 1921

Tabarant, A., 'Suzanne Valadon et ses souvenirs de modèle', *Bulletin de la vie artistique,* 15 December 1921

Tabarant, A., 'Couleurs', *Bulletin de la vie artistique,* 15 July 1923

Terrasse, A., 'Renoir', in *Encyclopedia Universalis,* Paris 1972

Terrasse, C., *Cinquante portraits de Renoir,* Paris 1941

Thiébault-Sisson, 'Une Histoire de l'impressionnisme', *Le Temps,* 17 April 1899

Thiébault-Sisson, 'Auguste Renoir et son oeuvre', *Le Temps,* 15 December 1919

Tuleu, J., *Souvenirs de famille,* [Paris] 1915

Valéry, P., 'Souvenirs de Renoir', *L'Amour de l'art,* February 1921

Vassy, G., 'L'Exposition des impressionnistes', *L'Evènement,* 6 April 1877

Vauxcelles, L., 'Collection de M. P. Gallimard', *Les Arts,* September 1908

Vauxcelles, L., 'Dessins de Renoir', *L'Art moderne,* 14 July 1912

Venturi, L., *Les Archives de l'impressionnisme,* 2 volumes, Paris 1939

Verhaeren, E., *Sensations,* Paris 1927

Vollard, A., *Tableaux, Pastels & Dessins de Pierre-Auguste Renoir,* 2 volumes, Paris 1918

Vollard, A., 'La Jeunesse de Renoir', *Renaissance de l'art français et des industries de luxe,* May 1918

Vollard, A., *La Vie et l'Oeuvre de Pierre-Auguste Renoir,* Paris 1919; reprinted as *Renoir,* Paris 1920; and in Vollard 1938

Vollard, A., 'Renoir sculpteur', *Beaux-Arts,* 12 October 1934

Vollard, A., *Recollections of a Picture Dealer,* Boston 1936 (French edition, *Souvenirs d'un marchand de tableaux,* Paris 1937)

Vollard, A., *En écoutant Cézanne, Degas et Renoir,* Paris 1938

Warnod, A., 'M. Pierre Renoir évoque pour nous le souvenir de son père, à propos d'une exposition des sculptures de Renoir', *Le Figaro,* 23 October 1934

White, B. E., 'Renoir's Trip to Italy', *Art Bulletin,* December 1969

White, B. E., 'Renoir's Sensuous Women', in *Woman as Sex Object,* edited by T. Hess and L. Nochlin, New York 1972

White, B. E., 'The *Bathers* of 1887 and Renoir's Anti-Impressionism', *Art Bulletin,* March 1973

Widman, D., 'Prins Eugen', *Gazette des Beaux-Arts,* May–June 1983

Wildenstein, D., *Claude Monet, Biographie et catalogue raisonné,* Lausanne and Paris, I, 1974; II and III, 1979

Williamstown, Sterling and Francine Clark Art Institute, *Exhibit Six, Impressionist Paintings,* [1956]

Wolff, A., 'Le Calendrier parisien', *Le Figaro,* 3 April 1876

Wright, W. H., *Modern Painting, Its Tendency and Meaning,* New York and London 1915

Wyzewa, T. de, 'Pierre-Auguste Renoir', *L'Art dans les deux mondes,* 6 December 1890; reprinted with 'postscriptum (1903)' in *Peintres de jadis et d'aujourd'hui,* Paris 1903

Zervos, C., 'Idéalisme et naturalisme dans la peinture moderne, III, Renoir', *Cahiers d'art,* 1928

Zola, E., 'Notes parisiennes', *Le Sémaphore de Marseille,* 19 April 1877; reprinted in Zola 1970

Zola, E., 'Le Naturalisme au Salon', *Le Voltaire,* 18–22 June 1880; reprinted in Zola 1970

Zola, E., *Mon Salon, Manet, Ecrits sur l'art,* edited by A. Ehrard, Paris 1970

White, B. E., *Renoir, His Life, Art, and Letters,* New York 1984, was published after this catalogue went to press.

Photographic credits

The publishers wish to thank the owners of works reproduced in this catalogue for kindly granting permissions and for providing photographs.

The publishers have made every effort to contact all holders of copyright works. All copyright-holders we have been unable to reach are invited to contact the publishers so that a full acknowledgment may be given in subsequent editions.

Photographs have been supplied by owners and by those listed below:

Colour

Courtesy Acquavella Galleries Inc., New York: no. 115
Jörg P. Anders: nos. 8, 74
E. Irving Blomstrann: no. 114
Will Brown Photographer: no. 101
Photograph by A. C. Cooper Ltd, London, courtesy Christie's: no. 43
Prudence Cuming Associates Ltd: no. 24
Documentation photographique de la Réunion des musées nationaux:
 nos. 2, 6, 33, 36, 39, 40, 55, 56, 68, 69, 89, 90, 91, 93, 94, 97, 104, 106, 110, 116, 125
Reproduced by permission of the Syndics of the Fitzwilliam Museum, Cambridge: nos. 25, 49
Fotografoval Vladimir Fyman: no. 34
Colorphoto Hinz Allschwil-Basel: no. 10
L. Hossaka: nos. 5, 15, 53, 80, 111
Ralph Kleinhempel GmbH & Co., Hamburg: no. 3
Studio Bernard Lontin, La Tour de Salvagny: no. 96
Studio Lourmel, Paris: nos. 22, 27, 66, 88, 113
Geraldine T. Mancini, New Haven: no. 82
Miet Museum (Fotographie): no. 41
Museum of Fine Arts, Boston: no. 7
Courtesy Museum of Fine Arts, St Petersburg, Florida: no. 79
Reproduced by courtesy of The Trustees of The National Gallery, London: nos. 47, 58
Otto Nelson, New York: no. 112
Editions Nichido: no. 119
Courtesy Philadelphia Museum of Art: no. 103
Thomas Prader, Photograph, Maur: no. 83
Gordon H. Roberton, A. C. Cooper Ltd, London: no. 26
Tom Scott Fine Art Photographer, Edinburgh: no. 16
Courtesy Sotheby Parke Bernet, New York: no. 98
Studio Service, Bonn: no. 9
Swedish National Art Museums: nos. 4, 13
Joseph Szaszfai, Branford, Conn.: no. 23
Eileen Tweedy: no. 117
Malcolm Varon, NYC: no. 18
Rodney Wright-Watson Photography: no. 65

Black and white

Courtesy Acquavella Galleries Inc., New York: no. 115
Jörg P. Anders: nos. 8, 74
Photograph © 1985 The Barnes Foundation, Merion Station, Pa 19066, USA: p. 251 fig. b, p. 252 figs. e and f, no. 81 fig. a, no. 82 fig. a, p. 269 fig. a
Bibliothèque Nationale, Paris: p. 181 figs. g, h, i, p. 312 (Renoir at home)
E. Irving Blomstrann: no. 114
Lee Brian, Palm Beach, Florida: no. 100
Will Brown Photographer, 1978: no. 101
Photograph by A. C. Cooper Ltd, London, courtesy Christie's: no. 43
Prudence Cuming Associates Ltd: nos. 24, 59
Documentation photographique de la Réunion des musées nationaux:
 Frontispiece, nos. 2, 6, 33, 36, 39, 40, 55, 56, 68, 69, 89, 90, 91, 93, 94, 97, 104, 106, 110, 116, 125, p. 179 figs. a and b, no. 6 fig. b, no. 9 fig. a, no. 18 fig. a, no. 20 fig. a, no. 52 fig. a, no. 72 fig. a, p. 242 fig. b, p. 250 fig. a, p. 251 fig. c, no. 95 fig. a, p. 269 fig. b, no. 117 fig. a, p. 296, p. 298 (Monet)
A. E. Dolinki Photographic, San Gabriel, California: p. 181 fig. j

Photographie Durand-Ruel, Paris: nos. 27, 66, 88, 113, p. 179 fig. c, nos. 12 and 13 fig. b, no. 29 fig. a, nos. 89, 90 and 91 fig. b
Reproduced by permission of the Syndics of the Fitzwilliam Museum, Cambridge: nos. 25, 49
Photo Giraudon: no. 6 fig. a
Kunstmuseum Basel: no. 10
Laboratoire de Recherche des Musées de France: p. 180 fig. e
Studio Lourmel, Paris: no. 22
Geraldine T. Mancini, New Haven: no. 82
Robert E. Mates: no. 37
Eric Mitchell, 1984: no. 103
Museum of Fine Arts, Boston: no. 7
Courtesy Museum of Fine Arts, St Petersburg, Florida: no. 79
Reproduced by courtesy of The Trustees of The National Gallery, London: nos. 47, 58
Thomas Prader, Photograph, Maur: no. 83
Rheinisches Bildarchiv, Cologne: no. 9
Tom Scott Fine Art Photographer, Edinburgh: no. 16
Courtesy Sotheby Parke Bernet, New York: no. 98
Swedish National Art Museums: nos. 4, 13
Joseph Szaszfai, Branford, Conn.: no. 23
Courtesy E. V. Thaw & Co. Inc., New York: no. 112
Eileen Tweedy: no. 117
Liselotte Witzell: p. 181 fig. f
Rodney Wright-Watson Photography: no. 65